DAVID SMITH

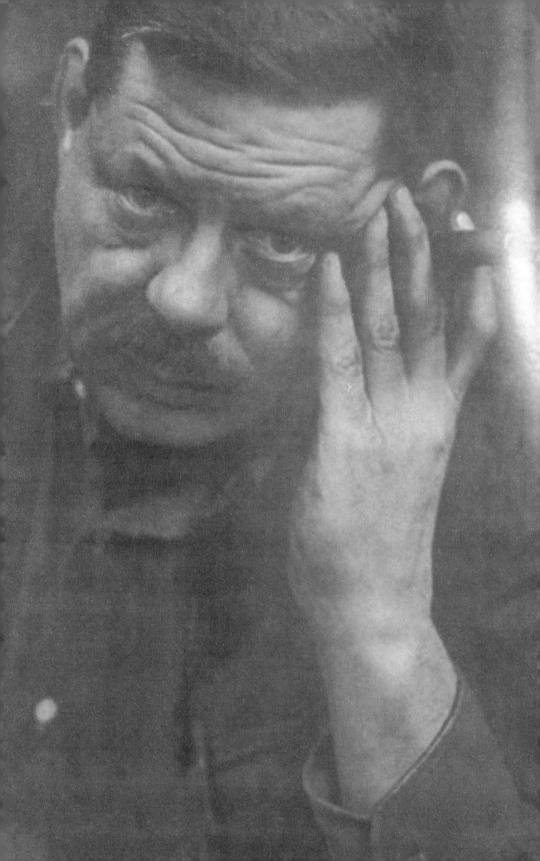

DAVID SMITH

The Art and Life of a Transformational Sculptor

MICHAEL BRENSON

Farrar, Straus and Giroux

New York

Farrar, Straus and Giroux
120 Broadway, New York 10271

Illustration credits can be found on pages 837–842.

Library of Congress Control Number: 2022021738
ISBN: 978-0-374-28146-5

Our books may be purchased in bulk for promotional, educational, or business
use. Please contact your local bookseller or the Macmillan Corporate and
Premium Sales Department at 1-800-221-7945, extension 5442, or by email at
MacmillanSpecialMarkets@macmillan.com.

www.fsgbooks.com
www.twitter.com/fsgbooks • www.facebook.com/fsgbooks

10 9 8 7 6 5 4 3 2 1

For Sharon

Contents

Author's Note

David Smith was part of an Abstract Expressionist generation that was convinced of the destructiveness of words. They believed that most critics and aestheticians, a category for which Smith felt scathing contempt, violated art by explaining and reducing it. By approaching it through the conventions of the past, these authorities on art could not possibly do justice to the potential of new art to reimagine experience. Regardless of their suspicion and even hatred of words, however, Smith and almost all his Abstract Expressionist painter friends were adept with language. They were well read and many were allied with poets. Given the burgeoning of the culture industry and the fascination, if not intoxication, of mass culture with them, these artists *had* to speak for themselves. Taken together, the talks and writings of Philip Guston, Hans Hofmann, Willem de Kooning, Robert Motherwell, Barnett Newman, Mark Rothko, Smith, Jack Tworkov, and others provide a powerful record of how these artists thought and of how they wanted their work to be engaged.

Smith produced a wealth of written material. The 2018 anthology, *David Smith: Collected Writings, Lectures, and Interviews*, is 450 pages. Like his art, Smith's talks and essays have a deceptive immediacy. On every public occasion, Smith was very aware of what he wanted and did not want to say. He knew how to make a direct connection with listeners and readers but valued poetic density and had a gift for knowing how to

lodge a reference or idea in the reader's mind in such a way that it would suddenly surface in front of one of his works. The more time one spends with his writings, the more revealing and generous they seem.

Many of the important writings in the 2018 anthology were talks. Jean Freas, Smith's second wife, who lived with him from 1953 to 1958, explained the agonizing process through which many of them emerged:

> I would write down what he said, I would type up these notes, and then I would listen to him . . . I would make a cleaner copy. And then he would say, "No, that *isn't* what I meant," and this would go on for, like, twenty hours. Then for two hours he'd be on the road, going wherever it was. And I would get exhausted, just exhausted. And he would get so mad, and he always would cry at some point, and he'd always say, [singing], "I've got but one song to sing," and he'd be crying. And if I suggested changing one word, he'd be in a rage over that . . . and he was right. I was wrong, he was right. Because his style was so inimitable, and he didn't want one word changed.[1]

Smith did return to certain ideas and themes, and his writings can seem repetitive and bombastic; Freas would occasionally and rightly criticize him for pompousness. But his remark about having but one song to sing reveals more about patterns of thought during particular periods and his aversion to repeating himself in his art than it does about the monotony of his speaking events. Smith did not want to be codified. He did not want to become a capitalist brand.

I have used the 2018 anthology as the primary source for Smith's published texts. The editor, Susan J. Cooke—from 2002 to 2018 the associate director of the Estate of David Smith—sorted through the various versions of talks and essays. She corrected spelling and grammatical mistakes while respecting Smith's meaningful idiosyncrasies—for example, his preference for "tobe" and "todo," rather than "to be" and "to do," and for "bot," "brot," and "thot" instead of "bought," "brought," and "thought." When including excerpts from Smith's notebooks, Cooke occasionally reproduced the actual page, by so doing revealing that

Smith's mantra, "No rules!," applied not just to his visual art but also to his written work. He could write over an image, all over a page, or across and upside down as well as right side up, which is also how he might draw images on a page.

After World War II, and particularly after 1950, the year Dorothy Dehner, his first wife, left him, Smith was a profusive letter writer. Bolton Landing, New York, his home after 1940, was more than two hundred miles from New York City, and into the 1960s he remained in contact with friends primarily through the mail. When he wrote to curators and museum directors, for the most part he did so with warm professionalism. With friends he often dashed off letters, sometimes writing to three or four people in a day, mentioning his work, reflecting and gossiping, communicating with urgency and sarcastic or jaded humor his hopes, moods, opinions, and ideas. Smith wrote extensively and expansively to Marian Willard, his dealer for eighteen years; Freas; Lois Orswell, his most important collector; and the painters Herman Cherry, Kenneth Noland, Helen Frankenthaler, and Robert Motherwell. He needed to write these letters and needed to hear from them. His candor is a blessing, providing intimate access to his heart and mind. The painter Grace Hartigan had strong disagreements with Smith, including about his views of women, but she liked and trusted him in part because of his candor. "I thought he was an absolutely authentic man and an absolutely authentic artist in a world in which you've got a lot of phonies," she said. "He rang true all the time."[2]

In his letters, as in his art, Smith took liberties. He could write structurally "normal" letters but he was more or less indifferent to grammar, and he was both a bad and an indifferent speller. Sometimes his misspellings are playful. Some of his misspelling of names can be intentionally mocking, but others seem inattentive or careless; he could misspell names he gave his daughters. Although his grammar is almost always coherent, meaning that his sentences and thoughts are easy to follow, he frequently used dashes rather than periods. Sentences can start, keep going, and end with a period, then a new sentence begins another flow, and who could predict when the next period would appear. How he joined words can never be taken for granted. In contractions, he preferred to include an "e"—as in "diden't," "doesen't," and "coulden't"—and often

omitted apostrophes: "Ill," "Im," "Ive," "dont." He uses "tobe," "todo," "bot," "brot," and "thot" in his letters as well as in his essays. While his mistakes and eccentricities can be jarring, rather than correcting grammar and repeatedly pointing out that mistakes in the excerpts were in fact in the letters, I have not included "[sic]" and left the excerpts as is.

While Dorothy Dehner's letters are cleaner than Smith's, they contain their own eccentricities of grammar and spelling. I've left her excerpts verbatim as well. Dehner's letters from the 1930s and '40s were, of course, written decades before email and before people could rely on telephones for extended personal exchange. Dehner shared information, joys, fears, gossip, and stories with their close friends Lucille Corcos and Edgar Levy, who lived in New York City and then in New City, just as Corcos shared news and stories with Dehner and Smith. Some of Dehner's letters are handwritten, some typed; like Freas later, she typed some of Smith's professional letters. Many of her letters are novelistic. They're filled with personality and don't deserve to be invaded with "[sic]."

For the catalog of his spring 1947 show at the Willard Gallery, Smith sent Willard three prose poems: "The Landscape," "Spectres Are," and "Sculpture Is." Mixing biography, geological, and psychoanalytical study, political and personal anger, observation and dream, Ancient Near Eastern images and myths, and much more, the poems provide a portrait of an artist who is direct, elusive, shrewd, irrepressible, and brilliant. Willard did not pretend to fully understand the texts but was happy to have them. In her view they provided a "TRUE picture of DAVID SMITH 1947," and she promised not to cut or change them in any way.[3]

In this book's search for a true picture of David Smith, the multiple aspects of the man and his art must be in play. The parts of him that shock must be present along with the charisma of his art and person, his genius for work, and his breathtakingly fertile mind. In any book, tone and balance are defining challenges, but this is particularly true when writing about someone who was fond of his invented verb "uninhibit" and given to extremes, and who for art's sake was willing to cultivate imbalance. I would no more think of modifying words and stories describing behavior about which the reader needs to know than I would of avoiding aspects of Smith's work because I am not yet capable of writing fully about them. Even as I am on every page writing with the reader

in mind, my first responsibilities are to Smith and his work, to art and sculpture, to myself and my histories, and to the community of people, alive and dead, who have devoted months and years to thinking about David Smith. It is the unknowable totality of his art and life that I am after.

DAVID SMITH

Introduction

I first encountered David Smith's work in 1967, in a graduate art history seminar on modern sculpture at Johns Hopkins University. The seminar began with Rodin and spent much of the semester on the present. Modern sculpture was barely a field; living artists were rarely taught in art history departments then. During this semester of discovery, Smith was a revelation. He had died less than two years earlier, and his welded steel sculptures had a haunting immediacy. The ones that I remember most vividly are not the *Cubis*, his best-known works, or the *Tanktotems* and *Zigs*, two of his other wondrous postwar series, or the *Wagons*, which to the sculptor Robert Murray were "like monstrous Etruscan toys, big-wheeled chariots . . . probably the best toys ever made."[1] Rather, I recall small sculptural tableaux from the late 1930s and mid-1940s, miniature theaters with signs of domestic dissolution, potent dream objects, and hints of forbidden knowledge. The sculptures were abstract and open, everything in them exposed, but they seemed to be teeming with secret stories.

While I was researching a doctoral dissertation on the Cubist and Surrealist work of Alberto Giacometti, writings on Smith kept showing up in many of the same publications in which studies of Giacometti appeared. In the 1980s, as an art critic for *The New York Times*, I saw several Smith shows and became familiar with the thirteen Smith sculptures

that are foundational to the Storm King Art Center, the great sculpture park an hour north of New York City. In 1990, I reviewed a Smith gallery show for the *Times'* Arts & Leisure section and five years later wrote a catalog essay for "David Smith: To and From the Figure," at the Knoedler Gallery. This led to my first visit to Bolton Landing, in the Adirondacks by Lake George, whose most renowned citizen is Smith. Thirty years after his death, a few sculptures remained on his hillside, which seemed animated by Smith's life and spirit. Biography was emerging as the literary form to which I was most drawn, the one that would best allow for approaching art from multiple perspectives while holding at the center the mysterious reciprocity between an artist's work and life. Smith's sculpture mesmerized me, and no biography on him existed. He needed one.

Soon after beginning this biography, I sensed the magnitude of the project and had a clear intuition that it would take every intellectual and emotional resource I had. For decades Smith was widely recognized as America's greatest sculptor, and some art historians consider him America's greatest artist. My first interview for the book, in 2001, was with the painter Kenneth Noland, whose first words after we sat down to talk were "No one has yet taken the measure of David."[2] When interviewed for his 1969 David Smith retrospective at the Solomon R. Guggenheim Museum, the curator Edward F. Fry said that Smith's was "the most extraordinary artistic career this country has ever known."[3] Clement Greenberg and Rosalind E. Krauss, two of the most influential American art critics, wrote extensively on Smith, and both communicated the singularity and difficulty of his work and person.

Smith belonged to an Abstract Expressionist generation that believed that after the Great Depression, two world wars, concentration camps, and the atomic bomb, human beings had better find ways to face the entire spectrum of impulses and desires that existed within them. "'Humanism' is a useless word in my time," Smith wrote to the sculptor and critic Sidney Geist in 1962, commenting on one of the most sentimentalized and moralistic words of the 1950s, one used to attack abstract artists for not being sufficiently accessible and referential. "I know of nothing that is non-human. Everything goes through the eyes of the human . . . Every response is human; there is no response that is not human."[4] He

was not going to decide that this emotion, thought, or act was human and that one wasn't. Art had to make room for all of it while still moving forward, toward a future that could both remember and transform.

From the time Smith fled the Midwest and arrived in New York City at twenty, in 1926, to become an artist, the most talented people he met were drawn to him. He was curious and quick and physically appealing, with an instinctive sense for what was most vital in art and in life, and the courage of his convictions. He could be enchantingly inventive and bawdily funny, and he liked having a good time, whether that meant raising hell on nighttime prowls through lower Manhattan; listening to jazz at his beloved Five Spot; shooting and cooking game for city friends; organizing and hosting extravagant birthday parties for Rebecca and Candida, his daughters; hanging out on tropical beaches with Dorothy Dehner, his first wife, herself an artist; visiting the painters Helen Frankenthaler and Robert Motherwell in Manhattan or Provincetown; or uncorking bottles of wine in a bar and gossiping and talking art into the night.

Almost everyone who spent time with him was aware of his intelligence and will, and his capacity for work. Beneath his occasionally gruff and coarse mountain-man persona was an artist of startling erudition. With little formal education, having dropped out of college after his freshman year, he read widely not just in the art of almost all times and places, but in anthropology, archaeology, psychoanalysis, and theater. Whichever metal he used—steel, bronze, or silver—he studied its properties and history exhaustively. He could fix or build just about anything. A big man, a shade under six foot two—almost everyone remembered him as two to three inches taller—with thick shoulders and back, he had Herculean strength and stamina. His friends knew of his determination to continue surpassing himself and delighting others, pushing his art— and sculpture as a field—to places it had never been.

His friends were also aware of his capacity for grievance, pettiness, and self-pity. In his last years his address book included a "shit list": when he got angry at someone, he would cross out their name.[5] Friends knew and at times were alarmed by the growing severity of his loneliness and sensed what the sculptors Beverly Pepper[6] and Anne Truitt[7] recognized

as his sadness. Motherwell referred to "the black abyss" in Smith and in himself.[8] His temper could be volcanic. Few people saw actual evidence of his physical violence, but all his friends heard him rant and rave and either sensed or knew that he was capable of disturbing behavior.

Smith's wives struggled with his extremes. Dehner, who was married to Smith from 1927 to 1952, said in an interview, "His strong sense of injustice could be also wreaked on someone else. He could project the violence that he suffered on another person as well, not only verbal but physical, and he was a very violent man, exceedingly." But, she added, he was also "at times marvelously sunny! Why do you think I stayed up there" all those years? "Marvelous! Just wonderful. Full of gaiety, full of tenderness, but with unreconcilable extremes of temperament. And his angers and his rages were monumental."[9]

"The man was complicated," Jean Freas, the mother of Rebecca and Candida, who left Smith in 1958 after five years of marriage, wrote. "Salty and bombastic, jumbo and featherlight, thin-skinned and Mack Truck. And many more things."[10] She feared "his lightning changes of mood" and reveled in his vitality and capacity for attention.[11] "I have never experienced a walk in the woods so fully with anyone else . . . He knew where to look for the deer-yard in that battered copse where starving deer hid. In those woods he would hunt for trailing arbutus, blooming regardless of snow-cover, which he would wrap in moss and then in brown paper, and post to the city . . . That was his rite of spring."[12]

In 1945, after studying Joyce's *Finnegans Wake*, for Abstract Expressionists a watershed book, Smith wrote to his dealer, Marian Willard: "I always thot I understood Joyce pretty well—and I have a tendency to think in six different ways of association of objects—like I interpret him."[13] Smith's mind could not just turn in a flash but also move in several directions at once. His work is startlingly unpredictable, often moving not from point A to point B, but from A to G, or A to Z. It is not merely that his sculpture has multiple points of view—all sculpture in the round does—but that the movement from one point of view to the next can be radically unexpected. Krauss, whose career as a critic and art historian began with her PhD thesis and monograph on Smith, pointed out that moving from one of Smith's sculptural points of view

to the next can be like encountering an entirely different sculpture.[14] It's not so much that transition is in crisis; it ceases to exist. Previous notions of sculptural coherence are blown up. "I try for imbalance," Smith told an audience of artists in 1956.[15] In one welded steel sculpture after another, he engineered what seems to be an impossible equilibrium. His sculpture is never this or that; it is this *and* that, and that . . . It appeals to vision, it depends on sight, but what you see seems to be constantly shifting and you cannot be sure of what you are looking at.

Beginning in the early 1930s, Smith worked with found objects, things that had defined functions and histories but "that kind of miss their use in culture—or have exhausted their use."[16] These objects became symbols and carriers of transformation. In Smith's sculpture, the identities of the found objects become fluid. After the war, almost every form Smith incorporated or invented seems to have not just memory but also, remarkably, something like its own unconscious, within which, pushing at the surface, is an indescribable density—an utterance—of desires, voices, and histories. For Smith, "freedom"—he used the word repeatedly—referred not only to his own way of creating but also to viewers, who were welcome to bring their own associations without fear of being wrong. Acknowledging every person's subjectivity without judgment was for Smith a political imperative and a new possibility for how to think about sculpture. He wrote and spoke constantly about his work but adamantly refused to control its interpretation. It is whatever you see in it, he told residents of Bolton Landing who asked him to explain its meaning. He intended his work to be available on multiple levels and believed that all ways of entering it were welcome. For those who wanted to linger, his work offered journeys of discovery, new combinatory possibilities, and rituals of conflict and release.

For decades David Smith's stature was a given. As early as 1943, Clement Greenberg, concluding a review of an inconsequential group sculpture exhibition, wrote, "Smith is thirty-six. If he is able to maintain the level set in the work he has already done . . . he has a chance of becoming one of the greatest of all American artists."[17] Four years later Greenberg wrote that Smith was "already the greatest sculptor this country has produced."[18] He would write that Smith had given American

sculpture a new authority, making it for the first time a player on the international artistic stage, showing what was required for sculpture to raise itself to the level of painting.

Many art writers—including Elizabeth McCausland, Eugene C. Goossen, Hilton Kramer, Fairfield Porter, and Frank O'Hara—revered Smith. Part of what distinguishes the Smith literature written during his lifetime is the degree to which critics *wanted* to write about his sculpture, wanted to stamp it with their insights, wanted to be identified with it, and with him. For them, the magnetism of Smith was inseparable from the magnetism of his work. They were fascinated by his constructive imagination; by his projection of a new image of the artist, defined more by the factory than by the studio; and by the way he lived, on a remote hillside—his "outpost," Goossen called it.[19] "What Pollock was doing, living out in The Springs was nothing compared to what David was doing," Smith's second wife, Freas, said.[20] Like almost everyone else who visited Smith after 1950, writers were amazed by the ever-growing, ever-changing fields of sculpture around his house and his shop-studio, in which he invented a new kind of sculptural world, one that seemed to require analogies with writers like Balzac and Victor Hugo, rather than with other sculptors.

Artists also gravitated to him. The British sculptor Anthony Caro brought his Bennington sculpture students to Bolton Landing to be with Smith. Noland explored buying a house in Bolton Landing so he could live near Smith. Frankenthaler and Motherwell were so enamored of Smith that they gave him alone a key to their Manhattan townhouse. The sculptor Anne Truitt said, "I learned a lot from him. Ken Noland learned a lot from him. I think everybody who knew him" learned a lot from him. "His ambition was not for himself," she added. It "was for American art."[21]

Smith was deeply interested in the connection between art and life. He devoured Janet Flanner's *New Yorker* profiles of Pablo Picasso, Georges Braque, and Henri Matisse. He liked the bilingual French art magazine *L'œil*, several of whose articles on artists merged personality, life, and art. In preparation for the one essay he wrote on another artist—in 1955 for *ArtNews*, on the Spanish welded steel sculptor Julio González—Smith spent as much time learning about the man as he did

studying his work. He had to know the biography in order to write about the work. He wrote to the French American painter and printmaker Henri Goetz, speaking of González:

> I'm looking for the gentle intimacies which artists know about each other, and which relate to their work in the unofficial museum way . . . I'd like to know things about his nature, his battle for existence, whether the French gave him his due, how he fared with the dealers . . . the nature of his wife, her sympathy and encouragement, his intimate friends, whether he liked Kandinsky and Mondrian, whether he liked music and what kind, the cafes he went to and with whom he talked art.
>
> He must have been discouraged at times for lack of reception. How he took it, or if he mentioned it. And did he feel that he would eventually be recognised. Was he ever bitter?
>
> How did he keep the workshop going? Materials and gas cost money, more than paint and canvas, as I well know. Did he want tools and materials that he couldn't afford? What kind of sacrifices did his family have to make to keep him at work?[22]

"No one has yet taken the measure of David," Noland said to me. Connecting Smith's epic work to his epic life is a way to begin.

1
Roots

Roland David Smith was born at home in Decatur, Indiana, on March 9, 1906. He was the first child of Golda Stoler and Harvey Martin Smith. Golda, twenty-three, tall and bone thin, was born in Portland, Indiana, about thirty-five miles south of Decatur. Harvey, twenty-four, known by family and friends as Harve, was a strapping six-footer, a true son of Decatur in his resourcefulness and ingenuity. They met in Decatur as teenagers and courted for five years before marrying on June 1, 1905. She became an elementary school teacher; he was a telephone lineman. They were a pious couple, hungry for respect in a proud and ambitious town. In 1881, with a population not yet 2,500 but brimming with entrepreneurial purpose, Decatur incorporated itself as a city. Its heroes were the gritty, indomitable pioneers who had formed it out of wilderness. Tales of frontier hardship and triumph and of tough, tireless, self-reliant men and women who had cut trees, dug wells, drained swamps, raised livestock, buried children and spouses lost to disease, and fought off wild animals haunted Smith's childhood world.

Home was a two-story wood house with an attic on the corner of Jefferson and North Sixth Streets. Its location near the railroad tracks was respectable but not quite middle class. The house was spare, if not severe, with a small porch. The windows were narrowly vertical, almost

Gothic. As throughout Decatur, primary heating came from coal stoves and woodstoves on the ground floor; kerosene stoves typically warmed the bedrooms.

Harve's family was Decatur royalty. Smith would claim that he was the great-great-grandson of Samuel L. Rugg, who was considered the founder of Decatur. Rugg was, in fact, Smith's great-great-*step*-grandfather, but he was still family and pretty much every family member for the next hundred years was eager to claim an ancestral relationship with him and through him partake in Decatur's heroic formational story. Rugg was born in 1805 in Oneida County in upstate New York. After the completion of the Erie Canal in 1825, he was part of a large westward migration. In Cincinnati, he worked in a cotton mill, married, and had a child. He was a blacksmith, one of several among Smith's ancestry. By 1832, Rugg's wife and child were dead, and he made his way by ox team to Indiana, which in 1816 had become the nineteenth state.

In 1835, after finding the land he was looking for beside the St. Mary's River, he petitioned the state legislature to create a separate county. With Thomas Johnson, another Methodist, Rugg recorded the plat in 1836. He named the land Decatur, after Commodore Stephen Decatur (1779–1820), a hero in the War of 1812. An Adams County history book noted: "What to name the blamed thing might have been puzzled some. Not Samuel however . . . Was he not born in 1805, that gallant year when Stephen Decatur made his brilliant exploit in far off Tripoli? . . . Samuel was a Stephen Decatur enthusiast. Decatur to him was a magic word, that had power within itself."[1] It was Stephen Decatur who is credited with the toast "Our country! In her intercourse with foreign nations may she always be right; but our country, right or wrong!"

Rugg not only dreamed big but also made his dreams for Decatur and Adams County reality. By 1854, he was elected state senator. Four years later, he was elected state superintendent of public instruction and moved to the capital in Indianapolis, roughly 170 miles away. He gifted city lots to Decatur's Methodist, Presbyterian, Catholic, and German Reformed churches. He donated the public square on which the courthouse was built. He built roads and promoted the Cincinnati, Richmond and Fort Wayne Railroad. His initiative made it possible for the plank road from St. Mary's, Ohio, to Fort Wayne to pass through Decatur. Building

the twenty-two-mile stretch from Decatur to Fort Wayne involved cutting and laying upward of a million strips of wood over swampy ground.

After fighting in the Civil War, Jay Rugg, Samuel's son from an Indiana marriage, married Catherine Rowley, another of Decatur's legendary pioneers. When Rowley died in 1923, the *Decatur Democrat* ran her obituary on the front page: "Mrs. Catherine Rugg, A Pioneer of County, Dies. Nearly 87 years old. Came to Adams County with Parents When Country Was Still Wilderness."[2] Rowley had eight children from a previous marriage, one of whom, William R. Smith, was Harve's father.

One of Smith's other paternal great-grandfathers was another local legend. In 1835, at age fifteen, William Pendleton Rice—a recent convert to Methodism—arrived in Indiana from Culpeper County, Virginia, with his older brother, Benjamin. "We built a log cabin, one story high, with puncheon floor, clapboard roof and an old-fashioned wooden chimney, with the back and jams of mud," Rice wrote. He likened his and his brother's "experience that first year . . . to that encountered by every pioneer. Nature had been on the ground a good long while, and when we, as the van guard of approaching civilization, undertook to take possession of the small territory which the government said was ours, Ben and I had to fight for it."

The rest of Rice's family followed, including his father, a soldier in the War of 1812. From splitting rails and chopping wood, Rice saved enough money to buy forty acres of land on which he "built a shanty in the year 1842," where he lived with his wife, Frances Rabbit, also from Virginia.[3] In 1865, he purchased a 280-acre farm near Decatur from the man for whom he had worked, eventually moving into town. The Rices had ten children, forty-one grandchildren, and nineteen great-grandchildren. Catherine Smith, David Smith's sister, told Smith's elder daughter, Rebecca, that the county was crawling with relatives. After Rice died at home in 1899, the *Decatur Democrat* published a photograph of him with his long white beard along with a description of his ailments: "He died of chronic dilatation of the heart, complicated with gall stones and chronic inflammation and the growing together of the liver, stomach and contents of the right side. Several years ago while lifting at some work about his farm he over strained himself which caused the terrible complications and which eventually caused his death."[4]

"I was raised with enough food, but I came from pioneer people," Smith would tell Thomas B. Hess, the executive editor of *ArtNews*, in 1964. "Grandmothers and grandfathers, great-grandmother, my great-great-grandmother, all of those people I talked with were early settlers. They had been deprived of salt and flour and sugar, things like that, they were deprived of for periods of time. I came directly from pioneer people that were scared about survival."[5]

Harve Smith was the oldest of nine children. When he was five, his father moved into Decatur and opened a meat market and then a dairy with Joseph M. Rice, one of William Pendleton Rice's ten children. Like many of his relatives, Harve began working as a child. He and his brothers helped their father in his meat market and dairy. He learned early on to keep his needs to himself. He was a man of action, not words. "A self-made man," Golda said. "Sometimes he would wish he had the advantage of college, but he had to learn the hard way."[6]

The Citizens Telephone Company opened in Decatur in 1894, and

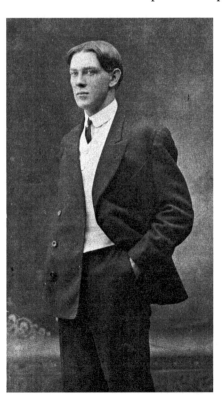

Harve took a job there as a telephone lineman. During the next decade, some five hundred residents would acquire phones. Suddenly, people could talk to other people on the other side of town, or beyond. Being a lineman required ingenuity, agility, and fortitude. In Decatur, a worker installing and maintaining telephone lines would have known most everyone. Much of the town would have seen Harve on call up and down the grid of streets and thanked him for his service.

In a formal photograph taken just before his marriage, Harve is

Harvey M. Smith before
his marriage, ca. 1905.

handsome and alert. His dress and look are smartly respectable; his eyes smolder with energy. His left hand in his pocket suggests less a posed gesture than a readiness to remove the hand and act. He acted with his hands, building and repairing. He was a tinkerer and an engineer; he took apart telephones and other machines in order to understand them, confident that he could put them back together.

Decatur was a town of inventors. As a child walking along its streets, David Smith saw men building automobiles—occasionally even planes—in their backyards. Near the end of his life, he told Thomas Hess that his father "was the manager of a telephone company—Independent Telephone. And I was kinda born into that. My father was an inventor. He invented electric kind of things, you know, electric coinboxes so you couldn't fill them with slugs and things like that. He invented the electric Victrola, before they were ever on the market."[7]

Harve sent his son other messages with his hands. At that time it was not unusual, was perhaps even commonplace, for fathers to hit their sons. "Spare the rod and spoil the child" was something of an unwritten rule in homes and schools. Smith's first wife, Dorothy Dehner, said, "His father used to whip him . . . I think his father's way of dealing with him was very hard for a little boy from what David has told me. David was whipped . . . and of course in my house you weren't ever whipped."[8] Smith admired, even revered, his father. Sitting on Harve's lap while he drove his car was a memory of enduring intimacy. But he also hated him for the whippings and feared his authority. "I could never beat pop," he blurted out in his interview with Hess.[9]

Freemasonry was a staple of life in the formative decades of the Midwest. The first lodge in Decatur was established in 1860. Decatur Lodge No. 571, which Harve joined, began in 1883; by the turn of the century, its membership would rise to around 125. Masonic lodges were expected to meet at least once a month. Initiation usually occurred at twenty-one. A Mason began as an apprentice and could rise to master. Much of the knowledge that makes these men a brotherhood is esoteric and secret. They value nonverbal communication, learning the "universal Practice of conversing without speaking, and of knowing each other by Signs and Tokens."[10] Masonry provided a connection to a great myth of worldmaking: the Old Testament description of King Solomon's temple built

by Freemasons. It also provided a connection with the Founding Fathers and other American heroes: George Washington, Benjamin Franklin, John Adams, James Monroe, and Andrew Jackson were all Masons. In its high-mindedness, anti-materialism, and commitment to charity, Masonry was compatible with the church.

Smith saw the value to his father of the Masonic brotherhood as a refuge from a home from which he himself, as a child, periodically tried to escape. Some of the formative components of Masonry—including ancient, esoteric, and secret knowledge; the power of symbols; a close community of workingmen; and the creative uses of geometry and repetition—entered Smith's work. On the plaque he carved for his father's tombstone, Smith included the Freemasonry logo. On the circular bolt that holds together the two arms of the compass—at pretty much the dead center of the plaque—he inscribed ΔΣ, delta sigma, his initials in Greek, which he had begun to use as one of the signatures on his sculptures after returning from Greece in 1936. In doing so, Smith presented himself as the guardian, or continuation, of a bond that he and his father shared.

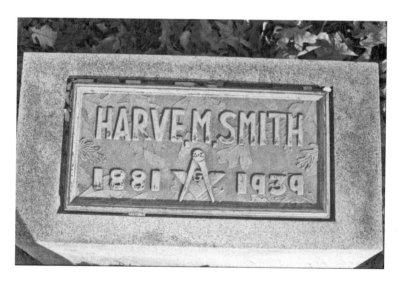

David Smith, *Harve M. Smith (1881–1939) Memorial Plaque*, 1942.
Bronze, dimensions unknown. Installed in
Live Oak Cemetery, Paulding, Ohio.

Golda's family history is more tenuous than Harve's. She had Scottish
and French blood. Like Harve, her ancestors came to Indiana from Vir-
ginia, Pennsylvania, and Ohio. Her grandfather was one of the men in
her family who couldn't stay put and seems never to have found a place
in which he wanted to settle. When Golda was born, her father was still
recovering from a hapless second marriage that had left both him and
his ex-wife on the verge of nervous breakdowns. It was Golda's mother,
his third wife, who brought him peace.

Golda upheld the authority of the husband: she referred to Harve as
"the mister."[11] She also believed that taming the wild beast in men was
part of women's civilizing mission. Golda's mother was a creature of the
Bible, a model of saintliness. "Goodness and kindness just radiated from
her," Golda once wrote.[12] Golda herself was voluble, in social circles per-
petually pleasant, and beyond temptation. Late in life, she would refer
to herself as "Mother Smith."

She took care of the home. She
cooked and cleaned. She read
to her son and disciplined
him when Harve was at work.
Like many women then, she
was a skilled seamstress. She
sewed her son's christening
dress. When Smith fled the
Midwest and went east, he
took the dress with him, us-
ing it in the 1950s as a rag in
his shop-studio.

Golda and Harve were
both Methodist, but Golda

Golda Stoler before her
marriage, ca. 1904.

was hard-core. She saw the world in black and white: us versus them, good versus bad, right versus wrong. In the words of Jim Stahl, a family friend, Golda was a "rootin-tootin Methodist, and under no way, shape or form would she ever have a drink of alcohol, because true Methodists don't do that . . . No smoking, adultery, of course. Divorce, she didn't approve of."[13] She wanted to be a paradigm of virtue and was reluctant to let her rectitude lapse, even for a moment. Virtuousness encouraged well-mannered behavior. It was a way of believing oneself close to God. It was also a structure of control and a means to social status. The more Golda and Harve were known for their support of Christian values, the more respect they would command and the greater their social legitimacy.

In full-length photographs taken in Decatur, Golda looks like a crusader for temperance. Her dresses cover her from jaw to toe. She was wary of the body. Smith told Jean Freas, his second wife, that Golda had told him that "the nine months she carried him were the nine most unhappy months of her life."[14] When Freas and baby Rebecca first met Golda, Freas was startled by Golda's phobia about the body. "I was cleaning Becca's behind after changing a diaper, and she literally—Golda—" Freas stopped and made gagging noises. "They had this little powder room. I was just shocked. I've never seen anyone respond in that manner."[15]

Because Harve was a Mason, Golda was able to become a member of the Order of the Eastern Star; she eventually rose to the rank of Worthy Matron. Like her husband and much of the rest of Decatur, Golda was a patriot. She was proud of having connections with the Founding Fathers and with women who had contributed to American independence and the development of the nation. At some point, she joined the Daughters of the American Revolution.

It was Golda who named the children. She chose Roland for her son because of the medieval French legend *The Song of Roland*, which included a fanciful commemoration of a noble nephew of Charlemagne named Roland, who gave his life to the Christian struggle against the pagans. Identifying their son not just with a legendary hero but also with one of Europe's most devout periods suggests both Golda's hopes for him and the role he played in her fantasy life. Her choice of the name Roland also hints at her sense of difference or peculiarity, and mission, in Decatur, one of a legion of New World towns and cities in which most

citizens, certainly most men, prided themselves on leaving European literary culture behind. Smith was sensitive about his name. After moving to New York, he changed his first name to David and eventually rid himself of the name Roland altogether. Freas said, "I used to twit him and call him 'Rollo,' . . . and he didn't like it. 'Roland,' he thought, was effeminate . . . David was a good, strong name, but Roland wasn't."[16]

Golda chose her son's middle name, David, after her father, David Stoler, and the name of her daughter, Catherine, after her mother, Hannah Catherine Hileman. Golda was the sixth of her father's children but the only child of her father and his third wife. She barely knew her half siblings, whom David Stoler left behind in Ohio when he moved to Indiana in 1880 to escape his second wife to be with Catherine. Golda was born out of wedlock: her parents did not marry until December 2, 1884, two years after her birth. Until Golda was in the eighth grade, they lived in Kendallville, where her father worked as a carpenter and house painter. In 1899, they bought land in Decatur from J. M. Rice, with whom Harve's father had worked. During the five years Stoler needed to recover from his second marriage, they lived on a farm. Golda finished eighth grade, then attended summer school at Marion Normal, now Ball State Teachers College, where she passed her teaching examination.[17] Teachers had to gain experience teaching in the country before obtaining positions in the city. She taught in schools on the border of Indiana and Ohio.[18] After Golda and Harve's marriage, her parents moved to Decatur.

The saga of David Stoler began in 1838. He was the second of six children, all born in Ohio. He married Celestial Baird when he was twenty-three and she was seventeen. Their five children included two sons, the elder of whom died at six. They lived on a 106-acre farm Stoler purchased from Celestial's father. Stoler was a hothead who yelled at his wife and beat her; his rages at Celestial were such that their daughter Eunice wondered if he would kill her. Eventually, they sold the farm, divided the money, and separated. Stoler moved to LaGrange, Indiana, about a hundred miles west. Although his wife sent the new owner of their farm to LaGrange to try to convince Stoler to come back, it was only after her death, less than three months later, that he returned to Ohio and their children.

Stoler purchased sixty acres in Ohio and accumulated livestock and planted crops in hard, almost barren soil, which he would later describe as "infirm" land. He built a cistern and a smokehouse. He desperately needed a wife to look after the children, and they made clear to him their need for a mother. Working from morning till night and living miles from the nearest city, he looked to nearby farms. One of them belonged to Michael and Elizabeth Shelly, who had come to Ohio from Pennsylvania as pioneers. He met their daughter, Eliza Ann Shelly, in early spring 1879 at the house of one of Celestial's sisters. Eliza was thirty-one, a professional seamstress who had always lived with her parents. After seeing her fewer than ten times, Stoler proposed. The marriage was set for October 20, 1879.

Yet, for almost two years prior to proposing to Eliza, Stoler had been involved with Catherine Hileman, whose father owned another nearby farm. Catherine was born in 1850, in Montour County, Pennsylvania, one of fourteen children of Joseph Hileman and Anna DuFrahn. When Catherine was four, the family moved to Ohio. When his brothers went to Missouri around 1870, Joseph followed them there, too, but Catherine did not go with him. Like Eliza, she had never married, but Kate, as she now was known, had a stronger and more independent personality. Although she and Stoler had discussed marriage, she did not want to remain in that part of Ohio and had little interest in raising his children. When Stoler decided to marry Eliza, Catherine sued him. He bought her a gold watch by way of settlement and agreed to pay her $945. A few weeks before he was to marry Eliza, Stoler tried to back out. When Eliza sued him, Stoler asked if she would rather have $500 or marriage. She preferred marriage.

On December 7, 1879, David Stoler and Eliza Shelly were married by a Lutheran minister in Reedsburg, Ohio, where Celestial was buried. The night before the wedding, Stoler was with Catherine, who had sent for him. Just four weeks later, Catherine left Ohio for Indiana.

"After we came home," Eliza said of her wedding day, "he treated me very well." But the tirades began the next morning. "I will always abuse you and I want you to leave my premises," he told her.[19]

"He began swearing. He would call me a God damned woman . . . said he did not intend to treat me well and treat me right. I told him that

would be a very unpleasant way to live . . . His treatment was altogether different from before the marriage." The next day "he just fainted as he had the day before called me a God damned woman told me go to hell."[20]

Within a month, Stoler ordered Eliza to leave. She told him she had no place to go. He told his daughter Eunice to take Eliza to the Bitner home, about two miles away, and leave her there. When Stoler visited Eliza at the Bitners' a few days later, she pleaded with him to let her come back and to treat her right. He responded: "I will die before I let you live with me."[21]

They did live together from January 15 to February 21, and then he abandoned her. In the civil action suit she filed against him in 1881, Eliza told the court that Stoler was "sullen contemptuous and abusive in his manner . . . and was daily in the habit of addressing profane insulting and abusive language to her and ordering her to leave his said premises."[22] He railed against her in front of the children, who, with the exception of Stoler's remaining son, Anson, all preferred Eliza to Catherine. Stoler threatened to poison himself and to do it in such a way that they would blame her.

Stoler's aversion to Eliza was certainly, in part, physical. Every night, Eliza said, he would say, "God damned woman go to hell." He periodically refused to sleep in the same bed. "He slept on the floor in the kitchen our room was on the floor above the basement which is a furnished room where we mostly staid and cooked and ate. Then he slept on the floor," Eliza said in her suit.[23] "Other times he made a bed on four chairs on the kitchen."[24] He refused to let Eliza bring her things into the house. He refused to let her put liniment on his foot, asking Eunice to do it instead. Eliza testified that "he wanted me to take all my clothes."[25] He told the court that she did not take care of herself: "I told her when I got married if a girl couldn't comb her head in a week I wouldn't have them."[26]

Wanting to end the marriage without Eliza getting any of his property, Stoler tricked her into giving the property to his children as soon as Eunice turned eighteen, in spring 1880. He promised Eliza that he and she would "have a good home" if she signed the deed. "I would have signed anything to have peace," she said.[27] But the day after she agreed to the transfer of property, he resumed his abusive behavior. Six months

into this calamitous marriage, Stoler "absconded . . . whereabouts un-
known."[28] He had left Ohio for Decatur, Indiana, to be with Catherine.
The property was turned over to Eunice on her eighteenth birthday. In
April 1881, soon after marrying a man named Eli Conklin, Eunice was
appointed legal guardian of her siblings. In her suit, Eliza claimed that
the deeds and transfers were wrongfully and fraudulently designed "to
prevent her from obtaining satisfaction of any decree for alimony."[29] The
court ruled in her favor, and Stoler was required to pay her $1,500 in ali-
mony, in five annual installments.

Once Stoler settled down with Catherine in Indiana, he seems to
have become a relatively stable presence. After Golda's birth, he took a
job varnishing and bronzing pumps.

For Catherine Hileman and David Stoler, Indiana and Ohio, al-
though adjacent states, were discordant worlds. Their grandson, David
Smith, identified with Indiana, a region of great family triumphs and he-
roes, as well as of childhood trauma. Ohio had its own usable myths, but
they were not attached to his family; later, when his family moved there,
he felt more of a stranger and was never sure he belonged.

Smith adored his grandmother Catherine; she was the great solace
of his childhood, the one person with whom he felt entirely safe. Cath-
erine lived in Decatur until after Smith left the Midwest. In 1928, after
her death, David Stoler returned to Ohio. In 1931, he died at the home
of Golda and Harve, who were then living in Paulding, Ohio, where his
funeral took place.

There are no known references by David Smith to his namesake.

2
Growing Up

In "Sculpture Is," one of three prose poems that accompanied his 1947 exhibition at Manhattan's Willard Gallery, Smith planted in the writing on his sculpture the anecdote of the mud lion. Aware during World War II that the world, if it survived, would be fundamentally different,

and that his art, and art in general, would have to be reimagined with it, he was reading Freud and Joyce and returning to his roots. The poem includes references to ancient creation myths. Within an abbreviated and disjunctive childhood chronology, he presents fragments of his own creation myth. The poem begins: "My year A.D. 4 God and father, moving forms, ice cream flower odors, fears." Year 5 is a single incident: "praise from a grandmother for a mud pie lion." Year 6:

David Smith, around age 5,
Paulding, Ohio.

"The spectre human headed bird, the soul of ani revisiting the body."
Year 7: "the found book of nude marble women hidden by a school
teaching Methodist mother."[1]

In the years after "Sculpture Is," Smith mentioned the mud lion to
several critics, including Belle Krasne, making sure that this reference
would enter the Smith literature. "About the earliest incident he recalls is
that when he was five, he made a mud lion which both his grandmother
and mother praised," Krasne noted when visiting Bolton Landing in
preparation for her 1952 profile of Smith in *Art Digest*.[2]

In interviews with Dorothy Dehner, Smith's first wife, the reference
to the mud lion in "Sculpture Is" becomes a story. When asked, soon after
his death, if teachers were impressed with Smith, Dehner replied: "He
did tell me that when he was three years old he was being punished . . .
because he used to run away . . . He was tied to a tree with a length of
rope . . . and there was a mud puddle there and he made a lion out
of mud . . . It was so remarkable and so lion-like that his mother was
delighted with it and called in the neighbors to look at this wonderful
lion that little David had done, and he told me he got the idea of the
lion from pictures he had seen in his grandmother's Bible . . . And that
was his first sculpture of course."[3] Twenty years later, Dehner made the
point that Golda actually remembered "very fondly . . . that David had a
habit of running to his grandmother's house. So [Golda would] tie a long
length of rope to him, to a tree. He could run over their property, but he
couldn't go down to Grandma's. He was there, and under the tree was
a mud puddle. David was three, and he molded a lion in the mud, from
the mud, and Mother Smith saw it, and she was so excited."[4]

Smith was terrified of being left alone. According to one family story,
in order to keep his mother from going out, he smeared her party dress
with a pound of Vaseline, "thinking that that would keep her home."[5] But
he did not always feel safe when his parents were at home. His escapes
to the Stolers', who lived about a quarter mile away, could be desperate.
He told Dehner that "in a snow storm he . . . went out his bedroom win-
dow and slid down the porch and [ran] barefooted and in his pajamas to
his grandmother's house because his grandmother always was the com-
forter and the great accepter."[6]

In a large family in which *the* book was the Bible, the family Bible was his maternal grandmother's possession. In it, Catherine recorded the family's intricate genealogy. Smith was fascinated by its cuneiform images, as well as by pictures that inspired the mud lion. "In the back," drawn in black-and-white linecuts, "were some . . . pictures of Assyrian lions," Dehner remembered.[7] In "Sculpture Is," and in Krasne's notes, Smith is two years older than in Dehner's recollections. In "Sculpture Is," the decisive recognition comes not from Golda but from his grandmother Catherine. In Dehner's tellings and in Krasne's notes, the recognition came from both women, which makes sense since Golda surely saw the mud lion first. Thinking about a boy running away from home and, while tied to a tree, forming a mud lion that impressed adults, it seems likely that Smith was indeed five.

In her interviews, Dehner does not question Golda's decision to tie her son to a tree with a rope. When Golda told the story to Dehner, she did not question it either. To Golda, her act seems to have been natural. Your son threatens to run away, you leash him to a tree like a dog or a horse—any parent would do it. Certainly a mother with a son as difficult and demanding as David Smith. Such behavior may not have been as unthinkable then as it seems now. According to his biographer Carol Sklenicka, the great short-story writer Raymond Carver was occasionally kept on a leash by his mother in his small-town childhood in the state of Washington in the 1940s. "A leash!" Carver's mother said. "Well, of course I had to keep him on a leash."[8]

Smith intended the phrase "praise from a grandmother for a mud pie lion" to stick in his readers' memories and provoke analysis and speculation. Such as: The mud lion was a dramatic response to subjugation by a civic-minded, do-gooder Methodist mother who did not have the means to deal with her son's unruly energy and discomfort with her. In a situation defined by his desire for his grandmother's refuge and his mother's forcible detainment, he modeled a sculpture of the king of the jungle, an assertion of unmistakable but exotic animality that was less threatening than his real-life wildness. The mud lion emerged as a result of Smith's openness to the materials at hand. It lived outdoors. The admiration for it let him know that his sculptural imagination was more palatable to

the rest of his family than his periodic drastic behavior. His mother may not have known how to cope with him, or how to come to terms with his desire to flee her, but she could admire what he had made.

It was Golda who introduced Smith to art. She gave him plaque copies of Thorvaldsen's *Night* and *Morning*, circular low-relief marble sculptures. In *Night*, an angelic winged figure protectively carries two children across the sky. Behind them, an owl seems to be flying out of the low relief, into the viewer's space. David "would make these images and set them along the window sill" and "would try to copy those in modeling clay," Golda said.[9]

When she read to her son at night, it was from an art book. "He was always a problem to get to sleep so I developed the habit of reading to him. Since books were scarce in those days I used a book . . . on Greek sculpture. He liked this and liked looking at the pictures. By the time he was in school, he could identify most of [the sculptures] when he saw them elsewhere. I never read fairy tales to him."[10]

Estelle M. Hurll's *Greek Sculpture: A Collection of Sixteen Pictures of Greek Marbles with Introduction and Interpretation* was published by Houghton Mifflin in 1901. The slim volume is a rah-rah appreciation of Greek art. "The most refined and imaginative of the ancient nations were the classical Greeks," Hurll writes on the first page. Each of its sixteen chapters was inspired by a sculpture; some are canonical, but many are Roman copies. Hurll presents myths of Greek gods such as Athena, Demeter, Hermes, and Persephone as morality tales to advocate a world of dignity and nobility in which art embodies timeless moral values in the service of the nation. She extols "simplicity," "naturalness," "modesty," "purity," "sane," and "calm."[11] The book is basically a sermon. In its support of civilized values and the rewards, through art, of sublimating unpleasant feelings to Christian ideals, it could have been written by Golda.

Smith would come to loathe moralistic approaches to art, and he would be adamant that masterpieces were made in his time. "The division point between the artist and most writers of books on art history, museums and critics is the artist's belief that the present is the most important for making works of art. And that he is part of the present. To have other than that working belief would be to admit defeat."[12]

Yet reading a book on Greek sculpture to a boy in Decatur, Indiana, soon after the turn of the century would also have been an imaginative and generous act. Art bound mother to son in a way that essentially excluded Harve, just as Harve's tinkering with machines with his son excluded Golda.

Hurll's book included reproductions of statues of naked, or almost naked, women; some, like the *Venus de Milo*, were both voluptuous and truncated, full-bodied and broken. Whether or not "the found book of nude marble women hidden by a school teaching Methodist mother" mentioned in "Sculpture Is" was Hurll's *Greek Sculpture*, Smith's remembrance makes a point of a tug-of-war between mother and son over the female body. She showed him the book but hid it from him after he tried to possess it.

Smith's attachment was to the images. Words messed with desire, controlled, perhaps even feared it. They stopped it. Sanctimoniousness could be repressive and hypocritical. After World War II, Smith would insist on the primacy of images and the power of visual perception and his attack on the destructiveness of words on art would become unrelenting. "In childhood we have been raped by word pictures" became something of a refrain.[13] The artist "uses the language of vision."[14]

Almost from the time he began speaking, Smith drew. At West Ward School, where he spent his first four years of elementary school, his drawing helped him win the attention of a popular art teacher. "Georgia Vachon was a beautiful woman, extraordinarily nice to boys," a classmate remembered.[15] "He had such an intimate relationship with [Miss Vachon]," Golda said. "Sometimes he would come home a little late from school. He said he would stay and help . . . her put up some of her displays and take some down; and then she would give him some of the copies and he would put them in his room."[16]

Like his passion for art, Smith's attachment to flowers spoke of interests and a temperament different from those of most other Decatur boys. In dogwood season, Harve would drive Golda and David to look at the blooms. "David even had a corner in the garden of his own that he planted with wild flowers," Golda said. "He loved flowers."[17]

In 1911, Harve and Golda acquired from Golda's father, David Stoler, a large two-story house on Tenth and Nuttman. It was on the edge of

the town, with beet, corn, soybean, and potato fields nearby, some tended during the summer by Mexican migrants. It had a cistern and an out-house. A porch with four stately white columns stretched grandly across the front. The ceilings were around ten feet tall. This house had more win-dows than the previous one, and more space inside and out. Harve had risen to superintendent and bought the telephone company in the nearby town of Monroe. The Smith family was on the way up. They were now middle class.

In the basement, Harve had a worktable. "David and his father spent a great deal of time together building things," Golda said. Like his fa-ther, David took objects apart to study them, and Harve's inventiveness lured David's friends. "After Junior League [David's friends] all came home to our house," Golda said. "The mister would bring up a pan of water and charge it. Then the boys would try to see who could get the nickel. He was doing something like that all the time."[18]

David's sister, Catherine, was born on April 7, 1911. Even-tempered and well adjusted from the beginning, she was a good student and, from childhood on, a model citizen. With her, Golda and Harve could feel they were the family they aspired to be. After David went east, Catherine mar-ried a postman and continued to live near her parents, helping to look after Golda as she aged. Smith told his two wives that he believed his fa-ther preferred Catherine to him, but rarely, if ever, did he speak of her critically. He rarely spoke about her at all. Because of the five-year age difference, they were never at the same school at the same time. There's no indication that they played together. While Catherine understood her brother better than her parents did, his flight from the Midwest jolted her, and she, too, could extend herself only so far toward Smith's art and New York life.

As a young boy, Smith was "such a spindly little shaver, we thought he'd never grow up," Golda said.[19] In his eighth-grade class picture, he looks like an outsider. The twelve other boys are all wearing dark sports jackets; Smith's jacket is light—perhaps gray or beige. Most of the boys, like the sixteen girls, stand erect, radiating confidence. Smith is hunched, and he appears smaller than most of the other boys.

Decatur had a tough side. The heart of town was prosperous and safe, but some neighborhoods were territorial, and boys formed groups,

sometimes roaming from one part of town to another. When a street was being laid at Third and Marshall, under the carbon lights Smith and his allies built forts with leftover bricks in case the southwest boys came over for a rock fight. Dehner later said that Smith "had millions of scars and we used to go over all his scars and he would tell me how he got them. So and so threw a brick at him as he was going down the street. He had a big scar on the back of his head [that] took a patch of hair out . . . You couldn't see it because his hair was tremendously thick . . . like Samson's."[20]

His parents never knew what their son would do next. He shot at robins with slingshots and "threw stones at bigger kids" he could outrun. Once, determined to fly, he took an umbrella, opened it, and jumped off the shed roof.[21] He placed cheese in his school's heating system, so successfully stinking up the building that school had to be canceled for the day. During one of Golda's women's evenings at home, he climbed out his bedroom window and suspended himself outside the window of the room they were in, making them wonder if they were being visited by a ghost.[22]

Giving him jobs was one way to try to keep him out of trouble. At ten, "he went to work at Hunsicker's ice cream parlor confectionary. He had a popcorn stand and would sell popcorn and peanuts out on the sidewalk. We were so relieved because he was always getting hurt. We knew this was one day he would not."[23] He sold fruit and vegetables and had to clean celery early Saturday mornings. "He had great resentments about working on the weekends," Dehner said, "because he saw other kids playing."[24]

But Smith always felt himself a child of Decatur. He had many friends and for the most part welcomed the challenges in the streets. He admired the town's ingenuity. What he discovered on his walks stayed with him. Not just men building cars and planes. In 1947, the year he wrote "Sculpture Is," he remembered "the most wonderful object," one that "has been in my mind every year of my life." It had the same enduring impact as the cuneiform and images of Assyrian animals and kings in the family Bible. It was a glass jar tree made "from a square post with projecting handles running up each side of the square, quart mason jars were stuck on the handles for sun drying. This was earlier than art and exerts a basic form relationship quite often, without my conscious

effort." The glass jar tree was the invention of a neighbor, Minnie Ball. Jim Ball, her husband, whom Smith also remembered for wading in mud to soothe his sore feet, maintained a mulberry tree. "It was full of birds and we kids were full of his yard."[25]

For Smith, the most alluring and dangerous objects were trains. He heard them during the day and while lying in bed in the dead of night. A train's arrival could seem like a "providential event."[26] With three rail-road lines running through town, including the Erie, which connected Chicago and New York, Decatur was blessed with several such events each day. Trains evoked a larger world that exposed Decatur for what it was: a proud and thriving Indiana town but still just one of a myriad of towns in the heartland—a dot, one stop, on the vast and ever more pop-ulous American landscape. In 1964, Smith was asked by Thomas Hess, the *ArtNews* executive editor, "Is there anything in your past or your childhood that relates particularly to steel or railroads and wheels?" He responded, "As a kid in Indiana, the most fascinating things in my whole world were railroad engines and trains and also the things that I was most warned to stay away from. So consequently . . . I used to hop trains, ride on trains, ride on the tops of boxcars like brakemen did, run on the tops of boxcars. And when they came to a building, run on the building and jump back on the boxcar again."[27]

Factories were similarly alluring and forbidden. "I used to play around factories . . . like I played in nature, on hills and creeks . . . They were just a part of nature to me."[28] In a town that still had one foot on the frontier, factories evoked an industrial future. They were places of opportunity and brotherhood. Smith was drawn to deserted factories where the spirits of those who had worked there could still be felt. He climbed through their windows, feeling "awe" and what he described as their "scared air," imagining that these abandoned monuments were his alone, sensing the potential of his rapidly growing body, finding in them, as in trains, per-mission to desire and dream.[29]

3

Paulding

From Decatur, Indiana, to Paulding, Ohio, is only around forty miles, but for the Smith family the move in the early summer of 1921 was a sea change. Harve was now a manager. With a partner, Jack Dailey, he acquired and ran the Paulding Telephone Company. The house the Smiths acquired at 612 North William Street was located "in a very established neighborhood in Paulding."[1] Like the house they left in Decatur, it, too, was two stories with an attic and a front porch, but it was even more ample and located near the central square and the Paulding United Methodist Church, alongside which Golda would eventually buy land. Now it was she who was in her element. Her parents had roots in Ohio, and family identity was not dictated by the Smiths' ancestry and heroic pioneer stories. In Paulding, Golda rose to almost saintly status. She would be remembered as an exemplar of charity, a marvelous and generous cook, and a tireless servant of the church—a pillar of Sunday.

Paulding's population of 2,100 was less than half of Decatur's. The identity of Paulding County was viscerally shaped by the county's emergence from the Great Black Swamp, "a primitive forest of oak, ash, elm, cottonwood, maple and black walnut."[2] The thirty-four-mile-long swamp was inhabited by wolves and infested with insects. It was so dense that attempts to lay tracks through it bankrupted the Ohio Railroad in 1845, though eventually tracks were laid and towns and commerce followed.[3]

In 1921, just one railroad, the Cincinnati Northern, passed through Paulding. Its tracks separated the haves from the have-nots. "There was always economic segregation," Jim Stahl, a longtime resident of Paulding, said.[4]

Northeastern Indiana is flat, but northwestern Ohio has a pitiless flatness. "The Toledo, Wabash & Western Railroad completed in 1855, ran east and west through the northern part of the county," reads a description in a local history. "It was so straight and level that on a clear night the headlights of a train leaving Defiance [twelve miles from Paulding] could be seen at Antwerp. Which was twenty-three miles away."[5] Decatur's streets were structured around a grid, but in Paulding the streets' right angles were so incisive that they created the impression that any divergence from its exacting geometry would be interpreted as deviance. In Paulding County, the expanse of the eye seems limitless. To escape notice and feel safely out of sight, someone who felt alien there might feel that it would be necessary to go far away, or to run forever.

In the early twentieth century, Paulding's primary industry was sugar beets. The Paulding Sugar Company, manufacturer of Krystal Klear Sugar, had a yearly production of approximately twenty-two million pounds of sugar. Pulling beets from the ground was backbreaking labor. Smith worked in the beet fields and would not forget the endlessness of the rows. He also labored in the production of clay tiles, although it is not clear if this meant working in clay pits or maneuvering prepared clay onto the dies that shaped the tiles. Or both. Tile was used for drainage systems, and clay tiles were built into farm fields as ditching. One of Smith's high school nicknames was "Tile Mill."[6]

"Paulding High School was farm people," Virginia Paulus, the town historian, said. The school had its own forty-acre farm and a respected agriculture program. It also offered courses in industrial arts and the classics. Smith graduated with two credits in Latin and four in English. He was drawn to theater and writing. The school introduced him to Emerson and Whitman, who would inform his work in lasting ways. Smith also took courses in ancient as well as American history, and in plane geometry and mechanical drawing. Paulding High School students were expected to learn both literary culture and a trade. In the town, physical

labor may have been more valued than intellectual labor, but in the school there was no clear hierarchy between them.

The writing on Smith's Paulding years has tended to emphasize his unhappiness and anger. Dehner told of his exploding dynamite in the fields outside Paulding. She also said that "one night he told the story of firing off the Civil War cannons in the public square when he was a high school boy."[7] Rosalind Krauss, an influential writer on Smith, studied the recurring motif of the cannon in his work. For her, firing the cannon was an example of "the violence that Smith directed toward the people who were closest to him [and] that had always been his characteristic reaction to stress."[8] Joan Marter, a prominent Dehner scholar and president of the Dorothy Dehner Foundation, characterized Smith as "an aggressive, even violent man"—an uncouth country boy who had no curiosity or culture before meeting Dehner: "Their life can be viewed as the joining of a cultivated, talented, and attractive young woman with a blustery young artist doggedly ambitious, arrogant, and often crude."[9]

Smith certainly could be volatile. From childhood, he was given to extremes and capable of outbursts of frustration and rage. When he felt abandoned or thwarted, particularly by women, he could lose control. But his curiosity and resourcefulness were also notable from childhood on. In Paulding he drew pictures, wrote poetry, acted in plays, and pursued a correspondence course in cartooning from the Cleveland Art Institute. At Paulding High School he was a leader, a yearbook presence, vice president of his senior class—someone whose imagination, initiative, extravagance, and outrageousness commanded attention. He was funny, theatrical, and clever, both down-to-earth and dandyish, physically imposing with a sometimes seductive, sometimes grating erudition. As he grew taller and stronger, he became strikingly handsome.

During his Paulding years, he went to parties and was an active participant in the school's social life. He was a decent student who took poetry seriously, but he was also a free spirit whose pranks were not always appreciated by school authorities. Periodically, he went off on his own, sometimes to roam the fields or go fishing, sometimes to blow off steam. He already had a rare gift for finding talented and independent mentors who recognized his independence. One of these was Jack Sprague,

a local lawyer whom Golda characterized as "eccentric": "Goatee and moustache. Prince Albert Coat." Smith, she said, "always spent time with Jack. Jack was a student of poetry. They would discuss poetry and books, things like that."[10]

Toward the end of his life, Smith would make a point of his rebelliousness and misfittedness in Paulding. In 1964, he told Thomas Hess, "My radical assumptions were manifest before I ever went to art school . . . When I was a sophomore in high school, I wrote a thesis . . . on Darwin's *Descent of Man*. There were many things that my social position in the town were denied to me, so I took the opposite position . . . It may not have been from the rebellious part but it was an attitude, my attitude about a whole lot of other problems."[11]

Regardless of the accuracy of this story—did he write a "thesis" on Darwin in the tenth grade?—Smith's attraction to Darwin suggests a clash with the local culture. The caption under his senior portrait in his high school yearbook, *The Echo*, reads: "Bud"—his nickname—"argues that men were developed from monkeys."[12] The caption implies a mocking attitude to Smith's position. At home and perhaps in Paulding as a whole, passages from *The Descent of Man* claiming affinities between humans and other animals would probably have been a shock. Smith's awareness of the impact of environment on identity and his interest in evolutionary development stood in stark contrast to views of human beings in Hurll's *Greek Sculpture* and in the church. Although the quotation by his junior-year photo in his 1923 yearbook reads, "A flattering painter who made it his care, to draw men as they ought to be, not as they are," he was already convinced, at fifteen, of the animal in the human and of prehistory in the now.[13]

Smith worked on the yearbook throughout high school. As a sophomore, he wrote *The Echo*'s one-page class history. By the eleventh grade, he was the yearbook's artist. In the staff photograph, he stands in the center, the tallest of the group. He seems as comfortable with his appearance and accomplishment as he was uncertain in the Decatur class photo two years earlier. "Roland Smith" was also a featured performer in the junior class play: Roland was a good theatrical name. His two drawings for the 1923 yearbook are his earliest known artworks. Earlier, as a freshman at Decatur High School, in an ode to the senior class in the

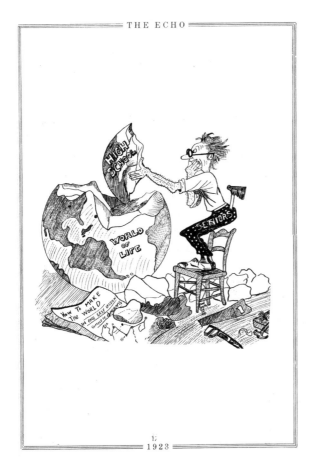

David Smith,
drawing for *The
Echo*, 1923.

yearbook, he had embraced the romantic world-making image, or cliché,
of the sculptor:

> Sculptors of life are we, as we stand
> With our lives uncarved before us;
> Waiting the hour when at God's command,
> Our life-dream passes before us.
>
> Let us carve it, then on the yielding stone,
> With many a sharp incision;
> Its heavenly beauty shall be our own—
> Our lives that angel vision.[14]

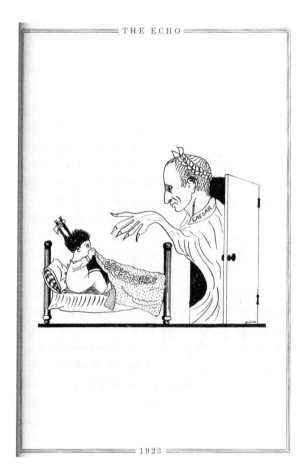

David Smith,
drawing for *The
Echo*, 1923.

The idea of the sculptor as a creator of the world stayed with him
even as he moved to Ohio and changed schools. One of his two drawings
for *The Echo* features a world-making sculptor; the tone is not syrupy but
rather in keeping with the yearbook cheekiness that reflected the student
style. A geeky-looking young man with glasses and straight hair combed
back and standing on end contemplates his stone sculpture of a globe on
which is written, between the continents of South America and Africa,
"world of life." The sculptor, the word "seniors" visible on his pant leg,
is pondering how a chunk of stone, called "high school," fits into the
global sphere. On the floor is a paper reading: "How to make the world in
one easy lesson, complete diagram." In the other drawing, a ghost with
ghoulish fingernails, wearing a laurel crown and a toga, with "Caesar"

on his collar, wafts through an open door into the bedroom of a compar-
atively tiny cringing youngster, pigtails standing on end, who is trying
to hide under a blanket that says "sophmores." The night sky is visible
behind the door through which Caesar's ghost emerges. The drawing is
signed "Bud 24."[15]

"Bud," the nickname that Paulding residents would still remember
Smith by decades later, was drawn from Bud Fisher, the creator of *Mutt
and Jeff*, perhaps the first daily newspaper comic strip. Launched in 1907,
it featured a goofy duo whose appeal depended as much on their out-
landish height differential as on their inane gags. The characters shared
a passion for horse racing and engaged in preposterous, get-rich-quick
schemes. Smith was drawn to disproportion and caricature. He was
looking for ways to think about image-making that could be entertain-
ing and caustic and through which he could make money.

Smith's junior year was one of passion and achievement. Early in the
school year, he had a crush on Mary Bitner, an accomplished athlete and
class leader. Under her 1923 photograph, *The Echo* identified her with
her own words: "The worser I try, the gooder to be, the worser I am."[16]
For Smith, the yearbook noted, "We find that Bud Smith sleeps at home
and spends the rest of his time at Bitner's."[17] *The Echo* refers to Bitner
as "jewess" and uses the word "Jew" elsewhere with a casual insularity, as
in "Mary F gets vexed in geometry class. 'Jew' tries his hand in helping
her."[18] Such uses of the word mix self-congratulatory and affectionate
informality with stigmatizing difference. In October, Smith and Bitner
were still an item: "'Jew' seeks aid in Caesar—as usual."[19]

By the end of 1923, Smith had a more serious crush. In its roundup of
the academic year, *The Echo* notes, "Joe Durfey and Bud S. seem to have
something up their sleeves. We wonder."[20] Forty years later, Josephine
Durfey was the one girlfriend of her son's whom Golda mentioned by
name.[21] She took art classes in Fort Wayne and told Smith about them. In
January 1926, a year and a half after Durfey went away to college, Smith
wrote a poem that wished her well and then damned her.[22] Perhaps she
was the one to whom Smith's sister Catherine was referring when she
told his older daughter, Rebecca, that her brother was so disconsolate
when his girlfriend left him that he cried and threatened to kill himself.[23]

In his senior year, Smith expressed himself confidently and provoc-

atively, with flashes of grandiosity. In the yearbook he is now Roland D. Smith (the initial "D." was not there in 1923). In the senior class play, he is again a featured performer, playing another comic character. In *The Echo*'s "Class of '24 Prophecy," student Esther Ream irreverently imagined the graduating students twenty-four years later. Smith was a misunderstood painter steeped in myth and dream: "Roland Smith, a future artist. His latest picture was a woodland scene, with nymphs dancing on the green. The critics when writing it up referred to it as that famous masterpiece with Jersey cows grazing in the pastures. Poor Bud!"[24] In Paulding, artist was not a dignified profession.

The 1924 yearbook suggests Smith's magnetism, quick-wittedness, and unrest. In the seniors' "Class Will," a yearbook tradition, "Bud Smith bequeaths his diabolical genius to Kenneth Greer."[25] Under the section "Jokes": "Mr. Huffman [the principal and director of the class play]: 'Bud, why were you late?' Bud S.: 'School started before I got here.'"[26] In the senior class picture, Smith looks dapper, with his hair parted down the middle.

4

Transitions

In September 1924, Roland David Smith enrolled at Ohio University, in Athens, 230 miles southeast of Paulding. He had never been so far from home and previously may not have seen a college campus. He may have had mixed feelings about college, but his parents had long expected his education to rise above theirs, he wanted to study art, and it was imperative for him to leave Paulding.

Ohio University is located near the Hocking River in the rolling hills on the edge of the Wayne National Forest. Of its 1,842 students during the 1924–25 academic year, 1,734 were from Ohio. Ohio students were admitted automatically if they had completed four years in a high school classified as First Grade by the State Department of Public Instruction. Dormitories were reserved for female students. Male students lived in fraternity houses or private homes. Smith was one of three freshmen from Paulding and one of the 530 students enrolled in the College of Education. His father wanted him to be an electrical engineer. His mother wanted him to be a stenographer or teacher. He leaned toward becoming an art teacher.

As one of the twelve assistant editors of the yearbook *Athena*, Smith went by his nickname, Bud. His closest friend in Athens was William Darrell "Dal" Herron, two years older, an Athens native who graduated from Ohio University's College of Education in 1924 and shared Smith's

passion for art and literature and desire for free living and thinking. They railed against puritanism and materialism, painted together in the hills, and shared plaints and hopes that were commonplace after English Romanticism. Both were drawn to Louise Stahl, the head of the art department. She had studied in New York with William Merritt Chase and at the Art Students League and painted in Provincetown. Stahl may have been the one faculty member from whom Smith wanted to learn. "Tell her I like her way and her work and I'm anxious to learn under her," he would write Herron after leaving Athens.[1]

Academically, Smith's freshman year was a debacle—D's in French, D+ and C in English Composition, D– and C in Mechanical Drawing. He failed General Psychology the first semester and Physical Education second semester. His respectable grades were a B+ in Art Structure (basically a design course), and a B– in Freehand Drawing.

In the summer of 1926, while taking two poetry courses at George Washington University, on a page inside the cover of *The Poetical Works of John Keats*, Smith drew small boxes in which he distilled two of his three college experiences. In the box "Ohio—U—1924," he sketched two liquor bottles. One, with "O.U." written on the bottle, is upright; the other is empty and fallen on its side.[2]

Smith neither flunked out nor was placed on probation, but a failing grade required the student to repeat the course in order to receive credit, and he was not going to repeat courses he hated. Given his unhappiness with his curriculum, his alienation from campus life, and the fact that it was his mother who had pressured him to attend college to pursue a practical education, it is hard to imagine that he seriously considered returning for a second year. Smith had no interest in textbook teaching. He did not want institutions telling him what to do.

Art classes were his biggest disappointment. "He had been very disillusioned by his college teaching," Dehner said. "I mean the kind of teachers that he had that taught him as he said 'how to teach art but not how to make art himself.'"[3]

In 1952, Smith remarked that artists succeed despite art teachers, who tend to be "reactionary." "The real contemporary influences," he said, are "not those men teaching in the schools . . . Art teaches freedom of expression and observation. It teaches one to have courage, and the

courage of conviction. Art is not like geometry, or chemistry; there is no\
matter of rules in art."[4] In a lecture he gave at Ohio State University in
1959, he said:

> When I lived and studied in Ohio, I had a very vague sense
> of what art was. Everyone I knew who used the reverent word
> was almost as unsure and insecure.
>
> Mostly art was reproductions, from far away, from an age
> past and from some golden shore, certainly from no place like
> the mud banks of the Auglaize or the Maumee, and there didn't
> seem much chance that it could come from Paulding County.
>
> Genuine oil painting was some highly cultivated act, that
> came like the silver spoon, born from years of slow method,
> applied drawing, watercoloring, designing, art structure, re-
> quiring special equipment of an almost secret nature, that
> could only be found in Paris or possibly New York . . .
>
> Sculpture was even farther away. Modeling clay was a mys-
> tic mess which came from afar . . . The Mystic modeling clay
> is only Ohio mud, the tools are at hand in garages and facto-
> ries. Casting can be achieved in almost every town. Visions
> are from the imaginative mind, sculpture can come from the
> found discards in nature, from sticks and stones and parts and
> pieces, assembled or monolithic, solid form, open form, lines
> of form, or, like a painting—the illusion of form.[5]

In "Memories to Myself," a speech given in 1960 at the Eighteenth
Conference of the National Committee on Art Education at New York's
Museum of Modern Art, Smith looked back in anger:

> I want to start with some resentments. They begin early. I'll
> start with the first college I attended, my first hope. I resent
> their art without painting. I don't think I'd seen a genuine oil
> painting. I had not seen an original sculpture, when I went
> there to study. They had me making tile designs in the Depart-
> ment of Education. I was not able to enroll in the department
> which they call Fine Arts until a year or so after I had made tile

designs. I had never seen a tile design in my life and I didn't know what I was doing, and neither did the college, except that they were teaching me how to teach something I couldn't do. I've been sore at art education ever since. There are a lot of things I wish people had taught me. I wish somebody had taught me to draw in proportion to my own size, to draw as freely and as easily, with the same movements that I dressed myself with, or that I ate with, or worked with in the factory. Instead, I was required to use a little brush, a little pencil, to work on a little area, which put me into a position of knitting— not exactly my forte. There wasn't a movement in my life up until that time that ever made me knit or make a tile design. I think that the first thing that I should have been taught was to work on great big paper, big sizes to utilize my natural movements towards what we will call art. It doesn't matter what it might look like. I think the freedom of gesture and the courage to act are more important than trying to make a design.[6]

When the school year ended in early June, Smith returned to Paulding and took a job, probably with his father, "as a telephone linesman, stringing cable, laying cable, potting lead for joints etc. I used to dig holes in the ground of figures and form my own lead casts."[7] Digging "holes in the ground of figures" and forming "lead casts" is unclear, but what he did may have been his first sculptural work. After about a month, he traveled 130 miles northwest to South Bend, Indiana, where a friend, Bill Crookshank, had taken a job at the Studebaker plant. Why don't you try it? he said to Smith. They roomed together, Crookshank working the day shift and Smith the night shift.[8] Smith handled metal parts, learning their roles and relationships in producing a sleek, powerful machine. He learned different ways of working with metal. "He said later he thought that these big forms he was pressing out were interesting forms to him just in an abstract way," Dehner said.[9] His gestures involved his entire body. The machine imagination that was valued in Decatur was useful here. And for a nineteen-year-old, on his own, the money was good: "More than I ever made in my life."[10] He felt in his element.

Studebaker was established in South Bend in 1852 by Henry and Clement Studebaker, who descended from a long line of skilled metal-workers in Germany. By the 1890s, it was the largest maker of horse-drawn equipment in the world. Studebaker made ambulances, water carriers, wagons, fire engines, sleds, limousines, toys, and wheelbarrows. Its vehicles served ordinary Americans and presidents. Studebaker made the carriage that brought Lincoln to Ford's Theatre the night of his assassination. In 1904, the company began producing gasoline cars. It may have been the only vehicle manufacturer in the United States to successfully make the transition from horse-drawn to motorized vehicles.

In 1920, Studebaker's automobile production was transferred from Detroit to South Bend. In 1924, "construction of a new iron foundry in South Bend completed the postwar capital expansion plans of the company."[11] The factory complex covered 225 acres. Its number of workers was more than ten times greater than the population of Paulding. At Ohio University, all twenty-eight art courses were taught by women. At Studebaker, Smith felt part of a brotherhood of workingmen:

> After four months in department 346 at the Studebaker plant alternating on a lathe, spot welder and milling machine, I was transferred to 348 on Frame Assembly. This was worked on a group plan, payment made to 80 men in proportion to the completed frames which were riveted and assembled on an oval conveyer track. It was necessary for each man to be able to handle at least six operations. Riveting, drilling, stamping etc. all fell into my duties but my interest was the $45 to $50 per week which would enable me to study in New York.[12]

Albert Russel Erskine, the president of Studebaker, was adamantly and paternalistically respectful of labor. In an interview in 1925, he said:

> The first duty of an employer is to labor. By labor I mean any man that does what he is told. It is the duty of capital and management to compensate liberally, paying at the least the current wage and probably a little more, and to give workers

decent and healthful surroundings and treat them with the utmost consideration. If management cannot do this, then something is wrong.

"Nobody will pay you more or will treat you better than Studebaker," the company had announced to its workers eight years earlier. "We are your friends." As a result, Erskine said, "our men build their very souls into the Studebaker cars . . . Every man eats and thinks and dreams Studebaker."[13] However propagandistic such words were, for Smith the job at Studebaker was transformative.

Smith's accounts of his length of time at the factory vary. On one occasion, he said four months. In his late-1940s biographical sketch, he wrote that it was a summer. The curator and critic Katharine Kuh remembered him telling her that it was a year. It was in fact less than a summer. When asked by Kuh how he got started with metal sculpture, he mentioned the factory.[14] "His experience at Studebaker loomed larger and more important as his sculpture methods became identified with industrial production," Dehner wrote. "Once he had achieved the image of his work, he found his factory experience the most congenial of all."[15]

In the fall, Smith enrolled at the University of Notre Dame as a "special student," which the university defined as "a student over twenty-one years of age who does not wish to become a candidate for a degree by following the prescribed subjects of a regular program." That Smith was nineteen didn't seem to matter. The Register of Students 1924–1927 lists "D. Roland Smith" from Paulding, Ohio, but does not indicate what courses he took. The official bulletin shows seven courses in the art department. The emphasis was on providing a traditional foundation in studio practice. At Notre Dame, Smith reversed his first two names, registering as "D. Roland Smith"—although he still signed letters "Roland." When he registered at George Washington University in June 1926, it was as David Roland Smith. Within two or three years, Roland disappeared from his name altogether.[16]

Smith seems to have lasted at Notre Dame around two weeks. Inside the cover of that book of Keats's poetry in which he made cartoonish sketches of his college experiences, he drew a box marked "NOTRE DAME 1925." It includes an image of the dome of the university's famous

church, with a cross on top, emanating light. It also includes two dice and what looks like a jug of foamy beer.

His friendship with the son of the Studebaker vice president led to a job in the company's finance department. This was followed by a job in a brokerage office of the Associates Investment Company. "He met some man in South Bend who got him a job selling bonds," Dehner said, "and David sold bonds, if you can imagine this young, very young man selling bonds."[17] Smith managed not just to support himself but also to invest in bonds for his future. At home he read Oscar Wilde. "I rather like the old boy," he wrote to Dal Herron. His letters are peppered with Victorianisms like "shall" and "kindly note." The dandyish side of him welcomed the name "Roland." This tall, lean young man must have been a provocative sight walking around South Bend sporting a large square scarf bearing fifty-four prints he'd made:

> It (each print) contains 2 nude figures (female) 1 snake, various plant formations sort of a Garden Eden effect. I made a wood cut and printed it on silk with permanent blue. Some people say "Oh those horrid figures"—to my knowledge it is very good in design and *fair* in technique. But I and only I wear the scarf and they can all go to hell.

Smith had just turned twenty and he had big gripes and big ambitions. Belief in a divine creator was still with him:

> I'm going to remodel the world and drag it from this infernal commercial nickel grabbing gang of jackasses to a bunch of stupid people, running naked, living in caves, and living—not merely existing. They will have time to think of their souls and their creator. In time I think our creator will put them back into the uncultured cave man race again. From the beginning they start to decline. I'm not worried about myself however.

Eager for an expansive liberal arts education, he set out to educate himself. He went to the opera (*Madame Butterfly*) and to plays (*Abie's Irish Rose*). He attended a recital by the Italian soprano Claudia Muzio.

He read profusely. "Books are delightful when prosperity happily smiles; when adversity threatens, they are inseperatable comforters, arts and sciences depend upon them," he wrote at the beginning of a letter, quoting, or misquoting, Richard de Bury, the fourteenth-century English writer and cleric who attacked the callousness of the nouveau riche.[18] He read about art in *Scribner's Magazine*. In *The Golden Book Magazine*, which began in 1925 and published short fiction, he read Anatole France, O. Henry, Melville, Whitman, Poe, Thackeray, and Dickens.

Smith told Herron that McCready Huston's 1925 novel, *Hulings' Quest*, was "the best modern fiction" he'd ever read.[19] Huston lived in South Bend. Smith was proud to meet him. Published in the same year as *The Great Gatsby*, the novel captures the anxiety in the Roaring Twenties about the ruthlessness of new money, its disrespect for grounding American values, and the danger of the country losing its soul to rampant materialism. Its main character, the architect Ethan Huling, returns from serving overseas in the Great War to his hometown of Gallatin, Pennsylvania, to find it transformed by wealth. The new Gallatin has been shaped by Joab Martin, who grew up in poverty and spent years on a tenant farm before striking it rich by speculating in coal. Martin symbolizes the "brute force of capital."[20] He does not read and has no curiosity about the outside world. He engages Huling to build a bank that will be an enduring testimony to him. After Martin goes bankrupt and returns to his farm, Huling encounters Sheila and Eric, puppeteers who, in contrast with the fast lives identified with new money, move about the countryside slowly, mostly on foot, with a van-like wagon drawn by an old white horse. They support themselves by passing the hat after their performances. Huling is mesmerized by their puppet shows and even more by the youthful but ageless Sheila. In the end, Huling, like many of the other main characters, finds his center.

Smith's brokerage job led to a more important position, this one salaried, with the Industrial Finance and Acceptance Corporation, which was affiliated with the Morris Plan Bank, Studebaker's banking agency. The Morris Plan Company opened a branch in South Bend in January 1915. Its directors included Clement Studebaker, Jr., the first vice president of Studebaker. The bank was instrumental in developing proce-

dures, unusual at the time, for making loans to the middle and working classes. Smith explained his job to Herron:

> My work is to dictate letters, send telegrams, write sight drafts, write for investigations on men thru banks etc. Easy job 8 hrs day 5½ days week. I've made $40 cash on my stock and about $10 in interest since January . . . I should judge the average stock gamblers life is from 5 minutes to 5 years. I'm living until 90 tho. My stock is only a side issue.[21]

In another letter, he gave further details:

> I correspond with dealers and write many letters, send telegrams . . . etc. I started at $20 a month. I'll get a raise of presumably $20 at the end of the first month.
>
> I'm including this in my liberal education. I've done hard labor thus getting the view of the laboring class, sold stocks which is an education in its self together with being intimately acquainted with high powered bond salesmen of NY & Chicago. Now I'm corresponding with people of N.C., and S.C. and Virginia . . . Some of the letters are pathetic, coming from a very illiterate class of mountaineers . . . I'll say some of those miners are equally as ignorant. The letter I recall was very pitiful—showing neither the influence of foreign or negro languages. Just pure unadulterated ignorance.[22]

Smith wanted a bigger world:

> I want to study art and English and yet to go to an Art School. I'll have to work my way for some of it . . . Could you advise me any school such as I seek and yet be close to you Dal I'd love to go to school near you, we'd live and not give a damn what the rest thought or said.
>
> I love music, poetry, classics, art and nature and I adore education, liberal or limited. I'm going after an education just to

please satisfy myself. Why live in the practical side of life? I'm starving for art. I want to learn more. I want to learn to draw from nature, nude, and everything that lives. I want to write, I want to live, I want to reform the world. Oh bunk I couldn't do that but if the proper man writes the proper thing it is possible that he could set the world crazy or happy which ever he should choose . . .

What are you going to do this summer? I wish we could go to school together or be together this following year and then go up to Provincetown and all over.[23]

In May 1926, Smith took a job with the Morris Plan Bank in Washington, D.C. Soon after renting a room at 1913 Pennsylvania Avenue NW, he moved to a boardinghouse at 725 Twentieth Street NW. His office was near Dupont Circle, the cultural hub of the city.

This job was more demanding. "Sorry to relate I haven't been reading much outside of finance," he wrote to Herron. "I read my Golden Books of course and an occasional article in the papers. I visited the senate in session. What a pack of rowdy 'rubes'—could not be equaled even if they all were from Ohio."[24]

His job frustrated him: "I'm about disgusted with the commercial world . . . I have a good job etc good chances for advancement but it doesn't appeal to my innerself I only have one life to live—I live that purely for my own satisfaction and I'm not staying in 'finance' over a year longer."[25]

However, he continued investing: "Bought 10 shares Studebaker common at 51¾ + Brokerage charge Its now down to 50½ showing a loss to me of $18—hope it does not continue as 'thusly'. My associates Investment is still up and paying good."[26]

Smith often passed the Corcoran Art School on his walks, but he did not take courses there. The only indication of lasting contact with art while in Washington was a remark he made years later to Thomas Hess: "The first sculpture I ever saw was Hiram Powers' *The Greek Slave*, in the Smithsonian."[27] In 1926, this sculpture—of a youthful naked woman, her hands chained together, standing on a relatively small circular base—was probably still the best-known American sculpture. Powers

made five marble copies of his 1841–42 plaster; between 1847 and 1851, two versions toured the eastern United States.

As David Roland Smith, Smith registered for two summer courses at George Washington University. He received a D in The Romantic Movement, and a C in Chief American Poets.

He kept two books from The Romantic Movement. Inside the cover of *The Poetical Works of John Keats*, he wrote responses, such as "appeal in Keats is primarily emotional & imaginative" and "attempt to please by excess (beauty)." Learning about the destructive effect of critics on artists, Smith noted: "Quarterly Review—written by—Croaker—Review supposed to have killed John Keats—(one sided)." In this book and in *Poems from Shelley*, which he borrowed from the university library and did not return, his notes are scornful of overblown sentiment. Near "O Poesy! For thee I grasp my pen," in "Sleep and Poetry," he wrote, "bunk." Alongside the line "I die! I faint! I fail!" in Shelley's "Indian Serenade," Smith wrote, "whorray!"

But Smith held on to these books, and his work has connections with Romantic poetry. He was drawn to ancient and other mythical references, and to beauty defined by sensuality and savageness, even "barbarism," a word he scribbled three times on one page of Keats's "Hyperion." In the long preface to the Shelley book, Smith put an asterisk next to two sentences: "Of this class of poems *The Cloud* is the most perfect example. It described the life of the Cloud as it might have been a million years before man came on earth." On top of two pages of Keats poems, Smith doodled prehistoric creatures.

The preface to *Poems from Shelley* emphasized Shelley's "double nature." He was both in society and outside it. His personality and imagination moved in several directions at once. His poems were in perpetual movement. Shelley embraced the "undefined" and the "constantly changing": "His intellect, heart, and imagination were in a kind of Heraclitean flux."[28] It is hard to imagine that such thoughts and passages did not leave a mark on Smith.

Whatever romantic relationships Smith pursued during this time seem to have been total failures. Either a woman he was interested in was not interested in him, or a woman he went out with briefly dropped him for someone else. In South Bend, he may not have had girlfriends, but

he had pals. In Washington, he asked Herron to join him: "If you will share my humble room I'll be glad to have you stay as long as you like I wish you'd come maybe you'd like it well enough to go to school here this fall."[29] In another letter, he almost pleaded: "My bed is big enough to hold both and we'll eat where ever we happen to be—that is the way I do."[30]

In early August, Smith wrote Herron a remarkable letter that describes wandering through a drizzly weekend night in which the city's gaslights give the nearly deserted streets an otherworldly glow. He tells of holding a rose that he picked in the dark in a nearby park while circling the White House, and hours of roaming other parts of his neighborhood. Suddenly, in the light, he looks at his rose. It is not what he thought it was; it is not what he believed he was holding dear but rather "a withered old flower about to fall to pieces." He begins a wild rant in which his experience of the flower becomes a metaphor for "the way of women":

> You think your treasure almost suberb but upon the first casting of the avenue light—they are foul, potent, withered rotten at heart—when the real truth is known they are all rusted at the edges or browned on their under petals—some transforming their brown and rust to a brilliant scarlet which when this metamorphosis takes place—cannot even be inspiration in the dark and satisfy no man—may lend satisfaction to a beast in the form of man but if the real truth were known I doubt if complete pleasure is ever witnessed by anyone man or beast.

He mentions "poor [Edgar Allan] Poe," who "saw nothing but love and death and the mean deviation between the two," and expresses a wish to spend nomadic years in Europe with Dal, away from everyone they know: "To wander and paint to wander and write—with no definite aim, would be the realization of my souls desire."[31]

At the end of the month, in the bank, Smith erupted. Dehner recounted the story:

> One night he was working late. Only himself and the guards were there, and (he told me this, I was not present, of course) he had opened the drawer of the vice-president's desk, and he

saw a gun in it—a pistol, a hand-pistol—and he fired the en-
tire magazine into the floor. The guards came running, from
downstairs—because he was up in the offices—and—You see,
guns weren't any terrible mystery to David, because his family
were pioneers in America . . . That was why he left the Morris
Plan Bank. But I don't think he was fired. You know, David
also had enormous charisma and charm . . . He could charm a
bird off the tree.[32]

To what degree the story is true is impossible to determine. What is
clear is that Smith was done with Washington. He could no more remain
there than he could have remained in Paulding, Athens, or South Bend.
The man who'd gotten Smith the job in Washington now got him a job
with the Industrial Acceptance Corporation in New York. By the end
of the summer, just twenty years old, Smith made the move that he had
fantasized about for more than a year:

When I first came to New York, I stayed at the Great Northern
Hotel [on West Fifty-Sixth Street]. I walked up the street on a
Sunday night and came to Carnegie Hall. I had no idea what
Carnegie Hall was. When I worked in the Studebaker factory
in South Bend, I went to concerts there . . . strictly provincial
kind of things. There was a concert on. I think it was the New
York Philharmonic, and Stravinsky's *Firebird Suite* was being
played that night . . . I liked it right off. Nothing has surprised
me since.[33]

5

A New Life

On Saturday, October 9, 1926, Dorothy Dehner returned to New York after a summer in Pasadena. She had just entered her apartment at 417 West 118th Street and put down her bags, exhausted from five days on a train, when she heard a knock on her door. A new resident of the building had told the elevator man to let him know the minute she arrived. "My name is David Roland Smith," he said, "and my landlady said that you go to art school and I want to know where I should go to art school."[1]

"He was very tall and skinny," Dehner remembered. "He was very appealing. I liked him."[2]

"You have to go to the Art Students' League," she told him. "It's wonderful! It's a real art school and there are no marks and you can move from one class to another if you care to and nobody takes any attendance and you have to be totally self-motivated . . . because you're not going to get an A. Nobody's going to graduate you summa cum laude or any such thing."[3]

No matter how often Dehner spoke about those first hours together, they never lost their magic. Smith was more than four years younger, energetic and ambitious, new to a city in which she had acted professionally, studied art, and lived for several years. She had recently been to France and Italy and was happy to be an authority on art and life. They began talking in her room at four in the afternoon and then took a walk.

"I introduced him to Harlem. We bought records . . . *Rhapsody in Blue* . . . and other things that were called 'race records'—Negro singing and playing—that wasn't commonly recorded . . . in those days. We bought hot dogs, and apples, and peanuts and stuff, and ate them. We came back and sat in Morningside Park until 2:00 or 4:00 in the morning."[4]

He learned of her life. Dehner was born in Cleveland on December 21, 1901, the youngest of three children of Louise "Lula" Uphof, age twenty-seven, and Edward Pious Dehner, forty-one. Dorothy idolized her older sister, Louisa: "[She was] a very brilliant girl, and she would have been a really good artist. She was much better than I ever was. She had honors at school for this."[5] She never knew her brother, John, who died in infancy, but she was "taught, always, to go to the cemetery, kneel down and put flowers on his grave."[6]

Both sides of her family had settled in Cincinnati in the early nineteenth century. Her maternal family was Dutch and German, the paternal side German. Both sides were Roman Catholic; her father's middle name, Pious, referred to the pope. The two families did not get along. The Uphofs included religious and social hotshots, some of whom could act ostentatious and entitled. The Dehners were progressive and down to earth, but Dehner found them insular and drab: "There wasn't as much money around as in the homes of my mother's family. There was no style, no show, no light touch, and the gaiety was intellectual, a bit heavy. On my mother's side, things were always buzzing. The Dehners always resented the Uphofs, and after my father died, THEY didn't speak to one another either."[7]

After marrying, Louise and Edward left Cincinnati for Cleveland, a lively and growing city. The move was surely also inspired by the need "to get away from all the relatives . . . They had a kind of war going on that I was very conscious of, as a very small child."[8] Edward's sisters, Rose and Caroline, "working women, very intelligent," changed their minds about financing his education as a physician because they were upset with his marriage. They resented what they considered the "racehorses" on the Uphof side. "My mother wasn't a bit like that," Dehner said. "She didn't feel like a racehorse at all."[9] Immediately after the couple lost their financial backing, her mother enrolled in the Amy Campbell Secretarial School for impoverished gentility and went to work. Waste

and showiness were vulgar to her. She passed on to Dehner her frugality and modesty.

Louise's sisters provided Dehner with diametrically opposed models of female behavior. Aunt Flora—"Flo"—was a warm, loyal, cautious, sweet homebody. Aunt Cora, a Francophile, was adventurous, extravagant, and extreme. Dehner used words like "scandalous," "schizoid," and "schizophrenia" to describe her. She "was a wild woman, given to terrible rages, and love—enormous love, enormous, demonstrative love—gifts, hugs. I was always on her lap. Then she'd throw me off her lap and say, 'Darn! You've ruined my beautiful French dressing gown, just by wiggling around on my lap!' Always drama. Everything was drama."[10] Deciding that Uphof "sounded too German," Cora changed her name to Upton during the Great War, to the disgust of Flora. When Cora was good, she was irresistible. When she was bad, she was ruinous.

The Uphofs and Dehners agreed on the importance of artistic creativity. Dehner and her sister were raised on the arts, which both parents, especially her mother, championed. Like Cora, Louise was a skilled pianist. Dehner used to turn pages for her mother when she played Mozart and Bach. She also assisted Cora, who attended the Cincinnati Conservatory of Music before studying music abroad. Dehner and her sister were once taken to a performance of the Metropolitan Opera in Cleveland. She heard Enrico Caruso sing when she was nine and saw Anna Pavlova dance when she was twelve. As children they both painted.

Their father was a pharmacist and a political activist. She got politics from him. He was a crusader for unpopular causes, in 1905 fighting against pollution of the Great Lakes. He campaigned against child labor and advocated for juvenile court and for pure food and drug laws. "He ran for county commissioner on one of his campaigns," Dehner said, "and I used to wear large buttons on my chest that said, 'Dehner for County Commissioner,' 'Dehner for Board of Education,' which was an elective office in those days . . . But he never got elected, alas."[11]

While there was clearly love at home, there was little affection. "I hadn't lived in a 'married' house, so to speak," Dehner explained. "I didn't know what a regular family type thing was, very much. Because of my mother being ill"—with rheumatoid arthritis—"there was no expression of sex, or even bodily contact, to any great extent. This was all mys-

tery. What is this ecstasy people talk about in books? What is this thing? This totality of love?" From the age of ten, she said, "I was searching for that, and I was searching to do something wonderful in the arts."[12]

Edward Dehner died in Cleveland in 1912. Louise's rheumatism worsened; she could no longer play the piano. Flo moved in to manage the household. In 1914, weary of a climate that had contributed to Edward's death and was damaging to her and her daughter Louisa's health, Dehner's mother decided to move to Pasadena. They rented a one-story Frank Lloyd Wright bungalow for $60 a month. It "was expensive . . . at that time, for us. We loved it, though." After moving into a two-story house, Louise slept on the porch, "so she could get the most air."[13]

At Pasadena High School, Dehner wrote poetry and short stories, studied agriculture, and took courses in art and in art history. On a field trip to the Los Angeles Museum, she had an artistic awakening: "I caught sight of this great room with all this bright strange color. It took my breath away . . . It wasn't that I liked it or I didn't like it, but what is this! I never saw such a thing."[14] She found the style "ugly and . . . beautiful and fascinating and colorful, and scary, and all the things I still feel about German Expressionism." She felt "hit in the gut by it."[15]

Roughly a year after moving to California, Louisa died at the tuberculosis sanitarium in Monrovia. A year and a half later, Louise, too, was gone. Thus, before she turned fifteen, Dehner had lost her entire immediate family. Her mother's inheritance was divided between Dehner and Flo. Dehner was to receive roughly $2,000 a year (equivalent to nearly $53,000 in 2021 dollars).

She went to UCLA for "a very disappointing, bad year," she said. "I couldn't find my own people." In an art class the model wore long pink bloomers. "I wanted to go to an art school, a real one, like I'd read about in France, and you'd draw from a nude model, and this kind of pruderie turned me off greatly."[16]

Theater became Dehner's passion. She began acting at "the famous Pasadena Playhouse, which was considered, at that time, the finest little theater in the country."[17] Gilmore Brown, its director, programmed cycles of Molière, Shakespeare, and O'Neill, Dehner said, "not the ordinary Broadway junk, which was the only thing that was very apparent at that time."[18] Dehner welcomed the recognition: "When you're on stage,

you're a character, and you're somebody else, you know. And there's also instant love. Instant! You don't have to wait years, until you grow up. You get this right away, and that was very seductive. I loved it." She often spoke of "this terrible dichotomy in the life, of big ego and no ego. Big ego and squashed ego."[19]

Dehner decided to go to New York to study theater. Like Smith, she was just twenty when she made the big move. She and Flo settled in an apartment near Columbia University. Dehner could afford to travel. She wanted to go to Europe to talk to George Bernard Shaw: "I thought he could tell me about life . . . I became a Socialist, a vegetarian, an atheist the first time I read his volume of plays . . . and that was when I was still in high school."[20] While abroad, she became engaged to a Harvard graduate even though her cultural values clashed with his and those of his friends. She was enthralled by artistic modernity, and they thought modern was ugly: "I saw Cubist painting, because the 1925 Exposition of Art in Paris was on at that time, so Picasso's paintings and Matisse's paintings were up, Braque . . . I was excited by it."[21] In front of Picasso's paintings, she said, "my hair was just standing on end. I had gooseflesh the whole time, with the whole world of contemporary art."[22]

On the boat back to the States, when she told a man that she wanted to be an artist, he said she needed to study at the Art Students League. She found the apartment on West 118th Street. "I had been living with my aunt more or less in that neighborhood," she said, "so it was familiar to me. The very next day I went to the League and registered."[23]

Smith was as eager as Dehner to talk. He spoke "about his family and troubles with his family; what he wanted to do in life."[24] They spoke about politics. He described himself as a pacifist. Dehner had seen the battlefields of France and the destruction of the cathedral at Rheims. She would become a pacifist after reading *The Nation* and similar publications. They spoke about religion:

"What religion are you, Dorothy Dehner?"
"Oh, I'm an atheist."
"I guess I am, too."
He said, "God damn those Methodists. I'm going to write to them and have them take me off the rolls of the church. They

just want to have a lot of numbers." So he wrote to the minister and resigned from the Methodist church because he had come to feel that this was not the answer for him. I told him that I had my own Dorothy's religion. Which was a total brotherhood of all men, without regard of turf, or color, or religion, or anything else.[25]

That Monday, they went to the Art Students League and "registered, together, he for the night class, because he had a job."[26] Richard Lahey's Life Drawing, Painting and Composition met from seven to ten, five evenings a week. Smith was still working for the Industrial Acceptance Corporation of the Morris Plan Bank, whose office happened to be next door to the League. He was still writing letters to people about their credit standing. Dehner described them as "high-falootin' . . . They were really crazy letters . . . full of grammatical errors. I don't mean hideous grammatical errors, but kind of provincial America, where he had come from."[27] They were definitely not official bank letters. "They were very fancy, they were unbelievable letters, they were so great, formal and full of very large words . . . He was having fun with them." Once or twice he called her "to read one of those letters" when "he thought that one really hit the nail on the head."[28]

Smith could also dress with flair. Sometimes he carried a cane. "He was a bit of a dandy," Dehner said. "David would wear spats . . . Not that that was his uniform because he would swing wildly from that kind of outfit to blue jeans which were not even worn in those days." He asked how men dressed abroad. She told "him about the kind of clothes that European men wore, English office suits, with striped pants, and Oxford grey top, jacket and vest, musket and derby."[29]

They ate breakfast together, after which Dehner regularly went horseback riding. "I used to ride around the reservoir in Central Park every morning, then I would go to the Art Students League for the afternoon class."[30] Often they lunched together near the League. They shared most dinners as well, usually at the cafeteria of Columbia's Teachers College.

Dehner had broken off her first engagement. Now she was engaged again, this time to "a young naval officer who was doing post-graduate work at Annapolis."[31] When she met Smith, the limitations of the

relationship with her new fiancé, too, became apparent: "He was a gentle, lovely young man but when I met David, we just wanted to be together all the time."[32] Unlike Smith, other young men would take her to nightclubs and dance halls. She wasn't interested. "What was entrancing to me," she said, "was this give and take and give and take [with Smith] that seemed to be endless."[33]

The Art Students League became the center of their lives. They both liked drawing and painting from the model. They kept sketchbooks. He took courses in printmaking as well as in drawing and painting. Dehner found Kimon Nicolaides, her first teacher at the League, a "revelation."[34] Teachers and classmates became part of an enduring community. Robert Henri, the League's founding spirit, believed that artists belonged to a "great brotherhood" with "many members . . . All change that is real is due to the brotherhood." Students were as much a part of it as teachers. "That [the student] may *use* the school, its facilities, its instruction," Henri wrote, "that he may know that the school and the instructors are back of him, interested, watching, encouraging, as ready to learn from him as to teach him, anxious for his evidence, recognizing in him a man—another or a new force."[35]

The Art Students League began in 1875 as a student reaction to the hidebound teaching at the National Academy of Design. Its four-story French Renaissance building at 215 West Fifty-Seventh Street, half a block from Carnegie Hall, has been its location since 1892. The school was always student-friendly. Dues were $5 a year, and students chose their courses. Smith's classes with Lahey cost just $10.50 a month, those with Nicolaides and John Sloan $14 a month. Students were able to become members and participate on the League's board of directors. Smith became one of the four student members.

Groundbreaking modernists studied at the League, including Georgia O'Keeffe, Stuart Davis, Alexander Calder, and Jackson Pollock. In addition to Henri and Sloan, the roster of celebrated teachers includes Thomas Eakins, Augustus Saint-Gaudens, George Bellows, Thomas Hart Benton, Max Weber, Stuart Davis, and Jan Matulka. Almost all of the League's legendary teachers were painters. Sloan, Matulka, and Davis would be mentors to Smith. When Dehner returned from Europe, she intended to be a sculptor, but she was put off by William Zorach, the

League's leading sculpture teacher, who was carving figures in a sentimental, watered-down modernist style: "It wasn't like any of this exciting stuff that I had seen in Paris . . . I never did study sculpture [at the Art Students League]. Neither did David, because there was nobody" there worth studying with "in those days."[36]

Lahey and Sloan were Henri students. Stuart Davis described Henri's pedagogical impact:

> The Henri School was regarded as radical and revolutionary in its methods, and it was. All the usual art school routine was repudiated. Individuality of expression was the keynote, and Henri's broad point of view in his criticism was very effective in evoking it. Art was not a matter or rules and techniques, or the search for an absolute ideal of beauty. It was the expression of ideas and emotions about the life of the time.[37]

Henri's *The Art Spirit*, published in 1923, was one of the two most beloved books written by American artists in the first half of the twentieth century; Sloan's *Gist of Art*, published in 1939, was the other. Henri believed that artists were ahead of their time; he used the word "pioneer." They were anti-puritanical: "I am always sorry for the Puritan, for he guided his life against desire and against nature . . . He believed the spirit's safety was in negation, but he has never given the world one minute of joy." Categories were inhibiting. Process mattered. "I don't believe any real artist cares whether what he does is 'art' or not," Henri wrote. "Who, after all, knows what is art? . . . I think the real artists are too busy with just being and growing and acting (on canvas or however) like themselves to worry about the end. The end will be what it will be." Temperament and personality were essential. So was identity: "Courbet showed in every work what a man he was, what a head and heart he had . . . Here is a sketch by Leonardo da Vinci. I enter this sketch and I see him at work and in trouble and I meet him there." Henri's inspirations were literary as well as artistic, American as well as European. "It seems to me that before a man tries to express anything to the world he must recognize in himself an individual, a new one, very distinct from others," he asserted. "Walt Whitman did this, and that is why I think his name so

often comes to me. The one great cry of Whitman was for a man to find himself, to understand the fine thing he really is if liberated."[38]

In November–December 1926, the Brooklyn Museum presented an immense exhibition that was intended to be a successor to the legendary 1913 Armory Show, which rooted the European avant-garde in the United States. The "International Exhibition of Modern Art" may have been the largest and most ambitious of the fifty exhibitions organized in the 1920s by the Société Anonyme, founded in 1920 by Katherine S. Dreier, Marcel Duchamp, and Man Ray to bring contemporary European art to the American public. All major twentieth-century modernist movements were represented: not just Cubism, Dada, Futurism, German Expressionism, and Russian Constructivism but also more recent developments such as de Stijl, Surrealism, and the Bauhaus. The catalog was dedicated to Wassily Kandinsky, to whom Smith would refer as often as to any other twentieth-century artist other than Picasso. The exhibition introduced the paintings of Paul Klee and Piet Mondrian to the United States.

Given sculpture's subservience to painting and its insignificance in the development of modernism in the United States, the exhibition was eye-opening. From the sculpture of Alexander Archipenko, Jean Arp, Constantin Brancusi, Raymond Duchamp-Villon, Naum Gabo, and Antoine Pevsner, it would not have been surprising for someone sensitive to sculpture to sense its potential to compete with painting as a transformational field. The found objects of Marcel Duchamp and Man Ray made the argument that art could be what the artist said it was. The exhibition included artists who worked across media, some of whom experimented with photography, like László Moholy-Nagy, who after immigrating to the United States would ask Smith to teach with him in Chicago. With Alfred Stieglitz, Arthur Dove, Marsden Hartley, Georgia O'Keeffe, Karl Knaths, Marguerite Zorach, and John Marin, the show demonstrated that the United States was already a force in artistic modernity.

The exhibition was widely reviewed by the press. The inclusion of artists who had studied at the League, like Davis and Yasuo Kuniyoshi, as well as Max Weber, who was teaching there at the time, increases the likelihood that Dehner and Smith saw this great sprawl of modernist creativity. Dehner had some context for the work, but Smith had almost

none, although he already had the ability to recognize which art demanded attention. He was hit with artistic modernism all at once, before he had even the outlines of a map.

On the first day of winter, Smith and Dehner's relationship changed. "I said, this is my birthday," she recalled, "and he said, oh, and then I'm going to kiss you. He had never kissed me before, and put his arms around me, and then I just wanted to stay in his arms forever . . . So that was the beginning of a much more serious relationship."[39]

The building where they lived had rules. The women, mostly college students, rented rooms downstairs, the young men upstairs. In May, Dehner said, "he was in my room . . . and the landlady even admonished me. She said, 'One of the girls in the room, in your apartment, is complaining that Mr. Smith is there all the time. She said, I hope you are observing the 11:00 rule.' I said, 'Yes, for the most part.'"[40]

Deeper Bonds

In the summer of 1927, Dehner went to Pasadena, and Smith to Ohio. Dehner drew and painted and began making watercolors. She and Aunt Flo traveled a bit, vacationing in Carmel. She read the biography of Isabella d'Este, a patron of the arts in the Italian Renaissance, which she enjoyed hugely because it was "so closely wrought with the lives of the great painters of the Renaissance," and she eagerly brought to Smith's attention a young American writer, born in the rural Midwest in 1899, to whom he would later be compared, to his consternation. The writer's first novel had just been published. "I finally read *The Sun Also Rises*. The book that shocked the aunts. It is wonderfully written," Dehner wrote to him. "[It's] really fine in every way. Do read it and tell me what you think of Brett. It is by Ernest Hemingway and surpressed in Pasadena. The brilliance of style simply left me gasping." Dehner went on: "I was so glad to get your letters & cards. You know David Roland I miss you rather like the devil—there are so many subjects one can't even begin to discuss with so many people."[1]

After visiting Paulding, Smith returned to his job in South Bend. He had probably convinced the Morris Plan Bank to send him to Washington and New York with the idea of gaining big-city experience that would serve his banking career back in Indiana, but remaining in that job was unimaginable. Years later, he wrote that the bank fired him.

In his letters, he addressed Dehner as "Dorothy Dehner" and asked her to send him a lock of her hair. She did. He asked her to visit him in the Midwest. She didn't. She signed her letters "Dorothy Florence." "See you at the A.S.L. at 12:30," she wrote before returning to New York in October.[2] He rented an apartment at 231 West Fifty-First Street, within easy walking distance of the League. Dehner moved into an apartment with her friend Chiquita Marching, a classmate at drama school.

In one of Smith's 1927 watercolors, the Indiana landscape has a luminous density. The farmland seems to breathe. A road that seems to flow like a river rises to the top of a hill, alongside which is a farm; tiny in the far distance, almost in the dead center of the watercolor, is a red barn. Blues dominate; the white clouds dwarf the tiers of fields and the trees aligned processionally on both sides of the road. (See Figure 1 in the insert.) In *The Spy's House*, another watercolor from that year, there are no people either. The color is occasionally porous, the composition compressed and layered. In the lower foreground is a gate. The property rises past steps along a path to a castle on top of the hill. The trees are performative and monumental presences; this is largely their scene. There is a story here, but what is it?

Using the money he had invested, Smith now studied art full-time. Dehner said in one interview that it amazed her "that a young person . . . was investing" that money "so that he could go to art school."[3] In another interview she said, "David could have been a financier if he hadn't been an artist, because he . . . could really do anything. He could fix the plumbing, or wash the car, or make a piece of sculpture, or make a drawing that would be better than anybody else's . . . He was able, physically and intellectually and emotionally, to be all kinds of people."[4]

Smith took another course with Richard Lahey, whose "encouragement after the first year of art school was decisive," and studied woodcuts and color prints with Allen Lewis.[5] In October and November, he took a class with John Sloan, who provided Smith with his first model of an American male artist. Sloan was feisty, hard-drinking, plainspoken, occasionally profane, and defiantly, even arrogantly independent. Like Henri, he admired Whitman. He was open to European modernism and helped bring into American art an inspired attention to New York City grit. The *New Yorker* art critic Robert M. Coates would refer to Sloan's respect for "the commonplace and the vulgar," which to most early-twentieth-century

art critics seemed "an affront not only to art but to morality."[6] Sloan "seemed to be personally involved with all of us," Dehner said. "[He] was very tender with us, and helpful."[7]

Born in Philadelphia in 1871, Sloan was largely self-taught: he never finished high school, and he worked in the railroad yards. In 1904, he moved to New York, where in 1908 he helped organize the exhibition of eight painters at New York's Macbeth Gallery that inspired the label "The Ashcan School." In 1910, he joined the Socialist Party. "I don't like war," he later wrote. "The economic interests get out their propaganda machines and persuade the people that democracy is at stake. And what do millions of innocent people go out and get killed and maimed for?—to protect the economic interests of the few."[8]

Sloan began teaching at the Art Students League in 1916 and took over running it 1930. He resigned in 1932 because the school refused to hire the German painter and satirist George Grosz. A number of Sloan's comments, some clearly marked by Henri, lead into Smith's work: "The mental technique today is the same as it was [in cave painting] fifty thousand years ago." "Originality cannot be sought after. It will come out when you express your convictions." "Today the artist is constantly questioning himself, 'What am I doing, is it art?' This is a very irrelevant question. The real creative artist doesn't care whether his work is art or not. He has his work to do, is driven by a creative fire."[9]

Nearly thirty years later, Smith would include Sloan in his artistic "family." From Sloan, Smith wrote, he "got a certain amount of feeling—of knowing the artist's position as a rebel or as one in revolt against status quo."[10] It was probably with Sloan that Smith had his first serious discussions about Paul Cézanne and Cubism. "Heard about cones and cubes and Cézanne from him," Smith wrote. But Sloan "was only radical in talk," Smith would also write.[11] To understand Cubism, which in the 1920s was still something of a mystery in the United States, Smith would need another League teacher, Jan Matulka.

After months apart, Smith and Dehner grew closer. In the fall of 1927, Smith proposed. "He said, 'Dorothy Dehner, if I were only a millionaire, I'd love to marry you,'" she recalled. "And I said something to the effect

that the only thing that counts in marriage is if you love the person. He said, 'Well, I love you, and I want to marry you.' I said, 'Well, you know, I'm self-supporting, so you don't have to worry about being a millionaire.'"[12] They were married on December 24, 1927, at city hall, with Chiquita Marching and her husband, John, as witnesses. They sent telegrams to her aunt Flo and to his family, who were "astonished when David got married ... But then they were very nice after that ... and invited us to come out."[13]

In a photo-booth snapshot taken a week or two later, which stands as the de facto wedding portrait, Smith has a bit of a mustache and is wearing a derby, a sports jacket, a white shirt, and a tie. He looks proudly, reverentially, toward Dehner. She is smiling. She wears a necklace, a white blouse, and a cloche hat. The picture was taken in the basement of Gray's Drugstore, at Forty-Second Street and Broadway, where Dehner and Smith had gone to purchase discount theater tickets. Soon after

their marriage, Smith gave her a copy of George Bernard Shaw's *The Intelligent Woman's Guide to Socialism and Capitalism.* "To you my cabbage most representative," he wrote in it.[14]

David Smith and Dorothy Dehner, ca. January 1928. Photo taken in a Times Square photo booth.

Their first apartment was at 15 Abingdon Square, a quiet mini-park on the western edge of Greenwich Village, three blocks from the Hudson River. North and west was the meatpacking district, with dozens of slaughterhouses. The neighborhood included townhouses and markets. The square was not far

from the customs office on Gansevoort Pier in which Herman Melville
worked from the mid-1860s to the mid-1880s, when the Village's history
of bohemianism began.[15] Edgar Allan Poe and Walt Whitman lived in
that area before it was known as Greenwich Village; Hart Crane and
O. Henry were among the later writers who lived there. By the 1920s,
Greenwich Village had become a magnet for artists and writers. "We had
to be in the Village because that's where artists lived," Dehner said.[16]

Within a week of their wedding, Dehner prepared their first big meal:

> David's mother had not even met us, me, or "us" as a married
> couple—and she sent us a chicken from Paulding, Ohio, a raw
> chicken. In those days the mail was so good that it wouldn't
> possibly spoil. It was special delivery . . . She sent the whole
> dinner. She had sweet potatoes. They weren't cooked yet, you
> see, nothing was cooked, with cranberry sauce, strawberry
> jam and things.
>
> I made our first real feast that day. There was the chicken,
> and I put little truffles, like the French do . . . We didn't drink
> wine (it was Prohibition, I guess). But, anyhow, we drank milk.
> I had put two glasses of milk at our place, because we always
> had a glass of milk with our dinner (we were still babies), and
> I said to David, "Okay, it's all ready." He came into the little
> dining part of the kitchen, which was a little separate from
> the kitchen itself, and he bumped against the table, and he
> knocked over the milk. I said, "Oh, David," and he took the ta-
> ble cloth and he threw the whole dinner—the chicken, and the
> gravy, and the strawberry jam, and the cranberry sauce went
> all over the floor—he ran out, and the next time I saw him he
> came in with two men who had pulled him out of the Hud-
> son River, where he had flung himself, next to a barge. There
> were ice floes in the Hudson River (this was about a week after
> we were married), and his clothes were frozen on him . . . I
> took his clothes off. The men said, "We pulled him out. We
> happened to be standing right there." . . . I hope he had seen
> them . . . I suppose he thought I was reprimanding him, like
> his mother did, and like his father did.[17]

When she asked him to promise he'd never do anything like that again, he said, "I won't promise anything to anybody."[18]

The only reference to this episode in the Smith literature is a footnote, based on an interview with Dehner, in Rosalind Krauss's 1971 book, *Terminal Iron Works: The Sculpture of David Smith*: "As an adult, in a frenzied reaction to a reprimand by his first wife, Smith attempted suicide."[19] Smith's reaction was obviously extreme and, for Dehner, mortifying, but it's unlikely that his leap into the Hudson was an attempt to kill himself. Dehner was convinced that if he hadn't wanted to be rescued by the stevedores on the docks, he wouldn't have been. He was clearly rescued quickly from the icy water, and he told the men where he lived so that they could take him home.

Smith's bolting from the apartment recalls the story of the mud lion and his desperate escapes to his grandmother. Years later, Smith provided clues to his shocking flight. In a description of the symbols in his 1945 sculpture *Pillar of Sunday*, he refers to "the unity of chicken dinner and communion, which as a kid was one and the same." His 1947 prose poem "Spectres Are" ends with the following lines:

> Fascist mothers with voluminous vitelline vesicles
> Dead birds—limp curls—racist mudball lungfish
> The burning bush and the chicken dinner.[20]

For Smith, his mother sending a chicken dinner to celebrate his wedding was not an innocent gesture of generosity and goodwill but an attempt to insinuate her values and presence into his married life; her gesture was thick with family rituals that she idealized and he abhorred. The milk at the table may have rooted the event even more deeply in Smith's memories of infantile powerlessness and parental control. He had no appropriate language with which to express his anger and dread. His sense of being reprimanded for spilling the milk made him snap.

That same month, while driving a taxi, Smith had an accident. "Night scene in January—same night hit lamppost at 114th and Riverside with Cab," he wrote on a 1928 watercolor. The experience of the city in that painting is spectral. Four purple-black cars as heavy and boxy as hearses seem to be speeding on a road beside a body of water that suggests a

canal. Two cars are close enough to collide; a third looks in danger of running into or being cut off by them. Beyond leafless trees, on a hill, near the top of the watercolor, are hints of low-rent high-rises that seem as hollowed out as stage sets.

During his two-week stint as a taxi driver, Smith came home every day for lunch. "We lived in a comparatively fancy neighborhood," Dehner said, "and he didn't want anyone to know he drove a taxi, so he would park it a few blocks away and walk home. He wore an Alpine hat with a brush instead of a cap. One day he was threatened with an iron pipe by some other drivers because he parked in the wrong taxi stand area. Soon after that he stopped driving a taxi."[21]

Dehner and Smith embraced New York's cultural and ethnic richness, attending a dance recital by Martha Graham, going to plays, seeing paintings at the Whitney Studio and a Charlie Chaplin film. In another of Smith's watercolors, a butcher stands near two barrels and a two-wheeled wooden cart on a cobblestone street. His arms are tucked inside his apron. He is taking a breather in front of a bakery. In the doorway to his kosher shop, an overbearing heavyset woman, perhaps his wife, hands on hips, seems to wonder impatiently where he is.

Smith's letters to Dehner's aunt Flo were childlike. He ended the first one, in February, "With love from both your children David."[22] In March, referring to his wife as Dottie, he mentions an upcoming trip to Pasadena: "I hope I will not disappoint you but I do not feel like I'm making an acquaintance for I feel that I know you. When I knew about Dottie I knew about you and when ever with her I heard about you, and Sammie [formerly Dehner's dog]." He was effusive about his wife: "We are both so happy Aunt Flo I've never loved anything in the world like I love Dottie. She is the best squirrel in the wood. Life is so much fuller now—I had no idea how it could be."[23]

He assured Flo that he was looking after Dehner, carrying her costume books to the Art Students League and accompanying her on other days as well. In a sketch of them in front of their building, they are like Mutt and Jeff: Dehner is half his size and wearing a schoolgirl's outfit. He's wearing a suit and holding her hand. It's as if she's waiting for him to parentally guide her across the street, although he's waiting, too, so perhaps she is the confident one, and he is the one ready to be led. They

stand like a couple onstage about to take a bow: the boy-man like a big brother and daddy, the child-wife like a daughter.

Smith was also disarmingly innocent in letters to Aunt Flo about spending money, as if commitment to thrift would convince her of his maturity: "Dottie and I yesterday day before, went shopping on First Avenue. It is quite a lark for us—please do not reprimand us Aunt Flo but we both bought a 5 cent hot dog and some candy at the 5 + 10¢ store. We bought shrimp (jumbo) at 16¢ a pound. Oranges egg plant 12¢, celery, artichokes bananas 3 for 5, oh, and such a nice steak, the end of which we made meat balls Saturday night. We both worked Saturday night." Beside "egg plant" and "celery, artichokes bananas," Smith sketched images of each.[24] In another letter he told Flo: "I suppose Dottie told you that [her] Uncle George sent her a check for fifty dollars . . . The money is going in the savings bank at 4½%. New York pays a low rate of interest. I received 6% and 7% on savings in South Bend and 5½% in Wash. D.C."[25]

Smith told Flo that he was applying for grants: "What I really want and shall try every year until I do get it is the Guggenheim scholarship of $2,500. Then Dottie and I could travel and paint for a year or more. The Tiffany fellowship only gives two months, room and board in Mr. Tiffany's Long Island Mansion with a small amount for supplies. I cannot leave Dottie that long and besides this summer I want to come to California so I really do not know when I could accept it—but nevertheless I should appreciate the honor of the award."[26]

Smith was an industrious student and an eccentric personality. Some peers remembered him as "noisy." He wanted to stand out. "As a reaction from his spats and derby kind of dressing he would go home and get into a pair of old slacks and some things he called romeos—they were great flapping bedroom slippers with rubber sides," Dehner said. "And he would wear those to the League and this made him distinctive."[27]

On her recommendation, he took classes with Kimon Nicolaides, the League's most respected drawing teacher, who had already noticed and praised his work. Nicolaides's students drew from nude models and casts, and Nicolaides encouraged them to see the same form in multiple ways. To emphasize the role of memory in working from life, he would have them draw with their eyes closed, attempting to recall a series of poses. He had them make drawings of a pose in reverse—an imagined

mirror image. "Whatever the pose," Nicolaides advised, "draw as if the model were facing the opposite way and were using the opposite limbs for the gesture . . . Draw 'in reverse' a great variety of things, such as a piece of furniture, a house, a pitcher, an automobile."[28] Dehner remembered Nicolaides saying, while commenting on her and Smith's work as they sat side by side, "Well, you two are both pretty good. She can do what you can't, and he can do what you can't."[29]

Dehner and Smith found something like surrogate parents in Wilhelmina Weber and Tomás Furlong, who were connected with both the school and with Greenwich Village. They lived at 3 Washington Square, a ten-minute walk from Abingdon Square. Their neighbors in that building included the Calder family (whose son Alexander visited frequently from Paris), Rockwell Kent, Jean Charlot, Thomas Hart Benton, Edward Hopper, and John Graham. The Furlongs owned a house in Bolton Landing, a town in the Adirondacks where each summer they invited students to live and work. As soon as they found out about the place upstate, Smith and Dehner were interested in visiting.

Both Weber and Furlong were born in St. Louis, she in 1878, he in 1886. Before the Great War, she spent seven years in Mexico, where she and Furlong met. Both studied with the painter Max Weber. She painted predominantly still-lifes, marked by abstraction but never fully abstract. Her intelligence about color and form and attention to the personality and disposition of everyday objects shaped her pictorial poetics. Dehner revered her and painted her portrait. She believed that Weber never got the recognition she deserved. The 1928 Art Students League's annual catalog lists Weber as its executive secretary; Tomás Furlong was treasurer and a member of the board. "Actually she was the director," Dehner said, "and she was responsible for trying to get people like Hans Hofmann at the League."[30] Smith was one of Weber's favorites: she let him take classes without paying for them.

Smith fell into a regular job through a woman who belonged to the Anthroposophical Society. A nineteenth-century occult movement related to theosophy, anthroposophy played a decisive role in the formation of Mondrian and Kandinsky, and of abstraction. The woman wanted signs made for a medicine, "birch elixir," produced by the society. Dehner and Smith got $5 for making approximately twelve signs; she made the pic-

tures, and he did the printing. The woman who hired them encouraged Smith to apply for a job with her brother, who was president of the sporting goods outfit A. G. Spalding & Company. Smith became the company's director of accommodations, a position that seems to have involved, among other things, arranging window displays.

Soon after starting the job, however, Smith asked to take off for the summer, claiming he "had very bad sinus trouble, and that he would have to leave and go to California; and could he have his job back [when he returned]?" The answer was yes. Dehner went to Pasadena to be with Flo; some time later, Smith joined her. Then, in August, his beloved grandmother Catherine died in Paulding, leaving him a small amount of money.

Like many other artists since the dawn of industrialization, Smith and Dehner fantasized about making art in places uncorrupted by materialistic rot. Living in nature, through their resourcefulness, they would liberate themselves from repression and be in tune with their instincts and bodies. In Santa Catalina they photographed each other in bathing suits sitting on a large rock on a beach. Their poses are nearly identical—in profile, staring with self-conscious dreaminess. It was probably during this summer that they photographed each other naked and largely unposed in a cove. She's standing on the sand drying her right hip, her discarded bathing suit by her right foot. He's sitting on a rock toweling his right foot. Both are brown except for the skin that had been covered by their bathing suits. His "naturalness" is aggressive: with his mustache and baby face, he projects an image of mercurial defiance. She looks more than four years older than he.

Smith wanted adventure. He was attracted to preindustrial and non-Christian civilizations, excitingly documented in art magazines and books. He wanted to participate in archaeological discoveries and linger in the presence of vanished civilizations. In an autobiographical sketch twenty years later, he wrote: "In early spring of 1928 shipped out of Philadelphia on an oil tanker for San Pedro, thru Panama. Stayed all summer—returned on oil tanker to Bayonne, N.J."[31] It's very unlikely that he left in the early spring, and he could not have been away for five or six months. This would be the last trip Smith would not document with a camera.

For such a dramatic journey, it's notable that Smith never seems to have spoken about it. What is known of it is almost entirely through his watercolors, few of which have titles or dates. A number reflect the expressiveness of European modernist developments, including German Expressionism. Like paintings by van Gogh, the watercolors communicate a feeling for the personalities of everyday objects, like stoves, chairs, and beds. Smith's hills, valleys, and clouds are dense and irresistible presences; his trees are often visionary. In one watercolor, a blooming apple tree seems to surge with life, its branches unfurling like wild hair. Smith's feeling for landscape is intense and animistic.

Some watercolors hint at stories. In one of the few with images of people, a naked dark-haired man lies facedown on a mattress in the sparest of rooms, beside a window without shades, sunlight pouring in. The walls are bare. Beside the bed is an empty rocking chair. The man's right arm is wrapped around the top right edge of the mattress, his left foot tucked around one of the vertical rails at the foot of the bed: his body seems stretched. From the waist up, his skin is light brown; his buttocks, muscular legs, and even the soles of his feet are almost crimson. Other works point toward harsh economic realities: in an oil field, pumping wells have virtually replaced trees. An essentially black-and-white watercolor presents a regiment—in effect, an assembly line—of anonymous workers marching into a mine. Atop the office beside the mine is a cross.

When Smith and Dehner returned to New York, they moved from Greenwich Village, which was increasingly expensive, to the Flatbush section of Brooklyn, first to 2111 Beekman Place, then to 163 Sterling Street. They lived in a two-story building near the Brooklyn Botanic Garden and a mile from the Brooklyn Museum.

On his Guggenheim application, Smith's dream of spending a year or more in Europe entirely devoted to art was alive and well. He described his plan: "To do creative painting in Italy and France (principally landscape) and to study the honesty of my conception, employed by the Italian Masters that I may acquire the same truth in my own conception." And under the heading "Purpose of Study" he wrote: "I have been painting outdoor subjects in the summer; figure and interiors in the winter . . . My winters have been spent studying in New York City . . . My summers have been spent in various places working my way on steam or tramp

steamers, enabling me to paint various subjects which I found in Costa
Rica, Panama, Nicaragua, Mexico and California. I have also painted
much in New York State and in the Mid-West."

The application was shamelessly puffed up. Smith wrote that "for
the last five years," his "entire time" had "been devoted to painting and
drawing." To make himself seem older, he gave his birthdate as 1903.
To make himself seem more educated, he wrote that he attended not
just Ohio University but also "Notre Dame University, 1924-1925" and
"George Washington University, 1925-1926."[32]

7

Bolton Landing

In the summer of 1929, Smith and Dehner were guests of the Furlongs in Bolton Landing, 220 miles north of New York City. Golden Heart Farm was on a hill, about a mile from the center of town, with majestic views of Lake George. Since buying the property in 1921, the Furlongs had invited League students to visit. The young artists were lodged in rudimentary wood structures in a field a few hundred yards from the main house. Roof, walls, windows, and floor—that was it—no plumbing or electricity. Students could swim, fish, hang out in town, or hike—to Black Mountain, for example, or to Cat Mountain. According to a historian of the area speaking about the latter, "Mountain lions were wiped out of the Adirondacks sometime after the Civil War, but the name stuck."[1]

The Furlongs' guests could draw, paint, or read without distraction. In the evenings, they gathered in the big house, talked about art, and showed their work. Dehner remembered "a very beautiful landscape in more or less Impressionist style which [Smith] presented and sent out to his family in Paulding."[2] In one watercolor from that summer, he painted houses nestled into the landscape with dirt roads winding gently through fields. In another, he twisted Bolton Landing's Methodist church, making it seem organic through an expressionist approach that denied its rectangular severity. Even as he was painting from what he

saw, however, Smith wanted to hear about abstract art. He and Dehner had asked John Sloan and Kenneth Hayes Miller, Sloan's archrival at the League, about it. At the dinner table, he said to Tomás Furlong, "Tell me about abstract art. What do you think?" Dehner recalled, "Tomás talked very intelligently about it because he had studied with Max Weber, and Max Weber . . . hadn't forgotten about his Paris experiences in which he became an offshoot of Cubism in America."[3]

On August 11, 1929, Dehner wrote a check for $100 as a down payment on Old Fox Farm, a seventy-seven-acre property on Edgecomb Pond Road, less than a mile as the crow flies from Golden Heart Farm and roughly three miles up from town. A previous owner had used the land to raise foxes for the fur trade. The property included a pre–Revolutionary War house, two or three barns, and a chicken coop, all roughly 1,300 feet above sea level. The buildings were so run-down as to be barely usable. The property seems to unfurl down the hillside toward the lake, which rises like a vision beyond the trees between the property and the water. "We thought, how marvelous this is, to have a farm, up in the mountains. The only thing that's important is the view; that we have something marvelous to look at," Dehner said.[4] "We named it Red Moon Farm after the Indian designation for August, the Red Moon or Harvest month."[5] The $3,000 would be paid in installments: the deed would

David Smith (photographer), outbuilding, Red Moon Farm, Bolton Landing, New York, 1936.

be drawn up with the next payment, $400, on April 1, 1930. Charles H. Roberts, the previous owner, retained timber rights. He could enter the property and cut trees whenever he wished.

Lake George is thirty-two miles long and dotted with 172 islands, seventeen of which are privately owned; the others belong to New York State. Formerly known as Lac du Saint Sacrament, the lake was renamed by the British general Sir William Johnson for King George II during the French and Indian War of 1754–1763. The French general Marquis de Montcalm's burning of Fort Henry, which Johnson had built on the lake's southern end, was made famous by James Fenimore Cooper in *The Last of the Mohicans*. In 1783, General George Washington visited the head of the lake on his northward inspection tour following the revolution; he was followed in 1791 by Thomas Jefferson, who explored the "strategic waterway" and found, in words that remain irresistible to the tourism industry, that "Lake George is without comparison the most beautiful water I ever saw, formed by a contour of mountains into a basin—finely interspersed with islands, its water limpid as crystal. And the mountain sides covered with rich groves—down to the water-edge: here and there precipices of rock to checker the scene and save it from monotony."[6]

During northward migrations following the Revolutionary War, many settlers looking for land in Vermont ended up in the Lake George region; in fact, a section of Bolton Landing was called "New Vermont." The town of Bolton was founded in 1799; Bolton Landing came into existence in 1882, the year in which trains began arriving in what is now Lake George Village, ten miles to the south. "The name was derived from the boat landing, which became important to the town for delivery of passengers, mail and supplies," William Gates, Jr., a local historian, wrote.[7] Between 1880 and 1914, a building surge saw the construction of most of the estates on the lakefront stretch between Bolton Landing and Lake George Village known as "Millionaire's Row." The estates belonged to men like William K. Bixby, the first president of American Car and Foundry; Hugh Harold, a sponsor of Charles Lindbergh's flight across the Atlantic in 1927; Russell C. Leffingwell, chairman of the board of J. P. Morgan & Co.; Adolph S. Ochs, publisher of *The New York Times*;

and the Wall Street tycoon George Foster Peabody, whose guests included Booker T. Washington and other trustees of the Hampton Institute.

With the advent of the automobile after the Great War, more and more people began to visit the region. By 1929, Bolton's seasonal cycle was similar to that of other northern tourist centers. For eight to ten weeks each summer, the population increased ten- to fifteenfold. The summer population stimulated the growth of jobs, including those in carpentry, masonry, and lawn care. Around Labor Day, as suddenly as the summer people had arrived, they disappeared. From 1915 to 1960, the year-round population of Bolton Landing remained roughly 1,400. When cold set in, the town hunkered down. Winter jobs included logging and cutting pulp and ice. The town had a school and churches. Bolton residents met regularly in the few bars and restaurants that remained open all year. With the North Country's biting winds, deep snows, and below-zero temperatures, properties even half a mile up from town could feel as remote in winter as farms on the outskirts of Decatur and Paulding. Adirondack forests were home to deer, foxes, bears, panthers, ravens, and eagles. Outside town, animals were as much a part of winter life as other people. Men hunted for food as well as sport.

The cultural presence in Bolton Landing and throughout the region was substantial. Although best known as a speedboat racer who brought the Gold Cup Regatta to the lake for three years (1933–1935), George Reis was also an actor who had performed in the Pasadena Playhouse for several years, beginning in 1921. Composer Sidney Homer was a cousin of the painter Winslow Homer. His wife, Louise Homer, a singer at the Metropolitan Opera at the time of Enrico Caruso, recorded the first record for RCA. German-born Franz Boas, a founder of modern anthropology, and his wife, Marie Krackowizer, also an anthropologist, were regular summer residents from the end of the nineteenth century through the mid-1920s. Smith would refer to Boas in talks and three Boas books—*Primitive Art*, *The Mind of Primitive Man*, and *Race, Language and Culture*—were in his library at the time of his death. Boas's research convinced him of the contingencies of scientific knowledge and the instability of human identity. His belief that "mixing is the natural state of the world" and his rejection of the long-accepted assumption "that social development is linear, running from allegedly primitive so-

cieties to so-called civilized ones" would also become integral to Smith's work.[8] One of Boas's six children, Franziska, born in 1902, founded the Boas Dance School in New York City and ran a summer dance studio in Bolton Landing from 1944 to 1949. Smith and Dehner would sit in on her classes, Dehner would create sets for her, and she would send students to Smith's studio.

Alfred Stieglitz remains the cultural figure most identified with Lake George. In 1886, when he was twenty-two, his father, Edward, bought an estate, Oaklawn, in what would become Lake George Village. Until his death in 1946, Stieglitz regularly summered there. He took many remarkable photographs of the region's landscape, fascinated by its trees and sky. Dramatic in his black cape and hat, he brought to Lake George some of the famous artists in his circle, including Arthur Dove, Marsden Hartley, John Marin, Edward Steichen, and Max Weber. Georgia O'Keeffe first visited the region in 1909 with nineteen other members of the Art Students League and then, with Stieglitz, became a regular summer visitor. Like his photographs, her paintings of barns, flowers, and foliage helped form an image of Lake George as a grand and unspoiled region with a powerful national history where, during the summer at any rate, artists could feel at home.

At the end of the summer, Smith and Dehner returned to Brooklyn. He continued to commute by subway to his job in lower Manhattan with A. G. Spalding. At the same time, he was cultivating job connections with magazines for the leisure class. He made illustrations for *Tennis* and sketches for *The Sportsman Pilot*, a magazine "devoted mainly to the activities of wealthy Long Island yachtsmen and pilots who could afford to fly purely for pleasure rather than business."[9]

In September 1929, Smith and Dehner enrolled in Jan Matulka's Life Drawing, Painting and Composition. Matulka had studied at the Art Students League in 1924–25 but was newly installed there as a teacher. His class met five evenings a week. He was present for two; his monitor ran the other three. Tuition was $12 a month.

Matulka was a revelation. He "gave us that extra feeling of confidence in ourselves which acknowledged our serious intent to become profes-

sional artists," Dehner wrote. His "dedication to his own painting was passed on to us, an awareness of what it meant to live the life of an artist and accept the responsibilities to one's work."[10] Smith wrote, "Jan Matulka influenced me last and most as a teacher."[11] In an interview he said that Matulka "was the most notable influence on my work—I was going to say 'life,' because my work is my life."[12]

Born in 1890 in Czechoslovakia, Matulka was more cosmopolitan than the League's other teachers. He kept a studio in Montparnasse, and he made illustrations for *The Dial*, a progressive literary magazine. He was enthusiastic about tribal sculpture and passionate about jazz, modern dance, and literature. He understood Cubism. Except for when Max Weber taught at the League, "no abstraction, no cubistic approach, and certainly no nonobjective painting had been introduced," Dehner wrote. "Matulka, both as a painter and a teacher, was for that period a very avant-garde figure."[13]

Matulka exhibited regularly in New York. Katherine Dreier included his work in a 1920 Société Anonyme exhibition and in her immense Société Anonyme exhibition at the Brooklyn Museum in 1926. He had solo shows at Manhattan's Frank K. M. Rehn Gallery. Like Sloan but less noisily, Matulka was a leftist: between 1926 and 1930 he contributed two dozen illustrations to *New Masses*. He preferred not to fit in, preserving his identity as an outsider and exile. During his sixty years in the United States, he never became fluent in English. He remained hostile, at times self-destructively, to money and power.

In the classroom, Matulka was inspiring. "He treated his class as peers, not as pupils," the curator Patterson Sims wrote. "What happened in his classroom was exciting and almost magical, for this shy and nonverbal man came alive with his students. Much of his teaching was done by example, with Matulka dashing off rapid sketches to make his ideas accessible."[14] Smith wrote, "Matulka was the kind of a teacher that would say—'you got to make abstract art'—got to hear music of Stravinsky—Have you read the 'Red and the Black'—'Stendhal.'"[15]

Matulka worked in different styles and encouraged students to think across artistic media. For him, photographs of artwork could be themselves works of art, essential to how art was experienced. "Matulka persuaded the League to acquire for his class three large, blown-up

photographs—reproductions of two Picasso paintings and a wooden African head of a woman," Sims wrote.[16] He blurred the boundary between painting and sculpture. "All the students in the Matulka class worked with textured paint," Dehner wrote. "We used to mix old paint scrapings, pumice stone, sand even small pebbles in with the paint." She made paintings "THICK with texture." Matulka "spoke a great deal about PLANES, and we analyzed the figure from that point of view in the drawing we did in his class. (His class was a drawing class officially, but we were all so *fired* that we painted at home and brought our paintings regularly for his criticism."[17]

On Saturdays, Matulka's students went in search of art they learned about in class. According to one Smith scholar, he "sent his students to the few commercial galleries in the city that exhibited the works of the Fauves, Cubists and German Expressionists. They also visited A. E. Gallatin's collection of modernist art at New York University."[18] Gallatin's Gallery of Living Art opened at New York University, near the Furlongs' Washington Square apartment. "Gallatin," writes the Picasso scholar Michael FitzGerald, "conceived a space that resembled the Whitney Studio Club more than it did any future museum—a series of lounges filled with tables and chairs, where individuals and groups could gather to examine the art at their leisure and engage in conversations, serious or casual. While N.Y.U. students often ridiculed the paintings hanging on the walls, the gallery truly became a cradle of 'living art' in the Depression years."[19] The inaugural exhibition included five Picassos.

In Matulka's class, Smith found Cubism: "Then the world kind of opened up for me," he told an interviewer.[20] In an Analytic Cubist painting, objects can be seen simultaneously from multiple points of view. Each body part—head, arms, legs, belly—and each object—table, chair, musical instrument—can be rearranged, in process, in movement from one stage or shape to another. The boundary between inside and outside, above and below, front and back, is ruptured. Bodies and objects are no longer solid and monolithic, like statues; they can be transparent. Cubist space can be dynamic and mysterious. The areas within, around, and between objects can be as thick and sculptural as the objects; space is mass, and mass space. The possibilities for artistic analysis, play, and discovery seem endless. Analytic Cubism can reward intense looking with a sense

of special access. Seeing is not just active; it can become a transformative act. No one sees the same painting. Synthetic Cubism, which began later, around 1912, developed the most generative twentieth-century art form, the collage. In a collage, the painting surface can hold objects from outside painting in ways that challenge as well as assert the adhesive power of the pictorial surface. How forms meet and join can be matter-of-fact, gentle, or abrupt. With Cubism, art is not a given. Reality is not a given. They are not so much unstable and in process as unknown. The Cubist object becomes its own thing, its own vision, in the hands of Picasso and Braque at once rigorous and hallucinatory, hermetic and exposed. This new artistic totality can seem so mesmerizingly unexpected that the world outside art seems tired.

Toward the end of the year, Wilhelmina Weber Furlong resigned from the League. Dehner believed that "they hated her because she was trying to introduce the avant-garde at the League . . . When she finally got [Vaclav] Vytlactil and she got Matulka [to teach at the League], that was just marvelous. But she was out." She and her husband, Dehner went on, "started a school themselves, down in Washington Square, and they made me the monitor."[21] Officially, Weber Furlong was dismissed for making herself too big for her job: "There was a great difference of opinion between Miss Weber and the Board as to what the position called for." And for receiving double pay for the summer of 1929 because her husband was the League's treasurer.[22] The money issue was not minor. The school was dependent on tuition, and particularly at the beginning of the Great Depression it was imperative for classes to be self-sustaining.

With the crash of the stock market on October 29, 1929, the economic system collapsed. Millions of people felt broken and betrayed. Art needed new forms and languages. On November 7, the Museum of Modern Art opened in Midtown, in the heart of the city, with the support of financially prominent and aesthetically enlightened patrons. Led by its founding director, Alfred H. Barr, Jr., MoMA became the first American museum to make a home for Picasso, Matisse, and other great European modernists. Its opening exhibition consisted of a hundred works from American collections by European artists, including the Post-Impressionists. MoMA's second exhibition—its artists selected from lists by trustees—was devoted to nineteen American painters,

among them Max Weber, Kenneth Hayes Miller, John Sloan, Georgia O'Keeffe, John Marin, and Charles E. Burchfield. The third exhibition, "Painting in Paris from American Collections," opened with fifteen paintings by Picasso as well as paintings by Braque, Matisse, Joan Miró, Fernand Léger, and Robert Delaunay. That same month, January 1930, the Whitney Museum of American Art, which grew out of the Whitney Studio Club, announced that it would open a year later. Museums were creating a larger and more vital space for modern and contemporary art. American and European art would battle it out in institutions.

John Graham

In the fall of 1929, also at the League, Smith met his other great mentor, John Graham. Graham "was a painter, he was a collector, he was an intellect, he opened great windows for both of us," Dehner said. "A very sophisticated, a very intellectual man. And very erratic and as mad as a hatter in many ways, you know, but very wonderful."[1] She also said, "Matulka was the great influence on David's painting, but John Graham was a perfectly tremendous influence on his life and philosophic attitude. He introduced David to a wider world."[2]

The occasion of their first encounter was a meeting to prevent Wilhelmina Weber Furlong's ouster. "Graham and Elinor [his wife] had been students of Sloan a number of years before and . . . [they] supported her," Dehner said.[3] Soon after, the Grahams invited the Smiths to dinner at their apartment, where they saw not just Graham's paintings but also his collection of African art.

Over the next decade, Graham would be a constant in their lives—in the city, upstate, and abroad. Like Matulka, Graham directed them to art, but he also gave them art and introduced them to other artists, sometimes in artists' hangouts like the cafés in Greenwich Village run by Marie Marchand, widely known as Romany Marie. Through him they met Milton Avery, Stuart Davis, Arshile Gorky, Frederick Kiesler, and Jean Xceron. Graham introduced Smith to Frank Crowninshield,

editor of *Vanity Fair* from 1914 to 1936, one of the seven founders of
the Museum of Modern Art, and among the most important American
collectors of African art. Beginning in the mid-1920s, Graham bought
African art for Crowninshield in Paris.

Also like Matulka, Graham understood Cubism and painted in a va-
riety of styles, although his styles were so varied that a Graham show
could seem to have been painted by different artists. Unlike Matulka,
Graham actually knew Picasso. He was a crucial bridge between New
York and Paris. He spoke fluent French and was friendly with promi-
nent French modernist and African art dealers and collectors. He knew
Guillaume Apollinaire, the poet and theorist of Cubism; André Breton,
the poet and "pope" of Surrealism; Christian Zervos, the editor of the
influential French magazine *Cahiers d'art*; and Julio González, with
whom Picasso collaborated on the welded iron and steel sculptures that
were instrumental in Smith's turn to welded metal sculpture. Graham
"brought the excitement of the French art world to us," Dehner wrote in
the foreword to his 1937 book, *System and Dialectics of Art*. "He told us
many things about that scene, in brief sharp comments. What he said
was very much to the point, profound, flavored with a caustic humor."[4]

Graham entered Smith and Dehner's life at an extraordinary mo-
ment for him, Smith, and American art. In 1928, Graham had met Stu-
art Davis, who lived near him in Paris, and Arshile Gorky, who had fled
the Armenian genocide and in 1920 immigrated to the United States.
In 1929, Graham met Willem de Kooning, who three years earlier had
arrived in the States as a stowaway on a ship from Holland. De Koo-
ning called Graham, Davis, and Gorky the Three Musketeers; de Kooning
would become, in effect, the fourth.[5] Also in 1929, Graham exhibited
in Paris, where a small monograph on him was published, as well as in
New York and Washington, D.C. Duncan Phillips, a founder and long-
time director of the Phillips Collection, was paying him a stipend for his
paintings.

Graham was married to Elinor Gibson, a painter and the daughter
of the musician and composer Archer Gibson. They met at the League
in 1922. She became Graham's third wife in 1924 and in the summer of
1929 the mother of his fourth child, David. In 1929, Smith was still just
twenty-three. It is evidence of his and Dehner's intelligence and vitality,

individually and as a couple, and of Smith's magnetism, that the Grahams wanted to be with them. "Our little quartet" is how Dehner referred to them.[6] She later wrote, "He was a mature artist, and we were still students, members of the group of young artists whom he characteristically accepted as his peers."[7]

Smith and Dehner had never met anyone like Graham. There was no one else like Graham. Ivan Gratianovich Dombrowski was born to Polish parents in Kiev in 1886. During his storybook early years—fictionalized and obfuscated by him—he seems to have earned a doctorate in jurisprudence, served in the tsar's personal footguard, been imprisoned by the Bolsheviks, and joined the Grodno Hussars of the Circassian Regiment of the Wild Division of Grand Duke Michael. He immigrated to the United States under duress in 1920, changed his name to John Dabrowski, and then to John D. Graham.[8] To the end, Dehner and Smith called him "Ivan."

Graham provided Smith with a different model for an artist. Sloan had a combative independence. Matulka was an essentially private person. Graham was contradictory, flamboyant, and perpetually reinventing himself. An occultist and performer, he could be cryptic and blunt, tasteful and outrageous, aristocratic and trashy, mercurial and measured, loyal and cruel. He fell in love, married, fell out of love, fell in love again, then moved on again, marrying four times. Around five foot eight and bald, he had a gymnast's hard and supple muscularity. When he was in a room, people noticed him. He was physically as well as emotionally and artistically acrobatic. He was capable of unforgettable gestures.

Repression was the enemy. "Love and sex are vital elements of all life," he wrote. "Tampering with them leads to warped conceptions, to desires driven inward, to fictitious balance and eventually to disaster, as well for nations as for individuals." He was an advocate for "divination, evocation, revelation, *power unlimited*, power procreative, power advancing directly from point to point without the tedious procedure of logical argumentation, the power of the unconscious organized." Graham read Freud and Jung and extolled the unconscious as "the storehouse of power and of all knowledge, past and future."[9] His mind worked in leaps, sometimes seemingly illogically and capriciously but with its own kind of coherence, one that made it impossible for others to explain him or

box him in. The Graham scholar Marcia Epstein Allentuck wrote: "One of Graham's underlying assumptions was that not only the aesthetic experience but all human experience is so convoluted and complex that it cannot be treated without characterizing apparent opposites in terms of each other; interpenetrations, not reconciliation, was his emphasis."[10]

Graham was passionate about African art. He proselytized for its emancipatory aesthetic potential, seeing African sculpture in its connection to memory and improvisation as a "liberator for [Western] sculptors and painters. It has shown them that, in the plastic arts, proportions can be rearranged, so long as the aesthetic impulse involved in their rearrangement is inspired and noble." African art had special access to the unconscious: "Access to the unconscious affected the 'primitive' artist in two ways: it allows the retrieval of information from the 'primordial past' and permits spontaneous composition. The resulting form can thus be reduced to its most elemental components, which may also be shifted at will."[11]

In addition to collecting African art for himself and for Frank Crowninshield, Graham would inspire other artists to collect it, including Smith, Edgar Levy, and Adolph Gottlieb. To seek, to acquire, to own, to possess. The basic act of collecting, Graham wrote, "begins the respect for things and consequently respect for human life . . . The desire to collect . . . comes from the painful fact that most people have lost contact with nature, with SPACE, with matter, they have lost contact with themselves, and thus are incapable of direct communication with other human beings . . . Collecting is not merely investing money in art objects, collecting is rather buying with privations to establish a personal contact with art objects, artists and spiritual life of past epochs."[12]

Through the 1930s, Graham's hero was Picasso, whom he began promoting well before Picasso was embraced by American critics and collectors. For Graham and his circle, Picasso was the first inventor of Cubism and collage. He was a protean painter-sculptor of unceasing inventiveness, a shape shifter, a provocateur, and a magic man, many of whose paintings seemed as much conjured as made. He was the one living artist who seemed always ahead of and larger than his time. He did not transition from stage to stage but leapt from one approach, one style, to another, each of which was persuasive. "Picasso became the paragon, the

exemplar of new art for the Graham circle, both for his Cubist art and his figurative painting and drawing," William C. Agee wrote. "Not the least of his teachings in the early 1920s was that art could explore many avenues at the same time, both figurative and abstract, a lead followed by Graham, Gorky, and de Kooning."[13]

At times, Graham could be Ivan the Terrible. His rejection of inhibition, a standard feature of avant-garde aesthetics, licensed entitled, petulant, and disruptive behavior. He was an unreliable parent for the three children he left behind in Russia and for his American son. He could be negligent with and disdainful of women. "Graham didn't like intelligent women—didn't want the intellectual type," Dehner said.[14] In the 1930s, he dismissed the value of Elinor's work as mother and in the home, and her teaching job that supported the three of them. In public with wives and girlfriends, he could "pick and pick," Dehner said.[15] He reserved his cruelty "for the women who were intimate with him."[16] Graham never seems to have apologized for his abusive behavior. When women left him, he felt victimized. In his "erotic drawings" from around the 1940s, sexuality is a space for fantasy, but the fantasies, while at times savagely burlesque and bold in Graham's determination to visualize obsessions without regard for social norms, are also defined by disconnection, sadism, and torture. Sex here is a war zone. He scorned normality, often inspirationally, in the service of creative possibility, but also, for some of the people closest to him, destructively. For every artist he brought into his circle, however, his impact was indelible. Even if their friendships with him ended, it was impossible not to remember him with affection and gratitude.

In 1930, Smith became an abstract painter. His early still-lifes and portraits are clearly marked by Matulka and Graham even as his shapes and edges have a distinctively raucous and caricaturish charge. He kept up with American art magazines, quickly absorbing developments not just in painting but also in sculpture and photography. He and Dehner made the rounds of galleries in the Village and Midtown and made a point of visiting modernist exhibitions. Whenever work by Picasso and Cubism was shown in the city, Smith saw it.

In a photograph from around 1929, surely taken by Dehner in front of their Sterling Street building, Smith stares at the camera while sitting on the stone ledge by the entrance, his back against the stone building. His right leg rests on the ledge; his hands are clasped around his shin. He has a mustache and is wearing what look to be wool pants and a white cotton shirt; his collar is open. A lock of black hair falls over his forehead almost to his left eye. In another photograph by the steps of the same building, the address number 163 painted on one of the four stone steps visible beside his right leg, he is also facing the camera. His hair is carefully groomed, and he's wearing a suit that seems incapable of containing the energy pent up within him. In both photographs, his leanness and long legs make him seem taller than six foot two. He's clean-cut, even preppy, but his eyes and mouth seem to be saying: Look out!

David Smith in front of his Brooklyn apartment building, ca. 1929. Photograph probably taken by Dorothy Dehner.

The musician Mordecai Bauman vividly remembered meeting the Smiths in 1930. "David was a very friendly person, very open and very easy to be part of, and Dorothy was a very attractive woman," Bauman recalled. They were "dashing." "Smith came on as a most proper kind of human being, in the sense that . . . his dress was very, very formal, very much ac-

ceptable in high society . . . He was—well, he was a very powerful figure, physically, you see, and she was very delicate. So you always felt he could take her and break her in two if he wanted to."[17]

In two painted portraits of Smith, he appears to be two different people. Around 1930, David Burliuk, born in Ukraine and one of the Russian painters in Graham's circle, drew Smith as a thoughtful, inward, and acutely sensitive—and remarkably good-looking—young man. In the comic, affectionate and perhaps somewhat satirical portrait Edgar Levy painted of him a few years later, Smith is a bear of a man, wild, brutish, a priestly blacksmith out of Marsden Hartley's rural America, all gruff and stubble except for his concentration on drawing, his instrument not a pencil but a railroad spike. Smith looks preindustrial, but there is delicacy in the way he holds his instrument and he is totally absorbed in his task. Levy is mesmerized by Smith's massive yet adroit hands.[18]

In the spring and summer of 1930 and 1931, Dehner traveled regularly upstate and remained there for long stretches, usually with her and Smith's black cat, Bohack (named after a grocery chain with branches in Brooklyn). Periodically, Smith joined her on weekends and they worked to get the house in shape. They communicated mostly by mail. "Dearest Peanut," she addressed him in one letter, "Dearest D.R." in another. With his office job and daily commute, he did not want her to be away for so long, at one time at least during the summer commanding her to return. She remained upstate.

Jan Matulka's position at the Art Students League, uncertain after Wilhelmina Weber Furlong was kicked out, was eliminated because of too few students. Smith, Dehner, and more than a dozen other students left with him. Most of them, including the Smiths, Lucille Corcos, Edgar Levy, Michael Loew, George McNeil, Irene Rice Pereira, and Burgoyne Diller, became established artists. The class, which would become known as Matulka's Class, found a studio at Fourteenth Street between Seventh and Eighth Avenues. The students made the arrangements, found the chairs, brought coffee. "The students usually drew or painted from still-life arrangements . . . one of their props being a plaster cast of the head of Voltaire," the curator Patterson Sims wrote.[19] Matulka and his students grew even closer in this setting. Friends and lovers were welcome. "He was lucky," Dehner said, "because who has students like that, you know,

and who were we that we should have such a great teacher. It was a felicity thing all the way around."[20]

Dehner and Smith's closest friends in the class were the Levys. Both were Jewish New Yorkers. Lucille Corcos, born in 1908, and Edgar Levy, born in 1907, met at the League. In 1929, the year after their wedding, they moved to Brooklyn Heights. By the mid-1930s, roughly five years after she set out to see if she could make some money as an illustrator, Corcos became one of the most successful illustrators in the country. Like Dehner, she was a gifted storyteller. In her paintings, she gave the city, as well as her family life, an infectious intimacy. She is known for her illustrations of children's books and of fanciful novels such as Nikolay Gogol's *Dead Souls* and Oscar Wilde's *Picture of Dorian Gray*. Among the Smiths and Levys, Corcos would be the first to be selected, in 1936, for the Whitney Biennial of Contemporary American Sculptures, Watercolors and Prints. Levy painted jigsaw-puzzle constructions that look like Matulka's, Graham's, and Smith's pictorial responses to Cubism but also suggest Matulka's cityscapes and landscapes. Like his wife, he was first of all a narrative artist. His portraits have wit and affection and pathos, his cityscapes a playfulness that can give the intimidating scale of lower Manhattan the charm of a fairy tale.

Levy was the intellectual leader of the class. "His approval of a piece of work, for example, would mean the world to all of them and his disapproval would be horrible," Levy's older son, David, named after Smith, said.[21] The painter Larry Rivers wrote that Levy "was generally regarded as an *enfant terrible* by the others, eliciting admiration mixed with fear of his sharp tongue and acerbic criticism. His judgmental attitude, which was tolerated because he was a leader in those beginning days, turned outright nasty as his contemporaries moved to 'pure' abstraction."[22]

Graham, who met the Levys through Smith and Dehner, praised Edgar Levy in *System and Dialectics of Art*: "Young outstanding American painters: Matulka, Avery, Stuart Davis, Max Weber, David Smith, W. Kooning, Edgar Levy . . . are as good and some are better than the leading artists of the same generation in Europe."[23] For Smith, Levy, and de Kooning the statement was flattering although odd, the grouping typically Graham in its improbable coherence. Graham knew that by then

Smith was as much sculptor as painter and that several of these artists were not young.

In mid to late October 1931, Smith gave up his job. He and Dehner left Bohack with the Levys and drove the possessions in their Brooklyn apartment to Bolton Landing, where they would be stored. They boarded a freighter for the Virgin Islands. No more classes, office jobs, suits and ties, or subway commutes. They could step back from the human misery and economic bleakness, from job and career pressures, and from art world polemics over what was and was not American art and whether or not American artists should be influenced by French artists and whether it was an outrage for American collectors to collect French artists at the expense of Americans. They could gain some distance from conflicts among friends. Matulka and Graham were not getting along. "Matulka does not seem to reap the fruits of the land like Graham," Smith wrote in late December to the Levys. "Matulka calls Graham a watch trader and in the last year or so they seem to have gotten quite hostile." Away from New York, Smith could "get organized with a viewpoint not subject to the French school and dear old Picasso."[24]

The artist who inspired their departure had set sail for Tahiti forty years earlier. In *Noa Noa*, Paul Gauguin wrote that on Tahiti he was "far, far away from the prisons that European houses are." There he had "escaped everything that" was "artificial, conventional, customary." For him, Tahiti was a place of the "Yes!" where the Old World civilization within him was dead and he was "reborn; or rather another man, purer and stronger, came to life within" him.[25] "In the first years of the twentieth century Gauguin was considered the typical bohemian-artist rejecter of bourgeois living and morality . . . cutting both his life and his art to the bone in order that he might find and express reality," Robert Goldwater wrote in his 1938 book, *Primitivism in Modern Art*. "His was an exoticism which thought that happiness was elsewhere but which at the same time—and this is what is characteristic of his part in a new tendency—sought not the luxurious and the intricately exotic of the earlier nineteenth century, but the native and the simple."[26]

Both she and Smith had the idea to go to the Virgin Islands, Dehner said: "We had met a girl. She was a relative of a friend of ours, and she had lived in the Virgin Islands." When she and her husband told them about "their adventures," Smith and Dehner realized, "We don't have to go to the South Seas. That's too far."[27] She wrote, "This was a typically romantic idea of ours. We wanted to be like Gauguin and find a paradise in a tropical climate. We had just read *Noa Noa* and were learning more and more about the lives of the artists."[28] They boarded a freighter on which the little amount of money Smith brought with him was stolen. Dehner's inheritance would support them. In the Virgin Islands in those days, she said, "the tourists had not started to come. It was very simple and very lovely . . . we lived there for almost a year."[29]

The Virgin Islands

"We finally felt we wanted to paint on our own, no more classes, and our last year at the League with Jan Matulka had given us new ideas to follow." With time to explore materials and methods and, in Dehner's words, to "paint, swim, fish, take pictures and spend days with sun and sea," Smith's work took off.[1] He was still a painter: "In the Virgin Islands I painted very seriously and very well—large and small paintings."[2] But photography, the found object, and sculpture began to define his work as well. Able to structure his life as he wished, he moved freely, searchingly, across disciplines. His work became a sprawl.

Soon after arriving in St. Thomas, Smith and Dehner met Ethel and Ralph Paiewonsky. Born in the Virgin Islands in 1907, Ralph Paiewonsky attended New York University, after which he returned to St. Thomas. Much later, from 1961 to 1969, he would serve as governor to the territory, appointed by President John F. Kennedy. He was the chief pharmacist in his drugstore in Charlotte Amalie, the capital. An agent for Eastman Kodak, the drugstore sold and developed film. It was a "meeting place," Paiewonsky told the art historian Joan Pachner in 1986.[3] Paiewonsky became something of a mentor: through him, Smith learned to develop and print photographs. Probably for the first time, he studied chemicals and their processes.

In the Virgin Islands, Smith was obsessed with photography. He took

snapshots with Dehner's Brownie camera. "He photographed constantly and then sometimes I would photograph him," Dehner said. Often it was "just click, click, click. Sometimes he'd say, 'now you stand there' because I was very agile and I could climb up a tree or something and he'd say 'take that' and I could be able to do it."[4] He bought an expensive reflex camera, which Dehner described as one "with a bellows . . . that you pulled out. It was a press camera . . . the film was large . . . big negatives."[5] He photographed motifs that would continue to fascinate him, for example, masts—towering signposts, crosses of a kind—their linearity silhouetted against the sky. He photographed markets, factories, and street scenes as well as individuals and crowds, from up close, above, and far away. He photographed harbors and boats—the West India Company dock where huge freighters loaded and unloaded cargo, wood piers at which fishing boats docked and rowboats clustered like a school of fish, and inlets where schooners anchored.

Smith was mesmerized by cannons, which the art historian Rosalind Krauss would identify as a recurring motif in his work. Asked by Joan Pachner if there were cannons all over St. Thomas, Dehner replied: "Not all over, but he'd find them."[6] He liked positioning his camera behind them in such a way as to emphasize both aggressive intent and disuse. In his photographs, cannons seem to remember violent purpose but to have been deprived of the ability to enact it. They seem active and anachronistic, ominous and absurd. No longer able to defend or attack, they are out of place in island life, remnants of another time, emblems of threatening but lost and unrecoverable potency. In Smith's world, the found object was redeemable. The cannon was not.

The photograph *St. Thomas Looking West from Bluebeard's Castle* shows the view over the town and hills from a spot accessible by tram. In the right foreground are a cannon and, close beside it, two white conch shells. Smith surely staged the sexualized contrast between the delicate shells and the derelict, imperial cannon. His caption has a documentary straightforwardness: "St. Thomas (pop. 10,000) is the principal island of the main three American Virgin Islands. This view shows the city, which is built upon three hills. It possesses the finest harbor in the West Indies."[7] Against this deadpan matter-of-factness, the juxtaposition of the cannon and shells has a burlesque but pointed prankishness.

Three weeks after their arrival, Dehner and Smith went on an extended island tour. The first time Dehner had made the trip from California to New York, it was with her mother and sister on a boat through the recently opened Panama Canal. Smith had traveled to Central America on a freighter. Now they were together on semi-freighters in the balmy weather and tropical light. The boats unloaded and loaded cargo. Movement was slow, trajectories vast. Even as he gathered information about economic and social systems, Smith absorbed a sense of expansive and continuous space and time that he needed as much as the velocity and abruptness of New York City.

After ten days in Tortola, they visited Trinidad, 550 miles south of St. Thomas. In his only known letter from the Virgin Islands, Smith wrote to the Levys:

> Tomorrow Dec 24 will be our 4th wedding anniversary which will go uncelebrated except for a bottle of Chablis 1921. We are staying at a middle class English boarding house @ $2 English or about $1.40 or less per day American money. Very decent and respectible with curried kidneys—roast mutton and puddings and tea at 3:30—room breakfast at 8 and big breakfast at 11:30 and dinner at 7:30 and a pot under each bed. Tell Bohack about it—he might be interested.

"Thanks for the care of our child," Smith added, referring to their cat.[8]

After returning to St. Thomas, they finally settled in. They found daily staples more expensive than in New York and, in Dehner's words, "not half as good. Sodas are 15 [cents] and perfectly vile. We send to N.Y. for the few things we need."[9] Depression bleakness could be felt here, too, but the artists welcomed the freedom to work and wander that Smith had yearned for in letters to Dal Herron. They got a Virgin Islands cat, a female, hard of hearing, with black spots—and, soon, purple ones. "Purple ones by D.R.S.," Dehner wrote to the Levys. Smith painted the cat! Their living quarters were all they could have hoped for. "We have a swell old Danish house," Dehner wrote, "furnished without dishes & sheets for $20 a month but it has a Frigidaire to make up for" the things it lacked. "We have a cook who does every thing including washing for

$10 a month and no food. And you can eat on $1 a day & have .20 left to spend. Really its grand & I'm disgustingly spoiled and do nothing but eat & paint & moan when I think of the way I scrubbed woodwork in Bolton Landing."[10]

Along with occasionally going to bars and socializing with the Paiewonskys, they made friends with rich men like Horace Fairchild, who, in Dehner's words, "had isolated himself down there and built a mansion on the peak of the island." When Fairchild wanted them to visit, he sent a "boy and a donkey down" to them and Dehner would ride the donkey back up.[11] But they prided themselves on blowing off officialdom. "Because no doubt of our great charm we were at first invited to all the government parties & functions," Dehner wrote, "but we acted so nasty about refusing that now we are left quite to ourselves."[12] Smith did not want to play social games. Someone's platitudinous behavior provoked him to write: "Say something without bromide—no analogys—analogys always from fairy tale adolescence." Even here, his upbringing pressed in. "Praise god and a Methodist mother," he wrote with sarcastic anger.

They expected to find in the Caribbean both proof of American malignity and ways of life that could not be corrupted by American imperialism and materialism. When they ran into local residents who did not share their contempt for American mass culture, Smith's pronouncements could be arrogant and dismissive: "Trinidad is a knick-knacky place. The architecture is influenced by the pagoda, Moslem combinations and doesn't compare with the simple masonry and constructions of the old Danes in St. Thomas. Everything is American in part . . . Broadway love ballads and the toothpaste is Colgate so one week is enough for us. All the other islands are beautiful especially the French Guadeloupe & Martinique."[13]

Before leaving the States, Smith conceived of a photographic project that would be a mix of travel, anthropological, and political journalism. He was convinced that it was important for Americans to know about life in the Caribbean and took for granted the authority of his perspective. With no more than a rudimentary knowledge of photography, he was confident of his ability to produce reportage of commercial and sociological interest. It's not known how many such photographs he took for

his project. Less than two dozen negatives related to it exist in the Smith archives. Ten photographs were sold. None were published. There is no evidence that he contacted a magazine about them.

Smith wanted to do a comparative study of the impact of colonialism and capitalism on island life. In 1917, ownership of the Virgin Islands had been transferred from Denmark to the United States. Until 1931, the islands were ruled by the U.S. Navy. Smith's and Dehner's dissatisfaction with capitalism had become vehement. Smith arrived in the Virgin Islands believing that a country under the rule of the United States was worse off—more exploited, more defiled—than one managed by Britain, France, or Denmark. In an essay titled "David Smith's Photographs," Joan Pachner refers to "a series of politically pointed documentary photographs, which he hoped to publish," that were "intended to show that living conditions on both the British-ruled islands (Tortola and St. Lucia) and the French (Guadeloupe) were superior to those of the American Virgin Islands."[14] Dehner told Pachner that Smith intended to call the essay "Uncle Sam Rapes the Virgins."[15]

A photograph that he called *Municipal Market at Basse-Terre Guadeloupe* shows a throng of men and women, most of them in dresses or suits, almost all wearing hats, packed into an outdoor market. Smith's caption reads: "The native women dress in gay plaids—and bright rayon. These creole women are the most beautiful of any in the Southern Is-

David Smith (photographer), *British West Indies—Saturday Morning Market at Roadtown,* ca. 1932.

lands. They seem more industrious and the general appearance of the island points to the superior colonization of the French."

He photographed a roofed market by the sea, its customers in local dress gathered inside or standing or walking on a pier, with one island that seems untouched by industrialization in the middle ground and another, even more dreamlike, on the horizon. Smith called the photograph *British West Indies—Saturday Morning Market at Roadtown*. The caption distinguishes between American and British rule: "The natives are self supporting and manage to own a piece of land. The British Government (Colonial) governs the British Virgins with an annual surplus which is sent to the colonial administration seat at Antigua . . . The natives are simpler in living, more satisfied, pay less taxes and enjoy fewer luxuries than the inhabitants of the American Virgin Islands which adjoin."

In some photographs, Smith made a point of his outsider status. In one, taken in Guadeloupe of men packing bottles of vermouth for shipping to Puerto Rico, three black men look at him as if to say, Who are you and why are you photographing us? In another, the way in which a black man looks at Smith across crates of fish also stamps the photographer as alien. The disjunction does not bother him. On the contrary, the camera establishes and empowers his otherness. While confirming him as a presence that does not belong there, to him it gives him as much power as the reality pictured within the frame.

Disjunction and disproportion mobilize other photographs as well. He photographs a papaya from so close that the fruit seems enormous and almost pornographic: "The meat is sweet luscious and pungent with texture somewhat like the muskmelon. The meat is brilliant orange—the seeds black." In *View of the Harbor and City with the Munson Boat at Dock*, his focus is a large steamer that the photograph presents as a colossal interloper in the tropical expanse. His photographs of men crating rum and vermouth create the impression of an economic system marked by sharp economic and cultural differences. These images have a black market feel. The discordances in all of them evoke a sense of illicitness to which Smith is drawn.

While structured around disjunctions and superimpositions, his paintings do not have the same edge. They, too, are rooted in everyday life. Some are thickly textured, their surfaces heavy and slow. In others,

a light, fast-moving tracery of lines suggests diagrams of journeys and trajectories of aquatic life. Lines can seem superimposed on shapes. In some paintings, it's hard to determine specific objects. Others include easily recognizable images, like a ghostly fish or a rowboat. Some landscapes seem still, others windblown. The sea is a constant presence. Sometimes a landscape or seascape unfolds into the distance; sometimes artifacts or residues of seen and remembered experiences seem packed into the surface plane. One small painting evokes a head and reclining body in the foreground, a sail tethered to the body and the triangle of an island in the distance. "David Smith" is the signature at the lower right. "DEHNER 1932" may identify the boomerang- or hammock-shaped reclining female form, or perhaps it is an indication that Dehner and Smith worked on the painting jointly. The painting seems almost to map their island time together.

Smith spent countless hours roaming beaches. "What he loved," Paiewonsky said, "was to go to these beaches and pick up pieces of driftwood, pick up pieces of shell, especially shells that had weathered the storm so to speak. And parts of the shell might have been broken, part might have coral growing on it."[16] What the Paiewonskys considered good specimens for their collection, Smith was not interested in. What they discarded, often he picked up.

He arranged some of these objects into miniature theaters and photographed them in ways that made them seem familiar and alien, archeological and futuristic. Some objects, like conchs, could suggest humans, particularly women. Sometimes Smith combined beach items with factory-made objects, like a chain or a mannequin head with goggles. Conchs, sea fans, bones, or chains created frames or lenses through which other objects were seen. The settings hint at beaches, or ruins, or *Alice in Wonderland* fantasies. Objects can seem very old and degraded, relieved of function, but endowed by the camera with the potential for other lives. Smith circled his mini theaters, looking from many angles, including above and below. When point of view shifts, a recognizable arrangement in one photograph can be unrecognizable in another. The size of the objects is difficult to determine. When the camera moves in close, small objects can seem gigantic. Objects and identity are mutable. Objects from entirely different contexts find themselves together.

In the Virgin Islands, the found object becomes integral to Smith's work. Smith was drawn to things abandoned—orphaned—but not yet lost.[17] In this state between life and death, disappearance and survival, the objects are un-possessed, un-owned. They are not property. He is not competing for them or buying them. The only demands that they make on him are from those desires and stories that he projects onto them. Residues of history and desire seem stored in them, waiting to be awakened. "There is something rather noble about junk," Smith wrote in a sketchbook in 1953, "junk which has in one era performed nobly in function for common man" and "has fulfilled its function, stayed behind, is not yet relic or antique, or precious / which has been seen by the eyes of all men and has been left for me—to be found as / the cracks in sidewalks / as the grain in wood . . . tobe now perceived by new ownership."[18] When he encounters the found object, it is both between states and state-less. The moment Smith picks it up and transports it, it enters a new state. When his camera clicks on the found object, its identity changes again. The resulting photograph severs the object from its previous existence and invests it with the hope that Smith had been drawn to when he picked it up. In Smith's photographic choreographies, past, present, and future all seem to desire attention.

At some point in his exploration of found objects, probably near the end of their stay, Smith began to experience in coral a desire for sculptural speech. Dehner said:

> He began picking up stuff on the beach, and he picked up a chunk of coral . . . and he carved the head of a negro rather cubistically, and he painted it a dark purplish brown. That was the beginning of his painted sculpture, and then he made another little torso that was almost an object trouvé because there was hardly any carving on it but it was quite charming and he emphasized certain things in it so that it really made a little figure . . . From then on he got very excited about sculpture.[19]

Smith had painted purple spots on the cat and now, with a pleasure Dehner would always remember, he painted the white coral.

Dehner referred to these two sculptures several times, almost always

with wonder and affection, usually but not always claiming that the head came first. It is a man's head, smaller than an adult hand. Its helmet-like skull, sunken eyes, almost cartilage-free nose, straight mouth, negligible jaw, and softly rounded geometry give the head a warmly severe and regal feel. The white torso sculpture, one of the dozen or so Smith sculptures Dehner would own, is even smaller, 3¾ inches tall, with a surface that seems soft, like baby flesh. "He had little carving to do, except to emphasize the forms of breasts and buttocks," Dehner wrote.[20] Although in all likelihood female, gender dif-

David Smith, *Untitled* (*Coral Head*), 1932. Coral, paint; wood base, 4⁵⁄₁₆ × 3⅛ × 3⁹⁄₁₆ in. (11 × 7.9 × 9 cm). Base: 2 × 4¹⁄₁₆ × 3¹⁵⁄₁₆ in. (5.1 × 10.3 × 10 cm).

ferentiation seems still in process. Each part—head, arms, torso, legs—is distinct in length and shape; all are rounded off like stumps, and the figure seems in motion, both running and aquatic. In neither of the sculptures is there any sense of violence in the making. As with pretty much every found object that entered his sculpture, Smith is respectful of what he understands to be the coral's nature.

While Smith's letter to the Levys indicates that he went to the Virgin Islands in part to gain distance from French modernists, particularly Picasso, and from Graham and Matulka, who led him to Picasso, his experiments on St. Thomas moved him deeper into modernism. The found object was essential to Gauguin's sculpture. It was essential to Cubism and to the Dadaists and Surrealists, who while Smith was in the Virgin Islands were dramatizing the importance of surprise encounter and deepening their investigations into objects and the unconscious, often with the help of photography. Walter Benjamin praised André Breton,

who, in his Surrealist novel *Nadja*, was "the first to perceive the revo-
lutionary energies that appear in the 'outmoded,' in the iron construc-
tions, the first factory buildings, the earliest photos, the objects that
have begun to be extinct."[21] In drawings he made in or around 1931 in
Gloucester, Massachusetts, Stuart Davis was inspired by beach objects.
The Spanish Surrealist Joan Miró scavenged for objects on beaches. In
the drawings he made for his *Projets pour un Monument*, reproduced in
Cahiers d'art in 1929, Picasso imagined constructions of bones on imag-
inary beaches; the scale of these constructions is indeterminate. Smith
did not yet know these drawings, but he knew Picasso's beach paintings,
and from photographers like Edward Weston and Alfred Stieglitz, he was
aware of the magic photography could perform on objects and bodies.
Away from New York, he began to absorb and reanimate the modernism
that he had been looking at since 1926.

His first sculptures are connected to ways of making art that prob-
ably existed in every country, mostly in towns and villages, and surely
on ships as well, and in nineteenth-century Decatur, in log cabins and
on covered wagons, where men, women, and children carved, whittled,
and assembled humble matter that to them seemed to be asking for a
different life. His movement into sculpture coincided with his attach-
ment to the found object and his excitement about the possibilities of
photography.[22]

For Smith and Dehner, their eight months in the Virgin Islands
would remain a golden memory. In the early 1940s, Dehner would com-
memorate their stay in paintings. Smith would include objects from the
trip in sculptures and look back on it with gratitude. In some of his most
exhausted moments, he believed that if only he could get back there he
would revive. Toward the end of his life he returned twice.

10
Entering the 1930s

Although Smith and Dehner had been married for more than four years, she still had not met his family. Soon after returning to the States in late spring, they went to Paulding. Dehner made a good impression on Smith's parents. She would never have a clear sense of Smith's father, but she and Golda became lifelong friends. The visit seems to have been uneventful, but Dehner had heard Smith's stories of childhood violence and sexual repression, and it was on this trip that Golda told her the story of the mud lion. Smith's grandmother Catherine Stoler had passed away. It was probably on this trip that Smith stole her Bible, the family Bible, with its cuneiform writing, reproductions of Assyrian art, and notes on family genealogy.[1]

On May 31, 1932, Dehner paid off the mortgage on Red Moon Farm, where daily existence remained one step above camping. The house had no running water or electricity, and the artists did not have studios. Nevertheless, they prided themselves on their resourcefulness and worked hard to make the place more livable. Summer gave them a chance to prepare for their return to New York City, where they would have to begin again. To their great joy, the Grahams were now neighbors, Elinor having bought a house on Federal Hill Road, roughly four miles away. She, too, had been introduced to the area by the Furlongs. Over the wallpaper on the dining room walls of their house, Graham painted scenes

of Paris that included a Picassoesque harlequin. Every Sunday night
the Grahams joined the Smiths for dinner. Dehner recalled, "I loved to
cook for Graham as he was most appreciative . . . and we always had a
huge platter of hors d'oeuvres as well as meat, home grown corn or other
vegetables from our garden."[2] Through Graham and to a lesser degree
the Furlongs, Smith renewed contact with artistic developments in New
York and Paris.

The energy and purpose with which Smith had moved in the Virgin
Islands from material to material, discipline to discipline, and between
indoors and outdoors, now defined his artistic process. "We brought back
huge boxes of shells and coral," Dehner said, "and subsequently David
made a number of works using either coral alone, or coral in combina-
tion with other materials . . . brass rods, lead sheet etc. Some he painted."[3]
He assembled seven- to fifteen-inch-tall vertical constructions in which
he crossbred shapes, materials, and methods. Incorporating coral, wire,
brass, and stone, along with wood from a local lumberyard, he mixed
objects from the Virgin Islands with objects from Bolton Landing. On

St. Thomas, he had left
objects unattached. Now
he experimented with
different, often provi-
sional ways of joining
them. Each shape and
object is given a role
and function. Although
a block of wood can
orient the construction

David Smith, *Construction*,
1932. Wood, coral, bronze, lead,
paint, 15¼ × 9¼ × 5½ in.
(38.7 × 23.5 × 14 cm).
Base: 3 × 6½ × 6½ in.
(7.6 × 16.5 × 16.5 cm).
Private collection.

around a vertical mass, the movement of wire around that block creates the impression of energy spun and spells cast. The wood platforms on which objects were mounted, sometimes like idols, and the presentational energy of the constructions, contribute to a sense of ceremonial purpose.

That summer, Smith made the first of his many sculptural birds. In one of them, 7 inches tall, chunks of coral are mixed with plaster, wood, aluminum, and lead, the coral parts for the most part assembled into the bird's body, tail, and head, with a boomerang-shaped chunk mounted on its back like a rider. The spiraling neck and feet are lead. The sculptural creature is mounted on a wood base. The bird seems funny and vigilant, and Smith's sculpture already seems to project in all directions. "Graham admired these sculptures, which were figurative, though abstract in treatment," Dehner wrote.[4] He more than admired them. After seeing the birds and constructions, Graham told Smith: "You're the best sculptor in America." Graham scholar Anne Carnegie Edgerton wrote, "Thereafter, when Graham introduced them, he would always identify Smith with this high compliment."[5]

Graham brought back from Paris a supply of *Cahiers d'art*, a still relatively new (inaugurated in 1926) yet crucially influential publication that gave extensive coverage to

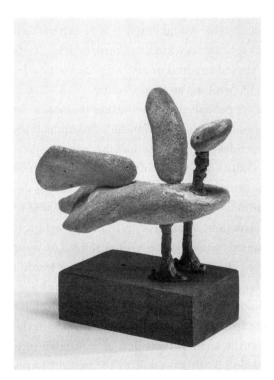

David Smith, *Untitled* (*Coral Bird*), 1933. Coral, plaster, lead, wood; wood base, 7 × 7¾ × 6¹⁄₁₆ in. (17.8 × 19.7 × 15.4 cm). Base: 1⅞ × 6⅛ × 4 in. (4.8 × 15.6 × 10.2 cm). The Estate of David Smith, New York.

Picasso and regular coverage to Matisse, Léger, and Braque. It was at-
tuned to new sculpture by Constantin Brancusi, Jacques Lipchitz, Al-
berto Giacometti, and Henri Laurens, and indeed to pretty much the
entire history of sculpture. The magazine commissioned articles about
architecture, theater, and prehistory, and forums on artistic issues. It was
a strong supporter of African art. With the help of its copious and some-
times remarkable black-and-white photographs, *Cahiers d'art* demon-
strated the experiential value of photographs of art. In this magazine,
the art of all times and places seemed simultaneously present. Smith
could not read French, but he pored through these magazines, absorbing
the art visually. When he had questions, he asked Graham.

Graham showed Smith the early-1929 issue of *Cahiers d'art* that in-
cluded Christian Zervos's essay "Picasso à Dinard été 1928." It contained
the first reproduction of Picasso's wire constructions, largely rectilinear
soldered networks of pencil-thin iron rods. In them, the mass that for
centuries had been synonymous with sculpture was gone. These metal
armatures seemed to be asking for penetration by, or perhaps fusion
with, their environment—an interaction that would give air, emptiness,
or void a sensation of materiality that would enable it to be experienced
as "space." Like some of the revolutionary Russian Constructivist devel-
opments, these sculptures exposed a radical unease with the boundaries
separating sculpture, drawing, painting, and architecture.

Later in 1929, *Cahiers d'art* published another article on Picasso by
Zervos. "Projets de Picasso pour un monument" included reproductions
of nearly a dozen of the recent drawings Picasso had made in consider-
ation of his monument to Guillaume Apollinaire. The oddly intimate
yet still often heroic forms, set in an undefined landscape, almost de-
manded new sculptural methods and an expanded scale: it's possible to
imagine these vertical constructions a hundred feet tall. The arrange-
ments of five to eight clustered forms—some with perforations at or
near the top, suggesting eyes—pointing to, pressing against, or leaning
into one another, allude to family, even to domestic conflicts. The bone-
like shapes also communicate a sense that these dramas would have
been as much at home in the Iron Age or prehistory as they were in the
twentieth century. Although the compositions hint at enormous con-
structions, monuments, nothing binds or stabilizes the upright forms

except the density of the negative spaces, evoked by Picasso through a myriad of marks.

Dehner and Smith remained upstate until after the Grahams found an apartment in the city, on Lexington Avenue around Ninety-Second Street, then stayed with them there until they, too, found an apartment, at 124 State Street in Brooklyn Heights. Brooklyn Heights did not feel like the big city. Side streets were quiet; there were many neighborhood stores and no skyscrapers. Their apartment was in a five-story redbrick building one block from Atlantic Avenue and three from the East River. Rent was $24 a month. They had a small bedroom, a tiny kitchen, and a main room that Smith used as his studio. They were near friends. The Levys, at 66 Montague Street, were a few blocks away. Upstairs from the Levys, as of November 1933, lived Esther and Adolph Gottlieb. Adolph would become an Abstract Expressionist painter. So would Mark Rothko (then Markus Rothkowitz), who would also be a neighbor, as would the painter Louis Schanker. Graham, too, would move to Brooklyn Heights.

In Smith and Dehner's artistic community, more often than not wives paid the bills. Matulka and the painter Milton Avery, another friend, who lived in Manhattan, were financially dependent on their wives. Lucille Corcos was the primary breadwinner in the Levy family. With her teaching job, Esther Gottlieb largely supported Adolph. Although Graham made money selling art to American collectors he found in Paris, he needed the economic support of Elinor. Dehner's inheritance gave her and Smith a financial base.

In this stark time, artists selling their art was almost unthinkable. "Today for all practical purposes, the private buyer has disappeared," the art dealer Edgar J. Bernheimer wrote in 1932. "There remains only the museums."[6] Looking back at 1933, Davis would write, "The perpetual and specific kind of economic depression, to which the artist had learned to innure himself, took on a new character. Even the sustaining hope of hypothetical 'miracle' sales was dashed."[7]

"The interval between Roosevelt's election in November 1932, and his inauguration in March 1933, proved the most harrowing four months of the depression," Rothko's biographer James E. B. Breslin wrote. "One

historian has called those months the 'winter of despair' . . . All during
the harrowing winter of 1932–33 banks were closing; by March 4, the
day of Roosevelt's inauguration, they had shut down in forty states and
that day the New York Stock Exchange did not open."[8]

In January or February 1933, the Grahams and Lois Wright came to
Dehner and Smith's apartment for dinner. Wright and her husband had a
place near the Grahams in Bolton Landing. "Mrs. Wright fell in love with
one of the sculptures which were standing on an old packing box in our
living room," Dehner wrote to an art dealer. "She decided to buy one, and
David was so impressed and so overwhelmed by his very first sale that he
presented her with another and similar one, made from the same variety
of materials."[9] A precedent for this transaction had been set the previous
year. "About 1932," Dehner wrote at another point, "Graham held a sale in
which he decided to sell all his paintings for $15 each"—the price he said
he had paid for each of the three Julio González sculptures he had recently
bought in Paris. "Previously he had had a show at the Dudensing Galleries.
Not Valentine Dudensing, but Valentine's father's gallery. I do not know if
any sold, but Lois Wright . . . bought one, and he also gave her one."[10]

"I asked him if I could buy this one and [Smith] happily sold it to me,"
Lois Wright said. "A little later he told me this had been his first cash
sale and insisted on giving me the second one." Wright was a teacher
and guiding spirit at the Town School, a private nursery and elementary
school on Manhattan's Upper East Side, where, at her invitation, Smith
taught for a short time, almost surely at the end of 1932 when financial
worries drove him briefly back to Spalding. "I used those sculptures in
teaching art to children and they had an immediate appeal to the chil-
dren," Wright wrote. "Many years later, when David was at the peak of
his fame, we sat in the Museum of Modern Art, and I told him of using
these sculptures in this manner. He was delighted and much interested. I
asked him if he recalled his teaching that short time at the Town School.
His face lit up and he said, 'Golly, I'll never forget it! I loved that experi-
ence with children! And how I needed the money then!'"[11]

Toward the end of 1932, Graham brought Smith to Arshile Gorky,
who although just four years older was a generation ahead of Smith in
knowledge and success. Early in 1930, Alfred H. Barr, Jr., had visited
Gorky's studio on Washington Square South and invited him to partici-

pate in "An Exhibition of Works by 46 Painters and Sculptors Under 35 Years of Age," which opened at the Museum of Modern Art that April. "In 1931, Stuart Davis had asked Gorky to write a piece about him for *Creative Art*," Hayden Herrera wrote in her Gorky biography. "The twentieth century—what intensity, what activity, what restless energy!" Gorky wrote. "Has there in six centuries been better art than Cubism? No."[12] Gorky lived for art. With legendary astuteness, he studied centuries of art in museums.

Wiry, with thick black hair, he was one of the few artists in New York taller than Smith. He could put on airs, adopting the kind of flamboyantly Bohemian artistic persona in which Smith had no interest. But his art judgments were unsentimental. "Gorky was notoriously dismissive of other people's art," Herrera wrote. "It was as though he had no idea what should and shouldn't be said—at least he pretended to have no idea. In [Rosalind] Bengelsdorf's view, Gorky 'loved to create an uproar. And he was very open about his dislike of an artist . . .' At exhibition openings, he'd say, 'Very beautiful walls' or 'The frames are terrific.'"[13]

That Graham chose this moment to take Smith to Gorky's studio indicates his confidence in Smith's work. Dehner remembered:

> David had brought to G. studio three paintings that he had made in the Virgin Islands. They were small, and painted on boards from Bay Rum crates. They used shell motifs, boat forms and abstractions of rock and beach things. Before Gorky looked at the paintings, Graham had introduced us as two talented American artists. Gorky looked at us and rather sneered. He said, they look like college kids, they can't paint. But when he looked at the paintings, he held his tongue although there were no compliments. Gorky and David never got on well together. There was something roused immediately in both of them that made them hostile to one another. And it was always so.[14]

During that meeting, Herrera wrote, Gorky conceded, "Well, he is not without talent."[15]

Smith bridled at being in a subservient position, and he did not like being patronized. There are stories of Smith's and Gorky's rage at

each other. While Dehner said their relationship was testy from start to finish, Smith's references to Gorky after his death in 1948 were for the most part warmly respectful. "Gorky was a great and gifted man," Smith told Thomas Hess in 1964—while adding: "But he never freed himself from his inhibitions and his foreign pretentions."[16] Smith and Gorky did get along, kind of. They were both passionate modernists who revered Cézanne and came through Picasso and Surrealism. They were both exiles. At age twenty, Smith had fled a homeland to which he knew he could not return. Gorky's exile was epic. Born into a village culture in Armenia soon after the turn of the century, he fled with his family during the genocide in which Turks killed more than one million Armenians. Smith recognized Gorky's heroic struggle. "We were friends with him in a way," Dehner said, "though it was difficult to penetrate the front that he presented to the world."[17]

Smith presented two Virgin Islands paintings in a group show at the American Contemporary Art Gallery, which had opened in August 1932 at Madison Avenue and Ninety-First Street, not far from the Town School. The ACA Gallery would develop a connection with the Artists Union and become a hotbed of protest art. Smith's politics fit into the gallery, but his art didn't.

Battles about art and politics had begun to define this artistic era, and Smith and Dehner were about to enter them. The increasingly politicized Graham took them to the John Reed Club, an organization founded in 1929 by artists close to the Communist Party. The meeting discussed realist versus abstract art. Dehner said:

> A number of paintings were ranged about the hall of both schools. The artists were mostly refugees from the middle class that they had disowned. One artist got up and said we should paint pictures that taxi drivers could understand. This was widely contradicted by a vocal minority. The realists said how could the intellectuals ever lead a revolution if the proletariat didn't understand their works. Gorky got up, cleared his throat and said slowly, "Why don't you just teach them to SHOOT." This brought down the house, everybody laughed, the meeting broke up.[18]

11

Mounting

Frank Crowninshield was the editor of *Vanity Fair* from 1914 to 1936 and a founder of the Museum of Modern Art. He was one of the foremost American collectors of African art, for which Graham was his principal buyer; most of Graham's African sculpture was acquired from Parisian dealers, who got the art largely from French colonies. At one point, Crowninshield described *Vanity Fair* as a "foster parent of African Art and a cheer-leader for its increasing good name in America."[1] Several works from his collection would be included in MoMA's "African Negro Art" exhibition in 1935, which was intended, its curator, James Johnson Sweeney, wrote, to give "the art of Negro Africa . . . its place of respect among the aesthetic traditions of the world."[2] In 1937, the Brooklyn Museum of Art exhibited "African Negro Art from the Collection of Frank Crowninshield."

Crowninshield also collected modern art—a combination rare in the United States apart from visionary collectors like the sisters Claribel and Etta Cone and the siblings Leo and Gertrude Stein. "Graham took us up to Crownie's apartment for cocktails," Dehner said. "He was such a marvelous example of a real American gentleman of the old school . . . an aristocrat . . . with genuine interest in art. His apartment was full of paintings. [André Dunoyer de] Segonzacs all over the place . . . Marie Laurencins in the bathroom and bedroom. African sculpture on shelves

on the living rooms walls . . . Crownie wanted it mounted and David did the mounting. This took almost an entire winter."[3]

"I think the influence of having Crowninshield's collection in our house for many months whilst David was mounting it was of enormous importance," said Dehner. "It was the first time we had ever had, right in our own house, to touch to live with and to admire, genuine works of art and in great quantity."[4]

"Smith carefully selected the wood for Crowninshield's collection bases, seeking out dark, exotic woods such as ebony rather than pine," noted Christa Clarke, a curator at the Newark Museum of Art.[5] Smith cut and finished the wood. Some of the bases were single rectangular blocks. Sometimes he set the block onto a thin rectangular wood slab. In photographs, the glue between the layers of wood can be conspicuous, its thick ooze suggesting welds. It is unlikely that there were rods inside the sculptures securing them to the base, so the glue had to be strong. Sometimes Smith used a metal or wood post on the back of a sculpture to attach it to the pedestal. Many mountings are intentionally a bit too large for the bases so that the sculptural energy seems to overflow into the surrounding space.

Crowninshield's collection included finials, headdresses, masks mixing diverse materials such as hair and metal, and reliquary figures in which the features of the face, or the size of the head in relation to the limbs and torso, bore no relation to

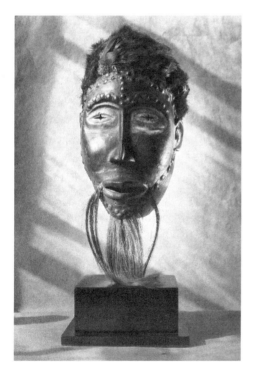

David Smith (photographer), *Photograph of African Sculpture in Collection of Frank Crowninshield*, ca. 1933. 4¾ × 4⅜ in. (12.1 × 11.1 cm).

Western naturalism. The collection included a striated, pigmented wood Songye *kifwebe* mask from Zaire, with protruding blocky eyes, a projecting mouth, and a forehead and nose running together in a line shaped like a ram's horn. "All the orifices are treated in a similar manner," Graham wrote about such masks. "Cubistic conception. Insistence on the unity of origins of shapes. Insistence on stripes, on horizontal stripes only, thus producing a great variety and significance out of the tedious medium . . . Nose and brow are treated as if they were one shape, one genetic form. Compare Picasso's painting and sculpture of 1929/1932."[6] The collection included at least nine Fang reliquary figures, their hands pressing or resting against their stomachs; the verticals running through the spine and head are ramrod straight. Most of the sculptures were frontal and intended to be encountered head-on, but some needed to be seen in 360 degrees. The functions of the sculptures tended to be ceremonial.

Smith photographed a Kota figure from Gabon. Picasso owned Kota figures, which helped inspire his 1907 *Demoiselles d'Avignon*, the shock of which depends in part on the mix of artistic influences, including Iberian and Egyptian as well as African art. In 1922, Juan Gris made his own Kota reliquary figure out of cardboard. At formative moments, other influential modernists, including Alberto Giacometti, also lived with Kota figures. In a Kota sculpture, the ways in which copper is worked and its skin applied to wood can be exquisite. The open and disproportionately small "arms" are lozenge-shaped. On top of the roughly oval head is a semicircular crown. In the villages for which they were made, the sculptures could be buried so that only the heads were visible. The play of concave and convex, round and angular, receptive and severe, can give these small figures not just a startling inventiveness but also a combination of authority and intimacy. They exemplify "the expression of convex by concave and vice versa" that for Graham was a key part of African sculpture's "aesthetic argumentation."[7] Writing on Kota sculptures in his essay on Picasso for the catalog of MoMA's bitterly contested 1984 exhibition, "'Primitivism' in 20th Century Art: Affinity of the Tribal and the Modern," the curator William Rubin defined a vital play between recognizable body and abstract sign.[8] This play, like the play of concave and convex, would contribute to the dynamism of Smith's postwar work.

Smith had to impress Crownie and Graham—and did. "Crowninshield

complimented 'David Boy' as he called him on the ingenious mount-
ing of his collection," Dehner said. "Graham took great satisfaction
and pleasure both in the work on the bases and in our response to the
sculpture."[9] Dehner wrote, "When the mounts were finished, he induced
Crowninshield to give a small party at which the sculpture was the main
entertainment."[10]

It would be hard to overemphasize the importance of this commis-
sion. Although African art had been essential to the development of
twentieth-century European and American avant-garde, including Ger-
man Expressionism, Fauvism, and Cubism, in 1933 it was still little known
in the United States. Suddenly, through the most privileged access, Smith
could study the kinds of sculptures that had left their mark on André
Derain, Henri Matisse, and Constantin Brancusi, as well as, of course, on
Picasso. The sculptures were identified with a prominent collector and
publisher and, through him, with the most ambitious American institu-
tion of modern art. Through his extensive physical handling—Graham's
"tactile understanding"—Smith could grasp how the sculptures were
made and how they worked. By studying them from every angle and
arranging a multitude of them throughout their apartment, he learned
about the impact of presentation, accumulation, and installation in trans-
mitting artistic experiences and messages. With this commission, Afri-
can art became a signpost for Smith, helping to shape his understanding
of what sculpture—and what a field of sculpture—could be.

With wood left over from the commission, Smith began a creative ex-
change with the sculptures. He "carved three sculptures mostly with a band
saw . . . with a little carving and a bit of sandpapering to soften the edges,"
Dehner said.[11] From 4 to 13 inches tall, they are vertical and, like Crown-
inshield's African sculptures, mostly smooth. Depending on the point of
view, they change from figurative to architectural. They do not have open-
ings. They seem to reflect the belief in material energy informing the Af-
rican sculptures, but Smith was using scrap wood, which for him was just
another material. All these works are sculptural exercises or experiments.
They suggest Picasso, Laurens, and Brancusi but keep their distance from
them. They speak to the African sculpture but are distinct from it.

In early summer, with Dinah, their new black cat, Smith and Dehner went upstate. They planted vegetables and fruit and raised poultry. Smith now wanted to work with metal. With the ingenuity that awed Dehner, he "established a studio of sorts in a small wood shed behind the old frame house. He had acquired a forge, anvil and tools from a defunct blacksmith's shop" in Ticonderoga.[12]

The Crowninshield commission was completed upstate. In a September letter to Edgar Levy, Smith wrote, "Crowninshield has sent me a few things the last I'm sending tomorrow a Mpangwé XV century mask—white face of magic clay rather Chinese looking. This is not a good one however." He then added, "Graham intends to have a big Negro Art show this winter."[13]

Whatever Crowninshield paid Smith, it couldn't have been much. He and Dehner were scrambling for money to cover Dehner's medical expenses. They rented out their house and pasture, returning in midsummer to "find the garden in a mess, Dinah with a kitten and the general unpleasantness" of seeing strangers occupying their house.[14] Smith and Dehner photographed each other holding Dinah in a field. Dehner is standing barefoot on a log. She looks happy to be there but fragile. Smith is sitting on the same log, in city dress: a white shirt and slacks. He seems happy, too.

He made sure influential new publications were sent upstate. "Did [the book and art dealer] Weythe ever get any more 'Minotaure,'" he wrote to Edgar Levy.[15] *Minotaure* was a visually extravagant pub-

David Smith (photographer),
Dorothy Dehner at Bolton Landing,
New York, ca. 1933.

lication and the one most identified with Surrealism during the 1930s. Its coverage of sculpture was dramatic. Its first two issues appeared in June 1933. The first, with a collage by Picasso on the cover, included Brassaï's photo essay revealing the then unknown sculptures Picasso had been making outside Paris, at a converted stable in Boisgeloup. Even more crucial for Smith, the issue also included photographs of welded steel constructions Picasso made in collaboration with the Spanish sculptor Julio González.

Dehner and Smith were still in Bolton Landing in early fall. "It froze here already & killed squash tomatoes and cucumbers it is cold at night & we are wearing wooly pajamas," Dehner wrote to the Levys. "Wish you were here tho. Its swell & the trees are starting to turn. If the money rolls in & you have time wish you could come up for awhile. We have loads of apples, applesauce & even apple pie." Yet their existence was threadbare. "I have 2 pr of shoes that need soling," Dehner wrote, "& since I can't get it as well or as cheaply done here as in Bklyn would you take them to Jim or Charley or whatever his name is on either Joralemon or Remson . . . I haven't a thing to put on my feet. I am now wearing rubbers!"[16] When the

hard cold set in, they returned to the city, bringing fifty-four chickens that Dehner "roasted for the starving artists . . . David killed them and we fattened them up enough so they were edible indeed and so we gave them to people like Rothko and Gottlieb and Graham."[17]

Dorothy Dehner (photographer), *David Smith at Bolton Landing,* New York, ca. 1933.

12
Welding

During the summer of 1933, Smith forged *Reclining Figure*. He had seen photographs of Picasso's iron constructions in *Cahiers d'art* earlier that year. Graham showed him Julio González's forged iron *Reclining Figure*, one of three sculptures that Graham acquired from the Spanish sculptor. "These were the first González sculptures in America I think," Smith later wrote.[1] In 1934, Graham gave one to Smith—the most prized of his many gifts to him—which Smith described to Roberta González, the sculptor's daughter, as "an early mask in iron, smaller than a hand, with 'strings' across the brow forming the lines of the features."[2] In the woodshed behind the house, with the blacksmith tools from Ticonderoga, Smith responded to González's forged iron sculpture with his own.

González was born in 1876 in Barcelona. According to a monograph on his work, "Not only was his father an accomplished craftsman, who introduced all his children into the craft of metalworking, but he was also an occasional sculptor, and took an active part in the artistic life of Barcelona."[3] Like Smith, González had worked in an automobile factory, began his artistic career as a painter, and as a sculptor was essentially self-taught. He, too, believed that "the truly novel works" are "executed with love" (Smith used the word "affection"), and was fiercely proud and given to dramatic mood swings.[4] González grounded his work in drawing, and with his flair for the sculpted line—thick, airy, abrupt, extended,

venerated, beaten—was able to activate an experience of space as sculpturally persuasive as the spaces of painting. González's metal sculptures were the first modern sculptures to reveal the conceptual and mythical potential embedded in the properties and histories of iron and steel.

As a young man, González learned forging. Toward the end of the Great War, he mastered a new skill: oxyacetylene welding. Modern acetylene welding was initially used during the war in the production of armaments. It eventually replaced forging as the chief method of joining metal elements.

González and Picasso met in Paris around the turn of the century but went their separate ways; it was more than twenty-five years later that Picasso initiated a collaboration. Picasso wanted to make sculpture in iron but knew that in order to do so he needed someone else's knowledge and hand. González had the equipment and the technique.[5] They began working together in the spring of 1928, most often in González's studio. Their partnership was, in the words of John Richardson, Picasso's most comprehensive biographer, "the most fruitful collaboration in twentieth-century art since Cubism . . . Picasso would always prefer working with craftsmen—scene painters, weavers, printers, potters, metalworkers—rather than with fellow artists, especially now that he was coming to see his work as shamanic."[6]

The six metal sculptures on which González assisted Picasso between 1928 and 1931 exploded the Cubist collage. They included found objects, among them scrap iron. The welding gives the constructions a force of unpredictability and disjunction that can suggest uncontrollable metamorphosis. Picasso's previous sculptures could be mischievous, disruptive, exalted, and enigmatic. The collaborations with González feel more brazen and unruly, even dangerous.

González's 1927–1929 forged iron *Reclining Figure* is no bigger than a hand. Judging from photographs, the figure has one erect breast and a schematic masklike head that together suggest both come-on provocation and vulnerability. Her right knee is raised, her legs spread. Torso and head are supported, with effort, by her stiff arms, extended uncomfortably behind her back. Her left hand is barely formed; she does not seem to have a right hand or foot. The two rectangles of her right leg seem jammed together. The interior of the right elbow appears scooped out—perhaps through the welding process. González treated the metal and the female

body both reverentially—photographs reveal many of the iron surfaces to be gently modeled—and savagely. In this sculpture, there is a sense of sacrifice and mutilation.

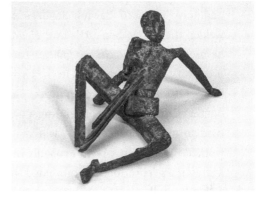

Julio González, *Reclining Figure*, 1927–29. Welded iron, 3½ × 7½ × 4½ in. (8.9 × 19.1 × 11.4 cm). The Baltimore Museum of Art.

Slightly larger, Smith's iron-and-steel *Reclining Figure* seems put together with aggressively, even ludicrously, disparate parts. The head is as disproportionately small as the heads in many Picasso sculptures and paintings. Some of the metal edges are more serrated than those in the González; they seem bristling, almost antisocial. Parts appear to have been jammed together, making the forged joinings more abrupt than the joints in González's *Reclining Figure*. Although the elongated figure is supine, the tiny feet rest on their soles and toes and seem to be walking. This female figure is more raw and disruptive than the reclining women in Smith's paintings. Incorporating flat sheet, heavy bar, and thin bar metal, as well as found objects, his construction is more conspicuously unpredictable and impulsive than González's figure, the space activated by the metal more restless and variable. It is also messier and more heavily worked. The González sculpture appeals to the hand; Smith's construction appeals first of all to sight. It says, in effect, if you touch these lines and surfaces, you'll learn nothing more than you did by

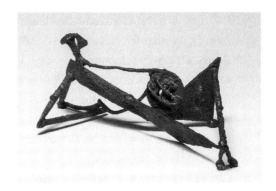

David Smith, *Reclining Figure*, ca. 1933. Steel, iron, bronze, 3⁹⁄₁₆ × 11 × 6⅝ in. (9 × 27.9 × 16.8 cm). Private collection.

looking at it. After Dehner expressed her enthusiasm for the sculpture, Smith gave it to her.

In the late summer or early fall of 1933, Smith "made up some things and took them to Barney Snyder's garage—a garage in Bolton—and welded them together."[7] His four *Heads* follow directly from the process he used to make *Reclining Figure*. They are informed by the months of proximity to African masks in the Crowninshield collection and by Graham's gift of González's iron mask. The sculptor Matt King has pointed out that the "operations of bending, punching and welding" that González used to make this sculpture "would have been common to artists who worked in auto assembly."[8] Probably in mid to late September, Smith saw *Minotaure*'s reproductions of welded steel constructions that Picasso and González collaborated on between 1928 and 1931. Brassaï's photo essay did not discuss how the constructions were made, or González's role in them, but Graham told Smith about the collaboration. The coin dropped. "Since I had worked in factories and made parts of automobiles and had worked on telephone lines I saw a chance to make sculpture in a tradition I was already rooted in," Smith wrote.[9] It was "liberating" to be able to "start with steel which before had been my trade, and had until now only meant labor and earning power, for the study of painting."[10] Recognizing the artistic potential of his factory experience was a revelation.

"My first steel sculptures . . . were partly made from found objects, agricultural machine parts of past function," he explained.[11] *Saw Head, Chain Head, Head with Cogs for Eyes*, and the sculpture that is now known as *Agricola Head*—according to Dehner, it was "first known as *Man with Bandages*"—are all under 20 inches tall; all were to some degree forged and painted.[12] They include industrially made objects, many of them found. To the rusted, serrated circular-saw-blade face of *Saw Head*, Smith welded round and angular metal objects, including a small sieve and a pair of shears. One eye is closed and set high up, toward the top of the head, the other like a monocular frame. The nose is long and birdlike, the mouth defined by two rods. A number of welds are like splotches, spontaneous, if not brash, in effect. They communicate excitement about the act of making: here's this thing and here's that thing, from here and there, and *wham!* let's join them. Smith's exhilaration that he could now be aesthetically receptive to any piece of metal and able to reinvent its identity as he pleased is

part of the experience of these works. Through welding, he could reawaken the found object more vigorously than he had with photography. He could create improbable composite images that are playful and forbidding. The sculptures have an electric, caricaturish, comically monstrous charge. With their odd yet boldly jolting eyes—part human, part insect, part animal—the sculptures don't sit quietly. They have a surging, go-for-broke conviction. In American sculpture, there had been nothing like them.

According to *The Columbia Encyclopedia*, "Iron is an abundant element in the universe; it is found in many stars, including the sun. Iron is the fourth most abundant element in the earth's crust . . . and is believed to be the major component of the earth's core." Iron and ironmongers, a word Smith used for himself, have mythical histories. In his 1956 book, *The Forge and the Crucible: The Origins and Structures of Alchemy*, Mircea Eliade, a prolific and widely read historian of religions, wrote that "there would appear to have existed therefore, at several different cultural levels (which is a mark of very great antiquity), a close connection between the art of the smith, the occult sciences (shamanism, magic, healing, etc.) and the art of song, dance and poetry." Of iron, Eliade wrote: "Like the smiths, iron retains its ambivalent character, for it can also embody the spirit of the devil. The idea vaguely persists that iron has been doubly victorious: victorious through civilization (through agriculture) and victorious through war. The military triumph will sometimes be the counterpart of a demoniac triumph." Eliade reveals the connection between mining metals and sexuality and taboo, particularly incest. By reaching into or drawing metals from the earth, Eliade writes, "there is the feeling of venturing into a domain which by rights does not belong to man—the subterranean world with its mysteries of mineral gestation which has been slowly taking its course in the bowels of the Earth-Mother. There is above all the feeling that one is meddling with the natural order of things ruled by some higher law and intervening in a secret and sacred process."[13]

In the catalog for the 1993 exhibition "Picasso and the Age of Iron," the art historian and critic Dore Ashton remarked that "just a cursory glance at the art journals of [the late 1920s and early 1930s] indicates how very much the 'primal' metal sculptures of all eras and cultures preceding the Modern epoch were the focus of renewed attention, including such diverse examples as wrought-iron animals from Luristan,

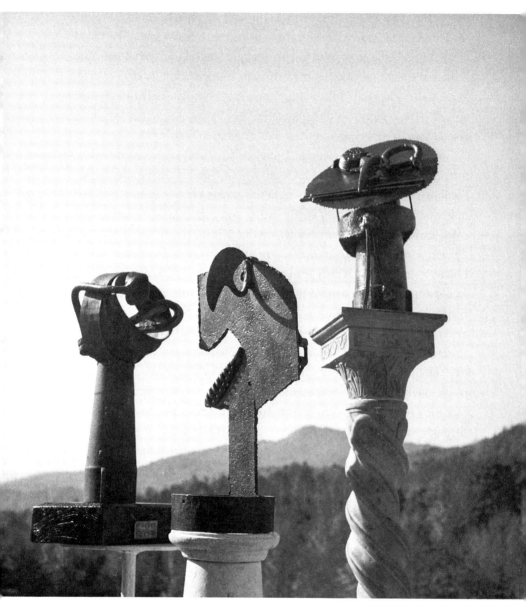

David Smith, *Agricola Head*, *Chain Head*, and *Saw Head*, Bolton Landing,
New York, ca. 1960. *Agricola Head*, 1933. Cast iron, steel, paint, 18⅜ × 10⅛ × 7¾ in.
(46.7 × 25.7 × 19.7 cm). *Chain Head*, 1933. Steel, paint, 19 × 10 × 7 in.
(48.3 × 25.4 × 17.8 cm). *Saw Head*, 1933. Cast iron, steel,
bronze, paint, 18½ × 12 × 8¼ in. (47 × 30.5 × 21 cm).
The Estate of David Smith, New York.

Iberian pre-Roman heads, and Hispanic Arabic elongated, forged-and-hammered figures."[14] In the late nineteenth and early twentieth centuries, iron was probably most identified with modern architecture. Gauguin called the Universal Exposition of 1889 the "triumph of iron."[15] In 1893, the Spaniard Santiago Rusiñol, whom Picasso knew, hinted at radical underground energies in the forge: "There, in the darkness of those sooty workshops" in the forges of old Barcelona, "under the ringing chorus of constant hammering on the anvil, I think I see springing from the fire . . . an art without aesthetic rules or absurd restrictions, an art free as smoke, born of fire, and wrought in fire."[16] "This is the age of steel," Frank Lloyd Wright wrote in 1927. Steel is "the epic of this age . . . This stupendous material—what has it not done for Man!"[17]

Smith was drawn to steel's multiple identities, and to its ancientness and yet newness. In 1951, he told the painter and critic Elaine de Kooning: "Possibly steel is so beautiful because of all the movement associated with it, its strength and function. Yet it is also brutal, the rapist, the murderer, and death-dealing giants are also its offspring."[18] The next year he wrote, "The metal itself possesses little art history. What associations it possesses are those of this century: power, structure, movement, progress, suspension, destruction, brutality."[19]

Oxyacetylene welding, or torch welding, requires oxygen and acetylene tanks. When their valves are opened, oxygen and acetylene pass through rubber hoses into the metal torch, with which the welder applies flame to the two pieces of metal "at the point where they are to be joined." The pieces "are bonded by introducing a compatible filler material."[20] The welding process can be deliberate or improvisational, or both. It allows for impulsiveness and suddenness and balancing acts unimaginable in modeling or carving. Anne Wagner, an influential sculptural historian, noted that "parts can be joined in any logic that works."[21] Which metals are welded, of what size and weight, depend on the welder. Welding is ritualistic. It requires a uniform: helmet, goggles, apron, and gloves. It is sonic. Looking at a single point hit by fire can be trance-inducing. Melding objects in the presence of oxygen flow can be erotic.

Forging enabled Smith to connect his artistic process to blacksmiths in his family and to blacksmith pioneers. It enabled Smith to be a smith. Welding connected his artwork to the factory, which in South Bend

had been for him a place of promise and community. Encountering his welded steel sculpture, factory workers could find themselves in it: they could recognize its materials and procedures, whether or not they liked or understood the work. They might imagine different possibilities for their knowledge and, with it, for their lives. Sculpture could be "a dream of what labor can do," Anne Wagner wrote. "Welded sculpture testifies to skills, to livelihoods and life-worlds that, as Smith recognized, capitalism makes use of so as to leave behind. Under these conditions, artwork and archive are one."[22] Steel became Smith's first material and welding his signature method.

He needed a welding outfit. Soon after Smith began welding, he and Dehner started a conversation with a rich woman—Dehner did not give her name—with a residence by the lake. They were standing on the sidewalk, she was sitting in her chauffeured car. When they expressed their support for Norman Thomas, the Socialist Party candidate in the previous two presidential elections, she told them that Thomas was a nut. She told them her husband was president of Union Carbide. I'm interested in young people, she said, and invited them over. "She named the day and so we appeared for tea. This was during prohibition, and out come the drinks, about half a dozen servants moving about the house, Japanese butler, and two or three maids and whatnot, the gardener is working out in the garden." The woman wanted small talk. Smith wanted a welding outfit and pushed her to arrange for him to buy one wholesale. She'd bring it up with her husband, she said. Smith persisted, showing up at her mansion on Manhattan's Upper East Side. While Dehner waited in their ratty pickup truck, he knocked on the door. The maid did not invite him in. "Well I guess we'll have to get that damn thing and pay a full price," he concluded.[23]

"In fall of 1933," Smith wrote, "went back to New York and got a job again at Spalding's—bought a welding outfit (same one I have now) air reduction oxyacetelyne welding torch."[24] He brought tanks of acetylene and oxygen to his and Dehner's State Street apartment. He started to weld, essentially teaching himself from trial and error and books, and then, Dehner remembered, "things would catch fire because he had drawings all over the wall . . . I'd go around with a sprinkling can and sprinkle after him . . . and I said, David you can't do this, you're going to burn this house down, and it's going to be terrible."[25]

13

Terminal Iron Works

The pier at the end of Atlantic Avenue was five minutes from the Smiths' apartment on State Street. They must have walked it dozens of times. After he began welding at home, they saw it differently:

> One Sunday afternoon we were walking on the navy pier. Down below on the ferry terminal was a long rambly junky looking shack called Terminal Iron Works. Wife said: "David that's where you ought to be for your work." Next morning I walked in and was met by a big Irishman named Blackburn. "I'm an artist, I have a welding outfit. I'd like to work here. Hell! Yes—move in." With Blackburn and Buckhorn I moved in and started making sculpture there. I learned a lot from those guys and from the machinist that worked for them named Robert Henry. Played chess with him, learned a lot about lathe work from him.[1]

Dehner recalled that transformative moment as well:

> They made fire escapes for public schools but this was in the Depression, and they were not only not building any public schools but no one was fixing up their fire escapes, or anything

else, so they were delighted that David wanted to have space and they rented him enormous space, any amount that he wanted, and he could bring his tools and they would let him use their tools for $15 a month. That was his studio, and that's where the name Terminal Iron Works came from and . . . that was . . . where the beginning work really started.[2]

Terminal Iron Works described its services on its letterhead: "Engineers, Boilermakers and Manufacturers, Stationary and Marine Repairs." Smith's shop studio had been its boiler-fitting room. Long, windowless, and eventually equipped with a forge and anvils, and smelling of fire, this was a different kind of artist's studio. Because of it, as much as because of the strange metal constructions that were being made there, art critics concluded that Smith was a different kind of artist. In 1940, Elizabeth McCausland, the art critic for the *Springfield Sunday Union and Republican*, stated directly what other critics had been implying in their writings: "Smith makes his steel sculptures in an old iron works on the Brooklyn waterfront. If laymen have the idea that art is an effete luxury, they should spend a morning in his 'studio,' where forge and other equipment stand on the cold earth. Smith meets the necessities of his environment by having the shoemaker put a half-inch layer of cork between the outer and inner soles of his work shoes."[3]

For Smith, the "rambly junky looking" Terminal Iron Works was enchanted. It was bustling and gritty, a place of labor and dream. The Manhattan skyline loomed across the river. Smith relished the "all-night activity, ships loading, barges refueling, ferries tied up at the dock. It was awake 24 hours a day, harbor activity in front, truck transports on Furman Street behind." He loved "the harbor lights, tugboat whistles, buoy clanks, the yelling of men on barges."[4]

In his published references to Blackburn and Buckhorn, Smith never mentioned their first names. His emphasis on the hard, round Joycean cadences of their surnames conjures them as mentors/elders/heroes. Blackburn was "a big gentle ironmonger whose best expression was 'if you can't stick your foot in it, it's flush.' Buckhorn was white collar, the job digger and checkwriter, his was 'balls and six are eight.'"[5] In their mini factory, Smith felt no hostility to art or to him as an artist. Black-

burn and Buckhorn were available when he needed them, for advice and banter. His work could be public or private. When he closed the door, his studio had a cave-like closeness. When the door was open, passersby could watch him construct and weld, just as residents of Decatur had watched blacksmiths in their shops and inventors in their backyards.

When reminiscing about the Studebaker factory in South Bend, Smith evoked workingmen who challenged him to develop his skills and gave him help when he needed it. When describing the Atlantic Avenue waterfront, he evoked another community of workingmen held together by practicality, economic necessity, and know-how, but this one was more intimate and varied, and he contributed to its camaraderie. The "men only" saloon at 13 Atlantic Avenue was part of this world: "We ate lunch got our mail and accepted it as a general community house. It was the social hall for blocks around. Any method or technique I needed, I could learn it from one of the habitués, and often got donated materials besides these were the depression days."[6]

In Smith's shop studio, magic happened. Objects from the neighborhood entering in one form could leave in another. Dehner explained to one of her interviewers in the 1980s:

> That's an original David Smith, that table. It was the original clock face from the Brooklyn Borough Hall. The Brooklyn Borough Hall had been demolished and boarded up, what was left of it, and it was right around the corner from where we lived in Brooklyn Heights. And we went up, the bums in the Depression used to go to sleep there, and we went up through this place one day, and up in the top this enormous clock had all been dismantled, and the hands and springs and . . . everything were all over the place. He loved this. I said, isn't that marvelous, that would make a wonderful table. So he took it down to his shop, and he put the legs on.[7]

Smith photographed ship masts, decks, and docks. His double and triple exposures dematerialized parts of boats, opening views onto other boats and skyscrapers. In one multiple exposure, a woman in a coat and cloche hat on a cobblestone street—probably Dehner—is seen from both

the front and side. Smith's photographic manipulations position her between two buildings receding in sharp perspective while the square arch of a loading dock seems to open a passage through her chest and neck. The image is both full and spare. Living by the water again, he made apparitional images.

Smith welded in the studio and painted in the apartment. Some of his paintings suggest cramped domestic situations, with hints of unnamed tension or conflict. Edges were becoming sharper, surfaces less congested, interactions more dynamic. Often there's a sense of looking through or into forms, although what is inside is hard to decipher. He was making small sculptures, similar in size to his paintings, but they're more performative in the array of movements they suggest, including dancing. Although both his paintings and sculptures are intensely animated and suggest the same image bank, the sculptures emerge from the various physical processes of bending, turning, twisting, and joining steel.

The Smiths, Levys, and Gottliebs formed a close-knit group. Milton Resnick, Sally and Milton Avery, Irene Rice and Humberto Pereira, and Mark Rothko and Edith Sachar were welcome in it. The Grahams were, too, although Ivan was teaching in Wells College in Aurora, New York, a 250-mile commute, and he was a mess. The Levys' apartment was the hub. Graham was the primary source of knowledge about contemporary and African art, Levy the authoritative commentator on work by other members of the group. They needed one another. At the Levys' home studio, the group drew together from life.

Soon after the Gottliebs moved to Brooklyn Heights from Greenwich Village in November 1933, Adolph, who had his own printing press, arrived at the Levys' with an etching plate. On it, Adolph, Esther, David, Dorothy, Edgar, and Lucille etched portraits of one another. Who portrayed whom was determined by lots. Dorothy was drawn by Adolph, Adolph by Edgar, Edgar by Esther, Esther by David, David by Lucille, and Lucille by Dorothy. The portraits appear within square frames in two horizontal rows, three portraits in each row. Lucille Corcos's Smith has a mustache, thick lips, big ears, and dark triangular eyebrows rising to points. To the right of his head, she wrote "DAILY MIRROR," the name of a tabloid newspaper popular within Smith's waterfront culture; to the left of his chin, she wrote, "HEY POPPA / DAVID BY LUCILLE." ("Poppa"

was one of Dehner's nicknames for him, too.) Smith drew Esther as a Cubistic portrait bust; she's wearing a tight high collar and flaring lapel and, with her mane of dark hair, looks Byronesque. Behind her, he drew a long three-story apartment building on a deserted street receding into the distance, perhaps with a sailboat at the end; Adolph was a passionate sailor. In Adolph's eyes, Dehner is wearing a light-colored sweater. A reading lamp is positioned above her head like a hair dryer. She is the most elegant and delicate of the six.

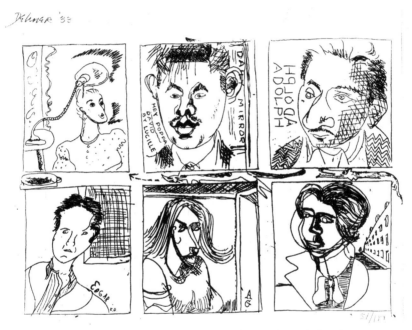

Dorothy Dehner, Adolph Gottlieb, Esther Dick Gottlieb, Edgar Levy, Lucille Corcos Levy, David Smith, *Six Artist Etching*, 1933 (printed 1974). Etching on wove paper, image: 5¾ × 7¾ in. (14.6 × 19.7 cm); sheet: 9¾ × 10⅝ in. (24.8 × 27 cm).

While these couples drew closer, Ivan and Elinor's marriage ended. At Wells College, Graham fell in love with a student, the daughter of a trustee. Dehner wrote:

I remember him telling me how well groomed she was, how pretty. All this was excruciatingly hard on Elinor, for much

of that sort of conversation took place in front of her. He had asked her to marry him. This was the last straw for Elinor. They were at our house in Brooklyn. We had a date to go out for dinner in the neighborhood. As we walked along, David and I behind Elinor and Ivan, they began to quarrel, at least Ivan did. Finally he began to hit her violently, I tried to interfere and David grabbed me and pulled me back forcibly, saying that we shouldn't interfere. I felt horrible. Elinor was being beaten and we were supposed to look on calmly, or at least like something in a movie. We were close to our house. Elinor was bruised and had a terrible black eye. David went out for some ice, after many hours they left. The next thing I heard was that Elinor decided not to live with him any longer and to get a court order to keep Ivan from bothering her . . . The girl from Wells College refused his proposal.[8]

In February 1934, Smith walked into the offices of the College Art Association at 137 East Fifty-Seventh Street with a shoe box full of sculptures. He was looking for a job on the federal government's Public Works of Art Project, for which Graham and Stuart Davis were working. Along with being the umbrella organization for art historians and artists in American universities, the CAA dispensed funds to artists from the "privately-funded Gibson Committee, one of the earliest—if not the earliest—of the work-relief programs to function in this community."[9] "In New York City," wrote Audrey McMahon, the regional director of the Works Progress Administration Federal Art Project from its inception in 1935 to its termination in 1943, "Mayor LaGuardia was the official sponsor, and employment quotas for artists, models and allied personnel were allocated by his office to the CAA."[10]

Mildred Constantine greeted Smith at the CAA office. She was McMahon's secretary on her WPA job and an editorial assistant on *Parnassus*, the CAA's publication. Just twenty in 1934, Constantine would become an influential MoMA curator of fabric art and one of Smith and Dehner's closest friends. "When David . . . brought out his sculptures to show me, I looked at him and I said, 'I've never seen anything like this,'"

she said in an interview. She walked into McMahon's office: "'There's a sculptor outside, his name is David Smith . . . and he has a couple of pieces of his work.' She said, 'What's it like?' and I said, 'I can't describe it. It's like something I've never seen before . . . It's not like sculpture that we have standing around the country . . . this is certainly a man we must help.'"[11]

McMahon did not believe Smith's sculpture was sculpture—during the next twenty-five years, many other people, including prominent artists, did not believe Smith's sculpture was art—but she was so impressed with his technical skill that she commissioned him to make bases for her Mexican heads and some of her ancient sculptures. "At that time," she said, "he was just a craftsman . . . but he was a visionary."[12]

Smith would remember his stark economic situation: "In the case of Blackburn and Buckhorn—there were times when I couldn't pay my rent—I'd go out on a ship and work with them for a few days and we'd call the rent even . . . These were the depression years—life was hard—taught for a time at a Jewish Settlement house."[13] When Dehner saw these words soon after Smith's death, she rejected the implication that her inheritance was not enough to cover their expenses. "We always had rent money, we always had food, we had a car and a house in the country," she asserted. "Outside of necessities our money went mostly for his work. We never had a fight about money. He was anxious about money but that was another question."[14] However, their "house in the country" was barely livable, their scrappy pickup truck was not a "car," and Smith needed money for materials and tools. Given the community of male workers at and around Terminal Iron Works, the image of self-reliance he was determined to project, and his sense of fellowship with the many artists struggling to survive, he had to have a job. He needed to negotiate and do battle with the system.

Years later, Dehner acknowledged the legitimacy of Smith's claims of economic precariousness. "It wasn't enough. What I had wasn't enough to pay for materials, and the rent that he had, and our everything."[15] She, too, sought extra money, making Christmas cards, "because making art is quite costly. It's like supporting a couple of kids, sculpture and painting."[16] Dehner was gratified by being able to contribute to the creative development of an artistic powerhouse whose drive and imagination

astonished her. What pained her was that Smith, particularly after 1950, rarely seems to have acknowledged the impact on his art and life of her inheritance.

Since he was not impoverished, Smith was not eligible to join the Public Works of Art Project as an artist in need of relief. Instead, he sought an administrative job and proposed a study of the content, application, and preservation of paint. He and Edgar Levy had already begun such a study in 1933, when the Treasury Section of Painting and Sculpture was encouraging artists to develop and present projects. Smith believed that artists' materials were not of the best quality and that this was one of many ways in which artists were being taken advantage of by a cultural and economic system that did not respect them. He knew Ralph Mayer, who was researching art materials, and whose uncle, Maximilian Toch, was a paint chemist. Toch was an expert on paint, "walls, and frescoes, and all that—and the WPA had nothing" like that knowledge. "Nobody was ever taught that. The best art schools never mentioned this . . . So David decided he would learn about paint technics, and apply for that."[17]

On March 22, 1934, Smith was put on the Technical Division of the Civil Works Administration, Public Works of Art Project. After a month, he was transferred to the Treasury Section of Painting and Sculpture, which was part of the Temporary Emergency Relief Administration. "The Treasury Project was the one that decorated all public buildings, public government buildings, like post offices," Dehner said. Smith's job was "to supervise the murals, and he studied everything."[18]

"He was running an office, he was working out of the office," the painter Charles Mattox, one of the assistants Smith hired, remembered. "We went out and surveyed walls, decided what condition they were in, how they should be handled and we did all the buying of materials for the Project . . . We did a lot of research on paint labeling, and we finally got manufacturers to begin to publish on tubes of paint what was in them . . . so that we had some way of knowing what we were buying."[19]

Kirk Varnedoe, the former Chief Curator of Painting and Sculpture at MoMA, described Smith as a "voraciously inquisitive autodidact."[20] Whenever he set out to learn a process, material, or field, his research was exhaustive. A college dropout with little formal education and no training in how to study, he felt he had to know everything about a mate-

rial and method in order to understand it, and in order to prove to himself and others that his knowledge was sufficient. His archives include technical studies on casein, lime, cellulose, resin paints and varnishes, and linseed oil as well as studies on "specifications and standards for paint," "oil paint on plaster," and "problems of sanitation/preservation." He wrote to experts, like Toch, who informed him about the chemical makeup of brown oxide, cadmium red, yellow ochre, ultramarine blue, burnt sienna, and other paint colors. The chief engineer of the National Lime Association wrote him about the makeup of plaster for frescoes. Edgar Levy worked on the Treasury Project, too, and some of Smith's research into the components of paint was with him.

When Dehner earned $180 for her Christmas cards, Smith took the money in order to buy, in her words, "all the books he could get—translations from German, translations from French; French, Italian, some English books, there were no American books."[21]

Smith and Dehner were, as she put it, "wildly political. We judged everything on the basis of whether people were reactionaries or progressives."[22] Smith joined many other artists on the project as well as political activists. In the summer of 1933, he had been among the artists who picketed Rockefeller Center in order to prevent the destruction of Diego Rivera's mural *Man at the Crossroads Looking with Hope and High Vision to the Choosing of a New and Better Future.* Rivera began working on the mural commission in March 1933. In early May, he included in it a portrait of Lenin that had not been part of the original drawing. Nelson Rockefeller asked Rivera to substitute another figure for Lenin. He refused. In February 1934, the mural was destroyed.

In April 1934, Smith joined the Artists' Committee of Action for the Municipal Art Gallery and Center. "The Artists' Committee of Action (A.C.A.)," the Smith and Dehner scholar Paula Wisotzki wrote, grew "out of a protest against the obliteration of Diego Rivera's mural at Rockefeller Center and outrage at the fact that a municipal art exhibition had been held at Rockefeller Center just weeks after the destruction of the mural."[23] In October, Smith was one of five hundred artists who marched to city hall to demand the creation of the Municipal Art Gallery, which was to be a circulating artist-run library for pictures and sculptures with no jury system and no discrimination based on creed or color.

In February 1934, the Unemployed Artists Group—an organization formed to fight for artists' rights—had changed its name to the Artists Union. Smith joined this group as well, and Stuart Davis was elected president.

Smith and Dehner marched in the May Day parade. Participation "wasn't a choice," Stuart Davis said. "It was a necessity to be involved in what was going on." The parade had an artist section. "For the first time I know of," Davis said, "the artists felt themselves part of everything else, general depression, the needs of money and food and everything else."[24] Poverty and homelessness were terrible and inescapable. "Washington Square was one big bed at night—not a blade of grass uncovered," the art historian Marchal E. Landgren said. "Hoovervilles in the drained reservoir of Central Park, on the banks of the Hudson, on the lower East Side."[25]

The threat to left-wing "abstractionists" was aesthetic as well as economic. Thomas Craven's *Modern Art: The Men, the Movements, the Meaning* was published in the spring of 1934. No other art book that year received more attention in the United States. "Again and again," Craven wrote in his America-first screed, "I have exhorted our artists to remain at home in a familiar background, to enter emotionally into strong native tendencies, to have done with alien cultural fetishes."[26] Picasso was the "king of the international Bohemian in which whim and lazy cultivation of illusion take the place of life."[27] He was "rude and illiterate" and his art was a fraud "sold to dealers" by "Max Jacob, an apostate Jew."[28] It "carries no significance beyond the borders of the Bohemian world of its birth . . . he is at the service of nothing. The content of his art, where any is to be discerned, pertains to those vague generalities by which youth unconsciously betrays its ignorance of life."[29]

Craven's ideal was Thomas Hart Benton, proselytizer for the American heartland. Benton's image was put on the cover of *Time* in conjunction with its December article "The U.S. Scene in Art," which lumped Benton with Grant Wood, John Steuart Curry, Reginald Marsh, and other painters of the American Scene as the future of American art. Benton, Craven wrote, "has painted our capitalist America and the America of the pioneer and the individualist—its history and its current phenomena, all of which he knows and understands. The rushing energy of

America, the strength and vulgarity, the collective psychology, are embodied in his art." Benton had created "the outstanding style in American painting, perhaps the only style."[30]

During the summer at Bolton Landing, Dehner's piano was moved into the house. Smith built a two-foot-tall wall around their garden and moved the shed that he would use for welding away from the house. After they hosted Toch, who in Dehner's words "enjoyed himself by patting" her "bottom" while she was washing dishes—"I'll kill him. I'll kill him for you," was Smith's response when she told him—Toch sent them a gift of enough paint to paint the house.[31] In August, Smith was promoted to Assistant Project Supervisor on the Treasury Project and given a raise to $30 per week.

The first issue of *Art Front* appeared in November. Introducing itself as "sponsored by the Artists' Union and the Artists' Committee of Action," the magazine was intended to answer the "urgent need for a publication which speaks for the artist, battles for his economic security and guides him in his artistic efforts . . . ART FRONT is the crystallization of all the forces in art surging forward to combat the destructiveness and chauvinistic tendencies which are becoming more distinct daily." *Art Front* had less impact on Smith's aesthetic imagination than *Cahiers d'art* and another French magazine, *Formes*, but it had a lasting impact on his language and convictions. *Art Front* fought for all artists, regardless of approach, including the most traditional. It included reviews— Graham was one of its reviewers—listings of exhibitions, and articles by artists and other writers on many issues, among them art materials. It closely monitored federal arts funding. It debated Surrealism versus abstract art—each side talking past the other. It battled over communism and socialism and what was truly radical art. It raged against the American media, servant of a ruthless and imperialist ruling class. It had no faith in the art market. In response to the December 1934 *Time* article with Benton on the cover, Davis ridiculed the notion of "direct representation"—meaning recognizable and therefore inherently more truthful figurative imagery—held up in this article against "introspective abstraction": "Craven's ideas are unimportant," Davis wrote, "but

the currency given to them through the medium of the Hearst press means that we must not underestimate their soggy impact."[32]

For an American artist in the 1930s who wanted to be both a political activist and a serious abstract artist, Davis was the most important model. Physically unprepossessing, with none of the bohemian theatricality of Graham and Gorky—the two other members of "the Three Musketeers"—Davis was pugnacious, tireless, and anti-defeatist. He had worked under John Sloan at *The Masses*, for which he drew high-spirited and sometimes caustic satirical cartoons. He remained a thorn in the side of institutional power and was not averse to attacking individuals and institutions who could help his career. He knew Paris, where in 1928 he lived in Jan Matulka's studio. In his paintings he helped to integrate Cubist space with an American vernacular. He loved the snappy energy of puns and slang. His passion for jazz left a mark on many Abstract Expressionists. He believed art had to be of its time, which in the mid-1930s required being anti-provincial and culturally aware. "The cultural heritage of the American artist today has its roots and is fed by the cultures of all times and races." Davis's Whitmanesque list of inspirations was Smith-like in its embrace:

> American wood and iron work of the past; Civil War and skyscraper architecture; the brilliant colors on gasoline stations; chair store-fronts, and taxicabs; the music of Bach; synthetic chemistry; the poetry of Rimbaud; fast travel by train, auto, and aeroplane which brought new and multiple perspectives; electric signs; the landscape and boats of Gloucester, Mass; 5 & 10 cent store kitchen utensils; movies and radio; Earl Hines hot piano and Negro jazz music in general.[33]

Smith and Davis were not close, but Graham brought Davis to Smith's shop-studio, Smith read Davis's writings and was often in his presence. He made many references to him. For years, in solidarity, he wore the same kind of cap Davis wore.

14

Radical Decision

"Abstract Painting in America" opened in February 1935 at the Whitney. The exhibition of 135 works by 65 artists spanned two floors. Stuart Davis wrote the catalog preface. While the exhibition was in its planning stages, David Smith and Edgar Levy were among the artists who approached the museum collectively. "It was in [Romany] Marie's where we once formed a group, Graham, Edgar Levy, [the Russian painter Misha Reznikoff] Resikoff, de Kooning, Gorky, and myself, with Davis being asked to join," Smith wrote in 1952. "Our only action was to notify the Whitney Museum that we were a group and would only exhibit in the 1935 abstract show if all were asked. Some of us were, some exhibited, some didn't, and that ended our group. But we were all what was then called abstractionists."[1] Graham, Gorky, Pereira, Davis, and Matulka made it into the show, along with more established painters such as Marsden Hartley, John Marin, Georgia O'Keeffe, and Max Weber.

However positively critics responded to the exhibition, few felt comfortable writing about it. There were so many issues to address: abstract art was too subjective; the emotional responses it elicited were too vague in these years of emergency. Furthermore, unlike figurative art, abstraction lacked a forward-moving dialectical tension between art and nature. Besides, abstraction was too rooted in Europe. And what was abstract art anyway? "They speak another language this week (and through

March 22 when the exhibition of 'Abstract painting in America' closes)
at the Whitney Museum of American Art" is how Emily Genauer began
her review in *The New York World-Telegram*. She continued:

> It is a language whose vocabulary consists of symbols—cubes,
> planes and a raft of unrecognizable, nameless shapes—instead
> of naturalistic forms. Mind you, I am not suggesting that this
> is not an understandable language, that it is a meaningless
> jargon of explosive sounds. I say simply that it is a language
> which even at this late date (remember it was introduced to
> the general American public more than a score of years ago)
> still sounds like Choctaw to the large majority . . . I did not
> enjoy it.[2]

In his preface to the exhibition catalog, Davis wrote that the ques-
tion of what abstract art is "will be answered differently by each artist
to whom the question is put. This is so because the generative idea of
abstract art is alive. It changes, moves and grows like any other living or-
ganism." He defined a materialist position and identified it with abstrac-
tion. A painting is "a two-dimensional plane surface and the process of
making a painting is the act of defining two-dimensional space on that
surface." Abstract painting respected the conditions of painting—for ex-
ample, its flat surface and the geometry of canvas and frame. Because it
respected the conditions of painting, abstraction was in fact more real-
istic, more grounded in material facts than modes of representation to
which it was unfavorably compared, such as Social Realism or American
Scene painting.[3]

Smith's sculptures called attention to the tangibility and histories of
their materials. They connected viewers with the properties and physi-
cality of steel. They compelled an awareness of laborers, tradesmen, and
factories. How Smith incorporated once-functional objects recalled their
original purposes even as the objects took on other identities within the
new sculptural unit. The sculptures were immediate and fluid, their sur-
faces active and anti-precious. They connected consciousness of class
and labor to invention, transformation, and surprise. They may not have
had the image flow and chromatic range of his paintings, but they had

every bit as much fantasy and more clearly than the paintings, they were animated by his politics and everyday life.

In the spring of 1935, Smith defined himself as a sculptor. "Remember May 1935, when we walked down 57 St. after your show at Garland Gallery, how you influenced me to concentrate on sculpture?" he wrote to the abstract painter Jean Xceron in 1956. "I'm of course forever glad that you did, it's more my energy, though I make two hundred color drawings a year and sometimes painting, but by having my identity as a sculptor, I can paint and I thus know myself better. But I paint or draw as a sculptor . . . Forever thanks."[4] Graham, the first person to recognize Smith's sculptural gift, was present at that conversation.

In Bolton Landing, Smith continued to fix up his shop-studio. "The windows are all in & he got a swell anvil & blower for $3 & made a work table out of planks & covered it with cut up tin cans," Dehner wrote. "All studded with galvanized nails like a baronial feasting board."[5] Dehner, her activities limited for two weeks by trench mouth, which she believed she had contracted at a soda fountain in the city, planted and tended the garden and sewed curtains for a new window. He painted the shed red, the outhouse white, and the toilet seat blue. They cleaned out the barn and in it set up easels for both of them.

Their upstate community now included Bea and Bernard Ainsworth and their twenty-year-old son, Philbert, who lived down the hill, toward town. The day after Philbert showed up one night crying from tooth pain, Smith took him to Glens Falls for his first visit to a dentist: "He had 16 fillings put in all in one jug (as he said)."[6] The Ainsworths' sweet and hapless dog, Snooker—"a basset hound, something like a dachshunde but white with a brown spot"—gravitated up the hill, too, as during the summer the Ainsworths did not want to have much to do with her. Along with distemper, Snooker would have an abscess on her head that "broke all over the back seat of the car & it stank like a son of a bitch & we were simply wrecks cleaning everything & taking care of dog."[7] Where Smith went, Snooker followed. When he was down the hill at the pond fishing under the stars, Snooker picked up his scent and joined him.

The Smiths felt increasingly distant from Wilhelmina Weber and Tomás Furlong, who had introduced them to Bolton Landing just six years earlier. "Haven't seen Weber. D. saw them in the village. I just haven't the

vinegar in me to go over there any more," Dehner wrote.[8] They did see Lois Wright and her husband, who provided lodging for Alter and Celia Brody, friends from Brooklyn who wanted no part of Elinor Graham's run-down house, where they intended to stay. Alter Brody was a Russian poet—one of several Jewish intellectuals who were part of the Smiths' lives. Edith Sachar and Mark Rothko—Mark also a Jewish immigrant, in his case from Latvia—were renting a house in Trout Lake, a couple of miles from the Smiths'. They joined a spaghetti party at the Smiths' and introduced them to Bernice and Charles Berman, who, unlike the Brodys, made do in Elinor's house. Dehner gushed: "They are true pioneers & cleaned & scrubbed it & got everything organized in one day & are having a swell time."[9] In September, the Levys made the trek to Bolton Landing by bus. This seems to have been their first visit, and they, too, had a swell time.

The Smiths kept up with *The Catholic Worker*, edited by Dorothy Day, the first issue of which appeared on May Day 1933; *New Masses*, affiliated with the Communist Party, which believed in the roles art and literature could play in changing the world; and the Stalinist *Daily Worker*, published by the Communist Party. They read R. Palme Dutt: "English writer but Indian—had written an analysis of Fascism (a Communist)," Smith would later remark.[10] In *Fascism and Social Revolution: A Study of the Economics and Politics of the Extreme Stages of Capitalism in Decay*, published in 1934, Dutt wrote, "Fascism is not merely the expression of a particular movement, of a particular party within modern society," but the "most complete expression of the whole tendency of modern capitalism in decay, as the final attempt to defeat the working-class revolution and organize society on the basis of decay." The world was faced with a choice between fascism and communism. Only "the revolutionary working class" could save "the whole future of civilization and of human culture."[11]

In Glens Falls the Smiths saw *The Informer*. In this 1935 John Ford film, a former member of the outlaw Irish Republican Army informs on a friend to get money to take his girlfriend to the United States. He asks for forgiveness, but the IRA kills him because he is a danger to the organization. "It surely is swell we were simply crazy about it," Dehner told the Levys. "Most of the people *laughed* all the time! But the Italian troops

were actually hissed." They followed union struggles for better wages and working conditions. "Have you been to any Union meetings? . . . A.F. of L.," Dehner asked."[12] She wrote to Lucille Corcos that she "bumped into a whole nest of radicals in the local dress shop. They are Glens Falls women only they haven't got it hitched to anything. I got them to sign my Angelo Herndon petition."[13] Paula Wisotzki described Herndon as "a black Communist who had attempted to enlist others as members of the Party. He was arrested in Atlanta, Georgia, in 1934, under an antiquated state law against inciting insurrection that had originally been drafted to prevent slave uprisings. In the Georgia courts Herndon was found guilty and sentenced to twenty years in jail. Eventually the decision was reversed by the Supreme Court in *Herndon v. Lowry*, 1937."[14]

As an artist, Smith was ready for a big move. Much of the art that inspired him was European or in Europe. He and Dehner feared that if they did not go there soon, they might not get another chance. They urgently wanted to visit the Soviet Union, too. Among the far left, a second world war was a given. In the January 1935 *Art Front*, the painter Jacob Kainen wrote of "a world driving toward Fascism and the second world war."[15] R. Palme Dutt wrote, "All the existing policies of capitalism are policies of ever-sharpening war, of ever more formidably organized imperialist blocs; of tariff-war, of gold-war, of currency-war; of war with every possible economic, diplomatic and political weapon. It is no far step from these to the final stage of armed war."[16] Dehner said, "We felt that certainly a war was coming and that Hitler would start something terrible in Europe and we wanted to see it before it was all smashed up."[17]

Near the end of September, Dehner and Smith made the decision. Smith wrote to Levy:

> Here is the dope. We just got folders from American Express and have almost picked—barring acts of God and misfortune—the Manhattan which sails Oct 9th for Harve [Le Havre]. We have planned to convert everything cashable to cash and go to Europe . . . We decided quickly to go now—this being as good as any time and before inflation sets in more and the money we have or can get might as well be spent before its worthless.[18]

During the summer, they had heard from Graham in Paris. "We told Graham of our decision," Dehner said, "which was a big one since we planned to stay away for nine or ten months."[19] Smith did not want the WPA to know about the trip. "We better keep it quiet," he told Levy, "because if something came up we couldn't go—I might have too hard a time getting my job back."[20]

Without giving the reason, Smith asked his parents for money. They provided it, an act that left Dehner and Smith "flabbergasted." Dehner wrote to the Levys, "D's mother & father are probably knocked for a loop. I suppose they thot that we would take the dough & buy a swell new car & come to Paulding for a *long* visit. We are going to invite them here for the hunting season. I mean, we wouldn't be here but they might enjoy the fall scenery & the deer hunting."[21] They also asked Aunt Flo to help fund the trip, which she generously did. Dehner again wrote to the Levys: "We are terribly excited as its all so sudden and I can't even write straight . . . D. is trying to figure out money & gosh even if we have enuf to go we are still always broke anyhow I mean everything will be the thirdest class imaginable."[22]

Aunt Flo came to New York to see them off. In the days leading up to their departure, she, Dehner, and Smith all stayed at the Pierrepont Hotel in Brooklyn. On October 8, on CAA letterhead, Audrey McMahon typed a letter saying that Smith was associated with the organization. "And we would deeply appreciate any assistance that he can be afforded," she added, "in his studies and research while he is abroad."[23]

The following day, Smith, in a three-piece suit, and Dehner, in a dark velvet hat and wool suit, along with Lucille Corcos and Aunt Flo, were photographed, surely by Edgar Levy, on the deck of the SS *Manhattan*. As the boat pulled away, Dehner and Smith looked down at the pier, wanting to keep sight of the Levys, who kept waving as they got smaller and smaller.

In November, *Art Front* published "Call for an American Artists' Congress." The tone was urgent. "A picture of what fascism has done to living standards, to civil liberties, to workers' organizations, to science and art, the threat against the peace and security of the world, as shown in Italy and Germany, should arouse every sincere artist to action." Smith was one of the hundred or so artists to sign.[24]

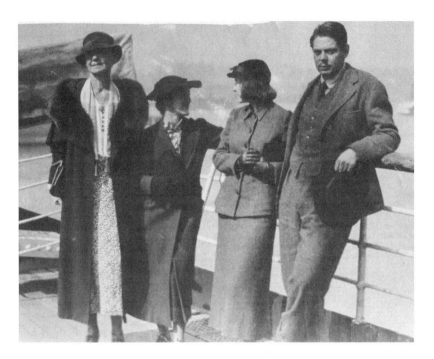

Dorothy Dehner and David Smith on the SS *Manhattan*, 1935. From left
to right: Florence Uphof (Aunt Flo), Lucille Corcos, Dehner, and Smith.

15
Paris

When their train arrived at the Gare St. Lazare, Graham was there to meet them. He led them to their hotel near Montparnasse, where he, too, was staying. The Médicale, Dehner wrote, was "the craziest hotel—kind of a hospital that was a flop so they made it into a hotel & and do the hospitality on the side." The next day they awoke bright and early, and Graham took them all over the city, to so many places that they could not remember them all. At the Galerie Simon, they "saw the newest Picasso, hot off the easel. Entirely different from any he has done before. Not very abstract in general conception but parts abstractly painted—leaves for hands & so on." They met "dealers & collectors in negro and oceanic art." By the end of the day, they "were simply coo-ku with exhaustion."[1]

Thus began Smith and Dehner's European adventure. In the fall and spring, they would spend roughly three months in the City of Light, which in 1935 and 1936 was as much a city of gray. Paris was starker and tenser than it had been when Dehner had visited a decade earlier, gaiety disturbed by scarcity and strikes, but Smith and Dehner were there for the rough as well as the sweet of it. More than ever before, aesthetically and politically they felt in the thick of things. For them, Paris was cheap and marvelous, a city of strife and wonder whose secrets and knowledge were inexhaustible.

What Smith learned there was immense. He met artists he and

Dehner had studied and saw work by artists they had followed from afar as it entered the world. He saw extraordinary collections in homes as well as in museums. The passion with which great collectors acquired and lived with art would contribute to his belief that collectors were closer to artists than curators and critics were. He came to trust individual collectors more than he did institutions. In the process of studying and buying tribal art, he also educated himself about the art market. He studied not just contemporary art but also the relationship between premodern art and the present. At the Orangerie, he was blown away by "De van Eyck à Bruegel": "When I saw a show of five hundred drawings of Dutch and Flemish artists at the Orangerie in Paris in 1935. I realized what an inadequate draftsman I was. That is why drawings have been a large part of my work ever since."[2] He learned etching and engraving, and he spent days at the Louvre analyzing the conditions of paintings and sculptures, as invested as any artist has ever been in learning art materials and methods.

Stéphen Chauvet was one of the many people who showed Smith a way of life that did not exist in America. It was not just the quantity and quality of his collection but also the way he lived with it. Smith wrote to Levy:

> [He] is a surgeon and lives in an ill heated ramshackle string of apartments on the left bank. He has everything from Cycladic to Oceanic. The most rare sort of bone and ivory objects and all the stuff has an authentic source. There is all kind of fakes in Paris from Cyclades to African. Chauvet has his objects all over the house in cases—in little rooms piled up—in the basement and he even tells me his finest things are stored at his villa and that I am to come see him in the spring—if there is no appearance of war—and he will have brot them to Paris. Chauvet is a communist I think—or a sympathizer by his conversation on fascism and war and by the left magazines that were in his racks—which I examined while waiting for him. His whole house was in a note of decadence—a prustian stuffiness with all these objects mixed up all over the house with Victorian furniture—Flemish drawings and paintings—in other rooms huge wine press screws used a[s] decoration in

beam supports some rooms cold as hell—some hot and stuffy from little fireplaces sucking up all the oxygen. No windows seemed to open—vision was entirely within the room.[3]

Chauvet was not the only great collector Smith and Dehner visited who combined a commitment to tribal art with left-wing politics. Through Graham, they met the legendary Félix Fénéon, who collected modern and contemporary art as well. As a writer and editor Fénéon had spent a lifetime around poets and artists. His portrait had been painted by Paul Signac and Édouard Vuillard. He owned work by Toulouse-Lautrec, Modigliani, and Matisse. Formerly an anarchist, he was now a communist who was planning to leave his art collection to the Soviet Union. In his daily life, including love affairs, he crossed classes and managed to define himself as both a political radical and an aesthete. His life with art was intimate. In his apartment on the avenue de l'Opéra, it was apparent that great art was made by human beings.

"M. Fénéon was lying ill in a room completely plastered by African sculpture which Mme. F. urged us to look at," Dehner wrote. "Other rooms held what Graham said was the largest collection of African spindles in the world. The house for many years had been a sort of refuge and dining place for hungry artists. In payment they would leave a painting occasionally. The halls were lined with Braques, Picassos, Des Fresnayes, Légers and others of the period. They were for sale too as well as the African sculpture. We were offered a Braque for $500."[4] They didn't buy it, to Dehner's lasting regret. "Not only did he advocate the connection between Modern art and 'Primitive' art, he lived it," wrote John Rewald, the renowned Impressionist and Post-Impressionist scholar.[5]

In Paris, Smith encountered the full force of both Surrealism and abstraction. He had expected to see Surrealism. Graham had told him about Luis Buñuel and Salvador Dalí's 1929 Surrealist film, *Un Chien Andalou*, with its violently disjunctive structure and images. Yet it was one thing to see Giacometti's Surrealist objects and Dalí's paintings in 1934 at New York's Julien Levy Gallery, or in *Cahiers d'art*, or a Surrealist publication, and another to see them in the city in which they had been made. Surrealism pervaded the Salon des Surindépendents, which Smith visited. But Paris was also a melting pot for painters interested

in geometric abstraction that defined itself against Surrealism. Cercle et Carré was a short-lived group of abstract artists that began in 1929 and published its own periodical. Mondrian, Kandinsky, and Moholy-Nagy, artists of lasting importance to Smith, as well as Léger and Le Corbusier, were members; so were Graham and Jean Xceron, although more on the group's fringes. Abstraction-Création was a group of abstract artists who exhibited together from 1931 until 1936. It, too, had its own publication. Mondrian, Kandinsky, and Moholy-Nagy were also members of this group; so was Calder, as well as Xceron, whom Smith and Dehner were forever trying to contact while in Europe. Jean Arp, another member of this group, exhibited in both the abstraction and Surrealism camps. Aesthetic divisions were not always absolute.

Smith was not in Paris to be a tourist. Letters from him and Dehner make no reference to the Arc de Triomphe, the Tuileries Garden, Notre-Dame, the Eiffel Tower, or any other tourist landmark. The famous café La Closerie des Lilas, still a hangout for American expatriate writers, was near their hotel, and they went to Le Dôme, one of Montparnasse's gathering places for artists, but they did not feel the allure of café life. "Just the artist's life bumming around in cafes and drinking and that kind of thing we didn't have because Graham was not that kind," Dehner said.[6] Smith was there to study modern art in the birthplace of modernism, to fill in gaps in his knowledge of art history and technique, and to acquire artworks and objects to inspire him and perhaps to sell. He was there to educate himself and become part of the larger world.

The Médicale was on the rue du Faubourg Saint-Jacques, an extension of the rue Saint-Jacques, a narrow north-south street that had been part of the old Roman way once connecting Paris to Rome. Close by was the rue Campagne-Première, where Rimbaud, Rilke, Modigliani, Whistler, and de Chirico had lived. From Port-Royal, the boulevard Raspail, and the top, or southern tip, of the Luxembourg Garden, all within easy walking distance of the hotel, they could board buses and Métro trains to other parts of the city.

They visited the Galerie Pierre in the Latin Quarter and the Galerie Paul Rosenberg near the Champs-Élysées and the flea market at the north end of Paris, at the Porte de Clignancourt. They met Louis Carré—a modern and African art collector from whom Graham bought work for

Crowninshield—and in his spacious Le Corbusier–designed apartment in the affluent sixteenth arrondissement helped him prepare the catalog for his upcoming New York exhibition of Benin bronzes. They went to events organized by the Maison de la culture, founded by the Association des écrivains et des artistes révolutionnaires, in working-class neighborhoods, and to the Père Lachaise cemetery. They saw films, attended political meetings, and saw art in exhibitions throughout the city. They may have visited Burgundy on a gourmand expedition as well.

By and large, Smith called the shots. What he wanted to do, he did, and what he didn't want to do, he didn't. He refused to learn French. "He gets around . . . by drawing pictures of everything including the clothes on the laundry list," Dehner wrote a couple of weeks into the trip.[7] Learning French, the language in which they would have to navigate Europe, fell to her: for much of the time they were in Europe, she took French classes at Berlitz. She did quite a bit of drawing in Paris; Smith did not make much art there, but if he needed space to work in their hotel room, he took it. "You know what a spreader outer Smith is," Dehner wrote to the Levys.[8] For both Smith and Dehner, buying cheap was a matter not just of economic necessity but also of principle. Unlike Dehner, however, Smith, after establishing the price he would pay, bought without hesitation. With exceptions, notably embroidery, Dehner was inclined toward frugality, although she could be enthusiastic about Smith's acquisitions. With an aversion to skimping that was already a characteristic of his relation to art, he bought and bought, probably with her money more than his, without concerning himself about the consequences. Graham's attitude—"collecting is not merely investing money in art objects, collecting is rather buying with privations to establish a personal contact with art objects, artists and spiritual life of past epochs"—was probably a factor in Smith's approach to collecting, but he also sensed that he might never again be in the presence of so many cheap or reasonably priced charmed objects.

Dehner and Smith tried to find an apartment or studio, not just because of Smith's reaction to the antiseptic smell at the Médicale but also because a one-room residence was too small for them. Eventually they made their peace with the hotel and stayed there. It was an artists' place. Dehner wrote:

Graham loved it because the walls were all painted white, therefore we dispensed with the horror of French wallpaper. There were large glass balcony windows from ceiling to floor which provided beautiful light. [The Italian painter Massimo] Campigli lived there and other artists, and I believe at one time Stuart Davis had a studio there. Graham had in previous years done a great deal of painting there . . . The elevator bore a sign ne march[e] pas [i.e., broken] all the time we were there, hot water was on one hr. each day, few of the johns worked and those of the most primitive squatting kind. It was typical of Graham that he had found such a place. It was a horror, and yet it was marvelous for our purposes . . . It had light, air, and plain walls, and it was well located.[9]

During their first three weeks, until he returned to the States, Graham was their constant guide and companion. He introduced them to other artists. Jacques Lipchitz had immigrated to Paris from Lithuania. His open bronze sculptural presences, reproduced in *Cahiers d'art*, reflected his affinity for Cubism and African art. Dehner recalled that Lipchitz, who would be represented by the same gallery as Smith, was cold. "A great snob," she said.[10] Graham also took Smith to the studio of Julio González, who in 1934 had had two exhibitions in Paris; he was not there. Graham offered to introduce Dehner and Smith to Picasso, but "David felt he had nothing to say to him because he did not speak French," although the language barrier did not deter him from going to meet González. "Also, Graham had told him to address Picasso as 'Maître,' and David was not about to call another artist 'Master.'"[11]

Through Graham, they also met Stanley William Hayter, an English printmaker and painter, who founded the experimental printmaking workshop Atelier 17, not far from the Médicale. Hayter contributed to the workshop any income from sales, and artists contributed what they could for materials and upkeep. "You know the way we work, there is no sort of professor and student deal going on here," he stated. "I have always had the theory since I started this thing that if you are going to get anything done about this craft it is going to take a lot of people to do it and you have got to work with them, which means a damn sight more

than it sounds because there are hardly any cases of it being done."[12] Hayter worked with beginners and he worked with Miró, Picasso, and Giacometti. He and the Smiths dined together often. "A strong and mature character" whose "approach to work at the Atelier was simple and unpretentious" is how Hayter remembered Smith.[13]

Hayter developed methods through which printmaking would become, in effect, automatic writing. Even more important for Smith, he helped to develop intaglio printmaking, which would have a lasting effect on his sculpture. In intaglio processes, which are different from etching, lines are cut or incised in the copper plate, ink placed in the lines, and paper rolled over the lines with great pressure. Intaglio is tactile and sculptural: Hayter likened it to relief sculpture. The intaglio printmaker feels the physicality and fluidity of line.

In Paris, Dehner and Smith flaunted their communist affiliation. They bought buttons supporting Ernst Thälmann, the head of the German Communist Party, who had been jailed because of his opposition to Hitler. Dehner reported gleefully to the Levys that while watching a newsreel, she and Smith

> hissed at the royalists & Croix de Feu [a right-wing nationalist party] & clapped at the British Miners strike. As did others (lots of others) but everybody near us turned around & yelled "Communiste" at us. There are hundreds of white Russians living around here & they are the worst. They all think U.S.S.R. is just ready to collapse & then they can all go back & be rich again. The fact that they have been hoping for 17 years does not discourage them.[14]

A left-wing alliance led by communism that would defeat the fascists seemed possible. Dutt had written that "the united front pact of the French Socialist Party and the French Communist Party was finally signed on July 27, 1934; and the powerful influence of this common front is stimulating and mobilising the entire working class, and spreading confidence and fighting spirit, has been the decisive factor in delaying the planned rapid offensive of Fascism in France during 1934."[15]

Dehner declared:

The United Front is simply wonderful here. It actually has
some effect on the gov't. Every news stand sells L'Humanité
[the French Communist newspaper] & hammers & sickles
are all over the billboards. The Socialists are sticking to the
Com. to get the Govt. to suppress the Croix de Feu which is the
stinkingest outfit imaginable. They had a terrific fight at a city
near Paris between the Front Populaire & the Croix de Feu &
filthy little Fascist brats go around chalking swastikas on the
walls.[16]

Smith and Dehner arrived in Paris hoping for proof that commu-
nism was compatible with the avant-garde and convinced themselves
that it was. Smith wrote to Levy, "The fascists (Croix de feu) here threw
a rumpus during the sale of Cubist painting and—brot up the issue of
spending the peoples money for such crap—the artists and writers club
(Communist) is defending the Cubists."[17]

At the Louvre, Smith was absorbed with Flemish painting, particu-
larly Pieter Brueghel. "Fish cutting—fish walking fish flying—surrealist
imagery fish suspended from trees." He was drawn to Brueghel's "un-
usual placement of unreal objects" and ability to combine improbable, if
not outlandish, images. He noted the condition of one of his paintings:
"Color good—but browned—tree leaves made like signpainters." His
notebooks are filled with remarks about paint applications and condi-
tions. "Raised figuration of textiles noticeable panel—joints noticeable
colors clear brilliant—red veils good ... appearances of restoration." Of a
Quentin Matsys painting, *The Banker and His Wife*, he noted "browned
veil" varnish "over brilliant underpainting." Perhaps at the Louvre, he
began studying polychrome sculpture, including the ways in which
paint adhered to the surface.

Smith gave tribal objects the same attention. He studied them in mu-
seums, back rooms of galleries, and collectors' homes. He was interested
in strategies of collecting: what was for sale, where it came from, how
good it was, how it compared with related works, could he buy it at a
bargain price. He was determined to be able to tell a good sculpture from
a bad one, an authentic one from a fake. In Paris, Smith's study of Af-
rican art was rooted not only in a belief in the power of the objects and

the will to understand the effect of that power on modernist painters and
sculptors but also in his awareness of a burgeoning market in the States
in which he might make a killing. He was not interested in cultural and
historical context any more than Graham was—or hardly anyone else at
the time—but wanted to know directly and intimately the objects he was
looking at. Material analysis was crucial not just to this knowledge but
also to being able to incorporate that knowledge into his own work.

Smith and Dehner believed that any assumption of the supremacy of
Western civilization was a delusion. Embedded in their hatred of capi-
talism was incredulity at the West's notion of itself as the acme of civili-
zation, as well as doubt about the superiority of industrial cultures over
those that had not entered industrialization. In May 1936, near the end
of the European trip, in the Soviet Union, Smith jotted down the names
of two books: Robert H. Lowie's *Are We Civilized? Human Culture in
Perspective*, published in 1929, argues against any assumed superiority
of civilized society over "primitive man"; and Franz Boas's *Primitive Art*,
first published in 1927, rejects notions of cultural hierarchy and artistic
progress. "Anyone who has lived with primitive tribes . . . who sees in
them not solely subjects of study to be examined," Boas wrote, "will agree
that there is no such thing as a 'primitive mind', a 'magical' or 'prelogical'
way of thinking, but that each individual in 'primitive' society is a man,
a woman, a child of the same kind, of the same way of thinking, feeling
and acting as man, woman or child in our own society." Boas, with whom
Lowie studied, found in all cultures evidence of aesthetic pleasure and
beauty, and of an intuitive feeling for form. He found the "technical per-
fection" necessary to the highest artistic activity in the "manufactured ob-
jects of all primitive peoples that are not contaminated by the pernicious
effects of our civilization and its machine-made wares."[18]

At the end of November 1935, Dehner and Smith traveled to Brus-
sels, where they went on another buying binge. Smith bought twenty-
four canvases of Belgian linen, all stretched, for about 15¢ each. Dehner
had planned on buying a winter coat but "we got so excited about the
Af[rican] sculpture we bought that instead & got some swell pieces from
[dealer Gustave] de Hoondt—Graham knows him . . . I guess we were
nuts but we couldn't resist the stuff." As a result of this spree, she added,
"we have to go south because I haven't got a coat & besides (since we

spent such a lot) we *have* to go someplace where it's cheap to live. It costs $45 to go to Greece 3rd class from Marsailles & $8 to go from Paris to M. 3rd class."[19]

Smith made four paintings in Brussels, beginning a series of women on bicycles, inspired in part by newspaper clippings. He also made a handful of drawings. No sculpture.

On the train back to Paris, Smith made Dehner tape under her sweater the Browning pistol he had just bought. They were afraid their stash of cigarettes would lead the police to search them. Dehner wrote to the Levys:

> We didn't declare a thing & D had three flats of Camels in a paper which he stuck under the seat. At the border they went thru our stuff very lightly & *then* a guy came along & looked *under* the seats & I sat there (they were under me) *too* parylized to breath[e]. I think he saw them as he grinned when he got up but didn't say a word & then a very official looking guy got on the train & rode across from us all the way to Paris & didn't take his *eyes* off of us. We thot he was an agent going to pounce on us as soon as we reached for the cigarettes but at Paris he got off & of course he wasn't an agent at all, but he kept us scared stiff for four hours.[20]

Their last night in Paris, Smith and Dehner went to a movie that, she wrote, "was made by a Communist guy & the thing was given by the Party. Parts of it were swell & in the one picture very abstract. (All jubilantly accepted by the Comrades, abstraction and everything.)"[21] The train trip from Paris to Marseilles was eleven bumpy hours. There, on December 3, they ate bouillabaisse with boiled yellow eels. "Not so hot," Smith wrote Edgar. "We board in a few minutes and away for bedbugs and Cyclades. You and Lou meet us in Paris in the spring and we can both take furnished studios on a 3 mo. lease."[22] After a foul boat ride, rough weather, a bed a foot too small for him, bouncing, and then broken piss pots, they arrived in Greece.

16
Greece

Athens was a larger and, in 1936, more dangerous city than Paris. Many parts of it, including the transportation system, were as run-down as the art galleries. With its competing factions—monarchal, fascist, liberal, and communist—the political situation was explosive. Smith decided that Greeks were "seemingly quiet people and undemonstrative—not like the french—but they have shooting in the blood."[1] He and Dehner met few artists with whom they wanted to spend time. "The artists here are all punk," Dehner wrote to the Levys in one of her rants.[2] They also met terrified people from northern Europe fleeing persecution, which dramatized for them the threat of fascism and dire state of the continent. The exploitation and poverty disturbed them. "The soldiers in the army here get 20 lepka a day," Dehner wrote. "That means that every five days they get one drach or one cent. And its compulsory for 2 yrs. What a place! They make little boys apprentice themselves & work all day & till 10 at night in shops for nothing."[3] One of Dehner's expressive, almost Social Realist drawings of street figures is of a woman selling lottery tickets attached to a pole that she wields like a flag. Another is of a shoeshine man, a communist, polishing a shoe as he sits straddling his stand.[4] Smith took his camera into refugee settlements outside Athens where open sewers ran through the streets. His photographs are first of all a record of human misery caused by economic inequality and politi-

cal callousness, but Smith also saw them, like the photographs he took in the Virgin Islands, as reportage for possible publication.[5]

Dehner and Smith regularly visited the Communist Party headquarters, where they picked up the *Daily Worker* and *L'Humanité*. Most everyone they enjoyed spending time with, including English-speaking classical scholars, was communist. Dehner wrote: "Its funny here or I mean its so diff. in Europe than America. For one thing there is no Red Scare & no scandal stories of U.S.S.R. So everyone who isn't actually something else like a Monarchist or a Fascist or a Democrat is a Communist. Or at least lots of them are—more than in America & its *respectable* to be one too even in the eyes of the bourgeoisie."[6]

They loved the sun and views from the hills. They liked café life here, on warm days spending hours at a table, on leisurely Sundays Dehner drinking lemonade and Smith regularly downing as many as five cognacs. Needing to get through the winter months on little money, they found a "big studio about 20×35 dining room—bed room—Greek kitch. (dirty as hell but I'm having it scoured tomorrow) & kookoo Greek bath. All for 25 bucks a month inclu. furniture linen, what there is of it and a lot of dishes 2 knives 2 spoons & no forks."[7] They ate regularly at an international center where the common language was French and main courses cost less than 50¢. Retsina tasted like paint water, Smith said, but he got used to it. A year's pass to art sites cost $3. They paid $1.50 to a woman to clean their apartment and do their laundry each week. At the beginning Smith did indeed get bitten by bedbugs. They did not learn Greek, which could turn buying salt into an ordeal. "The language is simply *fierce* & its silly to try and learn it except for household words etc as it would be absolutely impossible to ever master it even superficially," Dehner wrote.[8] Still, Smith prided himself on picking up street Greek. They got a cat, then a second one.

They were in no hurry to visit the Acropolis and never did write about it, but they frequently visited the National Archaeological Museum, with its extraordinary collection of prehistoric and Egyptian art, and art from Crete, the Cyclades, and mainland Greece. Smith wrote:

> The National Museum is near us, and what jesus good things
> they have, and one realizes what jesus rococco shit the Greeks

did with colored statues too—and how the f—ing Romans grabbed it all and added too it. Most of the things show better in photo—those beautiful patinas, the result of age and decay—are half of the value cleaned down to clear marble without corrosion—they are quite commonplace—my affinity still is with the Cyclades & the Archaic bronze & iron pieces—everybodies is I guess.[9]

They monitored archaeological excavations. New sites were being discovered, sometimes in unexpected places, including under the Athens-Piraeus Railway, now the Athens Metro, and a private cemetery. They cultivated archaeologists and other classical scholars who helped them decipher inscriptions and gave them a feeling of being in on the action. At archaeological sites, works could be layered with time. "The American School starts excavating in a couple days and it will be interesting to watch the process of uncovering," Smith wrote to Levy. "They are cleaning a big slum area of modern houses to get down to the Byzantine level—then thru the Roman level to the Greek. One of the arches. [architects] took me through the excavated areas and showed me the maps of the various stratas."[10]

They traveled throughout Greece, seeing art where it had been made, which was often far from cities, at the edges or off the tourist map, in small towns and in glorious and largely untouched landscapes that could be reached only by pilgrimages and where pilgrims could feel special access to icons and to the ancient stones that were still in place and those that lay crumbled on the ground. The eleventh-century mosaics in Daphne astonished them. "The most beautiful mosaics I've ever seen," Dehner wrote.[11] They visited the temple at Sounion, overlooking the sea, one of many grand temples whose columnar beat predicts the vertical processions in Smith's drawings, paintings, and sculptures, and eventually in his sculpture fields. They visited Aegina, a site layered with history going back to the Bronze Age. Its Temple of Aphaia, on a promontory, once contained some of the finest Archaic Greek sculpture; fragments of polychrome stone could still be found there. They visited Epidaurus, whose famous fourth-century BCE theater was built into the hills. "We

met a couple of Antique Early Americans Ladies from New Haven who took us 50 miles in their private car to see Epidauros," Dehner wrote. "The most beautiful—practically completely preserved Greek theatre. We would have never seen it if it hadn't been for them."[12]

David Smith (photographer), *Theater at Epidaurus*, 1935.

Smith would make sculptures evoking different geological strata. Many of his sculptures—many of his forms—seem like archaeological, psychoanalytical, and art-historical sedimentations. In Greece, he was periodically obliged to look down, into the ground. The sense of a buried past pushing at the present yet still far back, someplace else, demanding attention and yet inhabiting another register of history and consciousness, would become part of his post-1950 sculptural animation. In his encounter with Greek temples, Smith was obliged to follow the rise of the columns and look up at the sculptures on friezes and pediments. In one of his photographs of the theater at Epidaurus, from the proscenium looking up, Smith captures the hypnotically articulated precision

of the theater's sweep. The perspective of down to up, with sculptural matter set against the sky, would for many years become a feature of the photographs he took of his sculptures. Greek temples were porous; their walls had crumbled so that viewers looked through the columns at the surrounding landscape, which brought into the experience of the architecture a sense of extension and boundlessness. This looking through animated matter and experiencing its participation in the surrounding environment, too, would become part of Smith's work.

While continuing to analyze paintings, taking samples to examine surface and color, Smith also engaged in serious study of sculpture. Marble, the material most identified with the nobility of Greek sculpture, was everywhere. He wrote to the Levys:

> Edgar would be nuts in our neighborhood because of the dozens of marble yards. All colors, all depths of translucency—chunks—slabs—and loads of tools. Even the sinks and drainboards are chiseled out of marble. They polish it to mirror smoothness. It is easy to understand the patine on the Greek & Roman statues. The romans got it from the Greeks. I've been reading Pliny and Vitruvius & Theophrastus and learning their methods. I intend to take color specimens from the colored statues in the museums for micro slides etc.[13]

In Greece, too, Smith and Dehner were constantly on the lookout for art at bargain prices. They knew that the best opportunities lay with objects that had not yet entered the system, but at the same time Smith was skeptical about artifacts that had not been excavated and examined by credible archaeological organizations:

> I'm disappointed in these Greek antiques. They are all fakes—Except the stuff actually dug up by arch. outfits. What good stuff (genuine) that is for sale is not good enough to bother with. Even so from the mass of Byzantine paintings few are genuine from the 8-9-10 centuries. Most are 16-17-18 century copies—the Greeks aren't good enough to make modern

copies. I'm a much wiser boy now than I used to be—the shit
in Paris is 9/10 fake I'm sure. There is rigid inspection by the
Govt. and they sieze all antiques and keep it in the country. I'd
a hell [of a] lot rather have photos of the good stuff than bush-
els of crap just because its antique Greek. Unless it was painted
objects for pigment tests.[14]

In four months, they bought only a handful of objects, none as impor-
tant to them as their African art, whose company they missed.

Smith did some modeling with clay but struggled to make sculpture. "I
made a sculpture and had it cast then welded it together—but broke it up
again," he wrote. "Greece not being the place to do such things—craftsmen
are too clumsy."[15] In a provisional setting, without his tools and shop, it
was easier to paint. "I have been painting—all (small) 30×40 & 34×40 cm
canvases that I bot cheap in Brussels. Some good picts some bad."[16] Smith
developed two painting series: women riding bicycles, which he began in
Brussels, and billiard players. He explored both themes "in paint, pencil
and ink over a period of months, and in more than one location," the art
historian Paula Wisotzki noted.[17] Billiards was a common pastime in Eu-
rope: many cafés had billiard tables. The players were almost exclusively
men. One painting shows a spare room with a player prepared to strike
the ball; a woman stands behind him. The painting is a field of geomet-
rical trajectories. The body of the player seems wrapped in a sorcerer's
robe. The tip of the billiard cue turns into a tongue. The other series—
seven paintings, six drawings, one print—is based on magazine and
newspaper clippings of young women on bicycles. In one girlie maga-
zine photo, three full-bodied women in bathing suits are all smiles while
posing on bicycles so disproportionately small that it seems impossible
the women could actually ride them. In the related comical yet strangely
dramatic painting, a heavyset, perhaps maternal figure, her bathing suit
covering nearly her entire body, puts her arm around the shoulder of
the younger but not smaller woman in the center, who turns toward her
affectionately, while the girl-like figure on the right, with straighter hair
and a large diamond-shaped torso, seems more sign than person. Every
limb is distinct. The setting could be a boardwalk by the sea.[18]

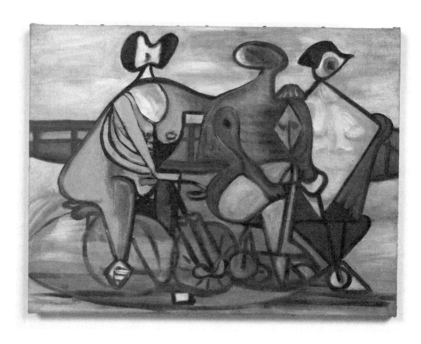

David Smith, *Untitled*, 1935–36. Oil on canvas, 11⅞ × 15½ in.
Musée d'Art Classique de Mougins.

Daily life in Greece could be tense. Having to pay customs on material
sent from America irritated them. Refusing to pay the $1.50 duty, Deh-
ner returned a box of candy from Aunt Cora. Because of the language
barrier, ordinary acts like shopping could be a hassle. In late winter,
Smith had a blowup with policemen who had been following him:

> I had a tiff with 3 plain clothes boys on the main street—thot
> they were horehouse pimps when they accosted me—the 2nd
> time I started to smash one and called a nearby tourist for-
> eign language cop to get the dirty bas-ds out of here before
> I swatted one—He says they are police, we talked in Greek
> style through an interpreter and I told them to go to hell—that
> this wasn't a fascist country yet—I compromised by telling
> them my name—they explained they were looking for some-
> one who looked just like me—I havent heard from them

since—alls lovely and sunny now . . . We are off to Crete in a day or two. I'm getting paint specimens and doing some research.[19]

But Crete had to wait until the political situation there quieted down. The deaths of right-wing leader Georgios Kondylis and his archenemy Eleftherios Venizelos led to battles among their supporters. Dehner and Smith did take the boat to Crete in mid to late April 1936 and stayed a couple of weeks. They undoubtedly saw the polychrome Minoan idols and Knossos palace ruins. After the Virgin Islands, Smith would always feel at home in island cultures. He would tell friends that he found on Crete the freest people alive.[20]

As outsiders, cut off from events and friends back home (whose letters took a minimum of two weeks to reach them) and having to ride out the winter before traveling to the Soviet Union, Smith and Dehner depended on newspapers. But the only ones they trusted were communist. "John L. Spivak is writing for the British Labor (Socialist) paper. God, I hope he improves it," Dehner wrote. "What a lousy almost-fascist sheet it is!"[21] They read the *International Herald Tribune* and were surely grateful for it even if they considered it, too, a "fascist rag." They read George Seldes's recently published book *Freedom of the Press*, which named William Randolph Hearst, whom Smith would savage in his sculpture series *Medals for Dishonor*, the most important of the "fifty-nine men who rule America" and characterized him as "a collection of egotisms, ideals, whims and prejudices, which are translated daily into news read by ten million people." Citing a 1934 editorial in Hearst's *American* titled "Get Rid of the Reds," which ended with, "In fact, throwing Communists out of the colleges and universities ought to be the prelude to throwing Communists out of the country," Seldes asserted that "Mr. Hearst's latest phobia is Red."[22]

In early 1936, Dehner and Smith were shocked to learn that Graham had married for the fourth time, and shocked to learn it not from him but from the Levys. Constance N. Wellman was twenty-one. Her uncle was William Wellman, a director known for his adventure and action movies. She attended schools in Switzerland and France and was fluent in several languages, including French. Dehner described her as "pretty

and pink," with "lovely blond hair, and she spoke with what Graham called a ruling class accent."[23] She worked for Frank Crowninshield at *Vanity Fair* and was very different from Elinor, who remained a friend to the Smiths. "I guess its just another of Grs. Wives & I'd better not get too used to her," was one of Dehner's first responses to news of the marriage.[24]

Their New York circle seemed to be thriving. Edgar Levy was working on a mural for Bloomingdale's. Lucille Corcos had been selected for the 1936 Whitney Biennial and was making illustrations for prominent magazines. Both sent Smith and Dehner their news clippings, some of which appeared in Hearst publications, for which the Smiths gently chided them. Edgar met Smith's request for art supplies, including watercolors, drawing paper, and tubes of paint. They also sent plum pudding. And news of *Art Front* and the Artists Union. And information about political controversies around Fernand Léger and the Lithuanian-born artist Ben Shahn. And information about fascist demonstrations in New York and a split within the Socialist Party. Dehner asked the Levys if they had gone to the "Norman Thomas & Browder debate & who was the best?"[25] She and Smith had voted for the Ohio-born Thomas, the Socialist Party presidential candidate in 1928 and 1932, and would vote for him again, but Dehner now considered Thomas a wimp and was more interested in Earl Russell Browder, another midwesterner, from Kansas. Browder was secretary-general of the American Communist Party from 1930 to 1944 and the party's candidate for president in 1936. In March, Dehner received a letter that contained a speech by Browder. This was one of the letters that had been opened by the post office.

Smith and Dehner seemed happy as winter turned to spring in Greece. "We went to see the huge agora excavation yesterday," Dehner wrote. "We are really enjoying living here a lot . . . We have really just begun to see things as now we are truly settled and at home."[26]

But Smith's mood soon darkened. He turned thirty on March 9, 1936, and he was frustrated that their provisional setup made it impossible for him to work as he needed. He wanted to hear from Charles Mattox about

the WPA but never did. "He's so damned dilatory," Smith wrote.[27] He did receive news from a young woman in the CAA office that enabled him to feel he had not been entirely forgotten there. "I wonder what sort of a job I can get in the fall," he wrote to Levy.[28]

Dehner wrote to the Levys:

> It has gotten cold as hell, i.e. about like November and D. has a sinus & we burn coal by the ton. D is sick to death of it here, simply decided yesterday that he *hates* Greece. The ruins are swell & the museums etc but it doesn't take a year to do them in & its all right wing here . . . D. loathes it now—quite sudden & *very* uncomfortable. We can't go to USSR because its too effing cold so I suppose we will have to stay. He wants to go back to Paris only we haven't really enuf money to live there & besides we couldn't go to USSR then & that is one of the reasons for being here & I *won't* give it up & he *doesn't want* to either.

At the end of the letter, Dehner referred to Smith's outbursts: "D. busted his sculpture on a rock & other acts of violence. He can't paint here & I'm sorry we're stuck."[29]

Their plan had been to go by boat to Odessa at the end of April and from there take another boat to Russia, then return to Paris in three or so weeks. "Up to the last minute we thought maybe we could get a boat to Odessa," Dehner explained. "They are all cargo boats & they never know just where they are going till the last minute. We finally heard that the boat we intended to take to Russia first had to stop at Crete, Palestine, Egypt & a million other places & took three weeks to Odessa. Which of course was hellish expensive as it took so long."[30] Their new plan was to return to Paris, stay a month, and then take a Soviet boat to Leningrad from Antwerp or London.

At the end of April, pretty much the only passengers except for a British couple and a hundred cattle, they went by boat from Athens to Naples, this trip a smooth one, and then from Naples to Malta, where they visited a museum with Stone Age sculptures and pots and Neolithic ru-

ins, including the hypogeum, an intact underground sanctuary/cemetery discovered in 1902 in which thousands of people had been buried. From Malta, they took a boat to Marseilles and from there the overnight train to Paris.

Back at the Médicale they saw Graham and Constance. Some dinners were pleasant, like old times, others not. "One night Graham accused Constance of not being a good sport," Dehner wrote. "Elinor, he said, was a good sport, a fine sport, the very best. He taunted Constance this way, before us, a number of times. It was his way. He had done it with Elinor." The Smiths were sympathetic with how difficult it was for Constance to adjust to Graham's world, but they could not feel close to her. "I never got to know Constance really," Dehner wrote. "I felt she was always playing a role, and although she was completely friendly we never thought she was *there*."[31]

It was election time in France, and the left was expected to win big, which it did. They went on to London, where they stayed with the architect Sir William Holford and his wife—the other passengers on the boat from Athens to Naples. They visited the International Surrealist Exhibition at the New Burlington Galleries, the largest and most important Surrealist exhibition to date, and attended an event at which Dalí performed. They found him ridiculous. "He came out in a diving suit, with this great ball thing over his head," Dehner said in an interview, "but he got hot in the middle of it and he must have really lost face because he had to get this thing off of him, so he was panting and sweating."[32] They went to the Sadler Wells Ballet and to a talk by the French communist Maurice Thorez, even though Smith could not understand him. At the British Museum, Smith saw the Elgin Marbles and Assyrian lion reliefs and studied war medals and Sumerian seals. *Medals for Dishonor*, his first great series, had begun to germinate within him.

In June, they boarded a steamer for a 1,300-mile journey through the Thames estuary and across the Baltic to Leningrad. Finally, they were in the Soviet Union.

Apart from photographs, Smith's notebook, a postcard to the Levys, and Dehner's descriptions of their visit with Graham's family in Mos-

cow, little is known about this trip. Their relative silence may partly be explained by the difficulty communicating from the Soviet Union. But Dehner never spoke or wrote much about the trip afterward, and Smith said almost nothing about it. Their hopes were so high that reality may not have been able to approach their expectations. But given their continuing faith in the Soviet Union, the astounding art they saw, and their appreciation of non-materialistic ways of life, in all likelihood they were not disappointed. It is hard for many people to talk about faith, which may help explain why the Smiths largely avoided fixing responses to this trip in language. It's a sign of how important their shared political beliefs at this time remained to them that there is no evidence that either Smith or Dehner ever publicly criticized the Soviet Union.

Most of their roughly three-week tour was spent in Moscow and Leningrad. What Paula Wisotzki refers to as the "web of personal ties" that was crucial to their experiences in Paris and also, to a lesser degree, in Athens, was a factor here, too.[33] On the boat, they met Eslanda Goode Robeson, wife of the legendary African American actor and singer Paul Robeson, and Milly Bennett, a correspondent for International News Service with whom the Smiths would remain in contact for many years. "She immediately introduced us to all the newspaper people there," Dehner said later, "and would give us her interpreter to go around with us for a whole day at a time, get us theatre tickets and ballet tickets and so we got around very much better than we did."[34]

Smith photographed landmarks. Wisotzki wrote that one photo taken in Moscow "recorded a city view looking toward the Kremlin and Red Square, with Spasskaya Tower and the onion domes of St. Basil the Blessed prominent in the skyline."[35] One of his panoramic shots imagines in a less urban part of Moscow the intimacy of a Greek hill town. He also photographed scenes of daily life. A photograph taken on what seems to be the edge of a forest shows two butchers standing beside the hanging carcass of a massive cow, sliced open so that the viewer can see inside. In Smith's photographs, Russian cities appear calm, almost timeless, immune to the turbulence of Paris, Athens, and New York.

They saw remarkable modern paintings—including Cézannes and Picassos and Matisse's mural-sized *Music* and *Dance*, which had been acquired by the Russian collectors Ivan Morozov and Sergei Shchukin

(the latter of whom was also an important collector of African art). Their paintings were installed in Moscow's State Museum of Western Art. After seeing such work here, at the end of the trip, it was apparent to Smith that masterpieces of modernism were as good as any other art, ever, and that modernism had the capacity to embrace all the art that had influenced it—including prehistoric, ancient, African, and Old Master. In the Soviet Union, great modern art seemed not just compatible with but even treasured by the communist state.[36]

Here, too, Smith studied technical conditions of art. Of a Lucas Cranach painting in the Winter Palace, he wrote: "varnish old—picture better than it appears compares equally well to panels." He studied ancient and prehistoric art. "Paleolithic statues from Don Basin earliest known original Russian Museum." He and Dehner saw that museum's famous collection of icons, including ones by Andrei Rublev. On another notebook page, Smith mentions "Altamira, Spain" and two scholars of prehistory, Abbé Henri Breuil and Émile Cartailhac. He noted sculptures from New Ireland, Borneo, and the Belgian Congo and made drawings and comments about Egyptian art, which fascinated him throughout their European trip. He sketched strange hybrid creatures.

Graham had encouraged them to contact his family in Moscow. They invited Graham's son Cyril, an architect, for lunch and visited the house that Graham's family lived in before the Russian Revolution—"a great, beautiful house and all built around a courtyard with beautiful stonework." The presence of the past was Tolstoyan, or Faulkneresque. The pageantry, history, and bigness of Russia seemed to be alive in the stones, customs, and speech, to which the Smiths were specially attuned because of Graham and his flamboyant and semi-mythical autobiography, *From White to Red*, which they had read in Paris. "The horses, you could hear the horses come clattering in, you know, and the wolfhounds leaping up and all of that," Dehner said.[37]

Catherine Dombrowski, Graham's first wife, was a gracious hostess. "She was about Graham's age . . . 55 at that time . . . Her daughter Maria looked exactly like David Graham, Elinor's son," Dehner wrote. "Maria was 18 and studying to be a painter . . . Mme. D. was curator of icons [at the Tretyakov] . . . She was an important art historian, although Graham had never told us that."[38]

They found the Graham family "marvelous! Just marvelous," wrote Dehner:

> They had brought along a young Russian girl who was a friend of Maria's who spoke perfect English. And I said, "Where did you learn your English?" It was phenomenal; it was perfect. "Oh," she said, "in high school." And I wondered if any American ever learned any foreign language in high school so beautifully . . . David wanted to give his shirt to Cyril and I gave my umbrella to Maria. They were so warm and lovely, you know, we felt like divesting ourselves of everything because they— they were well off in relation to people in Europe but they probably didn't have many luxuries.[39]

In a photograph taken by Dehner, Smith is standing in the middle of five people, towering over Catherine, Cyril, Maria, and a friend of Maria's. He is wearing a light-colored suit, white shirt, and tie. With his crew cut, he looks younger than thirty. The Russians all have an arm extended and a hand touching a flowering plant they are holding in front

David Smith with Cyril Dombrowski and others, Moscow, 1936.
3³⁄₁₆ × 4³⁄₁₆ in. (8.1 × 10.6 cm).

of him, which seems to have been presented to him or by him as a gift. Smith is beaming.

When the family asked about Graham, Dehner and Smith told them "he had married a young girl . . . Mme. sighed and said, well M. Graham always was a brave man." When they left, she told them: "You know the children love their father. After all I have told them only the good things about M. Graham."[40]

The image on a postcard Dehner sent the Levys is of the People's Commissariat for Agriculture in Moscow. "We are leaving this new world day after tomorrow," she wrote. "Gosh, what a place! We sail from London the 2nd & arrive in NY the 9th on the Manhattan."[41]

They arrived with crates of African sculptures that Graham bought while they were in Europe. In gratitude, Crowninshield gave Dehner "a very beautiful ivory 'Kings' bracelet" from his collection.[42]

A quarter of a century later, in New York, Smith told the English art critic David Sylvester: "The one thing that I learned in 1935 and '36—I was in England and Russia and Greece and France, and places like that— [was that] I belonged here. My materials were here, my thoughts were here, my birth was here, and whatever I could do had to be done here. I thoroughly gave up any idea of ever being an expatriate and I laid into my work very hard."[43]

Even so, the nine months abroad changed his art and life.

17

Back in the Swing

Dehner and Smith joyfully reunited with the Levys, who put them up in their Brooklyn Heights apartment for a few days, but after so many months away they were eager for their own place, their own beds. They arrived in Bolton Landing after midnight, waking up the Ainsworths to get their keys. In Greece, Smith had written to his parents promising them a visit, so about a week after returning to the farm, having just begun the task of making it livable, they went to Paulding. His parents wanted news of the European trip, as did Dehner's Aunt Flo, who had also contributed money to it. The Smiths picked her up in Cleveland and drove across northern Ohio. After a few days with Smith's family, they drove Flo to Bolton Landing, where she stayed for nine days before returning, by boat, to California. Finally, on August 2, Smith and Dehner settled in.

The Ainsworths had planted vegetables. "Corn will be in, in a day or 2," Dehner soon wrote. "We have beets, squash, carrots etc. already."[1] She found a good rhythm for painting and drawing while tending the garden and sewing. Smith did heavy jobs and fixed what broke. He filed down the African bracelet so that Dehner could wear it. One of his priorities was converting the woodshed into a fully equipped shop-studio. He could make sculpture again. "Im now sticking together 10 bronze pieces I had cast to make up a figure—the first try at it up here—I did it in Greece but diden't have the equipment to weld it myself or finish it—

I now have a motor with flexible shaft—grinders & polishers," he wrote.[2] With canvas that Edgar Levy sent, Smith also painted.

They lived in the hills, far from the city, but did not feel isolated. The Rothkos were nearby visiting the Bermans. After splitting with her husband, Lois Wright was up with her new partner. Elinor Graham was visiting from Baltimore with her son, David, and wanted the word on Constance. The Levys continued to respond regularly and forwarded letters from Graham in Paris. The Spanish Civil War had broken out the month the Smiths left Europe. The workers in Spain should have thrown out the fascist military at the beginning of the Popular Front, Graham wrote. At a Glens Falls cocktail party for friends of a bookstore, Smith and Dehner ran into Douglass and Margaret Crockwell, who would become their closest friends in Warren County.

They lived close to animals. They believed that they and animals were all part of nature, as in preindustrial cultures, where interdependence between humans and animals reflected a more integrated existence. Smith liked guns and was glad to be able to hunt again, but he rarely hunted just to kill and for as long as he and Dehner were together they tended to make use of the entire animal so that its death went toward the continuity of life and was not in vain. Smith shot partridge for food. He hunted deer, whose meat they ate and some of whose hides Smith turned into rugs. The Ainsworths' dog, Snooker, was back in their lives, and she was part of the hunt. Snooker's haplessness disappeared when she helped Smith track down deer. Snooker seemed to lurch from crisis to crisis as always, but she responded to the Smiths' care, which endeared her to them that much more. "Snooker got in Hedghog quills—had a fight with one—we pulled them out with pliers," Smith wrote to Levy. "And how is your family of happy little half breeds—I'll bet the great cat mother is a dog mother now."[3]

That summer they spent more time with Anton Refregier than with anyone else. Refregier was born in Russia in 1905. His parents moved to Paris when he was fourteen and to the United States a year later. A figurative painter and hard-core leftist with whom the Smiths could share sympathetic talk about the Soviet Union, he became a muralist in 1928 and was in the Public Works of Art Project, and from 1935 to 1940 in the WPA. Among his many murals was one for Café Society, in Greenwich Village, the first integrated nightclub in the United States. "Ref & Lila leave next

week," Dehner wrote in late September. Lila, Refregier's wife, was "only 21—twas his *pupil*—(a la Graham) He's a lot like Graham but not as mean."[4]

Smith, Dehner, Refregier, and the painter Eugene Morley were in a fall exhibition at the Crandall Public Library in Glens Falls. "Naturally we were not bowled over by being asked to exhibit & David didn't want to but I thot we could use Morley's and Ref's things from a propaganda angle . . . The library is 100% agog," Dehner wrote. "Its really amazing—can you imagine a N.Y. library putting on a show with such pics in it?"[5] All the reviewer could think of to say about Smith's four drawings and two paintings was that his work "represents the abstract school of painting which has been the progressive outgrowth of impressionism, cubism and surrealism." He found Dehner's work more accessible. Her "landscapes are of particular interest in this locality since they represent familiar scenes around Bolton landing where she has lived for several summers." Morley, "born and brought up in the coal mining center of Scranton, Pa., has portrayed with realism the living conditions of the miners." Refregier's "pictures are comments on social injustice, fascism and war."[6]

Dehner and Smith voted, unenthusiastically, in the presidential election, which Franklin Delano Roosevelt won in a landslide over Alf Landon. By contrast, they were "thrilled about the prospect of forming a Farmer Labor nucleus . . . There are at least a dozen local people interested."[7]

The sculptures Smith made after returning from Europe are like small force fields. *Reclining Figure* is roughly 5 inches wide and 17 inches long. Its tiny ring-shaped head projects over the edge of the base. The figure's raised hands have three fingers; disproportionately long insect-like or vegetal legs seem jammed into the torso. The four spiky protrusions, each a bent nail, hammered into each side of the midsection, are like ribs of a person or a ship. Clearly inspired by Giacometti's 1932 Surrealist sculpture, *Woman with Her Throat Cut*, Smith's 1936 *Reclining Figure* evokes both an endangered woman on her back and a predatory insect or animal. When Smith took this sculpture to Manhattan's Pierre Matisse Gallery, Matisse said, "It looked better before you unwrapped it."[8]

In contrast with *Reclining Figure*, the 10-by-31-inch *Aerial Construction* is defined by clean lines and smooth forms. Here and there among the metal lines are small flat steel planes painted burnt orange. Here, too, Smith's gift for association is unmistakable. The composition's darting

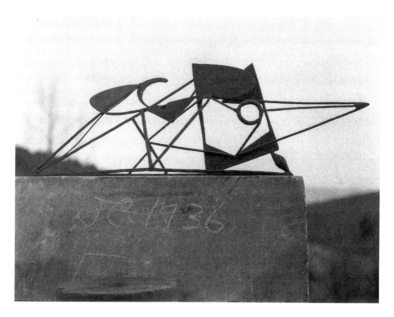

David Smith, *Aerial Construction*, 1936. Steel, paint, 10 × 30⅞ × 11½ in. (25.4 × 78.4 × 29.2 cm). Hirshhorn Museum and Sculpture Garden, Smithsonian Institution.

triangles suggest two ballet dancers, a bull's charge and matador's feints, and a tug-of-war. The sculptural mass is so reduced that from any point of view, it is possible to see through the work. There is no monolith, no center. This is the earliest Smith sculpture in which Rosalind Krauss singles out his rejection of the sculptural core: "It is immediately obvious that" an "insistence on intersection and a core, of which the sides are logical projections, is simply rejected . . . Because of this, the viewer cannot feel he has any guarantee about the order that will obtain among these shapes should he examine the work from a different angle."[9] The sculpture asks to be experienced without preconceptions, to be known as it is encountered, looking into it from above and through, and from all sides.

At 52 by 47 inches, *Untitled* (*Billiard Players*) was Smith's largest and most ambitious painting to date. (See Figure 2 in the insert.) Two figures, near the left and right edges, hold cues, but there is only a hint of a billiard table. The figures, like the objects, are composites; pretty much every object is discontinuous. Each form and section, no matter how small, has its own energy. Identity is shifting and unstable. The space looks like that of a room in an apartment, not a café or pool hall. The palette—with its

blues, browns, grays, reds, and whites—does not suggest either billiard tables or the places in which they are found. The space is packed, almost clotted. Many shapes are darkly outlined and ghostly. Picasso is obviously present in the form language and Cubist structure, but some objects have an incisively physical yet dreamlike quality. The conspicuous object near the center that looks like a gigantic letter opener with an eye seems to ask: What is this? What is anything here? Is this a sorcerer's world?

Smith and Dehner loved the clarity and crispness of sunny days at Bolton Landing, but the dampness got into their bones. Fierce storms were followed by periods without rain, and finally the well ran dry, obliging them to lug water in buckets. Smith wanted to finish a couple more sculptures and equip his shed for winter, so they stayed even as winter approached. By the time the cold set in, he had installed a stove, a skylight, and a forge. He built the smokestack with a former Glens Falls lamppost that reminded him of a Greek column. A forge in a woodshed in the country was not unusual. Smith's ancestors had done that. But what Smith was trying to build in a woodshed in a mountain landscape was a small, well-equipped miniature factory that would be an artist's studio. He was joining the industrial and the agrarian.

When they returned to the city in deep fall, Smith brought with him photographs of his sculptures and of the farm covered in snow, and ten sculptures. They rented an apartment at 57 Poplar Street, near the river, on the edge of Brooklyn Heights, about a mile from Terminal Iron Works. John and Constance Graham rented an apartment near where the Levys lived. The Gottliebs, who had lived in the apartment above the Levys, moved to Tucson, Arizona, because of Esther's arthritis, but Mark Rothko, Milton Avery, Lou Schanker, Harold Baumbach, and other artists were still nearby. Although they no longer lived around the corner from one another, the Smiths and Levys were as close as ever. They considered buying a house together.

The Smiths returned to the city a couple of weeks before the opening of MoMA's exhibition "Fantastic Art, Dada, Surrealism," the sequel to the equally groundbreaking "Cubism and Abstract Art" in spring 1936, when they were abroad. The exhibition brought together historical precedents of

troubled dream imagery, such as Henry Fuseli's late-eighteenth-century painting *The Nightmare*; two engravings from Francisco Goya's sharply satirical *Los Caprichos*, and eleven early-twentieth-century paintings by Giorgio de Chirico, including some of his uninhabited cityscapes. The exhibition included "art of children," "folk art," and "art of the insane." It also included a recent welded steel sculpture by Julio González; a 1935 etching by Stanley William Hayter; eight paintings by Picasso that reflected his many styles and periods; paintings by Salvador Dalí, Paul Klee, and Joan Miró; and Giacometti's 1932 *Palace at 4 a.m.*, a fragile dream structure of wood, glass, and string. In the exhibition catalog, MoMA's director, Alfred H. Barr, Jr., provided a rationale for the exhibition:

> There is much about Dada and its successor, Surrealism, that may seem wantonly outrageous and iconoclastic. In fact, these movements in advocating anti-rational values seem almost to have declared war on the conventions and standards of respectable society. But it should be remembered that the Dadaists and Surrealists hold respectable society responsible for the War, the treaty of Versailles, post-War inflation, rearmament and a variety of social, political and economic follies which have made the *realities* of modern Christendom in their eyes a spectacle of madness just as shocking as the most outrageous *super-realities* seem to the ordinary world which believes itself sane and normal.[10]

In his shop-studio on the waterfront, Smith constructed a part-reclining, part-seated female figure out of steel and cast iron. Her arms and legs are inordinately long, the legs like tentacles or feelers. Her back is erect near the top but curves elegantly as it touches the ground. Her breasts are set one above the other. Where torso meets legs, the figure's right hand is wrapped around a circular form that resembles a large doughnut or small tire. The Picassoesque two-part head rises above the spine with a dignified rectitude, seemingly blessed with an ability to see far and wide, like the captain of a ship. It is crowned by a flat disk that suggests a fashionable hat. When Smith carried the sculpture to the Levys' apartment, he did not mention its title—*Portrait of Lucille Corcos*. Dehner re-

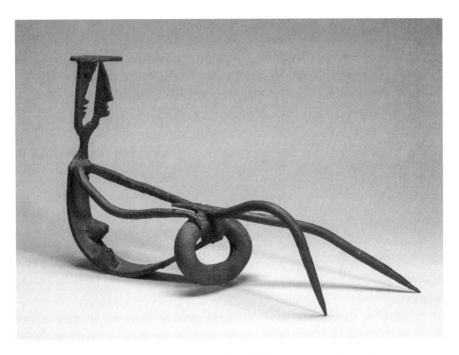

David Smith, *Seated Figure (Portrait of Lucille Corcos)*, ca. 1936. Steel,
cast iron, 15¾ × 27 × 8¼ in. (40 × 68.6 × 21 cm). David C. Levy.

membered the moment: "David brought it directly from the studio (still
hot) & put it on the rug in front of the fireplace. We four stared at it for
a minute & then Edgar said, 'that is the best sculpture ever made by an
American.' David said, 'well, then it is yours.'"[11]

The account of the event passed on to David Levy, Smith's godson, is
similar:

> He brought that piece home, meaning to my parents' home,
> and he had just finished it, and he put it down in the middle
> of the floor, and he said, what do you think of this piece? And
> my father—you have to understand that my father's position
> was one in which he was feared, people wanted him to like
> things—and he said, that is the best piece of sculpture made
> in the United States in the twentieth century. And so Uncle
> Smith said, "well, if you feel that way about it, it's yours," and
> he gave it to him.[12]

In the Mix

Knowing how much Audrey McMahon, the regional director of the Works Progress Administration's Federal Art Project, respected him, Smith was confident that she would find him a job when he returned to the city. On February 1, 1937, he began working for the Federal Art Project, once again as a technical supervisor. "Working for the Treasury Department—surveying post offices for murals and mural installation" was his shorthand for the job.[1] His monthly salary was $103. Later that month, three of his recent sculptures were included in an exhibition at the Boyer Galleries on East Fifty-Seventh Street. The same month, Graham's *System and Dialectics of Art*, which had been published earlier in Paris, was published in a limited edition in New York. Smith and Levy were among the artists Graham favorably compared with artists of their generation in Europe.

Dehner missed the Boyer show. At the beginning of January, she had taken the train to Pasadena, where she planned to spend the rest of the winter with Aunt Flo. The European trip was unforgettable, but it had been grueling and the demands of the farm were unrelenting. She did not like the cold and had been obliged to remain upstate through the first snows because of Smith. Then they had to find an apartment in the city, which Smith seems to have chosen. Dehner had no parents; her mother had been gone for twenty years. Flo's home in Pasadena was comfortable

and Flo loved her unconditionally. Dehner went to the Monte Carlo Ballet and to Maxwell Anderson's play *Winterset*, based on the celebrated case of Sacco and Vanzetti, Italian immigrants to the United States who were executed in 1927 not for the murder for which they were wrongfully convicted but for their radical political beliefs.

But she felt alien in California. "This town is unbelievably prosperous," she wrote to Corcos and Levy. "Everybody has a car. We took a walk yesty & were the only ones on foot. The streets are so clean & a bum would be scared to come within 5 miles of the place. Altogether its like living in a Chamber of Commerce folder." The conservatism agitated her. "The papers out here are so awful I cant read them. They are so anti-union & anti-everything I am that I hate to look at them." She sent money to subscribe to the *Daily Worker*.[2] She read Henri Barbusse's 1935 book, *Stalin*, "which is good but not for the general public," she concluded, and Ernst Henri's 1936 book, *Hitler over Russia: The Coming Fight Between the Fascist and Socialist Armies*, which prophesized that Hitler would try to take over the world and Russia would be the country that beat him back.

Smith largely stopped communicating. "Does D like his place?" Dehner asked the Levys. "He never says a word about it or if he cooks there or what or who sews his buttons on." She "missed everybody including my poppa something fierce."[3] In March, she wrote: "I hope David is O.K. He sounds kind of lonesome but just in spots I guess."[4]

On March 16, her news to the Levys was disturbing:

> I just wrote David a long letter. Before I comment on yours, (which I just got) I'll tell you my news. My effing insides are bad again. I have to have another op. This time uterus & ovary *both*. I could die when I *think* of it. I'm not scared or anything but *mad*. It is *so* lousy. Anyhow I just hate to face it. I will wait till I get back. I cant come until my unwell time is over as the Dr said I might have a haemorage from the jolting of the train.[5]

Dehner hoped to persuade Flo and perhaps other members of her family to contribute money to the house that the Smiths and the Levys were thinking of buying together: "I can hardly think about the house at

all. It will take a lot of money again for my hospital & so on, so the best we can do on the house is $2,500. If David wants to go ahead with it Im for it & we will get the $ to him as fast as possible. Personally Im pretty upset about my middle & cant think very well."[6] The surgery and recovery seem to have gone well enough for her to board the train on March 29. On April 2, she arrived in New York's Grand Central Terminal.

Artists were embattled. The previous November, in protest against the Whitney's limited attention to living artists, Graham, Gottlieb, Rothko, Ilya Bolotowsky, Nahum Tschacbasov, Schanker, and others had formed a group called The Ten Whitney Dissenters; the group later included Levy. "The Ten" would have several gallery shows in the city. The WPA, on which thousands of artists depended, was under siege, and pending cutbacks made its future uncertain. "Save the Arts Projects" was the headline of an essay in *The Nation* by Elizabeth McCausland, an art critic whose arts activism seemed everywhere during these years. "The Renaissance lasted three centuries," she began, "the Age of Pericles and the Augustan Age each a half century; for the 'cultural birth of a nation' our government allows less than two years. With drastic cuts in the Federal Arts Projects effective July 15, the arts in America are on their way back where they came from, to the status which made necessary the WPA and white-collar projects."[7]

Sponsored by the Federal Art Project, a November 1936 symposium called "Shall the Artist Survive?" was supposed to be the first of twenty addressing the issue of artistic survival, but the FAP canceled the rest of them. At the end of 1937, the fate of a bill introduced in July to establish a permanent bureau of fine arts was uncertain.

In 1937, the most pressing international emergency was the Spanish Civil War. On April 26, fascists bombed the town of Guernica. On July 12, under the headline "Death in Spain: The Spanish Civil War Has Taken 500,000 Lives in One Year," *Life* wrote: "On July 17 the Spanish Civil War will be one year old. In that time it has brought death to 500,000 Spaniards, has shattered such ancient cities as Madrid, Toledo, Bilbao, Irun . . . and has kept Europe in a state of jitter."[8] The spread featured Robert Capa's iconic photograph of a falling Spanish soldier.

That summer, *Cahiers d'art* published a special double issue illustrating Picasso's artistic response to the destruction of Guernica. His mural-size painting, surely the most famous artwork of the twentieth century—Smith would call it "a masterpiece of all time"—inspired artists in many countries to believe that art could have an epic urgency.[9] With several exhibitions in New York, Picasso was the contemporary artist more than any other about whom politically and aesthetically vanguard artists in New York and elsewhere had to think. At the December 17, 1937, opening event of the second annual National Convention of the American Artist Congress, at New York's Carnegie Hall, Picasso was the lead speaker. Since his last visit to Spain in 1934, he had refused to set foot in his home country. The Museo del Prado had made him its honorary Director in Exile. His words were relayed by telephone via Switzerland to New York:

> While the Rebel planes have dropped incendiary bombs on our museums, the people and the militia at the risk of their lives have rescued the works of art and placed them in security.
>
> It is my wish at this time to remind you that I have always believed, and still believe, that artists who live and work with spiritual values cannot and should not remain indifferent to a conflict in which the highest values of humanity and civilization are at stake.[10]

Artists battled. The Artists Union and the WPA fostered a sense of solidarity and camaraderie that had not previously existed among artists in America. Looking back in 1961, Smith reflected:

> Practically everybody I can think of that is of our age or our time . . . and sort of "arrived" artists, in a sense—all came from a depression time. We all came from the bond of the WPA, which we affectionately call it . . . For the first time, collectively, we belonged somewhere . . . We belonged to society that way. It gave us unity, it gave us friendship; and it gave us a collective defensiveness . . . In a sense we belonged to the society at large. It was the first time we ever belonged or had recognition from

our government that we existed . . . I can't think of one thing
that stimulated the response of the public better than the WPA
educational projects did. Nor do I know anything that kept so
many artists alive during the thirties than the WPA. There was
nothing else.[11]

In October 1937, Smith joined another group. American Abstract
Artists had begun with "weekly sessions, trying first of all to find a
name which would suggest the broad spectrum of abstract art while
clearly separating this abstract artists' organization from the other art-
ists' groups of New York City."[12] Its enemies were not only the Ameri-
can Scene painters and everyone else who believed abstract art was too
removed from everyday life to credibly respond to the realities of the
time, but also people like Hilla Rebay, who had founded the Guggen-
heim Foundation in 1937 and would be the guiding spirit behind the
Museum of Non-Objective Art, which opened in 1938. Rebay wanted ab-
stract art "to remove the artist and the public from concrete realities and
from the world of nature."[13] "Like all great ages, ours is a religious one.
Non-objectivity will be the religion of the future," Rebay wrote. "Very
soon nations on earth will turn to it in thought and feeling and develop
such intuitive powers which lead them to harmony."[14] In October, *Art
Front* published a letter to the editors signed by seven abstract painters,
including Matulka, who declared that abstract art forms are not sepa-
rated from life, but "on the contrary are great realities, manifestations
of a search into the world about one's self," based in actuality, "made by
artists who walk the earth." Colors "are realities," squares "are realities,
not some spiritual mystery." The artist "identifies himself with life and
seeks generative force from its realities."[15]

Smith's sculptures were considered abstract. Their formal inven-
tiveness and material energies were more apparent than their figura-
tive associations and often obscure, if not cryptic, narrative references.
Smith began to sign some of his sculptures ΔΣ, delta sigma, his initials
in Greek. In *Billiard Player Construction*, Smith explored in a small
encaustic-and-steel sculpture a theme that he had developed in draw-
ings and paintings in Europe. Parts of the sculpture hint at a billiard cue
and ball, but the primary movement of the sweeping planes and lines—

torsal lean and leg lift—is balletic. Behind this performative movement is an upright rectangular sheet of steel out of which two quirky standing figures—apparently one male, one female—have been cut out. They loom like parental phantoms over the acrobatic exertion. They and the performer are ghostly in different ways.

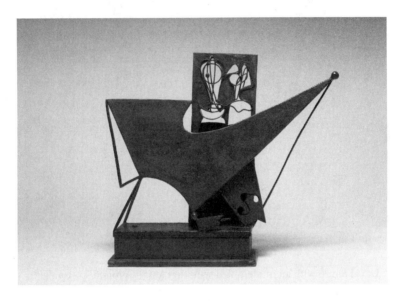

David Smith, *Billiard Player Construction*, 1937. Steel, paint; wood
base, paint, 14¾ × 20½ × 6⅜ in. (37.5 × 52.1 × 16.2 cm).
Base: 2¼ × 12¼ × 4¼ in. (5.7 × 31.1 × 10.8 cm).
Collection of Mr. and Mrs. David Mirvish, Toronto.

In the photograph of Smith standing beside *Sculpture and Model* in the doorway of his shop at Terminal Iron Works, this 1937 sculpture looks like his child. A bit taller than 2 feet and 18 inches wide, it features a standing female figure, as much girl as woman, one foot on point, who seems to be showing off a sculpture on a three-legged pedestal; inside the frame of this smaller sculpture is another figure, perhaps male, seemingly aroused, although it is as much tree or vegetation. The iron is coated with red oxide. The sculpture points toward Picasso's paintings of artist and model, but here the artist is not named in the title and is outside the work, in the photograph standing beside it, while sculpture and model perform their own independent relationship, perplexing, comedic and erotic.

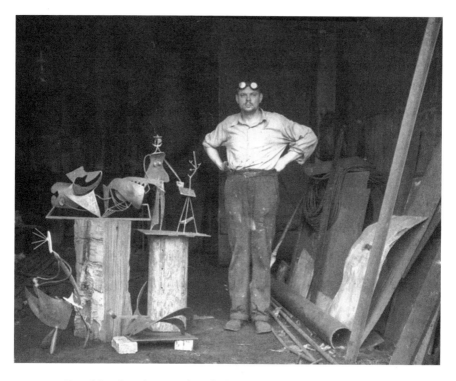

David Smith with an unidentified sculpture (on the ground, bottom left);
beside it, *Bent Blade Plane*, 1936; and on wood stands, *Construction in
Bent Planes*, 1936, and *Sculpture and Model*, 1937 (in progress), photographed
at Terminal Iron Works, Brooklyn, ca. 1937. *Bent Blade Plane*, 1936. Steel,
iron, 13⁵⁄₁₆ × 21⅞ × 15⅝ in. (33.8 × 55.6 × 39.7 cm). Private collection.
Construction in Bent Planes, 1936. Steel, 13 × 32½ × 6 in. (33 × 82.6 × 15.2 cm).
Collection of Mrs. Linda Lindenbaum. *Sculpture and Model*, 1937. Steel, paint,
28½ × 18⅞ × 16⅝ in. (72.4 × 47.9 × 42.2 cm). Aaron I. Fleischman.

Interior, too, is small—15½ × 26 × 6 inches. The open skeletal struc-
ture was clearly inspired by Giacometti's *Palace at 4 a.m.* On one side,
there is a suggestion of a protective standing female figure, her torso
open, and a pyramid of three balls suggesting a baby not far from her
but out on a limb, on the far edge of the work; on the other side of the
sculpture, even more abstracted, are hints of another figure with a tiny
head and a comparatively huge ring ballooning out from the body like
a swollen or pregnant belly. The figurative presences inhabit the same
sculptural field but are cut off from each other by a fanciful architectural

scaffolding and linear network of open ovals and rectangles that seems haunted by other figural presences. The interior is exposed. The story may be a secret, but the construction is open. The intensity of Smith's sculptural making brings the viewer into the work.

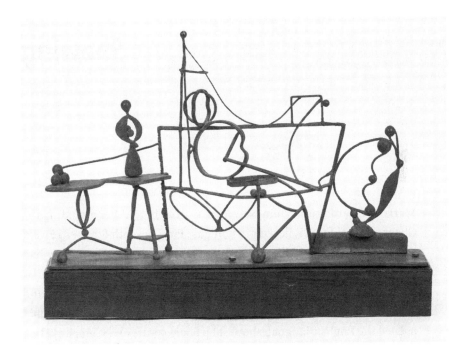

David Smith, *Interior*, 1937. Steel, cast iron; wood base, 15⅝ × 26 × 6 in. (39.7 × 66 × 15.2 cm). Base: 3½ × 26⅜ × 5 in. (8.9 × 67 × 12.7 cm). Weatherspoon Art Museum.

In December, the artist Hananiah Harari, one of the seven artists who signed the letter to *Art Front* in response to Rebay, stopped by the studio of Leo Lances, a photographer Smith knew from the Art Students League, as he was photographing Smith's work. Harari recommended Smith to Marian Willard, a young art dealer just starting out. Willard visited 57 Poplar Street to look at Smith's sculpture. Just before Christmas, he signed an agreement with her for his first solo show.

19
Showing

Marian Willard was born in New York City in 1904. After attending the Chapin School for privileged girls on East Fifty-Seventh Street, she went to Barnard College, where she took art history courses. Her family had strong links to France. In Locust Valley, on the north shore of Long Island, her grandfather built a replica of the Château de Meudon. Around 1925, in Paris, she became friends with Sylvia Beach, who in 1919 had opened the English-language bookshop Shakespeare and Company. Two years later, Beach published James Joyce's *Ulysses*. Willard bought the page proofs. In Europe, Willard "attended lectures of Carl Jung. And he was talking on Nietzsche at the time in English . . . And I got very interested in all that area because it was at that time in . . . 1937, that I went to see Klee. I was in Zurich and I went over to Berne and spent a whole day with him. Mother had given me money to buy clothes, a thousand dollars, and I bought six Klees instead . . . And that's what got me started into the art field."[1]

Willard opened the East River Gallery, at 358 East Fifty-Seventh Street in Manhattan, on November 10, 1936. She was drawn to artists who engaged materials in direct physical ways and through the personal creative act provided access to the unconscious. She felt that Jung "was going down into man's unconscious and uncovering the layers which each civilization had gone through . . . I think what people are still looking for is

something that they can in a personal way orient themselves to the universal."[2] She had strong instincts and trusted them. "There was scarcely a gallery in New York, not more than a couple, that would look at the work of an unknown artist," the MoMA curator Dorothy Miller said of the New York art world in the 1930s. "Marian Willard was one that would."[3]

"David Smith: Steel Sculpture" opened at the East River Gallery on January 19, 1938. In the small space were eighteen small sculptures, most of them made after Smith returned from Europe, as well as sculpture-related drawings. The image on the cover of the modest catalog, more like a brochure, was *Billiard Player Construction*.[4] Prices were listed: *Interior*, $275; *Torso and Model* (the original title of *Sculpture and Model*), $300; *Aerial Construction*, $350. The gallery would take a one-third commission. Smith was responsible for transporting the works to and from the gallery and for constructing the bases. If sales did not cover the estimated $200 cost of the exhibition, Smith would be required to compensate the gallery with sculpture. There had never been such a dynamic exhibition of direct metal sculpture in the United States. The sculptor and sculpture critic Sidney Geist remembered the show as an "event," although it would take a while for it to be recognized as such.[5]

Visitors included three officials of the American Artists' Congress (Max Weber, Lincoln Rothschild, and Rockwell Kent), as well as Elizabeth McCausland, Herman Baron (director of the ACA Galleries), and friends from Terminal Iron Works. "The young men who worked at the iron works got all dressed up to come and see David's show," Esther Gottlieb remembered. "They were so enthusiastic."[6]

Howard Devree of *The New York Times* was not. "One torso in forged steel is almost academic in contour, but most of the pieces are rather complicated constructions of masses resting on points or mechanisms that seem to await a Calder to set them in motion. It is a very earnest endeavor rather in the heavily modern decorative manner."[7] But in the *New York Herald Tribune*, Carlyle Burrows singled out Smith as a sculptor to watch:

Virtually unknown until now, David Smith promises henceforth to be a much-discussed sculptor. A cartload of his latest creations—perhaps a ton or more abstractions in steel—have

issued from a Brooklyn waterfront foundry, where he is an expert craftsman in metal . . . The metal has been literally beaten into art. The pieces are hammered, as well as welded, twisted or peeled, and there is one which, in addition to all, has been neatly polychromed. This gives us in metal, and by an American with French experience, art forms comparable with recent developments in abstract painting—filling a niche in American sculpture which has not been filled before. As objects of craft, one may view these compositions with a certain degree of genuine amazement, for they evidently involved vast ingenuity and skill in their manufacture.[8]

Willard hoped Smith would convince Frank Crowninshield to commission an article in *Vogue*, where he had been working as an editor after *Vanity Fair* folded in 1936. She vowed to get the MoMA curator James Johnson Sweeney into the show. Nothing sold. In October, Willard itemized her costs, noting the eight dollars she was still owed her after the two sculptures she had selected to cover expenses.

During the run of the show, Smith had work in three group exhibitions. On February 14, the second annual American Abstract Artists exhibition opened at the American Fine Arts Society at 215 West Fifty-Seventh Street—the building that housed the Art Students League. Accompanying the exhibition was an American Abstract Artist yearbook with eleven essays making the case for abstract art. Interest in abstraction was growing: the exhibition drew more than five thousand visitors in two weeks. Most reviews were negative. The one that mentioned Smith appeared in the *Daily Worker*. "Technically the exhibition as a whole is much better than last year's show at the Squibb Galleries," wrote Jacob Kainen, a painter and writer for *Art Front*, "but from the standpoint of creating new insights into modern life, little new material is offered." Kainen made an exception for Smith. "David Smith's forged steel sculpture is perhaps the most original and rewarding work on exhibition. Based primarily on caricature and machine forms, Smith's pieces are rich in contemporary association. That makes them really modern."[9]

Smith's 20-inch-tall cast-iron torso was included in a March exhibition of work from the Federal Art Project at the Federal Art Gallery

at 7 East Thirty-Eighth Street. The critic E. A. Jewell hated the work. "I cannot deplore in terms too strong the ghastly 'torso' by David Smith," he wrote in *The New York Times*.[10] Smith never forgot this thrashing. "Edward Alden Jewell made a remark about one of Smith's sculptures— I can see no earthly reason for its existence—in *New York Times*," he wrote a dozen years later.[11] Soon after the review appeared, Adolph Gottlieb, now living in Tucson with Esther, wrote to the artist Paul Bodin that Jewell's "articles . . . reach an all time high for imbecility."[12]

In 1937, Smith made four female sculpture torsos. With some regularity—perhaps an evening or afternoon a week—he continued to work from the model. "Like every artist I am always drawing from the figure," he said in 1940. "It is the source of almost everything we do; it provides motives and orders association."[13] Smith's torsos were considerably more naturalistic than his other sculptures. Their surfaces can be as fluid as smoothly modeled plaster or clay. Breasts and hips are voluptuously curved. But these sculptures, too, were abrupt and at times irreverent. Necks seem indented, scooped out; arms are lopped off just below the shoulders, legs truncated halfway down the thighs. Smith signed two torsos by inscribing his initials in Greek, ΔΣ, on the buttock.

It was probably in late 1937, while a technical supervisor, that Smith joined the WPA's sculpture division. Dehner said:

> He wanted to be not on the technical project but on the sculpture project . . . previously they would not accept his work, it was too avant garde. It didn't look like sculpture and they wouldn't let him be on it; his work was much too abstract for them. And besides it didn't pay enough. But by this time he wanted to be on the sculpture project and he decided that he could make enough sculpture for them to satisfy them and at the same time be working full time with his own work, and he would throw them a bone every once in a while, often enough, you know, because he was so prolific he could make ten times as many things as anybody else.[14]

WPA sculptors were expected to maintain a 130-hour per month work schedule. In 1936, the recommended size for portable sculpture

was 24 inches or less. There were two categories of Creative Sculpture: architectural sculpture—"the design and execution of work which will become part of a building, such as: relief friezes, statues, weather vanes, fountains, sun-dials, corbels, buttress figures, etc.," and "portable or free-standing sculpture, which, like easel paintings, may be either special assignments for co-sponsoring agencies, or sculpture that is allocated after completion and in which the subject matter is selected by the artist in the same manner as in the case of easel painting."[15]

It was Girolamo Piccoli, head of the WPA sculpture division, who got Smith on the sculpture project. Piccoli wanted sculpture to break free of its subservience to painting. To do so, he believed that it needed a public and it needed to reestablish a connection to architecture. The sculpture project would "unite the distinct but related arts of sculpture and architecture" by harmonizing sculpture "with architectural plans." By so doing, it would "stimulate a large demand for sculpture in public buildings."[16] At the same time, Piccoli supported individual creativity and encouraged his sculptors to make work without worrying where it would end up: "The one thing the Project requires is that you do your best work. We are aware that some of the work which you create is not immediately allocated. But we know, too, that if the work is true and creative it will find its place. If you do your best work for the Project, the standards of the Project are thereby raised. Do not create 'pot boilers' and STOP WORRYING ABOUT ALLOCATIONS."[17]

Sites included schools, parks, hospitals, housing projects, and sewage treatment plants. Public sculpture had to meet "the earnest official sanction of edifying and instructive subject matter."[18] Much WPA sculpture was conservative: it had its share of jaguars and generals; dancers and workers were common themes. But Piccoli also hired abstract sculptors, like Ibram Lassaw, one of the founders of American Abstract Artists, and José de Rivera.

Smith was asked to contribute an essay to an anthology to provide a record of the achievements of the WPA and convince skeptical politicians that the WPA was not a boondoggle. *Art for the Millions* was ready for publication in the spring of 1939; it would not be published until 1972. In "Modern Sculpture and Society," Smith agreed with Piccoli that the necessity of sculpture depended on its age-old collaboration

with architecture. But he believed that it was a mistake for sculpture to subordinate itself to architecture. The sculptural imagination was unlimited. Sculpture had to contribute to the modern age on its own terms.

> Although the TVA [Tennessee Valley Authority] has utilized modern architecture, it has not included sculpture. It would be fitting for TVA to use sculpture in relation to its architecture, which is based on similar concepts. The need would be for sculpture that will uphold the monumental dignity of Morris Dam, sculpture aesthetically as functional as the mechanics of Wheeler, Pickwick and Guntersville. Sculpture with aesthetic elements related to space and contemporary time as are their gantry cranes and gauge houses. A sculpture to complement the monolithic majesty of their structures and adjuncts. A sculptured literary message would be out of the question.[19]

The half dozen or so sculptures that Smith made for the WPA, like many other WPA sculptures, were not treated well. "One was allocated to Radio Station WNYC the municipal broadcasting company," Dehner said. "It has disappeared although I tried to trace it. I found a dead end . . . David had another piece allocated to Erasmus Hall High School in Brooklyn NY." That work was called *Construction with Points*. "It may still be there." Another of his sculptures for the WPA "was a cast iron torso . . . no arms of a female figure made from a WPA model! . . . It was about 16" high. I haven't the faintest idea of what happened to that one . . . but I do know that the casting division for the sculpture project made several duplicates."[20]

The WPA sculpture to which Smith seems to have felt most attached was *Horse and Rider* (*Horseman*). It wasn't treated well either. In the photograph, it recalls sculptures that Smith would have seen on Greek pediments and metopes. It seems simultaneously processional and like a tug-of-war. An elongated and upright figurative form with two legs, a triangle body, and a pointy head pulls the sculpture in one direction. A slightly smaller and more abstracted figure with stumpy legs pulls it in the opposite direction. The figures are attached to each other by what seems like the shawl or cape of the taller figure and a trail of horizontal lines

suggesting strands of hair and a blank musical score. Where cape and score meet, a gryphon or serpentine creature with a bristly wing holds the reins and perches like a charioteer. In the etching related to the work, this creature is like a wild child and the setting a barren and enchanted agricultural landscape. In a notebook, Smith wrote: "If Polygnatis Vagis memory is correct this 'horse & Rider' 1936 or 37 was destroyed by Government WPA closeup. At the time I made it thot it was my best. Painted black—blue—white. Fuck the bastards. Adolph burned the books."[21]

On April 10, 1938, Lucille Corcos Levy gave birth to a son, named David after Smith. (David Corcos Levy would become chancellor of The New School for Social Research and president and director of the Corcoran Gallery of Art and Corcoran College of Art and Design.) Smith commemorated the event with a 15½-inch-long steel spoon, gracefully voluptuous and maternal, a talismanic object, functional yet beyond function, that would be welcome in metalworking traditions in Africa and around the world. Around this time, Dehner and Smith moved to Congress Street in Brooklyn, just a five-minute walk from the Levys and Terminal Iron Works.

Smith was asked to make a work for the 1939 World's Fair. The fair had "populist and utopian goals," the curator Carol S. Eliel wrote:

> A statement issued by the fair's Committee on Theme declared that "the New York World's Fair is planned to be 'everyman's fair'—to show the way toward the improvement of all the factors contributing to human welfare. We are convinced that the potential assets, material and spiritual, of our country are such that if rightly used they will make for a general public good such as has never been seen before."
>
> The fair's purely geometric Trylon and Perisphere, so popular they were depicted on a U.S. postage stamp, symbolized these lofty aspirations.

Smith's *Blue Construction*, Eliel wrote, is "an elegant and seemingly magically balanced play on the Trylon and Perisphere motifs."[22] (See

Figure 3 in the insert.) The surface is startling: thin sheets of cut and welded steel have a glossy cobalt blue baked enamel skin. The sculpture is acrobatic in its hint of a tall, thin female figure performatively joined with two partnering angular geometrical forms, each with figurative resonance. The upright figure and one of the other forms are anchored to a sphere. Another sphere on her shoulder seems to be rolling along her arm in a juggling act. The interactions are racy. The 3-foot-tall sculpture has the giddy optimism of a Constructivist painting or sculpture, but it's bawdier and more theatrical.

The silvery painted *Suspended Cube* is even more of a magic trick. The form that seems suspended within an arc, or hoop, is not a cube but a rectangle. Cylindrical and rectangular openings tunnel through the steel mass; smaller arcs are attached above and beneath the rectangular block. *Suspended Cube* was conceived "to be technically a minor tour de force," the curator Edward F. Fry wrote. "As the original sketches show, Smith intended the cube to be suspended by two struts at its midpoint, but the final configuration intensifies an effect of irrational levitation."[23] How did he balance that rectangle and how did he make this sculpture seem weightless?

Smith's job as technical supervisor required him to move about the city to see what artists were doing and what they needed. "Yesterday I went to Brooklyn with Brubaker, Harry Knight and the sculptor, David Smith, who is in charge of the Technical Unit of the Art Project, to see the place that is going to be our workshop. It's the shell of an old church," Anton Refregier wrote in his December 1938 notes. He was preparing a mural for the World's Fair's WPA building. In January 1939, Smith stopped by again to check in with Refregier and the other artists:

> We all [go] for lunch to a little bar down the block. For the price of a beer, we get free lunch—a plate of stew, pig's knuckles, or whatever it may be. Sometimes we stay on after work and have a few beers and talk. David Smith came over to check on supplies. As it was time to go for lunch, we left the studio. But when we came to the bar, David said that he had to get to

the subway. He had to get back to the project to attend to some urgent business. At that point, we picked him up by his arms and legs and carried him into the bar. It was a load to carry as David is a heavy man. We did not let him go until we all had had a few beers.[24]

20
Fractures

On March 15, 1939, Germany invaded Czechoslovakia. In April, Francisco Franco marched into Madrid and sealed the fascist victory in the Spanish Civil War. On August 23, the Soviet Union signed a nonaggression pact with Hitler's Germany. On September 1, Germany invaded Poland and World War II began. In November, the Russian invasion of Finland marked the end of the American Artists' Congress and the collapse of the radical left.

Nonetheless, Dehner and Smith continued to believe. Dehner recalled:

> There was a big split in the Artists' Congress over the Finnish War . . . We all reacted like mad because they wanted everybody to sign a petition about how Finland invaded Russia, you see. And of course, we thought that was right. We thought the guys that wouldn't sign this were perfectly terrible at that time . . . And Rothko wouldn't sign . . . We were really dumb, you know. Well, we were involved. We believed in something. We believed in it so strongly that we couldn't—I don't think they really saw any more clearly than we did. We just happened to fall on the other side of the fence.[1]

In the city and upstate, Smith and Rothko argued. "Smith offered the standard American left account of the treaty; the Russians were 'buying time,'" wrote James E. B. Breslin, Rothko's biographer.[2] Rothko "didn't buy that at all," Dehner said. "I think he feared the persecution of Jews wherever it might be and I think that was very prominent in his political attitudes, how the Jews were being treated."[3]

The WPA was in dire straits. Beginning in September, Congress funded only projects sanctioned by their respective states. "What were previously autonomous divisions, the Federal Art Project among them (its name was changed to WPA Art Programs), were placed under state and local control, severely limiting their freedom and funds," Francis V. O'Connor, the preeminent WPA art historian, said. In New York, the WPA was administered by Lieutenant Colonel Brehon Somerville, whom O'Connor described as a "rabidly conservative anti-Communist." He "did everything possible to harass the artists."[4]

"To say that Colonel Somerville did not like and did not understand the Project or the artists is a vast understatement, and to indicate that this distrust was mutual is not more than the fact," Audrey McMahon, the regional director of the WPA, wrote. "He was not only of the school of critics who felt that 'his little Mary could do as well' as, shall we say, a distinguished painter like Ben Shahn or Stuart Davis, but, in addition, he had a profound conviction that to create 'pictures' was not 'work.'" The colonel was convinced "that the projects were a hotbed of Communism, and that he had been appointed not only to administer them (his cross) but to 'clean them up.'"[5]

In late July, Smith received alarming news from his sister, Catherine. "I'm writing to tell you not to be too shocked if you hear of Dad. David, he's in very bad shape. The folks just returned from Ann Arbor a week ago and they told Mother then that Dad didn't have long to live. The doctor told Mother that the life of a patient that has Dad's disease lives about three years and Dad has lived over four." That morning Golda Smith had learned that no further treatment was possible. "Of course Dad doesn't know this and we won't want him to."

Catherine added that she would have called him, but in a small town with party lines it was safer to write a letter. "We don't want anyone else to find out about Dad as some old busy-body would make it their duty

to tell him," she explained. She didn't even want Golda to know she was writing him. Golda had health problems herself. "She had x-ray treatments" for a lump on her tongue "but it did not help."

Catherine told her brother that their father "made a will so Mother will be taken care of and that's all that matters . . . I think Mother will have enough to keep her and I hope she can travel some as she had to take care of sick folks all her life. She sure deserves a holiday from family cares."

She ended with a request: "If it's at all possible I hope you & Dottie can make a surprise visit." In a postscript, Catherine added that she "just talked to mother again and she asked me to write you and tell you Dad isn't so good and to write him. He isn't able to get up this morning. Oh David, I hope you can come to see him."[6]

On August 4, Harvey M. Smith died from Hodgkin's disease. The *Decatur Daily Democrat* obituary reported that his "son, David R. Smith of New York City, visited him this week and had left for his home just a few hours before his death."[7] The *Paulding County Republican* provided more information:

> Following an illness from which he had been a sufferer at various times for several years past, Mr. Harvey M. Smith passed away at the family home here, Friday night, August 4th. As he grew worse two blood transfusions were given, blood from his son Rolland [*sic*], was used. These seemed to give renewed strength and his family's hopes were revived, but in spite of all that could be done death resulted.
>
> Funeral services were held at the home Monday afternoon, with Rev. R. J. Derr, pastor of the Methodist church, of which the deceased was a member, officiating. Widow's Son Lodge, 571, F. and A. M., attended the services . . . and at the grave gave the burial rite. The business houses of Paulding closed during the hour of the funeral service as a token of respect and esteem.[8]

There is no record of Smith's response to his father's death. After the move from Decatur to Paulding, their relationship became more

distant. Harve expected David to take over the telephone business. We don't know what he thought of his son's decision to go to New York and become an artist, but we can assume that he felt disappointment, if not betrayal. As a successful manager and superintendent of a company that Paulding needed, he became, like his wife, a beloved citizen, a pillar of the community. Not much seems to have remained of the inventor's curiosity and resourcefulness that made Smith feel close to him as a child. Smith believed that his father's marriage to Golda, as much as his comfortable middle-class existence, had thwarted his inventiveness. He and his father mis-connected. Their love for each other could barely be expressed. Smith experienced his relationship with his father as a wound. Still, he remembered their moments of closeness when he was a child and always wanted his father to be proud of him. He would be haunted by the fear that he was doomed to contract his father's fatal blood disease. The tombstone he made for his father has a humble eloquence.

On August 24, 1939, Smith's employment with the WPA ended. Many other artists were also let go. On August 26, Gottlieb wrote Paul Bodin from Woodstock, where he and Esther were now living in a "small shack": "There are quite a few painters here who are on the project, some have already received their pink slips. In general they are apathetic, and also feel a bit guilty about being in this quiet place instead of helping the fight in N.Y. I guess they feel it's futile anyway. Does there seem to be any hope in N.Y.?"[9]

In September, Herman Baron of the American Contemporary Art Gallery organized an exhibition to give artists "an opportunity to answer the attack on their democratic right to self-expression."[10] Smith contributed a sculpture. Burgoyne Diller, George McNeil, and Irene Rice Pereira—other members of the Matulka class—also participated. Stuart Davis, Milton Avery, and Louis Schanker did as well.

Artists were in danger. Hananiah Harari wrote in the exhibition's accompanying statement:

> These are grave times for democracy, and therefore for art.
> President Roosevelt, in his stirring and profound speech at the

dedication of the new building of the Museum of Modern Art, said "the conditions for democracy and for art are one and the same." Concentration camps and bonfires are the lot of artists and their works in many lands of the earth. There are groups in this country who want that to happen here, the same groups that seek to crush the trade unions, the WPA, the New Deal, and world democracy. They are the blood brothers of Hitler, and like him they have their bigoted, fanatical, and anticultural theories of art.[11]

Twice in 1939, Picasso's *Guernica* was shown in New York. In May, under the auspices of the Artists' Congress, it was at the Valentine Dudensing Gallery as part of a world tour to raise money for the Spanish Republican cause. *Guernica* and its studies were included in "Picasso: 40 Years of His Art," which opened at the Museum of Modern Art on November 15. The mural-size painting was symbolic, allegorical, expressionistic, and visceral. It made the language of Cubism and Surrealism compatible with great storytelling. Picasso had developed an aesthetic language with which to communicate fascist terror.

Smith lashed out against injustices, large and small. In a passage from "Modern Sculpture and Society" that the WPA edited out in *Art for the Millions*, he wrote: "America has outright fascists. It has tendencies. Anti-cultural movements, even in art, advocate sanity in art and are sponsored by the yellowist and most fascist of presses. Certain political and cultural reactionaries who do not openly uphold fascism possess its tendencies. Culture is international, but so is fascist degeneracy."[12] Smith was furious at the dismantling of the WPA and at the agency's betrayal of artists from within. He wrote an angry letter to the Federal Art Project for painting all the bases for sculptures in its show, including his, a uniform pink. When the WPA was slow in returning the photographs he sent to accompany his essay, he sent an indignant letter; the photos were returned several months later. When he left American Abstract Artists, citing a petty grievance over annual dues, he wrote another insulting letter that created hard feelings.

Since returning from Europe, Smith's aesthetic resistance to purity and to "sanity in art" had become absolute. He combined steel with cop-

per, steel with bronze, steel with encaustic, and cast iron with bronze. He worked with cast aluminum. He had objects fabricated. He used scrap and bought metal. With the possible exception of plaster, the sculptural results of which remained confined to his apartment and shop-studio, Smith painted each material. His paint applications were surprising, sometimes jarring, always unpredictable. His surfaces could be wildly different from one another, even within the same work.

Some sculptures hinted at narrative. *Interior for Exterior* is related to *Interior* in that it's an open skeletal structure that seems to be activating remembered domestic events, but its vertical steel armature contains a bronze mass and its steel lines are more gnarled, its imagery smokier, its content redolent of fire. The threat of catastrophe seems both intimate and vast. Other sculptures could be biomorphic. *Growing Forms*, balanced on a Brancusi-like stepped base made from wood salvaged from a beach, is Henry Moore–like in its smooth, rounded surfaces and hint of embryonic forms within a maternal oval—although Smith's image of biological growth is not an idealization of mother and child and it's impossible to predict what the inner growths would be.

Many of his sculptures depended on circles and other geometric forms, which continued to be building blocks of anti-narrative, nonreferential abstraction. Smith's sculpture was forward-looking in its material inventiveness and ingenious combining, which could provoke new ways of thinking about modern materials, and in its capacity for an associative abundance that Smith hoped would enable many kinds of people to feel that his work was speaking to them. His sculpture also seemed to have an ancientness. Some works referred to antiquity and prehistory. Many insisted on the realities and potential of unmanageable irrationality and desire.

Smith's industrial methods did in fact appeal to people who might otherwise not have been interested in art. Modeled in plaster, *Growing Forms* was Smith's first work in aluminum. In "Blacksmith-Sculptor Forges Art," *Popular Science Monthly: Mechanics and Handicraft* was fascinated by his working process: "'Growing Form' [*sic*] was cast in silicon aluminum at a foundry, a machine casting at 65 cents a pound. The sculptor was handed over crude casts, which required a great deal of his work before the final object might be considered a work of art. He had to polish

and buff, just as in machine castings for industrial use ultimate precision would be obtained by milling the casts."[13]

Although the primary art-historical references for Smith's work have remained Cubism and Surrealism, in the late 1930s it was clear to some curators and other artists that Smith was also a student of Russian Constructivism and the Bauhaus. Early in 1939, the Museum of Modern Art commissioned Smith, for $250, to make andirons, a poker, and a tong for the fireplace of the members' lounge in its new building, which opened in May. Smith made the sculptural objects out of cast iron and forged steel. Even his functional objects were associative. The andirons suggest tusks and guardian animals; the poker and tong, too, are creaturely. At the end of the year, the Metropolitan Museum of Art invited Smith to participate in its 1940 exhibition on contemporary American industrial art. The museum requested, along with andirons, "a swinging arm or hook from which to hang a tea kettle over the fire."

In fall 1939, Willard wrote Smith that László Moholy-Nagy, a former Bauhaus teacher, was looking for someone to head the metal department at his School of Design in Chicago. Respectful of Moholy-Nagy's work, and hoping for steady income, Smith pursued the job. "It's a good feeling to know that we have in you a good friend," Moholy-Nagy wrote, in response to Smith's letter with photographs.[14] In 1940, Smith was approached by Josef Albers at the Bauhaus-influenced Black Mountain College in North Carolina. Albers, like Moholy-Nagy, had been an influential teacher at the Bauhaus. Smith admired Albers's paintings, particularly his color. Unable to afford a sculpture show, Albers inquired about the next best thing—an exhibition of photographs of Smith sculptures. In the end, Smith accepted neither Moholy-Nagy's nor Albers's offer. When Albers asked Smith to teach at Black Mountain in 1945, Smith turned down that offer as well.

While Smith's interest in design and architecture reveals his awareness of Russian Constructivism and the Bauhaus, it also aligns him with core principles of the WPA. "The importance of an integration between the fine arts and the practical arts has been recognized from the first by the Federal Art Project, as an objective desirable in itself and as a means of drawing together major aesthetic forces in this country," said Holger Cahill, national director of the WPA Federal Art Project.[15]

Smith made it clear, however, that if he did move close to architecture and design, it would be on his own terms, as a sculptor. His artistic fight was as a sculptor. In 1939, he joined the Sculptors Guild, founded in 1935 "to further the artistic integrity of sculpture and to give it its rightful place in the cultural life of this country."[16] Beginning in 1938, the guild organized annual outdoor exhibitions, the first two of which were on Park Avenue and Thirty-Ninth Street. Smith would participate in its outdoor sculpture show in 1941 and perhaps the one in 1942.

For a Sculptors Guild exhibition at the Brooklyn Museum in 1938, John Bauer, who would later become director of the Whitney Museum, defined sculpture's uphill battle:

> Few decades passed in the Nineteenth Century that did not produce distinguished painters, but good sculptors of that era can be counted on the fingers of one hand. Sculpture, the step child of American art, is still struggling for a place in the sun . . . It is only in the present century that American sculpture has felt an independence justified by its achievements. In departing from outworn canons, and joining the frankly experimental front of modernism it deserves a hearing as one of the creative arts of this country.[17]

Smith's sculpture was gaining visibility inside galleries and museums, and it was beginning to be shown outdoors. For the opening of the Museum of Modern Art's new building, Dorothy Miller installed Smith's *Blue Construction* in the sculpture garden. Marian Willard installed several Smith sculptures near her Locust Valley property, by the Long Island Sound, where she had them photographed by Andreas Feininger, the son of the artist Lyonel Feininger and a student at the Bauhaus. *Growing Forms* and *Interior for Exterior* were photographed against the sea and sky in such a way as to "demarcate the edges and contours of sculptural forms."[18] So was *Ad Mare*, whose title and forms referred to the sea, and *Structure of Arches*, a 40-inch-tall steel-copper-and-zinc sculpture that seemed to want to be larger, even an architectural monument. Feininger's photographs reinforced Smith's growing

belief that his sculpture could be as much at home in wild landscapes as in galleries and museums.

By the end of this tumultuous decade, Smith's friendship with John Graham was over.

In 1937, Graham auctioned off much of his collection of African art. He was still working with Frank Crowninshield and was still a magnet for gifted artists, not just because of his track record and knowledge but also because of his continuing determination to place new American painting alongside the best art in Paris. But he had turned violently against Picasso, was down on collecting and tired of New York, and was on the road to esoteric figure paintings that disavowed much of what aesthetically he had staunchly believed in.

Speaking with Anne Carnegie Edgerton, Dehner remembered Smith's break with Graham:

> We went up to Bolton and I didn't know that he and David had quarreled. But they had; David and he disagreed on aesthetics, although it was Graham that had pushed the aesthetic with David which resulted in the Smith oeuvre—he was a great influence. And then he completely turned it over, you see. That's when he did those women with the wounds and the crossed eyes and so on. David felt that John had betrayed him. He had encouraged him to abstraction and introduced him to the avant-garde and the French literary world, and then he renounced it all. Graham and Gorky also split around this time.[19]

21
Leaving the City

In February 1940, at Local 60 of United Abstract Artists, Smith defended abstract art and defined his aesthetic position. He argued that abstract art was anti-provincial and fully contemporary: "The tradition of our art is international, as are American people, customs and science. There is no true American art and there is no true American mind. Our art tradition is that of the western world which originally had its tradition in the east. Art cannot be divorced from time, place or science." His enemies were purists, categorizers, and reductivists, anyone who constricted human subjectivity. He attacked "super-nationalists and the 'blood in mind' fascists" who "object to Abstract Art on the ground that it is a foreign 'ism.'"[1] To be equal to this historical moment, an artist had to be curious, informed, and open to a broad spectrum of creativity:

> Parallel to "impressionism" were the Helmholtz and Chevreul theory of light "vibrism"—Daguerre the painter and physicist, and [his] machine for reproducing natural images—Darwin, the evolutionist, and his theory of natural selection—and the economist and philosopher Marx. Paralleling our own more immediate tradition have been Einstein, with the Relativity Space-Time theory and Freud, who has been the greatest single influence on the theoretical side of art, providing an analytical system

for establishing the reality of the unconscious, that region of the mind from which the artist derives his inspiration and proclaims the super reality which permits use of all manifest experience.[2]

For Smith, the "all-inclusive term 'Abstract' include[d] sur-realism and tangent schools . . . the artist is essentially the instrument, his work stands above him . . . Relatively, a great abstract work is like a dream. It presents beauty or its associate, imagination. It does not interpret itself. The dream, like the painting, is the product of both the conscious and unconscious factors of the mind."[3]

Smith grounded abstract artists in daily and global struggle: "The problems of the abstract artist in a democratic society are common with those of all men of good will. He rejects participation in the present imperialist war, and acknowledge[s] his position with organized labor—to keep America out of war, for art and peace can only exist together."[4]

The New York Artist, published by the Cultural Committee of the United American Artists (the new name for the Artists Union), excerpted the talk. The issue appeared during Smith's second solo show, at the Neumann Willard Gallery, 545 Madison Avenue, from March 25 to April 15, 1940. Among Smith's dozen sculptures were the predominantly figurative *Bather* and *Leda*; the more architectural *Vertical Structure* and *Structure of Arches*; *Growing Forms*; and the comically and maliciously titled *Headscrew*, which suggests an erect figure with weather-vane arms, like a signalman or traffic cop or, as in Greek statuary, a man launching a trident or spear. The show included *Bi-Polar Structure*, a 19-inch-tall sculptural constellation coated—almost splashed—with encaustic. It was to *Bi-Polar Structure* that Smith later referred when he wrote, "The first piece I ever sold to a collector was out of [this] exhibition—sold to George L. K. Morris—as I recall this was the only piece sold in the exhibition."[5] Morris, an abstract painter and occasional sculptor, had written the main essay, defending abstract art, for the catalog of the 1939 American Abstract Artists exhibition and was a regular contributor to *Partisan Review*. In fact, Smith had already sold a sculpture to a collector, Lois Wright, but for him it was more noteworthy to sell a sculpture out of a show, and to another artist. Marian Willard chose *Bathers* and *Headscrew* to help cover the show's expenses of $426.84.

The press coverage was remarkable. Critics were won over by the architectural dimension of the sculpture. "Smith's first show, several years ago at the East River Gallery, was of primarily abstract work without, it seemed to me at the time, much point," Howard Devree wrote in *The New York Times*. "Now he has hit upon a line of development with a number of the pieces clearly possessing architectural potentialities."[6] Andreas Feininger's photographs in the catalog and in *The New York Artist* contributed to the sense of sculptures that could not be boxed in. "One would like to see these works out of doors, against a background of sea or mountains, for they have an elemental strength which seems almost to burst through the four walls," the painter and critic James Lechay wrote prophetically in the periodical then titled *The Art News*.[7] *Popular Science* imagined the sculptures "as monuments in public parks or grounds along a waterfront or seashore."[8]

Elizabeth McCausland continued to be drawn to Smith's materials and process. In the *Springfield Sunday Union and Republican*, she declared the show "an impressive demonstration of an idea." She then continued:

> The idea is, briefly, that modern sculpture should base itself on the technology and materials of the present instead of relying solely on methods and materials which evolved from other ages. [Smith used] an oxy-acetylene torch to eat through half steel like soft wood. Then following designs he has sketched carefully and with color indications, he welded the pieces with his torch, thus fabricating large forms which to the eye seem as solid and monolithic as a granite boulder. It is surprising to grasp one of these abstract sculptures with a spread of four feet, and find that it can easily be lifted. The relatively light weight due to hollow construction is plainly a great boon to the sculptor, who is usually weighed down like Atlas by the bulk and weight of his work. Transportation loses its horrors.

McCausland, whom Smith would single out for her "wonderful write-up" of this show, was the first writer to reveal Smith's imaginative

approach to color. She notes his burnishing and spraying, methods that would become essential to his work two decades later:

> Using a different nipple and more air pressure in his oxy-acetylene torch, he blows molten metal on the sculpture as copper, stainless steel, aluminum or zinc. A thin wire of the metal is fed through the nipple and this melts and is forced through the air in minute particulates which harden as they reach the surface. There is a sort of mechanical penetration of the basic steel, so that this color is actually "organic."
>
> By burnishing a brilliant patina may be achieved; the surface may be left with a kind of matte finish: metals may be mixed. Thus a variety of colors and surfaces may be obtained.[9]

With this show, Smith's personality, life, work, and workplace became inseparable. Critics visited Terminal Iron Works with Smith, and one of them also visited his home. They liked him. He was a big man, warm, outgoing, very male, an artist with whom nonartists could imagine having a beer. "Smith is over six feet tall, husky and strong as any of the shop's workers," *The Daily News* noted. "Like them, he wears denim when busy at the welding machine or at the forge and his hands are as dirty as theirs any time."[10] He had gone to Europe and absorbed European modernism and studied art of all periods, going back to the Neolithic Age. Since returning to the States, he had been making avant-garde work that was unmistakably American—direct, resourceful, unpretentious, and endlessly inventive. Although groups had been essential to Smith's identity through the 1930s, now he was revered as an individualist. He was becoming a modern-day Vulcan, an almost mythical figure.

"From Studio to Forge," Ernest W. Watson's interview-profile in *American Artist*, has a novelistic beginning:

> It was New Year's Eve, cold. In the gathering dusk we drove in David Smith's Chevrolet Truck down Atlantic Avenue toward the Brooklyn waterfront. When it seemed as though we could go no further, unless indeed we would collide with a tugboat

and some barges that were tied up at the pier, Smith turned his wheel abruptly to the right and we rolled through a wooden gate, passed some piles of lumber, and pulled up in front of an ancient shop—a dark silhouette against the gray mists of the harbor.

Entering the shop-studio was like crossing a threshold:

> The big barn-like door swung open. We stepped over the sill into a black interior, fragrant with the odor of dead cinders on an unseen forge; and stumbled over some scraps of iron lying on the cinder floor. The light of a match for an instant disclosed shadowy forms. Heavy chains were festooned from the gloom overhead.
>
> A high cylindrical stove radiated welcome warmth. Three or four anvils of varying sizes stand near the forge. Tanks of oxygen for welding were hard by a heavy work bench. Great sheets of metal eight feet high occupied one corner, along with assorted pieces of iron. Sledge hammers lay handy for use here and there, while dozens more of as many sizes and shapes hung in racks along the wall. Tacked in the rough boards was a color reproduction of Renoir's "Bathers," framed by a link of chain draped over nails at the upper corners. That and a plaster cast of a nude figure poised over the door were the only visible evidence that Art had taken up her abode in this place of iron and fire.[11]

The title of Maude Kemper Riley's article, "Sewer Pipe Sculpture," was taken from a remark by Smith: "That torso in the corner there was beaten out of a steel sewer pipe—not a New York City pipe, but an outlet pipe from a ship." Riley, too, was smitten by Smith and his place of work. "If you should walk along the waterfront in Brooklyn any day of the week or any Sunday morning," she wrote, "and peer into the boiler-fitting room of the Terminal Iron Works at No. 1 Atlantic Avenue, you'd see a big 200-pound man, wearing leather apron and gog-

gles, working over a glowing forge with hammer and tongs, making sculpture."

Smith told Riley:

> It's wonderful how you can control elements of steel! Just heat it up, quench it, take it out and work on it right away. It will bend with its grain and back again and it stays there . . . But mild steel, that means without carbon—responds better than any of them [other metals] and you can get it from mail order catalogues, by the pound, or by the ton. Scrap iron can be had for the asking from junk houses. It's rusted, but you can take off the rust.

Riley moves from the studio to describe Smith and Dehner's apartment:

> And so the Smiths, like many other artists, put up with things. That is, they do without the things you think you have to have. They live in three big high-ceilinged rooms in Brooklyn, six blocks from the river "studio." What to you would be a living room, is banked above the bookcases with many steel figures. The marble mantel is covered with colorful apothecary jars containing the materials he used to color his sculptures— oils, waxes, resins, cadmium, sulphate, polishing compounds, etching agents. A fireproof color he has developed himself is cheery red and he mixes it with hard wax and melts it on the metal when it is cooling.
>
> By the kitchen door there are some fine chunks of marble. He's not working in marble just now, but he saw these odd pieces up at Parker, Vermont, in a quarry, and bought them at the rate of 2 tons for $5.
>
> The "library table" is a huge flat drawing board where designs are studied fully before steel goes into furnace. A fire roars in the fireplace, burning wood that won't make sculpture.
>
> "Last of all, I'm going to work in wood," David Smith says. "It has to be *last*, because I've only just now started laying by wood and it should age for from 8 to 30 years."[12]

On April 4, the American Artists' Congress broke up. It had always had a strong Communist contingent. Defenders of the Soviet Union remained on its executive board, and their Stalinist line led to the formation of a dissident group led by the medieval and modern art historian Meyer Schapiro. At this April meeting, the dissidents urged those in attendance to "make clear to the world whether the Congress is a remnant of the cultural front of the Communist Party or an independent artists' organization."[13] Support of the Soviet Union had become dangerous to the cause of artists.

Stuart Davis was the first artist to officially resign. The repressiveness of the Soviet Union had been vexing for him. He condemned the Moscow trials in 1938, but two weeks before the signing of the Hitler-Stalin pact, he signed a letter rejecting the "fantastic falsehood that the USSR and the totalitarian states are basically alike."[14] To Lewis Mumford, a member of the congress, war was now necessary. The historian Gerald M. Monroe wrote that "during the popular front period the liberals had accepted the leadership of a Communist minority because the Communists"—and here Monroe cites Mumford—"'alone among the political groups had firm convictions and the courage to act on them.'" Now that the communists were allied with the fascists, Mumford believed that "many of the liberals have on practical points at issue, even drifted into a covert defense of Hitlerism."[15]

From the dissident group emerged the American Federation of Modern Painters and Sculptors, described by Monroe as "a nonpolitical organization to 'promote welfare of free progressive art in America.'"[16] Smith joined later, and Dehner may or may not have become a member, but their continuing sympathy with the Soviet Union contributed to schisms with Gottlieb and Rothko, who were among the federation's leaders. When the Smiths and Rothkos ran into each other upstate that summer, they avoided politics.

On May 10, 1940, France fell, the news of which made Dehner weep. "The laboratory of the twentieth century has been shut down," is how Harold Rosenberg famously began his essay "The Fall of Paris" in *Partisan Review*. "Let us admit, though, the rapping of the soldier's fist did not

interrupt the creation of fresh wonders. For more than a decade there had been a steady deflation of that intellectual exuberance which had sent out over the earth the waves of cubism, futurism, vorticism—and later dada, the Russian Ballet, Surrealism. Yet up to the day of the occupation, Paris had been the Holy Place of our time. The only one."[17]

A few days later, Smith and Dehner moved out of the city. "We left New York just before the Project broke up," Dehner said. "Congress really beat it to death. And they were investigating everybody and they were investigating our friends, and they would come and sit in the house and ask questions about different artists that we knew and it was all terribly unpleasant."[18] One of the friends the FBI questioned them about was Anton Refregier.

Dehner described their departure: "We finally got ourselves out of Congress St. Saturday noon—& did we look like the Grapes of Wrath. The truck was loaded to the gun walls, with all the tin chairs tied on behind & a mattress on the top. While David was running around doing last minute errands he unexpectedly rented the apt . . . to a steel salesman from the iron works & Buck[horn]'s brother, who just left his wife. A helluva combination. They bought our furniture—bed, big chair & a couple of tables & will move in."

The Smiths arrived in Bolton Landing after midnight. "We had to drive very slowly because of the dam load & the fan belt gave out besides & had to be fixed," Dehner wrote to the Levys. "Anyhow we are here & I never was so glad just to *be* in my life. The house looks as if it had been blitz krieged but its home sweet home to us."[19]

22
Adjusting

They were no longer in the thick of things, in a city suited to Smith's metabolism. He could not walk over to Terminal Iron Works for counsel and cheer, or hang out with "the boys," which was how he referred to the men who worked there. No choice of dance performances, music recitals, bookstores, and films. No give-and-take in coffee shops on exhibitions of art from all over the world. In the city they could speak freely; they had to be careful upstate. Dehner wrote to the Levys: "We certainly miss our N.Y. friends . . . You can't imagine how stifling it is not to say what we think about the war etc. Everybody talks about it so we just kind of act not interested. I wouldn't trust any of these middle class liberals as far as I could see. But boy, do they cook good dinners."[1]

Smith existed in a state of agitated disquiet. In a sculptural series on which he had been steadily working since their return from Europe, which he was preparing to show, he had anticipated global calamity. Now war, material scarcity, and social unrest were spreading. Other species had become extinct. Smith wondered if humans would, too. He and Dehner believed that if the United States were invaded, they would be safer upstate, but there, too, eligible men were required to register for the draft and be subject to the lottery. "I will come to NY around the 8 or 9 of October, unless you want me sooner," Smith wrote Marian Willard. "I will probably register for the draft there rather than here for reasons I'll

tell you later. I must keep out of an army camp it would spoil my work and ruin me as well."[2]

Smith had been turned down for a Guggenheim Fellowship, so he considered teaching, even if the job required him to leave New York. He approached Cameron Booth, who had organized his exhibition of small sculptures at Minneapolis's St. Paul Gallery and School of Art, which ran concurrently with his recent show at Neumann Willard. Was there a sculpture post at the school? "I am equally able in most mediums and methods," Smith asserted.[3]

On August 30, Elizabeth McCausland asked him to teach a sculpture class at a New York City "school devoted to progressive art teaching"—although pay would be "token": "The school (as you know) has no money."[4] Smith responded: "I cannot accept because I don't know where I'll be this winter or why. The situation is this—with New York the highest priced living place and without any job there, wpa, or sales expectations—I may not be in New York except as a visitor. I've tried for out of town teaching posts but—I have had no success as yet . . . If I were in New York and had a part living subsidy—I am certain I would accept the offer."[5]

"We are at the farm and as far as I know will try to hold out part of the winter at least, as I have no job or anything," Smith wrote to the painter Jean Xceron. "This war stuff has me worried but I'm working just the same. It's a bad looking future for an artist—as well as all humanity."[6]

"I can see no future," he wrote McCausland. "I'm in the draft sooner or later as are all men—good men artists too are dying every day I'm not sure of a future let alone a living."[7]

Conditions on the farm were as rudimentary as ever. Dehner and Smith used an outhouse and had no running water or telephone. In cold weather, they bathed indoors. "We had no tub, and a sink was difficult, although I could get my leg way up," Dehner, the former dancer, said.[8] During the summer, they often bathed in the wheelbarrow. One of them sat in it while the other targeted buckets of water. That year, Smith photographed a naked Dehner smiling in the wheelbarrow and memorialized this ritual in a 4-by-4-inch bronze sculpture about the size of his Virgin Islands idols.

Dehner developed a full life upstate. She considered neighbors family, and they welcomed her. She liked to sew, not just for herself and Smith

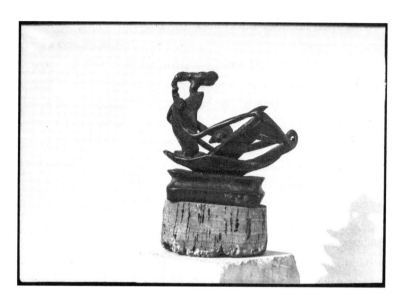

David Smith, *Bather*, 1940. Bronze, 4¾ × 4¾ × 3⅛ in.
(12.1 × 12.1 × 7.9 cm). Cleveland Museum of Art.

but also for Aunt Flo and the Levys. She had her piano. She planned an
album of Christmas cards, which she expected an artist in Warrensburg
to publish. She had an idea for an illustrated map of Lake George and its
surroundings. If it sold for 25¢, she would get 50 percent; she anticipated
sales of more than five thousand during the first season. She sent for fruit
trees for their orchard and did much of the planting and harvesting; she
canned and pickled. Like Smith, she read two of William J. Blake's novels,
The Painter and the Lady and *The World Is Mine*. Blake was best known
for his 1939 book, *Elements of Marxian Economic Theory and Its Criti-
cism*. Smith would settle on him and Christina Stead, his wife, to write
the essays for his *Medals for Dishonor* catalog. Dehner's painting flour-
ished. Her wit, powers of observation, and storytelling gifts contributed
to an infectious diaristic narrative style that local residents could relate
to far more easily than they could to Smith's abstractions. Her art helped
her belong. She wanted it to evoke a warm sense of place, and it did.

Still, Dehner's letters are laced with ambivalence. "It is kind of
isolated—intellectually you can bet," she wrote. "But in a way it is better
than the hysteria of N.Y. City."[9] The Levys had bought a house on Fire

Island—along with a boat that they named *Pinafore*—and spent much of the summer there. "Your summer sounds good . . . That is such a perfect beach & nothing is more fun than a house—or more a pain in the ass either of course—I know, but you seem optimistic anyhow."[10]

Smith needed people with whom to talk about art, but he also needed to be on his own, thrown back on himself. On the waterfront at the foot of Atlantic Avenue, he could leave his door open and work in public or enclose himself in a shop-studio that could feel like a blacksmith shop in nineteenth-century Indiana or, for that matter, the Middle Ages. In Bolton Landing, he hired young men to help with construction on his 18-by-36-foot shop-studio and devoted himself to art for eight to ten hours a day. He and Dehner felt little connection with the Furlongs, and the vibrant summer evenings with Graham were now distant memories. Smith had no one other than Dehner to speak with about art and aspirations and the dreams and visions that obsessed him. While thriving artistically on undistracted concentration, he was hyper-susceptible to loneliness. In Bolton Landing, "lonesome" became one of his signature words. "No city dust—but some country lonesome and no shot deer as yet," he wrote McCausland in the fall.[11]

Letter writing had been second nature to them. It was how Smith and Dehner communicated with the Levys and with each other when they were apart. In the Virgin Islands and in Europe, writing letters and bringing them to the post office had ritual weight. Letters were physical things, activated by handwriting, repositories of desires, reactions, stories, and hopes that were sealed in envelopes and over days and weeks transported hundreds or thousands of miles. When the letters reached their destinations, they were opened and pondered with anticipation and gratitude, and then placed back in their envelopes and often carefully preserved. Smith and Dehner pored over letters from the Levys, as the Levys pored over letters from Dehner and Smith. Marian Willard's letters to Smith were also lifelines. She had the ability to be informal and even chatty without ever being indiscreet or unprofessional. In his letters to her, Smith wrote about more than art and business; he could be candid about his moods and fears and the vicissitudes of North Country life. The postman's arrival at the entrance to their property, on the dirt and sometimes the mud of Edgecomb Pond Road, was a daily event.

Visits from city friends were indispensable. The Levys and Louis Schanker, another painter who had lived in Brooklyn Heights, visited. Soon after the move, so did Mildred Constantine, whom they called Millie. She had left the College Art Association, where she and Smith met in 1934, and in a few years would become a curator in the Museum of Modern Art's department of architecture and design. She adored Smith and Dehner and was so enamored of Smith's sculpture that she became a de facto representative for it. While vacationing in Mexico soon after her summer 1940 visit, Constantine made inquiries about venues for a West Coast Smith show. In early August, after attending the Berkshire Music Festival, Willard spent three days in Bolton Landing. "She is awfully nice & relaxed & lots of fun once that restraint is broken," Dehner wrote to the Levys.[12]

One purpose of Willard's visit was to discuss the exhibition of Smith's *Medals for Dishonor*, with which she was planning, in October, to inaugurate the Willard Gallery, a small exhibition space on the tenth floor of 32 East Fifty-Seventh Street. Instead, she opened with a Klee exhibition, organized jointly with Curt Valentin and his Buchholz Gallery next door. Klee had recently died, on June 29, 1940, hence the change of schedule. Smith was fine with this decision: "I am pleased that that has been arranged because it is better policy to open on an accepted thing with joint prestige than a contraversial issue like mine (or it may seem so to the general critics)."[13]

Willard had become a friend. Smith and Dehner regularly visited her at her 350-acre estate in Locust Valley, by the Long Island Sound. Their time by the water hastened Dehner's recovery from a hysterectomy for recurring gynecological issues. In 1944, Dehner painted *Vacation at Marian's*, an exuberant night scene of four men and four women (including Marian Willard and Mildred Constantine) skinny-dipping in the Sound. Smith, in the water, gestures to Dehner, alone on shore but accompanied by a starfish, a conch, and a horseshoe crab.

The Smiths, in turn, were good hosts. Willard enjoyed her visits to Red Moon Farm. She had been raised in privilege but was not a snob. Far from being put off by the spare conditions, she relished them. Although never a business powerhouse, she was savvy about art world politics, passionate about modernist art, and loyal to artists she wanted with her

in the trenches. "Modern art is a fight, and so is modern life in the terms that we understand it, and so what fun," she wrote to Dehner and Smith after a visit. "At least we know what we are fighting for and that is a step ahead of most people today."[14]

By Thanksgiving, Smith and Dehner had a wood and oil heater, and an oven that warmed up the whole house. "Jesus I haven't been so hot since I was in the Virgin Islands," Dehner wrote the to Levys. "Anyhow that guarantees our winter here, come hell & sleet & snow."[15]

Getting electricity, however, was an ordeal. "I suppose I told you how the light Co. bitched us," Dehner wrote. "We wrote to Rural Electrification in Wash. & they were swell (I suspect the guy is a red.) But there is not much they can do in our case."[16] In November, Smith, who still had to go into town, to Barney Snyder's Garage, in order to weld, wrote to Willard: "We have ice and snow—and I'm working on light wiring and line, so I can get at sculpture work."[17] Shortly before Christmas, the great moment arrived. "We have *lights*," Dehner exclaimed. "You can't imagine the delight. We are listening to the Basin St gang now. Swell. We get all N.Y. stations at least as well as we did in N.Y. Except they fade once in awhile."[18]

Electricity continued to amaze them. The problems in getting it contributed to Smith's decision to build his shop by Edgecomb Pond Road. He wrote in an exceptionally long entry in a later biographical sketch:

> In 1940 I had been successful in making the electric co. give me light service to Bolton Landing house . . . forced them to bring elect. service into our area and since their fee [was high] for bringing the line into the house, which was 600' off the road—I built a studio down on the road—cut my own poles and strung my own wire. Designed and made this studio (on an industrial factory type).
> Was in debt for the building, new ice box, and a truck.

He "christened" his new studio Terminal Iron Works:

> Partly because *the change* in my particular type of sculpture required a factory more than an "atelier." Partly because I had

already established credit thru the Terminal Iron Works in Brooklyn and because I had become the Terminal Iron Works after Buckhorn had sold out the equipment and gone to work for a government agency.

The last year I was in Brooklyn, until spring of 1940 when I moved up to Bolton, I was the Terminal Iron Works.[19]

That Christmas, Dehner and Smith's guests were first-timers in Bolton Landing. Smith met James Marston Fitch through Mildred Constantine. Fitch and his wife, Cleo Rickman, were raised in Tennessee; he lived for several years in a log house outside Chattanooga. Three years younger than Smith, and also without a college degree, Fitch was a social and cultural progressive with a commitment to architectural and wilderness conservation. He arrived in New York in January 1936. As an editor of *Architectural Record*, he commissioned an essay from Smith arguing for the importance of sculpture to architecture. "Never before have the sculptors had as rich and varied a selection of materials, tools, and techniques with which to work. It is the purpose of this paper to summarize these new means," Smith wrote.[20] The first new means he mentioned was welding.

From 1954 to 1979, Fitch taught at Columbia University, where with Charles Peterson, he developed the first American academic program in historic preservation—a field he helped invent. With the Fitches' Tennessee ham and the Hungarian sausage Willard included in her Christmas package, they ate well over the holidays.

Trying to persuade Willard to return, Smith touted the joys of a North Country winter. "The house is warm, the air clear and dry and cold. The snow is good and as you know the conveniences primitive. There is skating and skiing . . . We had it 26° below zero but . . . it is some 20 or 30 above now," and with electricity "we can cope with the cold stuff so don't be afraid. You can make it New Years or any time you state, now or later, as long as you like."[21]

But there was another side to the North Country winter:

> Our car is stuck in a ditch. Everything is ice & sleet & D. went right off the road even with chains. Driving is fierce. I scared

myself shitless by driving to the village & I nearly died coming back as everybody in the village said I was crazy to try it. Anyhow I didn't go in the ditch. This will be the fourth time David has had to be dug out by the neighbors & I'll bet they wish to hell we'd go back to N.Y.[22]

Medals for Dishonor

Although Smith had been working on *Medals for Dishonor* for nearly four years, only a few people knew about the series. He made the reliefs in private, mostly at night and on Sundays. They were not abstract but realist and symbolic. They were not made of welded steel but intricately carved in plaster before being cast in bronze. Instead of revealing themselves differently from near and far and a variety of angles, they had to be explored up close. Drawing had long been essential to him, but for the *Medals* Smith made dozens if not hundreds of drawings, some of them studies, some elaborations of a theme, some flights of fancy. He had to learn a new way of thinking about sculpture. "I spent a year of nights acquiring my ability to carve and experimenting with materials," Smith wrote to Elizabeth McCausland. "I had no experience at this work. I had only my respect for the ancient use and certain experiences of seeing mechanical objects take form when stamped from dies (which were carved in reverse). Neither of the ways answered my needs—but a direction for the aesthetic approach from ancient seals and a suggested possibility of what I could attain by modern means . . . I wanted a sculptural medium with the fluency and subtlety of drawing," one that would take "the place in my work that etching—engraving—did before, which was my relaxation in the evening, after working at the shop on big sculpture. It was also a pleasing reaction to the bold forms I made in the daytime."[1]

In the 1940s, Smith would make lurid, sardonic "specters" commenting on war's coupling of cruelty, greed, and lust. He made pins, realized small medal commissions, and sought larger, more politically based medal commissions. After 1950, seriality would become a defining feature of his work. But he never undertook another project like this one. In 1961, he told the British art critic David Sylvester:

> I had strong social feelings. I do *now* . . . And about the only time I was ever able to express them in my work was when I made a series of medallions which were against the perils or evils of war—against inhuman things. They were called *Medals for Dishonor* . . . It was about the only thing I have ever done which contributed by my work to a social protest.[2]

The *Medals* are outraged and outrageous, prankish and disturbing, scrupulous and excessive, direct and slippery. With biting sarcasm, they honor reprehensible behavior by pillars of the establishment. They rage at the hypocrisies of the press and the Christian right and the sadism of the ruling class. They point fingers at individuals and at many of America's most cherished institutions. Derisive, at times breathtaking in their anti-capitalist, anti-fascist, antiwar ferocity, they are also impure hybrids so insistent on interpretative density that it is impossible for anyone, even comrades in outrage, to settle in with them. They are statements of alarm about fascism not just as a phenomenon out there, in Europe, but here, in the United States. In *Private Law and Order Leagues*, the eyes within the pyramidal heads of ten or so Ku Klux Klansmen peer from over the horizon, near a tree on whose six limbs eight black men hang lynched—their hands untied, their bodies active, still haunting—while just in front of this scene, to the right, the Statue of Liberty rides backward on a pig. Standing in front of, seemingly outside, the medallion frame, a Klansman takes aim at the viewer. "The superamerican rises from the pit of mediaevalism and by the grace of modern industrialism is aiming directly at you," Smith wrote in the accompanying caption.

Smith began the *Medals* a few months after he and Dehner returned from Europe. He made fourteen of them in their Congress Street apartment, where she watched him work. The fifteenth, *Reaction in Medicine*,

was completed over the summer of 1940 in Bolton Landing. Dehner felt close to them. Like her paintings they were figurative, and forms of storytelling. They are the one work by either of them that provides a definitive statement of the politics they shared. In the only essay that she devoted to a Smith work, Dehner grounded the *Medals* not only in their trip to Europe but also in Smith's childhood:

> [He was] only eight years old when World War I broke out. It is probable that even at that time he became aware of some of the distortions and contradictions of our society. He had often spoken of boyhood memories that found later expression in his medals. He remembered tales of the Klan, and of lynchings. He remembered Henry Ford, prophet and God of the early automobile culture, swinging wildly from Peace Ship to his own machine gun squads during strikes at Dearborn, and his dissemination of the forged *Protocols of Zion*. He remembered the war fatalism of the Clergy in sermons he heard in his boyhood. All of these memories and many others merged with the erudition and insight of a gifted adult, the whole adding up to philosophic and intellectual convictions that stayed with Smith all of his life.[3]

Circulating within the *Medals* are Smith's feelings about pregnancy, abortion, infanticide, defilement, desecration, and venereal disease. This surplus of intense and conflicted desires and impulses functioned for him as an energy field. He implicated himself within the machinery of violence as well as taking an unequivocal stand against the wreckage it caused. While a number of the *Medals* are signed "David Smith," on *Munitions Makers*, his initials in Greek, $\Delta\Sigma$, are inscribed on the butt of a tommy gun; in *Bombing Civilian Populations*, they are on the upright bomb on which a boy is impaled; in *Death by Bacteria*, they are on a coffin. Smith's awareness of the force of his own unsettling fantasies contributed to the urgency with which he struggled for a language that could communicate capitalism's brutality. The dangerousness of these fantasies was evidence of their creative necessity; he needed to find

out what would result if he allowed them to manifest themselves more overtly in his work.

The height and width of the *Medals* range from 7½ to 14⅛ inches. No two are the same size. Their shapes are imperfect circles, ovals, rectangles, and squares whose edges and boundaries can seem pulled and stretched—even violated. While their sizes and shapes suggest masks, the reliefs also evoke plates, bread boards, even bowls—home things, poisoned. Patinas vary from medal to medal and cast to cast. Smith reinvented every aspect of the process, even the separator used in casting. He worked with different foundries and experimented with chemicals and alloys. Every tool, material, and method was meticulously decided, including the fine French sand he chose for casting. "Finally as a result of a conversation with his dentist," Dehner wrote, Smith "bought a dentist's electric drill and an endless supply of different sized burrs, grinders, and polishers, provided by his friend Laslo Schwartz. To these he added some jeweler's hand tools."[4] He used the drill and jeweler's hand tools to carve the plaster.

The key to the process was reverse carving—a technique used throughout the history of metalworking but new to Smith. It enabled him to feel that he had gotten inside or around the back of the image. "Reverse engraving or carving has opened a plastic field to me—A fuller realization of what form means when I can direct it both ways—turn it inside out," he wrote.[5] He had made woodcuts at the Art Students League and studied intaglio engraving in Stanley William Hayter's Atelier 17 in Paris. He had worked with reverse images at the Studebaker factory in South Bend in 1926. The process of reverse carving that he taught himself in the *Medals*, however, required another order of attention and skill. "Instead of being outside working in on the object," he wrote, "reverse cutting required a conception such that I was inside working out. Oftime I envisioned myself inside the object space cutting outwards to the farthermost edges to define it—first you cut out farthest away and gradually recede with objects until you are out on top of the surface."[6] In the *Medals*, he could be both within the body of the sculpture and outside it.

He began by making drawings on tracing paper. Then he put graph-

ite on the paper, turned it over onto the plaster, and traced the outlines. Then he carved into the plaster. When he had an image field, he pressed wet plaster, and sometimes plasticene, into the negative mold. "As he worked, drilling and scraping and proving what he had carved with plasticene pressed into the carving, in order to see the image as a positive, his ideas flowed," Dehner said.[7] He continued to work the positive cast, making corrections and other changes, including adding inscriptions. The first bronze was "cast from the positive plaster—which is the master bronze," Smith explained to McCausland. "This is the master because it is chased, engraved and corrected to conform to the transformation to metal. Thereafter the master bronze is the pattern from which the first and each successive castings are made."[8] Smith sand-cast the *Medals* himself.

Smith made the fifteen medallions with several audiences in mind. First, he was thinking of the leftist artists who, like him, read *Art Front*, marched in May Day parades, and had no faith in the American system of justice. Second, he was speaking to the metalworkers at Terminal Iron Works and to bar buddies near the pier on Atlantic Avenue who would appreciate his dissent, raucousness, bad jokes, and verve. Seeing the *Medals*, they would have no doubt about his artistic skill as well as his political alignment with them. He was also speaking to museum professionals who would recognize Smith's knowledge of the history of metalworking and art-historical references.

Throughout the 1930s, abstractionists had had to endure endless accusations that paintings by Social Realist or American Scene painters were morally superior because abstract art did not directly address social injustice. Smith bridled at the claim that artists who depicted the exploitation of the working class cared more about its plight than artists who didn't. "On the backs of worker and soldier rest the joys of exempt sons," he wrote in the caption for *War Exempt Sons of the Rich*.[9] Large coins are about to topple on a shelf where voluptuous, truncated female nudes serve as bookends. The shelf presses down on the shoulders of a laborer (welder) and a soldier. A woman nursing a pig evokes a Madonna and Child; the breasts of a harpy nestle into wine glasses: she is literally in her cups. "It was class warfare which remained uppermost in Smith's thinking," the art historian Paula Wisotzki wrote.[10]

Each *Medal* includes Greek inscriptions. While they imply classical

erudition, to Smith they were first and foremost street Greek. "Greek inscriptions—all medals have high falutin' falsifications in Latin, Greek, etc. Mine are coffee pot Greek—slang—modern slang Greek—my slight acquaintance of the language while I was there with my Greek conversational guide—my love for the people who spoke it—my joke on classic Greek scholars who expect the classic language—but can't read this— only I and coffee pot Greeks can get it," he told McCausland. "Besides," some of the inscriptions "are dirty."[11]

The caption-like texts accompanying each *Medal* are informational, theatrical, and esoteric. Some writers have described them as "legends." Rosalind Krauss referred to the text for *Propaganda for War* as a "libretto."[12] In her essay on the *Medals*, Dehner wrote:

> Finally one morning he made a few notes himself, and saying that he wanted to have them typed at once he called upon a friend and fellow artist, his Brooklyn Heights neighbor, Lucille Corcos. She set up her typewriter and Smith began to dictate. Instead of sticking to the notes, out poured stream of consciousness poetry, straight from the source that created his art. A poet friend, Alter Brody, was present and he stated afterwards his amazement at Smith's performance. Those introductory statements served as captions to each of the medals and were perfect for their purpose, using as they did a verbal language that matched the spirit and content of the visual images.[13]

The *Medals'* artistic sources include ancient seals, coins, and statues; paintings by Pieter Brueghel and Hieronymus Bosch—Smith referred to them as the "Flanders boys"; engravings by Jacques Callot and Goya, murals by José Clemente Orozco, drawings by André Masson; the Rodin of *The Gates of Hell*, Picasso of *Dream and Lie of Franco* and *Guernica*, and Julio González of *The Montserrat*. Art history, contemporary art, natural history, archaeology, current affairs, biography, comics, mythology, girlie magazines, medical books, the mass media machine, material and technical research—Darwin, Marx, Joyce, Freud. Here, for the first time, is the Smith "workstream."

The ordering in the catalog was decided for the exhibition and only occasionally corresponds to the order in which the *Medals* were made. *Propaganda for War*, number one in the catalog, introduces the series with the national incitement to battle: a muscular Red Cross nurse calls the nation to war by blowing her clarinet on the back of "the curly bull," her running legs like those of the famous Gorgon, or Medusa, on the temple of Corfu. Beneath the bull are his droppings: propaganda is "bull shit." Number two, *Fourth Estate*, also sets the stage: "The Free Press— whose presses run with oil and sex—whose presses are gummed by patent medicine—whose censors, the Power Trust, wield scissors of every known kind—whose hand has wrapped five columns from the Citadel of justice around the index finger—which has tied with ragged knots the brunhildean key to sex and fish." The Statue of Liberty, still holding her torch and a book, is strung up, her genitals exposed.

David Smith, *Propaganda for War*, 1939–40. Bronze, 9⅝ × 11¾ × ⅞ in.
(24.4 × 29.8 × 2.2 cm). The Estate of David Smith, New York.

Next comes *Munitions Makers*, in which skeleton soldiers dutifully maintain their will to kill. Crawling out from the center of the lower

register is a giant "antediluvian land tortoise," its shell like a helmet, its head a skull, its feet and belly spidery; its "low-hanging buttocks" bounce off the ground. Its eye pits do not so much confront as receive the viewer. The tortoise appears pained by the human obscenity that seems every bit as prehistoric as it is. "Look forward to seeing you & civilization (not that civilization is much these days)," Smith wrote to Willard in the spring of 1941.[14]

David Smith, *Munition Makers*, 1939. Bronze (master model),
9 × 10 × 9/16 in. (22.9 × 25.4 × 1.4 cm). Private collection.

In *Death by Gas*, number eight, Smith turns the idealized ice skater Sonja Henie into a monster on roller skates—a "death venus on wheels"—holding above her a toxic sphere, both a perpetrator and a victim of toxic behavior. Paula Wisotzki wrote:

> This figure was derived from a newspaper photograph of Sonja Henie, the famous Norwegian ice-skater, in which she was shown wearing a two-piece bathing suit and holding a large beach ball over her head. Smith altered his copy of the

newspaper clipping . . . eliminating her clothes to reveal her genitalia. Eventually, he transformed Henie into a horrific figure with portions of her flesh eaten away and her breasts strapped on around her neck, dangling in front of her exposed rib cage. The beach-ball prop, which in the photograph Henie held directly above her head in a pose intended to throw her breasts into relief, became a womb inhabited by a mutated fetus.[15]

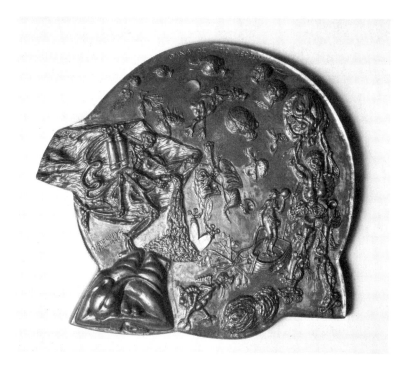

David Smith, *Death by Gas*, 1939–40. Bronze (master model), 10½ × 11½ × ⅞ in. (26.7 × 29.2 × 2.2 cm). The Estate of David Smith, New York.

About *Reaction in Medicine*, number twelve, Smith wrote: "Medical medal is for the A.M.A. [American Medical Association] who cause 200,000 deaths annually (stated by Dr from Mayo clinic) by opposing social medicine, the point being that this like prostitution, starvation etc is increased in wartime." *Elements Which Cause Prostitution*, number

thirteen, has the mawkish urgency of a street poster. The Venus "knee deep in classic water" is pocked with worm holes. On the horizon, a woman on her elbows and knees with hypodermic needles seemingly hurled into her back is racked by venereal disease; a disemboweling vulture is beneath her. "Since middle ages military and Prostitutes are linked—the former unthinkable without the later," Smith wrote in an addendum to the caption.

Scientific Body Disposal, number fifteen, is the end of the road. We are back at the beginning, after human life: "The song of sewage—dust to dust returneth and life to food returneth—mass bombing and mass murder. Those who are meant not to be can be used—as fertilizer, as food for propaganda—transposed through modern industrial channels like pulpwood." Dehner considered this medal and *Food Trust* to be prophetic. "Scientific Body Disposal, one of the first of the medals to be conceived, was made before Hitler's ovens were known to the world. *Food Trust*, depicting the destruction of food while people starved, an-

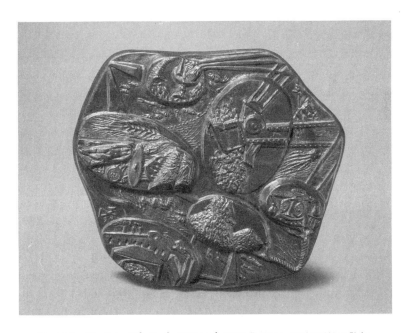

David Smith, *Scientific Body Disposal*, 1939. Bronze, 10½ × 9½ × ⅞ in. (26.7 × 24.1 × 2.2 cm). The Estate of David Smith, New York.

ticipated the massive dumping of wheat and other grain, and the huge stockpiles of surplus food, denied to the hungry."[16]

Smith had big hopes for the *Medals*. There was a market, albeit small, for satirical medals. He planned to use die stamping to produce as many as needed to meet the demand, imagining them as unique objects that could be identified with the protest traditions of graphic reproducibility without actually being mass reproduced. The *Medals* signal a desire for mass appeal without participating in mass culture. Smith wanted them to mobilize antiwar protest and to produce income, and perhaps generate commissions for more such work, without entering the commercial system.

At the same time, he wanted them to be recognized as art that would endure. "I think its wise to stress the technical and aesthetic elements," he wrote to McCausland. "There could be no chance for the political aspect anyhow and there are plenty of papers etc that may stress the political and not be competent to view the art. After all my point is the art—and I hope it will live long after there is use for the political injustices to be stressed—I mean after they are remedied in a more ideal society."[17]

Smith began the medals in Brooklyn, during one historical moment. He completed most of them in 1938 and 1939, after Picasso's *Guernica* was exhibited in New York, as the WPA was collapsing and leftist artists were being harassed by the government. He finished the series in Bolton Landing in the summer of 1940, in a very different moment. If an argument was still to be made against America entering the war, it would have to be made that fall or never. "War spirit had gained momentum to such an extent that it was a poor time to show them," Smith would comment after the war. "Almost not quite ethical."[18]

The show opened on November 5 and ran until November 23. Most critics agreed that the series was worthy of attention. In *The New York Times*, Howard Devree wrote that "the medals need a socio-historical interpreter, rather than, primarily an art critic," but added that "they must be seen to be appreciated."[19] In the *New York Herald Tribune*, Carlyle Burrows recognized an element of fantasy that was rare in sculpture. "Those who remember Mr. Smith's large abstractions in welded metals will doubtless be surprised by the descriptive minutiae to which he has

turned in this work from relatively monumental decoration. Also they may be surprised by his gift of fantasy—a gift which is rarely, it appears, ever carried over into sculpture with such meticulous skill."[20]

Time was mocking:

> Husky, wispy-bearded, big-handed Sculptor Smith . . . Ernest, unaffected Midwesterner Smith . . . From his cabin in the Adirondack Mountains he commutes periodically to Manhattan in a truck which he and his wife use for pleasure as well as business trips . . . David Smith will cast copies of his medals for about $100 each, for anybody who wants one . . . Sculptor Smith calls himself a humanitarian, regards his medals as a purely personal protest against war, which he resents because it may keep him from his work . . . The Smith works were as full of symbolism as the Freudian moon is of green cheese.[21]

"What punks they are," Dehner wrote of *Time* to the Levys.[22]

McCausland's article in the *Springfield Sunday Union and Republican* was the most serious discussion yet on Smith's work, but hardly anyone in New York saw it. Guided by his letters, McCausland emphasized his energy, invention, and emotional and technical resources: "David Smith worked evenings for three years to make his 'medals for dishonor' . . . Days he worked in a Brooklyn water-front foundry, fabricating monumental abstract sculptures. This is duality. For the medals represent a new scale and idiom; represent, too, a new method of work, of reverse carving of meticulously minute planes, compared to which Smith's fabricated metal abstracts are leviathan." She believed in their timeliness and she, too, remarked on their fantasy: "The medals speak in a straight tongue to those familiar only with Smith's abstractions. Yet they are closely related to his drawings, both being Gothic and grotesque in character, subtle and exquisite in line. Fantasy raised to the power of frenzy pervades the medals. They reveal that other world of chaos and death, severely excluded from the planned order of his metal fabrications."[23]

Smith thanked her: "I shall make an attempt to express my appreciation for your brilliant and appreciative review. You have stated many times, things which I never put into words myself but which was what

I meant. It couldn't have been stated better than you have done. I shall always be grateful."[24]

Anxious for sales, Smith reminded Willard about the price—"$110 for any in bronze."[25] She reported that "many people have come and liked it and time will only add to the reputation and create the value. But right now no one will buy them . . . I am not without all hope of making a sale eventually, if not before the show closes, but it is discouraging."[26]

Along with being discouraged, Smith was embarrassed. "I'm sorry for both of us that we were low on sales I had really expected some of that stuff I guess I will have to look to teaching for bread & butter . . . I'm sorry for the galleries end and I'm perplexed about my future. Not that I will ever stop my work but I've got to find something to get along with. I just don't know how to go about teaching jobs at places I would like to teach, or places near me. I'll work something out."[27]

By January 1941, Willard was convinced that the *Medals* were unsalable. She wrote the curator Elodie Courter, hoping the Museum of Modern Art would include them in one of its touring shows: "You can readily see that this is not suitable, except in rare instances, for individuals to own, but that it is most important for it to be widely shown in Museums and to circulate in communities where many can see it."[28] On March 22, Willard wrote to Smith that "Elodie Courter of the Mod art has put the show on her lists of available material for the coming season, which goes to all Museums, etc in the country. As yet no one has requested it on the circuit. The Museums I have approached personally have also fought shy of it. They can't afford to 'shock' the Directors."[29]

Life on the Farm

Smith nicknamed their hillside Tick Ridge. He and Dehner were so fond of the name that Marian Willard and the Levys used it as well. It was probably one of the Ainsworths who anointed Smith "Mayor of Tick Ridge"—an affectionate designation of him as hillside papa. "Our neighbors were always good friends," Dehner said, "not the wealthy ones who had mansions along the lake, but the real country people who, like ourselves, lived a relatively primitive life."[1]

The Smiths were frugal and resourceful. They wanted to be anti-materialistic and anti-consumerist and as self-sufficient as possible. They raised animals, grew crops, planted trees, and tended the land. For eight dollars each, Smith bought sheep. For three dollars each, he purchased pigs, which he sometimes referred to as "boars." He bought the pigs, she fed them, he slaughtered them, they smoked hams, and he lifted the hams off the hook. The pigs ate some of the garbage, most of which became compost. They made egg tempera for drawings and paintings; Dehner used the leftover egg whites for meringue. They made wine and cider. Smith became a knowledgeable mycologist, which heightened their appreciation of the forests and fields. Dehner probably could have been a professional seamstress. He brought in water and wood, repaired the house, and continued building his studio. She did the cooking and cleaning and washed the dishes—no easy task without running water.

They heated bricks to warm icy sheets and used bedpans. "We invented everything—everything, everything, everything. It was like our ancestors did, when they first settled America," Dehner said.[2]

With Smith, anything could become something else and no identity—animal, flower, and tree, as well as human—was settled. He was forever experimenting—not only in the shop, with forms, materials, and processes, but also in the kitchen, where he would become a sometimes wacky and more often inspired chef, and in the meadows, successfully transplanting trees. Early in 1941, he made butter crunch using olive oil instead of the butter they didn't have. Wanting to develop his own lost wax process, he baked wax in the kitchen stove until he had the kind he needed to make bronze. He tested his own fertilizers. Some worked, some didn't. "I have become a plant mother & have nine sweet little plants & only 4 are dying," Dehner wrote. "David fucked them up with all kinds of chemicals & I think that's what ail them."[3]

In *Jamie's Visit*, a 1944 painting in her series *My Life on the Farm*, Dehner commemorated one of Smith's enchanted inventions. She told Lucille Corcos:

> David made me a perfectly wonderful surprise. It is a bird station. On a small round table sits a round grind stone, and in the hole stands a tree limb with jutting branches, and on the branches are Bundles for Birds, consisting of suet, bread, and a bit of left over chop suey. It is very very fine, right outside my window where I can see it all, and I intend to make a painting of it as soon as the birds start coming.[4]

Her painting shows four-year-old Jamie Dodge bundled up in the snow, extending his mittened hand filled with bird food to what looks like a nuthatch perched on a limb of the feeding station. Other limbs seem to be beckoning to him while at the same time, baton-like, conducting the landscape. A conch from the Virgin Islands rests on the round table.

On a whim, Smith and Dehner raised pigeons as squab, clipping their wings so they would not fly away. He hunted and fished for food, regularly visiting the reservoir down the road, giving some of the bass and perch he caught to the water commissioner in return for being allowed

to fish where fishing was not permitted. When Mildred Constantine and her new husband, Ralph Bettelheim, visited on Thanksgiving 1942, Smith shot game for the holiday meal.

He turned livestock into pets. Wolf F. Muller, who owned a factory and engineering laboratory in Glens Falls, gave him a pig in exchange for *Morgan Mare*, a 1942 sheet-thin transparent sculptural drawing of a horse's head and neck, with a yellowish rustproof surface; Smith hoped Muller would hang it from a maple tree. Muller owned horses, which Smith occasionally rode "bareback all over the pastures." Muller wrote, "He had much fun with the pig. It roamed all over his hillside, through his house and his studio. It acted more like a dog—he hand fed it and he could pick it up like a baby. When he welded and the sparks were flying the pig would scram with a squeal, knocking over some iron bars and paint pots. I don't know if he ever butchered it."[5]

In 1941, they planted twenty-four apple trees. At one time or another, they also planted peach, cherry, plum, and pear trees, as well as poplars. In *Garden of Eden*, another painting in Dehner's *My Life on the*

Dorothy Dehner, *Garden of Eden*, 1942. Egg tempera on Masonite panel, 7 × 9¼ in. (17.8 × 23.5 cm). Storm King Art Center, Mountainville, New York.

Farm series, Dehner and Smith stand naked and strong as Adam and Eve surrounded by saplings, each one named on a ribbon-like label. His right arm is around her waist, his left hand holds a shovel. Above them is the rickety barn, a passageway open through it, below their small white house. In her description of the painting thirty-five years later, Dehner wrote: "How wonderful it was to finally have our own orchard set in. We were positively euphoric and thus it was that this painting came to be." The orchard did not pan out. "Alas, in later years it became clear that in our particular situation on a windy hill with icy blasts straight from the North Pole, the trees did not flourish. The orchard, tiny as it was, and planted with such fine expectations was an unsuccessful project."[6]

But the garden did flourish—with tomatoes, potatoes, asparagus, grapes, and buckwheat, as well as flowers. "David would put in the garden and he'd say, okay kid. Now it's yours and okay, boy it was!" Dehner said.[7]

Dehner described their daily rhythm: Up "kind of late," 9:30 or 10. "Right after breakfast he would start to read and I would make his lunch . . . Then he would go down to his studio and I would go into my studio, mostly, unless I had to put the laundry together or some such thing." During the afternoon, she painted or drew and listened to the soaps, religiously reporting on some of them to Corcos. She entered a contest on Granville Hicks's show *Speaking of Books* and won a subscription to Reader's Digest books. After dinner, she would "just react and read, and lie down on the couch and do that, and David would go back to the shop . . . Before the bars closed he would come up and say let's go down and have a beer and we'd go down to the village and we'd have a beer at Dominick's, and kick around the fat . . . and talk with the local boys and then drive up to the house and go to bed."[8]

Some nights they stayed home. "I could knit and read at the same time," Dehner said. "I could even turn a heel between sentences, picking up a few stitches here and there. We'd listen to music." Their "luxury" was buying records, many of which were sent upstate by a friend who ran a record store in the city. Smith requested books from the State Library in Albany or checked them out of the Crandall Library in Glens Falls, where he found the Egyptian Book of the Dead. "Nobody knows what it is hardly and there it was in the Glens Falls library. And there was the

Tibetan Book of the Dead," Dehner said.[9] Her painting *David Reading About Himself* is an enchanted scene of domestic bliss. (See Figure 4 in the insert.) They're listening to a record as she knits and he reads about himself in *ArtNews*, his feet on the clock table they brought from Brooklyn; their black cat, Dinah, lies curled up on a blanket Dehner made for her.

Some days, Smith would say, "Oh, the hell with it! I don't feel like working. Let's go fishing." Dehner would throw together some food and they'd drive to nearby Schroon River. "I would sit on David's shoulders because I couldn't do the bit through the high water, you see, and I'd have my rod, and cast my rod, and he'd cast his rod, and we'd fish," Dehner recalled. "I had an enormous energy, and so did David. He was always very proud of me, that I could keep up with him. He'd say to me, am I too strenuous for you? . . . I would say, I can do it. I knew I had a heart condition but it was not supposed to show until I was 60 years old. That's when I had my operation, the first one. We could do anything."[10]

During the summer, they attended concerts. From 1935 to 1942, Mordecai Bauman worked as a singer and program director at Green Mansions, in Warrensburg, which he described as "one of the early adult summer resorts in the Adirondack Mountains." Dehner and Smith liked when Bauman sang songs from the collaboration between Hanns Eisler and Bertolt Brecht. "They always came," Irma Bauman said. "They didn't relate to Mordy's singing *Don Giovanni* or *The Marriage of Figaro*, but they related to his singing German lieder and the Eisler songs."[11]

In 1940, fifteen-year-old Hugh Allen Wilson was already choir director and organist for the St. James Episcopal Church in Lake George. He would become an internationally known harpsichordist, the conductor of the Glens Falls Symphony Orchestra, and president of Bolton Landing's Marcella Sembrich Opera Museum. Smith went to his house to hear him and his mother, Anna Allen Wilson, a classical pianist, play. Wilson was one of the few people Smith invited to his shop-studio to watch him work. He would give Wilson a 1945 drawing that is, in effect, a flock of harpsichordist's hands, each one different, most of them like fairy-tale creatures, whose fingers turn into claws or feet, and wings.

Dehner painted the works in *My Life on the Farm* between 1942 and 1944. Some of the eighteen paintings are gouaches. More are painted in egg tempera. Dehner's touch is light, her color—particularly in her blues,

browns, and reds—is often luminescent and, unlike Smith's approach to color, pure, seemingly unmixed; her feeling for fabric—rugs, shirts, dresses, blankets—is exceptional. She pictures the seasons, their farm and the town, as well as neighbors like the Ainsworths and visitors like Willard. Painted during turbulent years, the series is harmonious and even utopian in its faith in community, preindustrial existence, and love as the state of nature. There's little sign in it of Cubism, Surrealism, or of any other avant-garde movement. Nor is there any evidence of Dehner's sweeping dismissals of other people or complaints about neighbors or the wearing demands of the farm. There's barely a trace of tension with Smith, who lived close to the edge during these precarious years. Goodness emanates from—is willed into—this series. Dehner and Smith were in nature, together, and everything was going to be okay.

For Smith, in *Medals for Dishonor* the adjective "medieval" signified the worst human behavior. Dehner found in the Middle Ages an ideal of harmonious life and intimate picture-making. *My Life on the Farm* was inspired by *Les Très Riches Heures du Duc du Berry*, the beloved fifteenth-century French Book of Hours by the Limbourg Brothers; Smith gave her the book. Its scenes of the seasons and everyday life contributed to the popular image in the nineteenth and early twentieth centuries of the Middle Ages as a more humane and communal era than that of monopoly capitalism. While Smith studied the material makeup of Brueghel's paintings and felt an affinity with his wildly imaginative and at times apocalyptic visions, Dehner was inspired by Brueghel's infectious genre imagination. "The country side is heavenly under this deep snow," she wrote to Corcos. "You would see a million things to paint. I am going to do a picture of the men slaughtering the hogs with the big boilers going & some scraping & the already skinned & cleaned out ones hanging up white & solid in the trees. It's a real Breughal subject alright."[12] Like *Medals for Dishonor*, Dehner's series combines words and images, but her words, like her images, project a reassuring warmth and contrast sharply with the extravagant erudition and disruptive beauty of Smith's image bursts.

The art critic Judd Tully wrote that Dehner's paintings "remain a vivid document of two artists' lives, perched on a mountaintop, under the illuminating shadow of the Adirondacks," but, more accurately, they

tell the story of *her* hopes, *her* vision, and *her* world.[13] In the irresistible 1942 painting called *My Life on the Farm*, containing eleven scenes, none larger than 2½ inches square, Dehner chronicles the amplitude of her country life. (See Figure 5 in the insert.) She paints herself planting trees; standing at her toilette; reading mail on the spot at the foot of their long driveway; and feeding birds from her hand, like St. Francis. In other scenes, she and Smith are reading the leftist newspaper *PM*. She also paints them asleep, in two different seasons, both with a full moon visible through the window by their bed. In her series, Smith is present as fellow pioneer and dreamer, but in the painting after which the series was named, the life she paints is her own. She portrays herself at her easel. The series does not include an image of Smith making sculpture or building.

In *Poor Rosebud*, the 1942 Brueghel-inspired painting she mentioned to Corcos, the division between male and female is pronounced. Dehner is mourning a pig while two men are immersed in the act of butchering it, Smith intensely, the younger man joyfully. A third man smiles as he carries wood to a pot of water heating on an open fire. Dehner, in kerchief and apron, holds her hands open as if she cannot decide whether to comfort Rosebud or pray for her. The pig is larger even than Smith, who scrapes the fuzz off the innocent-looking creature on an improvised table. Soon Rosebud will be cut open and hung on a hook like the butchered pig inside the shed. Dehner and Rosebud form one affective bond, Smith and the two other men another, and her sympathy is with the about-to-be butchered pig.

Even as Dehner and Smith were basically accepted in Bolton Landing, the people in the town knew that they were different. The artists had been grilled by the FBI, and local residents must have known this. While upstate, Dehner was the more activist of the two. Smith had made the *Medals*, and his art was known to be abstract. It was he who concerned the authorities. "I think they thought he was a Communist," Mary Neumann, a neighbor, said. "He had such radical ideas. After all, he came from New York City up here, and you're an outsider to start with, right there. Then when you start spouting ideas that are not generally accepted in town, you're a radical."[14]

"I'll tell you one of the things that my mom remembers," said Tom Pratt, whose father, Leon Pratt, was Smith's indispensable assistant during the last seven years of his life. "I can remember her saying that the people in town . . . were sure he was a Russian spy or something, during the war, because he had studied in Russia."[15]

In 1941, Dehner wrote: "The Ainsworths always say something nice about the Russians because they think *David* is Russian. Because we were there & the beard etc. He told them he's a yankee but they still think he's a Russian. It's a good thing the Russians are on our side."[16]

What to Do

Smith was determined to do everything in his power to avoid being drafted. He had an aversion to regimentation and top-down authority and did not know how he would react in a situation that cultivated aggression. "Smith seems to have been genuinely concerned about the consequences of placing his volatile temperament in contact with sanctioned violence," Paula Wisotzki wrote after interviewing Dehner.[1] But he also knew that Hitler had to be defeated and it was unthinkable for him to remain on the sidelines like "war exempt sons of the rich" while neighbors, members of the working class, and art museums, including the Metropolitan Museum and the Museum of Modern Art, served the American war effort. On April 2, 1942, the leadership of the American Artists' Congress, to which Smith and Dehner still belonged, wrote its members that "the artist's need to be integrated in the war effort is clear to all of us." After the Japanese bombing of Pearl Harbor, it would have been unseemly and dangerous for Smith to be seen as believing, in Wisotzki's words, that the "second world war was no more than another imperialist conflict in which neither side deserved support," which was one of the messages of *Medals for Dishonor.*[2]

As local men were drafted and others went to work on defense projects, Bolton Landing emptied out. It is "just like a war town," Dehner wrote to Corcos. "Only old folks & kids (& *us*) & the Knaths." Karl

Knaths was a modernist painter. Young men "who learned how to do welding . . . are making over a hundred bucks a week at G.E. in Schenectady. It's like a boom town every weekend when they come home. They all get drunk as hell."[3]

Smith was #1282 in the draft in Warren County. By spring 1942, 524 men had been drafted. Smith pursued two kinds of jobs, both with the potential to support the war against fascism, serve his art, and keep him out of the army. To become qualified for high-skilled factory work in the defense industry, he took a welding course at Union College in Schenectady one night a week and classes at the free National Defense School in nearby Warrensburg. He wrote to Marian Willard:

> I'm in welding (electric) class, there is a lot I've got to learn in this field to be a production welder Im taking 10 hours a day, 3 days a week (Free Defense School) I'm here till 12 at night that gives me ½ day at home before I come over to school. Lathe and machine work is interesting. I'm studying texts outside also. I've an ulterior motive, after the war I'll show you some absolute precision art—I've been mulling on this several years and making drawings. I'm learning the technique and science to accomplish it later—learning is like art its one of the gratifying things in life.[4]

Smith probably began arc welding in 1939. Arc welding depends on electricity and is cheaper and faster than oxyacetylene or gas welding. Gas welding requires heating the metal in order to join it. With arc welding, electricity fires through the electrodes, touching and melting the steel. "Arc welding causes the different pieces to melt and run together; torch cutting punctures and burns the metal," Rosalind Krauss explained.[5] Because of its speed and the mobility of the welding machine, arc welding allows for greater experimentation. It allows for tack welding, in which parts can be temporarily attached, as in basting a pattern onto fabric in dressmaking. The variability of the power and settings makes it possible to work with larger and thicker metal—like the steel used to build tanks and locomotives. An arc-welded sculpture can communicate speed not just of cutting but also of attaching. "Arc welding is

a free and natural medium to me," Smith would write in 1947. "It is the most desirable method of joining metal . . . in sculpture."[6] Arc welding made possible his sculptural inventiveness and scale.

On May 15, Smith wrote to Willard that he would "soon be ready to go out to get a welding job. Will try Schnectady first—Some of the boys are at the Bell Aircobra plant in Buffalo." Bell Aircraft Corporation's Airacobra plant in Buffalo built state-of-the-art bombers. "If I don't get anything in Schnectady I'll try Bklyn Navy Yard maybe. Have to pass an electric welding test at any of the plants. Shaved beard & mustache—ready to fare forth like the other workingmen." At the end of the letter, he added, "How do you like the way our Rusky boys are holding the fascists."[7]

He also pursued jobs making medallions. In March 1942, Wisotzki wrote, "he registered with Artists for Victory, the professional organization devoted to actively supporting the American war effort. Smith did so as a medalist, suggesting that he might do 'some swell Red Cross–Industrial or anti-axis medals.'"[8] On May 30, to Robert Nathan of the War Production Board in Washington, Smith proposed "medallions to be awarded for extremely meritorious war production service in industry." They could be given, for example, to factory or shipyard workers who "have given Sundays work gratis for production in the war effort. This sacrifice should be rewarded." His shop-factory was equipped to "produce from 1 to 100,000 or more medallions of superior artistic quality." Hoping to ward off concerns about him that might be raised by reviews of *Medals for Dishonor*, he assured Nathan that these were, first of all, anti-fascist works and that his criticism of the "dishonorable and destructive elements of society" did not conflict with his commitment to the war effort. "My basic conception has always been anti-fascist and pro-democratic," he declared.[9] On June 1, he applied for a job in the design department of the American Locomotive Company in Schenectady, where as many as a hundred men from Bolton Landing would work. Here, too, he made the point of knowledge gained from factory work and the *Medals*, and the efficiency of his factory-like shop: "I have a thorough working conception of reverse carving and designing, which is applicable to medallions, name plates, insignias and die work." He wrote that he was "a recognized Artist Designer of the modern school" whose

"talent is not all visionary. I know when precision and when mechanical function dictates design, and understand the technical processes a part goes through on the production line."[10]

The Levys, too, left Brooklyn, moving to New City in Rockland County, thirty miles north of Manhattan. Their "compound" was part of what Joel Corcos Levy, their younger son, said was "an Upper Bohemia in those days, on a road that had many, many artists on it already—and playwrights and people like Maxwell Anderson, Kurt Weill, Lotte Lenya." South Mountain Road was "well-known in the annals of an earlier group of artists and writers" that included Maurice Prendergast, Edward Hopper, and other artists "who were not in the WPA, who didn't really need to be."[11]

When the Levys left the city, Dehner felt uprooted. However idyllically she pictured life on the farm, she missed the artistic community in Brooklyn. "I get pretty lonesome for people. Ive decided that middleclass people who have turned into radicals are about the only people I can stand very much of . . . There is a limit to how far you can go with an Ainsworth. Hope you come up soon," she wrote to the Levys.[12] But her ambivalence remained: "I dread the thought of living in a city again. I've gotten so used to being *healthy*. God knows where we will end up. We are pretty unprejudiced about it & will go *anywhere* a job is."[13]

Smith, too, was feeling increasingly isolated upstate. On a couple of occasions, he described himself as a "hermit." And in the country his sinus infections were worse. In spring 1942, around the time he was working on the plaque for his father's grave, anxiety about his lymph nodes led to two weeks in Mount Sinai Hospital in Manhattan; the test results were negative. "That was a hell of an incision—9 stiches + 5 in. deep," Dehner wrote to the Levys.[14] They had other physical woes. Dehner came down with hives. While visiting the Levys on Fire Island, poison ivy covered Smith's body. "He has it where Edgar had it & in fact it didn't miss anything," Dehner wrote.[15]

Sculpture materials were now scarce. Smith was grateful for the one hundred pounds of pig iron he attained for $50 from a young man from Glens Falls who came to him as a student. In 1942, gas and rubber as well as food rationing deepened the sense of uncertainty and lack. Willard's comments about the art market were disheartening. "The interest

in ART is most at a standstill right now," she wrote in May 1941.[16] In December: "The market for sculpture is going from 0 to sub 0."[17]

Like Dehner, Smith needed both the country and the city. "When I'm in New York my circumstances aren't pretty and I long for a country breath—and up here I miss the art gossip and shows," he wrote to Willard.[18] But he was building the shop-studio he needed and had space for his sculptures, and the variability and extremes of the North Country climate suited his temperament and tested him. At the same time that he was finishing the plaque for his father's grave, he was developing a sign for a theater in Skidmore as well as making fracture splints for the Red Cross and drawings and sculptures. In Bolton Landing he was productive and, through what he made, still in the world.

Beginning in 1941, he was a regular in the Whitney's "Annual Exhibition of Contemporary American Sculpture, Watercolors, Drawings and Prints"; ultimately, he would be in eighteen Whitney Annuals or Biennials. His sculpture was included in two exhibitions organized by MoMA: *Headscrew* traveled with "Twentieth Century Sculpture and Constructions," which was at the Honolulu Academy of Arts when Pearl Harbor was bombed. Smith saw the show at Skidmore College in 1943. "Our headscrew is in company with Picasso, Duchamp Arp, Moholy-N etc—about the best group company I've been in," he wrote to Willard.[19] *Growing Forms* toured with MoMA's "Fifteen American Sculptors." *Ad Mare*, *Bathers*, and *Private Law and Order Leagues* were included in "Artists for Victory: An Exhibition of Contemporary American Art," which opened at the Metropolitan Museum at the end of 1942. At around the same time, for $300, Alfred H. Barr, Jr., bought Smith's 1938 *Head* for the Museum of Modern Art, which exhibited it in the sculpture garden.

In January 1942, "American and French Paintings," which John Graham curated for the McMillen Gallery, marked the momentous shift of the center of the art world from Paris to New York. Graham presented American painters, most of whom Smith knew, including David Burliuk, Stuart Davis, and Willem de Kooning, alongside Braque, Matisse, and Picasso. The show included *Birth*, a ritualistic swirl of a painting by thirty-year-old Jackson Pollock. A year later Mondrian would be stunned by Pollock's *Stenographic Figure*: "I'm trying to understand what's happening here. I think this is the most interesting work I've seen so

far in America."[20] Graham is credited with discovering Pollock. "It was hard for other artists to see what Pollock was doing—their work was so different from his," de Kooning said. "But Graham could see it."[21] In October 1942, Peggy Guggenheim opened her Art of This Century gallery two blocks from Marian Willard's gallery. Her Surrealist room, with its curved gumwood walls, designed by Frederick Kiesler, offered a theatrically flamboyant viewing experience tailored to the art she was showing. Art of This Century provided a dynamic exchange between European and American abstraction and Surrealism. The gallery would give younger American artists like Rothko, Motherwell, and Pollock their first solo shows.

André Breton, Max Ernst, and Yves Tanguy were among the Surrealists who had fled to New York. Fernand Léger and Mondrian, both of whom had lived through the moment of Cubism and extended its possibilities, had arrived there, too. Some of the European refugee artists were curious and available, others condescending and chauvinistic. "We have met them and we have found that they were humans like we were and they were not gods, and they were human beings, and fine artists," Smith would recall in 1961. "And so we know more about the world now."[22]

Willard was a lifeline. She and Smith discussed his upcoming exhibitions and other artists in her gallery, including Stanley William Hayter, Alexander Calder, Lyonel Feininger, and Morris Graves. She showed Paul Klee, with whose paintings and writings Smith felt a special affinity. She was, however, no fan of Surrealism: "The art world is overpowered at the moment by the Surrealists but between you and me it is a mighty sick performance and I don't give them much more time, at least not on the 'new order.'"[23] But she showed the Surrealist André Masson, whose work had a graphic energy and imagination that Smith admired. Through her, he met people he wanted to meet. "I enjoyed your party so much," Smith wrote to her in March 1942. "I can feel a stimulating sence of rivalry with people like that [Jacques Lipchitz], tho I'm younger and less experienced but it gives confidence for progress beyond the status quo (of either), I'm glad to meet [Sigfried Giedion] and Masson. Hope Masson show a success. Am reading Gideons book [*Space, Time & Architecture: The Growth of a New Tradition*] (got it from State Library Albany by mail)."[24]

Willard's feeling that during the war a new artistic order was taking

shape hit a nerve in Smith. Reality was changing. When the war ended, the world would be different. He wrote to her:

> I think your right about the art of the country simmering— but it wont come out till after the war and how many of us are going to live till then is undetermined. Personally it wont do me a bit of good to know that the revival will take place—if I'm not there to participate. Funny feeling to be creating objects, images, which I know I can't complete for 5 years, all the time knowing that in 5 years, those objects I have created won't be congruent with my actions by that time.[25]

In late May, Willard visited Bolton Landing. Dehner and Smith had a truck, and trucks were not yet subject to gas rationing, so they could pick her up in Albany. He had built a guest room, and they were grateful for one another's company. "As always it was fine being with you both," she wrote to him later. "Since my last visit in October God knows the whole aspect of the world has changed and naturally our adjustment to it and to each other. Nothing remains static and as one changes so do relationships both personally and related to our work. It is good that our paths keep running along so well together. Such relationships make for a solid basis from which to work and strengthens our individual beliefs [in] the work."[26]

For Dehner, the isolation was becoming stark. "It is awful not to be able to talk to anybody *really* . . . I get terribly lonesome. It's not that I'm not *busy*. I work like hell but sometimes 2 or 3 weeks go by & I don't see a soul except David & I'm afraid for my 'normalcy.'"[27] They knew it was only a matter of time before leaving Bolton Landing—but where would they go, and when?

26

Welding for War

At the end of June 1942, Smith's efforts paid off. He got a job in the defense industry, at the American Locomotive Company in Schenectady, fifty-five miles south of Bolton Landing. Dehner passed on the good news to the Levys: "The forman on the tanks is a guy from Bolton who can help a lot in pushing David into better work & has ideas of some kind of decent future there for him in a few months after he does his ground work. So that is a lot easier than going in *cold* as you can imagine. He will get $60 a week to start (which looks good) and can go to $100 in a matter of months."[1]

Because of the American Locomotive Company and General Electric, Schenectady, with a prewar population of around fifty thousand, was a boom town. ALCO worked for the army and at the height of the war employed ten thousand people; GE worked for the navy and employed forty thousand. ALCO was known for its state-of-the-art tanks, tank destroyers, and locomotives; Smith worked on all of these machines, at one point shifting back and forth between locomotives and tanks. ALCO, and probably also GE, ran its plant nonstop, on eight-hour shifts. Security was tight. Soldiers, FBI agents, guards, and inspectors circulated throughout the plant, but not at night. Workers were fingerprinted and wore their ID photos on a button, and clearance took a half hour at both ends of Smith's graveyard shift, 11:30 p.m. to 7:30 a.m., seven days a

week. He drove or took a bus to work and wore a welding outfit that covered his entire body. "Its hot as all hell," Dehner wrote of it. "Leather & asbestos. And the work is hard. He has to heave armor plate of stainless steel around & make the frontal armor plates on the tanks."[2] At two or four in the morning, he ate lunch. In daylight he went to bed and slept badly.

Smith went to Schenectady alone. He "rooms with a middle aged bourgois couple & has a bath all to himself," Dehner wrote. They "don't know he works on tanks (nobody with decent rooms will take a laborer) and just took it for granted he was an executive because of [his] *mustache*."[3] Other men at the factory forcibly, and humiliatingly, shaved off his beard. Perhaps they shaved it off because, as Dehner noted, "all the guys think David is German & Jewish & think he was just kidding when he told them he was English descent & a goy (after they asked.)."[4] He had run-ins with foremen throughout his time at ALCO, but he made many friends there and his union, the Congress of Industrial Organizations, to which around 90 percent of the workers belonged, stood by him. "He actually *likes* his work," Dehner remarked to Corcos at the end of July. "He says huge guns bristle all over the place & long rows of tanks roll off the line. There is a kind of excitement in it I guess."[5]

Dehner followed him to Schenectady in late July or early August. They finally found a place to live, for $60 a week, "an attic apt. in a huge old fashioned frame house," Dehner reported. "It is crummy but not too awful & kind of cute in a way . . . We have the whole top & it has a private entrance & our own meters & stuff. We have to heat it ourselves & shovel the coal, but it is a positive blessing to have anyhow. It is absolutely the only thing we could get."[6]

Smith worked in a newer, more modernized part of the plant, with good ventilation. Pay was good and he had hospital coverage, but its responsibility was to meet government demand, which could either accelerate, obliging men to work two of the three shifts, or slacken off. Workers had little or no job stability. They could be laid off—as well as rehired—at the drop of a hat, and a laid-off worker was in danger of conscription. Smith did everything he could to prove himself. He took welding classes and was eventually designated a master welder, which made it harder for ALCO to avoid paying him what his labor was worth. He

mastered all the tools, materials, and techniques required for construc-
tion of the powerful machines. He learned the entirety of the production
process, including the part-after-part sequences in which the machines
were assembled. He learned the machines. When he needed moments of
refuge, he climbed inside the locomotives and probably also the tanks,
experiencing the machines from the inside.

The contradictions were extreme. Smith was around limitless quanti-
ties of steel but largely unable to make steel sculpture. He was producing
weapons after spending years on a scathingly antiwar series within which
one of the indelible images attacked the arms industry. As much as he
wanted to see the United States defeat fascism, he was making weapons
for a nation in which he and Dehner still believed less than in the Soviet
Union. Nevertheless, he was proud of his job. In her review of Smith's
1943 show at the Willard Gallery, Maude Kemper Riley wrote that "the
sculptor speaks with pride of the M7's which cracked El Alamein, and
which are 'ready to roll' when they leave the plant. Guns mounted and
test driven for a 50-mile fast run. He puts tank bodies together when he's
not turning out locomotives, and says this work is of tremendous help in
his art."[7] But Smith was also bitterly and sometimes violently frustrated
by having so little time to make art, and he knew that innocent people as
well as enemies were killed by ALCO machines.

The graveyard shift ground him down. "To tell you the truth, for the
first time in my life I am tired," Smith wrote to Willard in late August. "7
days a week or nights rather, straight day in day out is difficult. Not that
I haven't worked that hard before—but this work has no mental stimulus
behind it, nor any excitement. As I told you, trying to sleep days is the
hardest. My waking hours are lethargic, totally without art inspiration."
Smith and Willard planned a show for 1943 even though he was unsure
he could contribute new work. "A show should be new and exciting," he
wrote. "This war looks years to go yet. The industrial set up is planning
on it. But art won't be what it was before I'm sure of that.—what and how
it will tend no one can say. But my outlook will change, I feel it happen-
ing. Maybe a depth of seriousness not before possible will result."[8]

Smith and Dehner's marriage was tested. "He never talks about his
work or the factory or the men & I feel that it is unhealthy," Dehner
wrote at one point. "I try to talk casually once in a while but he's just a

clam & you know you can't do a thing with him then. At least I get rid of my neuroses by blabbing & letter writing & self pitying I guess, but he never says a thing & I feel that he's storing it all up."[9] Having to remain quiet all day while he slept was a strain on her, and given his resentment about limited opportunities to make art, she had to be careful what she told him about her paintings and drawings. She brought their cat from Bolton in order to have companionship and a warm body on which to lay her head. Occasionally they returned to Bolton Landing for short weekends, but the stays were rarely restful and even when they remained for longer stretches, they never had enough time to do what either of them needed to do. In the winter of 1942–43, the snow in their driveway was too deep to be plowed. Before the snow melted, he went back just once, she not at all.

They detested Schenectady—although toward the end of their nearly two years there, her daily walks inspired *Frosty Morning*, a soulfully serene painting in which seven pairs of nuns march in procession down a sickle-shaped path toward a neo-Gothic church. "This is a dopey bourgeoise (100 %) town," Dehner wrote. "All Middle class. All Republican."[10] In late October or early November 1942, "about to die of lonliness & house routine," she traveled to Cincinnati for the first time in fourteen years to see her family.[11] Aunt Flo, her good aunt, who was like a mother to her, had become an air raid warden and staunch leftist. "I hope I can keep my blasted mouth shut & not give any of the ancients apoplexy," Dehner wrote. "After all, they are all in their seventies eighties & I ought to be careful. Flo is the only one to really come out right. She thinks Stalin is fine . . . & gives money to the Russian Relief."[12] When Dehner showed her family photographs of Smith's sculpture, they were mystified: "They turned them upside down & every which way, finally my Aunt Jo, decided one of them was a dog & couldn't be swayed from that idea (83 yrs)."[13]

From Cincinnati, Dehner traveled to Paulding. Golda and Catherine, Smith's mother and sister, were easier to be with than Dehner's bickering relatives. They welcomed her and news of Smith and commiserated about her difficulties with him. In Catherine, as with Flo, Dehner found support for the Soviet Union: "Catherine has turned out to be a swell girl & you should hear her talk up for the Russians. This is not hard to do in N.Y.

but considering the un-e[n]lightened attitudes of the middle west middle class she is a honey."[14]

It was in Schenectady, in the winter of 1942–43, that Dehner painted the *Garden of Eden*, which envisioned better times after the war when she and Smith would return to their hillside, the Adam and Eve of their harmonious idyll. She liked the painting. He didn't. Because he was "so touchy about his Body," she was afraid to show it to him. "I suppose he would let me show it in Kalamazoo but not where he'd be recognized," she wrote.[15] It's hard to imagine that Dehner's admiring image of him naked is the reason he did not want the painting shown. His reaction surely reflects a collision between the painting's guilelessness and optimism and the ruthless pressures of war production and ALCO's culture of extreme masculinity. Dehner's artistic wager on the goodness of human beings in a state of nature jarred with an arms factory during a horrific war.

In 1941, with *Atrocity* and *War Landscape*, small tactile bronzes featuring phallic canons and prostrate female bodies, Smith had connected war with rape. In drawings he made while working at ALCO, he continued to create images that expressed his concern, perhaps obsession, with what he saw as the obscene sexuality of war. *Aryan Fold Type I* is set in a desolate warscape: Four women lie naked on their stomachs; another woman, bound to a stake, looks at her oppressor; a sixth woman, shackled to a post, her head clamped in what resembles a cow stanchion, bends down, exposed to the viewer. A weird brute male big-game hunter, as much prehistoric as modern, the boss of the Aryan fold, watches over them, seemingly with the authority to do what he wants, except that his hands are tied behind his back, the trophy beast under his foot seems to be laughing at him, and he, too, seems trapped in a scene of submission and domination. Desire has a sinister edge here, and if this is a state of nature, it is not Eden.

By the end of the year, three promotions and pay raises had brought Smith's salary to $82 per week, some of which he invested in stocks and bonds, including in General Electric. He was still on the graveyard shift but not always seven days a week. He had Sundays for artwork.

On January 5, 1943, the Willard and Buchholz Galleries opened "American Sculpture of Our Time." It was not a particularly ambitious show, not the kind that galleries organize with large expectations. But

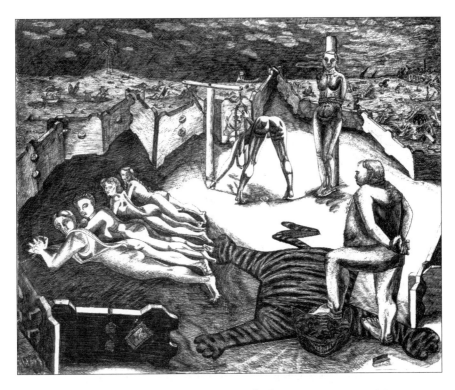

David Smith, *Aryan Fold Type I*, 1943. Pen and ink on paper, 19⅝ × 25¹⁄₁₆ in.
(49.8 × 63.7 cm). The Estate of David Smith, New York.

one visitor was a thirty-three-year-old art critic named Clement Green-
berg. *Partisan Review* had been publishing his essays on literature and
ideas, and his Marxist-informed meditations on the cultural conditions
that art needed to confront. Greenberg was determined to identify the
art that promised the most intense experience in that moment, made by
artists with the historical consciousness to understand, as he wrote in
1939, the "decay of our present society."[16] The following year, he wrote,
"It was to be the task of the avant-garde to perform in opposition to
bourgeois society the function of finding new and adequate forms for the
expression of that same society."[17] In 1942, he began writing regularly for
The Nation. His critical insight, his understanding of modernism begin-
ning with Impressionism and structured around Cubism, and his ability
in pointed, economical prose to articulate a vision of artistic and critical

mission were making him a voice for the art that was taking shape in, and making claims for, the new artistic vitality of America.

Greenberg's brief review of "American Sculpture of Our Time" announced nothing less than "a renaissance of sculpture in this century." He continued:

> Rising industrial capitalism, with its concern with distances, energies, and dreams, found sculpture too literal a medium in which to express itself well . . . It is mainly the work of painters Cézanne, Renoir, and even Seurat and Van Gogh—that has made sculpture once more possible as a great art form . . .
>
> The renaissance has reached our country . . . Now there is David Smith, whose work puts in the shade almost everything else at the Buchholz and Willard exhibition . . .
>
> Yet of the better work none comes close enough to great art . . . except David Smith's [1937] *Interior.* Smith, who, fittingly, is more smith than carver or modeler, has welded and molded rods of steel and bronze into a sort of horizontal cage figuring the skeleton of the organism which is the family, and whose corporeal identity is the house . . . Smith shows for almost the first time that a house can be a proper subject for sculpture in the round. However, the work does not stand on its symbolism but on its formal energy, for which the symbolism is only a springboard. One's eyes are led along the rods without a misstep; the divisions of empty space within them have a life of their own and develop and change like chords in music; and the rust on the metal adds just the right touch.

Greenberg ended his review with a pronouncement: "Smith is thirty-six. If he is able to maintain the level set in the work he has already done . . . he has a chance of becoming one of the greatest of all American artists."[18]

Two weeks after Willard sent him the review, Smith informed her that he had been classified 1A. He was available for military service and would be going to Albany for an induction physical. But he was still working at ALCO and not overly concerned that he would be drafted. He wrote to Willard of his visit to Skidmore College to hear Moholy-Nagy, the former

Bauhaus teacher who had started the School of Design in Chicago. Smith liked him: "Few foreigners get the temp of U.S. and its screwy aesthetics. I never want to be a foreigner—I'll stay where, I get the nuances and know all the angles. He offered me a job in Chicago. I promised to write after I had my physical . . . He diden't mention money, and Chicago is far away."[19]

He poured out his appreciation of Greenberg's review:

> It certainly was an experience having somebody stick their neck out for you. I've always felt confident of certain potentials but to have someone so state, is most gratifying & uplifting especially in this bourgoise damned—souless town Sometimes being with these middle class lugs—(that goes for certain supposedly G.E. engineers I've met at college)—I feel like a hunk of Alco steel, getting rusty because its more stimulating than their association. When you're tired and grinding—no amount of lofty theory can make you produce irrespective to the effort expended. I mean I work but Im not satisfied.[20]

In February, ALCO laid off many men. That month, both Dehner and Smith exhibited at the Albany Institute of History and Art. He showed three of the *Medals for Dishonor*, which he now called *Medallions for the Axis*, thereby directing their rage away from capitalism and the arms industry toward what Clif Bradt, in an article on Smith, referred to as "the debauch of the dreadfuls"—the alliance of Germany, Italy, and Japan.[21] Reviewers noted the differences between Smith and Dehner. "The strange forms of abstract sculptures contrast strongly with the gouaches and egg temperas on the walls," wrote one reviewer. "One is the translation into metal forms of an imagination that deals with genius in symbolic commentary on human living and the rhythms of a continuum that can be felt but not talked about. The other is a priceless group of pictures of native affairs that should be nailed down before they get out of this region."[22]

While Dehner was traveling regularly to Albany to paint a portrait commissioned by John Davis Hatch, director of the Albany Institute,

Smith was going to Saratoga Springs to carve stone at Mallery and
LaBrake Monument Works for his upcoming show at the Willard
Gallery.

"Ive been working nights, going to Saratoga 2-3 days a week carving
marble in monument shop getting 5 hours sleep these days," he wrote to
Willard in March. "Two days and Ill be old man of thirty seven. Christ
how short is life and how much to do yet."[23]

His exhibition of eighteen sculptures and five drawings opened on
April 6. It included *Atrocity, Aryan Fold I* and *II*, and *Widow's Lament*,
a small welded-steel-and-bronze sculpture that is evidence of his
Freudian-inspired delving into family, childhood, and desire. The title
seems to refer to Golda after the death of Harve Smith, her husband,
but Smith's thematic titles are rarely as straightforward as they seem.
The sculpture features an open rectangular frame perched on two bell-
shaped supports or feet. The frame suggests both a goofy head and an

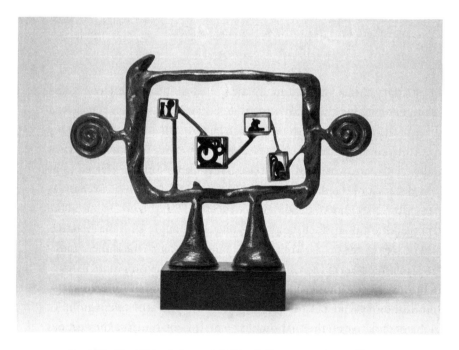

David Smith, *Widow's Lament*, 1942–43. Bronze, steel; wood base, paint,
13½ × 20 × 6⅝ in. (34.3 × 50.8 × 16.8 cm). Base: 2½ × 8 × 5 in.
(6.4 × 20.3 × 12.7 cm). Private collection.

equally goofy, almost hilariously squat little body. Inside it, projecting from metal rods, are four tiny frames, their contents hinting at family scenes that, in a notebook, Smith identified with "simplicities of child-hood," "knots of adolescence," "complexities of marriage," and "sorrow."

Reviewers were fascinated by Smith's double identity of artist and laborer. *Newsweek* wrote:

> By profession David Smith makes abstract sculptures. By av-ocation, he puts armor plate on M-7 tanks for the Army. But he isn't as versatile as he sounds, because he employs the same techniques as war-worker that he uses as sculptor; welding, forging, hammering, chiseling. For the tank job he has re-ceived the Army-Navy "E." For the other, critics praise him as the "strong medicine" which art occasionally requires.

The writer noted that "apparently this double life" as artist and indus-trial worker "agrees with Smith. He has lost none of his 220 pounds. He gave up his beard as a concession to the assembly line, but he still has his mustache and the close-cropped hair which gives him the sinister look of a Nazi spy in a Hitchcock thriller."[24]

But the artist and the laborer were not a seamless fit. At ALCO, Smith's situation was very different from that at the Studebaker factory in South Bend in summer 1925, which felt utopian to him in its collaborative energy and acceptance of him, and at Terminal Iron Works in Brooklyn, where the factory owners and dockside community accepted him as an artist. At ALCO, Smith largely concealed his artistic identity. "Few Welders at ALCO Plant Know Their 'Buddy' Is Famed Sculptor" was the headline of a February 3, 1943, profile of Smith in *The Knickerbocker*, an Albany news-paper: "To most of the boys on the midnight-to-8 a.m. graveyard shift, Dave Smith is just another welder, a pretty good one, too, but no high-and-mighty sort."[25] ALCO would value the positive publicity inspired by one of its workers and had publicity photographs taken of Smith, and it may have made available to him some of its equipment.

Smith's jobs transformed his approach to work. Building tanks and locomotives, Maude Kemper Riley wrote, "gains for him control over manual operations of all kinds; teaches properties of metals and pro-

cesses of shaping them."²⁶ Smith would write in 1952, "My aim in mate-rial function is the same as in locomotive building, to arrive at a given functional form in the most efficient manner. The locomotive method bows to no accepted theory of fabrication. It utilizes the respective mer-its of casting, forging, riveting, arc and gas welding, brazing, silver sol-der. It combines bolts, screws, shrink fits all because of their respective efficiency in arriving at an object or form in function."²⁷ But he did not discuss art at ALCO, and Smith the artist seems to have felt almost as alien there as he had as a young man in Paulding interested in painting.

Smith never stopped believing in an alliance between artists and workingmen, but after ALCO his hope for that alliance was pushed into the future. At the end of the war he wrote in a sketchbook one of his most fateful statements: "By choice I identify myself with workingmen and still belong to Local 2054 United Steelworkers of America. I belong by craft—yet my subject of aesthetics introduces a breach. I suppose that is because I believe in a workingman's society in the future and in that society I hope to find a place. In this society I find little place to identify myself economically."²⁸

At ALCO, Smith absorbed the energy of sequences: one metal part, one tool, one method after another, leading to a whole that projected function, force and surprise, and even danger. He felt the excitement of seriality: one dramatic machine after another, accumulating in a flow of production that seemed as if it would roll on forever. But he made his sculpture a negation of the assembly line in the individuality of every aspect of every sculpture and in his rejection of linear development and thought. His sculpture had always been unpredictable and multidirectional, but henceforth it would be even more marked by intuition and leaps. It would be defined not just by flow but also by disjunction. Where did this come from? How did he get from this part to that part, and from this sculpture to the next one? Smith would remain committed to transformation—every aspect of his work seems to be in process, on its way from one identity, one state, to a different one—but in his work, change does not result from pure se-quences and methodical development. It is not predictable or manageable but an event, a happening. Smith incorporates industrial methods—in particular, those of the arms industry—and turns them into signposts of audacity and wonder.

The month of his Willard Gallery show, Smith was laid off. "I'm re-classified into 2B so Ill have to get to work or go in 1A," he wrote Edgar Levy. "If Locomotive doesn't take me soon I'll go to G.E. In the mean-time I'm cutting marble. Godam them there doesn't seem tobe any man-agement at all. One month they work the ass off you—7 days a week—12 hrs a day—in couple months . . . [you're] out into the weather."[29] Then ALCO hired him back and put him on the swing shift, 4 to 12 PM. In late spring 1943, Smith reported to Willard that he "got another deferment (6 mos), but that is good as long as the job is—and the job doesn't look too secure—the whole plant is slow."[30]

He turned down Moholy-Nagy's offer to teach in Chicago: after ALCO, he would devote himself to his own work. After meeting Smith at the Willard opening, Louise Bourgeois, a thirty-two-year-old sculp-tor with ties to the academic world through her husband, Robert Gold-water, an art historian and art critic, told him about a teaching job at the University of Oregon. He thanked her but did not pursue it. "Maybe I'll never teach now," he wrote Willard. "Dottie and I talked it over. She backs me in the stand that I shouldn't work on anything but my own sculpture After all I'm 37, life is short, I've worked at dozens of jobs try-ing to be an artist—from now on we sink or swim on my chosen profes-sion I've saved some money . . . Its time we do what we want . . . Besides I have unemployment insurance for 20 weeks after the war."[31]

In his January 1, 1944, review of the Whitney Annual, Clement Greenberg again singled out Smith:

> [Abstract art] is the only mode by which painters and sculp-tors still master new experience; it furnishes the only pro-foundly original contemporary art; and the three best things at the Whitney are a piece of cast iron and bronze sculpture by David Smith [*Head as Still Life*] which obliterates almost everything else in the sculpture court, a pencil and crayon drawing by Arshile Gorky, and a [John] Marin water color— the first two entirely abstract in feeling.[32]

In early February 1944, a month before Smith turned thirty-eight, the cutoff age for the draft, the reprieve came. At his preinduction physical

examination, Smith was declared unfit for military service, "on account of sinus," he wrote to the Levys.[33] To Willard he provided more explanation: "I was turned down at selective service due to sinus, since it has been chronic for years. I was all thru and accepted when they happened to notice my chart wasn't filled in on #10—they sent me back to that station one that I somehow had missed and there I was rejected."[34] Dehner added still more information: "He was rejected on account of his sinus. They didn't seem to mind his having almost reached the age deadline, he was practically in, when the examiner asked him something about sinus, as it seems by some error, he had missed the sinus examination, and this guy was already asking him about branches of service etc. when he found out he had missed the sinus guy, and got sent back and rejected."[35] In the months after Smith's death, she made a clear statement about the 4-F classification declaring him unfit for service: "David was 37 then, right near the age limit. When he was refused because of sinus trouble, we felt very happy and relieved; the army would have been impossible for him."[36]

The controversy surrounding Smith's 4-F began years later, in the 1980s, when Dehner seems to have placed greater emphasis on his incompatibility with the army. In a footnote to her essay "Arcadian Nightmares: The Evolution of David Smith and Dorothy Dehner's Work at Bolton Landing," Dehner scholar Joan Marter wrote: "Contrary to the reasons given in the Smith literature, Dehner later acknowledged that military physicians questioned Smith about his violent tendencies, and ultimately declared him unfit to serve."[37] Marter referred to her 1983 interview with Dehner but does not report what Dehner said. It was a few years later that Dehner told Paula Wisotzki that "Smith seems to have been genuinely concerned about the consequences of placing his volatile temperament in contact with sanctioned violence." In her widely read 2018 book, *Ninth Street Women: Lee Krasner, Elaine de Kooning, Grace Hartigan, Joan Mitchell, and Helen Frankenthaler: Five Painters and the Movement That Changed Modern Art*, Mary Gabriel, in a footnote, repeated Marter's interpretation: "Smith was declared unfit for military service because of his 'violent tendencies.'"[38]

We can't know what happened at the physical, but Smith had had at least three previous physicals and been declared 1-A, available for unrestricted service, so concerns about his violence were not previously

flagged. We know that Smith did have chronic sinus problems and some-times debilitating sinus attacks, and that less than two months before the physical, his sinus made him miserable. "He just had the root of a front tooth sawed off as it was infected," Dehner wrote to the Levys on December 11, 1943, "and it has kicked up the sinus as its just a harsbreath away from it and he is feeling like *that*. &%$#&*"³⁹ We also know that in February 1944, he was desperate to return to his own work. "Some-how I think Ill be doing sculpture next year," he wrote to Willard in November 1943. "It's all I can think about."⁴⁰ He repeated the statement "Life is short." At the physical, could he have communicated frustration and volatility in response to effectively losing an additional two years, in an even more regimented situation than the one at ALCO? It's possible. Wanting at all cost not to go into the military, could he have told mili-tary doctors that he was concerned about how he might behave in cir-cumstances that expected aggression? It's possible. Does it seem peculiar that at the very last minute Smith was declared 4-F because of a step that on this and previous draft physicals had been passed over? Only if we overlook that his sinus was in all likelihood inflamed in February 1944, and it had not been at previous physicals. One of the distinctive features of Smith's life is that in dire circumstances he was regularly saved just before the bell, when hope hardly seemed possible. The providentially unexpected was part of both the actuality and the mythology of Smith's life and work. Even if it were accurate to explain his classification of 4-F by "violent tendencies," however, such an explanation would drastically oversimplify Smith's situation in February 1944 and deny, if not negate, all that he managed to accomplish during these two watershed years.

The long battle to stay out of the army had been won, and victory felt strange, almost anticlimactic. "Well . . . our future is settled to a certain extent," Dehner wrote. "I think we will be here [in Schenectady] for a while anyhow, although the layoff starts March first. And will carry into June."⁴¹ Smith wrote to Edgar Levy on March 10, "I am now 38 as of yes-terday . . . I feel older than hell. There is so much I want todo and realize. I've got to live out of my work. Since I'm 4F besides I think Ill quit by late spring and get to work on sculpture."⁴² To accumulate as much money as possible, he continued at ALCO on and off through June. In the fall, he would do design work for GE.

Smith was involved in one more major effort to produce medals that would enable him both to make money from the production method he had developed in *Medals for Dishonor* and leave no doubt that his leftist politics remained intact. Beginning in May 1943, he worked on a commission to design a medal to recognize Americans for their service to China. Wisotzki wrote:

> While much of the attention focused on the civil war in Spain, links were regularly made between Spain and China, a country which had been under attack by the Japanese since the conquest of Manchuria in 1936. The December 1937 exhibition organized by the American Artists' Congress, *In Defense of World Democracy; Dedicated to the Peoples of Spain and China*, reflected just such an equation of the fight against fascism in those two countries.[43]

Smith and Dehner did plenty of research. He provided symbolic, almost propagandistic, drawings to China Defense Supplies, the agent for the Chinese government, and went to see them in Washington. Following delay after delay, the commission finally fell though in June 1944, and Smith had to settle for a $250 kill fee, of which he gave Willard 25 percent. "Well, its experience, and on another job like that I'll have a contract, designating payment at various stages and at least ¾ full pay on termination before completion."[44] By that point, however, the Smiths had learned more about China's government under the nationalist Chiang Kai-shek: "China," Dehner wrote, "is becoming a fascist state."[45]

Smith was now determined to be his own boss. Anyone who disrespected him or got in his way would pay for it. A couple of months after John Davis Hatch of the Albany Institute, who had given Dehner the portrait commission, told Smith that his Willard show looked terrible, Smith let him have it. When Hatch denied Smith's request to borrow Dehner's work for a show she was having in California, Smith "told him to go fuck himself . . . I said ok if that's the way you want it, we wont show again with you."[46]

When Smith learned that his sculpture *Head* had been damaged at MoMA, he told the museum that only he could fix it: "I do not consider that the sculpture in its present condition is worthy of exhibition. Nobody but the sculptor is competent to make repairs."[47] When the museum officiously refused to pay him $150 for his efforts, he threatened to sue them with his union lawyer. The MoMA curator Dorothy Miller asked to meet with him when he next came to the city; the museum came up with the money. "Maybe I'm getting hard and cynical but my factory period—gave me long periods to think and certainly changed many values," Smith wrote to Willard. "From now on, I don't wear gloves."[48]

To Begin Again

When Dehner and Smith moved back to Bolton Landing on May 8, 1944, they were not sure they wanted to live there. The Levys had been urging them to join them in New City, where the Smiths would have bought a house with land, lived near their closest friends and within a cultural community, and been an easy drive from Manhattan. Dehner would have felt less isolated and exposed. The winters were less severe in New City than upstate. But after the ordeal of the move back from Schenectady, they could not face another move, and after returning to the farm, it was clear to both of them that that was where they needed to be. Work on the ratty old house was endless, but the cost of living was cheap and they were attached to the land and to the grandeur of the region. On their hillside in the Adirondacks, they could maintain their own schedules and keep their distance from what Dehner repeatedly referred to as the "boog-a-wahsie." The idea of building their own world in nature remained irresistible to them.

But the return was difficult. Smith expected to plunge back into sculpture, and the enthusiasm of critics and other artists led him to believe that once he did, he could finally earn a living from being an artist. After two years of relentless pressure and uncertainty, however, he could not just flick a switch and get back in the groove. Dehner, meanwhile, was tired of his "bumps" and of subordinating her art life to his. Their

life in Schenectady had given her time to make work and think more about her own career. She, too, had received recognition. "You've at last got the confidence to label yourself publicly as an artist," James Marston Fitch, the architectural historian and a valued friend of both of them, told her.[1] But, living with a temperamental powerhouse who was a magnet for critics and artists and who had resolved not to let anything get in the way of his work, would she be able to establish a studio space of her own and follow the demands of *her* work? They both sensed but did not fully grasp the impact of the ALCO years on their relationship.

Smith wanted his sculpture to flow. Whether smooth or torrential, the creative flow was consuming. It led him from one idea, one impulse, one hunch, to the next, and then to others that could propel, jolt, or bounce him in different directions. Anyone or anything that impeded or blocked the flow was a threat. His reaction to feeling thwarted could be extreme.

He labored on his shop-studio, described in April 1943 by *Newsweek* as "an 18-by-36-foot steel, glass, and asbestos concrete structure filled with all the equipment of a small boiler-repair factory."[2] Smith would soon write to Willard, "I like my shop so much. I'm approaching what my studio should be. Its incomplete yes but I can make things with out being frustrated by so much manual labor to arrive at a concept. There is a time element wherein conception and medium must flow to reach a conclusion, other wise the medium can retard the concept."[3]

Around a week after returning to the farm, Dehner took the cross-country train to California. She had been planning the trip for a while, in part because of an exhibition of her work in San Francisco. When she needed a break from Smith and their marriage, she often thought of Pasadena and Aunt Flo, who was now in her early seventies and losing her eyesight. She and Flo looked after each other, traveling together to the dry heat of Yuma, Arizona. Dehner visited Hollywood and saw Milly Bennett, for whose guidance in Moscow in 1936 she and Smith remained grateful. Young people she met convinced her that the West Coast had become more liberal and modern-art-conscious.

Smith often wrote Dehner more than once a day. "I'm glad kid you

are getting reception with your work," one letter said. "It adds zest to working doesn't it."[4] She wondered about a Manhattan gallery. "Marian isn't your dealer because I'm there," Smith wrote after someone, probably Flo, asked why she was not represented by the Willard Gallery. "Well that's nobodys business she doesn't have to be the familys dealer—her people wouldn't be your clients anyway and I wonder who her clients are myself—in my behalf." He asked her to approach the Bignou Gallery in Willard's building and assured her that he supported her career: "Kid I want success for you as much as you do and rest assured little Dehner it will come." Enjoy your moment, he told her.

It was up to him to get the farm going. He planted poplars, elms, apple trees, and pear trees, and looked after their garden of vegetables, including peppers, potatoes, corn, green beans, and lima beans. He let Dehner know that he was maintaining *her* garden, which, like the house and the two sheep that he bought for her, needed her. The sheep and pigs "send their love and await your return." He kept her in the loop about everything—the leak in the roof, sunbathing to deal with sinus trouble, losing weight. He told her that Marian Willard and Dan Johnson were going to be married. That Willard wanted to give him a retrospective in 1945 but he had not committed. That new art buildings had popped up on Madison Avenue near Fifty-Seventh Street. For the first time in years, he roamed Greenwich Village with artist pals like Byron Browne and Hertz Emmanuel. They settled in Washington Square, then moved from joint to joint, ending the evening with jazz. "We were on North East corner [of Washington Square] benches for hours—had coffee after—like old times."

Smith read *What Makes Sammy Run* in one go. Budd Schulberg's 1941 novel tells the story of Sammy Glick, a poor Jewish boy from New York's Lower East Side whose ruthless drive and cunning enabled him to become a Hollywood big shot by his late twenties. He cannibalized the work of real writers and had no capacity for relationships in which he was not in charge. "Best explanation I ever read," Smith wrote, perhaps referring to the kind of man bred by capitalism to run what he and Dehner considered an amoral entertainment industry that seduced the public with cynical, mindless junk, preying on workers and honest artistic work.

Clearly at Dehner's prodding—she may also have suggested Schulberg's novel—Smith went to see *Othello*, then bought a copy of the play. He assured Dehner of his appreciation for the story in which the jealous and enraged Moorish king ends up killing his innocent bride, Desdemona. "Might go to see Othello again," he wrote her, "since I have read it now. I was way up in the $10 seat which at the Shubert is 2 bal. but I got most of it and enjoyed it immensely."

Not long after Dehner's departure to reconnect with her family, Smith took the train to Fort Wayne, Indiana, to reconnect with his. For the first time since his father's death, he was in Paulding. With Forrester ("Frosty") Stewart, his sister Catherine's husband, and Leigh, their adopted son, he went into the countryside and "shot mark with Dad's Luger and Grandpa's old Colt." He roamed the town and fields, wanting to understand the farm culture and gauge changes from the Paulding he had left. "The tractors all have lights for night work and the grind goes on all over the county They get 3-4 crops a year out here on some crops. The good farmers use brains as well as brawn for rotative crops."[5]

He admired his father for providing for his mother after his death. That his telephone company was still going strong—it had a new building—was proof of his astuteness as a businessman. He did not admire his mother's abstemiousness. He wrote to Dehner:

> Mom is a dope. She doesn't spend her money—like Flo still afraid that it will stop or something . . . How much she has, now, I don't know but Im sure she doesn't spend ½ her income. Well she lived a skimping life for so long . . . that she cant change. However she has all the cream cookies butter chicken etc that she wants that she is not really unhappy. She saves in the guise of self-denial which is an inverted Christian merit I guess.

Paulding felt both familiar and alien. "Just got your letter while sitting on the front porch," he wrote to Dehner. "Its all very strange—I felt strange with mother—hardly knew her in feeling. I cant explain it. Its past life and I have a connection but yet it doesn't belong and I don't want it. However its fun in a way and I'll have enough by the time I go back."

Smith went to Decatur to see his uncle Fred Smith and his family. He visited Roy Kalver, "the Jewish intellectual of Decatur," who owned two movie houses there. Kalver's Chicago wife was "naturally a liberal intellectual (being a Jew and a college graduate.)." Nevertheless, he found the politics in Decatur stifling: "There is really no progressive spirit here that can be noticed—creature comforts and mental lethargy vie with moulding action—sweetness and love is the outward effect but under it is the vicious brutality of the middle class." After a few days, he took the night train from Fort Wayne to Manhattan, then returned upstate.

Dehner, too, struggled with alienation. Aunt Cora was impossible, and as dear as Flo was, Dehner's time with her was eventually constricting. "Its all just nuts and I feel nutty to be in on it," Dehner wrote Lucille Corcos. "David writes me every day and is an angel about it. He is in Paulding now, feeling the same screw loose as I feel here. Our world must even be smaller than Flo's as it seems to me we get off balance too easily."[6]

Smith wrote with the obsessiveness of someone who feared that, away from his presence, Dehner would forget or abandon him. He may also have been worried that he had given her reason to leave. Smith's behavior had long been volatile. "It was either A or it was Z and there was no elemental PQRST in the middle," Dehner told the interviewer Gordon Rapp.[7] When she returned from town, he often hugged her as if she had just returned from Pasadena. He could also knock into her, and hit her. When he flew into a rage, she got out of his way, sometimes hiding in the basement chimney. He could open letters to her from the Levys and invade her space. Once he grabbed her drawing board and used it to make a woodcut. "'Hey, I need that,' I said, and yes of course that left me without a drawing board," Dehner told Judd Tully. "I'll never forget how he just grabbed it. Well, that's what he did with the world . . . He was fanciful and extreme."[8]

"Keep yourself strong and happy and come back to me," he wrote her. "Dottie your letter of last Sat. night about how I had made you a better person was very touching. You've made me too—I owe my reaction to you and Ive often thought of how much nicer I should be to you youre such an angel." His letters began to include raunchy passages: "I'd love to be between your legs bouncing." "You come home and I'll show you

something big and hard." "I'll have to lear[n] to lay again. I've been a monk too long. Bring a good book on it if you can find one."

His names for her had a manic multiplicity: "kitten," "baby," "chicken," "chick a biddy," "little chicken," "chicken little," "birdie," "pip squeak," "little lost girl," "sweet child," "sweet mamma," "little biddy," "darling Dehner," "honey," "tomatoe," and "Mrs. Terminal Iron Works." His sign-offs projected for him, as well, multiple selves: "David" but also "pop," "Poppa," "Pappa David," "ΔΣ," "ΔSmith," and "D.S."

When after nearly two months Dehner returned to New York, Smith met her in the city. They visited Washington Square, where during their years at the Art Students League they had spent happy times. Smith promised that they would "get things settled" and that he would "help with the house." Once Dehner returned home, however, maintaining the farm became, once again, her responsibility.

In a severe and interminable winter, Smith's sculpture flowed. From 1942 through 1944, he had made fewer than twenty sculptures; in 1945, he made almost forty. Landscapes, figures, dwellings, allegories, satires, and many combinations thereof. Some of the new sculptures have moments of calm; some are monsters. Many reflect the widespread feeling among American artists and writers at the end of the war that the human propensity for destructiveness had to be confronted. One hundred million people dead; concentration camps all over Europe whose purpose was to exterminate entire categories of people because of their religion, ethnicity, or sexual orientation; ever more diabolical weaponry that was about to culminate in the atomic bomb. The traumatized world was eager to move on, but questions abounded: Who and what was the human animal? How deep were the sources of human savagery? Was that savagery ineradicable? If so, how could art turn it into creativity and knowledge? In 1945, after visiting Dachau, the journalist Dorothy Thompson wrote: "If only one could say, and dismiss it with that, 'These people are savages.' They are—but they are a new and terrifying kind of savage . . . When civilized man, with his science, his technique, his organization, his power, loses his soul, he becomes the most terrible monster the world has ever seen."[9] How would artists imagine and preserve this soul?

In several of Smith's postwar sculptures, strata of history inhabit the

present. The bottom register of *Jurassic Bird* evokes the primal muck from which life began. In the heart of the 25-by-33-inch sculpture are two winged phallic- and cannon-shaped prehistoric lungfish poised on a ledge like children on a swing. On the top of the sculpture, which Smith painted zinc white, bound to two vertical poles as if impaled on a spit, is a horizontal fossil with a tail, two hind feet, and a fish neck and head. The feet resemble gesturing hands, the tail seems at the same time a grotesque head. The ribs of the prehistoric bird bring to mind the ruins of an ancient ship, perhaps a slave galley; and the upright collar bone suggests a gibbet or mast. But the ribs also resemble pistons. The eternal spectacle of sacrifice and extinction is perpetuated in the factory.

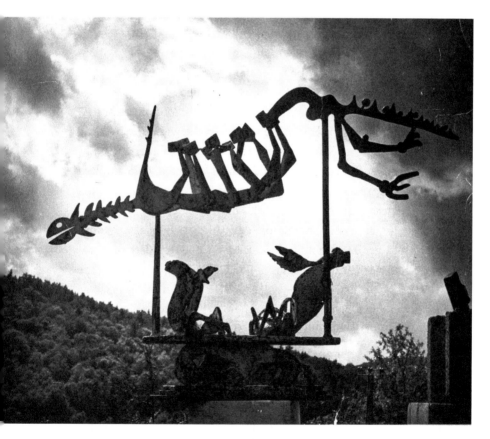

David Smith, *Jurassic Bird*, 1945. Steel, 25⅝ × 35¼ × 7½ in.
(65.1 × 89.5 × 19 cm). Private collection, Atherton, California.

Knowing that most people would come to his sculpture or know it only from publications, Smith became its first photographer. He photographed his sculpture on and around the farm, in all seasons. One of his primary points of view was from low to high, silhouetting the sculpture against trees and sky. Often he cropped the photograph at the base so that the sculptural forms appear to rise unimpeded. In the photographs of sculptures that accompanied shows and articles on his work, rarely is there a trace of the house or shop or any other human element. Sculpture and landscape seem very old and brand-new. The sculptures seem both distinct from and part of the rest of nature. The photographs present the sculptures but do not pretend to be reproductions—or copies—of them. They are realities in themselves. They direct those who encounter them to a place outside galleries and museums, where the sculptures were seen in person, to an elsewhere, part of an eternal continuum, as much dreamscape as actuality. In Smith's sculpture of *Jurassic Bird* set against a storm sky, the sculpture is a vision.

During this winter of 1944–45, Smith studied James Joyce, whose stream-of-consciousness style—embracing storytelling, sexual impudence, adaptations of myth, dense symbolism, and profusive, cryptic, and at times gorgeous language—marked Smith's Abstract Expressionist generation. Joyce provided a model for a poetic image that was voluminous and inexhaustible. Smith and Dehner read together *A Skeleton Key to Finnegans Wake*, by Henry Morton Robinson and Joseph Campbell, the celebrated interpreter of myth. This may have been the only time he read an explanatory book, which went against his mantra that good art and literature did not need the "verbalizers and the proselytizers."[10] He wrote to Willard:

> Getting Finnegans Wake and just for the general hell and information, the key also . . . Did you read the key—and what do you think of the idea. I always thot I understood Joyce pretty well—and I have a tendency to think in six different ways of association of objects—like I interpret him but I was interested in the key to learn what somebody else thot—and to learn Irish places, lore etc. Not knowing languages well some of his mixed language expressions allude me.[11]

Smith and Dehner named each of their four successive dachshunds Finnegan.

Marian Willard scheduled Smith's first retrospective at the Willard and Buchholz Galleries for 1946. "I really want my one show big and impressive," Smith wrote her. "I'll gamble all on it."[12]

Dehner was delighted and relieved by Smith's creative flow. "He is working like mad doing things all day long and half the night. Fabricated and cast . . . both. Some of the best yet. He feels entirely in the groove. Thank God," she wrote to Corcos.[13] A week later, she reiterated her admiration for his new work, alluding almost in passing to violence: "I am so happy about the work David is doing that . . . like you . . . have nothing REALLY to bellyache about. Only the minor wounds."[14]

They showed together twice in the spring of 1945. Joseph Jeffers "Jerry" Dodge, whose four-year-old son, Jamie, had inspired Dehner's 1944 painting *Jamie's Visit*, reviewed both exhibitions in the *Glens Falls Post-Star*. On the one at the Crandall Library in Glens Falls, he wrote: "David Smith of Bolton Landing, who is one of America's leading sculptors, contributed a metal 'Billiard Player,' which is easily the most original thing there. His wife Dorothy Dehner, who recently had a one-man show in Washington D.C., sent two almost miniature temperas. Both very delicate and extremely charming."[15] Of the exhibition in Saratoga, Dodge wrote:

> Dorothy Dehner and her husband David Smith of Bolton Landing top the show as usual. Dorothy's two small tempera panels have all of her considerable feminine charm. Dave's two metal statues reaffirm his originality, humor, craftsmanship and strength. His pen and ink drawing, "Women in War," makes all the war art in "Life" look childish and silly. This is real war art. It does not attempt to report events or facts but expresses principals [*sic*] and emotions. It represents, by means of profound and somewhat Freudian symbols, the rape of civilization by fascism and war. Equally as powerful as Goya's and

Picasso's efforts in this line, it will be effective as long as man's inhumanity to man exists.[16]

Smith was pleased to be in such company.

On May 8, 1945, Victory in Europe (V-E) Day, Germany surrendered. Nine days later Smith finished *False Peace Spectre*, one of the nine sculptures in the series that he began in 1944. The *Spectres* he made during and in the immediate aftermath of the war are nightmarish things, deformed by war and greed, as ugly and insidious as the incubus in Fuseli's *Nightmare*. In *False Peace Spectre*, one leg of this sardonic bird of prey seems about to march off the base in a goose step. Its wings resemble those of a bomber. In its beak is a smaller bird. In one talon is a plaque with an image of a prostrate female figure. "He is a blue bastard with bronze music cannon and bronze female offering on a tray," Smith wrote Willard.[17] "A terrifying blue harpy bringing brassy promises" was how Robert Cronbach referred to the sculpture in *New Masses*.[18]

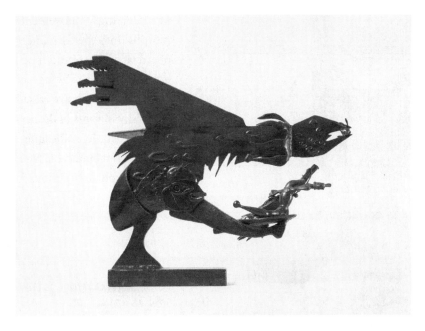

David Smith, *False Peace Spectre*, 1945. Steel, bronze, paint, 21½ × 27¼ × 10¾ in. (54.6 × 69.2 × 27.3 cm). Denise and Andrew Saul.

In the aftermath of VE Day, Smith also completed *Cockfight*. "I don't go to cockfights, but fighting roosters are raised by my friends in the hills and meets are regularly held near Saratoga," he noted in his autobiographical sketch.[19] "A large piece entitled 'Cockfight' looks realistic tho not one form is real," he wrote to Willard. "Its very open and full of movement—cantilever construction and about 48 inches high."[20] The sculpture conjured two roosters, or gamecocks, bred to battle in a cockpit, but it may also suggest a third. Each is a flat steel cutout, welded into a sculptural balancing act of frantic abandonment. In 1946, the art historian William R. Valentiner pointed out the importance in such works of Smith's experience with steel plates at ALCO and noted "new ideas of exploding energy, of which parts seem to break through the frame unexpectedly, as if darting into space."[21] While the sculpture suggests fight-to-the-death struggle, the violence is redirected. The sequence of "darting" movements morphs into performances of circus acrobats and modern dancers—the wings of the topmost cock are raised to the sky in hints of desperate yet ecstatic arabesques. Violence is ineradicable here, but it morphs into visionary creativity.

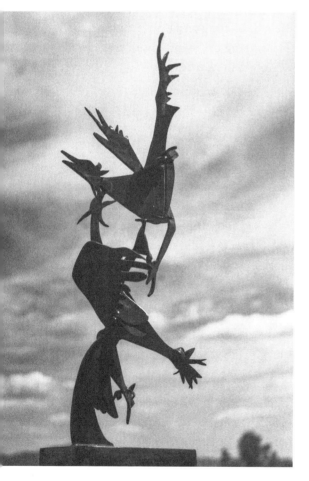

David Smith, *Cockfight*, 1945.
Steel, 45 × 21¾ × 10¾ in.
(114.3 × 55.2 × 27.3 cm).
Saint Louis Art Museum.

28
Outbursts

"We at last have running water and I feel like a lady finally," Dehner wrote Lucille Corcos on the edge of summer. "It was installed with no little pain griping cussing foul language heartache and finally indigestion."[1] She and Smith awaited the arrival of the choreographer Franziska Boas, who brought to Bolton Landing not just a lived knowledge of the history of modern dance but an avant-garde social justice agenda.[2] Each June, from 1944 through 1949, Boas would set up her dance school on the second floor of the Odd Fellows Hall, in the heart of town. As a child, Franziska had vacationed in Bolton Landing with her father, the anthropologist Franz Boas, who died in 1942. "She wanted a relation between the arts," Ellen Berland, a former student, said. "Every class was . . . so organic. It was completely different every time." A class could include an hour of improvisation, an hour of composition, and an hour of kinesthesiology, not to mention a swim in the lake.

Boas encouraged a symbiosis between the dancers and the authentic instruments that her father had brought back from his expeditions. "She had an incredible collection of drums, cymbals, rattles," Berland said. "She even had the guts of a baby grand leaning against the wall, like a harp. A great variety of sound." Her dance company was not only improvisational and interdisciplinary but also multiracial. The stir her summer

school created in Bolton Landing was intentional, Berland said, adding, "Boas undeniably was an agent of humanitarian ideas and social change."

Smith and Dehner sat in on her classes, and some of Boas's dancers posed for him. "We went to David's studio to see his things," Berland remembered. "We went as a group and he explained what he was doing." Boas asked Smith and Dehner to give art classes. "Franziska was very insistent that we do other things besides dance," Berland said. "We had poetry and sculpture. She related sculpture to dance. We had to make a clay model of our body. From that she could tell what part of our body needed work. For example, the pelvis or legs would be incomplete. Then a few months later she asked us to make another model to see if it was clarified then."[3]

Smith's 1945 sculptural tableau *Boaz Dancing School* commemorates Franziska Boas's visit. A woman at the top of the raked dance floor is at a barre; a woman near the center launches her leg upward in an extravagant arabesque; the third figure, by comparison almost grotesquely large—a seated female nude in the foreground—wrapped inward from one point of view and wide open from another, is in the midst of floor

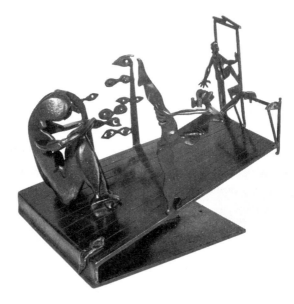

David Smith, *Boaz Dancing School*, 1945. Steel,
16½ × 14 × 14 in. (41.9 × 35.6 × 35.6 cm). Private collection.

work that seems influenced by Martha Graham, whose movements Smith studied. Near her, attached to an upright stand, is an array of what look like masks at masked balls, but the masks suggest a profusion of gazing eyes, perhaps those of town residents. They bring into a scene of female dancers absorbed in their exercises a foreign presence and, with it, comical yet voyeuristically invasive looking.

In early July, Smith was almost killed. Dehner told Corcos:

> It's only Smiths charmed life that allowed him to come home at all. He was hit by two cars doing sixty. He was standing on our runningboard on the st. side, and both cars hit him, one knocking him up in the air and tossing him down the block and the other running on to him afterward. Everyone who saw it thot he was absolutely finished but the X-rays show no breaks. He is bruised black and has terrible road burns right down to the flesh but did not even suffer from shock . . . what do you think it would take to shock DAVID??? And today he got in the car and insisted on going to the village to talk it over with the boys. He is really very lame of course, and he must hurt like hell all over tho he says not so bad . . . anyhow any one else in town would have been killed by the impact. The car has a two inch dent where his body struck it. All the ladies who went in for first aid and then the local MD fixed him on the stretcher and they took him to Glens Falls in another truck. The insurance companies are fighting it out at present.[4]

Smith was in a "bad state," Dehner would remember. "He was going through the most awful inner turmoil and conflict."[5] Soon after the accident, she left because of a scene, she said, that she could not accept.[6] While there were previous instances of Smith's physical abuse, near the end of her life Dehner told Miani Johnson, Marian Willard's daughter and herself an art dealer, that this was the first "real beat"—meaning multiple blows.[7] Dehner went to the city and took a room for $4 a night at a hotel in Gramercy Park. Then she called their longtime friend Mildred Constantine, whose husband, Ralph Bettelheim, was in the army and whose daughter, Judith, was eighteen months old; Smith and Deh-

ner were Judith's godparents. Constantine kept the first two floors of her house at 359 West Eighteenth Street for herself, the cook, and the maid, and rented the top floor. "Oh, yes, come over. I have a room to rent to you," she told Dehner. "'Wonderful!'" Dehner recalled thinking. "Another room was empty so I rented that for a studio—not much money for either."[8]

The accident forced Smith to postpone his show. "I'm afraid this has set me back," he wrote to Willard. "I'm so lucky in a way; as I lay on the street I thot I was crushed in the chest and pelvis both—my only thot was Christ almighty have I worked all my life to have the beginning stopped here. It was a great relief when I learned nothing was very serious. Now that that is over I fret because Im not back at the work 100%. Dorothy is in NY, Im running everything myself, along with the dog and the pig."[9] On August 10, he wrote that he would not be "down until fall. Dorothy still in New York with Millie—don't know if she'll come back."[10]

He wrote to Dehner, asking when she would return. "A letter from David awaited me," Dehner wrote to Corcos. "Largely in the spirit of the first, asking me what I intended to do and still unable to understand the whys and wherefores of my action. He phoned me while I was away, and Milly took the call and they had a conversation."[11] Constantine went to Bolton Landing to speak with Smith about his behavior.

In August, Smith worked on *Pillar of Sunday*—"a pillar of Indiana Sunday memories mixed religious associations etc."[12] The two-and-a-half-foot-tall upright steel plate visualizing the maternal body is flat. Five concavities seem to have been not so much cut as scooped out of each side. Each ridge between the round cuts seems like a truncated or amputated body part—arm, hand, hip, feet. The truncated limbs are adorned with miniature sculptures referring to memories of childhood. A toy-like sculpture, in Smith's explanation to Willard, suggests "flames from [a] burning bush" or a "coiled serpent," symbolizing the "maze of contradictions which religion represents." Another evokes "mother with two children in perambulator protected by her wings, between the wings is a letter," which refers, for the first time in his work, to the "letters scratched up as in Finnegans Wake." Perched on the head is a bird with a man's head, its wings outstretched like an early airplane: "Bird found

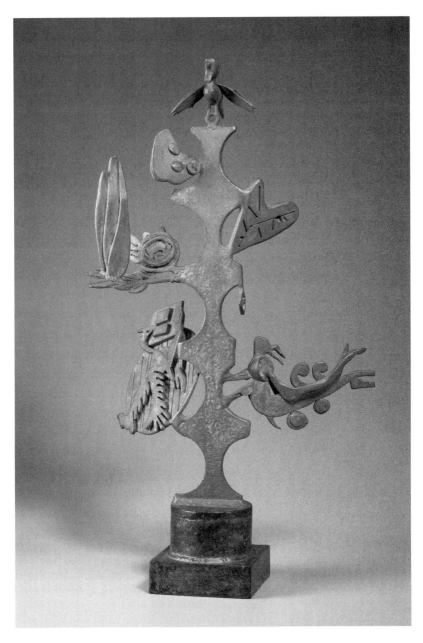

David Smith, *Pillar of Sunday*, 1945. Steel, paint, 31 × 16⅝ × 9½ in.
(78.7 × 42.2 × 24.1 cm). Sidney and Lois Eskenazi Museum of Art,
Indiana University.

in Assyrian sculpture, which was the bird that represented the soul that revisited the body."[13] The red paint coating the surface suggests watery blood. Henry Moore's sculpture is known for its round and nurturing images of the maternal body. There is nothing by Smith even approximating an image of idealized maternity. In this painful and iconic work, Smith turned a Christian idol into a totem.

In his 1964 interview with Thomas B. Hess, Smith spoke about the letter scratched up by the Little Red Hen in Joyce's novel. "I don't think any body knows what the letter really said," Smith said, but to him "the letter says, 'You sent for me.' Something like a very simple little cryptic message . . . All letters say you sent for me as far as I'm concerned."[14] His words are a clue to the mode of address of Smith's sculpture from this point on. Its energy moves outward, toward the viewer, in a way that makes it seem that the sculpture is responding to the viewer's desire for

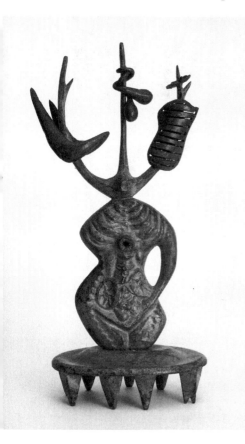

it. It is as if the viewer had asked for the sculpture and the sculpture had willingly, even eagerly, responded to that desire, even as it remains self-contained, beyond appeal, indifferent to what anyone thinks about it, containing a secret that only the sculpture knows.

Also in August, Smith worked on *Perfidious Albion* (*The British Empire*). "The most scathing denunciation of British imperialism throughout the ages you ever

David Smith, *Perfidious Albion*,
1945–46. Bronze, steel,
14⅜ × 7⅜ × 4³⁄₁₆ in.
(36.5 × 18.7 × 10.6 cm). The Estate
of David Smith, New York.

saw," Emily Genauer wrote in the *New York World-Telegram*.[15] In *The Magazine of Art*, Stanley Meltzoff described the sculpture as a "green patinated lump of bronze that looks like a paleolithic charm." It, too, is a menacing and menaced female form. This small standing figure, 14⅜ inches tall, is squat, with a narrow waist and voluptuous hips. In her chest is a small hole, like an exhaust. She has no breasts. The pointed antler—or anchor with a trident, a symbol of naval power—that takes the place of her head has a Sumerian, Minoan, or even Neolithic feel. She has a left arm but not a right one. "The thread lines" of her dress "turn into cords of a money-lender's scales which in turn are the wheels of a cannon," Meltzoff wrote. "The lacy lines of drapery are matched by the headdress of ghastly trophies, and cluster in the back to form a pig's snout crowned with a jeweled coronet."[16] Small but lethal, this imperialistic authority, presiding on what looks like a stool-throne, seems to demand ceremonial sacrifices and to be destined for sacrifice herself.

Smith went on working even though it would take him two months to recover fully from the accident. He knew that Dehner was staying with the Levys on Fire Island and talking about him with people who were as important to him as they were to her. In a September 1 letter to Edgar Levy, not mentioning Dehner, he was defiant:

> Who do I work for, and all of that—I have discarded that worry long ago. I've myself to live with . . . One is a product of his influences, associations, childhood, preferences, etc. That is true—I can't worry about that, the pattern is laid . . . If my end product doesn't please—if my crudity and uncouthness mix off key in my aesthetics to nicer people's concepts, then I can only say what all the black collar boys say to finish an argument—fuck-em.

He told his close friend that he had "lost years + in the Locomotive works—the same as you are losing some years in the army. As a 4F I'm damn glad I am." He provided insight into his creative process:

I am bound by a personal outlook which for me gets solved by
work—which I fight to do. I have a dilatory tendency—there is
so much to be read—so many women to lay—so much liquor
to drink—fish to catch, etc.—but I get the most satisfaction out
of my work . . . The more I work the more it flows (the concept).
Sometimes while I'm working on one piece I get a conception
for a wholly new and different one—on the last two pieces—
I've quickly drawn a new one, different, but suggested in a
thought process which somehow took place during the man-
ual work on the other. I would say that my product is always
about a year's work behind my conceptions, in number. Right
now I have drawings and thinkings for a year's labor.[17]

Despite the bravado and productiveness, and the company of a few
friends, Smith was eventually smacked down by loneliness: "Weeks go
by and nobody comes. Everything is closed in town now after 6 pm. [The
painter and illustrator Douglass] Crockwell has been most helpful . . . I'll
probably sell him a piece [*Perfidious Albion*] for 3-4 hundred. He sure is
a booster of mine tried to promote a magazine article in *American Artist*
for me as the best draftsman in America. I'd like tobe I'll admit, but—
I can't show it yet, yet I'd appreciate a cover—which he tried to put over
for me. Oh Jesus, I hope this show, shows results. I need it this year. The
press should shape up ok. Sat night 8 pm now—had lentil soup and will
be back to the shop right soon. I'll have 30 new ones."[18]

Smith told Willard that he had run for justice of the peace and lost.
He awaited the visit of William R. Valentiner, whom they were consid-
ering to write the introduction for their catalog. Valentiner was a Rem-
brandt expert whose *Origins of Modern Sculpture* would be published in
1946. On June 1, 1945, he had retired as director of the Detroit Institute
of Arts, where he had commissioned Diego Rivera's Detroit Industry mu-
rals. After the visit, Smith revealed his concerns: "He seemed to object to
symbolism . . . If he is whole hearted he diden't show it—nor did he ques-
tion me as to concepts etc." He urged Willard not to pull punches: "Now
you tell me—and spare no softening in relating his statements because
he doesn't change the tide of my life. But he would have been ideal for the
situation under the circumstances. I either want a first rate forward or

none at all. Still I'll leave that pretty much to you or you & Curt [dealer Curt Valentin]."[19] Two weeks later, Willard had good news:

> The old doctor will write for your catalogue—so there . . . He honestly believes you to be the best sculptor we got in these parts. He was rather bewildered by your symbolism, your meanings and explanations of your sculpture, he is not used to that evidently and prefers such pieces as the cockfight etc. So we wont tell him anymore then he can relax and get his own meanings . . . aside from this he likes your work.[20]

In an October 17 letter, Willard addressed Smith's marriage head-on: "Saw Dottie a moment yesterday, she dropped into the Gallery. She seems pretty determined to stay here and establish her own life. You never were one to respect the rights of women much, but you must have done something too much and too long, that was hard for her to swallow! No reproof, just surmising out loud."[21]

"Yes Marian I'm afraid I dident treat Dottie very good," Smith responded. "I'm an egocentric *sullen* sulky bastard at times—and steam roller everything in my path. Dottie didn't say that but I know it. Life is lonesome but work and time will adjust things. I dident intend to hurt Dottie."[22]

He was in the process of finishing *Home of the Welder*, the most written-about of his sculptures before 1950. It, too, is small—21 by 17⅜ inches—and as elaborately prepared, through multiple studies, as *Medals for Dishonor*. Like all of Smith's domestic structures, it is open: everything inside is visible, although the partitioned structure permits its inhabitants to be separated from one another. Its elaborate imagery includes a welding torch, a cross or ship's mast, a millstone and chain, and a painting of a dog near a painting of a headless and handless female nude. Part reliquary box, part shrine, and part barque, the sculpture hints at temptation, labor, burden, and growth. The home of the welder is abandoned and desolate.

Smith and Dehner decided to try again. On December 29 or 30, he moved in with her on West Eighteenth Street. She had been seeing a psychiatrist two to three times a week. After several visits, she realized: "I

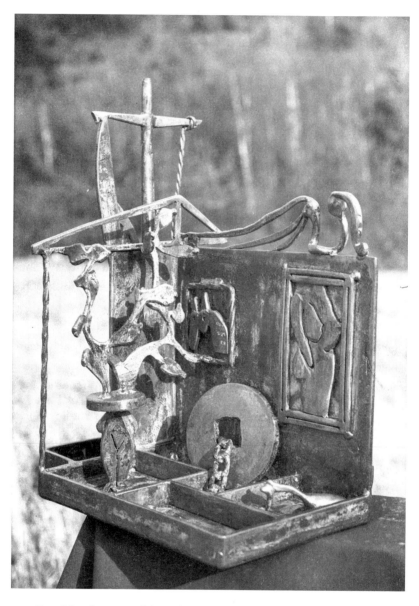

David Smith, *Home of the Welder*, 1945. Steel, bronze, 21 × 17¼ × 14 in. (53.3 × 43.8 × 35.6 cm). Tate Modern, London.

was talking, but I wasn't saying the right words. I wasn't telling everything. I guess I was still so in love with David that I couldn't imagine a life without him, even though I had left him." She was reluctant to tell him about these visits—"he was—Aargh! That was nonsense"—but after she did, she persuaded him to see a therapist of his own.[23]

Smith saw the analyst three or four times. Constantine remembered:

> [Dehner] was very much interested in analysis and she realized that a lot of what David was going through had causes that could not be easily classified . . . It was a disaster! I remember David coming back and saying to me . . . "I can't do it." This guy wants me to change myself. I *can't* change myself. I *won't* change myself. I said, "but did he help you, with regard to your aggressions?" "Yes, he helped me—a little." . . . He said, "He brings up things. I know what I'm like. If I change myself, I'm no longer David Smith, the artist." And I honestly had to agree with him.[24]

Smith and Dehner saw friends and looked at art together. She did some painting and he worked on a design for a medallion that he hoped the Container Corporation of America would award to plants with the best safety records. As with the China Medal, this project advanced through several stages before falling through. Smith had met Clement Greenberg in 1944. Now they began spending time together.

Dehner and Smith decided to give their marriage another chance. They bought fifty books. She would get "a very real kick," she said, where she needed it from Engels's *Origins of the Family* and its analysis of a woman's subservient position in traditional marriage. The Greek word for "wife" was "actually a high class housekeeper," she wrote Corcos. "The family as a monogamous unit" was "a modern invention" and "for the average monogamous in name only."[24] In early spring 1946, Dehner and Smith returned upstate.

Retrospective

"The Sculpture of David Smith" opened at the Willard and Buchholz Galleries on January 2, 1946, a few days after Smith joined Dehner in the city. The retrospective spanned ten years and included more than sixty sculptures as well as drawings. The catalog listed eighteen of the thirty-one sculptures from 1944–45 as steel; bronze was the second most prevalent material. Many sculptures were painted. *Boaz Dancing School*, *Pillar of Sunday*, *Perfidious Albion*, *False Peace Spectre*, *Cockfight*, and *Home of the Welder* were all in the show. Apart from four loans (including *Bi-Polar Structure* from George L. K. Morris, and MoMA's *Head*), all the works were for sale. The *Medals for Dishonor* were shown with their original titles. In 1946, after the Allied victory and global shock at the war's devastation, the *Medals* were understood primarily as antiwar. They were no longer politically controversial.

Smith's sculpture seemed to reject measure and boundaries. "The one word which keeps coming to my mind when I think of his recent stuff is 'frenzied,'" Robert M. Coates wrote in *The New Yorker*. "It is as if he were working against time to get rid of the ideas pent up inside him, and the ideas that come out have mostly to do with horror."[1]

In his review of the Smith, Hyman Bloom, and Robert Motherwell exhibitions, Clement Greenberg signaled an artistic shift from the pastoral to the baroque, "which [the art historian Heinrich] Wölfflin (who

died in Zurich the other day) defined as the 'open' style par excellence—open to variety and violence of emotion as well as to large and complicated formal rhythm." Greenberg continued, on Smith's sculpture: "Gone is the relatively simple trajectory of line, interrupted now by almost ornamental multiplications of detail. Gone is the 'geometricity'; under the new conception surfaces are broken, modeled, squeezed and incised within the smallest compass. Everything recoils back upon itself or else explodes into rococo elaboration. The pastoral tranquility of his former style is apparently no longer possible, and this phase of extravagance, disorder, and agitation is something he seems compelled to work his way through."[2]

The show was a triumph by any measure. "A tour de force," the reviewer in the *New York Herald Tribune* wrote.[3] "One of the most extraordinary exhibitions I have seen in seasons," Emily Genauer wrote in the *New York World-Telegram*.[4] "A smashing good show, and a most encouraging one at this time when American sculpture appeared to be in the artistic doldrums," Robert Cronbach said in *New Masses*.[5] In *MKR's Outlook*, her new monthly report on the art world, Maude Kemper Riley saw in Smith's "constructions" a "gathering" of "the main strands of modern art," "a concrete concrescence of all four dimensions of art: meaning, material, relation of forms, relation to life." For Riley, the thirty-one works in the 1944–45 section represented "the most remarkable, and concentrated production of an artist we have ever encountered."[6] In *The Magazine of Art*, Milton Brown wrote that "Smith, who is to my mind already the best sculptor in America, is creating out of a highly personal symbolism a sculpture which is rich, inventive and profound. He has borrowed heavily from Surrealism, but he has substituted for the symbols of the subconscious symbols of conscious, social experience."[7]

Writers praised the aggressive vitality of the work. "Those who expect from art loveliness and charm instead of strength and character," Valentiner wrote in the show's catalog, "those who are sensitive to sharp metal corners and rough surfaces, should keep away from David Smith's plastic works. For his art is harsh and intense and, since it is young and new, sometimes still awkward and heavy. But in its earnestness and directness, it has qualities that seem particularly American, such as we admire in Winslow Homer's and Marsden Hartley's paintings."[8] *The New*

York Sun wrote: "Of course there are certain crudities in execution, but always there is great strength, and a powerful feeling of motion."[9] *The New Yorker*'s Coates referred to the sculpture's "raw violence."[10]

Steel was understood not just as a modern but as an American material. It had served destruction during the war and would serve construction after it. Smith was made for steel. "It lends itself to Smith's qualities of sharpness, explosiveness and harshness," *Tomorrow* wrote.[11] The material and his body were aligned. Genauer described him as "a large, rough-hewn young man with the charred calloused hands you'd expect of a steel worker."[12] The affinity with steel gave Smith special access to this incipient American moment.

But there was erudition, too, which was evident in titles like *Perfidious Albion* and in symbolic and oneiric objects in sculptures like *Reliquary House* and *Widow's Lament*. Critics found some references unnecessarily learned. Referring to the *Medals for Dishonor*, Cronbach wrote that "these bitterly satirical drawings in metal are brilliantly executed, though they might be criticized for being overerudite."[13] Two years later, Robert Goldwater would criticize Smith's sculpture for its "over-refined wit" and "rather obscure allegorical references of his subjects."[14]

In the most important critical engagement with the retrospective, "David Smith and Social Surrealism," in *The Magazine of Art*, Stanley Meltzoff took on Smith's literary references. He used *The Rape*, a small 1944 bronze in which a winged cannon seems to be rolling into position between a naked woman's legs, as "a simple introduction to Smith's method." Meltzoff used the cannon to compare Smith's method to Joyce's: "The literary use of the pun to increase the weight of meaning born[e] by words is paralleled by the sculptural use of metamorphising objects. Using adjectives found in the first chapter of 'Finnegan's Wake,' Smith's cannon is 'sexcaliber' and 'camiballistic.'"[15]

Meltzoff found *Home of the Welder* "as complicated as parts of 'Finnegan's Wake,'" and a total "departure from previous sculpture." He mentioned Ovid: "Each part of the social Surrealist's sculpture is in the process of changing into another." Meltzoff admired that "each form is intended to be read on many levels." But he saw in the obscurity of the symbols and references a danger. The sculpture seemed to be speaking to two very different audiences. "Smith's work raises the further problem

of a work of art which makes a biting and embittered social comment, intended to help in the reconstruction of the world, but does so in a way comprehensible only to a minute, if highly cultured, audience."[16]

Flow, fantasy, and profusion of ideas had rarely been considered attributes of sculpture. They were attributes of painting, a faster, lighter, and less literal discipline. In the first half of the twentieth century, sculpture lagged far behind painting in prestige and market value, and in its ability to affect culture. But even as painting remained the first visual art—the widespread assumption was still that art *was* painting—the traditional limits of sculpture were being broken open, primarily by artists who began as painters. Picasso's Cubist collages, Giacometti's Surrealist objects and tableaux, Duchamp's readymades, Vladimir Tatlin's experiments with materials and scale, and Picasso and González's open welded steel constructions charted new sculptural directions. Smith was knowledgeable about all of them. He began as a painter and never stopped painting. With the exception of Brancusi, virtually all his modern artistic inspirations were painters. In 1946, pretty much all his friends among artists were painters. But he was first of all a sculptor. A sculptor with a mission to prove that sculpture could be as fluid, imaginative, and complex as painting.

By the spring of 1946, Smith and Dehner had read *Artists on Art: From the XIV to the XX Century*, a 1945 anthology of artists' writings compiled by Robert Goldwater and Marco Treves. Smith came to depend on this book, referring to passages in it and, in 1950, recommending it to his students at Sarah Lawrence College. In his copy, Smith marked passages by Leonardo da Vinci on the differences between sculpture and painting, comments that for centuries had defined the *paragone*, the competition between sculpture and painting. To Leonardo, sculpture was laborious and dirty. The sculptor was the laborer, the painter the intellectual. The painter was at home with concepts and dreams, the sculptor was bound by the slow weight of matter:

> I do not find any other difference between painting and sculpture other than that the sculptor's work entails greater physical effort and the painter's greater mental effort. The truth of this can be proved; for the sculptor, in carving his statue out

of marble or other stone wherein it is potentially contained, has to take off the superfluous and excess parts with the strength of his arms and the strokes of the hammer—a very mechanical exercise causing much perspiration, which, mingling with the grit, turns into mud. His face is pasted and smeared all over with marble powder, making him look like a baker, he is covered with minute chips as if emerging from a snowstorm, and his dwelling is dirty and filled with dust and chips of stone.

How different the painter's lot—we are speaking of first-rate painters and sculptors—for the painter sits in front of his work at perfect ease. He is well-dressed and handles a light brush dipped in delightful color. He is arrayed in the garments he fancies, and his home is clean and filled with delightful pictures, and he often enjoys the accompaniment of music, or the company of men of letters, who read to him from various beautiful works to which he can listen with great pleasure without the interference of hammering and other noises.[17]

In the next section on Leonardo's writings, called by the editors "Sculpture Is Less Intellectual Than Painting," Smith drew a huge question mark alongside the following passage: "The lines of perspective of sculpture do not seem in any way true; those of painters may appear to extend a hundred miles beyond the work itself. The effects of aerial perspective are outside the scope of sculptors' work; they can represent neither transparent bodies, nor luminous bodies, nor angles of reflection, nor shining bodies such as mirrors and like things of glittering surface, nor mists, nor dull weather, nor an infinite number of things, which I forbear to mention lest they should prove wearisome."[18] Smith would bring aerial perspective into his sculpture. With the help of photographs of his sculptures in the hills and by Lake George, he also brought landscape into the experience of sculpture, by so doing making the space of sculpture seem indefinitely extensive, potentially as infinite as the space of painting.

Smith also marked passages in the selection of writings by Michelangelo, including Michelangelo's response to a book by Benedetto Varchi that developed from artists' responses to questions about the compar-

ative eminence of the arts. Michelangelo pulled painting and sculpture together in a way that predicts Smith's attempt to make each—and art itself—stronger by combining them even while maintaining differences between them. He emphatically marked off a passage rejecting a hierarchy between them:

> I used to consider that sculpture was the lantern of painting and that between the two things there was the same difference as that between the sun and the moon. But now that having read your book, in which speaking as a philosopher, you say that things that have the same ends are themselves the same, I have changed my opinion; and I now consider that painting and sculpture are one and the same thing.[19]

If ending sculpture's subservience to painting was central to Smith's aesthetic mission, this was because it was for him also a financial issue and a class issue. How he worked to win the competition for sculpture and in the process helped make sculpture the umbrella artistic field in the second half of the twentieth century, a field without limits, is part of the David Smith story.

Building

In 1946, at least ten Smith sculptures were sold, and *ArtNews* named Smith's retrospective one of the year's ten best shows. "Im just beginning to break ice," Smith wrote to his college pal Dal Herron, who had regained contact after many years. "My last show was a 10 year retrospective at the Buchhotz [Buchholz] and Willard Galleries . . . and am in a few museum collections."[1]

When the author and educator Lura Beam met Smith at his retrospective, she raised the possibility of an exhibition for the American Association of University Women. "The Association specializes in making exhibitions available at a very small rental fee ($5 to 10 or 15) to our branches in small communities where the idea of art exhibitions is relatively new," she explained. "Our median city is 12,000, and more than three quarters of the places where our exhibitions have gone are under 15,000."[2] The exhibition she requested was unusual. Along with a handful of sculptures that collectively weighed less than a hundred pounds, she wanted thirty photographs of sculptures, which she would enlarge to poster size and mount on Masonite.

Smith was intrigued. Crating was time-consuming, shipping and insurance were costly, and while traveling, sculptures could get damaged. What would it mean for people outside New York, many with little or no experience of modern art, to encounter his sculpture primarily through

photographs? He told Beam that he could loan four or five sculptures and "a medallion or two besides, which could still come under the 100 lbs limit."[3] He provided information about photographs of his sculptures by Andreas Feininger and Eliot Elisofon, and promised cooperation.

The art historian Sarah Hamill has established this small offbeat exhibition as a turning point in Smith's understanding of photography. Through photography, Smith saw that he could introduce his sculpture to people who did not know it and may never see it in person. He could fix images of his sculptures in people's minds and do so in such a way that the photographs would not seem like copies. "Smith employed his camera to create independent images in their own right," Hamill wrote. "Not straightforward or mechanical copies, his photographic reproductions unsettle expectations of what a document is."[4] Even as these images stood in for the sculptures, they gave them a distinct aura, often by siting them in a serene preindustrial landscape, and in the end they remained as distinct from the sculptures as Smith's drawings and paintings. Just as important, Hamill writes, Smith's photographs "made his sculpture more accessible, containing welded steel in a pictorial image."[5] For people who might be put off by the sculptural disjunctiveness, and by a sense of threat produced by the darting movements and bursting energies that Valentiner and other writers admired, the photographs could make the sculptures seem manageable. Even while containing the sculptures by holding them in two dimensions, however, the photographs infused them with magic, making them seem visionary, and apparitional.

In her "Memorandum to the Branches" helping them prepare AAUW audiences for Smith's work, Beam anticipated resistance. In places unfamiliar with abstract art, Smith's sculpture needed mediation. "If some of the visitors say that these 'industrial' works look ugly and brutal, explain this is the natural reaction of sensitive people to forceful new statements," Beam explained, "and that the very great art of history appeared positively brutal (e.g., Goya) when it was first seen."[6]

The exhibition, which traveled for more than six years, included between two and nine sculptures, depending on the venue, and twenty-one of the thirty photographs were Smith's. One of the fourteen stops, in 1947, was Fort Wayne, where Golda, Smith's mother, attended the opening. She told an Indiana state official that "the material was too intellectual for

the inexperienced."[7] Lewis L. Smith, a relative and lawyer in Decatur, wrote to Smith, "Your aestheticism has penetrated the woods of Adams County." It was "gratifying to know that we are growing such a substantial and notorious limb to our family tree. I, of course, felt some measure of pride when the paper inquired about you, however, I must confess that an out-country lawyer doesn't know a damned thing about abstractions." In the catalog's biographical sketch, Smith continued to assert that he was the "great-great-grandson of [Decatur's] founder." But Lewis Smith corrected him: "I understand that Samuel Rugg's son, Jay, was the second husband of Catherine Smith, whose lineal descendant was William. This would make Samuel Rugg a great great step grandfather if my blood lines aren't tangled."[8]

In Bolton Landing, Dehner and Smith had many good times, square dancing in town, visiting friends, and, in Dehner's words, "beering around joints up and down the line. It is fine to have a little change in the pocket even if it is only that we eat at the hotel once in a while or something like that, but it makes for a little relaxation."[9] They finally got a phone, on a party line, which was installed not in the house but in his shop-studio. With the marble table he made for her, set on cinder blocks, they could eat outdoors, which delighted them both. Mushrooms were abundant, and Dehner and Smith made good use of his expertise in picking them. Smith rode with George Reis, one of the town's social and cultural leaders, in *El Lagarto*, "The Leaping Lizard of Lake George," the speedboat in which Reis won three racing gold cups. "The damn thing gallops when it gets over 40 miles an hour but turns in a washtub and keeps an even keel. More exciting than an open plane," Smith wrote.[10] Fall, Dehner told Corcos, was "a perfect time. The country here is beautiful beyond words." Smith was working "very hard and with great fluency. And perhaps greater serenity than before."[11]

The Crockwells were their closest North Country friends. Smith and Dehner had been introduced to them by Graham, probably in 1932. Before leaving for Europe, Smith had helped Douglass Crockwell install a mural he had painted for a post office in White River Junction, Vermont. Crockwell was born in St. Louis, Missouri, in 1904. In 1933, a year after he moved to Glens Falls, he married Margaret Braman, also a painter. Crockwell designed *Saturday Evening Post* covers in the vein of Norman

Rockwell. "He was extremely inventive," Dehner remembered. "I think he was better than Norman Rockwell."[12] More interestingly for Smith, Crockwell was not only painting abstractions but also looking for ways to animate them. In 1934, he began creating experimental animated films, some of which he made available on Mutoscope, "a turn-the-crank moving picture machine that you found in every penny arcade." *Glens Falls Sequence* and *Fantasmagoria I, II,* and *III* were shown at the Museum of Modern Art by 1940. In September 1946, Crockwell "gave a studio warming" at his house, at which he showed movies from the Museum of Modern Art, including Buñuel's *Un Chien Andalou.* "The folks from Glens Falls all but took to their beds over the shocker movie," Dehner wrote. "Anyhow, the sex episodes gave the Glens Falls boys some new ideas I bet."[13]

The Crockwells' large, hospitable home in Glens Falls was a social center. "Everybody who went into my mother's house was safe," their daughter Johanna said. "I remember him [Smith] at the kitchen table all the time . . . My mother used to feed us all very well." She remembered Smith's playfulness during her visits to Bolton Landing with her sister and brother: "We'd go up there, we'd just hang out, and I just remember David always took to herding me with wonderful things—ginger beer, or something like that, whatever he had going." Alongside her father, Smith was a giant. "He always scared me in terms of his size," Johanna said. Her father revered Smith. Prior to 1945, he acquired *Structure of Arches* and *Leda,* as well as two Smith works on paper. For artists, "your life is you and your work, and there's nobody else in it," Johanna Crockwell said. "I could see that with my dad. He just absolutely adored [Smith]."[14]

More socializing was one of Dehner's conditions for returning to Bolton. "We had a lot of company," she wrote, "which was awfully good for me and just what I needed."[15] Marian Willard and Dan Johnson visited; so did James Marston Fitch, and Mildred Constantine and Ralph Bettelheim. Both Willard and Constantine were pregnant. "The stability we have arrived at amazes me," Dehner wrote. "It is all truly better than ever by far . . . but I am the burnt child. Oft and badly burnt. Nevertheless it makes a better life than it was ever before, and I have worked a lot. Such things . . . too . . . part of the burning I presume."[16]

Fitch brought with him Melinda Norris Kennedy Talkington, a

twenty-two-year-old graduate of Smith College who posed nude for
Smith for a week; she would pose for him again two to three years later
in his life-drawing class at Sarah Lawrence College. One of the photo-
graphs Talkington took in 1946 shows Smith's 19-inch-tall 1937 sculp-
ture of a high-stepping rooster in a field, looking toward the rickety
house. Another shows Smith standing beside his 1941 Chevy pickup
truck, cigarette in mouth, hands in pockets, sleeves rolled up, his belt
buckled high above a bit of a paunch. His close-cropped hair gives him
a hardscrabble Depression look.

In a letter to Corcos, Dehner was catty about Talkington: "She is a
good poser, with fine legs. Less good tits, and breast construction. Her
new husband came up for over Sunday and they had a fine time relaxing
all over each other. I never saw anyone quite so like a Shetland pony or
a young panda in heat as Melinda. It is all but too much for poor Hank,
who is only up to a very normal amount of carrying on."[17]

Dehner made a point of introducing Smith to Dr. Bernard Glueck,
described by Rosalind Krauss as "a former analysand of Freud who sum-
mered near Glens Falls. The analyst and Smith became good friends;
according to Dehner's report, Glueck spent hours with Smith in his stu-
dio while Smith worked and they talked together."[18]

For Dehner a new house was mandatory: the old one held traumatic
memories and "was a real shack. It was falling apart and full of rats."[19]
She and Smith would both contribute to the new building financially
and physically. Dehner drove the pickup truck to Vermont and came
back with cinder blocks that Smith piled in the meadow. They gathered
sewer pipes, wiring, windows, and insulation, as well as materials for
the floor and roof. Building would begin in earnest in 1947, and the old
house would become a guest house. Dehner wanted everyone to know
about the big development, but Smith didn't: "Its supposed to be another
of Smiths goddamn secrets . . . although how you can keep a house secret
I don't know . . . probably paint a canvas cyclorama in front of it with the
old house pictured."[20]

On October 31, Willard reported a gallery visit from a forty-six-year-
old Latvian-born businessman who had made a killing in mining and
oil. Purportedly a friend of the critic Milton Brown, the businessman was
intent on building a serious art collection. A relative newcomer to the

Fifty-Seventh Street art scene, he selected three Smith medallions and "made an offer of $600 for the lot. Then he looked over the smaller pieces of sculpture, selected 'Woman in the Subway' and offered $200. A total of $800. Immediate payment." Willard wanted $900. "Let me know your feeling as soon as possible as I want [to] phone him early in the week," she wrote to Smith. "He is accustomed to bargaining everywhere, which is something I hate to do and next time I see him the prices will just have to be raised for him I guess . . . Then we can come out even . . . Name Joseph H. Hirshhorner [*sic*]."[21]

Smith replied:

> To tell you the truth I don't like bargains—when its up to me to give them. 900 splits up for both of us much better, but if 800 is his limit OK take it. I've only got $50 to look forward to this remaining year and the money will be good. I've a good stock of materials—but the dam truck cost 150—what with new tires and overhaul. Take it little mother for all our futures; and I'm glad of it. That means I'll have to extend something to Milton Brown which I will and be glad. He is first rate. Its ones rooters which count.[22]

Joseph Hirshhorn bought four works by Smith. Over the next three decades he would buy almost thirty more.

Before the end of 1946, Perry Rathbone bought *Cockfight* for $1,275, a 15 percent discount, for the St. Louis Art Museum. Smith could now count on $850 in the new year. Your "letter was a Godsend—we were pretty close," Smith wrote Willard. "Luck it was too."[23]

31

Creation Myths

The exuberance and relief at the end of the war did not last. As Stalin extended the Soviet empire and the Cold War emerged as the defining geopolitical reality of the atomic age, fear of even deadlier conflict permeated America. In September 1947, General Dwight D. Eisenhower wrote in his diary, "Russia is definitely out to communize the world. It promotes starvation, unrest, anarchy, in the certainty that these are the breeding grounds for the growth of their damnable philosophy." Eisenhower believed that "we face a battle to extinction between the two systems."[1]

Artists were vulnerable. Many had been or were still communists. The WPA was gone, and in Congress artists would be accused of advocating "alien philosophies." The baiting of the artist, particularly of the avant-garde, was becoming an American pastime. In "The Present Prospects of American Painting and Sculpture," written for a special fall 1947 issue on American culture in the English magazine *Horizon*, Clement Greenberg evoked the estrangement of the emerging abstract artist's situation:

> It is still downtown, below 34th Street, that the fate of American art is being decided—by young people, few of them over

forty, who live in cold-water flats and exist from hand to mouth. Now they all paint in the abstract vein, show rarely on 57th Street, and have no reputation that extends beyond a small circle of fanatics, art-fixated misfits who are as isolated in the United States as if they were living in Paleolithic Europe.[2]

Smith's growing reputation as a voice for artists led to an invitation to join the board of the Artists Equity Association, which offered its members legal services and other benefits. Smith knew its president, Yasuo Kuniyoshi, from the Art Students League, and he accepted. At the end of that year, he agreed to be nominated for the role of director.

His 1947 talk at Skidmore College was inspirational. Like many founders of abstract art, Smith believed artists could bring into being a new public, one that would not collaborate with the cultures of deception and repression that had led to two world wars and massive exploitation. The artist, Smith said, revolts "in aesthetic terms against the banality of monopoly-controlled cultural standards." His work resists "conventionalized restraint, mass conformity, false standards [that] are propagandized by monopoly means for the sale of goods. The press, radio, and movies, which are the chief means of cultural control in our civilization are not operated as mediums of higher learning or the advancement of culture; their monopoly control uses these mediums for financial gain. Any cultural knowledge that seeps through is a very secondary quality."

He assured other artists that they mattered and encouraged them, particularly younger ones in the Skidmore audience, to believe in themselves. "It is rewarding if others understand your aim, but it is never your duty to explain it." He concluded his Skidmore talk: "So, you the artist—if you are an inspired mind, if you feel that you can express something that has not been expressed before, if you are willing to lay yourself open to opprobrium and tough sledding in a wealthy country with a narrow culture—be the artist—have the courage of conviction—for you will never be happy being anything else."[3]

In the Skidmore talk as well as in his talk in Woodstock, New York, seven months later, Smith cited the psychoanalyst and aesthetician Ernst Kris. Kris's essay, "Approaches to Art," in the book *Psychoanalysis Today*, which was given to Dehner by a psychoanalyst in 1946, was so important

to Smith that he tracked down Kris's contact information and wrote it in his notebook. Kris, born in Vienna in 1900, had studied art history and psychoanalysis and knew Freud. He rooted art in childhood and in charged, if not forbidden, psychological content:

> Certain themes of human conflict are recurrent wherever men live, or where certain common cultural conditions prevail. From Sophocles to Proust the struggle against incestuous impulses, against guilt and aggression, has remained a topic of western literature . . . Nor does it any longer seem doubtful that what a man has experienced in his early childhood may, without his knowing it, become a recurrent subject not only of his dreams but also of his creative work.[4]

Kris's essay helped Smith to understand the extraordinary attachment of an artist to his work. "The relationship of the artist to his work is complex and subject to many variations," Smith said. "In the typical case the work becomes part of and is ever more important than the self. Kris further states that in psychoanalytic terms we speak of a shift of narcissistic cathexis from the person of the artist to his work."[5]

Dehner was awed by the Skidmore talk. "David made a truly remarkable speech. Quite unbiasedly it was the best art speech I have ever heard," she wrote to Corcos.[6] Skidmore's Marion Pease, who had invited Smith, was equally enthusiastic. "Ever so many students and faculty members have expressed their appreciation to me," Pease wrote to Smith afterward. "It meant a lot to all of us to hear you express so sincerely and clearly your philosophy as an artist. It is what we need to hear and like to hear."[7]

For his forty-first birthday on March 9, Dehner had moving and melancholy words for her husband. Smith dated the letter and placed it in his grandmother's Bible:

> David . . . Today is your birthday . . . happy birthday David . . . creator. . . . genius is the vulgar word . . . I watch you make and I watch you do . . . and I am filled with wonder . . . and pride . . . it is rare to watch that quality . . . so few have it . . . and I am

priviledged. Thank you David. With the creation of your work
comes life to the world . . . a new mans new ideas . . . unde-
finable in the true sense . . . defined they turn into something
less than they are. No exhortations of the patriots of art are
needed . . . my wish for the year for you . . . work good . . . be
happy as you can.

At the bottom of the page, she wrote: "Ps. Well . . . no PS."[8]

It was likely during this spring that Smith drew a heart on the sheet of
a pad, inside of which he wrote "PURE GOLD DEHNER." Over the rest
of the sheet, on all sides of the heart, he listed grievances over economic
injustices to which he had been subjected in childhood jobs and about
which he continued to obsess: "The first time I sold apples—I worked
for a german woman with a wagon—sold a bag for 25 cents—returned
to woman 25 cents"—under which he wrote in larger letters, "offensive
approach." "The paper route wasn't good too many people ducked on
Sat collection." "Hoed corn 10 cents a row the rows never ended 30 cents
a day." "The most satisfactory was hoeing beets—that was in competition
with whole Hungarian family the dentists son the bankers son who were
bigger."[9] While these written memories surround the heart and some-
times enter it, the heart seems bigger than the childhood woes.

Soon after the Skidmore talk, Willard asked if Smith, in just a few
days, would be willing to write for the catalog for his April show at her
gallery. "So many people ask what your work signifies, its meaning etc.,"
she wrote, "that I feel it would be the moment to do such a thing."[10] A
week later, he responded: "I've been working on your request,—what my
work signifies, its meaning, controls, etc. For whatever its worth, here it
is. It is the words, notes, and thoughts which I've taken out of my work
books and grouped under their related headings." He demanded that the
texts "must be used in whole. No excerpts or changes. Its not explanatory
to the photos and not all the sculptures. But there are parts that are re-
lated or explain as fully as my use of words can."[11]

"Spectres Are," "The Landscape," and "Sculpture Is" are among Smith's
essential writings. They are, he insisted, "not fancy, nor poetry" but "verbal
working controls."[12] They have a stream-of-consciousness momentum, but
their sequences can be discontinuous and even disruptive, starting and

stopping, jumping from one reference to another, one moment in time to another, both attacking coherence and proposing a new experience of it. The multiplicity and multidirectionality can be overwhelming. Despite Smith's claim that they are not poetry, they are closer to prose poems than they are to any other genre of writing.

"Spectres Are" begins with an attention-grabbing sequence:

> The race for survival—the capital dog
> Banners of Royalty with Caesarian cannon
> Race of stegosaurs with Queen Ann collars.[13]

"The Landscape" is orderly until it isn't. It begins:

> I have never looked at a landscape without seeing other
> landscapes
> I have never seen a landscape without visions of things I
> desire and despise
> lower landscapes have crusts of heat-raw epidermis and the
> choke of vines
> the separate lines of salt errors—monadnocks of fungus.[14]

The poems are revealing about Smith's work, but they do not explain it; to decipher them fully would require a key that they hint at but do not provide. Willard wrote to Smith, "My knowledge is not great enough to follow you in many of your allusions, associations etc. and it therefore is unclear to me in many instances. But I take your word for it and have not cut or changed it in any way. The catalogue will be a TRUE picture of DAVID SMITH 1947."[15]

"Sculpture Is" suggests a series of creation myths, or perhaps a proliferation of images and associations rippling out from one creation myth that might be constructed from Smith's childhood. It is in "Sculpture Is" that he mentions the mud lion, his father's authority, and his mother's inhibiting puritanism, and contrasts his maternal grandmother's "yes" with his mother's "no." It begins out of the blue with age four, and with age seven the chronology ends.[16] It goes on to accumulate references to ancient practices and mythical stories that develop from "childhood

impressions and pictures (Assyrian and Mesop[o]tamian sculptures in back of [his grandmother's] bible—before I could read)."¹⁷ One sequence moves from "Diana of the Ephesians," to "Egyptian embalmers and the sepulchral barge," to "women who utter cries beat their breasts tear their hair," to "the cun[e]iform of Nebuchadnezzar."¹⁸ Nebuchadnezzar was a Babylonian king whose dream from the Book of Daniel describes a wondrous and disturbing giant metal statue mixing gold, silver, bronze, and iron.¹⁹ "Sculpture Is" also evokes ancient Near Eastern creation myths:

> Assyrian cun[e]iform where water is
> the parent of all things—where universal
> darkness reigns—where gods had been
> forgotten.

And from the Sumerian *Enuma Elish*:

> the fight between the monster Tiamat
> personification of chaos darkness
> disorder evil and Marduk god of light.²⁰

Marduk, like Nebuchadnezzar, is mythically identified with the power of fantastical statuary.

Smith's interpretation of Tiamat and Marduk is probably his own. Tiamat, which means "primeval waters," is deeply female. In *The Fate of Place*, Edward S. Casey refers to "the depth of her womb (she is continually bringing forth new gods and monsters) and the depths of her oceanic being . . . 'The coil of Tiamat,' the Sumerian gods admit, 'is too deep for us to fathom.'" Casey writes that "it is precisely because Tiamat's coil—her troublesome tumult—is too deep to fathom that Marduk must rise up against her. For Marduk can only deal with *measurable* depth."²¹ In Smith's reference, Tiamat and Marduk are locked in eternal battle. Her inner depth is frightening and dangerous. Marduk's capacity to bring light to that darkness is as indispensable to the generation of the world as her depths. Tiamat and Marduk may both be part of Smith. They *are* both part of his sculpture, where they are not so much in battle as miasmically intertwined.

"Sculpture Is" ends with references to music and thought and to an-
other eternal struggle, between knowing and unknowing:

> the bald headed harpist in Thebian tomb plucking the
> strings of the goddess body
> the dialectic of survival
> everything I sought
> everything I seek
> what I will die not finding.[22]

No great creative battle is definitively won. Sculpture is forever
unfinished.

"David Smith: Sculpture 1946–1947" ran through April at the Willard
Gallery. Disturbed by his behavior, Dehner did not attend the opening.
Half the fourteen titles point toward or include the word "landscape."
Like most of Smith's sculptural landscapes, *Landscape with Strata* is de-
nuded. It suggests movement from one geological plane to another. The
titles *The Puritan* and *Spectre of Mother* evoke bleak childhood. *Spectre—
Race for Survival* is ominous—a voraciously bloodthirsty fossil machine
that seems endowed with the ability to power through any containment.
In *Art Digest*, Ben Wolf singled out this "grim, mechanized pre-historic
monster, who rises to aid man's final Gotterdammerung, bearing twisted
bits of metal in its forepaws."[23]

By contrast, *Helmholtzian Landscape*, which refers to the nineteenth-
century physicist and pioneer in visual perception Hermann von Helm-
holtz, is polychrome, with a palette unlike any Smith had used before.
Inside the mostly green, roughly 15-by-17-inch frame, bright blue, red,
and yellow painted steel forms seem to parade like puppets. Yet, even
with this animated palette and rambunctiousness, the figurative beings
seem vulnerable, the tone stark. Clement Greenberg was taken by the
work's richness of "suggestion and possibilities . . . In the future we may
expect to see chromatic works from Smith's hand that belong as much to
painting as to sculpture."[24]

Terpsichore and Euterpe is yet another kind of sculpture. While it was
shown at the Willard Gallery, the quite different *Euterpe and Terpsichore*
was in the concurrent Whitney Annual. Both versions suggest demonic

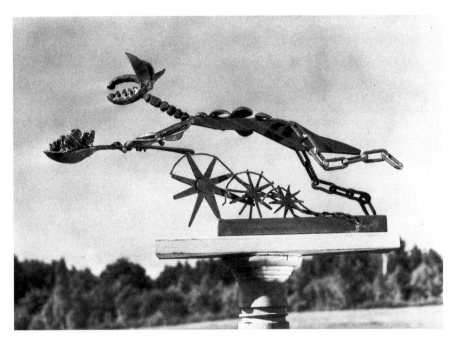

David Smith, *Spectre—Race for Survival*, 1946. Steel, bronze, stainless steel;
wood base, 18 × 33½ × 6¾ in. (45.7 × 85.1 × 17.1 cm).
Base: 1¼ × 22 × 5½ in. (3.2 × 55.9 × 14 cm). Private collection.

inspiration, comical and mad. Euterpe is the Greek muse of lyric poetry,
Terpsichore the muse of choral song and dance. The 32-by-45-inch low-
set fabricated bronze sculpture with a green patina at the gallery fuses
dancer/singer with piano, although she is much larger than the piano
player and beyond containment. The thickness of the metal forms makes
the sculpture feel massive, although openings provide passages, or lenses,
through the dancer/singer's metal block. The pianist's body, bent down
into his instrument, resembles a claw, the body of the dancer/singer a
ritual idol. From the sculpture's taller end, the forms consolidate into a
baying creature. To Maude Kemper Riley, *Terpsichore and Euterpe* repre-
sented "a powerful new direction in volume abstraction." This sculpture
"was arrived at after many studies of the relation between a dancer, a
grand piano and the piano player. The drawing exhibited nearby shows
the steps that proceeded resolution of these objects into a one-piece
force."[25] To Greenberg, however, this was a "bad piece." It "demonstrates

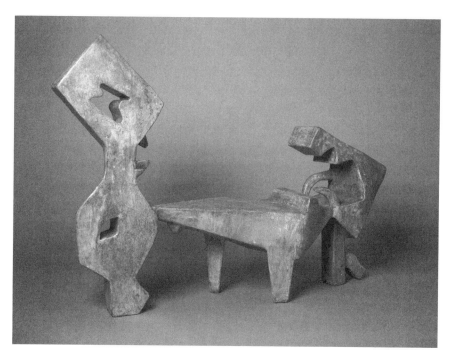

David Smith, *Terpsichore and Euterpe,* 1947. Bronze, 32½ × 45 × 12½ in.
(82.6 × 114.3 × 31.8 cm). Harvard Art Museums.

again how unsuited Smith's talent has become to the monolithic and
how much he remains a draftsman, not a modeler or carver." He added:
"But it can be said, really, that Smith needs his failures, for out of these
arise ideas that go on to become the nuclei of masterpieces in the end."[26]

Smith was irked by Willard's handling of the show. One complaint was
that the catalog had only three reproductions. He was also unhappy with
the lateness of the announcement, the lack of publicity, and the opening:
"I am still dismayed at the way the show got off. I believe the reception is
in part due to promotion. The attendance was dull. There could have been
a couple of ads in the Sunday before opening . . . The catalog aside from
the bad cuts and paper could have been improved with a cover . . . I see a
definite ratio between sales and promotion."[27]

Willard responded immediately to his letter. She, too, was "disap-
pointed by the opening. I am worried about sales from this exhibition as
I told you yesterday, because there has been a terrible lull. Many people

have asked prices but always they felt them to be high and no sale has resulted as yet. I agree that there is a ratio between sales and promotion and I have always put more effort into your sculpture than most of my group but it is harder to sell naturally than paintings." She encouraged him to write "anytime that something is bothering you. We have been associated long enough that we can speak up . . . I don't want any bad feelings harbored between us."[28]

In 1947, Greenberg went all in on Smith. His show at Willard "requires me to say . . . Smith is already one of the great sculptors of the twentieth century *anywhere*, deserving to stand next to Brancusi, Lipchitz, Giacometti, Gonzalez, not to mention Laurens and Moore. That is, he is making an absolute contribution to the development of world as well as American art. The course of sculpture in other countries will be affected by what he is doing."[29] In his review of the Whitney Biennial, he called Smith "the greatest sculptor this country has produced" and made him essential to the ascent of sculpture. "Here, as in France according to all the evidence I have seen, the future seems to belong to sculpture much more than to painting."[30] In "The Present Prospects of American Painting and Sculpture," in a judgment that provoked derisive attacks, Greenberg singled out Pollock and Smith as the only American artists producing "an art capable of withstanding the test of international scrutiny and which . . . justify the term major." Moreover, "Smith's art is more enlightened, optimistic and broader than Pollock's and makes up for its lesser force by a virile elegance that is without precedent" in America.[31]

For his lavish support, Greenberg anticipated special treatment. He did not expect to pay for *Vertical Figure—Construction Perpendicular*, on which he had made a $23 down payment in 1946. In May 1947, Willard said she had advanced that money to Smith and reminded him that he still owed $128 for the sculpture. Greenberg wrote that he would return the sculpture, "as I cannot afford at the moment to finish paying for it." He told her that she could keep the $23 as a kind of rental, "no regrets, no hard feelings."[32] Willard wanted to return the money. The same day he sent that postcard to Willard, Greenberg sent a flattering note to Smith: "You may be interested to know that I've gotten 3 letters on the piece I wrote on your show, all from people desirous of knowing more about your work. What's remarkable is that I average about 7 friendly

letters from readers a year, so this must mean a phenomenally high re-action."[33] On May 17, Smith wrote Willard that he had told Greenberg to keep the sculpture. "That situation is difficult . . . After such a review I diden't want to loose my only critic . . . This is unusual for me—I don't give work away."[34] A few months later Willard responded that it was an "auspicious" time to give the sculpture to Greenberg. "I'll write Clement and make the present," Smith responded. "I'll make you the refund."[35] Greenberg would describe the work as a "gift" from Smith.

32

The House

After the Willard show closed, the house in Bolton Landing became the Smiths' focus. They kept pouring money into materials. They hired a mason, whom Dehner described as "a remarkable character and a good mason, but with many of the mental and physical infirmities of eighty three years. So things go rather slowly. He was the only mason available, who is any good."[1] Others Smith had to supervise more closely. Two GIs camped on their property, "helping with the house, but one of them got a job he had been waiting for and so they both went off back home." David Graham, John's son, now nineteen and taller than Smith, stayed with the Furlongs, just over the hill, and he, too, contributed. "He is a huge handsome perfectly swell kid," Dehner wrote, "THOROUGHLY male with no mamas boy about him very sweet, and with a mind of his own (Graham)."[2]

Dehner made a few extra dollars by teaching an art class in town and helped with the Bolton summer theater. Franziska Boas was back, this time "with elaborate plans for building a school building here." Some of her dancers posed for Smith. "God how they do love to POSE," Dehner remarked.[3] Summer was very hot. After a day of labor on the house, Dehner and Smith swam in the lake.

In August, Golda, Smith's mother, accompanied by his sister, Catherine, made her only visit to Bolton Landing. Golda and Catherine stayed

in town. Over nearly two weeks, Golda could finally see how her son
lived, and while he had sent her an early landscape painting and she had
visited his show in Fort Wayne, she could also, finally, get some sense of
his life as an artist. More important for him, since he was hoping to bor-
row money from her, she could see the old, broken-down house along-
side the new foundation. "His mother lives with Catherine and the evils
of a mother in laws presence in their house has had a most ill effect on
the boy, tho Catherine seems unaware of it," Dehner wrote to Corcos.
"She is a selfish old woman . . . She does it with milk and honey and
son David does it with big noise, but I can see where he comes by it all
right."[4] The following year, Golda loaned her son $2,000, significantly
less than the $5,000 he had hoped for. He borrowed an additional $1,000
from Dehner's aunt Flo.

In late August, Smith spoke at the first annual Woodstock Art Con-
ference, called "The Artist and His World." The title of his speech was
"The Sculptor's Relationship to the Museum, Dealer and Public." The in-
vitation came from Herman Cherry, a painter who would become one
of Smith's closest friends. Cherry was born in 1909 in Atlantic City and
raised in Philadelphia. His father, from Kiev, had changed his name from
Cherkowski. Herman's given name was Hyman. Short and feisty, Cherry
"had a lasting memory of being hit in the stomach by his father and
wanting to be a prizefighter to get even," said Regina Cherry, his second
wife.[5] After dropping out of high school, Cherry spent fourteen years in
California and in 1929 sailed to Europe on a Norwegian merchant ma-
rine vessel, jumping ship in Hamburg. After resettling and attending art
school in Los Angeles, he moved to New York in 1945, studying paint-
ing with Thomas Hart Benton at the Art Students League, which had
close ties to Woodstock's art colony. Cherry's circle there included the
painters Philip Guston, Edward Millman, Fletcher Martin, and Arnold
Blanch, all of whom became Smith's friends.

At the conference, Smith offered an economic analysis of the art
world. He spoke about the cost of making art, which was greater for a
sculptor than for a painter, and concluded that "the wage per hour for
art work is usually below that of organized labor." The art system was
exploitative. Museums were a problem. Decisions by curators, many of
whom Smith believed were appreciative and knowledgeable, depended

on the support of trustees, whose views were shaped by money values, not art values. Given the cost of making art and how little income artists made from sales, the museum practice of asking for a 10 to 15 percent deduction of the sales price galled him. "This divine right is usually backed by some logical reason related to the budget or what the museum does for the artist. No artist lives on sales to museums. The museum has just as much need for the artist as the artist has for the museum."

While the museum's commitment to art was strategic and institutional, the artist's was intimate and absolute. His art was his life. "Exhibiting with museums and societies offers little economic salvation. In most societies and in some museums an exhibition fee is levied, which when added to the expense of packing, shipping, and insuring makes the artist pay dearly to show his child."[6] Identifying art as the artist's child was not new. Michelangelo considered his works his children.[7] But Smith's remark, and his assertion in the same talk that the artist's product "may always remain his child," are still startling, with far-reaching consequences for understanding his work.

Smith's financial hopes lay with state sponsorship and private collectors, particularly young ones. Because collectors, he believed, were driven by personal conviction and passion, they were more likely than museums to respect the conviction and passion with which artists worked.

As summer turned to fall and winter neared, the new house became consuming. "There is absolutely no chance of our getting the house fit to move into before next summer, but the rush goes on to get the roof up etc. so that the rest of it may be protected," Dehner wrote to Corcos. "We have the entire wonderful cellar which is just as good as most houses, all concreted and windowed and clean and fine, but the real house all has to be made yet. Each operation takes an age . . . It will be like the Kremlin when finished . . . solid, and built to last . . . mouseproof . . . fireproof . . . and I hope easy to care for."[8]

The work was endless and it wore them down. If they were going to keep living on their hillside and their marriage was to have a future, the house had to be built, and it had to suit the needs of both of them, but neither of them was convinced they wanted the marriage to survive. They continued to have marvelous moments together, but both were frustrated. Smith had been able to maintain the semblance of a rhythm

of working on the house during the day and on sculpture at night, but this summer he worked almost exclusively on the house. Whenever he could not immerse himself in his shop-studio for any length of time, he could be moody and tyrannical. Sometimes he went out at night and Dehner had no idea where he was or when he would return. "I haven't worked either," Dehner wrote. "The tension of the house is too much for me and my sense of guilt of having some time to work and Davids resentment of same are something I cant cope with so it will have to slide for awhile. We have no plans for the winter as yet."[9]

Dehner told everyone she knew of her apprehensiveness about another winter in Bolton, in the old house that was barely more than a shack, with mice, rats, stove and chimney trouble, unable to provide adequate shelter for either of them, their living quarters so confined that neither had any space. She felt unprotected. "Two huge dogs from across the road have been attacking me everytime I go to the outhouse or for the mail and everybody thinks its a joke but me, and I am positively scared stiff of them. Today they knocked me down with four milk bottles in my hands. David I think is afraid to give the people hell as they are very accommodating as neighbors and you need that in the country, but I could just as soon shoot their dogs as not and one day I shall."[10]

But the thought of winter in the city made her apprehensive, too. "I am certain we cant stay in this house as it is all shot to hell and back . . . I can possibly bear it till Xmas and then. I hope not N.Y. . . . I have such a nightmare everytime I think of my last stay in N.Y. that I am sort of neurotic about it I guess. I just don't KNOW."[11]

Early in 1947, Smith told Edgar Levy that for tax purposes he was defining the new house as part of his business operation: "This house is listed as a research building with living quarters. Aim it to be 2/3 deductible and aim to build it with timber money which we are getting weekly as the logs roll off the mountain."[12] To Willard, he referred to the house as *his*: "There is one thing certain. I've got to finish my house next year—to save it—freezing, winter ills etc. Got bathroom and furnace on the way. Prices are still rising but nowhere near where they will be 2-3 years from now. I look for uncontrolled inflation and boom with a war mixed in between within the next 5 years."[13]

In October, the two-day Conference on Cultural Freedom and Civil

Liberties took place at Manhattan's Hotel Commodore. The advisory committee included W. E. B. Du Bois, Paul Robeson, and Max Weber. The call to the conference, an echo of the 1936 Artist's Call, began:

> Today, in America, if you are an artist, writer, scientist, actor or educator, your activity and the basis of your life are under attack . . . In any guise, its intention is the same—to create the fear that will silence the writer, intimidate the scientist, paralyze the artist. The Presidents Loyalty Order, the Hollywood investigations, the sentencing of anti-fascists, the "little Dies Committees," in many states show that we have sat quietly too long.[14]

In 1945 the Dies Committee, named after former congressman Martin Dies, had become the House Un-American Activities Committee.

Possibilities and *Tiger's Eye* were launched in October 1947. Both magazines were intended to encourage and consolidate creative energy across the arts. The editors for *Possibilities* were Robert Motherwell (art), Harold Rosenberg (writing), Pierre Chareau (architecture), and John Cage (music). Motherwell and Rosenberg's mission statement provides an Abstract Expressionist answer to the urgent question: What, in the current "drastic" political situation, could constitute necessary creative activity? "This is a magazine of artists and writers who 'practice' in their work their own experience without seeking to transcend it in academic group or political formulas," the statement began. "Such practice implies the belief that through conversion of energy something valid may come out . . . The question of what will emerge is left open. One functions in an attitude of expectancy . . . The temptation is to conclude that organized social thinking is 'more serious' than the act that sets free in contemporary experience forms which that experience has made possible . . . If one is to continue to paint or write as the political trap seems to close upon him he must perhaps have the extremest faith in sheer possibility."[15] The only issue of *Possibilities* included interviews with Joan Miró, Virgil Thomson, and Edgard Varèse, an article by Stanley William Hayter, and statements by Pollock and Rothko. It reproduced nine Smith sculptures.

Founded by John Stephan, a painter, and his wife, Ruth, *Tiger's Eye*

lasted two years and published nine issues. The title was inspired by William Blake's poem "The Tyger," and its celebration of fierce energy and creativity blazing in darkness. The magazine combined art, literature, and philosophy in Europe, South America, and the United States. It gave space to sculpture as well as painting and placed emerging American artists like Mark Rothko, Barnett Newman, Adolph Gottlieb, and Clyfford Still in the company of European modernists like Miró and contemporary French writers like Antonin Artaud, Georges Bataille, and Jean-Paul Sartre. It, too, sought out Smith. *Possibilities* paid Smith one cent per word, *Tiger's Eye* two.

When Smith went to the city in early December, he was in bad shape. The cellar and window frames for the house were done, the floor was in process, and construction of the top story had begun, but the house would not be livable for winter, the uncertainty of which frightened both Smith and Dehner. Given its demands, it was hard to believe it would ever be completed. What would be left of their relationship when it was? More and more money was needed, and they didn't have it. His work wasn't selling and he couldn't make much work anyway. "The appearance of David was like a Freudian Dream," Mildred Constantine wrote to Dehner. "Freudian because you know the way I feel about your husband. Anyhow, a voice over the telephone and then the appearance of a big, shaggy man who wanted a bath was about all I remembered of his visit except that I did get a bear hug someplace in between. It left me completely unsatisfied for warmth, for detail, and for conversation."[16]

Earlier that year, Smith had begun an affair with Mitzi Solomon, a Bronx-born sculptor living on Manhattan's West Side. Born in 1918, Solomon was seventeen years younger than Dehner. In 1946, she studied in Paris, met Le Corbusier, and was inspired by the sculpture of Chartres Cathedral. She wrote poetry and would receive some recognition as a sculptor of dreamy stone figures, the kind of art Smith had no interest in. Solomon was also involved with the painter Fletcher Martin, a member of the Woodstock Art Association. In 1949, after marrying the English historian Marcus Cunliffe, she moved to England. She is best known for designing, in 1955, the golden mask that is the British Oscar.

A decade or so after his affair with Solomon, Smith spoke about it to Jean Freas, his second wife. Her words obviously reflect his spin on the affair. They do not indicate the starkness of his and Dehner's situation except in their suggestion of Smith's desire for a relationship in the city that would provide relief from his guilt and the tension upstate:

> Mitzi taught him, he said, everything about how to live well— foods, music and things like that—and he really admired Mitzi a lot . . . the whole thing about Mitzi was that he was not really emotionally involved, but he was being liberated, at the same time. He sort of treated her—he spoke of her like "a guy"—but she was a very voluptuous woman, there's no question about that—but she was teaching him all these things, about how not to feel guilty about having money (which, of course, he always did) . . . I don't think Dorothy ever knew about the affair. I know David was at great pains that she wouldn't know.[17]

Dehner knew Mitzi. She "has plenty of dough and doesn't need it" were her words to Corcos in June, referring to the Prix de Rome, for which Smith, like Solomon, had unsuccessfully applied.[18]

Smith and Dehner did, however, spend the winter at Bolton Landing. The cold was brutal. "We've had twenty to thirty below zero for quite a stretch, longest and lowest since '82," Smith wrote to Willard in early February.[19] When they put Finnegan's food on the floor, it froze. Smith could escape to his studio, where he had installed a second stove. The old house, where Dehner spent her days, was colder. Willard sent them a heating pad and an electric blanket. Smith preferred the blanket because the pad "costs about $2 a month to run." He "resents being warmed up in such a wonderful way because he says he hate[s] to pay even to sleep," Dehner wrote.[20]

She had little sympathy for his aches and pains. When he had blood poisoning she injected penicillin "into his ass ever[y] three hours for two days and nights [until] he recovered. Just a shop nick that got infected."[21] Emotional wounds, however, were deep and easily reopened. She considered adopting a child. Smith said no. With the tension between them growing, they visited Dr. Glueck, to whom Dehner had been periodically turning for help. Dehner wrote to Corcos, who now had two sons:

People of our age who have kids . . . seem to be getting great
pleasure out of them. David is a stinker not to let me adopt one.
Playing God is something I wouldn't want on my conscience.
But I'm sure it doesn't bother *him*. We talked to the great
Glueck . . . the psychiatrist . . . the other night. What a well tem-
pered clavichord he is and what a treat to listen to a wise man.
But he is old and tired and sick with the troubles of others, too.[22]

Dehner's *Damnation* series includes mute female figures in barren
landscapes; some heads are skulls. In one of these drawings, three naked
women are dancing with four other dancers in what looks like a prison
yard. In a seascape probably painted in 1948, naked female figures—
one facedown, one on her back, another on her side—are spread across
another barren landscape. The conch shell is a distant echo of the joy-
ful conchs she painted in her recollections of the Virgin Islands in her
series *My Life on the Farm*. Female figures exposed in an unprotected
landscape suggest sacrificial offerings.

Dehner still had her inheritance of around $2,000 a year, but build-
ing the house was so costly and money so tight that in March 1948 they
had to take out a bank loan in order to go to the city. Smith earned some
cash welding and took odd jobs, including, in Dehner's words, "mend-
ing childs carts, and a bunch of jobs for people stuff that goes on boats
and gates and other shit, but it does pay off . . . better than sculpture."[23]
In May, Smith got a bank loan to buy a 1948 green Ford pickup truck.
He traveled with guns: "a shotgun, in case he saw a bird that he wanted
to shoot; a 38 rifle, in case we saw a deer; and a handgun, for personal
protection."[24]

She considered the offer to teach for Franziska Boas in 1948 but fi-
nally declined. "I asked for what I thot was a modest guarantee," she
explained, "and she couldn't give it . . . I know she is broke . . . but since
the grocer and landlord all get paid what they ask I felt that I should be
paid what I asked so thats out. I still like her and we had no arguement
at all but suddenly it became a matter of principle." She felt used by the
local summer theater: "I put on a fortnightly art show for them in the
barn lobby and my take is a season ticket."[25]

Smith revealed his strained state in a letter to Willard:

I find it awfully hard to fit in with my world. I get very lonesome (we) up here alone. Yet the dives and conditions in Brooklyn sort of drove me here. I don't think I hit these lows when I'm more successful and doing my own work . . .

I'm in a soft mood—having just lost face a couple times lately with bankers etc—and I start to look over my past year. Is my work slipping, does my boorishness etc chase the people away. Am I overpriced. It just seems to me that I am somewhat responsible for my poor showing despite the compliments from critics this year. I start in on everything, like it's a battle, even battles don't occur that often. I start to battle before I know if there is an opponent . . .

What did you do with Hirshorn. Did he like the new work.

Smith asked her if she promoted "the Minneapolis project, and did I show ingratitude by raising the ante. I guess it was a cross between trade union standards and pride. I'm sorry if I gummed up the works. Dorothy is going to try to get a job at Skidmore, but its doubtful."[26]

Willard responded:

A little retrospective appraisal from time to time is always a healthy thing. You have been steaming ahead pretty fast these years and at times rather bull headedly and it is good to pause. I do think your battle armor is at times rather formidable and though it never puts people off you personally it affects your stands such as the Walker Art Center business which is hard to retract and start from scratch . . . You got too much to give boy to wear yourself out by being an "Aggressive Character." . . . Being a leader in your field we expect a great deal of you kid.[27]

Willard was referring to the Walker's canceling of a Smith show in part because of his fees. And *Aggressive Character* was a bristling and cartoonish sculpture that Smith constructed in 1947.

In sculptures Smith began or completed in 1948, humans are raucously monstrous. In the steel-and-bronze *Portrait of the Eagle's Keeper,*

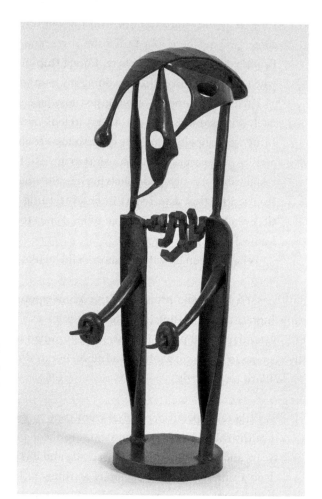

David Smith, *Portrait of the Eagle's Keeper*, 1948–49. Steel, bronze, 38 × 12⅞ × 22¾ in. (96.5 × 32.7 × 57.8 cm). Collection Helen Frankenthaler Foundation.

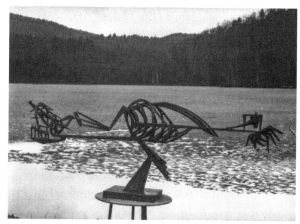

David Smith, *Royal Bird*, 1948–49. Steel, stainless steel, bronze, 22⅛ × 59¹³⁄₁₆ × 8½ in. (56.2 × 151.9 × 21.6 cm). Walker Art Center, Minneapolis.

a robotic fossilized figure, a hollow man, a thing-man, extends his arms in a "Here, kitty kitty" gesture, but the protected hands are like the stumps of épées ready to impale someone or something. Smith loved the sight of eagles. He knew the cliffs where eagles nested and periodically went with Dehner to see them. But the eagle was also a symbol of America, and the keeper of the symbol is another of Smith's freaky specters, as preposterous and creepy in its own way as the big game hunter in Smith's 1942 drawing *Aryan Fold Type I*. *Royal Bird* is one of Smith's great aviary creations. One of the dramatic sites in which he photographed this 5-foot-long steel-and-bronze sculpture was on the town dock, using the lateral sweep of Lake George and the distant shoreline to reinforce the sculpture's projectile horizontality. Another site was Edgecomb Pond, where the sculpture was set—drawn—against stone. This prehistoric yet industrial monster seems ready for launching and yet teeters ghoulishly atop its pyramidal support, its skeletal rib cage, maw, and tail seemingly picked clean. The bird is both lethal and ravaged, and carnivalesque.

In 1948, the former vice president Henry A. Wallace was running for president on the ticket of the Progressive Party he had helped found. The Levys supported his candidacy, and for several months so did Dehner, who reported to Corcos that Smith "has no interest in who gets elected." In July, they went to a fundraising event that featured Paul Robeson, a tireless campaigner for left-wing causes, and Rockwell Kent, the national president of the International Workers Order. Kent, a longtime acquaintance, lived in and painted the Adirondacks.

"It was all on a very primitive level," said Dehner of the event. She found herself out of step with the left-wing passions of the present. "Intellectually it wasn't even high school . . . David reacted the same as I did, and we were jointly so unhappy about it that we couldn't even talk about it. I certainly intend to vote for Wallace, but this kind of religious business must be a part of my past. The audience loved it."[28] Although in 1949 she would still label herself "a red and an atheist," Dehner was losing her ideological certainty. "I guess I am sick of the world," she wrote to Corcos. "With man so obviously bent on self destruction it seems insane to speak of salvation. It is the same old harrangue. But I feel I have not only betrayed myself by so feeling but my friends who believe, and in whose presence I feel like Judas Iscariot."[29]

Soon after the Wallace event, Smith received a letter from Sarah Law-
rence College in Bronxville, New York. On the recommendation of the
sculptor Theodore Roszak, Harold Taylor, the president of the college,
asked Smith if he would be interested in teaching sculpture two days a
week as a replacement for Concetta Scaravaglione, the sculpture faculty
member who had won the Prix de Rome that Smith and Mitzi Solomon
had applied for. He went down for an interview but initially refused the
job because of the pay. In September, just before the semester began, he
accepted. "To ward against eventualities and to meet loan responsibili-
ties, I have this minute accepted a post at Sarah Lawrence College," he
wrote to Willard. "I hated todo it but—the situation has me, where my
moves aren't all logical."[30] The salary was $2,000 a year, plus lodging; he
was hired for the first semester.

Dehner wrote an addendum: "This constitutes a break in policy for
me as I have always held out against anything but more production on
the T.I.W. assembly line. However it is for a yr. only as it stands now & he
decided to give it a try."[31] The job offer came "the day we were most des-
perate. I told you we were always saved by the bell. Its funny after almost
all the agony gets to the breaking point."[32]

Dehner was hopeful about the house. "He is making it like one of his
sculptures," she wrote to Corcos on September 13. "Crafted and finished
and strong to a fare thee well." It will be "wonderful to live and work in.
Convenient, easy, adequate as to space and well proportioned in all di-
rections. The view [over Lake George] which we now see for practically
the first time due to large windows is superb of course. It will be hard not
just to lean out and stare all day long . . . at first."[33]

33
Teaching

The commute between Bolton Landing and Bronxville was long, around six hours. In the dead of night, Dehner would drive Smith to the train station in Albany, where two to four days later she would pick him up. Often she brought Finnegan II along for company; Finnegan I had swallowed a needle and died. Once she pulled into an all-night gas station with Finnegan II sitting beside her with a cap on his head. The attendant laughed, but when she opened the glove compartment to pay, the man's expression changed. "I said, 'What's the matter?'" Dehner recalled. "He said, 'Well, you've got that gun there.' I said, 'Oh, my God, I didn't even know it was there. David left it for me, for protection' . . . and I didn't know it."[1]

The length of the trip notwithstanding, Sarah Lawrence was a relief. For the first time since ALCO, Smith could count on a regular paycheck. The scenic train ride along the Hudson gave him time to draw and dream. And he finally had a chance to put into practice his strongly held views on education. His students appreciated his knowledge, gained from years of making, looking, reading, and thinking. Also, Bronxville was just fifteen miles from the city, where he could go to exhibitions, visit old haunts, see Willard, the Fitches, and other friends. He could build friendships with Cherry and Motherwell.

Founded in 1926, Sarah Lawrence was a small, progressive liberal

arts women's college with an elite reputation. Harold Taylor, a friend and follower of John Dewey, was only thirty when he was named its president in 1945. Martha Graham taught there from 1935 to 1938 and periodically returned to give dance classes. W. H. Auden lectured and worked with students there. In 1948, faculty included Rudolf Arnheim, who wrote about visual perception and the psychology of art; Joseph Campbell, "Mr. Mythology" in the United States, whose 1949 book, *The Hero with a Thousand Faces*, was widely read by Abstract Expressionists; the dancer José Limón; the writer Marguerite Yourcenar; and Roszak, who sculpted steel in both a Constructivist and an Expressionist vein.

Smith's 1948–49 course was called Sculpture and Drawing. Its approach to the fundamentals of sculpture included introducing students to different materials—such as terra-cotta, wood, bronze, and stone—and having them sketch and model from life. His 1949–50 class, simply called Sculpture, required students "to keep a sketch book with impressions from daily life. This requirement is based upon the premise that drawing is the basic language of sculpture and necessary in producing creative work." Impressions from daily life included sketching animals in a zoo. Students were expected to visit galleries and museums in New York City at least once a month, and their visits would be discussed in class. "The accent of the course will be upon individual creative effort." Twenty-five students enrolled in Sculpture and Drawing, twenty in Sculpture. The enrollment in Smith's classes was as much as double that of classes taught by other art teachers.

Smith believed in encouragement: "Nobody teaches anybody to make art. In school, your teachers are there to encourage you." His emphasis was on doing: "It's nothing you have to know; it's something you have to do."[2] He dismissed preciousness. When Cornelia Langer, one of his students and later a lifelong friend, asked him, "tremblingly," how she should hold her drawing pencil, he roared: "Hell, hold it any goddam way you please—between your toes, in your nostrils, between your teeth."[3] He resisted puritanical studio conventions. "We had nude female models, but then the male models had to wear jock-straps, and David thought that was ridiculous," Langer said. "He made it a big issue." He was approachable. "I can remember the first time I ever saw Clyfford

Still's work, and I was so upset," Langer said. "He didn't make any value judgments. He just said, 'well, it must have affected you a lot, if you're so upset.' Which was true."[4]

Smith believed that artists learned the most from other artists. He brought Motherwell to lecture to the class and arranged for students to visit Manhattan studios, including Cherry's. This was in the spirit of The Subjects of the Artists school on Eighth Street, founded in 1948 by Motherwell, Rothko, Barnett Newman, David Hare, and others. Not a "school" in any traditional sense, during its one semester it brought in artists for a lecture series that was open to the public. Two of the school's principles were that art students learned best from other artists and that, in teaching, artists should treat art students as peers.

The beautiful red-haired Langer was one of four daughters of William "Wild Bill" Langer, twice governor of North Dakota, once forced out of office by a scandal that landed him in prison. From 1940 until his death in 1959, he was a Republican senator. For her and other art majors, Smith was a breath of fresh air, so different from Kurt Roesch, the department chair, who "painted in a very French style, kind of derivative," Langer said. Roesch "was so snotty to David," according to Jean Freas, Langer's best friend. "He was the painter," Freas said. "He was 'Mr. Art Department' at Sarah Lawrence."[5] Langer's older sister had studied with Roesch. "He had just absolutely devastated her as far as art went; he just told her she was no good," Langer said. "He was very cruel." Langer recalled "a girl who came in, crying, into David's class, because . . . she had made these little flower paintings, and Kurt Roesch had taken them and thrown them across the room, and told her she couldn't study with him, that she was no good. So David was very kind to her, and immediately took her under his wing."

Roszak and Smith were the same age. During the war, while Smith welded tanks and locomotives, Roszak designed tanks and aircraft. In his review of the 1946 Whitney annual of sculpture, drawings, and watercolors, Clement Greenberg singled out Roszak's *Transition*, "an abstract, skeleton-like piece in steel and bronze" as "the best thing in the entire museum," adding, "It expresses almost dramatically the composite character of its material—the tensile strength of steel and the fluidity of bronze—

and at the same time conveys speed, directness, draftsmanship."⁶ As much as other contemporary metal sculptors, Roszak communicated the rage and terror of living with the threat of nuclear war. Referring to Roszak's 1940s sculptures, the art historian Robert Slifkin wrote that "the exposed rusty surfaces of these works, like the simulated ruination caused by the dripped [sic] and pools of molten metal in other sculptors' work, summoned the afterlives of weaponry in a postwar world."⁷ In 1946, Roszak was included, along with two other sculptors, David Hare and Isamu Noguchi, in Dorothy Miller's influential "Fourteen Americans" exhibition at MoMA.

When artists helped Smith, as Roszak had in recommending him to Taylor, he remained grateful. He spoke positively about Roszak's work with students; in 1951, after welding a sculpture at Roszak's studio, he helped him get steel. Jean Freas did not remember Roszak fondly, calling him "the most conceited SOB [who] ever drew a breath. He . . . had his 'broods' and his 'longoos' and all that shit." If Smith was the object of snide behavior, he was unfazed by it. "He had some sense of who is real competition and who isn't," Freas said.⁸

In February 1950, Smith prepared a typewritten report on what the students could see during break, singling out the Klee show and Roszak's *Spectre of Kitty Hawk* at MoMA, and Roesch in the Whitney painting annual, which it would have been hard for him to avoid putting on the list. He mentioned gallery shows with works by Jean Dubuffet, Jean Arp and Sophie Taeuber-Arp, George McNeil, Braque, and Picasso. He also mentioned MoMA's film program "Social and Theatrical Dancing," which included *The Red Shoes*, the spectacular recent film on dance, obsession, and the visual imagination, and films with Irene Castle, Rudolph Valentino, Anna Pavlova, and Fred Astaire. Seeing *The Titan*, Robert Flaherty's film on Michelangelo, at the Little Carnegie cinema on Fifty-Seventh Street, was mandatory.

The report contained philosophical statements. The students' "duty" was to know art history and its concepts: "Your contribution will present a projection of your own concept, based on what is history for you." Cultivating the capacity for association was crucial: "The development and projection of your associative power is used in both visual reception and

the actual creation of art." Smith mentioned several of his heroes and heroines, including James Joyce, Gertrude Stein, Igor Stravinsky, and Arnold Schoenberg, whose "concepts were always beyond the time of public recognition." He told students that it was imperative to read.[9]

Langer discussed Smith's impact:

> He offered a whole different view of the world than I think most of us had at that time. He was macho. He was bigger than life. He was very assertive . . . He couldn't understand people who just lived their lives and never really wanted to do anything that would be remembered. He really believed in making—he wanted to make his mark on the world . . .
>
> He was really, basically, a Communist . . . He thought that art was an ennobling, wonderful thing . . . and he just felt that politics and business were really vile . . . He really felt that art was a power . . . He was a man who was, in his own way, very interested in power . . . He still thought in terms of the Spanish Civil War, in sort of broad strokes. I don't think he was involved too much in the politics of the day.

She did not mind his comments about her personal life. "My boyfriend at the time he called 'pretty boy,'" she said with a smile. "I think what he was saying was, 'Look for more interesting things in people.' I think it was more like you would say to your child, 'Oh, can't you find somebody less superficial?'"

In early December, as Smith's first semester at Sarah Lawrence was drawing to a close, Dehner exhibited thirty-three drawings and gouaches at Skidmore College—several works from *My Life on the Farm*, the rest from 1947 and 1948. Some drawings radiate sorrow: in one, a huge storklike bird seems suspended over a barren landscape as if struck dead in midflight. In his text for her catalog, Smith presented the two of them as devoted partners: "Throughout our rough times and the good times, she has painted seriously, and has been my most encouraging critic. I have always intended that her career be as important as mine . . . Certainly her painting shows the distinction of her personality and direction. And in

this particular family Dorothy Dehner is the one and only prize winner in national competition."[10] He was referring to a prize she had received from the Audubon Society in 1947.

Dehner was asked to be on a January 10, 1949, radio program in Saratoga, part of a regular Monday-evening live audience forum in which two people with opposing views discussed controversial questions, which in this case would be whether Americans appreciated art. Her opponent, who took the affirmative position, was the art director for General Electric. "I was very shocked that they asked me rather than David, but I can see why," Dehner said. "Because it was a woman's college, in those days. It wasn't co-ed yet." At the last minute, Smith refused to go, but then, too late, he changed his mind and began to drive to the debate. At a small party following the debate, Smith rushed in and told his story: halfway between Bolton Landing and Saratoga, Dehner recalled, he had "knocked on somebody's door he didn't even know, and said, 'My wife is on the radio, I want to hear her.' And he went in [and listened]. This is typical Smith, you know . . . I guess he felt bad that he hadn't gone with me, so at least he could say [he had heard me]."[11]

In spring 1949, Smith and Dehner finally moved into the new cinderblock house. "Cheap utility model—no fancies—pure industrial looking—maybe fancy color in outside cement and some arrangement with patio front in years to come" was how Smith described his idea to Edgar Levy in 1947.[12] Flat steel roof; steel-supported floor and windows. But the functional and severe cubic house had elements of expansiveness and dream. The living room, with its picture window, and the bedroom overlooked Lake George. A large woodstove sat near the center of the house between dining and living room areas that, not partitioned, created an interior flow. With Woodstock flat stone that they had trucked in, Smith built a beautiful patio. They were now able to hang paintings by Lucille Corcos and Edgar Levy, who with Mildred Constantine and James Marston Fitch and his wife, Cleo Rickman, were among the first visitors. Dehner at last had her own studio. By the end of August, the old house was finally "down. ALL of it."[13]

34
Jean Freas

Jean Freas first saw Smith in September 1948, on faculty introduction day at Sarah Lawrence. She recalled:

> David was wearing his best for his professorial debut. In this era of gray flannel suits and white shirts, he wore Irish tweeds complete with vest, tailor-made for him in Greenwich Village, a dark green knitted tie, and a shirt striped in orange and black, which a dressmaker upstate had run for him . . . Without him, the stage on which his colleagues were seated would have looked like an assembly of morticians. He was a knockout; his hair-cut was criminal. Not only had he the look of a Hollywood-style convict, the gloss and thickness of his dark hair had been savaged. The message was mixed . . . Pizazz and menace, in equal parts. We were wowed.[1]

Freas's junior year, 1948–49, had been disappointing. "It seemed to me that college was where I was giving up aspirations, not opening myself to more of them," she wrote. "I had come to study dance and acting, and now I was confused and discouraged. [My friend Cornelia Langer] thought she had the solution. I should get acquainted with her teacher, the new sculptor. She was sure that listening to him would undo my

negativism, but I was doubtful. More than that, I was scared to approach him."[2]

During the school year, Freas saw Smith in the company of veterans who had come to college on the GI Bill. "He always hung out with them, and they adored him," she said. "You can't imagine how popular he was . . . Oh, he had a following! Everywhere he went he had like five or six girls behind him."[3]

In May 1949, at a bar called the Dirty Spoon, they had their first conversation:

> It seems to me that I did most of the talking. I was deep in a paper on Marxist literary criticism, which seemed to interest him. Later with a crowd of his students, we walked back to campus, where he raised his cap: "Goodnight, Miss Freas." At this college we would call the president by his first name, so I was really impressed. But as I learned later from David, behind this polite address went the unspoken words of admiration: "Blonde Bomber."[4]

They didn't see each other again that semester.

Jean Winifred Freas was born on February 13, 1929. When she and Smith met, she had bleach-blond hair and stood around five foot eight. In photographs, beyond her attractiveness, she radiated restless energy, physical confidence, and uncertainty about belonging.

Her father, Samuel Allen ("Al") Freas, was born in 1887, the oldest of eight children. His mother was born in England or Ireland; her family was Irish. His father's ancestors came to the United States from Germany and included farmers and blacksmiths who lived in Pennsylvania for generations. His father finished two years of college, then worked as a contractor. "Everyone loved [my grandfather]," Jean Freas said, "even though he was a terrible alcoholic who stopped working in 1900. Al was taken out of school at ten. Sometimes the family survived on three meals of oatmeal a day. Al's first job was in a bakery, in which he slept."[5]

Al Freas was even taller than Smith. In his youth, he was a boxer and

rower. Wanting to be a cartoonist, he took a correspondence course in cartooning. He came home from World War I scarred by mustard gas and talking about the poverty he had seen in Europe. A liberal Republican who supported civil rights and was suspicious of the rich, he ran a wholesale fruit-and-vegetable market whose clients included hotels, the White House, army camps, and the jail. "I was the only kid I ever heard of who had Easter eggs with [paintings of] convicts on them," Freas said. Although he served the government, he did not work for it. "I think this is true of a lot of people who grew up in Washington: If you worked for the government that said one thing about you. My father never worked in the government. David Smith would have been boiled in oil before he'd work for the government. We really looked down on people like that." Al worked until five o'clock, went to bed at eight—"you have to be on the job at two in the morning, because that's when the auctions go on"—and almost never took a vacation. "We had breakfast with my father once a year—Christmas Day," Freas said.[6]

Katherine Reinhardt Hayes, Freas's mother, was born in 1896, also in Washington, D.C. Compared to Al, she was short, about five feet four. Katherine's mother was Danish, her father the son of a German immigrant who spoke five languages and worked for the government in Washington, D.C. Her father was a cigar maker and shoemaker who lived above the shoe store. Like Al's father, Katherine's was a raging alcoholic. At eighteen, she married Theodore Layton, who worked for the railroad at Union Station. In 1919, she gave birth to a daughter, Eleanor, by Cesarean section, in which she lost a great deal of blood. Soon after, Freas said, Katherine threw herself in the Potomac River. She was rescued, put in a straitjacket, and for six months confined to Chestnut Hill, "a mental institution where she was treated by one of the first psychoanalysts in the country," Rebecca Smith, Katherine's granddaughter, said. "The trauma of this incident was thought to be the cause of her lifelong hearing impairment, which gradually worsened."[7] When she left the institution, she lived with her mother and trained to be a nurse but quit because it required too much time away from Eleanor. Then she fell in love with a poet, which contributed to her getting divorced. Katherine and Al did not get married until the 1950s, after Layton died.

Al was Episcopalian, and Katherine taught Sunday school in the

Congregationalist Church of Christ for forty years. "She knew nearly [everything] about the Bible," Freas said.[8] Katherine was constantly trying to enlarge her husband's knowledge. She was a Democrat. She was also a worrier—unlike Al, who was mostly serene and withdrawn even as he was a dominating family presence. His affection for his daughters was clear, but he provided little guidance; in essential ways he was absent. He was very protective of Katherine's daughter Eleanor, who when Jean was ten went off to Goucher College, where she studied literature. "My father was totally on her side in everything, and, you know, no real father is ever totally on your side. But you can be that way with a stepchild."[9]

Jean Freas was uncomfortable with her family's lack of formal education. Her father "butchered the language," she said, adding, "Everyone was more educated than my family." She described a scene at National Cathedral School:

> The headmistress would get us every year, when school opened . . . Everyone would stand. She said, "Now, everyone whose father has a PhD may sit." And four people would go down. Probably more than that, because, this *was* Washington . . . Then we went to the MA, and then we went through college; and then we went through high school. And you know who was always standing, the last one standing . . . I was number two in my class. I never have understood why she did that.[10]

In November 1949, Smith and Freas began their affair in the music building, where he was staying. To get there, Freas said, she passed through a hole in the fence: "[It was] very famous for people in my area, and that was because you were supposed to be in by midnight and go through the gate . . . It was always sort of a thrill to go in through that hole, and I know there were people who never, never on earth, would have gone through that hole."[11] At the time, Smith was forty-three, Freas twenty; but Freas "liked older men," Langer said.[12] Freas had a serious boyfriend in graduate school at MIT whom she was going to marry, but she was finding him too authoritarian.

Despite their intentions to stop, Smith and Freas saw each other every week. "I had never met an artist, and here was art's purest exponent,"

Freas said. "There was absolutely no restraint in this man, no ambivalence, no irony. He was totally committed."[13] He did have his habits: "Before we'd get down to business, he'd take off his trousers and put them over the chair, very carefully, to keep the press in."[14] During the second semester, her parents paid for her to share an apartment off campus with a friend, which gave them more privacy.

She ragged him about his close-cropped hair, which now seemed to her not sexy but dated. "I just said, 'Man, you've got to get rid of that hair' . . . He cut it very, very, extremely close, because he had this notion that it sort of looked thirties, a real mensch and what not and what not." But this was not the 1930s; it was the late 1940s.[15]

Smith told Freas about Dehner's hysterectomy. When Freas mentioned her own gynecological problems, Smith was unsettled: "He got very upset about that, and he certainly was not ever going to marry me, nor would I ever marry him."[16] He "was still very much married to Dorothy. That was his big concern. And he thought (a) he was too old, (b) that he had no money, and (c) he was married, and was I aware of all these things? Of course, I was aware of all these things."[17]

The End of an Era

At the end of the momentous year of 1950, Smith and Dehner's marriage finally imploded. It was probably irreparably broken in 1945, but at that time it was impossible for them to imagine life without each other and it seemed worth trying to rebuild their relationship around a new house, one in which she would have her own studio and enough comfort to relieve her dread of winter. But her situation on that property, with him, would never allow her to develop as she needed to as an artist, and his sculpture was demanding a transformation commensurate with the ones that were making Pollock, de Kooning, Rothko, and other painters in his circle cultural signposts in the emerging postwar world. Around 1947, Smith wrote a prose poem in which he communicated his dream of sculpture that would not be bound by its previous conditions:

> I would like to make sculpture that would rise from
> water and tower in the air—
> that carried conviction and vision that had not
> existed before.[1]

Smith and Dehner's relationship had been formed in the 1920s and '30s, decades that his work now needed to leave behind.

Smith was involved in a passionate affair with a college senior twenty-eight years younger than Dehner, from a brasher and more liberated generation, who unleashed his sexual desire and yearning for children. His highs, with Freas and his sculpture, and with the professional recognition he was receiving, were tremendous. His lows, with his duplicitousness, guilt, and self-hate, tested even his capacity for conflict and compartmentalization. As they were investing massive amounts of energy and time in the permanence of a new home, neither Smith nor Dehner knew how to end their marriage.

Dehner continued to believe that their love for each other was intact even as his behavior grew more extreme. She repeated many times the story of what happened in late winter as Smith drove her to the city:

> I brought my work to the Whitney, and I had it in a portfolio, right next to me in the truck. About at Woodstock, David drove off the road, and he began wheeling around in the car. It stopped with a jerk, off the road, just in somebody's field . . . and his coat fell to the floor of the truck . . . He said, "Pick up my coat. Pick up my coat." So I picked it up. It was a Burberry that he'd bought in London. It was like a tent. I didn't know how to fold this big thing, except kind of do this, and roll it. He said, "Fold it up right. Fold it up right. If you don't fold it up right, I'm going to tear up all your work." I jumped out of the truck, and I held that portfolio . . . I said, "Don't you ever dare touch my work. You bang me, but don't touch my work. Never!'" It seemed like we stayed there for about three hours, but I guess it was five minutes. He said, "All right. Get in. I won't hurt your work."
>
> I had a nightmare that night, and I dreamed he tore up my work. I began crying in my sleep, and he said, "Oh, I'm so sorry." He didn't ever mean it. It was just something beyond his control. He said, "I didn't mean to do that. I didn't mean to say that. You're good, Dorothy Dehner. You're good." Other times, he would say, "You know, your work makes me vomit." And then he would say, "Gee, that's beautiful. I love

what you're doing. You've really got your stride." It was very teeter-totter . . . So, anyhow, I took it to the Whitney, and they took another thing for another show, which was their annual.[2]

For the first time Dehner was included—along with Smith and Corcos—in the Whitney's "Annual Exhibition of Contemporary American Sculpture, Watercolors and Drawings," which opened on April 1.

For a March 14 *New York Herald Tribune* forum on sculpture trends organized by the art critic Emily Genauer for New York City public school teachers, Smith made a powerful statement about artistic autonomy, aesthetic experience, and freedom:

> I believe that my time is the most important in the world. That the art of my time is the most important in art. That the art before my time has no immediate contribution to my aesthetics since that art is history explaining past behavior, but not necessarily offering solutions to my problems . . . That the freedom of man's mind to celebrate his own feeling by a work of art parallels his social revolt from bondage. I believe that art is yet to be born and that freedom and equality are yet to be born.

Making sculpture, he concluded, "is my way of life, my balance and my justification for being."[3]

From the beginning, Smith and Freas claimed that their relationship was just a passionate fling. Periodically, he ordered her to destroy his letters and wished for the relationship to be less consuming, or to stop. "Let me see you once a while . . . Make it casual like we were to be when we started," he wrote in one letter. But then, back in Bolton Landing, desire overpowered him. "I had to call you last night. I had to hear your voice. I was lonesome and sad my gut ached . . . my heart cried. I had to talk to hear your voice"—he called her from a filling station in town—"I had to sleep alone . . . I'm hard and old . . . I was in the depths last night."[4]

In the spring, shortly before her graduation, they broke up. "I was very intimidated," Freas said. "I knew I couldn't keep up with this . . . I was out of my depths with this. Besides . . . I wanted to go to New York, I wanted to have freedom, and find out a lot of things myself."[5]

On March 31, Smith received big news. He was awarded a $2,500 Guggenheim Fellowship. After applying off and on for more than twenty years, on his October 1949 application he marshaled influential supporters to write on his behalf, including Alfred H. Barr, Jr., and Clement Greenberg. He now had enough money to support himself for a year.

Smith's show at the Willard Gallery opened on April 18 and ran till May 13. "Smith and Dehner had a particularly nasty scene in the spring of 1950 while in New York for his show," the art historian April Kingsley wrote in *Turning Point: The Abstract Expressionists and the Transformation of American Art*.[6] A virus kept Dehner in bed at Willard's apartment for ten days, during which time she arranged for a show at the Laurel Gallery and received more disturbing news about Aunt Flo, who in January had had her right arm amputated. Smith was often in the city, too, going back and forth to Sarah Lawrence, preparing his "Notes on Books," which provided his students with a remarkably thoughtful annotated reading list, and hoping for sales that did not materialize.

As usual, Smith had sent critics photographs of sculptures previewing the show. Greenberg was won over by *Blackburn, Song of an Irish Blacksmith*: "Blackburn is terrific—I mean it, and don't have to see the piece itself for confirmation."[7] The show received brief but enthusiastic write-ups. In a review in *Pictures on Exhibit*, Charles Z. Offin mentioned the "tremendous vigor that is its [the work's] heartbeat." The sculptures were "rugged rather than effete, alive and open to the movement of light and air rather than anchored in solid mass."[8] In *Art Digest*, Margaret Breuning noted the prehistoric as well as the modern aspect of the sculptures and also referred to their increasing openness: "Some of the pieces do not so much exist in space, in the usual conception of sculpture, but seem to define space in limiting areas of planes and linear patterns, as in *The Eagle's Lair*."[9]

The thirteen sculptures included *Aggressive Character*, *The Insect*, and *Royal Bird*. *Royal Incubator*, roughly 3 feet by 3 feet, was part of the series of a half-dozen sculptures that, in *New Yorker* critic Robert Coates's words, "comprise what he [Smith] calls his 'royal series' in which he tries to express, with the eagle as the central symbol, both the outer pomps and the inner weaknesses of absolute power."[10] *Royal Incubator* reveals not only Smith's sense of the absurdity of imperial pomp but also his

preoccupation with birth and babies and the inside of a woman's body. Within the incubator's central steel portal is a bronze ovoid shaped like the uterine ovals in Andreas Vesalius's sixteenth-century anatomical treatise in which drawings expose organs inside truncated sculpturesque bodies. Smith gave Vesalius's book to Freas at Sarah Lawrence. The softly modeled shapes that seem to be growing within the ovoid suggest a fetus, a fallopian tube, and a placenta. Welded like rungs to the outsides of the two vertical posts defining the vertical armature of the portal are nine protruding steel objects, each distinct, some like primitive weapons and tools, that seem to be farcically guarding the stool-like throne, on which the fetal forms hint at embryonic figures with the inclination to hold hands in vows or dance. If this is a "royal" birth scene, it is one that seems both rollicking and deformed.

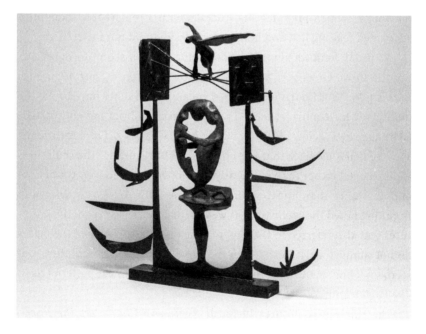

David Smith, *Royal Incubator*, 1949. Steel, paint, silver, bronze, 37 × 38⅜ × 9⅞ in. (94 × 97.5 × 25.1 cm). Seattle Art Museum.

Blackburn, Song of an Irish Blacksmith is more dramatically open and yet equally cryptic. The title refers to one of the two men who ran

Terminal Iron Works in Brooklyn. It's possible to read in the steel draw-
ing the head and outline of a broad figure, its capacious body as much
maternal as paternal. On a sketchbook page in which he jotted down
inspirations for his work, Smith lingered on the Brooklyn waterfront,
musing on how much had changed in ten years:

> The Ecstasy—of brilliant piano music black coffee—pieces fin-
> ished outside the studio—the piece under way—the piece
> finished conceptually—the odds on the wall—the view of ma-
> terials from which more pieces will grow—the machines which
> form them with out interruption from concept to finish—the
> ease of the 10 oclock rest in my barber chair—on 10 oclock
> news—this happened not 10 years ago at 1 Atlantic Avenue.[11]

Twenty years later, Rosalind Krauss contrasted the 4-foot-tall by
3½-foot-wide *Blackburn* with traditional sculpture's "internal consis-
tency" and emphasis on "the continuity between all the possible views
one could have of any single sculpture." From front and back, the sculp-
ture is "all open silhouette. Small clusters of cotter pins and pipe sections
punctuate the joints
of its hieratic torso.
From this prospect
Blackburn offers no
resistance to the eye,

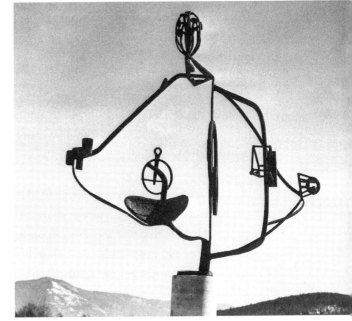

David Smith,
*Blackburn, Song of an
Irish Blacksmith*,
1949–50. Steel, bronze,
paint; marble base,
46¹¹⁄₁₆ × 40¾ × 22⅞ in.
(117 × 103.5 × 58.1 cm).
Base: h. 8 in. (20.3 cm),
diam. 7½ in. (19.1 cm).
Lehmbruck Museum,
Duisburg.

which passes through the interior, reveling in an unparalleled sense of freedom." From other points of view, however, the parts seem to tangle and cluster and any promise of access is denied. "By moving ninety degrees around the work we have the powerful sense of seeing a different work, not merely a new aspect of *Blackburn*."[12] *Blackburn* was one of the two Smith sculptures that Andrew Carnduff Ritchie chose for his show "Abstract Painting and Sculpture in America" at MoMA in early 1951.

The Willard catalog preface by Robert Motherwell, "For David Smith 1950," signaled Motherwell's emergence as one of Smith's most important friends. Motherwell was thirty-five at the time. Born in Washington, the son of a banker and child of privilege, but with a troubled relationship with both parents, particularly his mother, in 1940 he came by boat from California to New York via the Panama Canal. At Columbia University, he studied with Meyer Schapiro, the great art historian of medieval and modern art, through whom he met exiled Surrealists and became familiar with Surrealist poetry and "automatism." With the Surrealist painter Roberto Matta and his wife, Motherwell spent a summer in Mexico, where he met his first wife, Maria Ferreira, and began painting full-time. In 1948, he settled on Manhattan's Upper East Side. In 1950, he was riding high. MoMA acquired a fourth work by him. His writings appeared in catalogs and magazines. He was in demand as a voice for "the School of New York," a term he may have been the first to use, and an outspoken advocate for Abstract Expressionism. Motherwell was largely responsible for the invaluable Documents of Modern Art series, which has collected writings by Mondrian, Kandinsky, Picasso, Duchamp, Arp, and others (including, as of 2017, David Smith).

Motherwell's preface was informed by conversations with Smith and familiarity with his photographs and writings:

> If I see sculpture at all correctly, then like painting since Impressionism, modern sculpture is abandoning that grandioseness of past art that was meant to impress us with the power and glory of authority—rulers, the church, the property-loving world. Modern artists like to think of sculpture and painting as being in their beginnings, the painting and sculpture of freer men, that is; every period (or the artists in it) wants its own art.

Motherwell was the first writer to make the point that Smith wanted his sculptures to be considered in relation to the place in which they were made:

> When I saw that David places his work against the mountains and sky, the impulse was plain, an ineffable desire to see his humanness related to exterior reality, to nature at least if not man, for the marvel of the felt scale that exists between a true work and the immovable world, the relation that makes both human.[13]

Motherwell, Barr (now MoMA's director of the museum collections), and the sculptor Richard Lippold were the moderators of one of the most famous artists' conferences in the history of American art. It took place April 21–23 at Studio 35, 35 West Eighth Street, where the Subjects of the Artists school had been located; the related Western Round Table on Modern Art had taken place in San Francisco a year earlier. The April conference was Studio 35's final event. Twenty-five artists attended the sessions, eight of them sculptors. The men wore jackets and ties, and in the published transcript, no one addressed anyone else by his or her first name.

Their questions were urgent. For example, Barnett Newman: "Do we artists really have a community? If so, what makes it a community?"

David Hare: "In this country there is a feeling that unless you have a large public you are a failure . . . Why can't we find out what our community is and what our differences are, and what each artist thinks of them?"

Ad Reinhardt: "Exactly what is our involvement, our relation to the outside world?"

Richard Lippold: "Do we do it [make art] to be a success, to make money, understand ourselves, or what is the purpose: to describe our own creative nature?"

Robert Motherwell: "What is the content of our work? What are we really doing?"

Hans Hofmann: "What do you think quality is?"

Hedda Sterne: "Is art a problem of *how* or *what*?"

Louise Bourgeois: "Is art the process of being born or the process of giving birth?"

Norman Lewis: "Is art a form of self-analysis?"

David Smith: "Is painting leading sculpture or have they separated?"[14]

Inspired by the Studio 35 discussions, eighteen painters wrote an open letter to Roland L. Redmond, president of the Metropolitan Museum of Art, to protest "American Painting Today—1950," a large juried exhibition planned for the end of the year. "The undersigned painters reject the monster national exhibition to be held at the Metropolitan Museum of Art next December, and will not submit work to its jury." Several of these painters had been among the eighteen thousand who had been invited to submit; several had works in the Met's collection. Almost all the major Abstract Expressionists, including Pollock, who did not participate in the Studio 35 sessions, signed the letter. The ten sculptors who signed in support of the painters included Smith, Bourgeois, Hare, Seymour Lipton, Herbert Ferber, and Roszak. These artists did not believe in juries, which had invariably been unreceptive to their work. They did not want their work to be specks in the ocean of a massive exhibition in a museum suddenly eager to proclaim its concern for contemporary art.

Irving Sandler chronicled the sequence of events:

> Gottlieb drafted the letter and had it approved and signed. Newman hand-delivered it to the *New York Times* on Sunday, May 21. Luckily, there was no major news, and on the following day, the *Times* ran the story on the front page under the heading: "18 Painters Boycott Metropolitan: Charge 'Hostility to Advanced Art.'" On May 23, the *New York Herald Tribune* published an editorial titled "The Irascible Eighteen" (giving the artists a label), which condemned the protesters and defended the Metropolitan Museum.[15]

Photographed by Nina Leen for *Life*, fifteen of the painters (fourteen men and one woman, Sterne) would become known as "The Irascibles." These artists may have disliked media culture, but they were now part of it. Whether they wanted to be or not, they were now seen as a group. Whatever the ridicule, and they received plenty of it, they were no longer "nobodies"—a word Gottlieb used to characterize artistic outsiderness in the early 1940s.

On June 5, Dehner informed the Levys that her aunt had passed away: "Flo died in perfect peace. She had no pain or no opiate since her amputation although she was *riddled* with cancer . . . We had one day together, & then she hardly knew me." Dehner arranged for "a beautiful abstract medieval Catholic low mass" and had Flo buried in "the little mausoleum at Monrovia where Mother & Louise are and where she wanted to be."[16] She wrote Smith a long letter—"Dearest Baby," it began—with all her news of California and her time in New York and at Flo's estate. In early July, in order to be appointed executor of Flo's estate, Dehner took yet another cross-country train, perhaps her sixth such trip in seven months.

After Smith and Freas's breakups, it was invariably he who got back in touch. "This card would say, 'Freeman is going to call you, at such and such a time,'" Freas said. "That's also what he called his penis—Freeman. He really was a piece of work!"[17] Freeman had other names. "Save a place for Wilbur who will be a July bachelor," Smith wrote in June, referring to the time when Dehner would be away. "My sculpture is coming fine—flowing faster than I can make it. All experiences add to it. Beauty begets beauty."[18]

After graduating from Sarah Lawrence, Freas, Langer, and two friends drove across the country. Langer and Freas returned east by themselves. When they stopped in Bolton Landing, Dehner had not yet left for Pasadena. "I knew it was just unavoidable," Freas said. "I could have avoided it but, somehow, I didn't. I thought my beard was going to be Cornelia, with her red hair. And she was also very fulsome—and she threw her arms around David—and they never had a relationship—never, ever, ever. But I don't think that fooled Dorothy. Or maybe it did, I don't know. But she had a very, very, very sad look."[19]

"I didn't know anything about it [the affair]. I should have," Dehner told Maureen Bloomfield and Patricia Renick nearly forty years later. "If I had been a wise-eyes, I would have . . . I always thought we were so terribly in love."[20]

The September 1–2 Woodstock art conference was devoted to "The Artist and the Museum." Participants included the directors of the Whitney, the Met, and MoMA. The panel "Exhibitions and Juries" was co chaired by Smith, who came armed not only with his own gripes but

also with those of Willard, who, like him, was disappointed by the re-
luctance of museums to give contemporary artists solo shows and by the
depressingly small amount of money museums were spending on con-
temporary American art, as opposed to modern art from Europe.

The art dealer Edith Halpert, head of the Downtown Gallery, quoted
from "What Museums Buy," a July 31 article in *Life* articulating the dis-
satisfaction with museums within the contemporary art world. "It states
that we *now* have 2,500 museums of which 400 are devoted to art alone.
According to the figures, the Metropolitan Museum, plus the five muse-
ums featured in the spread, expend more than a million and a quarter
dollars. In analyzing the purchases listed, one finds that living American
art, including eleven local men, extracted approximately $20,000 from
this formidable sum—or a mere one and one-half per cent."[21]

Speaking to a group that consisted mostly of artists, Francis Henry
Taylor, the Met's bumptious director, said he was irritated by "how little
most of you know about museums and their operations and their prob-
lems." He scolded artists who complained about market and museum
resistance to their work: "It is a very curious thing that there is no class
of merchandising I know of in which there is not some self-examination
on the part of the producer if the sales don't seem to go. How ready are
you as an artist to re-examine the product you are selling?" The "grow-
ing separation between the artist and the public" was a serious issue: "It
is a separation which has taken place since the middle of the nineteenth
century" and "is one of the inevitable results of the age of specialization."
The museum was the in-between, "the broker, the spiritual broker, be-
tween two vitally important elements of the art world."[22]

Freas and Langer rented a small apartment—a "dump," Langer
called it—on Christopher Street in Greenwich Village. Langer worked
in the copy department of *Vogue*. She had begun dating Kenneth No-
land, an abstract painter whom she had met at his show in Washington,
D.C., where he lived. Freas was working at Celebrity Service compiling
a subscription-based daily information sheet on stars in the news. The
job, she said, "was wonderful, because I got second-night comp tickets to
everything. I got to interview these incredible people."[23]

Smith began spending time at The Club, also in the Village, at 39 East

Eighth Street. He had dinner with Greenberg and reported that the critic liked his new work. "Went artists party artistic club last night," he also reported to Dehner. "Cherry Guston—Castelli ran into all in afternoon we went party (was for Louise Bourgeoise—Robt. Goldwater wife) Stayed with Phillip Guston last night, talked till three . . . Had breakfast with Noguchi who is back now."[24] Smith also began hanging out at the nearby Cedar Street Tavern, a place for more informal or private conversations.

The Club was born in the late fall of 1949. Round-table discussions were held on Wednesdays for members. Friday's lectures, symposiums, and concerts were open to guests. Panels and lectures featured not only painters and sculptors but also philosophers, anthropologists, art historians, and musicians. While The Club is easily mocked for its sexism, drunkenness, and occasional brawling, it was, in the words of the art historian Debra Balken, "a remarkable gathering place, known for its erudite talks and as a place to assemble, gossip and take part in shoptalk . . . Moreover, it was avowedly nonpartisan, a place where politics was left at the door, and no single aesthetic credo dominated."[25] For many artists who had come of age within the group activities of the 1930s and felt the public and institutional enmity toward artists like them, The Club was indispensable.

In the early morning of October 10, Smith wrote to Freas in a moment of elation:

> It's 1:45, Phil Napoleon is on. Had my coffee at 11:30 when a quartet was on WQXR. 1 to 1:30 Nick's was on WOR.
>
> Riding high on a jag, but it's all in the mind. The hard piece is shaping up. Keys fit. I'm happy.
>
> I know where I start in the morning. I've taken big chances with some forms, and I'm glad I did . . . I have hopes of stretching out very far. I see specks on the horizon which I think I can make into strange and new things.
>
> I'm sort of self-satisfied that my own excitement, without even anyone else being involved, can key me to heights alone and in the quiet mountains. Sometimes I used to do it in NY going around—beering—listening to music, and mild hell-

raising—waiting for breakfast and sunrise—maybe to do it all alone is a kind of narcissism. But what the hell, it's fun to do it all ways, all places.

When she cited these words in an essay, Freas added: "The last phrase I'd heard from him before, but not about work."[26]

Sometime in October, likely late in the month, when Smith went to Louisville, Kentucky, for a conference, Dehner wrote to Smith from New York City:

Hell, David, I find it impossibly hard to say this and yet it is really simple. If I had a broken leg, or if you did I would not hesitate to get it fixed, and for that reason I came to New York . . . to get fixed. But it is nothing as easy as a broken leg. It is us, David. You know what I mean. The upsets we have are bad for us. As I get older, I find that each time we have one it takes longer to recover, and I just dont bounce back . . . at least not in tact . . . I feel damaged, really damaged. I know you do, too, and I believe you suffer torments lots of times when I am not even involved, but when I am involved, it is too much for me. David I love you, I want to live the rest of my life out with you, I want nothing else in this world except to do that, but I cannot do it and have these destroying scenes. I am not going to minimize them, now, as I try to do when they happen, and make them seem like a bad dream, because they are real, and that is how I live.

She had seen Dr. Glueck, who, she said, admired them both and wanted to see them happy but knew they could not continue as they were:

He realizes that not only my emotional reactions, but physical ones as well are tied up in this, and so he agrees with me that if we are to have a decent life without violence and terrible scenes, and without humiliating contrition afterwards, someone or something must help us . . . There has been much beauty with you, but the fighting blights things, and then I cannot work or perform like a decent human.

She would remain in the city. "Get in touch with me through the gallery," she wrote, "or leave a message with Marian."[27] She urged him to see Glueck with her.

Dehner told April Kingsley that Glueck had spent hours comforting her: "And then he said a terrible thing to me. He said, 'You know you have to leave him or he will kill you. Now do you think you can?' I said, 'I don't think I can.'"[28]

On one of her drawings from 1950 are the words "David Despair." The drawing includes thirteen nude female bodies of different sizes. Thin and unprotected, they are splayed and in positions of praying and falling.

Smith was jubilant about his work but felt no control over the rest of his life and very little over himself. In the same letter to Freas, he could be dominating, self-assured, solicitous, helpless, and miserable. He had to calculate when and how to call her, and where she should send her letters to him; when she went home to Washington he had to figure out how to get in touch, once, embarrassingly, calling college friends out of desperation to reach her. Although Freas was sure Willard knew about their affair—she had stayed with him in Willard's apartment—he concealed their affair from other friends he and Dehner shared, telling them that Dehner was happy and working well. He had never been a serious drinker, but now he occasionally drank himself into a stupor.

While in Louisville for "The Teaching of Sculpture" panel at the Midwestern University Art Conference on October 27, Smith wrote affectionate letters to Dehner and sent her a pair of slacks. After Louisville, he flew to Fort Wayne and went to Paulding to see his mother. On the way home, he met Freas in New York.

In November, Smith and Freas had what she characterized as a "serious quarrel." His November 13 letter to her is tormented:

> My life and work were so set before I met you. Right up until
> graduation I thot I was free. I hope my logic, or your judge-
> ment will with a sharp knife cut my bonds from you or that I
> can tell you to scat . . . I try to look at the places we might have
> to live—how I couldn't take it—how I would mess up both
> our lives + 1 other, and maybe even after we had kids. If you

were here I could talk it all out in 2 days. Yet when we talk, we
love and the use of logic and reason doesn't have a chance . . .
Oh Christ why haven't I the power—why can't I make life like
I can make sculpture.[29]

Freas shot back: "How dare you profess to be a Marxist—Marx was
opposed to the authoritarian personality—and that means you." His ac-
cusations of infidelity infuriated her:

No I haven't so much as seen any men here or in N.Y. I have
been here all the time. For health reasons—which should be
obvious to anyone with half a brain . . . Don't cry to me about
your loneliness. You wouldn't be lonely if you treated either
of 2 women decently. Financial responsibility is not the only
responsibility you couldn't handle. You would be jealous of a
child! Anything that distracted from the mother's constant
loving attention to you would go against your grain.

She ended the letter with "No I don't love you. You are too unfair & cruel &
selfish. You have to change that."[30]

On a snowy Thanksgiving night, Dehner left for good. She and Smith
had dinner with George Reis and his much younger female partner in
their beautiful stone house by the lake. After they returned home, they
got into bed—where, according to Theta Curri, Dehner's later confidante
in Bolton Landing, who worked for many years at the Bolton Historical
Museum, they both slept in the buff—and they started fighting. Smith
may have kicked as well as hit Dehner. Curri said that Dehner told her
that Smith went to town, and when he did she packed her bags and called
a friend to come get her. A neighbor, Mary Neumann, helped carry her
bags to her house, across the road, where they waited for the friend to
arrive. She spent the night at the friend's family's house. "She went from
there to Henrietta [Marietta] Davidson's house in Saratoga, and she was
there for two or three days," Curri said. "I think she had some fractured

ribs and some other stuff."[31] In one of her last interviews, Dehner told Miani Johnson, Marian Willard's daughter, "All my ribs, front and back, were broken."[32]

Based on her interview with Dehner, Kingsley provided a different account of Dehner's escape:

> Luckily for her he was so nearly comatose that she was able to escape; naked, she grabbed her coat and boots in the kitchen and jumped into the truck parked outside, its keys still in the ignition. She sought refuge at a friend's house, and the next day she dragged herself to the doctor's office. When he asked her what had happened, she tried to cover it up as usual but the doctor knew better.[33]

Dehner wrote to Smith's mother. "My Dear Daughter," Golda wrote back. "How I wish I could give you the comfort you need! . . . I have only one solution to offer which has been my strength, take it to the Lord in prayer." She said that when her son was at home, she told him that "if we would treat one another as we would like to be treated it would heal all the wounds of the world. He did not subscribe to that." She signed the letter, "Your Mother."[34]

Catherine, Smith's sister, wrote to Dehner on Christmas night:

> To say I'm sorry about you & David is putting it mildly, in fact it is unbelievable. You know Dottie I have always said you should have a medal for living with David, even tho I love him too. I know he is difficult, always has been, it isn't all his fault tho; You know mother is a very strong character too . . .
>
> My dear, David doesn't feel secure, I think that is the reason for his outbursts of temper and other actions. I'm hoping he will realize you are his security, just give him a little time and when he comes to his senses don't be so damn good to him Dottie. I don't mean to be critical but I think you love him too much and he knows it . . .

I'm writing David too, and I know he isn't going to like what I tell him but I'm his sister and he can like it or not. Don't worry he's had preaching letters from me before.[35]

Dehner told the Levys she would be enrolling in Skidmore College for the spring term. Until then, she would take a temporary job at a Woolworth store.[36] She got her first Social Security card and an apartment in Saratoga. Corcos and Levy had had many good times with Dehner and Smith and had lived through many of their blowups and reconciliations. They did not want to believe this was really the end.

Smith called Freas and, in turn, Golda. He hoped Freas would visit. Instead, she went into the hospital for a minor medical procedure. "We need to talk calmly and quietly," he wrote her. "Letters don't solve it . . . You are right about me. I'm what you say. But there are points overaccented and not quite accurate, according to my position . . . I'm keeping your letters of points in protest and will talk over certain things when we have time. Maybe these points which come up can be settled, admitted or equated."[37]

At the end of an unabsorbable year in which he had been many different people and his behavior had ranged from inspirational to abhorrent, Smith completed one of his most generative works. *The Letter* is a 3-feet-tall-by-2-feet-wide open steel rectangle within which, Emily Genauer wrote, eighteen forms "sit on horizontal rods like words on lined note paper."[38] Some were taken from a box of steel objects that Smith acquired from a defunct wagon and buggy shop. All suggest letters of the alphabet, "y's" and "h's," an "n" and an "I," and eleven "o's." Wafting in like a cloud from the upper left, in steel script, is what seems to be a greeting, one that the curator Edward F. Fry interpreted as "Dear Mother," but not a single letter in the greeting is distinct, or even clearly a letter.[39] In steel script at the lower right is what seems to be the signature "David Smith." But while "David" is unmistakable, and "sm" after it fairly clear, attached to this train of letters is not a surname but an image of what suggests the back or vertebrae of a fossil. "David" emerges from prehistory and is joined to extinction. *The Letter* is cryptic—"like a set of secret glyphs for which the viewer has no key," Rosalind Krauss wrote.[40]

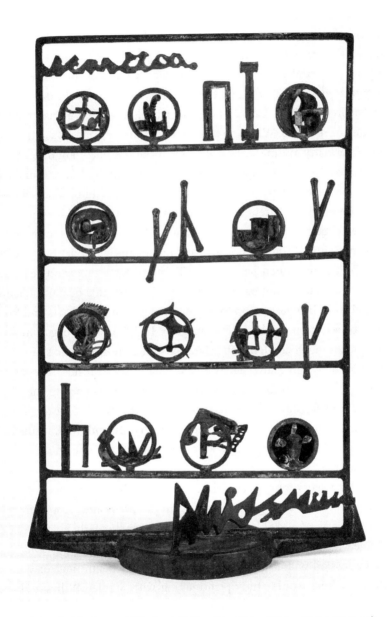

David Smith, *The Letter*, 1950. Steel, 37½ × 25 × 12 in. (95.2 × 63.5 × 30.5 cm). Munson-Williams-Proctor Arts Institute, Museum of Art, Utica, New York.

It has too many identities and moves in too many directions at once for any message to cohere.

All the letters in *The Letter* are first of all images. Fry interpreted some of them as "a schematic interior of a house, a running man, and a hermit crab."[41] Other images suggested through or around the "o's" hint at scenes of daily life and myth—a fan, a crank, a reclining woman, and a Greek gorgon. Each sign is associative. Each can be imaginatively rotated or reversed. While no interpretation of any image is secure, each letter is clearly an image. Historically, image preceded language. In his 1952 essay, "The Language Is Image," Smith wrote: "Judging from Cuniform, Chinese and other ancient texts, the object symbols formed identities upon which letters and words were later developed."[42] For Smith the detachment of language from image led to a fall into literalness and explanation that limited not just the understanding of art but also the possibilities of human perception. "Thirty or forty thousand years ago primitive man did not have the word picture, nor this demand for limited vision. His relationship to the object was with all its parts and function, by selection, or the eidetic image."[43] In 1950, Smith began making sculptures in which alphabetic signs exist in a pre-linguistic state. With each of these signs, language is image, what is seen cannot be separated from what is remembered, and human memory goes back to the caves. *The Letter*'s resistance to words is so forceful that the sculpture seems to be demanding a new language, one to which only sculpture, it suggests, can point. Existing languages don't work anymore is one of *The Letter*'s messages.

After twenty-four years Dehner and Smith's life together was over. They had grown up together as artists in the 1920s and '30s. Their relationship was remarkable—with many years, particularly before ALCO, defined far more by discovery and closeness and shared passions than by impossibility and pain. Now, new lives were beginning for both of them. Dehner would study printmaking with Stanley William Hayter and become what she could not be while living with Smith, a sculptor. She would remarry. She and Smith would develop an important, if uneasy, friendship. In the 1970s she began talking publicly about his abusiveness. She would continue to struggle to reconcile Smith's brutality with his politics and creativity, and with his capacity for supportive and

poignant gestures. From his death in 1965 to her own in 1994, she spoke tirelessly and for the most part warmly about him and the fullness of their relationship, and she never stopped revering him as an artist. "It was a miracle to watch him work," she told Karl Fortess in 1973. "He had such vitality and such energy . . . I learned a great deal from him about application and intensive work and the ruthless expenditure of energy that it takes to be an artist, and of course he was magnificently equipped for that . . . I learned how to work at my work from David."[44] She made herself a guardian of his legacy and made sure that anyone who wanted to fully understand his story had to pass through hers. Without Dorothy Dehner, David Smith would not be David Smith.

A New Landscape

Lucille Corcos and Edgar Levy invited Smith and Dehner for Christmas. She didn't go. He did, and was grateful. "Thank Lou and the kids for such a nice Xmas with you," he wrote to Levy. "I needed it."

Awaiting him in Bolton Landing was a near disaster. The furnace had caught fire. "If the house hadn't been fireproof would have lost all," he told Levy.[1]

"That was in a new house, virtually, and it burned the entire winter's oil supply," Freas remembered. "And it left a residue of grease, oily stuff, all over the house—soot inside every drawer. When he walked in there he started to cry. He called me immediately and told me what had happened. Oh! He was just sobbing."[2]

For weeks, he was without heat. "Im living in Dorothys studio—with little fireplace," he wrote to Edgar Levy. "When it gets zero will have to take a room outside. No water—take bath's around. No insurance Edgar—no money—I never dreamed that the furnace would burn. Insurance I don't like. They are bastards, you have to hire a lawyer to collect . . . The house has been freezing (its all drained) but I've survived in this one room."[3]

When Smith went to Washington to serve on a jury at the Corcoran Gallery of Art, he met Freas's parents. Her father liked him and did not seem concerned about the age difference between Smith and his

daughter. Her mother felt he was dangerous. He stayed at their house in Bethesda. "I lined the screens of my mother's porch with brown wrapping paper, thinking he could pin to it the drawing paper I had bought with such care," Freas said. "What would he do here if he couldn't draw? He needed a proper surface, but also a shield. Someone used to mountains would feel boxed in by backyards. The only way he could make sense of my suburban neighborhood was to re-cast it in archaic fashion of his imagining. Thus, the shopping center on Bradley Boulevard a quarter of a mile away became 'the settlement.'"[4]

On this trip Smith met Kenneth Noland. Born in 1924 and raised in Asheville, North Carolina, Noland served in the air force during World War II. With money from the GI Bill, he studied at Black Mountain College, where he met Josef Albers, Willem de Kooning, and Clement Greenberg. In 1951, he began teaching at Catholic University. Noland had not yet seen Smith's sculpture. "It was a shock . . . because it was *rusted steel*," he said. "It was like somebody had taken a crankshaft and welded it to a base or something. It's hard for you to realize how radical this was when it was being done."[5] When Noland and Langer visited Manhattan, they would spend evenings with Smith and Freas, many of them beginning at Chinese restaurants.

Smith's trips to New York City now stretched over several days. He stayed with Herman Cherry or Bob John, an artist and furnituremaker, who lived in the same building at 10 Cooper Square, in Greenwich Village, or with another artist, Eugene Morley—with whom Smith and Dehner had exhibited in Glens Falls in 1936. These were just three of the friends with whom he stored sculptures. He took Freas to exhibitions. "We visited every gallery that was showing any modern art (and there weren't that many, believe me), and it was mostly Fifty-Seventh Street," she recalled. She was struck by the seriousness at The Club: "It wasn't just people getting up and talking, and arguing. They really had an agenda, and they really talked."[6]

At the Cedar Tavern, they could count on running into other artists, among them regulars like Willem and Elaine de Kooning. "I didn't smoke," Freas said. "You can't believe how that place stank! It was horrible. There was a lot of drinking. We always had five-cent beers—and another thing we also loved to do, and we did it a lot, by ourselves, was we'd

go to Eddie's and Nick's, jazz places. And they were very smoky, too, and very dark. I sort of liked them, because nobody knew we were there."[7]

Gloria Gil, who in the 1960s would work with Smith at Bennington Pottery, which she ran with David Gil, her husband, met Smith and Freas at a 1951 party. "We were all being introduced. 'This is Gloria Gil and David Gil from Bennington. They have the Pottery,'" Gloria Gil said. "And [the host] said, 'This is Jeannie Freas,' and she said, 'David's paramour.' I always remembered that. I thought, 'Oh, she's great.'" Freas reminded Gil of the actress Barbara Hutton: "She was a blonde, very voluptuous, sexy—Jeannie was hot stuff, she really was. And he was absolutely enchanted with her."[8]

Smith did not take Freas to meet the Levys or the Fitches, or to parties at which Dehner's friends might be present. He could be hesitant about taking Freas to art world events. But Clement Greenberg, who was also involved with a much younger woman, did not hesitate to invite him. "Of course, bring Jean to Helen's party," Greenberg urged Smith. "It's going to be a big one."[9] Helen was the painter Helen Frankenthaler, twenty-two, a 1949 Bennington College graduate, and the party was after her opening. In 1951, Frankenthaler bought Smith's *Portrait of the Eagle's Keeper*.

Willard and Dehner, along with Norman Lewis, whose paintings Willard showed, went together to the January 1951 opening of MoMA's "Abstract Painting and Sculpture in America," where they ran into Smith. When he brought Dehner a plate of food, she refused. "It messes me all up when I see David, otherwise I do O.K.," she wrote to the Levys.[10] While Willard offered her apartment to Smith, she also made it available to Dehner.

Yet Dehner and Smith remained in contact. He encouraged her to buy her new station wagon and brought Finnegan to Saratoga to pay her a visit while she was at Skidmore. She visited the farm. She wanted to minimize exchanges and avoid hassles with him, but they had to decide what to do with the property and her belongings. "Send your tax data on to me," he wrote to her. "I'll have Clark [the lawyer] fix it in as soon as I get mine assembled. Got few things ahead before I can get to it . . . Will bring down the stuff soon as I can manage it. Have rocker and two straight chairs being re seated for you."[11] She wanted a divorce. He would

buy the property from her. In 1952, she would have the divorce. Four years later, he would own the property.

Smith's show at the Willard Gallery ran from March 27 to April 21. Along with drawings, it included nine sculptures, among them *The Letter*, *The Forest*, *Star Cage*, and *Song of the Landscape*. His handwritten notes in black ink around black ink drawings of the sculptures formed the basis of the brochure. All the sculptures had been made between May 1950 and the end of the year. "David Smith seems to have had a spectacularly productive six months," *The Christian Science Monitor* noted.[12] "Smith's sculptures can look like junkyard equivalents of savage fetishes," *Time* declared.[13] Smith's sculpture "isn't easy . . . and it isn't elegant, the forms being rough-hewn and unfinished. But it's about the most original, the most imaginative, and the most vital being done in the country today," Emily Genauer wrote.[14] Robert Coates was enthusiastic, although he continued to question what he saw as unnecessary obscurity:

> Every artist, even the most "representational" has to create a symbolic language to express his ideas and—if he is to succeed—make the world accept it. Smith, still fairly young as artists go, has perhaps not had time to make his own language valid. I also think that he sometimes stacks the cards against himself—as in "The Letter," which is in the show—by indulging in too personal and private references, to the confusion of his audience. But in others the symbolism is clearer, and in most of these, if one takes the trouble to study them, one finds beneath their slight surface difficulties a wealth of deep philosophical insight, compactly expressed and set forth with great sculptural ingenuity and power.[15]

Within a period of a few months, three critics, Genauer, Belle Krasne, and Coates, each approached Smith about buying a sculpture. Genauer sent a $75 advance. "We'll decide on a piece," Smith told her. "It will be very fair and the gallery need not necessarily get involved."[16] Krasne, as of 1950 the editor of *Art Digest*, also sent an advance. She and her boyfriend wanted *Song of the Landscape*, which Smith and Willard were reluctant to give her. The acquisition fell through; at the end of the year, the sculpture was sold to a collector in Chicago for $950. Coates, now living about an

hour south of Bolton Landing, had wanted to buy a Smith for some time. "I wouldn't have mentioned this some years ago, through some sort of diffidence," he wrote Smith, a few days before his review appeared, "but it's something I'm aiming at, just the same."[17] At the end of March, Smith received word that he had been awarded a back-to-back Guggenheim, this one for $3,000. The first Guggenheim had contributed to a burst of creativity. Now he had money with which to live and work for another year.

Smith's social circle was increasingly intergenerational. Krasne was twenty-seven. She brought into *Art Digest* Sidney Geist, Hilton Kramer, and Dore Ashton, all of whom would become strong Smith supporters. Helen Frankenthaler was the daughter of Alfred Frankenthaler, a New York state supreme court judge. Before they started dating, Greenberg had chosen her for "Talent 1950," an exhibition at the Samuel Kootz Gallery. With Noland and Morris Louis, Frankenthaler would be instrumental in the development of Color Field Painting, for which Greenberg was the lead advocate. Alfred Leslie, twenty-three, a filmmaker as well as a painter, who had also been selected for "Talent 1950," was becoming a friend. "Many of the older generation," like "David and Bill [de Kooning] . . . were not intimidated by young people," Leslie said. "There were a number of people, especially Rothko—whose work I liked," who "demanded from younger artists a kind of 'salaaming,' and obedience, and a deferring in judgment." With Smith and de Kooning and a number of other artists, "there was . . . an equalization—although, of course, there were tremendous differences in the stages and developments."[18]

Freas and Langer had moved to a cold-water flat at 344 East Sixty-Second Street, for which they each paid $8.50 a month. It was a sixth-floor walk-up, with three rooms and no bathroom, overlooking a convent garden. Smith stored work there, too. "Once he walked in unexpectedly and found several bras draped to dry across the sculpture called 'Star Cage,'" Freas remembered. "The problem was, I had no bathroom. The tub was in the kitchen . . . However, to my enormous relief, David wasn't upset . . . 'Star Cage' was a part of my life, as was my laundry."[19] Freas was now working for Alice Hughes, who had a nationally syndicated column called "A Woman's New York." She was as "as crazy as could be, but she was one of the very first woman columnists, and she certainly was the first one ever to go to, as a correspondent . . . to the Soviet Union. By the time I

knew her she'd gotten into fashion, because she could make a lot of money that way, which was her primary interest in life." Freas said that Hughes told her, "'I like the way you write but you've got to learn merchandising.' I have a tin ear with merchandising, so that was that."[20]

After Langer moved to Washington to be near Noland, the apartment was broken into. Freas called Smith. Two days later he arrived with a grate for her

Jean Freas in New York City, ca. 1951.

window. "Everything he ever made was sound. It wasn't just a thrown-together thing, *it was sound*. The grate attached to the window that led to the fire escape, and that was it. No longer a problem."[21]

Sometimes after finishing work on Friday, Freas would take the bus upstate for the weekend. Smith would meet her in Lake George Village and cook her a special dinner, for example, chicken breast speckled with apricot, and, at five in the morning, pomegranate for dessert. Sometimes he drove her upstate in his truck. "I think it's hard to top that ride, that Route 9, going up the [Hudson] river." Smith drove at his own pace. "David was never one to mind speed limits."[22]

Smith had one persona upstate and another in the city. During her visit to Bolton Landing in early July, Krasne described him as "about 6'1½. Hulking, strapping build—200-odd pounds. Close-cropped hair gives perennially hardy look. Hair is blackish, mustache is bushy and red-brown. Looks like a self-styled Hemingway character. By own definition he neither is nor looks like a city person. Dresses in levis—work-worn—and plaid wool shirt, heavy, road-slogging shoes."[23] By contrast, in the city Smith "never looked scrungy," Freas said. "He always wore an Irish tweed suit that he had. For some reason I remember how de Kooning

always had blue jeans, and shirts, and sweaters, and stuff like that. Well, that wasn't David's style in the city at all. He had his hat, of course—his cap. He always had that. But that was the only sort of casual thing about what he wore in the city."[24]

Smith did some work on Dehner's behalf. He asked Elaine de Kooning to talk to Thomas B. Hess, the editor of *ArtNews*, about covering Dehner's show at the Laurel Gallery. To encourage Genauer and other critics to write about this show, he sent them tiny Dehner drawings, several of which he had bought from her for five cents each: Dehner called them "nickel drawings." She explained, "I'd make 10 in a day, and then I'd choose one and make it bigger."[25]

"Dorothy to my mind is painting rings around very much of the abstract field," Smith wrote to Genauer. "She is even painting better since she left the bull in the China shop of David Smith."[26] When the Laurel Gallery abruptly asked for a one-third commission on the sale of her work at the Whitney, Dehner wrote Smith for advice. Would Artists Equity fight on her behalf? No, he replied. He was down on Artists Equity and would soon leave it. When the Laurel Gallery was suddenly sold, Dehner's show was canceled.

Before heading to Cape Cod and Fire Island, Dehner left Finnegan with Smith. Soon after, Finnegan disappeared. "He was lost in the hills somewhere," Freas said. "David went out every day and looked . . . He'd spend the day—and if you can believe David away from his work, to look for a dog."[27] Smith never found him.

Freas was pregnant, but a child was out of the question. Smith was still married, and, Freas said, "you never knew when they would get [back] together, because David was the kind of person that you just didn't know how it was all going to work out at the end."[28] Through the fashion photographer Genevieve Naylor, the wife of his friend Misha Reznikoff, Smith found someone in Toronto to perform the abortion. "We drove up to Toronto, and it was so horrible," Freas recalled. "Every story you ever hear, every one that sounds so far-fetched—believe me." When they returned to Bolton Landing, she came down with a "raging" fever, "like 104." The first doctor they called wouldn't see her. "I literally could have

died, and he wouldn't touch it," Freas said. The second doctor told Smith to bring her in: "[He] looked at me and said, 'Oh, you've got the flu.' And with that he gave me some heavy-duty antibiotic, and I got okay . . . Of course, he knew what was the matter with me." Smith, she said, "was so wonderful with that abortion." After he toned down the light in the bedroom by putting her slip or skirt over the lamp, the room looked "so cozy and nice. I was throwing up. He would wipe my face. I was sweaty and everything, and I was so scared, and he was so kind, and so gentle . . . A lot of people of that era, boy, you can believe, some guy who got his girl pregnant would not—a lot of them wouldn't act that way."[29]

Smith had always put sculpture outdoors, but now he began to populate the area around his house with sculpture. Krasne noted the "flagstone patio around which 14 or 15 sculptures stand on crude marble and cement blocks." One large sculpture, *The Fish*, which had been in the 1950 Whitney Annual, "painted vermilion—stands off to its strident self, like nothing nature could claim, yet in perfect harmony with the wild, free, mountain setting."[30]

After spending a recuperative summer on Fire Island with the Levys, Dehner dropped in on Smith. She went to get Finnegan, who had been lost since June. She wrote to the Levys: "I had no word except that Finn was OK in the letter of Aug. 23rd but what it meant was another dog that David had bought and named Finnegan. It was quite a blow and also finding another dame in the house which was indescribably filthy and disorganized with just the most utter dissaray and sluttishness in evidence, it sickened me." She learned that Smith had decided to buy the house from her. "With all of my stuff out of it I will never have to go back and can gradually work my way out of feeling that it is in any way mine or that I have a right or claim to it. This can all be done amicably I believe as I am in no mood to quarrell and David is soft and assenting to any claim I make . . . but I have been stuck with his soft words and harsh deeds so often before that I will have it legal with a lawyer. For me he acts sorrowful and tearful, but I am sure this is fairly superficial, which make[s] it easier for me . . . Meanwhile I have the new Finnegan, who is a sweet little dog and all, but that was getting a dog the hard way."[31]

In Elaine de Kooning's article "David Smith Makes a Sculpture," in the September *ArtNews*, Smith emerges as a singular—and epic—artist and person. In an expansive typescript he prepared for de Kooning that became the basis for her article, he made clear that he had many sides and that all were essential for his creativity. He was solitary and sociable, a day person and a night person, a country person and a city person, a realist and a dreamer. He worked with found objects and bought metal, responding to many sculptural traditions. In the same sculpture he could combine different techniques, including oxyacetylene and arc welding. He had two studios, "one clean, one messy, one warm, one cold." While he made his sculpture indoors, in a well-heated "cinderblock structure, transite roofed," with "a full row of north window skylights set at a 30 degree angle," his sculpture also had an outdoor life. His sculpture could begin with or without drawing.

He worked on as many as four sculptures at a time, in different stages of materialization, and though he worked long hours each day, like a laborer, he hated routine. "I like the changes of nature, no two days or nights are the same," he said. Classical music on the radio, often on WQXR, kept him "company in the manual labor part of sculpture, of which there is much. The work flow of energy demanded by a culture wherein mental exhaustion is accompanied by physical exhaustion provides the only balance I've ever found, and as far as I know is the only way of life." De Kooning included Smith's key words on the double identity of steel: "Possibly steel is so beautiful because of all the movement associated with it, its strength and function. Yet it is also brutal, the rapist, the murderer, the death-dealing giants are also its offspring."

In the country Smith thought about the city, in the city about upstate. "Terminal Iron Works at 1 Atlantic Avenue, Brooklyn" was "surrounded by all-night activity—ships loading, barges refueling, ferries tied up at the dock. It was awake 24 hours a day, harbor activity in front, truck transports on Furman Street behind." By contrast the mountains were "quiet except for occasional animal noises. Sometimes Streevers's hounds run foxes all night and I can hear them baying as I close up shop . . . I enjoy the phenomenon of nature, the sounds, the Northern Lights, stars, animal calls, as I did the harbor lights, tugboat whistles, buoy clanks, the yelling of men on barges around the T.I.W. in Brooklyn. I sit up here

and dream of the city as I used to dream of the mountains when I sat on the dock in Brooklyn."

Smith makes a radical statement about sculpture: "I do not accept the monolithic limit in the tradition of sculpture. Sculpture is as free as the mind, as complex as life, its statement as full as the other visual mediums combined." He leans on "identity" and "work stream": "I maintain my identity by regular work, there is always labor when my inspiration has fled, but inspiration returns quicker when identity and the work stream are maintained."

The sculpture on which de Kooning based her article is *Cathedral* (1950). Roughly 3 feet wide and 1½ feet tall, it suggests a scaffolding of upright forms of varying thickness on a stepped base. Three prostrate forms are lying around or pinned like trapped bodies under a monstrous three-pronged claw at the foot of the sculpture's tallest and most invasive form, resembling a bone or an elongated club that is supported by a columnar form resembling a drill. While open, the structure seems suffocating, crushing. In the brochure for his 1951 exhibition at the Willard Gallery, Smith described *Cathedral* and his 1950 sculpture *Sacrifice* as "melancholy songs about the fears and traps [with which] the world ensnares us."[32] The article includes photographs of the work from different angles and in different stages and against the sky. Smith asked Hess not to credit him as the photographer. De Kooning sees in the sculpture "a curious climactic stillness"—the end of something: "Evocative and complex, it expresses the termination of an event . . . Finally, the separate members of a violent situation are combined into parts of an architectural structure, as characters in Greek mythology are transfigured into symbols of their last act or emotion."[33]

By the time "David Smith Makes a Sculpture" appeared in *ArtNews*, Smith had completed *Hudson River Landscape*, a sculpture so different from *Cathedral* in mood and energy that it belongs to another historical moment. Inspired by Freas and by train rides along the Hudson to and from Sarah Lawrence, it suggests gestural painting—or the Mozartian fluidity with which Picasso painted on glass in Paul Haesaerts's famous 1949 film of his visit to Picasso in Vallauris, on the French Riviera. Every line is unpredictable, every image shifting, movement projects in all directions, the caricaturish merges with the ecstatic. With its two pronounced ovals near the top, like eyes or lenses, the configuration also suggests a

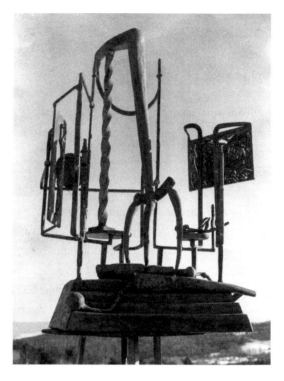

David Smith, *Cathedral*, 1950. Steel, paint, silver, 34⅛ × 24½ × 17⅛ in.
(86.7 × 62.2 × 43.5 cm). Private collection.

clownish face that the viewer is looking at and through. At 4 by 6 feet, the
sculpture approaches the scale of Abstract Expressionist painting.

In a late 1951 talk at Bennington College called "Hudson River Land-
scape," in conjunction with an exhibition there, Smith emphasized dis-
covery and associative flow. His sculpture was a journey, forever en route,
inhabiting different places at once. His presentation includes the kind of
unpredictable list that had become a feature of his writings and talks:

> My reality, which is never one thing but a train of hooked vi-
> sions, arises from things found under an old board, stress pat-
> terns, fissures, the structure pattern of growth, stains, tracks of
> men, animals, machines, the unknown order of forces, acciden-
> tal evidences such as spilled paint, patched sidewalks, structural

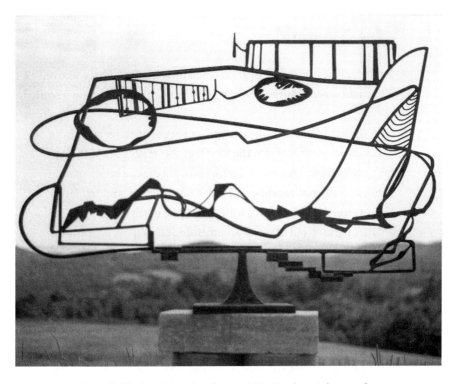

David Smith, *Hudson River Landscape*, 1951. Steel, stainless steel,
paint, 48¾ × 72⅛ × 17⅜ in. (123.8 × 183.2 × 444.1 cm).
Whitney Museum of American Art, New York.

faults, the arrangement of snow between hummocks during a
thaw, the lines in marble laid by glacial sedimentation . . .

My sculpture called "Hudson River Landscape" came in part
from drawings made on a train between Albany and Pough-
keepsie, a synthesis of drawings from ten trips over a seventy-
five mile stretch. Yet later when I shook a quart bottle of India
ink, and it flew over my hand, it looked like my landscape. I
placed my hand on paper. From the image left, I traveled with
the landscape to other landscapes and their objects—with ad-
ditions, destructions, directives, which flashed past too fast to
tabulate but elements of which are in the sculpture. Is "Hud-
son River Landscape" the Hudson River? Or is it the travel, the
vision? Or does it matter? The sculpture exists on its own; it is

an entity. The name is an affectionate designation of the point prior to the travel.[34]

By the end of the year, Smith's friendship with the Levys was over. Edgar Levy had already turned against Smith's work. David Levy recalled:

> In the late '40s, when Uncle Smith had begun to move away from his earlier work and into the stuff that was really part of the Abstract Expressionist movement, he brought down a bunch of photographs of stuff, and he showed it to my father, and my father said something like, "This stuff doesn't mean anything to me," or "I get nothing out of this," or something fairly nasty . . . Dorothy said they went upstairs—they had a room in the house—she said he cried all night . . . He said to me later on, when I was older, that his rift with my father . . . was entirely about art; that they just couldn't see eye-to-eye about art. And I'm sure my father was very abusive to him, first because he really didn't believe in what he was doing, and secondly, because he was jealous as hell. Because here he was, the king of the mountain, and all of a sudden, all these guys he was looking down on were zipping past him.

The Levys' break with Smith, however, was principally caused by his treatment of Dehner. David Levy said: "He was pretty abusive to Dorothy. He had the capacity to go into uncontrollable, violent rages. And you've got to understand that he was huge, and tremendously strong . . . He'd get mad, and he'd beat her up." After she left him, "Dorothy came to us, she stayed with us for a while, then she moved into a little house that belonged to a neighbor, about a mile away . . . She was escaping him, to us. Well, that completely made the relationship with him impossible. That always happens in divorces. Somebody winds up on each side."[35]

Since Jan Matulka's class, when they were both just starting out as artists, Edgar Levy had been Smith's most trusted friend. He admired and confided in him and during the early and mid-1930s they partnered like scientists on technical and material experiments. Smith considered Levy "the intellectual, the leading light among artists," Freas said. "Something in him was very hurt by that rupture." Losing Levy "was decisive."[36]

Embattled Freedom

Smith and Freas had wonderful moments together in the city and up-state, but neither could predict when he'd lash out, after which she might call him "dictator" and decide to date other men, one of whom—Smith referred to him as "old Shakespeare"—he periodically ran into in the Village. It was always she who broke off the relationship, after which he'd become despondent. "Your picture is in my wallet," he wrote to her in January 1952. "I haven't got you out of my mind. I'm trying, but I'm very lonesome. To find love or even try again seems hopeless."[1]

Freas had a job and an apartment, was intent on a career as a writer, and wanted to feel her oats in the city, but most of all, she did not want a conventional life. "One thing I did not want was a life like my sister's, or anybody I knew, or going to church, or any of those things. I just did not want any bit of it."[2] Despite her rebelliousness, however, she remained dependent on "mama" and "daddy." When she needed money, includ-ing for the psychoanalysis she entered in the fall, her father provided it. When she felt in trouble, she went home. In a variety of ways, she depended on Smith's support as well, including encouragement for her writing, which he invariably provided, sometimes tenderly, sometimes pushing her in ways she ultimately appreciated. "If you can speak—you can write," he wrote to her, "but that is not the question—the question is, will you? Have you the guts to."[3]

To Freas, as for many others, Smith seemed a model of creative in-
dependence. His determination to battle the world thundered through
his words. "The works you see are segments of my work life," he said in
February 1952 in a symposium titled "The New Sculpture" at MoMA. "If
you prefer one work over another, it is your privilege, but it does not in-
terest me. The work is a statement of identity, it comes from a stream, it is
related to my past works, the three or four works in process and the work
yet to come. I will accept your rejection, but I will not consider your
criticism any more than I will concerning my life."[4] He made a point of
"vulgarity"—"the extreme to which I want to project from, and it may be
society's vulgarity, but it is my beauty."[5] For the artist, no aspect of hu-
man life or nature—no feeling, action, or vision—was off the table: "No
subject is taboo in art."[6]

His wariness of commercial pressures, which stress mass acceptance,
and of an education system that he believed tended to "substitute words
for art," thereby leading to rejection of and even antipathy to the "for-
ward movement" of art, could contribute to his bombastic rants against
"the layman."[7] "Ask him how he would interpret his work for a layman,"
Belle Krasne wrote in her April 1952 profile of Smith in *Art Digest*, and
"he bluntly replies: 'I couldn't explain it to a layman . . . He doesn't want
to know—it's merely conversation or an opening to tell what he doesn't
like. The layman likes nothing or he wouldn't be a layman. What does the
layman represent or like? Television, movies, radio, Reader's Digest, base-
ball, etc. How could I deal with him? I have values, standards, truths.'"[8]

Smith's breakthrough works of 1951–52 did not so much transition
out of the 1930s and '40s as erupt into the second half of the century,
projecting an entirely different speed and flow, in their inventiveness
and performativity contributing to the revolt against "the fixed form, the
changeless and the self-contained" that the art historian Leo Steinberg
believed had led in part to the "curse of irrelevance" that "lay heavy over
sculpture for well over 200 years."[9] In one of his most eloquent state-
ments, Smith wrote:

> Art is made from dreams and visions and things not known
> and least of all things said. It is made from the inside of who
> you are when you face yourself, but since who you are is never

who you are but always an expectancy, it must amount to the declaration within yourself of who you aim to be and to what purpose your expectancy is pledged in ratio to the courage you have to put toward life devotion.[10]

At 6½ by 9 feet, *Australia* was, to this point, by far Smith's largest work. Earlier Smith landmarks, like the 1937 *Interior* and the 1945 *Home of the Welder*, were much smaller. Viewers look over and down into them. While these sculptures are open, their interiors exposed, they hint at decisive narratives, the keys to which are lost. Despite improvisational moments, these sculptures are clearly composed. While cobbled together and meticulously engineered, *Australia* seems to have emerged all at once, with a suddenness and prophetic utterance new to monumental sculpture. The surprise of the combinatory imagery is matched by the presentational immediacy. This steel animal/insect/plant/bird

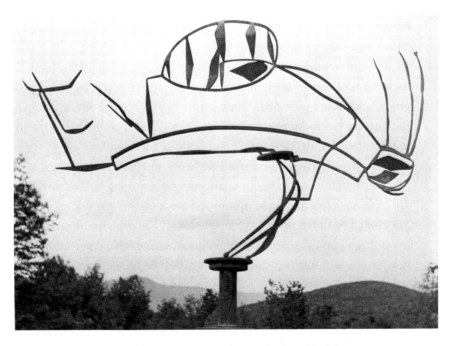

David Smith, *Australia*, 1951. Steel, paint; cement block base,
79½ × 107⅞ × 16⅛ in. (201.9 × 274 × 41 cm).
Museum of Modern Art, New York.

seems arisen, full-blown, and apparitional at its inception. It engages everyone and everything in its vicinity. Swinging its steel lines off the tiny metal plinth atop a relatively skimpy cylindrical base, atop a cinder-block base, its equilibrium, its ability to somehow maintain its balance, seems miraculous.

Australia mixes not only different categories of existence but also different media. Coated with brown paint tinged with flecks of green, and with other colors that appear to have been spattered on, the sculpture seems as fast and fluid as a Pollock painting. The linear vitality makes the sculpture like drawing. Etching is a decisive presence, too, in the way the steel lines seem to press into the space around it. In 1953, the sculptor and critic Sidney Geist observed that Smith's sculpture "bites into space."[11] The sculpture also incorporates writing. In odd, even comically cursive script, upper segments of the sculpture form "E," "U," "R," and "O," the first four letters of "Europe." It was characteristic of Smith to name a sculpture *Australia* and then to embed in it signs pointing toward a vastly different, if not politically disjunctive, continent on the other side of the world, but one crucially aligned with Europe in Freud's *Totem and Taboo*, a book Smith read.

The most iconic and probably the most reproduced of all Smith photographs is of *Australia* on his hillside, set against the sky. In the photograph, *Australia*'s cylindrical base seems to rise like an offering out of the trees and hills. More clearly than in the actual sculpture, the sweeping outlines that delineate the main body of the sculpture are like the hem of a steel garment, and space seems to intensify and thicken as it passes through its openings onto anyone and anything in its trajectory. The sky seems to *want* the sculpture and the sculpture the sky. Every image evoked by the sculpture is a shape shifter, a hybrid, in the process of becoming something else. The photograph creates the expectation that to be in the sculpture's presence is to be touched by the mysterious spatial density that the sculpture, with the help of the photograph, brings into being.

Australia wowed people. After Smith sent him the photograph in June 1951, Clement Greenberg responded with a postcard. "That insect figure looks terrific," he wrote, and drew the work.[12] After seeing *Australia* in 1952 in Smith's joint Willard and Kleemann Gallery show, Lura

Figure 1: David Smith, *Untitled* (*Indiana*), 1927. Watercolor, 10 × 13½ in. (25.4 × 34.3 cm). The Estate of David Smith, New York. © 2022 The Estate of David Smith/Licensed by VAGA at Artists Rights Society (ARS), New York.

Figure 2: David Smith, *Untitled* (*Billiard Players*), 1936. Oil on canvas, 46 × 50 in. (116.8 × 127 cm). Private collection. © 2022 The Estate of David Smith/Licensed by VAGA at Artists Rights Society (ARS), New York.

Figure 3:
David Smith, *Blue Construction*, 1938. Steel, baked enamel, 36¼ × 28½ × 30 in. (92.1 × 72.4 × 76.2 cm). Private collection. © 2022 The Estate of David Smith/Licensed by VAGA at Artists Rights Society (ARS), New York.

Figure 4:
Dorothy Dehner, *David Reading About Himself*, 1941. Gouache on paper, 7⅜ × 5⅜ in. (18.7 × 13.7 cm). Storm King Art Center, Mountainville, New York. Gift of Margaret Hovenden Ogden, 1978. © The Dorothy Dehner Foundation, New York. Photograph by Jerry L. Thompson.

Figure 5: Dorothy Dehner, *My Life on the Farm*, 1942. Egg tempera on Masonite, 12⅜ × 9¼ in. (31.4 × 23.5 cm). Storm King Art Center, Mountainville, New York. Gift of Margaret Hovenden Ogden, 1978. © The Dorothy Dehner Foundation, New York. Photograph by Jerry L. Thompson.

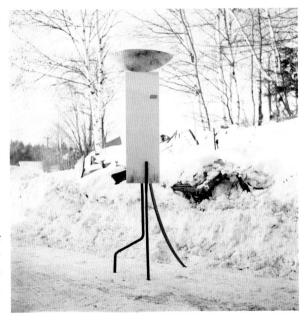

Figure 6: David Smith, *Tanktotem IX*, 1960. Steel, paint, 90 × 33 × 24⅛ in. (228.6 × 83.8 × 61.3 cm). Cake Collection. Photograph by David Smith, Bolton Landing, New York, ca. 1960. The Estate of David Smith. © 2022 The Estate of David Smith/Licensed by VAGA at Artists Rights Society (ARS), New York.

Figure 7: David Smith, *Island in Alaska*, 1959. Spray enamel on canvas, 98½ × 51½ in. (250.2 × 130.8 cm). Private collection. © 2022 The Estate of David Smith/Licensed by VAGA at Artists Rights Society (ARS), New York.

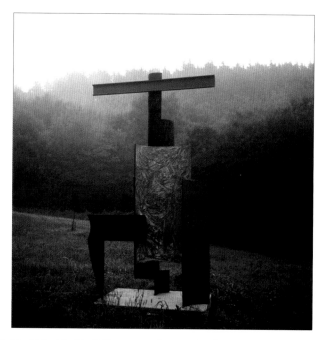

Figure 8: David Smith, *Zig II* (in progress), 1961. Steel, paint, 100½ × 59¼ × 33½ in. (255.3 × 150.5 × 85.1 cm). Des Moines Art Center Permanent Collections. Gift of the Gardner Cowles Foundation, in memory of Mrs. Florence Call Cowles (1972.89). Photograph by David Smith, Bolton Landing, New York, ca. 1960–61. The Estate of David Smith, New York. © 2022 The Estate of David Smith/Licensed by VAGA at Artists Rights Society (ARS), New York.

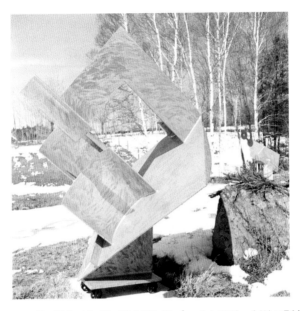

Figure 9: David Smith, *Zig IV*, 1961. Steel, paint, 95⅜ × 84¼ × 76 in. (242.3 × 214 × 193.0 cm). Lincoln Center for the Performing Arts, New York. Gift of Mr. and Mrs. Howard Lipman. Photograph by David Smith, Bolton Landing, New York, ca. 1963. The Estate of David Smith, New York. © 2022 The Estate of David Smith/Licensed by VAGA at Artists Rights Society (ARS), New York.

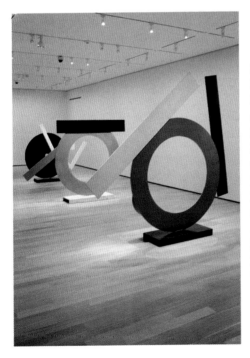

Figure 10: Installation view of (from left to right) *Circle V*, *Circle I*, and *Circle II* in the exhibition *Raw Color: The Circles of David Smith*, on view at the Clark Art Institute, July 4–October 19, 2014. Photograph by Mike Agee and courtesy of the Clark Art Institute, Williamstown, Massachusetts. © 2022 The Estate of David Smith/Licensed by VAGA at Artists Rights Society (ARS), New York.

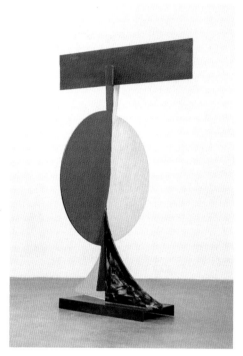

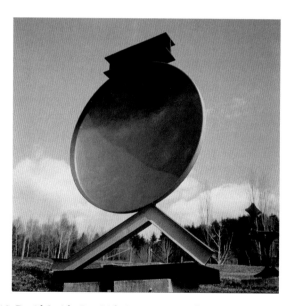

Figure 12: David Smith, *Bec-Dida Day*, 1963. Steel, paint, 89 × 65 × 18 in. (226.1 × 165.1 × 45.7 cm). Yale University Art Gallery. Charles B. Benenson, B.A. 1933, Collection (2006.52.68). Photograph by David Smith, Bolton Landing, New York, ca. 1963. The Estate of David Smith, New York. © 2022 The Estate of David Smith/Licensed by VAGA at Artists Rights Society (ARS), New York.

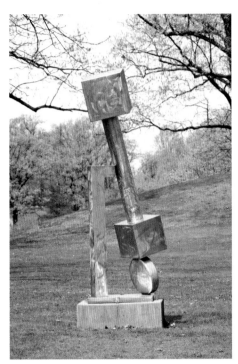

Figure 13: David Smith, *Cubi XXI*, 1964. Stainless steel, 116⅛ × 41½ × 40⅞ in. (295 × 105.4 × 103.8 cm). Gift of the Lipman Family Foundation, jointly owned by the Whitney Museum of American Art, New York, and Storm King Art Center, Mountainville, New York (2011.168). Photograph by Jerry L. Thompson. © 2022 The Estate of David Smith/Licensed by VAGA at Artists Rights Society (ARS), New York.

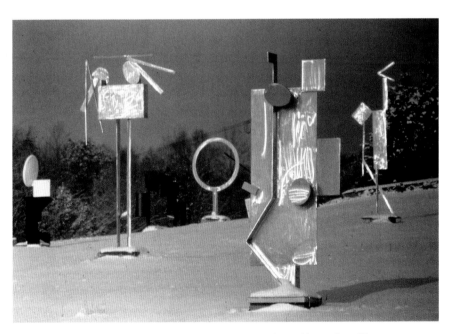

Figure 14: Dan Budnik (photographer), David Smith's South Field, 1963.

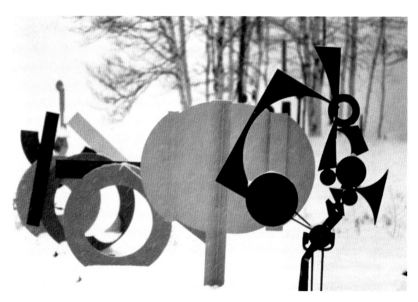

Figure 15: Dan Budnik (photographer), David Smith's North Field, 1963.

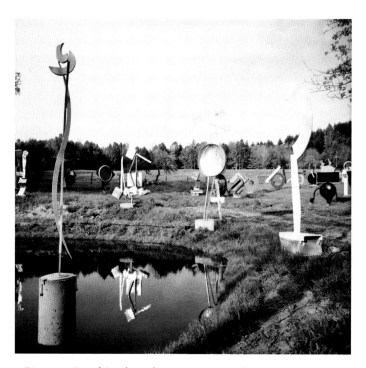

Figure 16: David Smith, sculptures, upper pond, North Field, Bolton
Landing, New York, 1964. Photograph by David Smith. The Estate of
David Smith, New York.

Beam, who had organized Smith's traveling exhibition for the American Association of University Women, wrote to him that she "took a great fancy to Australia,"[13] and the novelist Victor Wolfson praised the "great grasshopper or whatever in the corner."[14] When *Australia* was shown in Smith's 1957 exhibition at the Museum of Modern Art, Gordon Washburn, director of the Carnegie Institute in Pittsburgh, wrote to Smith that he was "staggered" by "its beauty and strength."[15] In January 1958, Washburn mentioned the sculpture again: "What I would like is a piece equal to your great 'Australia.' I can't tell you how magnificent I think it is."[16]

Australia was instrumental to the development of the fields of sculpture emerging around Smith's shop and house. Smith was running out of storage space, and installing sculptures outdoors was a way of resolving the storage problem, but since the 1930s he had been placing and photographing his sculptures in the landscape, where he could see them in relation to one another and under changing conditions, and he knew that if they retained their scale in this setting they would hold their own anywhere. *Australia* was catalytic. Sometime between Krasne's visit in the summer of 1951 and the summer of 1953, Smith placed it in what Freas remembers as "the dead center of the front meadow. I do not remember any other big piece there, and I am certain no small work was ever put there."[17] To their younger daughter, Candida, it was with the placement of this sculpture that "the fields were truly *born*."[18]

Australia and *Hudson River Landscape* were two of the twenty-two sculptures in Smith's April 1952 show at the Willard Gallery and at the Kleemann Gallery across the street. The catalog contained a poem by Howard Nemerov inspired by *Four Soldiers*, a roughly 5-foot-long procession of four ridiculously and operatically deluded misfits, each with a hook for a head—formed, Smith wrote, with "four turnbuckles which I happened to find in the ashes of a fire. I kept them around about four months before I found out who they were, and they were soldiers, any four soldiers."[19]

Along with *Hudson River Landscape* and *Australia*, the April show included *Agricola I*, which initiated the *Agricolas*, Smith's first great postwar sculpture series.[20] Agricola is the name of a Roman general, but more pertinent for Smith's work, it is Latin for "farmer." In all fifteen sculptures in the *Agricola* series, Smith used abandoned farm machinery

that preserved, if not redeemed, the kinds of agricultural implements that he had grown up with in Decatur and Paulding and was constantly on the lookout for in New York and Vermont. In Smith's words, *Agricola I* "was the first of a group that contain unities related to agriculture, especially the agriculture machines of a past age, I've made seperation of

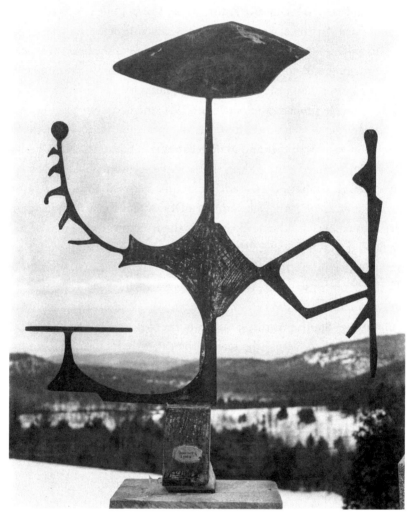

David Smith, *Agricola I* (in progress), 1951–52/ca. 1961. Steel, paint, 73½ × 55¼ × 24⅝ in. (186.7 × 140.3 × 62.5 cm). Hirshhorn Museum and Sculpture Garden, Smithsonian Institution.

their parts and organized a unity strictly visual. Some parts are actual parts some are hand forged unities necessary to complete my concept."²¹ Most of the *Agricolas* are small. Many are clearly related to other sculptures in the series, but some are distinct enough to seem like strangers. Some are clearly figurative, others more abstract. Some are painted, others not. The numbering is unpredictable. Smith completed *Agricola XII* before *X* and *Agricola XXI* directly after *Agricola X*.

A bit taller than 6 feet, *Agricola I* was for several years unpainted; by 1960 it was painted yellow, by 1962 red. With its verticality and evocations of a body with head and limbs, it is more like a human figure than *Hudson River Landscape* or *Australia*. Its imagery seems not just ancient and modern, and rural and urban, but also liturgical and burlesque. *Agricola I* suggests a high-kicking dancing girl. And a scale balanced on the toes of a ballet dancer at her barre. And a scarecrow. And a running girl. And perhaps a girl holding a doll that resembles a prehistoric idol. The body's nearly straight-up erectness and benedictory gestures give the sculpture a priestly frontality; it seems to be looking out and presiding. While its frontality evokes statuesque fixity, the lateral movement is fast. The "head's" seemingly cut-out fish shape seems both to release and to contain. Like a photograph, it is both a memory spark and a memory block. Every part of the sculpture seems to be an echo, or specter, of something known, present but somehow lost at the moment when the sculptural coming-into-being awakened it.²²

The eruption of Smith's serial imagination may roughly coincide with a five-hundred-word stream-of-consciousness burst unique in Smith's writing. It reflects the bleak mood in his January letter to Freas: "To find love or even try again seems hopeless." The text is a knot of disappointment, despair, determination, and defiance. Smith is confessional and unsparing about himself: "why do I have to shit when I know it would only be guts," "the goddamned ringing in my ears." The outpouring is marked by a sense of failure: of intimate relationships, of market support for his work—and of his futile search for Finnegan. Since animals, like children, were magnetized by Smith, and Finnegan knew Smith, it's not impossible that Smith did something to the dog to make it flee. In this extended paragraph, Smith's confidence in himself as an artist is intact, but he questions pretty much everything else about his

life and self, indicates the wear of "piling obligations" and "the fucking lonesomeness," and expresses doubt about whether his work could ever be all that he wanted it to be.

The text begins by acknowledging that while this was a very good moment, it also wasn't: "And so this being the happiest—is disappointing, the heights come seldom . . . the times of true height are so rare some seemingly high spots being suspected later as illusion." His work was his life but what was his life and where was work leading him? "The worth of existence is doubtful but if stuck with it—seems no other way but to proceed," he wrote. Without reliable income, he might have to return to "the factory or the classroom both undesirable yet possible at present but in 20 years neither will be open—and my cause may be no better." He dreamed big, but "nothing has been as great or as wonderful as I have envisioned. I have confidence in my ability to create beyond what I have done, and always at the time beyond what I do." He knew that his behavior contributed to his loneliness: "In what do I lack balance—ability to live with another person—that ability to have acquaintances—and no friends . . . Am I unable to give what it takes." Financially he could make it through May, when the second Guggenheim ran out, but then what? The search for Finnegan was harrowing; his consciousness would not stop. "If I walk 15 miles through the mountains looking for Finnegan I'm exhausted enough to want to rest and the mind won't," he wrote. He had to get through this despair, "to stay alive longer—I've slipped up on time—it didn't all get in—the warpage is in me—I convey it to the person I live with—where do I find it to change—do I like it that way, am I glad it's too late . . . would financial security help."[23]

Along with a letter about a proposed mortgage agreement, this extended paragraph, or some variant of it, is almost surely the cri de coeur that he sent to Dehner. They were negotiating the terms of his mortgage. Given their breakup, their history with the house, her ownership of it, and her role in its creation, shifting ownership to him was the most loaded of issues. In a response that, like his outpouring, is undated, she stated her displeasure over his seeming to decide terms "without any wish for them to be agreeable to me." Taking twenty years to pay the mortgage was unacceptable. She would be dead by then, she wrote. She responds to his claim that she insulted him: "I have no wish to insult

you . . . and I don't know to what you refer. I am afraid our tenseness and unhappiness about all this makes both of us more touchy than usual."

She tells him that his "paper is quite beautiful and quite scaring," adding: "It contains all the contradictions and conflicts and indications of events that have put us where we are now. I don't know if you have the capacity for happiness or any sustained kind. I don't mean just momentary kicks. I think you are deep inside an unhappy person, and I believe it is your work that sustains you. Maybe that is the way with a highly creative person, maybe not." She felt he was "like two people . . . with a strong conflict between them." She had her own problems: "I am lonesome and tired by myself. I can do my work, but the fine time is over. I hope to find contentment." In contrast with him, she wrote, "I love people, friends and acquaintances. I work for my life now . . . as this is all the life I'll ever know . . . and not for a fickle posterity."[24]

Dehner's exhibition at the Rose Fried Gallery opened on May 5. Two days later, Smith wrote her; he had sent his first mortgage payment: "It was very fine. I'm sure you will get very good reviews and I hope sales too. I mailed a check from N.Y. for 725 which is 500 plus 225 interest . . . If I get any breaks this year I'll pay more on the principal. Had expected much better on the show—but greatly disappointed . . . I hope your breaks are better than mine."[25] At the bottom of her receipt for his payment, Dehner wrote back, "Thanks—glad my show looked good to you."[26]

After eloping in the spring, Cornelia Langer and Kenneth Noland visited Bolton Landing. They saw a different Smith from the one they had known in the city. Langer remembered:

> He was in his real Paul Bunyan mode. He was . . . living off the land. . . . and he had caught these woodchucks. He had a meat grinder, and he had ground them up. Every meal, we'd have woodchuck. Finally, after several days I was so hungry— I mean, I was so disgusted with this, I just couldn't eat it—I was going out in the kitchen, and—so I said to Ken, "We've got to go into a grocery store. I've got to get some food." So we went into town, and I remember we put our money together and bought a roast beef, a beautiful, beautiful roast beef and brought it back. I said I wanted to cook it, and, oh, no, he

wanted to cook. So, anyway, we sat down to eat, and he had taken this beautiful roast beef, and he had ground it together with the woodchuck.[27]

On June 1, at Smith's instigation, Freas quit her job with Alice Hughes and moved to Bolton Landing for the summer. She recalled, "He said, 'If we're going to get married'—which was clear to him but not to me, I had huge amount of reservations—'then I want to try you out in the summer, and see what it's like.' . . . It was like a different world. And it was [radiant and beautiful]. Who wouldn't like Bolton in the summer?" Except, she added, "he'd get into rages sometimes."[28] Over the summer, Smith made half a dozen more *Agricolas*.

In late August, Freas accompanied Smith to another star-studded Woodstock Art Conference, this one titled "Aesthetics and the Artist." It featured Smith, Motherwell, Barnett Newman, George L. K. Morris, Buckminster Fuller, and two well-known aestheticians, George Boas and Susanne K. Langer. Smith continued his attack on aestheticians:

> The stingy logic of the philosopher, his suspicion that the ir-
> rational creative menaces the will, excludes that all important
> element of art-making which I call affection. This feeling of
> affection which dominates art-making has nothing to do with
> the philosopher's need for rationalization.
> We must speak more of affection—intense affection which
> the artist has for his work, and affection and belligerent vital-
> ity, satisfaction and conviction.[29]

Newman was on the same side as Smith: "I consider the artist and the aesthetician to be mutually exclusive terms." Newman said, "I'm not interpreting nature or reality—I'm making it." Near the end of his re-marks, he said: "I've done quite a bit of work in ornithology, and I have never met an ornithologist who thought that ornithology was for the birds."[30] His formulation of this conflict became famous: "Aesthetics is to artists as ornithology is to birds."

By the end of their summer together, Freas considered their relationship to be over and returned to her parents' house in Bethesda. By the early fall, she had applied for a 1953–54 Fulbright to study in India. Smith applied for a Prix de Rome in sculpture and a 1953–54 Fulbright in Italy for that same year. Part of his proposal was to "photograph Roman bronze casting method and procedure" and to "produce 12 intaglio carved medallions which would be completed and cast in bronze."

In mid-November, Smith and Freas were back together. He wanted her in Bolton Landing when the crew for the newsreel series *The March of Time* arrived to prepare a segment on him. Smith knew that Greenberg, Frankenthaler, Pollock, and the painter Lee Krasner—Pollock's wife— would be driving to Bennington, Vermont, that weekend for Pollock's first retrospective, opening on November 17, for which Greenberg had chosen eight of the paintings and written an essay. By arranging with the *March of Time* crew for Pollock to be included in the newsreel, Smith could both help a friend and ensure that the New York contingent would visit him. "Though never intimate, Jackson and David respected each other's work," Freas wrote. "If David thought of himself as 'Number One Boy' in sculpture, that was where he ranked Jackson as a painter."[31] Freas

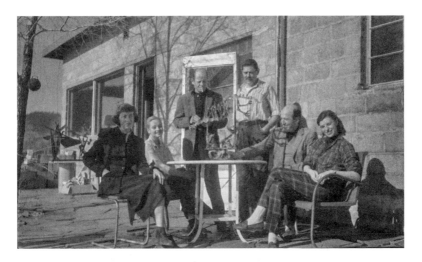

Lee Krasner, Jean Freas, Jackson Pollock, David Smith, Clement Greenberg, and Helen Frankenthaler with Smith's sculptures, left, *Cello Player* (1946), and center, *Jurassic Bird* (1945).

had seen Pollock—Smith called him "Jack"—in the city and thought of him as someone with two personalities: diffident when sober, horrible, a gargoyle, when drunk. "He was very handsome, you know, until he drank, and then his whole face underwent change," she recalled. "Ugh! I've never known an alcoholic to change so entirely as he did."[32]

After apparently spending the night in a hotel or motel in Bolton Landing, Greenberg, Frankenthaler, Krasner, and Pollock drove up the hill for brunch and a studio visit with Smith and the newsreel shooting. It was a crystalline fall day, warm enough for shirt sleeves. Freas remembered that Krasner "came, wearing a fur coat—because by then they were getting some recognition." Everyone posed for a group photograph, probably shot by the *March of Time* cameraman, sitting around the table on the patio. Perched on the table is Smith's 1945 sculpture *Jurassic Bird*. Everyone seems relaxed. Pollock and Smith are standing. Freas and Krasner are sitting next to each other. Freas was just a year younger than Frankenthaler, but she looks by far the youngest person there. Soon after, Pollock, Greenberg, and Frankenthaler went to Smith's shop. Whether Krasner was not invited or chose not to join the others is unclear, but she remained with Freas, who was preparing dinner. It was a huge effort, time-consuming and pressured-filled: these were important people in Smith's life, and the dinner had to be right. "She was very nasty, to me," Freas said of Krasner, "and I know why she was nasty: because I was young and pretty, and she was—I think she may have been the ugliest woman I've ever seen. The god that made her was not kind to her." Freas's animosity to Krasner would last a lifetime. "[She] was very tough," Freas recalled. "You talk about tough. Whoa! She was *the* toughest woman in the art world . . . She really told [Pollock] where to head in, at every chance she got . . . And he had to pay for every time he'd ever misbehaved, by her. And she was uncouth, she was mean . . . She may have had wonderful sides to her, I never saw them."[33]

After two to three hours "in Smith's studio having drinks and looking at his new work," Gail Levin, Krasner's biographer, wrote, "Krasner must have panicked, fearing that Pollock would be too drunk to show up at his own opening."[34] She lived with the dark consequences of his history with alcohol and insisted that they leave before eating. "I had made this really nice meal," Freas said, "and she said, 'Oh, we couldn't possibly

eat here.'" Pollock, Greenberg, and Frankenthaler went along with Kras-
ner's decision. Pollock "looked thoroughly miserable," Freas said. "He
was sober."[35] Levin wrote that since Greenberg later recalled that Pollock
had been drinking, "Freas might have been wrong."[36]

The information on Pollock's response to Smith's sculpture is con-
flicted. In their Pollock biography, Steven Naifeh and Gregory White
Smith declare that Pollock was competing with Smith: "After six months
of celebrity, being merely a great artist or a great sculptor wasn't enough.
Jackson had set his sights higher. He wanted David Smith's title, also
conferred by Greenberg, of the *greatest* sculptor in America."[37] Naifeh
and Smith quote the sculptor Reuben Kadish, who raises the possibil-
ity that Pollock was made aware of his sculptural limitations by Smith's
1952 show: "From the start Jackson's idea was to do sculpture that was
going to be greater than David Smith's . . . that was going to raise him up
to that other notch so that he could be both the greatest painter and the
greatest sculptor. Whether he was dissatisfied with the results at Larkin's
studio or, perhaps, intimidated by David Smith's one-man show . . . in
April, Jackson abandoned the effort after only a few sessions."[38]

"David had a very high regard for Jackson Pollock," Cornelia Langer
said. She did not believe Pollock had the same respect for Smith. She and
Noland met Pollock and Krasner one summer when they were visiting
Amagansett, and the two couples hit it off. Langer mentioned to Pollock
that she "had studied with this sculptor and I thought he was the great-
est sculptor in America. I said David Smith, and they sort of looked at
me—he and Lee—and they said, 'Oh. Well—' Lee spoke up, and she said,
'Well, Jackson and I have always thought of him more as a—Oh, he's
very good, but—' She said it in a very patronizing way. 'We've always
thought of him mainly as a folk artist.'"[39]

In a 1982 talk on Smith at the Metropolitan Museum, Greenberg re-
membered "Pollock dismissing Smith's work in 1952 as 'folk sculpture.'
A museum director said exactly the same thing in 1955, and couldn't
have known that Pollock had already said that. Some of this would get
to Smith's ears, indirectly—by vibrations, as it were . . . Now why was
he called a 'folk sculptor'? Because of his whimsies, the whimsies he
would inject into his sculpture, as if that prevented you from seeing the
whole."[40] But while Smith would continue making work that contained

a profusion of images, including puzzling pockets and clusters requir-
ing concentrated focus, the Smith sculpture to which Greenberg was re-
ferring was made largely before 1951. Applying this definition of "folk
sculpture" to *Hudson River Landscape* or *Australia*, both of which were
in the 1952 show and have been seen as inspired sculptural responses to
Pollock's "drips," makes no sense. If Pollock was dismissive of Smith's
sculpture in the early 1950s, it may have been because he knew he did
not have the sculptural means to compete with it.

Smith's work was flowing magnificently, and institutions wanted to
show it, but it was not selling. One reason was Smith's prices, which he
wanted to make commensurate with prices for Abstract Expressionist
painting. Another was that his sculpture seemed materially raw as well
as visually uncontainable. It had so much movement, in multiple direc-
tions. It did not meet anyone else's expectations. It did not seem to set-
tle down or sit still. Smith's expenses were growing—materials, house
and shop, and now mortgage payments. Both Victor Wolfson and the
publisher and bookseller George Wittenborn, from whom he bought
most of his art books, agreed to display Smith sculptures in their homes
where other people would see them. He had little or no help. For his
April 1952 show, he not only transported the twenty-two sculptures to
the city but also carried the big ones upstairs and installed them. For his
spring retrospective at the Walker Art Center in Minneapolis, he crated
and shipped almost every work; he did the same for his late October ex-
hibition at Catholic University, organized by Noland. For several more
years, he would remain largely responsible for getting his sculptures to
his shows.

ArtNews voted Smith's Willard-Kleemann show number four among
its top ten shows of the year. Since this was the third time a Smith show
had been included in an *ArtNews* top ten within ten years, from this
point on Smith exhibitions were hors concours. "I thought it was my best
show. Most people did too," Smith wrote to Noland. "Your compliments
were great. I sure wish you were a collector—but I'd rather have the re-
spect of other artists than the sales."[41]

In September, the month of Smith and Dehner's divorce hearing,
Smith was offered a second-semester appointment teaching sculpture
at the University of Arkansas. The salary was $3,400. A year after tell-

ing Krasne that teaching was "a waste of time," he accepted. "Is fishing good . . . Do they hunt wild boar," he asked the department chair David Durst.[42]

In the late fall or early winter, Smith had a session with Ernst Kris, the psychoanalyst and aesthetician whose writing on artistic creativity and the personality of the artist he regularly cited in the late 1940s. Kris lived in Stamford, Connecticut. "He just called him up cold turkey," Freas wrote.[43] Earlier, Freas said, "He wanted to talk to somebody . . . about the idea of remarrying. He cried, cried, and cried afterward, oh, god, he just cried . . . I never met Kris . . . I was out in the truck the whole time. But he just burst into tears when he came out, and cried and cried, over Kris."[44] Freas "had never seen him in such a state. He said something to give me the impression that he had never been so close to another man. Kris was like the approachable father David never had."[45]

Smith told Freas that Kris recommended that he not undergo analysis. "David also told me," Freas added, "that Kris said, Oh, these were just the problems that David and I had. They were ones that he could take in his stride, as time went on." He said that "the age difference—which was so important to David—was not all that important."[46] But to Smith, it *was* important, and his behavior with Dehner, which drove her away, he remembered and feared.

38
Arkansas

Samuel M. Kootz was smooth, market savvy, and well connected. He had worked in advertising and organized a 1942 art exhibition at Macy's department store in which Stuart Davis, Jean Xceron, George L. K. Morris, and Lucille Corcos participated. His book *Modern American Painters* appeared in 1930; his *Frontiers in American Painting* was published in 1943. In 1947, in his gallery on Fifty-Seventh Street, he gave Picasso his first postwar solo show in the United States. He represented not only Motherwell, Gottlieb, Hans Hofmann, and William Baziotes but also David Hare and was more open to sculpture than Betty Parsons or Sidney Janis, other dealers who were instrumental to the success of Abstract Expressionism. Kootz was friendly with Greenberg, whom he had invited to curate the "Young American Art" exhibition in the fall of 1950 that included Helen Frankenthaler and Alfred Leslie. Greenberg would write the foreword to a January 1954 exhibition at the Kootz Gallery of eleven painters who had not yet had solo shows in New York, among them Herman Cherry, Kenneth Noland, Cornelia Langer, and Morris Louis.

On January 26, 1953, a Smith show opened at the Kootz Gallery, at 600 Madison Avenue, at Fifty-Seventh Street. Kootz and Willard, who had moved her gallery to 15 West Fifty-Sixth Street, agreed that for a year after the opening, the dealer's 33⅓ percent commission on Smith

sales would be split evenly between them. Maybe Kootz could sell some sculptures. Maybe after showing with Kootz, Smith would have a better chance of equal footing with leading Abstract Expressionist painters. On the front of Kootz's brochure was a photograph of Smith wearing his welding helmet. The brochure included no essay, just the gallery state-ment: "Each sculpture in this exhibition is unique, having been created directly with metal. There will be no duplication."[1] Among the eighteen sculptures were nine *Agricolas*, the first two *Tanktotems*, another series that Smith would develop through the decade. Four sculptures were taller than 6 feet; *Tanktotem I (Pouring)* and *Tanktotem II (Sounding)* were taller than 7 feet. This show, too, was a knockout. "We both saw and were bowelled [sic] over by your show," the painter Harry Jackson and his wife, Joan, wrote to Smith. "It would be too presumptuous to go into a string of adjectives, but we still are moved by the power and beauty of your work."[2] After seeing the show, Smith's Ohio University soulmate Dal Herron, now living in Newark, wrote to the Newark Art Museum about buying a Smith.

Smith was overwhelmed by "Man of Iron," Sidney Geist's effusive, original, and highly gendered review, telling Krasne that it was "the most highly complimentary of any review I've ever had."[3] The thirty-eight-year-old Geist was or would soon be Krasne's boyfriend. His 1969 mono-graph on Brancusi was a groundbreaking study of the modern sculptor Smith most admired who was not also a painter. A WPA and World War II veteran, devoted to art, music, and literature, Geist was living from hand to mouth. He had been to Bolton Landing and seen Smith's shop and sculptural clusters outdoors and marveled at his ability to work with metal and suffer no ill effects—although Smith was, in fact, begin-ning to have problems with his eyes as a consequence of arc welding.

Geist saw in the *Tanktotems* a "new direction, and that direction is, briefly, up. They are over six feet tall and likely to get taller; and they are the beginnings of a sculpture that is monumental in more than size." In *Australian Letter*, Geist experienced a "massive masculinity . . . David Smith treats every piece that comes his way with poetic justice. Forging, cutting and welding an intractable material, he is in the process of creat-ing a series of monumental personages to fill out his world." He detailed some of the strange mixings in the work: "A brake pedal, a part of a

cultivator, an old tool, or a wheel rim—these elements are always handled with respect. Smith makes them his own as he combines them with his forged forms, or welds them together with stainless steel. In the final sculpture, they operate, not literally, nor as symbols, but as metaphors: they are 'like.' Thus a bolt becomes a bud." In Smith's inspired relation to work, Geist found a key to the eagerness with which the sculptures met the world: "Smith's invention appears endless and his energy astonishing. Needless to say, his is hard work. That is not virtue in itself, but in his case it imparts a vitality and enthusiasm—and a kind of Old Testament virility—that reach out to the spectator. In Smith's hands the work of art becomes a man's work and a man's art."[4]

During the last week in January, Smith seemed to be in many places at once. On January 23, he drove from Bolton Landing to Utica to speak at the Munson Williams Proctor Institute, which had bought *The Letter*. On January 24, he unloaded his sculptures in Manhattan for the Kootz show. On January 27, the day after the opening, his truck loaded with matted drawings and sculptures as well as tools and other equipment and belongings, he set out for Arkansas, stopping in Washington, D.C., where he stayed with the Nolands. He and Freas were smitten with Lyn, their two-month-old daughter. Freas broke off the relationship again. On February 1, Smith arrived in Fayetteville.

His job at the University of Arkansas was paid for by Winthrop Rockefeller, whose funding had made possible the building of the new art center designed by Edward Durrell Stone, a Fayetteville native who had designed New York's Museum of Modern Art headquarters at 11 West Fifty-Third Street. Louis Webster Jones, president of the university, wanted the arts to be integral to college education. Smith's presence would draw attention to the art center; in April, *Life* did a spread on it in which Smith was featured.

After a couple of weeks in a hotel, Smith rented a $50-per-month second-floor apartment, with three large furnished rooms and a porch, across the hall from Norma and Ed Millman, whose residency was also supported by Rockefeller money. Smith and Ed Millman were friends from Woodstock, where Millman was part of the painting community. He had been instrumental in Smith's appointment. Freas relished rolling

off her tongue Millman's description of himself: "I'm a piece of Old Chicago."

On Tuesday and Thursday afternoons, Smith taught a three-hour sculpture class with around fifteen students, a number of whom were married veterans. His large studio was adjacent to the classroom. When he didn't eat in the student cafeteria, "you could at night smell David cooking his steaks in the little kitchen off the gallery," Robert Nunnelley, a painter whom Smith singled out as his best Arkansas student, wrote. "He worked night and day when he wasn't teaching."[5] Nunnelley was interested in the New York School and determined to move to New York, but after learning that Smith was coming to Arkansas, he stayed and "took that semester with him." Of Smith, Nunnelley recalled, "He was funny. He was a big, clumsy man, physically, a large guy. But he was so sincere that you really wanted to try to find out what it was all about."

Smith emphasized drawing. "[He] set up a large still life arrangement which included a female nude," Nunnelley wrote. "He wanted us to make quick drawings of the setup with ink and brush on newsprint pads." Drawing on newsprint was intended to get students to concentrate on process and not be inhibited by the drawing surface. "He would look at what you were doing, and he would either say he liked it or he didn't like it," Nunnelley recalled. "If he didn't like what you were doing, he could want you to work faster." He encouraged students toward "an aesthetic appreciation of abstraction." In the last month, he had them stop drawing and begin making sculpture. "Most of us had never welded before. I made a structure with half-inch bars. They were just half-inch square bars, but abstract figure-shaped, and he cut it up for me with a torch, and then said, 'put it together.'"

Smith and Millman had two-person exhibitions in Fayetteville and Tulsa, where Smith appeared on television. In each exhibition, Smith presented New York and Arkansas work. He gave talks in Portland, Oregon, and Norman, Oklahoma. Despite Smith's travel schedule, Nunnelley felt his teaching commitment. "He was the most engaged teacher with his students that I ever had," he wrote. "He supported and encouraged you to fulfill your ambitions. I only saw him really angry twice in class. Once when a female student was trying to influence him by brushing up

against him. 'To get a grade she brushed her tits up against me.' And when he stumbled over the metal parts of a sculpture on the floor that I was working on. 'Nunnelley you have your stuff spread out all over the place!'" While students "remembered that he was one of the gods," and while Smith "didn't socialize with the students," he was, Nunnelley said, "very open." He added, "My being gay did not bother him. I think that he was trying to encourage me in becoming an artist, and I don't remember how the subject came up but the only two comments he made that I remember was [*sic*] that he had hemorrhoids and could not do that and that it could be the source of art."

In February, for *Art Digest*, Smith reviewed Ladislas Segy's *African Sculpture Speaks* and James Johnson Sweeney's *African Folktales and Sculpture*. He felt affinities with non-Western, non-Christian cultures and felt deeply attached to African art and myth. "African sculpture, like Cézanne, has become tradition for today's painters and sculptors," Smith wrote. "In sculpture, especially, it has been the most important influence on the development of direct working methods and on solutions to basic problems of mass." Referring to the Segy book, he wrote:

> There are tenets in mythopoetic projection common to both African and contemporary viewing. The contemporary likewise works with what he knows, the mythopoetic image of himself as part of nature, dreams, aura, association, science, in equal accent and like the primitive, the shape becomes the power . . . Form is projected to that imaginative edge of the beautiful-vulgar . . . That is the precipitous edge where I wish my own working concepts to be.[6]

He returned to this edge in a March talk in Portland:

> One of these projections is to push beauty to the very edge of rawness. To push beauty and imagination farther toward the limit of its accepted state, to keep it moving, and to keep the edge moving, to shove it as far as possible toward that precipitous edge where beauty balances but does not topple over the edge of the vulgar and beyond my time.[7]

"Who Is the Artist? How Does He Act?" probably written just before Smith's drive to Arkansas, appeared in the May–June issue of the Italian magazine *Numero*, accompanied by a commentary on Smith's work by Herman Cherry, who arranged for the spread. It reads like an essay but looks like a long poem and contains art and life questions Smith was wrestling with. One question concerned the compatibility of his belief in the artist as a visionary who must have "the courage to express alone, and to form his whole life to that end" with his need for family and stability:

> What concession will the artist make, consciously or
> unconsciously
> to the normal needs of man, the family and welfare? . . .
> No one can exist without feeling social expectancy.
> From what order does the artist feel most influence—the
> people of distinction,
> the bourgeoisie, the working class, his own professional
> associate artists?[8]

He reiterated that his first audience was other artists.

Smith's words to Freas from Fayetteville could be anxious and beseeching; they revealed the lonesomeness that he communicated to almost everyone he wrote to back east. To convince her to join him, he played pretty much every card he had. "I called in the greatest sincerity and need," he wrote soon after arriving.[9] Soon after, more of the same: "How much can I do / How much can I say / When I need you so badly."[10] He described his apartment: "Much space. We have a kitchen, electric ice box and all in our dept. You and I could have cooked and worked together like we use to do only here I could give you better space."[11] He continued, "Would that we could be with each other like my work is to the reviewer Geist."[12] He sent her plane fare, which she returned.

If they were not going to be together, maybe he would seek a teaching job on the West Coast. Maybe he would go abroad. He was rejected for the Prix de Rome and the Fulbright but continued to be drawn to Italy. The model he hired in order to draw from life was Italian, and he started to learn the language.

For his forty-seventh birthday on March 9, Freas sent him a birthday

cake. He thanked her, adding, "Maybe I don't like my age now since you are separated by it, partly."[13] They spoke on the phone more often. In a March letter brimming with longing and hope, he claimed a new self-awareness:

> We are in love. Do you realize that? . . . I have faith in total and absolute confession of fears and the confession of causes which have made me be unfair—I'll really give you the most honest ex-change that I'm capable of—I have never really done it . . . I need to see more clearly than I've seen before. I need to see clearly to make works of art and to make my life true and my girl happy.
>
> Do you know that you are really the only woman I've ever had this much confidence in—I am sexually confident with you—do you feel it I am with you like I am with my work but the narrow parts of me must be opened—I am very confident & free sexually with you terrifically so—now let me be confident personally—let me give you that mental virtue which I have been reserving—by fears, by burial, by I really don't know what . . . I'm ready for trust—love—equality, freedom and if you can give me a little help and exchange—I'll give you everything Ive been holding back . . . Help me—we belong together. I'll help you.[14]

When Smith learned that Freas was interviewing for an editorial po-sition in a Chicago publishing house, he said that when her train stopped in Joplin, Missouri, about ninety miles north of Fayetteville, he would be waiting for her. At first, she said no. "So then," she recounted in an in-terview, "he called back and said, 'Oh, you've got to come. I've just been to the infirmary, and I'm dying.' And I believed him. So he said, 'I'm not asking you to marry me. I'm not asking anything. Just get off that train. I looked it up and I know just where you can get off. It's near to me, where I can drive, I will meet you.'"[15]

Freas agreed:

> He said his scrotum was going to burst, or he had burst his scrotum . . . He had some infection or something or other . . . and he was going to die. He knew he was going to die if he

didn't see me . . . And I *never* would have gone out there, if it hadn't been for that job. Never. I would just have said, "Too bad. I've been around the block with you before, on this."

So off I got, and I met him. He said, Jean, I've changed. I cannot live without you. I will do anything you want. I'm not like I was. . . . Well, he'd said this to me before, on the telephone . . . so that was just more of the same. But, the sincerity in his eyes—he really meant it. There was no question about that. So, I said, "I'm going to this job." And he said, "This job means nothing. You can always get another job. You have to do this for yourself." And you know, I believed that, and I still believe it.[16]

On April 3, 1953, at the Joplin train station, Smith proposed. Freas recalled:

I got off the train, and I called up this guy in Chicago, and said, "I'm sorry. I'm getting married." And that was how it happened . . . It was mostly seeing him, and seeing how, oh, my God, he was so—he was crying, and he was very worked up. You know, we'd been through a lot together, already we had, and the choice of getting married was not some easy choice at all, because we'd been to the brink and back, several times. So this time I really was going to take his word for it.[17]

She asked her parents to attend the ceremony, but they refused. They did not believe the marriage would work. She tried to persuade them by telling them that Smith had prayed and had asked the Lord to cherish and protect her always. "I asked him later what he meant—and he said he meant the Unknown Quantity whose mysterious strength is greater than man's," she said. She did not expect easy going: "Life will not treat us gently. We do not ask for that. As creative workers, we ask for big problems, & humbly for the strength to assail them. In our life together we demand & expect the same thing." As "ill-pleased" as her parents were, they printed and sent out the wedding announcement she requested, and as a wedding gift they sent a check.[18]

On Monday, April 6, three days after Smith's proposal, Freas and Smith were married in Eureka Springs, fifty miles from Fayetteville. Freas picked the town on a map: "At the time Eureka Springs was a ghost-town, with a wonderful old hotel in mahogany gloom, that looked like it belonged in Dodge City. It was there that Jesse James was fatally shot in the steam bath, and there that Carrie Nation made her last stand. A big sign at city limits announced, 'The Little Alps of the U.S.A.'" The wedding took place in a feed-seed-and-fertilizer store—"the perfect setting to express the vitality, youth and fecundity of our union."[19] Freas noted that a sign outside the entrance said, "Larro," the name of the feed: "And I said, 'David, that's going to be our baby's name.'"[20]

Smith went by truck. The Millmans, the witnesses, followed with Freas in their station wagon. She wore the Claire McCardell dress that she had bought for her interview. She wrote her parents: "The bride wore a shocking pink hat with veil, a blue wool dress, ankle-strap shoes, long white gloves & a black silk coat."[21] To Thomas Colt, director of the Portland Art Museum, Smith described the ceremony as "short, straight, with no obeys, and as far as we could discern, a Baptist method, very dignified, quiet and honest, the bags of grain as fertility symbols and if it does as the sign on the window said, the boy child will be named 'Larro' after the trade name of feed. The sign also said 'Ful-O-Pep,' so all bodes well."[22]

Smith made sure Willard knew. "We talked over many things and took a long chance," he wrote, "but it's love and will be our future, crises, offspring, hardships come what may."[23] Willard had already heard the news from Clement Greenberg. She gave her blessing: "We congratulate both you and Miz Smif: May the Arkansas license bring luck, life and love to the hills of New York."[24]

On the drive back to Fayetteville, Smith stopped the truck. When he returned, Freas said, "he was carrying wild flowers in one hand, while in the other was what had detained him: a large, partly-feathered, dead-for-days black bird." Smith would embed the crow in plaster with half of a Ping-Pong ball. "Who could know that more than thirty years later the 'bouquet'—or the bird part of it—is now a picture, feathers and skeleton embedded in plaster!"[25] A few days later, Smith invited the entire art department to their apartment, where on his two-burner hot plate he prepared a twelve-course Chinese wedding feast.

That spring, Kootz sold three sculptures. Jay Steinberg bought *Tanktotem I* (*Pouring*) for $1,680 and gave it to the Art Institute of Chicago. The Met bought *Tanktotem II* (*Sounding*) for $1,890, both at the standard 10 percent museum discount. *Agricola VI*, one of the earliest of Smith's running and dancing girls, sold for $800, to the private collector Eugene Von Stanley, to be paid in installments. Kootz sent small checks for *Agricola VI* and assured Smith that other "checks will follow in due course."[26] "I commend you on both Tanktotem promotions," Smith wrote to Kootz in one of his many letters typed by Freas. "I need [the money] badly and I need it for my dealers . . . I'd like to see the costs paid off to both of us."[27]

Freas enrolled in a seventeenth-century literature course and took a modern dance class with Eleanor King, an acquaintance of the Seattle painter Morris Graves, who also showed in Willard's gallery and whom Smith had seen in Portland. At the end of May, Freas performed in a dance concert, cheered on by Smith. By the end of the semester, she decided that she enjoyed dancing more than writing.

"Please know that I am happy & well-satisfied with my choice," Freas wrote her mother on April 17. "David is too. A couple of times we could have fought like fish-wives—but we nipped it in the bud, talked things over, & everything was fine. I love & respect him, & also know his weak points. We are both behaving in more mature fashion."[28] Three days later, she wrote to Helen Frankenthaler, whom she addressed as "Dear Angel": "This marriage business is a cinch. So much easier than indecision, quarrels, absences, half-assed living—and despite what the analyst told me, as well as my mama, people do change, and marriage does make a difference. I am happy, David is happy."[29]

They were enthralled by the Ozark spring. Each week, they walked in the woods, where Smith could be as attentive as he was to art. They went to the Boston Mountain region, Freas wrote to her mother, "a summer resort area, now at its most beautiful and least traveled. This is a state park, but due to the state finances, it isn't clipped and manicured and patrolled the way New York is." After climbing down a cliff into a cave, they searched for fossils and Indian relics, finding "nothing except a very old rib from a cow." They came across "Indian symbols carved in a rock wall we had heard about . . . There were no guards standing around to inhibit us, and no pop bottles etc." They picked paper narcissus, weigela, and

honeysuckle, and Smith dug up some bulbs, which he intended to plant in Bolton. He made fishing poles from bamboo they found by a river.[30] "I don't know which he likes best—wild flowers, rocks or ancient animal bones," Freas wrote in another letter, to both her parents.[31] Near the end of the semester, Smith arranged a day trip for his two classes. He and Freas baked beans and led the thirty students to a rock ledge beneath an eighty-foot-tall cliff overhang by the War Eagle River, where Smith built a fire and roasted hot dogs and left students with an enduring memory of his affection for them.

The Smiths liked Fayetteville and the university, and the art department wanted him back, but by the time they left Fayetteville they were ready to go. The Arkansas heat bored in with heavy humidity, the Millmans' cat Purr-Purr peed on their mattress, and Freas burned her hand with boiling coffee. Smith was again worrying about money. The journey home passed through Bloomington, Indiana, where they stayed with the sculptor George Rickey, a member of the University of Indiana faculty. Rickey had lectured at Arkansas and visited Smith's class. The University of Indiana offered Smith a teaching job.

Then on to Bethesda, where they spent three or four days with Freas's parents. Smith hoped to gain an audience with Arkansas senator J. William Fulbright and a member of the jury that did not award him, or Freas, a Fulbright. He took photographs of Al Freas that he sent to him. They stopped in Manhattan for dinner in Chinatown and a visit with Greenberg and Frankenthaler, who presented the newlyweds with a bottle of French Champagne. In June they were home.

39

Life Change

Almost overnight, Freas went from being a student of seventeenth-century literature and modern dance in a university community to a wife with traditional domestic responsibilities in the Adirondacks. The house was as Smith had left it after more than two years of living largely alone, only more unkempt since it had been empty for four months. By himself, Smith could accept its unfinished state, but with a young bride he could no longer defer work on the bathroom (plastering), the kitchen (painting), and the unfinished fireplace and terrace, even if Freas was not bothered by the disorder and inconveniences. "I love this house, bare & cluttered as it appears to most people—it is just the way I like to live," she wrote to her mother soon after their return.[1] She accepted most of the drudge work, including scrubbing and waxing floors, but described sewing and ironing as "the curse of womanhood." She welcomed the challenge of preparing healthy food three times a day: "He doesn't give a damn about cob-webs, dust or dirt. I can do or not do anything I please—as long as I give him three full meals."[2] Whatever items she asked her parents to send, they did. They sent money as well, some of which went to pay the rent on Freas's flat on the Upper East Side.

Freas was determined to be the dutiful daughter as well as the dutiful wife. She wrote and called her parents constantly, sometimes surreptitiously from town rather than from the phone in Smith's shop. She

wrote to them of her daily summer routine and short-story writing and the drought that dried up their well: month after month Smith had to truck water from town. When the weather turned colder, they boiled water and bathed in a temporary tub by the woodstove. She gossiped about guests and neighbors, and left no doubt about Smith's commitment to the town and townspeople, and provided examples—which were evident every day—of his immense competence: he could fix and build just about anything and find solutions to just about every practical problem. She kept them abreast of the triumphs and vicissitudes of his never-boring professional life. She enumerated physical concerns, including about weight, and wrote, often with wonder, about cooking and food. Her parents learned of Smith's massive effort to get the garden up and running, the disease threatening their trees, and neighbors butchering pigs and cows. Freas experienced Smith's affinity for nature. In 1952, he had written, in Martin Buber–like terms, of being part of nature, not outside it. The artist "is not the modern scientific man to whom the natural world is 'it.' He is more the man who is an element of the phenomena of nature and regards nature more as a 'thou' than an 'it.'"[3] She realized that animals were always there and saw their visits as visitations. "The mountain on David's property is quite rugged, the home of cats as well as deer and an occasional bear," she wrote. "It is strange how in the daytime everything looks so peaceful and mild, and civilized, but at night the wild things come out of the woods and prowl . . . It gives a funny feeling—also makes me realize how true it is that no one owns anything—for there is always nature."[4]

Freas was happy to feel part of Smith's discoveries. "Today," she wrote to her mother, "we took a ride and found, to our great delight, an old surrey in a dried up river bed . . . All its parts were there, including a good deal of the original fringe! David decided the front seat could be taken out, fixed, and made into a comfortable little low seat for two in the house—and it is so prettily shaped that I am dying for him to get started on it."[5]

Smith ushered in each day as if it were the beginning of the world. Every morning he would stand outside naked, Freas smilingly reported, and make "this noise . . . The echo there is powerful, and you would hear several bellows from that initial bellow . . . If you didn't know it was

coming out of him, you'd wonder what the hell—Have you ever heard a bear do that? Well, it's not nice." While the loudness of the bellowing recalled a bear, it "was not high-pitched" like a bear's. "It was like, oh, I don't know what. And he had a very big voice. Very big. He had that round chest, and boy, when he hollered . . ." He had begun another of his daily rituals years earlier: "Summer, fall, spring, and even winter, when he could, he would go out there and he would pee off the parapet . . . he would say, 'I'm just shaking the dew off the lily.'"[6]

In late July, they drove 125 miles to Woodstock, where Smith was jurying an art show. Freas had never seen so much boozing. Smith brewed his own beer and made wine, and he could go on benders and act aggressively under the impact of alcohol, but his eruptions were rarely fueled by it and he was not an excessive drinker. The Woodstock artists they hung out with "literally drink more than they eat," Freas wrote. "On weekends they drink until 3 AM and later, and consequently sleep until noon . . . The sight of so much liquor kills what small taste for it I have and consequently I had one drink, very mild, which David mixed for me, all weekend. He had three. I'd estimate the average weekend consumption per person was 40 drinks. David left one dinner party and drove into town to eat, he was still so hungry."[7]

They returned to Bolton Landing with Clement Greenberg in tow. His visits were special. Smith rarely welcomed critical discussion of his work. For instance, when Herman Cherry made the kinds of questioning comments that most other artists would experience as signs of friendship, Smith could be defensive and argumentative. It was different with Greenberg, who had stuck his neck out for Smith, indeed staked his reputation on the quality of his sculpture, and helped to form a critical language that enabled others to recognize Smith's achievement. Smith and Greenberg respected much of the same modernist lineage, and pretty much every modern artist Smith cared about Greenberg had critically considered. For years, Smith had depended on Edgar Levy's critical engagement. He would have intimate discussions about his art with a handful of other artists, notably Helen Frankenthaler, Robert Motherwell, Ken Noland, and the sculptor James Rosati, but in the early 1950s Greenberg may have been the person whose responses he most valued in his shop. Greenberg wanted to know what Smith was doing, and Smith

wanted to hear what Greenberg thought. However much admiration Smith's sculpture received, his career was still volatile, his relationship with institutions uncertain. Greenberg's consistency of support and bi-annual visits to Bolton Landing meant the world to him.

Freas liked Greenberg—"such a nice person, besides being so intelligent"—as well as Frankenthaler.[8] They had been a couple since 1950. They did not live together but traveled and looked at art together and were the hub of an artistic circle in which a select few could count on serious talk, gossip, and community. Through Greenberg, Frankenthaler met Pollock, Krasner, the de Koonings, Rothko, and Newman, as well as Smith. Frankenthaler was attentive to Freas, who trusted her. A comment Greenberg made to Freas on this visit signaled a life change. "I had to take a nap," Freas recalled. "And he said, 'What is it with young girls? You and Helen. You're always sleepy. You're always tired.'" For the first time Freas asked herself about her fatigue. "It was because I was pregnant . . . I was the most surprised person in the world to find out."[9]

Although Freas was sick of travel, she and Smith went on the road for a two-week business and pleasure trip that introduced her to the beauty of New England. In Boston they dressed up for a fancy lobster dinner at Locke-Ober, Smith's favorite restaurant, and he met with the Finnish architect Eero Saarinen, who asked him to make a candelabra for a project a year or more down the road. When they arrived in Provincetown at three in the morning, not wanting to wake up the friends they would be staying with, Smith took the lock off the shed, where they spent the rest of the night. They were there primarily to meet with Sam Kootz, who had just opened his Provincetown gallery. Then they drove to Maine, where they visited Ogunquit, site of an art colony, where the Museum of American Art was showing *Hudson River Landscape*. Farther up the coast they visited Marian Willard and Dan Johnson, vacationing in a trailer. They camped in Smith's truck and after gathering crabs, mussels, and snails, bought a lobster and cooked chowder over a pit Smith had dug in the sand in order to build a fire. He traveled with "a head of garlic in his breast pocket," like a book of matches, Freas would write, "so even our impromptu feasts were full of flavor."[10] They did their "cooking on the rocks," in a "cove, wild and isolated," and "took sea water baths with a bar of special sea soap." Their last stop in Maine was Monhegan, an

island famous for its cliffs and fishermen and rejection of modern conveniences: no cars or electricity. Robert Henri, George Bellows, Winslow Homer, and Rockwell Kent were among the artists who had been drawn to the island's remote grandeur. "David knew everybody and we were royally treated," Freas proudly wrote to her parents on August 25.[11]

In that same letter, Freas told her parents the news: "Around March 11, 1954, we become a family." Her diet included "enormous quantities of vegetables." She was reading *Natural Childbirth*. Smith promised to design her maternity dress. "We are hoping for a girl, in a way; there are boys enough in Sch[e]nectady," Freas wrote. "What to call it? Not John or Mary."[12] Smith had a provisional name: Delta, which he felt could fit a female or male. When he signed sculptures with the initials Delta Sigma, $\Delta\Sigma$, Delta was his own first name. Through this name he and the child would merge. His heart was now set on a daughter. Larro was a distant memory.

Late in the summer, Freas's parents visited Bolton Landing for the first time. Smith and Freas made sure they met Mary and George Reis, their rich friends by the lake. Smith and Al Freas took walks. Spending time together, in Smith's place, Al and Smith got along. "My father really liked his independence," Freas recalled. "He liked the fact that he was an artist who was *a real man* . . . When they'd go out in the woods together, they had such communion together." On their walks, "they'd dig up different things that my father wanted, even though we were in a different zone in Washington . . . there were things that could make it, and he loved wild things." Her father returned to Washington with a U-Haul full of trees and plants.[13]

A few days after they left, Smith showed Freas a spot by the lake where her father could retire. "The only people who visit us and make their bed and clean up after themselves are your parents," he remarked to her a year later.[14]

Kootz had become a problem. Smith had learned that Kootz had been paid for *Tanktotems I* and *II* by the Art Institute of Chicago and the Met but had not passed on the money to him. "What is the status of the account?" Willard inquired of Kootz in mid-June.[15] "A strange character and as far as I know he has never had his head above water," she wrote Smith in July.[16] "It takes the edge off success," Smith wrote to Katharine Kuh of the

Art Institute of Chicago. "The two greatest museums bought two works," but without being paid for the sales he could hardly savor the acquisitions.[17] Smith and Freas's hunch was that Kootz had invested the money in his new Provincetown gallery. Not only was Smith having trouble paying his bills, but he was late on the mortgage payment as well, and they were considering a trip to Europe in the fall, a kind of honeymoon, which was impossible without money from the sales. To her parents, Freas tore into Kootz as "that crooked dealer" who "has $3000 of David's money." By contrast, Willard was honest: "Marian isn't a fireball selling but her integrity is absolutely unquestionable."[18]

Kootz kept dissembling. He assured Smith that he would pay, but he didn't. At the end of August, Smith, increasingly angry, wrote Kootz to convey the pressure he was under: "I'm in serious circumstances. Please see that the full amount comes by Labor Day as promised. Besides being pressed by the bank, my work is heaped up and my credit is being jeopardized because I am now three months owing on certain bills."[19]

On September 21, Kootz finally sent Smith a check for $2,440. He apologized and signed off with his "sincerest hope we think as highly of each other as in the past."[20] The check bounced and Smith hired a lawyer. On October 5, before the lawyer's letter threatening legal action reached Kootz, Kootz wired the payment to Smith's bank. "I am happy this is straightened out," Kootz wrote, "and I'm sorry my account was so slaphappy at the bank . . . that we figured it wrong."[21] Two days later, a relieved Smith wrote Willard: "money in bank—making good now. Paying debts, bringing oil and planning some casting projects."[22] Fifty years later, Freas still felt the impact of Kootz's deceitfulness: "Some periods were worse than others, and this was a very bad period."[23]

Freas was of two minds about receiving her parents' gifts and money. The money gave her some feeling of financial independence and made her and Smith's life a bit easier. But the gifts kept her in a dependent relation to her parents and were a statement of nonconfidence in her husband's ability to provide for her. Around Thanksgiving, Freas wrote her mother: "Mama, don't send me any more checks. I have [the city apartment] rented to a nice man—hope it lasts . . . About Christmas presents; you all have been so generous with me, every week is Christmas. So why

wear yourself out shopping? Why not let me play Santa for a change and you lay off the present giving entirely?"

She reassured her mother about Smith as a husband and provider: "Do not worry about my health or state of mind. David is usually most kind—and his anticipation of the baby is something to see."[24] Three days later: "He is a good, warm, loving soul, intemperate at times, but not for long."[25] Soon after: "David is the soul of kindness to me (brings me breakfast in bed practically daily) so you have nothing to fear on that score."[26]

Smith was in the middle of a brouhaha with Alfred H. Barr, Jr. Barr had acquired his 1938 *Head* for MoMA, but with the nickel-and-diming and demand for special museum treatment that Smith loathed. When Barr saw the 1952 Willard-Kleemann show he expressed admiration for *The Letter* and interest in *The Banquet*, another 1951 sculpture, which Smith hoped he would buy, and was considering acquiring a work in the Kootz show. But he did not buy a Smith even though he was buying sculptures by other artists, including, Krasne told him, four by Reginald Butler, an English sculptor whose work was shown at the 1952 Venice Biennale. In July, Tom Hess wrote to Smith: "The grapevine informs me that the Modern Museum wants to buy one of your sculptures but (don't get sore) think[s] the price is too high in relation to other sculpture, or something like that. I pass this rumor on to you in case it might be useful to you in some way."[27] Feeling misunderstood and disrespected by MoMA, Smith told its influential contemporary art curator Dorothy Miller that he wanted to buy back *Head*. Shortly afterward, two days after receiving Kootz's payment, he wrote to Krasne: "I can now get along without Bar[r] & M.M [Modern Museum] and macaroni salad."[28] For Krasne's October 1 *Art Digest* cover, Smith had drawn in thick black ink three vertical configurations, each suggesting a joyously animated dancing woman.

Hess's letter followed an airplane conversation between Barr and Alfred M. Frankfurter, the editor and publisher of *ArtNews*, in which they discussed the prices for contemporary American art, including work by Smith. Frankfurter related the conversation to Hess. After learning of Hess's letter to Smith, Frankfurter wrote Smith an explanation: "Both Alfred [Barr] and I agreed that with the limited funds available to any

museum, including the Museum of Modern Art, for the purchase for works of art by living American artists, it was a considerable hardship to have to spend the greater part of an annual allotment on a single work of art no matter by whom."[29] Smith explained to Frankfurter: "[My prices] are fair according to my work time and costs. My operating costs are high, and at no time have my returns met the cost of producing. I have to earn by other means the right to produce my work. I'll buy back my work anytime a collector is dissatisfied. I'm confident of my work."[30]

On November 24, after speaking with Dorothy Miller, Barr sent a formal letter to "Mr. Smith":

> We brought your request before the Committee on the Museum Collections, but the Committee decided that it did not wish to approve selling back your sculpture, *Head*. It did direct me to inform you that since you did not feel the work to be representative, it might be offered to you as partial exchange should the Museum purchase a later and more important example of your work.[31]

Smith was furious. He told Barr:

> Please inform the Committee on the Museum Collections that I will accept no trade-in . . . I have not stated that this work was not representative. The work was made in 1938. It is different than the work of 1952 but I refuse to accept the Museum's qualifying statement. I make all my work with all my integrity. The bargaining and this situation are not pleasant. I hope the Committee will sell back the work in question, and as far as I am concerned, not consider "a later and more important work."[32]

Head remains in MoMA's collection. At the end of the year, Smith wrote to Emily Genauer: "I've broken connections with Barr—told him to tell committee never to consider my work for purchase again. I'll have to make it without the Modern."[33]

40
Totems

The stars of Smith's January 1954 show at the Willard Gallery were *Tank-totems III* and *IV*. *Tanktotem IV*, finished just weeks before the opening, was selected for the 1954 Whitney Biennial and a featured image in "Abstract and Representational," Greenberg's essay in the November 1 *Art Digest*. To the painter and critic Fairfield Porter, one of the most perceptive Smith critics, the *Tanktotems* were a watershed. Smith "used to interest himself in descriptive comment, or even a story," Porter wrote in *ArtNews*, continuing:

> This year's welded steel sculpture is about the creation of living creatures . . . The creatures are completely made up. But they are not monsters. One, at least, suggests in its three-leggedness and crescent head, a praying mantis. However, it seems to this reviewer to be more accurate to see in all of them something that underlies animal, human or superhuman life, so that these abstract creatures might as well be angels. They are individualistic as well as general. This ambiguity may be the essence of their superiority as sculpture. They are simple and unique. In a formal sense they are better than his former sculpture because what he used to do by multiplicity of detail he does now by accuracy. The effect is less aggressive and dangerous.[1]

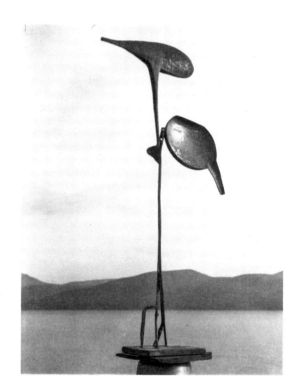

David Smith, *Tanktotem I,* 1952. Photographed by David Smith on the Bolton Landing dock, Lake George, New York. Steel, 89¾ × 39 × 16½ in. (228 × 99.1 × 41.9 cm). Art Institute of Chicago.

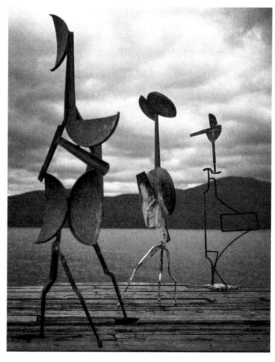

David Smith, *Tanktotem IV, Tanktotem III,* and *7/29/53.* Photographed by David Smith on the Bolton Landing dock, Lake George, New York, ca. 1953. *Tanktotem IV,* 1953. Steel, 93½ × 34 × 29 in. (237.5 × 86.4 × 73.7 cm). Albright-Knox Art Gallery, Buffalo, New York. Gift of Seymour H. Knox, Jr. (K1957:15). *Tanktotem III,* 1953. Steel, 84½ × 27 × 20 in. (214.6 × 68.6 × 50.8 cm). Collection of Mr. and Mrs. David Mirvish, Toronto. *7/29/53,* 1953. Steel, 85¼ × 32 × 21½ in. (216.5 × 81.3 × 54.6 cm). Museum Ludwig, Cologne (ML 01296).

In an *Art Digest* review illustrated with the same Smith photograph of *Tanktotem III* set against the sky that accompanied the Porter review, Sidney Geist, too, saw the series as a turning point:

> The first phase of Smith's sculpture [was] over. It was a sanguine phase in which he made vigorously three-dimensional objects, of which his "landscapes" and "interiors" were the most personal . . . They called for an involved and intimate participation on the spectator's part. His new work, done in the last year, is characterized by a compression which has flattened it in some cases and sent it up in columnar fashion in others . . . Several tall figures, ranging from six to eight feet, show Smith shedding all elements which do not contribute to monumentality. These tall spare structures, called *Tanktotems*, are female presences, voluminous, elegant, full of gesture.

To Geist—twelve years after Pollock is reported to have said, "I AM nature"—Smith was "an artist in touch with the forms and the forces of nature. He has himself become something of a force of nature, exfoliating in his work like a growing tree. Starting as a baroque, he has slowly developed into a classic artist. The interesting thing is that this has been accomplished without rupture, without a loss of identity."[2]

Smith made the first *Tanktotem* in 1952 and the last in 1960. Like most Smith series, this one seemed to come out of nowhere, develop irregularly, gather momentum as a peculiar tribe, clan, or troupe, and at a certain point not so much stop as be discontinued. Each *Tanktotem* includes at least one lid of an industrial oil tank. These circular tank ends are standard parts, forged from large dies, but in Smith's hands standardization is undone by individuation. Their sizes, types, and surface treatments vary from sculpture to sculpture and sometimes within sculptures. Turned on their sides and welded to the middles and tops of figurative constellations, many of the tank ends evoke bellies and heads, or shields and targets. To Smith, the "segmented concaves" could also be seen as "a dish, or a salad bowl or a halved melon."[3] Along with storage facility, "tank" suggests war machine: the *Tanktotems* carry within them the specific memory of Smith's job in the defense industry at ALCO but

also a broader awareness of military campaigns, from hand-to-hand combat with swords and shields to aerial bombardments that devastate nations.

In *Tanktotems III* and *IV*, human, animal, insect, and vegetal merge with industrial and technological. That these sculptures seem to be more nature than human contributes to the sense that they are more powerful than—*more than*—any person in their midst. Joseph Campbell would use the term "combinatory image" to describe the "Sorcerer of Trois Frères," a hybrid figure in a cave painting, discovered in 1914, that presides over hundreds of animals carved into the walls of a cave in the Pyrenees. Campbell saw the 2½-foot-tall figure as part stag, part man, part owl, part lion, part wolf or wild horse, part bear. "He is taboo," Campbell would write in *The Masks of God: Primitive Mythology*. "He is a conduit of divine power. He does not merely *represent* the god, he *is* the god; he is a *manifestation* of the god, not a representation."[4] The *Tanktotems* are among Smith's most potent combinatory images. *Tanktotems III* and *IV* seem to preside over whatever space they are in. They seem infused with taboo power.

Photographed by Smith where he installed them on the Bolton Landing dock, surrounded by pristine water and land, *Tanktotems III* and *IV* seem to be equally at home in a pre- and post-human world. They seem both prehistoric and futuristic—"as mysterious as men from Mars," Emily Genauer wrote of them.[5] They are anti-humanist as well as humanistic: in their presence there is an abiding sense that the human race is but one form of life and not better or more exalted than any other part of nature.

That Smith fused organic and industrial is not surprising. For twenty years his sculpture has been marked by the factory. The *Tanktotems* are, too. More than his previous works, however, the *Tanktotems* hint at a new stage in industrial development, one connected with robotics, science fiction, and space exploration. "Like limbs of some insectoid machine" is how the art historian Robert Slifkin described the three rod legs of *Tanktotems III, IV,* and *IX*.[6] More tellingly, the tank end concavities in *III* and *IV* are like receivers that seem to have been installed in such a way as to make them receptive to high-frequency signals. The top tank end of *Tanktotem IV* seems to be particularly attuned to electronic waves and beams

from across a landscape; the two cupping concavities of the head or insec-
toid eyes of *Tanktotem III* are turned up, toward the sky, as if to pick up
information from above, which in 1954 was where Americans expected
an attack from Soviet nuclear missiles to come from. Both sculptures,
indeed all the *Tanktotems* to a lesser or greater degree, project an aware-
ness of distant space. They bring awareness of the faraway, of what we can
sense out there but not see, into the body of the sculpture. The scribbled
scratches within the tank ends, which make the surfaces seem as sensi-
tive to light as photographic plates, suggest that the sculptures have been
etched into by intense light. *Tanktotems III* and *IV* and Smith's nearly con-
temporaneous *Sentinel* series are part of what Slifkin refers to as the "sen-
tinelism" that was a widespread artistic phenomenon during a Cold War
moment in which the United States felt itself in imminent nuclear danger.[7]
But it is unclear if the signals that *Tanktotems III* and *IV* appear designed
to register are in fact enemy signals. Their receptivity almost makes it
seem as if they are *eager* for signals from afar. They *want* them to arrive.

For many people "totem" has a generic significance—a look. A to-
tem is assumed to be a tall vertical construction, with multiple different
parts, that evokes tribal objects that were used in the service of ritual.
For Smith, however, as Rosalind Krauss made clear, "totem" had specific
meaning: "[It] was not an archaic object. Rather, it was a powerfully ab-
breviated expression of a complex of feelings and desires that he felt to
be operative in himself and within society as a whole."[8] Krauss noted
the number of American artists of Smith's generation who were drawn
to totemism. By 1950, Adolph Gottlieb, Frederick Kiesler, and Jackson
Pollock had used "totem" in titles.

Smith studied totemism. He read Freud's *Totem and Taboo*, Franz
Boas's *Mind of Primitive Man*, and Charles Roberts Aldrich's *The Prim-
itive Mind and Modern Civilization*; he was probably at least somewhat
familiar with James George Frazer's *Totemism and Exogamy* and *Golden
Bough*. By designating the *Tanktotems* as totems, Smith signaled his con-
nection to pagan systems that preceded "civilization" and Christianity
even as they continued to inform both. In totemic societies, boundar-
ies did not exist between human beings and the rest of nature, between
dream and reality, imagined and seen. "In the undifferentiated world the
eidetic image, the dream, and the reality are mingled," Aldrich wrote.[9]

It was outside the West, as well as in prehistory—and in Cubism—that Smith found examples of the nonbinary, the non-either-or. "Premythological man was completely embedded in the world around him," S. Giedion wrote in a 1962 book called *The Eternal Present*. "He formed one with it, he did not stand above it, he did not feel himself to be the center, but a humble element in it."[10]

The authority of totemism depended on the power of symbols. A tribe was identified with its totem, which in most cases was an animal, a bear, for example, or raven, or kangaroo, but it could also be a plant or an object. The animal was an actual creature but at the same time it was ancestral and godlike, the mythical progenitor of the tribe and consolidator and ensurer of the survival of tribal customs and memory. Among tribal members, the totem established a filiation stronger than consanguinity. The totem defined the tribe as a more primary family unit than mother, father, and child.

Like pretty much all religious systems, the efficacy of totemism depended upon what it determined to be taboo. For Freud, "the meaning of taboo branches off into two opposite directions. On the one hand it means to us, sacred, consecrated: but on the other hand it means uncanny, dangerous, forbidden, and unclean."[11] Totemism assumed both the difficulty and the necessity of managing certain desires. "The basis of taboo is a forbidden action for which there exists a strong inclination in the unconscious," Freud wrote.[12] Of the laws instituted by totemism, none was more crucial than exogamy. "The oldest and most important taboo prohibitions are the two basic laws of totemism," Freud wrote, "namely not to kill the totem animal, and to avoid sexual intercourse with totem companions of the other sex."[13]

Totemism prohibited incest. Aldrich refers to the "'horror of incest' that is so characteristic of primitivity . . . Among primitive people, it is impious for a man to have sexual intercourse with a woman of his own totem."[14] Committing incest creates disorder and awakens the demonic. It risks catastrophe for the entire tribe. The offender becomes a pariah, or worse. "The usual penalty for breaking primitive customs is avoidance—that is, the offender becomes taboo," Aldrich writes. "A dreadful influence inheres in him which makes the other members of the group afraid

to touch him or associate with him. But the penalty for incest is usually death."[15]

Totemism did not just recognize the allure of incest. Its absolute prohibition reinforced the power of that allure. This double operation is a model of ambivalence: asserting the force of the desire while ensuring a system of protection against it contributes to the totem's mana. Dehner, like Lucille Corcos, called Smith "papa," a designation he sometimes used for himself. Among the pet names he had for Dehner were "baby," "little lost girl," and "sweet child." When Smith began the *Tanktotems* in 1952, he and Freas, then half his age, were passionately and tumultuously involved. When Smith made *Tanktotems III* and *IV*, Freas was pregnant. While incestual desire and conflict may have figured in Smith's attachments and relationships, however, it's imperative to keep in mind this was also aesthetic material that he was handling with objective calculation, from a distance. At the time incest was considered an urgent and timeless theme, one that enabled artists to tap into desires and energies that had been essential to human creativity for millennia. Following the psychoanalyst Otto Rank, Freud writes that "the incest theme stands in the centre of poetical interest" and "forms the material of poetry in countless variations and distortions."[16] Incest is a theme in *Finnegans Wake*. In an essay to which Smith referred several times, Ernst Kris, whose 1952 book, *Psychoanalytic Explorations in Art*, which Smith would acquire, was widely read among Smith's generation, asserted this universality:

> The very fact that certain themes of human conflict are recurrent wherever men live, or where certain common cultural conditions prevail; that from Sophocles to Proust the struggle against incestuous impulses, against guilt and aggression, has remained a topic of Western literature, seems, after almost half a century, as well established as any thesis in the social sciences. Nor does it any longer seem doubtful that what a man has experienced in his early childhood may, without his knowing it, become a recurrent subject not only of his dreams but also of his creative work.[17]

In his reflections on artistic creativity, Kris put into language that was useful to Smith a definition of sublimation and reflections on ego and id, and on the relation between preconscious and conscious.[18]

Smith's *Tanktotems* suggest acts and even scenes of taboo behavior. His uses of paint can seem not just to coat and caress but also to smear, stain, and invade a female body. In *Tanktotems III* and *IV*, the tank ends that evoke the bellies of girl-women are scratched into. The scratchings, like the paint, can be experienced as a desecration, as illicit touching, even as they are an activation of the steel surface that enables the surface to become radiant with light. In the extraordinary *Tanktotem IX*, from 1960, the three upright rods—Slifkin's "limbs of some insectoid machine," or perhaps the tripod of Hephaestus—are welded to the massive rectangular plate that is the sign of the torso. (See Figure 6 in the insert.) The juncture is a charged zone. The rod-legs can seem like feelers as they lean against the lower part, or crotch area, of the large rectangle that constitutes the body of the female figure. But it is in the nature of Smith's sculpture that the emphasis and meanings a viewer ascribes to aspects of it are constantly changing, and the same rods that can make it seem as if a girl-woman is being groped shore up this steel plate, enabling it and the entire sculpture, almost miraculously, to arise and stand. Any experience of illicitness becomes inseparable from the feats of balance and the power of ascension. In *Tanktotems III* and *IV*, the disproportionately long necks contribute to the anti-gravitational thrust that seems to stretch the sculpture off the ground, away from whatever might be happening within its body. The tank ends at the top of the sculpture seem to be on guard; the sculpture seems designed to receive and redirect threat. Smith famously told the *ArtNews* editor Thomas Hess in 1964: "A totem is a yes and a taboo is a no. A totem is a yes statement of a common recurring denominator . . . Just plain Freudian references."[19] *Tanktotems III* and *IV* and indeed the entire *Tanktotem* series, and Smith's art as a whole, subsume the no in the yes. Fairfield Porter saw the *Tanktotems* as hopeful, and they are.

41
Rebecca

As Freas approached her due date, the Cincinnati Contemporary Art Center bought *Entrance*, Smith's first sculpture to enter the collection of a museum in Ohio, and the Whitney bought *Hudson River Landscape*, one of the seven Smith sculptures that MoMA chose for its 1954 summer exhibition in the Rockefeller Pavilion of the Venice Biennale. Smith was preparing an exhibition that would open in Cincinnati and travel to other midwestern museums. He accepted an appointment at the University of Indiana after it agreed to pay him $6,800, the same salary it paid sculptor Robert Laurent, who had recommended Smith as his replacement while he would be away on his Prix de Rome. Smith would be back in Indiana for an academic year.

Freas readied the house for their new addition. They bought a new refrigerator. Freas read about circumcision and subscribed to Smith's theories about food. "He had this idea about entrails, innards of—those organs—sweet breads and so on, that was very, very good for pregnant women, and I had to have plenty of that," she recalled.[1] They still did not have an indoor toilet. "We went out in the cold, that's what we did," she explained. "But, as you know, with pregnancy, you have to pee all the time." They made use of big "tin cans—it was the cheapest A&P coffee . . . and I always . . . kept them in the house. When we took trips I brought one right along with me."[2]

In February 1954, they welcomed "a gorgeous Basset hound," named Moonshine, said Freas, that had belonged to the actress Gaby Rodgers, a friend of Frankenthaler's. "He had these little legs . . . and he was enormous," Freas said. "And they actually called them Basset Hound Giganticus, or something or other . . . He was like a locomotive, that guy was, he was so big."³ In a group photograph taken in the snow, the glamorous Rodgers wears fur. Smith has his mustache. His hair was short but not the Depression-style buzz cut. Freas's hair is in a bun. As usual, she is wearing glasses. Her coat makes it hard to tell that she's seven months pregnant.

Golda sent childhood photographs of Smith. In March, Freas wrote to her mother that Smith said, "If the baby is a boy, I must be very careful to dress him & treat him with full respect for his masculinity. David still holds certain things against his mother—her attempts to sissify him in manners and dress, her ambition for him to be a male secretary (believe it or not)."⁴

Joseph McCarthy continued to cast a pall over American life. Many of the scores of Americans who had been Communists in the 1930s were terrified of being branded un-American and losing their jobs. "I went to some of those hearings," Kenneth Noland said. "I was teaching at Catholic University, and I was a modern artist. And just on the basis of being an abstract painter, a modern artist, I was kind of thought of as a Communist . . . Paranoia was widespread. People were suspicious of each other . . . If you did anything that didn't look 'proper,' you were some kind of a pervert, or some kind of a radical, a criminal, or you were up to no good. It was hell during that period."⁵

Smith and Freas followed the McCarthy hearings on the radio and in print. Sometimes they listened together; he listened in the shop as well. In the summer of 1953, he had been impressed and reassured by the testimony of Bishop G. Bromley Oxnam before the House Un-American Activities Committee. While declaring his opposition to Communism, Oxnam condemned HUAC's selective and distorted use of information and the danger to the country of pitting Americans against one another. He insisted on the worth of the individual and the importance of freedom. "Joe McCarthy got $200,000 from the U.S. taxpayer to persecute people," Freas wrote her mother. She complained about the scope of American

corruption—"the racetrack scandals, McCarthy, the Administration The Teamster Union . . . What has happened to us. I am mortified by the way Dulles wants to bully the South Americans. Wasn't America once the haven for those little people who Europe had bullied & persecuted."⁶

"A good time to go away and hope that new stimulous [sic] will arise in the fall with I hope the fall of MacArthy [sic]," Marian Willard wrote to Smith. "I am embarrassed to go to Europe with his monkey business predominating the home scene."⁷

In talks Smith now regularly used the word "belligerence," as in "defensive belligerence," and "belligerent vitality and conviction." He knew that his attitude could wear on people, but he also knew that others were inspired by him, *needed* his absolute conviction, and at any rate anything less than a clear and decisive position on being an artist was tantamount to collaboration and defeat. Conformity was not an option. He did not trust the system. On March 23, he wrote, "It is a constant battle, which never lets up—with the world—with Picasso & Matisse and everyone you know. It is pushing your energies and vision beyond those of your fellow men. If you are satisfied with any less you are an also ran."⁸

Later in the spring, he would declare that the "advanced artist" was now "very certain of his identity . . . and subject to no outside authority." Such outside authorities included the museum, the scholar, and the critic. Praise was a distraction unless it came from other artists: "The compliment one artist has for another artist is more than a mutual assistance pact. It is a sharing of dream." An artist could not be subservient to anyone: "He cannot ask for his recognition but he will not accept being tolerated."⁹

Art "is not entertainment," he told an audience of artists that summer:

> I work to express myself. I'm a human being, and I'm interested in making this human being work to the fullest extent of his capacity. I don't care how well it's received or how much it's received or whether it's a social good or not. I'm interested in making *one* person work to the fullest extent of his ability

and I have respect for other people who do that, too. I have respect for James Joyce or Arnold Schoenberg or Sean O'Casey, or anyone else who does that . . . in the end, they make a greater contribution to our social life than anybody else does.[10]

On April 4, 1954, three weeks late, Eve Athena Rebecca Allen Katherine Smith was born in Glens Falls.[11] The name was itself a hybrid, a sequence, a series, mixing present and past, the Freas and Smith families, Bible and myth. "Sunday 1 pm—as ordered female, 8-10¾—Jeannie hard pressed but okay," Smith wrote to Dan Johnson, Willard's husband.[12] "Overdue but beautiful," Smith wrote to Belle Krasne.[13] Freas called their daughter Rebecca. Smith called her Athena. Freas remembered:

> We went into the hospital, he stayed for a little while, then he came back. He stayed a little while longer, then he went home. He never so much as called there. The doctor tried to reach him the next morning—tried and tried, from around 6:00 in the morning until noon, never got David. Because he was calling the shop. Well, David wasn't in the shop. He never woke up until 10:00 or 11:00. And there I was, in this labor that wasn't going anywhere. The doctor wanted to . . . get his permission to have a Caesarian (this was a Catholic hospital). It didn't have that name, but the board, you'd better believe, was all Catholic. And I remember someone telling me, "Well, you know who they'll save, if it's a choice, the baby, because this board is really Catholic." But thank God for [the] endorphins . . . I never got worried all night long. I would have wished to have had a visit from him, but I just knew everything was going to be all right . . . Then he came in, and he was very excited when the baby was born.[14]

Cornelia Langer, Freas's close friend going back to Sarah Lawrence, commented: "When they had Rebecca, David was so thrilled. You know how you always hear men always want a son. Well, he didn't . . . He said to me,

'You can't imagine what a thrill it is to have somebody of the opposite sex that's your flesh and blood.'"[15]

Freas no longer found it acceptable to live without a phone in the house. The phone was in the shop, and Smith was going to the city once a month. She had to be able to call for help if she needed it. When Smith refused to get one, Freas, both angry and eager for her parents to see the baby, left:

> So I picked up, put Becca in the car, and we drove, she and I—this baby, who was six weeks old—and we drove down to Washington. So he came rolling behind me, my father took him out on the back porch, and they sat there for about two hours. And he always called him Davey. He was the only person I ever heard call him Davey.

Al told Davey: "You just better get that phone, or she won't come back." Freas believed Smith resisted the phone because "he really wanted me to be there, really, for him. Period."[16]

After returning to Bolton Landing, Freas reported to her father that all was well:

> David is a great help with the baby, whom he adores. He says he wants her to love him as I love you. He is very much impressed with you as a man . . . He is a very sweet person, and loves me wholeheartedly. Unfortunately this is marred temporarily by a sharp temper and a tendency toward irritability and impatience—but he is gaining more control of himself and certainly wants more than anything "to be a good boy." On the credit side, he is wonderful company, always interesting to be with and talk with, and always has a lot to contribute in the way of original ideas and point of view. I'd die with a dull husband.[17]

Moonshine was not as endearing as Snooker, the Ainsworths' dog Smith and Dehner had looked after in the 1930s, or the dachshunds named Finnegan that Dehner and Smith owned in the '40s. Freas de-

scribed Moonshine as "stubborn—in a sweet way." Soon after the return from Washington: "Moon returned from his evening's jaunt & David discovered he had a mouthful of porcupine quills . . . David tied his feet & covered him with a tarpaulin & then sat on him & pulled out the quills. They are barbed & break off as they come out. He fought but did not try to bite . . . David said the broken ends will gradually work out." If Moonshine was expected to deliver an aura of dog-in-front-of-the-hearth domestic bliss, he didn't get the message. While he loved his previous owner, "he never liked us, and God knows he didn't like David."[18]

Not long after Rebecca's birth, Smith ran into Dehner at the Willard Gallery. She didn't speak to him. "This is new," he wrote Cherry. "But alright if she wants it that way—we are bound to meet at rare occasions."[19]

The most important of Smith's new relationships was with G. David Thompson, president of Pittsburgh Steel Foundry and Fort Pitt Steel Castings, "a self-made millionaire . . . His passion was money, his obsession art. He amassed extraordinary quantities of both."[20] By 1954, he had an impressive group of Klees and had begun assembling a large collection of sculptures by Giacometti. Smith and Thompson met in New York; Smith and Freas then visited Thompson in Pittsburgh, probably on the drive back from Arkansas. Thompson "was from Peru, Indiana, and David was from Decatur, so you can imagine," Freas said. "They had a lot in common, and they really had the same frame of reference." They both swore like sailors: "'Fuck' and 'shit' every other word. *Every other word.*" Thompson "was outdoing even David. He really had met his master."[21]

During their first meeting, they discussed a "transaction." Smith followed up by sending a drawing. On June 22, Thompson wrote "that it would be impossible for me to make a choice without seeing the piece, which I will try to do some time this summer—though I hate the thought of driving up there."[22] On July 23, Thompson wrote to finalize the arrangement: "Stair Rail to be delivered prior to September 15/54. Outside Sculpture—Selected by me. Inside Sculpture—to be selected by you. For the three above items I am to pay you—$3000—Right??"[23] He sent a check for $1,845, balance due on delivery.

Smith wrote to Thompson that he would send *The Forest*, a 1950 painted sculpture in which the upright forms suggest enchanted Brancusi-like trees and birds. He provided an idyllic description of Tick

Ridge life: "Jeanie and Athena are out picking blueberries, Moonshine our basset hound is with me, all is peaceful and quiet on our ridge. I hope you'll visit the ironworks sometime."[24]

Thompson, with friends, finally visited in early August. Smith found him accommodations and rented a boat so they could go fishing. "He is the most nonchalant millionaire I ever heard of," Freas wrote to her mother.[25] Freas recalled that Thompson gave her a "$100 bill (that's like a $1,000 bill today) . . . He said, 'Here, go out and get yourself something.' And as soon as he left, David said, 'Give me that money,' and that was the end of that."[26]

"Thanks for being so nice to me and my friends," Thompson wrote to Smith. "You and Jeannie were really wonderful David that little baby is about the sweetest I ever saw."[27] He sent Smith file cabinets for his drawings, an overhead light for night work, and two baby bonnets.

Smith sent the two sculptures.

"Be good to yourself," Thompson wrote.[28]

42
Bloomington

"T.I.W. [Terminal Iron Works] closing up September 10 and will be located at Indiana University for 8 months except March and then it will be at University Mississippi," Smith wrote to Lucy Mitten, Marian Willard's assistant.[1] On September 15, 1954, Smith and Freas locked up the house and shop and drove nearly nine hundred miles to Bloomington, Indiana. Smith took Moonshine in the truck. Freas followed in her car with Rebecca.

They lived for little rent in the house of the sculptor Robert Laurent, whom Smith had known since the Art Students League. Freas enrolled in courses in creative writing and the literary origins of folklore, taught by George Rickey, and on primitive art. "The work load is enormous," she wrote to Belle Krasne. "But I am still so thrilled to have this chance. The work itself is valuable, but as important is having an extra-domestic life of my own, where I am responsible for myself alone."[2]

Less than two weeks after their arrival, Smith traveled to Venice as one of five American delegates to UNESCO's First International Congress of Plastic Arts. At first, he was not inclined to go, but the state of the artist was an abiding concern and he had not been to Europe in almost twenty years. He could see the Biennale, including his sculptures in the American Pavilion, which was now owned by MoMA. Porter A. McCray, MoMA's director of circulating exhibitions, sent him his itinerary and $505.11 for

expenses. "I am sorry this has to be such a breathless junket," McCray wrote, "but I do hope you will find it interesting and have fun."[3] Although his trip was paid for, Smith told Willard that it seemed "rather vulgar to spend 1200 for a 5 day trip to Venice. If I diden't have a job—my whole family could boat over and stay 3 months on same sum."[4] While Smith was away, Freas's mother traveled to Bloomington to help with the baby.

The ICPA took place from September 28 to October 3 in a restored monastery on Isola di San Giorgio. Seventy-five delegates from twenty-five countries, along with UNESCO officials, addressed the situation of the artist. They discussed customs barriers for works by living artists; an international exchange of artists; free admission for artists to museums; regular meetings of painters, sculptors, and architects to consider common problems; and artists' rights, including issues of censorship and copyright. The Japanese delegation wanted the congress to pass a resolution outlawing the atomic bomb.

"Two years ago, Unesco arranged for the artists of forty-three different countries to meet here to discuss a theme of urgent actuality and deep moral importance: 'The freedom of the artist and concrete means of preserving it,'" Angelo Spanio, the mayor of Venice, declared in his welcoming speech. In a dangerously divided world, artists represented hope: "Art has the magic power of making itself understood by all men throughout the world."[5]

To the Italian poet Giuseppe Ungaretti, masterpieces were made today and the avant-garde had never been more necessary. He believed that "that human achievements in the field of plastic artists go deeper than they did fifty years ago . . . Today the governing factor is the compelling need felt by the artist, if he is capable of accepting such responsibilities, to really be an artist. He must, today, more than at any other periods of history, extract, from the depths of the human spirit, forms which have never yet existed and which, moreover, can be renewed."[6]

For Gino Severini, who had been a leading Futurist painter, it was imperative for artists to stop being outsiders because only on the inside could they fight the crushing depersonalization of industrialization:

> The artist must be integrated into present-day society, transformed as it has been by the truly revolutionary development

of industry [while not submitting] ourselves to the demands of
the Technocracy which reigns throughout the world today
and to which we so largely owe our difficulties and our mis-
takes . . . But we cannot, on the other hand, deny the impor-
tance of technical progress.[7]

Smith was an advocate for artists' rights. He believed in the impor-
tance of artistic community and hoped for an organization that could
bring artists together and give them a base of support. While he was
probably sympathetic to speeches by artists and writers that went beyond
boilerplate, he could see that the ICPA would not be the organization
he hoped for. Despite high-minded bureaucratic talk about artistic free-
dom, here were yet more people who were not artists telling artists who
they were and what art had to do. Smith wrote in a notebook: "We do not
imitate nature. We are not the mirror of the external world that is the
camera—we are not even the illusionistic mirror—we are not the sweet-
ness or light mirror—we are not the mirror of art historians—or art crit-
ics or art philosophers . . . or the museums to complete the chronology
of their collections—if we mirror at all it is our own personal creative
vision."[8] His report to McCray at MoMA was scathing:

As a delegate I felt the lack of freedom in both procedure and
discussion. Since ICPA is directed by Unesco, you only need
ask any artist what Unesco has done for art or artists. The an-
swer is usually, nothing. So I wonder outside of the subvention
what it wants to do with I.C.P.A. that will benefit the cause of
art or artists.

He was disturbed by the choice of Belgrade as the site of the next con-
ference in 1957: "Yugoslavia is a communist state and its choice for the
next ICPA general meeting must be accepted on grounds not within the
delegates knowledge." The choice seemed to him obviously political: "I
am quite aware of the Yugoslavian policy of 'liberalica,' various US influ-
ences, all the way from diplomatic recognition of the Lotus Club, Porgy
& Bess and butter distribution," but "Belgrade is out of the center of art
or artists." Yugoslavia had little strategic military importance to the

United States, and a return to Belgrade "of the Cominform [Communist Information Bureau] by Yugoslavia could upset the plans of ICPA." So many motives were involved that were "outside art and artists" that the ICPA felt to him like a "'front' organization."[9] The Soviet Union was now a global threat, and Smith did not want to be a cog in the American propaganda machine. Artists had to fight to remain independent of both.

After the Congress, Smith went to Ferrara and Florence and visited other artists, including Alcopley, Afro Libio Basaldella (known simply as Afro), and Emilio Vedova. He spent a day in Paris: "Like a cat on a hot tin roof," he wrote Cherry.[10] There's no record of his responses to these places or to the Biennale, but it stunned him that Alfred Barr paid $700 to air-freight *Hudson River Landscape* back to the Whitney. The amount of money spent on shipping his seven sculptures to and from Europe "floored" him.[11]

"David had a most fascinating trip—Venice, Florence, Milan, Zurich, Paris & Shannon," Freas wrote to her father, enumerating the gifts he brought back. "His trip convinced him that America is the best place for an artist to live & make art, free of the dead past, America is as beautiful as any place in the world, and that Italy will shortly go Communist" as a result of the exploitation of the working class and the corruption of Italian politics.[12]

At Indiana University, Smith taught courses in first-year sculpture (Sculpture I and II) and in graduate sculpture. As at Sarah Lawrence and the University of Arkansas, he emphasized drawing and had students work from the model. When he felt they were ready, he asked them to draw bigger. He didn't "take a drawing apart or anything like that," his student the painter Jean Margolin said. "He just wanted you to keep looking, and try to get there . . . your own way." Eventually, he introduced them to welding. Margolin recalled that he spent "quite a while" teaching them how to use acetylene "before he would let them go near it . . . Arc welding is very scary . . . he made sure you knew the mechanical stuff."[13]

Smith had a decent studio—much larger than that of the sculptor George Rickey. It was in what Margolin remembers as a Quonset hut,

outside of which was the forge. But the demands of his courses and of setting up a new metalworking shop, and pressures of his exhibition career, not to speak of the demands of being a husband and father, plus health worries, left him little time for sculpture. "No welded works yet but many drawings," he wrote to Herman Cherry in December.[14]

Alton Pickens, whose studio was next to Smith's, was a kindred spirit. Eleven years younger, Pickens had been selected for MoMA's show "Fourteen Americans" in 1946, the year he began teaching in Bloomington. A figurative painter of expressive and at times corrosive and allegorical imagery, Pickens was represented by Manhattan's Buchholz Gallery when Smith showed there in 1946. "He is a real pal," Freas wrote to Frankenthaler about Pickens. "He rubs many people the wrong way," but "of all the art people I know he is one of the most interesting to be with—much more literate, interested in extra-curricular ideas, acid and marvelously funny."[15]

As in Woodstock, Freas was startled by the alcohol consumption: "I'd never been in academe, and boy, those people were hard drinkers . . . They had cocktails every single day. Oh! I never saw so much liquor in my entire life."[16]

At the end of October, Bloomington was the site of the three-day Midwestern College Art Conference, which was accompanied by a Smith exhibition that included the *Medals for Dishonor*. Smith participated in the panel titled "The Student as Artist." His talk—"What Makes a Student Good?"—fell flat. "I just went dry said that's all I can say and sat down," he wrote to Cherry. "I've never been so dulled. I was ashamed and fealt sorry for the performance but I could do no better—I answered a few questions not so bad but not so good. I want to retire from public speaking. I had been up till 5 AM drinking." Smith found the conference an exercise in self-congratulation: "These art conferences are all mutual respect and confirmation societies." He related to Cherry a paper by Lester Longman on how "artists have strayed from the ideal." It was time for artists to "come back to idealism." Longman "titled this new movement to come as neo-idealism." If you "see a new movement dawning remember Lester foresaw and named it. It was all so many bushels of philo-aesthetic shit."[17]

Freas lashed out at Krasne over Sidney Geist. On Krasne's recom-

mendation, Freas had helped out the perpetually strapped Geist by sub-letting her Sixty-Second Street apartment to him, which she and Smith had barely used since their marriage. He was months behind on rent. "No one could have been more shocked and sickened than I to realize that he is a deadbeat and destructive person," Freas wrote to Krasne in October. He "had no right to mooch off me . . . How Sidney can do this to a fellow artist, to David, I don't understand." Krasne reassured her, but when Freas learned that Krasne had showed Geist her letter in which she had been critical of him, she felt betrayed all over again.[18] Smith did not believe Geist would ever pay the rent, and there's no indication he did.

It was not easy for Smith to be in Indiana. "I was born in Indiana but it's still far away from home," he wrote to Lloyd Goodrich of the Whitney.[19] In a Q&A published in 1987, the curator and critic Katharine Kuh mentions that Smith wrote her "from Bloomington and said that he simply couldn't go on, that it was stultifying, deadly, and he was incredibly unhappy and missed his friends so much that he thought he was just going to take a walk and forget it."[20] Freas denied this: "Where Katharine Kuh says that he was 'moaning about being in Indiana and how he hated it,' that is not true . . . That might have been the impression she got, but that is not what David thought, or said, or anything."[21] But in November, Freas wrote to Krasne that Smith was "working on a job that robs him of at least 50% of his time to make sculpture, battling academic resistance and red tape just to get the equipment so that he can teach a lot of rigid, passive minds."[22] In early February 1955, Smith communicated his frustration to Cherry: "Teaching just occupies so much and is so anti-art that I find it difficult—I work but it doesn't add up like home nor is my concentration as continuous as I like."[23]

Freas and Smith's closest friends in Bloomington were George Rickey and his wife, Edith. Rickey, born in South Bend, was the primary reason Smith came to the University of Indiana, where Rickey began teaching in 1949. They met in 1951 or 1952. Rickey had a "farm" in Chatham, New York, just south of Albany; he would eventually install his ingenious kinetic metal sculptures in his yard and across the road, spread over the hilly landscape. Rickey "knew modern art," Freas said. "He knew primitive art." He was a great teacher. Her course with him was "one of the best courses I ever took in my life." She remembered "how everybody

respected him, and that isn't the way it is with a lot of people. And he was a man who was trying so hard to be a good husband, a good father, and a good artist, all at the same time . . . I know of nobody like that." Rickey tried to make his way in New York but in Freas's view remained an outsider. Instead, he spent many productive years living and working in Germany. Rickey was exceptionally generous and loyal to Smith, sensitive to his struggle, appreciative of his talent, and eager to expose his students to it, but Freas felt the differences between them. George "was a wonderful art historian, and he always listened to everything David said. He could certainly argue, toe to toe, with David, on any subject about art . . . But David, nonetheless—there was something almost too wholesome about George for David's taste. He never spoke against him, but I always sensed that he was a little reserved with George."[24]

Over Thanksgiving vacation, the family drove two hundred miles northeast to Paulding so that Golda could meet Freas and Rebecca. "He didn't much want to go, but it was like a duty call," Freas said. "The first thing she [Golda] said to me [was] 'What did you see in my son? He doesn't have any money.' I couldn't imagine my mother having said that."[25]

Freas saw the flat fields and straight roads of northwest Ohio and recognized that there was "something in David that so rejected straight roads." On the other hand, "he loved farm machinery." The *Agricola* series was "right out of that" world.[26] Freas met David's sister, Catherine, and her husband, Forrester ("Frosty") Stewart. She spoke about "the biggest impression" she had of Catherine and other women she met there:

> Wow, the way they talk to men, the stuff they do. They're much more—We didn't say "liberated" in those days, but that's what I meant, and they were! I'd never seen anything like that, and I thought I was such hot stuff—an easterner, brought up in Washington. Catherine would just talk back to her husband—and not in a rude, not in a mean way— . . . but she was a woman who had totally no . . . [self-]consciousness, . . . She was just direct with her husband, and with David.[27]

The family's affection for Dehner was clear, and Freas felt like a foreigner. "Those people there were as different to me as if they'd been Eskimos," she said. Their world seemed insular: "The only time they ever heard from anyone who was outside their little world was when the missionary spoke."[28] It was on this trip that Freas witnessed Golda's phobia about the body, making gagging noises when Freas was changing her baby's diaper.

While Golda was showing her son and daughter-in-law her garden, Freas was shocked again: "Out of the clear, blue sky, no provocation whatsoever, he turned on her, in my hearing, and he called her a corrupt old bitch. She turned her little head" and "she said, as calm as a cucumber, 'Well, I'm sorry you feel that way, son.' Where did she learn how to parry that? . . . She must have known it a long time, and how did she learn it?"[29]

It was the next day, Thanksgiving 1954, Freas believed, that their second child was conceived. "We went upstairs . . . and this happened," she said. "And I did not know that it was going to happen . . . We were always taking chances."[30]

43

Forgings

At the end of the semester, the Smiths drove to Washington to visit the Freas family doctor. Smith had been having bowel trouble. "Doctors found out he really had a pre-cancerous condition," Freas recalled. "And if he went ahead with what they wanted him to do, there was a very good likelihood—it was more than 50%—of impotence." The rectal polyps "were really in terrible condition . . . I knew David had this condition, for a long, long time. Hadn't told anybody and was scared to death, because that very same day he had found out that . . . I was pregnant."[1]

Smith spent January 3–6, 1955, in Manhattan's Memorial Sloan-Kettering Hospital. While awaiting surgery, Freas said, "he pestered the nurses until he had a supply of gentian violet to draw with . . . Using it calmed him so that he could cooperate with the doctors."[2] In order to communicate with the doctors, Smith had to remain awake during the surgery. It went well. "All evidence benign," Smith wrote to Herman Cherry the day after leaving the hospital.[3] Within two or three days, he drove back to Bloomington for the second semester. "Hard at work—but nothing heavy—no lifting. Returning late January for check up," he wrote to Willard on January 12. "Very lucky in this."[4]

When Freas and Rebecca got sick in Bloomington, Smith took care of them, doing much of the cooking, serving Freas breakfast in bed. He doted on Rebecca, whom he continued to call Athena. Freas told her

parents about his paternal devotion: "I am so glad David is the kind of adoring patient father he is. I don't believe I've known any father except Daddy, who is so crazy about his child."[5]

Smith's spring semester reserve reading list for his sculpture course reads like a primer on modern art built around Motherwell's Documents of Modern Art series: Guillaume Apollinaire's *Cubist Painters*, Daniel-Henry Kahnweiler's *Rise of Cubism* and *Cubism—The Creative Years*, Mondrian's *Plastic Art and Pure Plastic Art*, Kandinsky's *Concerning the Spiritual in Art*, Henri Focillon's *Life of Forms in Art*, and articles in several *Art News Annuals*, including James Johnson Sweeney on Miró, Cyril Connolly on Surrealism, and André Malraux's "Janus." He included the recently published *Picasso and the Human Comedy: A Suite of 180 Drawings by Picasso*. *ArtNews* was his magazine of choice. His artistic focus was New York. "He very much wanted to impart to the people in the Midwest what was happening" in New York, Jean Margolin said.[6]

In February, he began the series that would mark his time in Indiana. His *Forgings* are works of gestural conviction that affirm his Indiana blacksmith ancestry. Making these vertical sculptures required collaboration. In LeRoy Borton, Smith found a local blacksmith who could do what he needed and expand his knowledge of forging and other pre-industrial metalworking processes. Describing his 1956 sculpture *History of LeRoy Borton* to Sam Hunter, an assistant curator at MoMA, which acquired the work, Smith wrote of the kind of connection with "ironmongers" that he had also known in Brooklyn, at Terminal Iron Works, the kind of trusting work bond that contrasted with his battles with art institutions, dealers, and other art world people over the economic and aesthetic value of his work. Borton "aided me with the power forgings of the series called *Forgings* 1955," he wrote to Hunter. His "interest in my work was more than that of the subcontracting of man and machine. He was an excellent craftsman developed in the old school of hard forging, tempering of chisels, wagon repair etc. In the days we worked together we became friendly, talking of metalworking methods, etc., and his interest in raising and felling cut flowers." The 7½-foot-tall centaur-like three-legged sculpture "was named after it was made when the feeling of LeRoy Borton was sensed and then identified."[7]

In early March, Smith drove Freas, Rebecca, and Moonshine to

Oxford, Mississippi. Around that time, with three checks totaling $6,267.50, he paid off his house and property. Dehner responded:

> I got the checks . . . which check me out as a mortgager. It was a great surprise to have it all at once . . . In a curious way the part of my life on the farm is still with me, and I am up there too . . . built into it as one might say. But its all yours legally . . . except for things of mine still there. My piano, my Dickens books. (just sentimentality this . . .) and other things from the past like all my pictures in the cellar . . . (are they still there?) and so on. I hope you will find a way to get these things to me when you go back there. Also my dictionary.

She referred to her silence in the city: "I wanted to thank you for the press last yr. but somehow I couldn't speak. Since this is likely to be our last communiqué, I must speak. I hope that you are at peace with yourself, and will have a fine life."[8] In 1955, she had married the publisher Ferdinand Mann.

With a dozen sculptures and Moonshine, Smith drove his truck to the University of Mississippi art department. When Warren Dennis, the student assigned to welcome him, went to his studio the next morning to see how he was doing, he found a scene: "I heard a lot of noise—big crashes, one after another. Plaster sculpture and junk of all kinds was flying out of the doorway of the sculpture studio and crashing into the hallway and the lockers across the hall. He came out of the room, his arms covered with dust, and said he was 'cleaning out' the sculpture room. 'I am the God-damned highest paid janitor this place has ever seen!'" He had already hung fifty drawings on the walls across the hall. "They make me feel like I am here," he said.

For much of his monthlong residency, Smith spent twelve hours a day at the university—a teacher by day, an artist by night. He "made friends with the night janitorial crew—black farmers who worked at night to insure a cash income," Dennis wrote. "They referred to him as 'Big Smith,' which was also a brand of overalls. When they realized he was an expert welder, they began to bring in broken farm equipment for him to repair, which he did cheerfully. He seemed to enjoy their friendly

unaffected company more than ours." In Mississippi, Smith wrote in a notebook one of his statements against purity. "To make a mark—to set a stroke—which demands its space, to defile the white sheet as to make the mark of honor."[9]

His students would not forget him. Dennis wrote:

> He asked those of us in his class to go to a local junk heap and bring in scrap metal. I picked up the brake assembly of an antique A-model Ford. I saw I could make a reclining figure from all these knee-like angles. I began to bring these together into what was a sort of [Henry] Moore-like image. As hard as I tried, my efforts were lacking something to make the piece less obvious, less ordinary. Smith came over to look. He knelt down, tried this and that, and finally he placed a part of a brake-shoe which was the perfect solution. The curve of the metal served as an elbow on which the "figure" reclined. Students are always impressed when a teacher can spot exactly where they have gone wrong and what is needed.

He provided an admiring description of Smith:

> A big, strong, imposing man—friendly, but with limits he didn't want violated. Even though he was sophisticated and very intelligent, he dressed in heavy work clothes and wanted to be seen as a worker—adopting what was called in the 19th century the "mucker pose," with rough speech and a direct manner. Everywhere he went, young sculptors tried to imitate the way he dressed and talked. He smoked cigarettes almost constantly and made a big thing out of putting out the cigarette with one of his calloused fingers—calloused from handling so much hot metal.[10]

Freas let her parents know that Smith was "very well liked here . . . They want him back next year."[11] He "takes teaching very seriously, though he resents having so much taken out of him at the same time."[12] For her, Oxford was "a very strange world!" When she went to the newsstand, she

found "a lot, a lot, a lot of hairstyling magazines, but you couldn't buy *Time*, you couldn't buy *Life*!" She found the faculty "very subdued" but "preferred Oxford to "the dreary Midwestern towns." Several times she ran into Oxford's most famous resident: "I always used to walk around the square . . . and he was at the Rexall's Drugstore. And you couldn't mistake who Faulkner was. He had on a tweed jacket with leather patches, and he really looked very handsome and distinguished." The last time she passed him, William Faulkner spoke to her: "I really thought he was admiring the baby, and me for being pregnant. He wasn't—it was that dog! That worthless Moonshine! He said, 'Would you sell this dog? Because I like to hunt.' Well, I knew how Moonshine [hunted]. We had actually picked him up in the headlights of the truck being chased uphill by a snowshoe rabbit—this huge dog!"[13]

In his March 14 lecture in Oxford, in conjunction with an exhibition of sculpture and drawings, Smith emphasized the importance of art lodging itself in memory: "The eidetic image, the after-image, is more important than the object. The associations and their visual patterns are often more important than the object." He spoke about the emergence of American art from its dependence on Europe. In 1946, he said, "abstract painters and sculptors blossomed by thousands. With 1950, a new movement, yet unnamed . . . often referred to as 'abstract expressionism,' developed without manifesto or organization, indigenous and independent, the birth of the United States' first native art movement . . . We have come of age, and intuitively create with an autonomous conviction."[14]

On March 21, he was in New Orleans, 350 miles south, for a forum on drawing at H. Sophie Newcomb Memorial College, Tulane University. The moderator was George Rickey, who had begun teaching at Sophie Newcomb that semester and arranged for Smith's exhibition and visit. In one of his most lyrical talks, Smith told the largely student audience that drawing encouraged a language of "truth," "courage," and "honesty." Through drawing, the artist resisted "inhibition" and arrived at a "bareness of the soul." He continued: "Drawing is the most direct, closest to the true self, the most natural liberation of man—and, if I may guess back to the action of very early man, it may have been the first celebration of man with his secret self—even before song." Smith understood, after Cézanne, that what might look like conventional awkwardness or

failure could open up paths of discovery: "Drawings are not pompous enough to be called works of art. They are often too truthful."[15]

After Oxford, Smith drove to New York City. He visited museums, galleries, and friends, including Philip Guston. In Washington or New York, he saw an exhibition of Goya drawings and prints. He saw Herman Cherry's show at the Stable Gallery. Smith wrote to Cherry, "[It was] your best and by the fact that you show at Stable—it is sort of a challenge at the top level." He shared with Cherry thoughts about Greenberg, whose affair with Frankenthaler was nearing its end. Greenberg was in an "odd position," not because he was "a very published critic" but more because of "talk and hearsay." His recognition of artists was, Smith said, "like the nod of a Medici—but he is not a patron. His nod made Pollock but who else did the nodding work for. I like Clem. I differ often." Smith felt emboldened:

> Both Barr & [Guggenheim Museum director James Johnson] Sweeney have more power than Clem and both are not on my work. So what—one doesn't have everybody . . . Sometimes I wish I had total opposition. Maybe I wish I were that good— use everything for your own confidence and defiance— Cezanne must have.

When Smith refused to make a concession to the Art Institute of Chicago on the price of one of his works, he said:

> I've got to make it without them. If I can't then I'm not good. I insulted Sweeney at Burlin's Xmas—I told him he talked like a museum director and he said I insulted him—I said I meant it like that—Clem was there—he said I was too severe. Well hell—if an artist can't survive without the elite—he isn't worth his salt. We don't live off museums. I don't.[16]

During his last weeks in Bloomington, Smith threw himself into the *Forgings*. He made ten there and finished the eleventh in Bolton Landing, stamping "Ind" on all of them; he made all the bases in Bolton Landing. The *Forgings* range in height from 67 to 91 inches and in weight

from 45 to 60 pounds; he made sculpture he could carry. They're thin, in Smith's word "skinny," no more than a few inches wide. It was important to Smith, and something of a marvel to him, that, like independent people, they could stand. Some are dated and some aren't. Only one is painted; the others are varnished. They were made by pulling red-hot steel from a forge and then, while holding it in place with tongs, pressing a foot on the pedal of a power hammer, which came down "and smashe[d] it out."[17] He stamped the steel bars with plugs made with dies so that circles, ovoids, and amoeba-like shapes seem branded into the steel, even fossilized within it. Penetrating the steel and making the surfaces seem like skin softened the monolithic authority of the steel bars. The surfaces can seem dotted, smudged, or blotched—contaminated. *Forging IX* seems sooty, as if charred. For Betty Chamberlain, writing

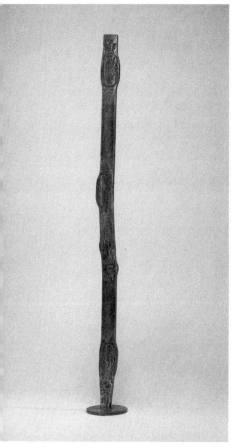

in *ArtNews*, "the beaten metal" had "an unexpected element of joy, as if pulsating from the echoes of a triumphant shout."[18] The *Forgings* seem male in their erect verticality yet female in the associations with girl-woman and in the protuberances and undulations. As with *Tank-totems III* and *IV*, Smith photographed *Forging V* on the Bolton Landing dock, where it looks like the beginning of the world.

In the fall of 1954, Smith made a few black-ink drawings in which long linear gestures stretch across and sometimes push against the edges of the paper. In February 1955 and throughout the year, he made many more such drawings. "The interest in making a vertical,

David Smith, *Forging V*, 1955. Steel, 74 × 8½ × 8½ in. (188 × 21.6 × 21.6 cm). Private collection.

a simple vertical, was a development of a drawing concept," Smith said. "I don't think I could have ever made" sculptures "like that without making three hundred to four hundred drawings a year."[19] While the sculptures are not nearly as associative as the *Tanktotems* and *Agricolas*, the drawings are. When horizontally aligned, one on top of another, the gestures suggest geological strata, a burial ground, or furrows in a field. Upright, they are strongly figurative, suggesting processions, or pairs or clusters of standing figures of different and sometimes indeterminate gender. Many seem Janus-like, looking in opposite directions. One 1955 drawing includes twelve forms of varying height: several suggest a girl-woman, two of them suggest young girls. Five of the pairs seem to couple off, seeking solace in each other, or, more often, while standing straight up, copulating.

Giacometti haunts the *Forgings*. When his attenuated postwar bronze figures were shown at New York's Pierre Matisse Gallery in 1948, the power of their stripped-down statuesque verticality was a shock. They were survivors, activating space in such a way as to make it seem thick, itself mass. Not only do the *Forgings* echo the thinness of Giacometti's figures, but figurative gestures in Smith's drawings evoke particular Giacometti sculptures. Nonetheless, the *Forgings* are clearly not Giacomettis. There is no memory in them of war, no evocation of concentration camps. The *Forgings* were "much less anxious" than Giacometti's "existentialist figures," art historian Hal Foster wrote.[20] No Giacometti sculpture is as bawdy as many sculptures by Smith.

As his time at the University of Indiana and months of travel were coming to an end, Smith wrote to his former Arkansas student Robert Nunnelley:

> Going back Bolton first week June and nowhere else to teach next year. Jeannie has another baby Aug 1 so we'll have to stay put for awhile. Anxious to get home and to a more productive environment, and away from teaching. I've set up a good department for I.U. and I hope it stays set and doesen't go to hell and clutter.[21]

44
Candida

When Smith returned to Bolton Landing, he was pretty much done with teaching. With dreams of bigger sculpture, as tall as 20 feet, he began to work more outside the shop, where he had "more space for composing" and where it was healthier. "Grinding and polishing in the open air . . . is less lung hazard," he wrote to Herman Cherry.[1] He placed a big order for stainless steel with the steel magnate and art collector G. David Thompson: "I want 16–18 ft. lengths, 5/16–3/8–9/16–3.4—maybe 1' about one ton in all, but here is the trouble, I do not like the warehouse stock of 18-8, it's too precise, polished and ground to .002 perfection. I want rough, irregular unfinished bars, somewhat in the nature of hot rolled bars, or even cruder."[2] Aware that the sculptures he planned would push the limits of galleries and might indeed be unshowable, he was now thinking of the fields as a viewing site and perhaps even sculptural home.

Over the years, Smith gave as gifts dozens of works, mostly drawings, often to commemorate a birth or birthday. He took great pleasure in making exuberant drawings, some with fanciful animals, for the children of friends. He was shrewd in calculating when someone who could help his career would experience a gift of his art as a gesture of gratitude rather than as an attempt at manipulation. With Thompson, however, a man equally protective of his independence, he miscalculated. "Along with the letter came two beautiful drawings," Thompson wrote him in

July. "Wish you would not do such things. I am proud and delighted to have them, but I do not want you to feel that I need something to get action. If I did not feel I wanted to do any little thing I may be able to do for you, you could not move me if you forwarded the Terminal Iron Works (that is, unless Jeannie went along with it)."[3]

Soon after Freas's parents arrived in Bolton Landing, Freas checked into the Glens Falls hospital. "I had a Caesarian right away," she said. "We picked the day."[4] When the baby was born on August 12, Smith was there. So was Freas's father. Her mother was taking care of Rebecca.

Smith wrote to Cherry: "A girl as I said 7 lbs 7¼ oz Jeannie making wonderful recovery, will be home ahead schedule . . . Getting grand ideas, want extension on my shop."[5]

He wrote to Willard:

> Like I said
> Like Dan [Johnson, Willard's husband] said
> Its in the mind
> And as I aimed
> It's a 7¼ oz girl.[6]

"Now we know that you are truly the master of your fate when you can call the sex of your children," Willard wrote back.[7]

His and Freas's second daughter would be named Candida Rawley Nicolina Helene Kore Smith.[8] Candida was the name of a beloved family friend. Catherine Rawley was Smith's paternal great-grandmother, who provided Smith with a link to Samuel L. Rugg, a founder of Decatur. Nicolina was the name of Freas's grandmother. Helene was the name of Thompson's partner. "Tell Helene our last daughter also is Helene," Smith wrote Thompson.[9] Kore, André Malraux wrote, "signifies the 'first young maiden' of the ancient myths."[10] Candida's names, like Rebecca's, form an extended multitemporal sequence. Soon, however, they would be simply called Becca and Dida—which for several years Freas spelled "Deeda."

Two weeks after Candida's birth, Thomas Hess asked Smith "to write a profound and witty article, full of insights, on González." MoMA was

organizing a Julio González exhibition "and we would very much want
you to write about the subject for us." González died in 1941, and the
MoMA retrospective would be his first in the United States.[11] Hess asked
for 1,500 to 2,000 words; the *ArtNews* deadline was December 1, the
honorarium $75.

The essay, the only one Smith ever wrote on another artist, was an op-
portunity to do justice to a sculptor whose impact he had repeatedly ac-
knowledged. Without González's collaboration, Picasso would not have
made the welded iron sculptures of 1929 to 1931 that Smith credited with
opening up the monolith. Smith believed that it was with these sculp-
tures, which incorporated found metal objects, that sculpture was freed
from its centuries-old dependence on bronze and marble. By adding "to
the prestige" of González's work and making "his name better known,"
Smith could help rectify an injustice. "Since he is dead, and died poor,
and lacked materials in his lifetime," he wrote to Cherry, "appreciation
can now come and can be safe in rarity since not too much of his work
exists."[12] Through the essay, Smith could stick it to museums and the rest
of the art establishment that treated living artists with disdain. González
"must have had a hard time; why didn't the now responsive elite appre-
ciate and buy then so he could have used the sales and the satisfaction
for more work?" he wrote to the painter and printmaker Henri Goetz.[13]

Many of Smith's peers were bitter that museums fully acknowledged
artists and paid fairly for their work only when they were dead. "Why
did not this appreciation come when Gonzalez lived?" Smith wrote to
the artist's daughter Roberta González. "Why does the artist have to
die for recognition."[14] Smith believed that museum officials like Barr
and Sweeney were so dependent on the moneyed class that they could
not begin to understand what was required of artists to make the work
that enabled museums like MoMA and the Guggenheim to establish
themselves as aesthetically and socially elite. While the best artists were
driven by total conviction and sacrifice, Sweeney and Barr "align their
egos with acceptance—those accepted enough that the elite will defend
their choice . . . Also in Barr's case his job is to solicit donations—never
lose sight of that—it is not all front work—much must be done over tea or
cocktails hand kissing and ass wiping." Within this economic structure,
"the artist is often incidental."[15]

Smith approached the task with the obsessive thoroughness with which he approached his job with the WPA. He tracked down catalogs and articles and got those in French translated, mostly by Hess; he approached everyone he knew who had known González, as well as artists he didn't know, like Picasso and Brancusi. He asked Thompson for photographs of his González sculpture head. He asked the Kleemann Gallery for photographs of the González drawings and pastels it would be exhibiting at the same time as the MoMA retrospective. He asked Cherry to get the testimony of the composer Edgard Varèse. He researched Antoni Gaudí's early-twentieth-century Barcelona church La Sagrada Familia, believing in its importance for understanding González. He sought a full picture of González's life and work. "I'm looking for the gentle intimacies which artists know about each other, and which relate to their work in the unofficial museums way," he wrote to Goetz.[16]

"Was he secret or just quiet—did he talk much or did he just listen, whom did he like to talk with most or listen to," he asked Jean Xceron. At artists' meetings with him in Paris, "did you drink wine . . . or coffee, or was it just art—did you go to cafe's afterwards for wine or coffee—if so— did Gonzalez team off with anyone whom he liked especially."[17]

In "Metal Sculpture: Machine-Age Art," in its August 15 issue, *Time* announced that metal sculpture had become mainstream. The article began:

> "Michelangelo complained about noise and marble dust in our profession," says sculptor David Smith, "but I finish the day looking like a grease monkey." Sculptor Smith's complaint reflects the rise of a new phenomenon in the art world: a flood of wire and metal shapes that is turning many a sculptor's studio into something resembling a blacksmith's shop, where the oxyacetylene torch has replaced the hammer and chisel, a welder's mask the smock.

Smith's description of himself placed him in sharp contrast with those paragons of respectability who were in search of metal sculpture for decoration. "Collectors are now buying it to decorate Texas and Hollywood patios and Manhattan rooftops," *Time* reported. "Topflight

modern architects—Walter Gropius, Marcel Breuer, Eero Saarinen, *et al*—are using it to decorate new library facades, chapels, and new college buildings."[18]

Freas's mother remained at the house for six weeks, helping out with the baby so that Freas could look after Becca. While for the most part she concealed her dislike of Smith, he knew what she thought of him. He "was very ugly to her," Freas said. He "called her Mrs. Freas."[19]

Worried and edgy and ever fearful, even now, of loneliness, Smith was also productive and generally content. He was at home, with two baby girls, making sculptures and paintings, with big plans, hopeful that he could find a way to support his growing family and still pour money into materials and devote himself to his work. "David says he has never been so happy in his life, & I think that goes for me too," Freas wrote to her parents on October 10.[20]

In mid-October, Smith spent a packed and crucial week to ten days in the city. The night he arrived, he wrote, he "went [to] Cedar Tavern [and] saw Jack Pollock."[21] Pollock was off the wagon and regularly coming in from Long Island for therapy sessions. He was having trouble finding his way in his painting, of which once loyal supporters, including Greenberg, were severely critical. Smith cared about him. He loved the Brancusi retrospective at the Guggenheim, organized by Sweeney. Brancusi "without doubt number one in the world," he wrote to Thompson.[22] He visited Jean Xceron and his wife and the painter Fritz Bultman and his wife, and Thomas Hess. He dined with Cherry and Noland in Chinatown, went to art bars and wandered downtown streets with buddies. From Andrew Ritchie, curator of MoMA's González retrospective, he picked up information on González. New people were entering his life, like Sam Hunter at MoMA, who had contacted him about a book he was writing on modern sculpture. His friendship deepened with James Rosati, a Cedar regular, who lived near Cherry in the Village. Rosati was becoming Smith's closest sculptor friend.

Smith underwent a medical exam that would determine if an insurance company would award him a $10,000 life insurance policy despite his pre-cancerous polyps. "Total ok," he wrote Freas. "Now we relax forever. Its got to kill me before I ever worry again."[23] And he finished serving on a jury to decide a sculptural commission for the United Nations. He was contemptuous of the proposal that was awarded the commission. "UN thing was fiasco," Smith told Willard, "a jury bound for compromise . . . I'm thru with stacked juries."[24]

Two weeks before Smith arrived in the city, Greenberg and Frankenthaler ran into each other at a party. Janice "Jenny" Van Horne, who in May 1956 would become Greenberg's wife, remembered, "He slugged her and then there was a big row. After that he was finished with her."[25] The day after the party, when Frankenthaler refused his marriage proposal, Greenberg became violent again. He got into at least one fight with the playwright Howard Sackler, Frankenthaler's new love.[26] He also fought with the novelist Chandler Brossard when Frankenthaler showed up with him at yet another party.[27] Smith now met with Greenberg and Frankenthaler separately. When Frankenthaler and Greenberg had visited Bolton Landing, Greenberg was the main event: Smith was eager for his attention to his work. Now Smith and Frankenthaler became close friends. They admired and liked each other. He had dinner at her apartment and they looked at art together, as they would regularly over the next ten years.

The art scene could be nasty. "The art world in the 50s, in New York, was not a place you'd want to be," Freas said. "You'd want to wear your armor there, and I believe David survived as well as he did [because he lived upstate]. He never got into feuds when I knew him. Everybody was feuding [with] everyone else . . . It was not a nice world."[28] But it was also dynamic, filled with creative people, and it was made up of multiple, often intersecting, artistic communities. Smith needed to keep his distance from the scene, but for a week or so a month he could immerse himself in it and then take upstate the ideas and information he needed. There were new players and alliances and it was important for him to keep up with the changes. With no regular income, a need for more, and ever more expensive, materials, like silver and stainless steel, and now

two daughters as well as a wife to provide for, it was imperative that his work sell. Was Willard the gallery he now needed?

Although still cordial, the relationship between Smith and Willard had been fraying. During this October visit, they planned a show in March of "18 or 20 verticals," plus drawings.[29] "Will need another show in 56 to get other work out," he told her.[30] For years, Smith worked harder on his career than she did: he was instrumental in decisions about advertising, often contributing his own money; responsible for getting his sculpture to and from the gallery; paying for his shows' expenses. He not only followed the art reviews but also studied reviewers, learning how critics wrote and what art they believed in. He sent them letters and photographs. It was often Smith who courted curators and negotiated with museums. When his works were damaged, he fixed them. In 1954, he was the one who had to deal with the damage to the 1938 cast-iron *Head*, which led to an imbroglio with the shipping company over responsibility and payment.

Disagreement about prices had been a bone of contention. Smith insisted on raising prices. "Everybody else seems to sell and sell higher so that's my reason for raising and sort of independence," he explained to Freas.[31] Willard believed that this made it harder for his work to sell. When directly approached by potential buyers, Smith furnished his own prices, which were often higher than those from the gallery. Occasionally, he made his own deals. In 1954, he negotiated a commission from Thompson that turned out to be a 116-inch-long, 30-inch-tall guard rail, now known as *Pittsburgh Landscape*. In all likelihood he did not give Willard a percentage.

He was adamant that his work be packed according to the standards of the Met and the Modern, and that no drawings were to be shipped unframed. "Needless to say I do not pay the costs," he wrote. "Whoever wants them must want them bad enough to stand that expense. From now on I am going to sink or swim on my own terms. This thing of bad packing and resulting claims is most distressing."[32] Willard believed that he was hurting his interests: "In most cases this new policy of yours is alright. On the other hand a shipment such as this recent one to Cincinnati could not be made and you would lose sales from such exhibitions which I believe would be too bad. Reputable museums should be permitted to

have things sent in groups and not each in a case."[33] "Packing is a problem tobe dealt with but I'm not sure about it all," Smith responded. "The Cincinnati show had sculptures and glass all loose in one crate."[34]

Deepening their rift was a photo shoot at the gallery that resulted in one of his sculptures being used in a corporate advertisement in a December 1954 issue of *Time*. Smith saw the ad while he was in Bloomington and called Willard immediately. She explained that she had insisted on certain conditions regarding the use of the photos that were obviously ignored. She took responsibility but added that all her other artists, including the sculptor Richard Lippold, were cooperative in such situations "and feel that no harm is done to their work." She continued:

> You however have a right to your opinion and I made an error permitting it and will put all your pieces away the next time such a thing occurs.
>
> If any law suit is contemplated I am afraid it will have to be you suing the Gallery, because I gave them permission to use the Gallery.
>
> This will NOT happen again, your work will be put in a dark corner and never see the light in any national or international publication of any sort.[35]

Aware of the instability of Smith's financial situation, Freas's father helped with money, sending monthly checks. Freas explained:

> It was at least $100, it might have been $125 a month. We ate on that . . . It was mostly beans . . . my father really wanted— *His* grandchildren and *his* daughter were not going to starve to death. He knew David, and he knew everything would go in his work.[36]

Smith could not refuse the checks, but he did not appreciate the persistent presence of Freas's parents, who continued to send gifts to her and the girls. While his insistence on artistic independence was absolute, the checks drove home to him his financial uncertainty and her family's lack

of confidence in him. "I don't think he wanted to feel beholden," Freas said. "He talked as if he resented my father."[37]

Freas's life was increasingly claustrophobic. She, too, could be volatile and subject to extreme mood shifts. She was responsible for the girls and still did not have a phone. While he went to the city for a week a month to do what he wished, she was stuck at home. She had friendly relations with a few neighbors and went with Smith to social occasions at the Lake George home of George Reis but was far less invested in Bolton Landing and Adirondack life than Dehner had been. Her parents were her main outlet: she wrote often and found ways to call, sometimes to complain about Smith. They questioned whether her life made good use of her Sarah Lawrence education, of which they were so proud. "Even now, when my world is as restricted as it could possibly be outside of invalidism, my education saves my spirit often," she wrote to them.[38] In December Freas, Smith, and their daughters were all sick. "David sawed the door to the girls' room in two—so I can confine them to quarters if need to—and yet be able to see in," Freas wrote.[39]

"Life is so precarious and if I stop to think how I'll survive and where I end it gets fearful—like the dark when I was a kid," Smith wrote to Cherry at the beginning of the new year.[40]

But Smith, nearly fifty, had been given the insurance policy so that Becca and Dida would be taken care of if something happened to him. With them in mind, he also bought 125 acres of land between their property and Trout Lake. "It is for the girls," Freas wrote. "A paved road is due there, the property has excellent water, a good brook etc. & good timber. The timber itself in 15 yrs. will be worth a couple thousand dollars at least."[41]

45
Down and Up

In February 1956, in the dead of winter, Smith, Freas, and their infant daughters were confined to the room with the woodstove. "We had no heat, because we had no money," Freas said. "God, was it grim." Smith asked if she had anything to read. She handed him William Faulkner's novella *The Bear*. The book "was short, and I knew David resented having to spend time with anything . . . He read it non-stop, and he loved it. And you know what he did at the end? He picked that up . . . and he threw it against that big window. As hard as he could, he threw that book. I think he was very discouraged."[1]

What provoked the frustration? Was it awareness of Faulkner's ceaseless and sometimes stream-of-consciousness workflow and Nobel Prize–winning achievement while Smith was struggling to feed his family and maintain the momentum of his work? Was it identification with Old Ben, the black bear that is the most mythical figure in the book, whose violent death was written in powerfully sculptural terms as a collapsing monument? Smith would frequently be characterized as a bear, or bearlike. Was it Faulkner's sense of the vulnerability of the wilderness, on which Smith depended? Or his sense from the book that the country's emergence from the wilderness was not a purely noble story of pioneer triumph but a saga marked as much by exploitation and cruelty as by heroism and resourcefulness? Or something else?

There were other outbursts. "One time he threw a whole plate of spaghetti at me," Freas said. "And you know why? Because I had not made meat balls. . . . Well, here I had two kids, no heat, no water, and you're asking for spaghetti and meatballs? . . . And meantime, there were all these drawings all over. And it was almost as if, 'And if any of you make a print on my drawings, you're dead!'" That winter, he was "at rock bottom, when he could not work at all, because there was no money for the oil . . . I remember his saying that he could go to work for the town . . . for the town road. He couldn't think of anything else he could do . . . And he was feeling his age . . . and it was going nowhere."[2]

In fact, Smith did manage to work. For months, he had been investing whatever energy he could into his March 1956 show, which he hoped would deliver them from financial despair. "I'll have twenty-two standing sculptures, some big, they range in heights of 65 to 100 inches, both bronze and iron," he wrote the painter Jean Xceron. "I think this is my best so far. I also have enough for another show this year not so big."[3] He assured Dan Johnson, Willard's husband, who was managing the gallery: "I think we will sail on the show Dan. We have a buildup [with] My Feb article in Art News—the Arts article in March and the works are all of a different nature as you can see."[4]

Smith directed the advertising and, once again, provided photographs. The one in the exhibition brochure, taken in summer or fall, shows nine vertical sculptures set against the sky. Six are *Forgings*; another, a comparatively mite-sized bronze with a ring head, looks like a young child among the elders of the clan. Smith framed twelve drawings upstate but planned to frame the big ones in New York City. "I too am gambling on framing etc since I am operating in red now."[5] Smith would truck his show to the gallery in two loads.

MoMA's González show, curated by Andrew Ritchie, opened on February 8, the month that Smith's essay "González: First Master of the Torch" appeared in *ArtNews*. He told Cherry that the essay was the best he could do "but it was weak—he was quite good but not all way—he lacked I was hesitant to take any decisive attitude, that was my biggest bloc. Will explain all."[6] In his notes, Smith attributed González's artistic leap to working with Picasso. González "was tied to the painter and

silversmith size & concepts, which does not relate to what makes art." The exhibition relieved his doubts. After walking through it, scribbling notes, González was again "a trusted guide and comrade."[7]

Eugene Goossen's article "David Smith," in the March *Arts*, provided the most insightful overview so far of Smith's career. Smith's work was "not only crucial to American art, but a permanent contribution to sculpture itself." The celebrated photograph of *Australia* set against the trees and sky is the lead image; below it is a photograph of Smith standing outdoors, leaning against a wood fence, cigarette in mouth, wearing a light suit, his signature cap, white shirt, and dark tie. No sign of hardship here.

Goossen lauded "Smith's stubborn refusal to settle for one manner and one method." He made the provocative point that Smith had "a predilection for taking positions in the middle of problems. He has certainly been continuously in the center of the sculpture-painting problem. That he is *there* may account for his saying he has no *credo*. A *credo* would have made it easier for him, but it would have cramped his style and would undoubtedly have deprived us of some of the best sculpture of this century." Goossen recognized the decisive role of the found object, "crystallizing and *forcing*, as it were, the total image to come." And the impact of tribal cultures. *Pillar of Sunday* and *Royal Incubator* were "among the strangest pieces of" the last half of the 1940s, "both perhaps stimulated by those eskimo ceremonial masks from the Pacific Northwest upon which all manner of objects are appended to a central figure." He signaled 1950 as the turning point: "Considering Smith's stubborn refusal to settle for one manner and one method, the recovery of balance and the renewed synthesis of vision occurring around 1950 formed truly an admirable feat." With *Australia, Hudson River Landscape*, and *The Banquet*, all from 1951, and the *Agricolas*, which began in 1951, Smith "began to produce the magnificent, courageous sculpture for which he is now widely known."[8]

Smith's last show at the Willard Gallery, "David Smith: Sculpture—Drawings, 1954–1956," opened on March 6 and ran through the month. Eleven of the twenty-two sculptures were *Forgings*. For Goossen, this series was yet another example of Smith's challenging variability. "They

are bound to raise new problems for everyone who sees them," Goossen wrote at the end of his article. They "are decidedly monolithic. There may be a little of the element of dada in them, but then it may only be that they cannot yet be viewed in the light of any esthetic or ritual we now possess."[9] Betty Chamberlain, writing in *ArtNews*, likened them to guardian figures and to drawing gestures and perceptively observed that they seemed to have been worked from the inside.[10] Emily Genauer detested them. "Critic Deplores New Art of Nothingness" was the title of her review of the Smith and Franz Kline shows: "The pieces in the show he himself appears to attach most importance to are eleven (generally seven feet) narrow slabs of forged steel that look like paddles stood on end, or maybe more like flattened stalks of asparagus." Their reductiveness represented a repudiation of everything that Genauer valued in Smith's work.[11]

For his fiftieth birthday, on March 9, Freas made a feast: "roast beef, wild rice with mushrooms, asparagus, crayfish tails (from Washington) and peach pie."[12] But this was not a festive time. Smith's work continued to gain attention and respect, but financial insecurity gnawed at him. The money troubles were bad enough without Freas having to constantly reassure her parents that the family would be all right. "I imagine you are concerned about how we are going to eat," Freas wrote them. "Don't worry. $1500 is owed David by a couple of purchasers—one is the uranium man so there is no doubt he'll pay! . . . If things really get tough, he could always go back to the locomotive works as a first-class welder. But we are a long way from that. Do not worry. David will always find a way."[13] Smith would soon seek Rothko's advice not just on dealers and finances but also on how to think about however many years he had left. He admired Rothko's ability to think coolly and practically about his situation, "knowing his sales are limited and age period 10-15 years."[14]

It was increasingly clear to Smith that the Willard Gallery was no longer right for him. In a letter that would be published in the April *ArtNews*, he publicized the theft from the gallery of his hanging sculpture *Ark. 53*: "I will pay a reward for any information. Communicate with

me, or with Detective Noonan, N.Y. Police, 18th Squad, 306. W. 54th St. CI. 6-0166."[15] He was upset with what he saw as the gallery's casual attitude toward the theft as well as with the fact that nothing in the show sold. He saw no solution to money troubles except sales of his work.

On December 2, Greenberg gave a party. "I came with David, for drinks," Ken Noland recalled. "We were standing in the kitchen. And everybody was drinking . . . Pollock began to tease David about something." Pollock "got right up, close," to Smith "and David said . . . 'Ah, shut up, Jackson. You don't know what the fuck you're talking about.' Then everybody laughed. But it was a little confrontation there."[16]

The next day, at a party celebrating Willem de Kooning's second show at the Sidney Janis Gallery, which opened on April 3 and from which every work sold, "Pollock & De Kooning both stuck fist thru window," Smith reported to Cherry.[17] The painter Vincent Longo remembered a party around this time "at a friend of Franz Kline's, on Tenth Street . . . Jackson Pollock came in. He was very drunk" and "began hitting" on a couple of the women. "They were being very polite and ignoring him. He then went over to the piano and started playing . . . pounding on the keys. Finally, he got up, and in a lot of frustration, put his hand through a window. At that very moment, David Smith happened to walk in. He practically picked him up, bodily, and got him out of there, just to kind of prevent any kind of embarrassment, or scene. Just taking care of him."[18]

During his spring semester teaching at the University of Mississippi, Cherry made his Cooper Square apartment available to Smith and his family. He also loaned Smith a lifesaving $100. For five weeks beginning on April 8, the Smith family, including Moonshine, their basset hound, stayed in the downtown apartment. Dida slept in a drawer. The break from Bolton Landing was a godsend, although Smith found the city dirty and cold. Once when he was out till four in the morning, he "met de Kooning hanging on [a] light pole."[19]

Buried in this letter to Cherry was dramatic news. The curator Andrew Ritchie had approached Smith about a show at MoMA, the second in a work-in-progress series that would begin with de Kooning. Smith would be the first sculptor in the series. No date had been set; Smith preferred 1958. Even during preliminary discussions, Smith declared his

animosity to the MoMA "elite," telling Ritchie that he would pick the "work with his help" but "no Rockefeller or Bundine dinners, or social stuff." The night of the opening, he and Freas would take Ritchie and his wife to dinner. No other celebration. "This is Ritchie's idea and meant to be a 'work in progress' showing and not a death march retrospective."[20] Barr soon canceled the de Kooning show. He believed that the artist who deserved the first show in the series was Pollock.

In May 1956, Smith finally left the Willard Gallery. "I've completely severed all connection with Willard and have accepted no bids from other galleries," he wrote G. David Thompson. "I've moved all my works home and if any dealer wants my work, they can buy . . . No more group shows, not even the Whitney—as far as I can determine now."[21] Smith passed on the news to Dehner. "You've heard I'm thru at Marians. No other dealer planned—I'm trying to sell to any dealer."

The Smith-Willard artist-dealer relationship had lasted eighteen years. The two had emerged in the art world at the same time, and Smith and Dehner were essential parts of a community of creative people that Willard had assembled and nurtured around her. In the 1940s, Willard had visited Bolton Landing several times, happy to be in the presence of Smith and Dehner's vitality and warmth even in conditions one step above camping. The Smiths spent fabulous weekends at Willard's grand house and property in Locust Valley, where they talked and ate and swam day and night in Long Island Sound. Occasionally Willard made her apartment available in New York City; while Smith and Freas were courting, they stayed there together at least once. With her special combination of discretion and candor, Willard was able to remain on good terms with both Smith and Dehner after their breakup. She never returned to Bolton Landing after Dehner left.

In 1969, Willard revealed her disconnect from Smith's post-1950 work and sense of his apartness from her after Dehner's departure. "I believed very firmly in David's work," she said, and described him as "a contemporary folk artist":

> He used his knowledge of metals to interpret the life around him in his early pieces up to about 1945. He would do *The Home of the Welder*. Or he would do the whole *Agricola* series

> related to farm instruments. And things of that nature. Which
> tied him very closely to what his personal involvements were.
> And that I think was almost his best period.

She believed that "at one point David cut practically everybody out of his life." She mentioned Dehner, Mildred Constantine, and herself. "Something happened to him," she said, adding that "he just didn't want personal relationships." His children "were the greatest things in his life," but after his second marriage, "his relatedness to other people and in a sense to himself passed out of his work at that point for me . . . The big forms that we see today are very, very beautiful. I have nothing against them. But he had lost that particular thing which interested me so much in his earlier work." He was the only one of her artists, she said, who left the gallery after achieving success. She was ready for him to go: "I felt that the work was getting so big and so spread out that it didn't mean anything more to me."[22]

On or around May 20, Smith returned on the spur of the moment to the city, just appearing at Cherry's apartment at 10 Cooper Square, hoping to be put up. Cherry was not there, so Smith went to 5 Cooper Square to wait for him. "Across the street from me, on Third Avenue . . . there was a bar at which the drunks hung out," Cherry told the Archives of American Art. "It was run by two guys," Joe and Ignatze "Iggy" Termini. "One night David . . . went over to the bar, and was watching for me to come home, and they had a little jazz group, just playing around. They were just using the place to get together." Smith spoke to the Termini brothers, who had just inherited the saloon from their father. "Why don't you have a jazz group here, permanently?" he said to them. "We want to do something," they responded. "We would like to have one of those groups play here." When Cherry walked in, he reinforced Smith's idea of a place for jazz. They "got a small group, and they began jazz evenings there."[23] The Termini brothers' Five Spot Café became a legendary venue for jazz and a celebrated hangout for artists, poets, and musicians, the gathering place in which Smith would feel most at home. Smith and Cherry are part of its history.

On his own now, Smith's fortunes changed. Along with a Thompson commission for a fountain and sculpture, he received a commission from the Art Institute of Chicago to produce a medal. New dealers approached him. In June, checks arrived for two sculptures, and the dealer Martha Jackson visited Bolton Landing and bought two sculptures as well as drawings. Also, for $3,500, of which $2,400 went to Smith, Willard sold the 1951 sculpture *Flight* to Lois Orswell—"just when David was most furious at museums," Orswell said. "He gave me orders to install it in cement and if asked to loan it to say it was impossible. Both of which I did dutifully."[24]

Orswell became Smith's most devoted and important collector. They had in common their Methodist mothers. "I said every so often I would feel the Methodism catching up to me try how I might to forget it," Orswell recalled, "and he said 'that is not the worst part which is being afraid it is creeping up on one without being aware of it.'"[25] Like Smith, she had an antipathy to explanation and her favorite magazine was *ArtNews*. She believed "Cubism was the greatest moment in 20th century art" and collected works by Picasso, Braque, and Juan Gris. She was drawn to sculpture defined by formal boldness and passion. It was Smith's support of Gaston Lachaise, whose female nudes she "adored," which they discussed at their first meeting, that cemented her connection with him.

Orswell was born in Rhode Island in 1904. Her father was treasurer of the family firm, the Pawtucket Dyeing and Bleaching Company. She wanted to be an opera singer and a sculptor. In the 1930s, she exhibited her paintings and fell in love with John Codman, a Harvard graduate, which began her connection with Harvard; she would leave her art collection to the Fogg Art Museum. With her father's death in 1941, she became financially independent. The first work she collected, in 1944, was a gouache by Paul Klee, the first artist whose work Willard had collected. In 1945, she married Fletcher LeBaron Barton Dailey, a designer and builder of custom high-fidelity systems. "The marriage ended very badly, in spring 1953," Marjorie B. Cohn, a curator at the Fogg, wrote. "L.O. said her husband came after her with a gun, and she feared not only for her own safety but for that of her collection, which by now filled both house and outbuilding at Rugosa," in Narragansett.[26]

Now focusing her collecting largely on contemporary art, Orswell was most interested in de Kooning, Kline, Guston, and Smith. When she moved to Pomfret, Connecticut, in 1957, collecting became her life. Of her visit to Bolton Landing to pick up *Flight*, she said, "We wasted no time and it was just the sort of conversation (artistic not personal) I revel in. We discussed the works and merits of just everybody we could think of, and I think agreed quite well . . . I was struck with the fact that he spoke of them ALL in a kind way which is unusual in the art world."[27]

On the first day of summer, Smith wrote to Cherry: "Indebtedness under liquidation Life is sweeter now—sun shines."[28] Six days later, he repeated his relief: "We are in after the drought—strange this hand to mouth business—we live and die the same way it would seem." He was enthusiastic about the plays he was reading—Jean Giraudoux's *Judith* and *Electra* and Samuel Beckett's *Waiting for Godot*. He refused a show at the Corcoran Gallery of Art because they would not assure him they would purchase a sculpture; they also required him to truck down his work. "Work hard Herman—It will be good—Quantity Herman—it's the struggle that's great."[29]

An Untimely Death

To acquire Smith's work, collectors now had to go to Bolton Landing. The fields had to function as an open-air showroom for a new artistic vision of which collectors could partake by buying. "You're making the mountain come to Mohammed. Museum directors, critics, dealers, artists, buyers, etc, visit you," Cherry wrote.[1] Through the summer and fall of 1956, a steady stream of visitors made their way to Smith's hillside. They included Frederick Sweet of the Art Institute of Chicago, with whom Smith was negotiating the Logan Medal, and artist friends like the sculptor George Rickey and the painter Ed Millman. Critics made the pilgrimage, too. Greenberg stayed over. Hilton Kramer "was beginning to relax when he had to go," Freas wrote to Cherry. "I think he might be nice & human, if he let go."[2] Robert Coates finally bought a sculpture.

Smith's garden bloomed. The weather was ideal—"ample rain, never hot, & lots of pretty days," Freas wrote. Freas was now convinced of the benefits of raising their daughters away from the city: "I can't think of a pleasanter, more interesting environment for young children than this. Rebecca's conversation concerns foxes, deer, blueberries, horses—a contrast to the city child's preoccupation with television characters."[3]

In mid-July, Smith returned to the Skowhegan School of Painting and Sculpture. In 1954, he had given a slide lecture there. This time his pre-

sentation was unexpected. He prepared forty-four questions. "I've been more concerned with questions than I have with answers," he said. "And in my work I really don't have any answers yet—outside of very personal ones. A number of years ago, I used to think I knew things, what things were, but now I'm very much in doubt about it—because it changes. I don't find that one thing is even the same thing at different times. So, I am asking you the questions." The sequencing of questions was unpredictable: some questions grew out of the preceding ones; others didn't. They were provocative, childlike, moralistic, searching, and profound. For nearly two hours, with cicadas bringing the sounds of midsummer night into the packed room, the audience, which consisted mostly of artists, many of them students, was riveted.

Question one: "Do you make art your life, that which always comes first and occupies every moment, the last problem before sleep and the first awakening vision?" Five: "How do you spend your time—more talking about art than making it? How do you spend your money—on art materials first—or do you start to pinch here?" Nineteen: "Do you think that your own time—and now—is the greatest in the history of art or do you excuse your own lack of full devotion with the happy belief that some other time would have been better for you to make art?" Twenty-eight: "Are you afraid of rawness and harshness, or basic forms of our nature? Especially United States nature?" Thirty-nine: "Do you think museums are your friend and do you think they will be interested in your work?" Forty-two: "How long will you work before you work with the confidence which says: 'What I do is art'?"

The first question to which Smith was asked to return was about responsibility. "Do you think the artist has any obligation to anyone but himself?" was his eighth question. "I absolutely do not," he replied. "In my position, I have no obligation to society, or any museum or the culture, or the Republicans, or the Democrats." He went further: "Far from me having obligations to society—they have an obligation to me." And further: "All I can be is to be the best possible artist and to utilize everything I've got, and to utilize all the time I can possibly put in on it, and drive everything just as hard as I possibly can drive it to express the most I've got to express." Artistic realization depended on workflow. "I want

to sell all my work," he said, contradicting what he had told some friends about wanting sculptures to remain in the fields, "because I want to live and my work is to make more work. I never cease to feel that that is my duty or my—I mean—that's my way of life—is to make more. And I also know that the more work I make, the less bad I become." This phrasing is odd. He seems to be saying: The more work I make, the better my work becomes but it will never be as good as I want it to be; it will never be good enough. But perhaps the sentence can also be read in another way: The more work I make, the more my work compensates for or per- haps begins to redeem my "badness," which remains ineradicable. "Bad" seems rooted in the morality system of Paulding and Decatur in the first quarter of the century, not in 1950s New York. At the end of 1957, he stated to Cherry: "The more one man does the more chances for good ones and then he doesn't even worry about good ones."[4]

Today, after decades of attacks on heroic individualism, Smith's in- sistence that the artist's first responsibility was to himself can seem ego- tistical and grating. But for many people, not just artists, and not just men, Smith's words, backed up by his achievements, were heartening. They felt Smith's devotion to art and to being an artist. They saw his conviction. Several times that evening, he expressed his belief that join- ing the middle class meant creative death. "You cannot deal with these low middle-class methods of evaluation"—like television—"and expect to create art and create things that are original and things that haven't been seen before. You're only walking in the paths of others." As an art- ist, he asserted, "you have to walk in the path that you bring and make for yourself."[5]

In October, Smith asked Cherry if he had read Janet Flanner's profile of Braque in *The New Yorker*. "Braque comes out quite bourgeoise and much the safe painter, and safe economist," he wrote. "Picasso is the real revolutionary, tho in 1912 Braque was showing equal ability, and had the grand nature on occasion—but he seems to me to have played it safe generally—and our work is no place for the safe player."[6]

In addition, Smith was proudly a sculptor, and while American sculptors of his generation were increasingly being written about and shown, sculpture was still far less valued and respected than painting. "[Sculpture is] more costly and it's more difficult in many ways," he told

his Skowhegan audience. "It takes a kind of solid, dogged tenacity to be a sculptor, because a painter can realize a conceptual aim much faster than a sculptor can. A sculptor has to maintain, to hold his inspiration up or his stimulus—he has to hold that and maintain that from day to day to day, much longer than a painter can." Smith ragged Cherry on the sweet life of the painter: "What a tiresome business called sculpture. What an easy life is painting." Sculptural labor is "physically hard and dirty . . . the cost of obtaining material makes me wish I was a water color painter."[7]

Smith's declarations of aggressive individualism do not communicate the breadth and intensity of his curiosity. In his 1954 Skowhegan talk, along with slides of his work, he showed slides he had taken of other artists' work, and also, in Sarah Hamill's description, of "rock specimens, a beach strewn with seaweed, an abstract pattern of a barn wall, and flotsam and jetsam sinking in the sand." He said that everything in abstraction is in nature: "No man can ever make an abstract sculpture, an abstract painting, in the sense that no man can make what he hasn't seen in nature. He makes certain organizations."[8] He was also making an argument for noticing—and valuing—the potential and spirit in the discarded and overlooked, in abandoned and forgotten industrial and agricultural remnants. His sculpture gave these remnants speech. And his work was part of the landscape. Smith believed it was imperative for his work to animate and be animated by hills, clouds, sun, moon, trees. As much as Pollock, he wanted to participate in a cosmic dynamism. This dynamism was one of his audiences.

Smith's immediate artistic family, his guides, the artists whose lives and struggles he studied, as well as their work, was, for the most part, modernist. At Skowhegan, Smith more than once mentioned Picasso, Matisse, Mondrian, and the Russian artist Kazimir Malevich, and referred to Cézanne as his "grandfather." Matisse had referred to Cézanne as "the father of us all"; Picasso had said "he was like our father."[9] Like Claude Monet, Cézanne was a model of aesthetic commitment and integrity who had made his most enduring and transformative work far from a big city and through that work forever stamped the place in which he made it. These artists, too, were part of his audience. "There will always be other artists who understand" what you do, "as there were with

Cézanne." He spoke about Paolo Uccello, too, and his obsessions with drawing and circles. He was part of a multitude of artistic conversations.

Shortly after ten o'clock on the night of Saturday, August 11, 1956, in East Hampton, Jackson Pollock drove his speeding Oldsmobile convertible into brush and trees. The car flipped over, and Pollock, forty-four, and Edith Metzger, twenty-five, were killed. Ruth Kligman, with whom Pollock had been having an open and abusive affair, was injured. Lee Krasner was in Paris, partly for what she called "a trial separation."[10] Greenberg telephoned the painter Paul Jenkins, with whom Krasner was staying. When Jenkins called her to the phone, Krasner knew without being told that the news was about Pollock, and dire.

Smith was shaken. "Jackson's death . . . leaves me feeling empty," he wrote to Cherry. "You & Bill take care of yourselves We need all our painters."[11] He wrote to Greenberg: "It made me weep. I'm so sorry—I feel his loss . . . Is Lee home yet [from Paris].—I kept working last night but couldn't get it off my mind so strange when a friend is gone—nothing but words to tell me I won't see him again—Its truth doesn't seem real—give my & Jeannie's love to Lee it must be so hard for her."[12] He wrote to Bob Nunnelley, his student in Arkansas, who had moved to New York: "My friend Jack Pollock was just killed Saturday in auto ax . . . Work out of your own guts—dig deep—art is hopeful always."[13]

Greenberg's and Smith's cards crossed. "Of course you've heard about Jackson's death by now," Greenberg wrote. "It was an ordeal in more ways than one, but I seem to have recovered fast." Pollock's end-of-the-year show at MoMA would now "have the character of a memorial rather than retrospective one. In a way it's a shame he couldn't have had it 2 or 3 years before, when it might have done his self-esteem some good (though no one in his right mind needs the Mus. of M. A. to certify the value of his art)."[14]

Cherry sent Smith a postcard: "Big party at Lee's house after funeral. Everyone drunk like Jack would have liked it. Clem there very sad. Place crowded."[15] Then a letter: "A big hole was made in the art world by Pollock's death. Now the myths will start. Even when I was in E. Hampton

no story was the same . . . I heard about six different versions before it began to fall into a pattern."[16]

Smith wrote to Frankenthaler in Amsterdam: "Jack has flirted with the edges of self destruction it seems to me quite often—what his problems really were I don't know—I liked him best sober. He was then reticent & introspective." He also reflected on his own journey:

> It takes so much and I feel so feeble to what I can see possible but I cannot get there without traveling the faltering long road. Cannot skip the distance and arrive at the goal. But each step feels better than the last and stronger—but so far to go—that too in sculpture. And sometimes there seem so many paths & projects I hardly know which to take—and then I just work at what is at hand and wonder if I'm a step backward—and should have abandoned this move, but this quandary doesn't last long—for I say shit this is my life and my work and to no one am I accountable or responsible—I'll work hard for my pleasure and fuck the elite & history.[17]

Smith mused to Cherry on creative and destructive energies among his friends:

> Adolph [Gottlieb] thot as I thot or wondered how much of the impulsive force in Pollock was towards destruction . . . I've often wondered about that element in Gorky whether it was involved with his other problems. He always talked like he had a penchant for tragedy. If Kline doesn't lay off the hops his liver will take him.[18]

And to Adolph Gottlieb he wrote:

> I was interested in what you said about Jackson of course the compulsiveness to self destruction is not a direct urge but to push it [gamble with it] as far as one can go—relishing the brink danger and the shock of others and this all takes place

until the accident happens which is what Jack never knew, but it was the accident only when it went over that narrow edge, which made it fatal and not the courtship of danger. Jack was playing—if he knew it was death he would have done it alone—He was rather a quiet and reserved person, soft, withdrawn, without the external stimuli. He was on the wagon one weekend when he was here and I enjoyed him more than most of [the] time. We talked about drawing etc I don't agree that he had shot his bolt. He had shot a bolt but he has been bolting for 15 years and he had bolts left. But bottles won.[19]

Through and beyond the summer, Smith continued to labor on the patio and cellar. When he and Freas entertained—now as likely for business as for friends—it fell to Freas to be the charming hostess but also to shop and cook and clean along with minding the children. "The past week or so have been the hardest of my motherhood," she wrote to her parents on September 10. "Both children are so active & there is much picking up to do . . . I used to complain that I never had 5 min. to myself—now I complain because I never have 5 min. free of interruption to do housework etc. I am bone-tired—yet I have the work better organized than ever. As long as everyone is well, I can stand it however."[20]

During a productive fall, Smith began a new series that he called *Sentinels*. He made *Portrait of a Lady Painter, Tanktotem V,* and *5½*. Each was a multipart vertical sculpture and an engineering tour de force. Yet each is different from the others. The surfaces and materials of *Portrait of a Lady Painter* give it a craggy, archaeological look. Its bronze parts seem to have been excavated. Symbol-objects are almost disorderly in their clustering, as in Smith sculptures from the mid-to-late 1940s. The construction is supported by three vertical rods, one wearing what looks like a steel shoe. Though the sculpture refers to a woman, Smith reused molds he had fabricated for the 1954 sculpture *Portrait of a Painter,* in which the gender of "painter" is ambiguous and probably male. "I hope the male projections are sufficiently subtle and feminine at the same time," he wrote to Cherry of *Portrait of a Lady Painter.*[21] The art historian Sarah Hamill sees the upside-down palette at one end of the sculpture,

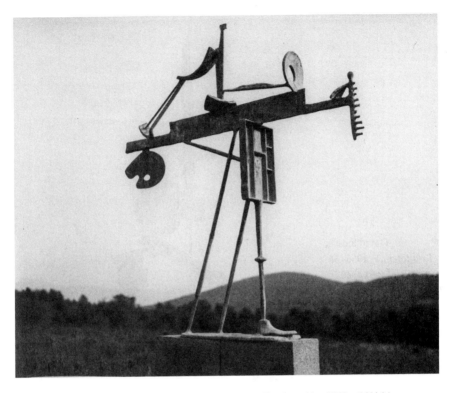

David Smith, *Portrait of a Lady Painter*, 1954–57. Bronze, 64 × 59¾ × 12½ in. (162.6 × 151.8 × 31.8 cm). Storm King Art Center, Mountainville, New York.

which suggests a dangling trophy head, as a reflection of the sculpture's "acute violence," but the palette also hints at the vulnerability of easel painting, which was coming to seem old-fashioned, and the sculpture hints just as strongly at a slapstick Quixotic search.[22]

He worked on *Tanktotem V* for well over a year. The 8-foot-tall varnished steel sculpture includes two round tank tops, one almost like a mother circle in relation to the littler circle beneath it. Both tank tops, particularly the baby one, seem in danger of losing their footing, and if they did the entire edifice would collapse. The construction is held together by steel beams, each a different length, on one of which the mother circle seems balanced like a ball on a shoulder in a juggling act. The one vertical beam, towering above the actions beneath it, lifting the sculpture upward, has a stabilizing statuesque fixity, but it, too, does not

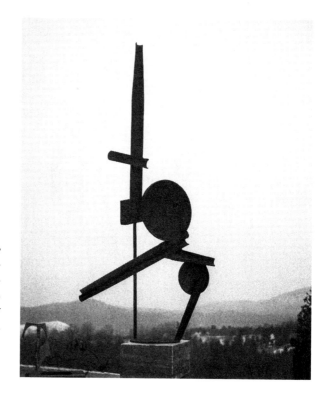

David Smith,
Tanktotem V, 1955–56.
Steel, 97 × 51 × 20 in.
(246.4 × 129.5 × 50.8 cm).
Peter and Beverly
Lipman.

seem to stand on firm ground. "I try for imbalance," Smith said in a 1955 talk, responding to the question "Do you teach balance?"[23] The balance is invariably a feat.

Structured around five stainless-steel rectangles shaped like large bricks, *5½* seems proto-Minimalist. The rectangular forms are stacked horizontally, joined to and separated from one another by thin rods. The rectangles look as if they could have been fabricated, but each— and this is one of their differences from Minimalism—was handmade by Smith. The steel rods that form the spine of the work also look fabricated—as if there were just one long rod from foot to head—but each rod, too, is distinct; the topmost of the five is the thinnest. On top of the sculpture, two more hollow rectangular forms seem to have been melded together into an "L" that resembles a tiny throne. Brown paint is brushed or lacquered with red oxide onto the rectangles so as to make it seem superficial, on but not of the metal; paint and metal touch but

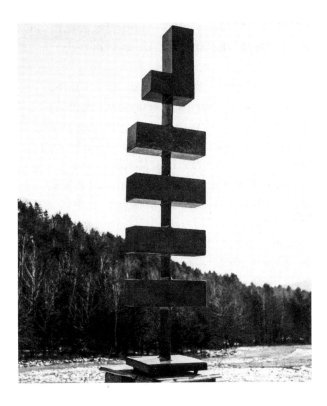

David Smith, 5½,
1956–59. Stainless
steel, paint, 81¾ ×
18¼ × 14 in. (207.6 ×
46.4 × 35.6 cm).
Harvard Art
Museums.

don't merge. "I'm working maturing my concept on sculpture painted instead [of] painted sculpture," Smith wrote to Frankenthaler. "A difference conceptually."[24]

When Smith went to the city in the fall, he went alone. Once the Five Spot opened, he immediately preferred it to the Cedar. He took Greenberg there in October, and at the end of the year, Lois Orswell, whom he introduced to Kline. By then he was on the edge again. He had invested in materials based on sales to the dealer Martha Jackson but had not yet been paid. "I've had rough time lately," he wrote to Cherry after Thanksgiving. "All the details of commerce and the harassment of so many things on hand, to do." He complained that "Jeannie cooked turkey too long" and that Dida was "a climber. Along with work, the problem of family life."[25] In December, both children had chicken pox. "Kids talk all the time long for the bright lights dancing girls etc like 5 Spot," he wrote to Cherry. "Otherwise I'm perfectly fine and buoyant."[26]

Smith refused to be in the Whitney's 1957 Annual because the museum had not appropriately cared for his work. He told Gottlieb:

> Im not feuding with Whitney—I'm dropping them. On the basis that their attitude to the artist is arrogant—solicitous when they want the work—careless in returning it. They sent back a 168 lb iron sculpture in a matchbox crate which, broke up in shipment and didn't even wrap the sculpture in wax paper in an open crate . . . The hell with them and any other person or institution which doesn't value my work as I do.

He understood the consequences of his defiance: "With a family to support and sculpture to make I shouldn't have this attitude but I suppose its my death defying act like Jacks. I seem to be getting more this way . . . I imagine this will bust me something when my gas is out, shop bare—kids need shoes etc—but I like the gamble."[27]

The November 30 memorial for Pollock devolved into a shambles. "De Kooning turned on B. Newman; Clem on Kiesler, Newman on Clem, and so on," Cherry reported. "God the art world is bitter. The groups keep shifting. One group won't talk to another and so on."[28] Smith drove down for MoMA's Pollock opening on December 11.

In his article on Smith in *Art in America*'s December sculpture issue, Greenberg began with the competition between painting and sculpture: "Painting continues to hold the field, by virtue of its greater breadth of statement as well as by its greater energy." To Greenberg, "modernist sculpture's common affliction, here and abroad, is artiness . . . Artiness is usually the symptom of fear for the identity of one's art, and the result of, among other things, a self-imposed restriction of subject matter. Sculpture must continue to look like sculpture—like art." By contrast, there was nothing "arty" about sculpture by Smith, "whom I do not hesitate to call the best sculptor of his generation."

Greenberg continued:

> That Smith shows everything he finishes, and that he has had a high frequency, at least in the past, of failure to success, has caused many misconceptions about his art. That he works in

such a diversity of manners (as well as tending to violate presumable unity of style within single pieces) does not make it easy to form a clear idea of his achievement as a whole. Add to this the fact of an almost aggressive originality, and we can understand [why his work has not earned the prizes or the museum attention it merits. Smith] is one of those artists who can afford errors and even need them . . . The inability or unwillingness to criticize himself . . . enables him to accept the surprises of his own personality, wherein lies his originality. Which is to say that he has been triumphantly loyal to his own temperament and his own experience in defiance of whatever precedents or rules of taste might have stood in the way.

Variability, refusal to censure himself and embracing every aspect of himself, rawness, defiance, "aggressive originality," "a headlong, reckless artist ready to chance anything he felt out of confidence in his ability to redeem in another piece whatever went wrong in the given one"— all of these observations about Smith's work and its importance reflect Smith's personality, which Greenberg knew well and felt compelled to publicly display. Greenberg's bountiful praise of Smith is perversely shot through with disparagement and indiscretion. He closed with a plea for "the kind of commission that will permit" Smith "to display that capacity for large-scale, heroic and monumental sculpture which is his more than any other artist's now alive."[29]

47
Visits

Soon after Smith returned to Bolton Landing in the new year, Herman Cherry had good news: "Martin Widdifield of the new Widdifield Gallery with loads of dough, saw some of your things at Martha Jacksons and wants to buy some. He is going to drive up next week . . . Martin doesn't know anything about art. He has made a lot of mistakes, he took on terrible painters to start with, but wants to mend his ways. He's a nice guy and terribly enthusiastic. He has been buying outright."[1]

"You've got to come with Widdecombe," Smith wrote back. He was eager for Cherry to see his new sculptures, including *Sentinel II*—"all stainless simple heavy pieces, Egyptian . . . I'll not take no for an answer and I've promised Rebecca—She asks daily what you are doing—living in Herman's house has become a peak in her life—associated with fire engines, the park (Wash) the boy she hit with a bucket, slides, swings. She asks for the story about when she lived in Herman's house every day."[2]

January 20 was not an ideal time to drive to the North Country, and Becca, Dida, and Freas were recovering from illness—the girls from measles, Freas from pleurisy—and they had so little money that Smith had to take out a bank loan to provide food, but he would not postpone the visit.[3] Widdifield wanted to buy work and discuss an exhibition. Another person on what Smith referred to as the "safari" had inherited a lot

of money and was about to become a dealer. "This was the time to get in on the ground floor with this guy," Freas said.

The fourth person in Cherry's car was a surprise. "They finally arrived, like three hours late," Freas recalled. "It was dark, it was snowy, and there was a knock at the door, and in, literally, fell de Kooning. I mean, he fell. So then the party went down to the shop, immediately, to see what David had done." Freas prepared dinner, but they remained in the shop so long that the food got cold. As she was cleaning up, "all of a sudden, in this dark house, I feel these hands around me, like that, and it was de Kooning. Whoooooo!" De Kooning slept in what Freas and Smith called the studio room. "Our bedroom was next to it, and, of course, I heard him throwing up," she recalled. "He threw up several times, and all I could think of was my precious Hudson Bay blanket that he was sleeping under. I could hear him mumbling about this painting. I got David and I said, 'You *have* to hear this.' He listened to it, and he laughed." When de Kooning emerged the next morning, he looked "like somebody on the cover of *The American Boy*. He was just pink and white, big blue eyes, no bags—nothing . . . He was very nice when he was sober."

When Freas told Smith that de Kooning had grabbed her, he threw up his hands. It was, Freas said, "such an honor to have him in our house, to him. And nobody, nobody said a word about how drunk he'd been. You would think he would have had a hangover, as colossally drunk as he was. He did not."[4]

This was de Kooning's one visit to Bolton Landing. He and Smith were never close, but they had known each other since the late 1920s, through the painter John Graham, and had followed each other's development. They admired similar artists and traditions. Both were friendly with Thomas Hess, whose writing on de Kooning was remarkable. Both were shaped by Cubism. Both made art that offered new experiences of materiality and space. A de Kooning painting, like a Smith sculpture, never *feels* small or containable. De Kooning's painting gestures, like Smith's sculpture gestures, can seem raw and powerfully physical, suggesting a force field in the ways in which they join and fight, in dance and combat, undoing and establishing new order. Smith kept up not just with de Kooning's painting but also with his love life, his Cedar Tavern life, his drinking, and the effect on him and his work of his baby daughter.

On February 3, 1957, with "First Exhibition," Leo Castelli inaugurated his gallery at 4 East Seventy-Seventh Street. "I wanted to indicate that the American artists were just as important as the European artists, maybe more so," Castelli said. "I placed three of them—de Kooning, Pollock and David Smith—next to a number of recognized Europeans, including Dubuffet, Leger, Picabia and Mondrian."[5]

De Kooning titled one of his 1957 paintings *Bolton Landing*. De Kooning's blue has a wintry quality, but it's thicker than the limpid blue of an Adirondack winter. It's hard to find evidence in the painting of the visit, but with the title it became part of the biography of de Kooning's work.

The day of the de Kooning visit, Smith turned down George Rickey's offer to teach at the University of Florida on the grounds of insufficient compensation and time away from his work. At this point in his life, leaving Terminal Iron Works for Florida and teaching made no sense, but Freas craved financial stability and a university community in which she could once again have her own life. When Smith rejected Rickey's offer, her heart dropped. "David turned him down . . . And that's when I started to cry," she recalled.[6] Increasingly fed up with home life, she let the children do pretty much what they wished. "That's one reason I am glad our house is theirs, and can't be damaged," Freas wrote to her mother. "I'd go crazy if I had to watch all the time for d[a]mages, and I don't think they'd be as happy. They have less taboos here than most children."[7] In February, she complained to her parents, "The kids have been so wild lately." She had to get Becca "off the refrigerator ten times a day, and Deeda climbs up into the bookcase and sits."[8] A week before spring, Freas complained, "I am not suited to motherhood . . . David says I beef all the time, and he is correct."[9] She was tired of the relentless demands. "There is just too much to do. When my children are reared I am going to have a room or two of my own, nothing but the essential furniture, do all my work in a library, eat raw fruit and vegetables and a steak twice a week. In short, no cooking or housework."[10]

Moonshine, too, could seem out of control. He could be a big warm presence but he could also be such a pest that Smith kicked or threw him across the room. Around this time Smith and Freas bought a fancy roast beef for special guests. "And behind my back (I was distracted by the kids, of course)," Freas said, "Moonshine got that whole rib roast, stand-

ing roast, he got on one end of it." Freas took after him. "And you know how Basset Hounds have this particular grip—that's why they're rabbit hunters and so on, you cannot unloose their mouth . . . I was determined to get that back, so the two of us—I'd pull this way and he'd pull that way, and the girls . . . were just fascinated." When she finally got the rib roast out of his mouth, a sizable chunk of it was missing. Smith "knew what that cost . . . And, boy, he didn't like it a bit."[11]

Smith escaped Bolton Landing on regular trips to Manhattan that were principally business-related but also included openings and meetings with critics, curators, and dealers. He had a rich, free-wheeling city life. He loved dinners in Chinatown and the Five Spot. In July, *Esquire* published a photo spread titled "New York's Spreading Upper Bohemia . . . Life Among the Avant-Garde." One photograph shows the poet and art critic Frank O'Hara with the painters Larry Rivers and Grace Hartigan around a table at the Five Spot. Smith is standing in the left foreground, chatting with a young woman. The article credited Smith and Cherry for "the Five-Spot's change-over from a bar where derelicts boozed to a rendezvous for Bohemians, Upper and Lower."[12]

Smith and Cherry were close friends who supported each other's work, and Cherry generously gave Smith a place to stay. But sometimes Smith could rag Cherry. "Can you uninhibit yourself or are you afraid to paint bad pictures?" he once wrote to him.[13] Other times his support was enthusiastic: "You have something wonderful going on in color—all I can say is push it, push it like hell and let nothing divert you. Throw caution, take unknown liberties, dive in where nobody has been. How I can say it to you and I wish I could do it all for myself. I feel so earth bound when I look at my work. I don't see why you can't fly high it seems so close for you and who else has color."[14] Along with their views on art, other artists, and women, they shared their physical woes. In response to Cherry's gout, arthritis, and back troubles, Smith recommended Blue Cross and Blue Shield's hospitalization group. He was having physical problems, too, including a bad elbow that prevented him from lifting more than fifty pounds. "Feeling old myself, joints aren't as flexible . . . getting gray hair also—don't worry about the latter its distinguished," he wrote to Cherry.[15]

In February, Freas went to the city on her own, "to mosey around and take my time." She visited Frankenthaler, to whom she poured out her frustrations. When she returned to Bolton Landing, primed again for family life, she blamed some of her discontent on her immaturity. But the problems persisted. Twice in the first half of the year, the whole Smith family went to the city, once so precipitously that they did not know in advance where they would be staying. Periodically, Freas bolted to her parents in Washington, leaving the children behind. "Kids raising hell—good bye" was how Smith signed off a letter to Cherry in May, when Freas was in Washington.[16] When she was away, a woman named Rachel, who now house cleaned for them, helped with the children, but Smith had to be mother as well as father to them. He had to bathe and dress as well as discipline and play with them. He did most of the cooking. He was determined that they would not think him less of a parent than Freas. He never knew how long Freas would be away. Her flights from Bolton Landing, and from him, triggered a mix of rage, resentment, abandonment, and relief.

The girls grew up with their parents' eruptions. "They were both ferocious people," Becca said. "They had these huge fights. And I know . . . that she would say very vicious things . . . It was like having a little fire, and they were both throwing gasoline all over it."[17] On some of Smith's rampages, Freas, like Dehner, went down to the basement. "I knew he would have to make that noise, going down those metal steps, with that weight, and he would come after me. I don't know why she [Dehner] went where she did, but I know I went, thinking, 'I'm better off there, because he has to physically remove himself from one floor to another.'"[18]

It was impossible for her to have the last word. "Anytime I said anything, he always had a comeback . . . He had a strange thing that he said to me . . . He said it repeatedly . . . 'You have a bull-roarer.' And you know what that is . . . It's in African mythology. It's something they say makes the sound of a bull . . . How could I do that? Have a bull-roarer? And in the second place"—Freas hesitated before revealing this—"he had this fear that people just despised him, or made fun of him, for looking, as he said, like a cow. Well, he didn't—I never would have thought . . . it was really hard for him to tell me that; that he was afraid he looked like a cow."[19]

A bull-roarer—a piece of wood on a string that makes a thunderous

noise when swung—was used in Australian Aboriginal tribal initiations and rituals such as circumcision and subincision. Its function could be propitiatory and forbidding, essential to a male's journey from one stage of life to the next. Bull-roarers were made and wielded by men. In Smith's gender reversal, he was a cow and Freas the bull. She possessed the phallic instrument and he was her/its victim. Her instrument was violent language. When Smith asserted that society had been "raped by word pictures," he identified words with rape. Dehner could be cutting in her comments. Becca and Dida made it clear that their mother could be verbally abusive. From the start of their relationship, when Freas was unhappy with him she lit into him verbally. As a boy in Decatur, Smith occasionally fled to his grandmother's house to escape his mother's scolding. The danger he felt at home, what made home no longer home, was attached as much to his mother's words as to his father's beatings. When he felt verbally attacked by one of his wives at home, he could feel so undone that no matter how destructive his behavior had been to provoke the attacks, he experienced himself as endangered.

Through the first months of the year, Smith worked diligently to put out fires ignited by the words Selden Rodman attributed to him in his book *Conversations with Artists*. In 1956, Rodman, an art writer and poet who owned a Smith sculpture, interviewed all thirty-six artists featured in the book. He and Smith had spent an afternoon and evening together around the heady time in which Smith left the Willard Gallery, met Orswell, and learned he would be the first living sculptor to be given a solo show at MoMA. In the book, Smith comes across as combative to the point of recklessness—to use a word Greenberg had included in his description of him as an artist.

Rodman's carelessness is obvious in errors of fact, and even spelling. The quotations attributed to Smith have some credibility but are clearly cobbled together from memory. Some comments make no sense. After a quote in which Smith says that when he works he has no conscious premise, and no sense of why he is working or of audience, he is quoted as saying what is impossible to imagine him thinking: "Nor do I feel any kinship with those who exhibit it [my work] or buy it. I don't want to know them, or see my things again—ever."

It was one thing for Smith to complain to friends about the museum

honchos Sweeney and Barr. It was another to be cited describing Swee-
ney as "the gravedigger of modern art." Or boasting about challenging
Barr: "I wrote a deliberately insulting letter to Barr, offering him ten per-
cent more than he paid and accumulated interest, if he would sell back to
me the one piece the Modern Museum has."[20]

Smith told Frankenthaler that he never made the "gravedigger" re-
mark about Sweeney or wrote an insulting letter to Barr. To Cherry, he
said that he didn't believe that what he said about Barr was intended
for publication. "I remember four times telling Seldon when he asked
a question—then summed it up for himself—I said—those are not my
words—You are misquoting—and several times I absolutely disputed
him—with absolutely no! He is not authorized to quote without approval
or checking, is he? But scandal seems his forte, to arouse interest which
he lacks in art perception."[21] Cherry loyally trashed the book in *Art-
News*, and the June issue of *Arts* published Smith's official disclaimer:
"The report of my interview is unreliable, untrue, contains 'quotations'
that are simply false. I denounce the validity of the entire bar-room
assignation."[22]

In May, the German-born art dealer Otto Gerson visited Bolton Landing.
He ran Fine Arts Associates, which was located in the Fuller Building
at 41 East Fifty-Seventh Street. Gerson was interested in sculpture and
had strong connections with the mass media and American and Euro-
pean collectors. "They seemed enthusiastic and so am I," Smith wrote
to Cherry. "They took 3 pieces . . . No strings attached."[23] The gallery's
percentage on sales would be one-third.

Jane Wade, Gerson's assistant, wrote to Smith confirming the gallery's
$10,000 payment for "the stainless steel 'Figure', 'Pilgrim' iron, 'Egyptian
Still Life' and two small pieces of our selection next Fall."[24] The gallery
took another sculpture and nine drawings on consignment. Its Septem-
ber exhibition, like the exhibition of small sculptures, paintings, and
drawings at Widdifield, would coincide with the MoMA show.

A week later, Gerson informed Smith that the previous letter "did
not mention our understanding that from now on you will give us first
choice and first refusal regarding your sculptures."[25] Smith, however,

wanted to be able to sell his work when, where, and how he wished. "Am not sealed with Fine Arts," he wrote to Cherry. "I'll hold my position as a no gallery as long as I can."[26]

In a letter to her parents in July, Freas expressed her relief:

> As you know, our income is impossible to predict from year to year. But it is, as of now, I'd say about $16000 for this year, and as a result of the show, the next year will be as good or better. Architectural commissions might possibly come out of the show, which would be very good. David's plan is to put back into his work as much as he can without stinting household expense . . .
>
> But the point is, that without having any guarantees, I believe this year is the turning point for him, and that in future what few needs I have can be met.

Smith told Freas to tell her parents that if they needed money—her father had been in the hospital—the Smiths could help out. "We have $2000 loose you are welcome to . . . Don't hesitate to ask," she wrote to them.[27]

He bought another truck. She bought a new car. They bought chairs and a table. A phone was finally installed in the house. "It is, to my eyes, more beautiful than a sunset, second only to a newborn babe! It is over the cellar steps, accessible to the hall, or you may sit on the step—a wall phone, Brand new too."[28] He was considering drilling a new well in order to resolve the chronic water shortages. Despite an early heat wave and the labor of making new sculptures and fixing up old ones, and the endless details for the MoMA show even as he was working on a commission for G. David Thompson, summer was a joy. Freas and the girls made almost daily use of the lake. The children picked berries and fed squirrels, celebrated birthdays, and played with toy locomotives. Smith installed a big bathtub outdoors, which the girls loved. Becca's word inventions continued to be enchanting. On heat lightning: "the eyes of the night are blinking."[29] On her mother's veal roast: "Jeanie you are a good cooker."[30] "We are all well here," Freas wrote to her parents in July. "Moonshine has been staying with us much more of late, and is seemingly contented. He is unfailingly gentle with the children. Deeda, the last 2 nights, has

waked up screaming, something about being scared by a bear—don't know where that comes from."[31] Visitors included Frankenthaler and Gerson. Hilton Kramer and Fairfield Porter came in preparation for articles on Smith. Richard Carver Wood took photographs for *Time*. "Needless to say, Hazle and I had a most wonderful time with you, Jean, Rebecca and Candide [*sic*]," Wood wrote Smith. "It was one of those few assignments that turn into pure pleasure and make a person wonder whether they should instead pay TIME for such a privilege . . . Tell me how your ornery side is doing. Living in the midst of steel giants and off weather there really makes for a rugged life."[32]

The MoMA exhibition was finally set: thirty-four sculptures, six of which would be installed in the sculpture garden, plus six paintings. Andrew Ritchie had visited Bolton Landing with Sam Hunter, who took over the show when Ritchie became director of the Yale University Art Gallery early in the year. The Scotland-born Ritchie had supported Smith's work since his days as director of the Albright-Knox Art Gallery. Patrician and scholarly yet down-to-earth, and a sculpture guy, he inspired trust. Hunter, eighteen years younger than Ritchie, worked out the selection with Smith and changed the title of the exhibition series to "Artists in Mid-Career." Smith was not enamored of him: "Don't candy much to Sam H way of choosing and method—the old historian arrogance."[33]

The show was a new experience for Smith. After Ritchie and Hunter left, he wrote to Herman Cherry: "I'm not sure how much I should say what should be used. The last 10 years yes, but there are big brutal ones, late which I do not think they took to . . . Some they picked, (for first draft) I'm not sure myself yet, some are too new to my eye. It takes me a few months to get a critical view myself."[34] Smith wondered how his work would hold up at MoMA: "I wonder if I'll look like junk, look strong or be dwarfed by the marble and aroma. I'm anxious to get it over."[35]

At the end of July, Smith wrote Frankenthaler: "Real beauty in life is well fed girls in the house black night, totally quiet except symphony from WQXR—cleaned up shop—acid etching name and date on last finished work, new one going on floor; and finished work about, sometimes the consciousness and the sequence bring the greatest glory I get. You know it all."[36]

48
MoMA Show

On September 4, 1957, Smith trucked to the city most of the sculptures in his show at Otto Gerson's gallery, Fine Arts Associates. With Cherry on Long Island, he stayed with the Hunters. Freas drove the girls to Washington, arriving in New York City for MoMA's cocktail party for Smith on September 10. "All artists are on list—like Jackson show!" Smith wrote to Cherry.[1] The public opening was on September 11. Till the end, Smith was opposed to an official dinner. "Got take Sam Andrew dinner that night to forestall any dignitaries invitation—5 Spot later," he wrote to Cherry in late August.[2] In September 1957, Thelonious Monk and John Coltrane were near the middle of their six-month run at the Five Spot.

Only three sculptures in his show were from the 1930s. The 1940s were represented by *Home of the Welder, Pillar of Sunday, Royal Bird*, and *Blackburn, Song of an Irish Blacksmith*. From Smith's series, curator Sam Hunter chose just one *Medal for Dishonor, Elements Which Cause Prostitution*, a timid and unrepresentative choice; one *Agricola*; two *Tanktotems*; two *Forgings*; and two *Sentinels*. The sculpture with the highest insurance value—$12,000—was *Australia*. The 1956 and 1957 sculptures tended to be valued much higher than earlier works.

"The exhibition revealed to me that you are an even better sculptor than I knew, though as a matter of fact I have thought highly of you for

some time," wrote Gordon Washburn, director of the Carnegie Institute. After *Australia*, at the beginning of the show, Washburn wrote, "I was lost in admiration . . . I look forward to meeting you in the near future."[3]

"I was impressed by the authority and consistency all the way through," Edgar C. Schenck, director of the Brooklyn Museum, wrote to Smith.[4] Schenck had brought Smith, Greenberg, and the art historian George Heard Hamilton to the Albright-Knox Art Gallery in Buffalo for a panel on art criticism. He was not alone in wanting to acquire a Smith. Of the works in the show, MoMA bought *History of LeRoy Borton*, and Nelson Rockefeller, the chairman of MoMA's board of trustees, bought *The Banquet*. The Brooklyn Museum bought *The Hero*, a 1951–52 sculpture that at that time was called *Hero's Eye*. Lois Orswell bought *The Fish*, *Sentinel IV*, and *Detroit Queen*, which Hunter characterized as "a chimerical creature whose nerve center and vital organs are actual impressions in bronze of machine parts."[5] *Man and Woman in a Cathedral*, a 7-foot-tall 1956 sculpture, was the first work Andrew Ritchie acquired for the Yale University Art Gallery; the $7,200 went directly to Smith. By the end of the year, he had enough money in the bank to make arrangements with Ritchie and Rockefeller to spread their payments over four years.

Smith's three overlapping shows were an event. "Sculpture by David Smith," at Fine Arts Associates from September 17 to October 12, included twenty sculptures, most of them small, and a few drawings and paintings. "David Smith: Sculpture in Silver," at the Widdifield Gallery from October 15 to November 2, included drawings and paintings. "All in all," Hilton Kramer wrote in *Arts*, formerly *Art Digest*, "these installations constitute a larger exposition of work by an American sculptor than has probably ever been presented in the past, and it is perfectly right that Smith should be the artist so honored. His sculpture is one of the major achievements of American art in the last quarter-century. One would be hard-pressed to name another American, or another artist anywhere of Smith's generation—he is fifty-one—whose work would sustain such concentrated attention."[6]

The shows inspired a new level of critical engagement. The writings generated by the shows were the most consequential since Smith's two-gallery retrospective in 1946. They are in some ways familiar, repeating approaches to Smith and his work that had been in play for years, but in

other ways they are fresh, articulating ideas and issues that continue to challenge writers on Smith's work.

Although MoMA did not break the bank on the publication—"the rather skimpy book they put out on the show" is how the playwright Clifford Odets characterized MoMA's thirty-six-page, black-and-white *Museum of Modern Art Bulletin* that served as the catalog—it was still the most substantial publication to date on Smith's work.[7] The essay, by Hunter, historicized Smith largely through early twentieth-century modernism: "The revelation of modern art," the contact all at once with Picasso, Mondrian, Kandinsky, and Constructivism, "struck Smith with a suddenness and as a totality . . . At the core of his art are the formal conventions of Picasso's and Gonzalez' iron constructions of the early 'thirties, and no matter how unbridled his fantasy or how much scope he gives to impulse, he has remained basically a formalist."[8] Hunter had a vivid awareness of the "polyvalent qualities of earlier" sculptures and "apparent inconsistencies in style" within Smith's work, and of its disruptiveness, but more than any other writer to this point he insisted on the independent life of Smith's forms.[9] While singling out the persuasiveness and intelligence of Smith's form language, however, Hunter does not examine this language, nor does he cite any of the prominent nineteenth- and twentieth-century thinkers who had developed ideas of forms as forces and realities in themselves. Hunter pays scant attention to Smith's scavenging for and transformations of found objects or to how seriously he thought about image, memory, art history, and survival. MoMA's David Smith is an aesthetic powerhouse but a depoliticized and largely decontextualized figure. The urgency of the *Medals for Dishonor* is explained by the "residual idealism and messianic fervor of early American modernism, which persisted into the 'thirties."[10] From Hunter's essay, readers would have no idea of Smith's class awareness and political rage. Nor would they know that many sculptures were painted.

Hunter and other writers emphasized Smith's roots in both the industrial and the pastoral. Steel was essential to the personality and potentialities of his sculpture. Smith was "addicted to iron and steel as a matter of vocational training, and as a search for vital, new expressive forms," Hunter wrote. He mentions steel's "great malleability . . . toughness and durability."[11] In "David Smith: Steel into Sculpture," in *ArtNews*,

Fairfield Porter wrote that welded steel sculpture was "threatening: you could hurt yourself on it; it is sharp-edged and non-resistant."[12] Both Porter and Hunter cite Smith's by now often-repeated statement on the modernity and ambivalent identity of steel: "The metal itself possesses little art history. What associations it possesses are those of this century: power, structure, progress, suspension, destruction, brutality."

Hunter, Porter, and Kramer all made a point of steel's inherent opposition to the monolith, which for all three of them was the enemy, the greatest obstruction to sculptural growth. For Kramer, the monolith, with its illusion of interiority, was dishonest. The Cubist opening up of the monolith broke away from the "subterfuge of imaginary mass."[13] "Metals readily lend themselves to an art of open, linear forms, held in subtle spatial tension, and release the artist from the monolithic mass of traditional sculpture," Hunter wrote.[14] For Porter, in contrast with bronze and marble, where the essential experience of the material is centripetal, steel provided no illusion of an interior or center. Steel, he wrote, "adapts itself to the air and surrounding space; there may be no core."[15]

Porter, a painter as well as a critic, one who was acutely sensitive to the densities of light and air and to other animating energies of landscape, had the telling insight that living in the country had enabled Smith to develop some of the radical implications of Cubism. His open sculptures made space and light sculptural. They activated the environment and by so doing brought it into his work. "Smith's artistic identity is not hermetic." *Australia* "fits the landscape below his house at Bolton landing, in the foothills of the Adirondacks" and "punctuates and merges with the landscape." The reality of "the sculptures called Sentinels . . . is continuous with the space around them; unlike the Cubist still-life or the Cubist portrait, in which the sitter must be, according to Cézanne's wish, as still as an apple—at least in the artist's imagination. European abstraction is one of something separate and actual, not of a process. American abstraction is closer to Japanese naturalism, or French Impressionism, or even to English Romanticism."[16]

With the MoMA show, Bolton Landing becomes the first site of Smith's work. Kramer put Smith's photograph of *Portrait of a Lady Painter* stretched out against the hills and sky on the cover of the Oc-

tober *Arts*. The lead photograph in Porter's article shows eight vertical sculptures spread out on a country road against a cloudless sky; the caption is "Steel sculptures gather outside the artist's studio." It was in Bolton Landing that Smith's sculptures most belonged. "Smith's rugged iron works are too brutal to sit comfortably close together in the whitewashed, antiseptic setting of museum walls," *Time* wrote. "They look best against the rolling mountains and lakeshore on which his Lake George studio faces."[17]

Smith, likewise, belonged in Bolton Landing. "Beside a mountain field overlooking Lake George, a heavy and muscular man lives, raises a family and welds sculptures out of the world around him," is the fable-like opening of "A Rugged Art Shapes out of Iron," Ormonde Plater's profile in *The Knickerbocker News*, an Albany paper. "To the natives of Bolton Landing, he is more neighbor than artist. Down on the lakefront, among the tourist dives, ask any native. 'Sure, David lives up there.' And he points to a road that twists into the backcountry. 'Just follow the TIW signs.'"[18]

Hunter wrote:

> While Smith has for many years led an urban existence, he is far more at ease, both in his personal and professional life, deep in the country . . . He is a familiar and welcome figure in his village wherever crackerbarrel philosophers gather and hold forth, and he is every bit their match when it comes to verbal cunning, expansive tall talk and picturesque colloquialisms. Smith has won acceptance there as a native, if not as a sculptor, and he in turn thoroughly enjoys his status.[19]

David Smith of Bolton Landing had become a folk hero. Smith's persona as both avant-garde sophisticate and quick-witted, incorruptible, don't-mess-with-me, mass-public-be-damned inventor-artist was almost irresistible.

Critics challenged one another about Smith's work. Kramer accused Hunter of sanitizing it. To Kramer, "something [was] missing from this exhibition, a quality which one always felt to be central to Smith's vision: what Herman Cherry . . . calls Smith's 'quality of anti-taste,' his 'rough

sensibility,' and anti-estheticism. This . . . seems nowhere in evidence in the Museum show, nor for that matter in the Fine Arts exhibition either."[20] Kramer's disagreement with Hunter is clear in their different descriptions of *Home of the Welder*. To Hunter, the sculpture is "a rambling, fanciful inventory of a fellow-welder . . . whose primitivistic allusions were inspired by some random doodles Smith found scrawled on the walls of the welder's shop."[21] Kramer finds in the sculpture a less civilized world, "a pervasive consciousness of the household as a kind of den inhabited by sexual animals who sense in everything around them a portent of gratification or frustration."[22]

Critics debated Smith versus Alexander Calder. "Smith has been one of the primary innovators in contemporary American sculpture," Hunter wrote, "and second only to Calder, in point of time as a pioneer in free-standing, open, metal forms."[23] To Kramer, even the faintest hint that Smith was artistically subservient to Calder was an affront to Smith's work. Like Smith, Kramer was distrustful of mass taste. He valued Smith's resistance to the "emotional fraud of public feeling":

> Unlike the art of Calder, say, Smith's art is lacking in the qualities of playfulness and frivolity which have been so easily assimilable to stereotypes of American innocence, and which no doubt have contributed to its vogue among Parisian critics who prefer to regard the American sensibility as childlike and unserious. Smith's sculpture, even at its most refined, is much more forthright. Its mode of feeling is infinitely deeper than Calder's.[24]

Porter also argued for Smith's greater depth of seriousness: "The particular that interests Smith more than anything else is his own identity. 'The real issue . . . is the identity of the artist.' As his sculpture is unlike Gonzalez's analytical Cubism, it is equally unlike Calder's open sculpture. (Calder's mobiles refer, not to the identity of the artist, but to the mechanical principles of trees and toys.)"[25] Porter saw identity as a big American theme. He was friends with Frank O'Hara, John Ashbery, James Schuyler, and other members of the New York School of painters and poets, and familiar with the poetry of Walt Whitman, for whom

identity was as much a call as a vision. Not only did Porter look closely at Smith's work, but more than any other critic at this time, and in decided contrast with Hunter, he took Smith's words seriously. Porter also may have been the only critic in this period who named Smith as the photographer of the images that accompany almost all the writing on the three shows.

Porter aligns Smith with de Kooning, and in the process offers a different way of thinking about the politics of Smith's aesthetics. While Hunter found in Smith's use of steel an "authentication of industry," Porter found a validation of labor:

> Art is the solution for the worker's alienation from himself that his labor causes. In those early paintings of de Kooning and in Smith's sculpture, labor is made into art. This is not to be confused with "craftsmanship" nor the charm of the hand-made. Labor as labor; workmanship, either good or bad, that of the apprentice or master craftsman, is looked at esthetically; like a game, it takes a form aside from its function. In de Kooning's abstractions of the 'thirties or 'forties, his training in a Dutch guild of decorators is part of the subject of the paintings, as if to say to the spectator that here is the work of painting (not the art of painting) in various aspects, presented for contemplation. Smith's sculpture says the same thing about skilled and unskilled factory work—the dominant American kind, work with iron and steel.[26]

Smith bracketed with pencil marks the remarkable last paragraph of the article. While Porter embedded Smith's sculpture in its environment, he also distinguished the sculpture from it. The sculptures activate multiple associations and by so doing mobilize in viewers desire and belief. The sculptures seem to be appealing directly to them. But because of their abstractness and planarity, and the power of their metal as metal and their paint as paint, at some point in the encounter with them, Smith's sculptures resist or pull back from the associations they provoke. They are not people, animals, plants, or garments. They are welded metal constructions. They are what is projected onto them, but they are also

not. "His figures," Porter wrote, "have the sort of life that inanimate manufactured objects have, or the sort of life that very small children see in things around them: things have expression without features, awareness without involvement, knowledge without memory, observation without judgment." The tension between the proliferation of associations and fantasy and severe materiality may vary from sculpture to sculpture, and it is not always a factor in the formation and experience of the sculpture, but from the mid-1950s on, it is increasingly present. The 6-foot-tall stainless-steel *Sentinel II*, completed in early January 1957, in the Fine Arts Associates show, seems to be both a dutiful guardian figure and a hollow metal sign from which the potential for protective efficacy has been evacuated. Porter is the first critic who tries to account for the push and pull in Smith's work between active and passive, powerful and exposed, fantasy and impersonality, human and machine. For Porter, the sculpture's main identity "stays at a level far below sentiment, where sex becomes neuter. This makes them like nature, like the world outside the

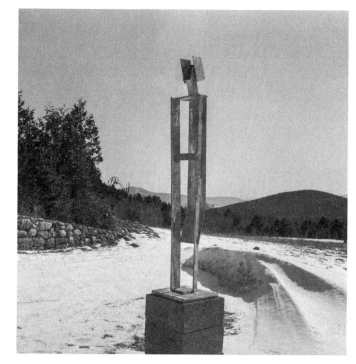

David Smith,
Sentinel II,
1956–57.
Stainless steel,
71⅜ × 14½ ×
14½ in. (181.3 ×
36.8 × 36.8 cm).
Hirshhorn
Museum and
Sculpture
Garden.

artist, with which Smith can be said to be competing. Nature is objective, but one's feelings about it are subjective."[27]

While characterizing Smith's sculptures in the MoMA show as "wild creations," *The Knickerbocker News* normalized him. "Though living in an unconventional home, and though the father is a famous father, the Smith family is much like any other family," the paper noted in its caption to the profile's accompanying photograph. It projects a Rockwellian *Saturday Evening Post* image of family bliss. Smith is the warm and secure paterfamilias, in proper white shirt, his sleeves rolled up. Dida is perched on his left knee with his arm around her. Becca is standing beside him, head pressed against his shoulder—in the only break in the script, she looks warily at the camera. Freas is back left, standing behind her man, wearing a casual light blouse, her expression redolent of marital content. The article concluded: "[Smith] now lives quietly in Bolton Landing with his wife, Jeannie, and daughters—Rebecca, 3, and Candida, 2—and renews his art."[28]

Yet when this photograph was published on October 12, there was little quiet to be found. At a party Frankenthaler gave for Smith, he and Freas had a scene. They made up, but in Bolton Landing the reciprocal animosity again took over. She invoked the positives—the children—as did Smith. "It is much harder *here* to see my course than when I was in New York," Freas wrote to "Dearest Helen" Frankenthaler. "Here the positive element is so much present—the love of the children—that no matter how hopeless the rest of the picture, one hesitates to take from them so much light and comfort."[29] The next day Smith wrote to Frankenthaler of *his* love of the children: "I haven't written either because of personal crisis. This is it, and you will have to take us singly. It's lonesome to look toward but I've got my two kids for whom I'll fight and who I love more than I've ever loved anyone before."[30]

On October 17, Smith checked into a Manhattan hospital for a week. He was concerned enough about his health to write to his mother about his fear of inheriting the blood cancer that killed his father. "Take it easy

now as your father's disease came from a rundown condition," Golda wrote back.[31]

Tests were negative. After his hospital stay, he and Freas spent several days on Cooper Square with Cherry. "One night we were going to the Five Spot, and he [Cherry] was very, very, very drunk," Freas said. "All of a sudden—I was wearing [an] 'off-the-shoulder' dress—he sunk his teeth into my left arm, and the blood spurted, and I turned to David, and I said, 'Herman bit me!' and he said to me, 'Well, you probably did something to deserve it!' . . . Did he apologize? No! Lord no, he'd never apologize . . . I was FURIOUS at David, for sticking up for him."[32] "Best to Jeannie," Cherry wrote Smith on November 1. "Tell her I'm sorry I bit her arm."[33] Smith may not have passed on his apology.

After his big show and MoMA's acquisition of an important sculpture, Smith offered sculptures to Barr, who wrote a handwritten note of thanks. In late fall *Death by Gas*, a *Medal for Dishonor*, and *Chicago Circle*, a recent medal, were officially given to the museum by E.A.A.K.R. Smith and C.K.N.R.H. Smith. Smith used the initials of his daughters' names but changed the order for each: Eve Athena Katherine Allen Rebecca has become Eve Athena Allen Katherine Rebecca, and Candida Rawley Nicolina Helene Kore has become Candida Kore Nicolina Rawley Helena. For Smith, not even the order of his daughters' names was fixed. He told them he had given them so many names in part so they could choose from moment to moment which ones they preferred.

Smith gave Ritchie a sculpture titled *Head* from the 1940s. It is likely that he gave Hunter a drawing. Earlier in the year, he made gifts of works to Kramer and Jane Wade. After his desperate struggles, he appreciated dedicated support and, knowing of the interest in his work among critics and curators, assumed that such gestures of appreciation would be remembered.

Martin Widdifield sold *Egyptian Barnyard* to Lois Orswell, and he expected to be the dealer to represent Smith going forward. When Otto Gerson, of Fine Arts Associates, received special prominence, Widdifield felt betrayed. Smith maintained that he had never made any promises. He

bought back his work from Widdifield and brought it to Bolton Landing, except for *Tower Eight*, which he gave Gerson on consignment.

In early December, Smith was experimenting with drawing "left handed," having "a hard time to get away from my involuntary banality."[34] On December 16, he received an inquiry from Walter W. Horn, chairman of the art department at the University of California, Berkeley, asking if he would be interested in teaching there for the fall 1958 semester, two and a half days a week, $5,182. Smith had considered a break from New York, and he and Cherry discussed teaching together in Berkeley, but he declined the offer, recommending the sculptor James Rosati, whom he had recently recommended to Gerson; Gerson bought several Rosati works. Freas left again.

"Kids had a great xmas," Smith wrote to Cherry. "I finished the doll house. Took same time as a sculpture. But they love it. Its not much, crude but strong. Krist how I love those kids. But kids don't want love, unless they want it, one has to wait for solicitation, but I like them better than the big girls."[35]

Over the winter, Smith brought to the shop a bull's head. "In the process of butchering," Freas said, "which everyone in the neighborhood did—he got a hold [of the bull's] head, because they didn't want the head, and he put it on a spike, and in that cold climate, it froze. It was right outside the shop, and he had it banged right down in the ground." The bull's head "was looking right up toward the house, and it was black, you know. . . . It was almost as if it was a scarecrow to keep away intruders." In Smith's photographs, the bull's black-and-white head is actually on a round steel disk. In one photo, the head sits straight up, propped on its neck, with its eyes prominent, an echo of the severed head of John the Baptist on a platter.[36] In another photo, the head is tilted back so that the nose is facing the sky. In the third photo, the head is on its side, almost undecipherable, so deformed or violated that the face and horns are no longer visible.

Moving Out

For Lois Orswell, Smith's January 1958 visit to her estate in Pomfret, Connecticut, was "the culmination of years of desiring."[1] His work was now her passion. After having assembled an important collection of Abstract Expressionist paintings, Orswell decided to collect paintings only by him. "David was rather surprised at my interest in his painting, which he took very seriously," she told Marjorie Cohn, a curator at the Harvard University Art Museums. "He knew no one approved of it and was reluctant at first to let it go. But I wanted the COMPLETE artist."[2] Believing that the creative souls of artists were in their drawings, she wanted his drawings as well. "As I have said a million times, if I had ten thousand dozen of your drawings I would still want more."[3]

She was smitten by *Detroit Queen*. She had acquired it directly from Smith in a package deal with drawings and a painting; he gave her a 10 percent discount on the group. Depending on the point of view, the 6-foot-tall multipart bronze, its patina an industrial-looking mottled bluish green, is sitting, standing, or dancing. The concave midsection or torso can be seen as a vessel and passageway; the body suggests pouring, an action integral to bronze casting. The three upright strips supporting the construction suggest the legs of a person or table. Atop the elongated neck is a featureless horizontal fish-shaped head, concave in front, with a

vertical armor-like slab down the center. The queen can be experienced as a hieratic female idol expecting an offering, an immobilized child, and an exuberantly performative party girl. Regal and eerie and a blankness.

Orswell asked Smith to bring the 1946 *Cello Player*, another sculpture in the MoMA show, so she could try it out. He stayed in the guest house, relishing the clarity of FM reception, and cemented *Detroit Queen* in place outdoors. Orswell sent him off with a bottle of Pouilly and some pâté. On the trip home, Smith visited Andrew Ritchie, who had just gotten out of the hospital. From the many drawings Smith brought with him on his truck—what he referred to as his "art mobile"—Ritchie bought one for the museum collection and one for himself.[4] Before leaving New Haven, Smith loaded up on fish, lobster, clams, and cheese, which, with the wine and pâté, became a family feast at home. "Your approach to life—straight on, direct, with all one's being—is a great tonic," Orswell wrote to Smith.[5] She told him that she had installed *Cello Player* at a right angle to her de Kooning.

Anticipating that Fine Arts Associates would be irked by his direct sales, Smith asserted his sovereignty: "On the work which I own in your gallery, I do not want loaned outside of New York City limits, and no reduction made from our agreed upon price, especially where it concerns my equity."[6] His insistent independence from galleries would lead to a tiff with the Whitney in the fall. Without consulting him, the museum agreed to Otto Gerson's request to list Fine Arts Associates as his dealer. In anger, Smith withdrew *Sentinel I* from the upcoming Whitney Annual. After the museum said it would not "credit the work to Fine Arts Associates," he agreed to participate.

Smith was one of the four artists selected by MoMA to represent the United States at the 1958 Venice Biennale. The ten Rothko paintings and fourteen Smith sculptures were chosen by MoMA curator Sam Hunter; the Mark Tobey paintings and Seymour Lipton sculptures by Frank O'Hara, who worked for MoMA's International Council. Smith's sculptures included *The Fish*, which Orswell owned; *Australia*; *Tanktotem IV*; and three *Forgings*. Hunter wanted to include *Detroit Queen*, but Orswell would not part with it. When Smith offered to make a related sculpture for the Biennale, she felt betrayed:

It appears to me that if you want the QUEEN to go to Venice so badly that you will take the trouble to make another, that you should have her. If I can be relieved of my agreement to purchase her, and take some other piece instead, I will see that she is shipped out when I can get two men together . . . I will not do it without sorrow not to say tears, for I am simply mad about her and she is the pride of my collection; with the Rodin and Modigliani.[7]

Smith apologized:

I think I was clumsy, and I am chagrined at the result. I had no intention of negating any statements. The idea of finishing up another Queen, parts of which I had, was a hasty view of a solution. And one which would keep the Museum from bothering you for the loans.

It was without due retrospection on my part, and without any thot of duplication for monetary gain, or to break faith on a declaration. As I told you on the telephone there will be no duplication, nor request for loan. I am calling MOMA to make very certain on this last part.[8]

At the end of April, "financially a bit depressed" and a "bit cross" with Smith "for being dictatorial to Jean," Orswell mailed Freas a mink coat that she expected to be an exchange for a sculpture.[9] Mink was warm, winter in Bolton Landing cold. Knowing Smith put money from sales back into his work, she wanted to be sure Freas benefited from her Smith acquisitions. Freas, however, was insulted. "You think, 'Oh! Mink coat!'" she said. "This is the most bedraggled—it looked like somebody had walked on it, or used it on the floor, or something. Really . . . Nobody would have wanted that thing . . . A mink coat and a young girl is so inappropriate." She said that Smith offered to send it back: "And that's all there was to it . . . It was insulting to David, as well as me, and he didn't seem to get it."[10] Smith wrote to Orswell: "I trust [the coat] arrived OK . . . It was very nice but I was against it, in our case purely on symbolic reasons. It is not in my scale of association and it doesn't fit our life

in symbol. A mink coat in a truck is too sporty. I'd have to get a Diesel Mercedes Benz (which I would like)."[11]

Now Orswell was insulted. She assumed the decision to return the coat was Smith's:

> You were kind not to be furious at the trouble of returning the coat. But do not for a minute think I "understand" nor sympathize nor condone all that rot about symbols. I do not think you do either. You are too great an artist—I do not mean sculptor or metal worker just ARTIST in the broad sense—to be cringing with fear before symbols and associations . . . To be sure, mink is something only a woman could understand; it is not in a man's ken at all and it means NOTHING except lots of warmth with the lightest weight. Being a mere man you could not comprehend THAT.

She signed off: "Again thank you for all your kindness, forbearance, patience and generosity, though you may keep your symbols."[12]

In early May, Smith attended the opening of "Barnett Newman: First Retrospective Exhibition" at Bennington College, for which Greenberg had written a brief introduction. At the Five Spot, Greenberg had recently told Cherry that Barnett Newman was the best living painter. Cherry was miffed and mystified by this claim. "I'm with Clem on Barney maybe different reasons," Smith wrote to Cherry. "Barney brot something only Jackson had done before Maybe even simultaneous . . . Barney in 1950 was hot."[13] He passed on his enthusiasm to Orswell: "I upgrade Barney again, he brot a revolt an opening which never existed before, outside Pollock." Newman "may have arrived at his concept intellectually (contrary to my way of working) but he has arrived on his own, a pioneer and an influence on a lot of painters in their liberation."[14]

For many people, it was hard to know what to make of Newman's stripped-down paintings, with their minimum of pictorial incident, so different from Pollock's profusive and haunted webs. Vincent Longo, an abstract painter and teacher at Bennington, remembered that during the

exhibition, "people from other departments—faculty" asked him, "'Well, is that really art? What is it?'"[15] Newman's stripes ("zips") and rectangles, which he returned to again and again, without repeating himself, generated their own sense of origins and continuity. As with Smith's steel lines, no matter how thin, energy pulses through Newman's zips and activates, gives density to, the spaces around them. "[His] shaped emanations of color and light," Greenberg wrote in the catalog, "[have] far more to do with Impressionism than with anything like Cubism and Mondrian."[16] In his stainless-steel *Cubis*, Smith would arrive at his own "shaped emanations of color and light," animated by Impressionism *and* Cubism and Mondrian.

On May 5, Smith graciously turned down an offer from his loyal friend George Rickey to visit Newcombe College for a month in spring 1959. Thinking a year ahead was impossible. He felt besieged by family problems, dealer problems, and an unfinished commission for G. David Thompson. He decided to expand the shop and include a space for his painting, which, like his sculpture, was getting bigger. Money invested in the expansion would not be taxed. "This building you see is a beauty," he wrote to Cherry, "built as good as a general electric factory."[17] During the fall and winter, when he was working on the building twelve to fourteen hours a day, he did little or no sculptural work.

Without asking Freas, Smith decided to take her and the girls on a week-long trip to Ohio and Indiana. Wanting his daughters to feel connected to his roots, and needing this connection himself, he visited Decatur. It was time for his mother to meet Dida, now almost three. "My mother is 75 same age as Picasso and vigorous," he wrote to Orswell.[18] Photographs show Becca and Dida sitting side by side in a wheelbarrow; Golda and Smith stand nearby. Becca, Dida, and Golda are smiling. Dida looks considerably younger and more vulnerable than her sister. Smith looks tired and very mortal; he is unkempt, his face puffy. His affection for his daughters is evident, but he seems of another time and place.

In the photographs there's no sign of Freas, and Smith did not mention her in references to the trip. Freas did not remember the trip. But she was there. In a letter to her son, Golda referred to Freas's responses

to both daughters, adding: "Jean was surely a good actress as I never suspected any riff whatsoever. She did say she wanted to get a job when the girls got older as she would like to have her own money but that idea is so common nowadays that I just accepted it."[19]

On the drive home, Smith stopped at the Toledo Museum of Art, where he "saw Impressionists Monet—Rubens etc. Some fine things— some odds," and contacted an old friend on the board of trustees.[20] He also stopped at the Cleveland Museum of Art, whose director, Sherman Lee, wanted to borrow *Detroit Queen* for a contemporary art exhibition, unaware that the sculpture had been sold.

As Smith's marriage was collapsing, two friends and admirers had become a couple. "Hold your well known hat," wrote Cherry. "Helen Frankenthaler and Motherwell have found each other."[21] They were married on April 6, 1958. On May 22, Smith congratulated them: "I hope the greatest happiness and good work for both of you. It will be a wonderful [*sic*] for you, and I hope very productive. Two fine painters, its never been done before—one of you better take up sculpture."[22] For Frankenthaler, he made a gold wedding ring, ⅝ inch in diameter, thicker than a conventional wedding ring, so solid that it looked indestructible. To other friends, however, Smith confided some concern about the differences between the newlyweds. "Frankenthaler vs Motherwell seems the ideal—perfect antipathetic match," he wrote to Belle Krasne the day after Christmas.[23]

On May 30, Freas left for good. The night before, she began packing the new car her father had given her. At midday, she loaded the rest of her clothes and books, as well as her desk. Smith made no attempt to stop her, which came as a surprise. She expected him to erupt. "The reason I suspected the worst was David was being altogether too nice about my leaving. Not that he was nice about it—he was mean as he could be—but he was sort of taking it all—'Oh, it doesn't matter,'" she recalled. "You're too old anyway," she said he told her.

She put the girls in the car and drove to the always welcoming home of Douglass and Margaret Crockwell in Glens Falls. "The day that I left

was one of the worst days in my whole life," Freas said. "I'll never, never forget it. My legs were shaking so, on the foot pedal of the car, that I didn't know if I could get out of there."[24] Interviewed as an adult, Rebecca said, "I was totally unprepared for it. Suddenly, my mother was putting us in a car, and I really, really didn't want to go. It just seemed inconceivable and hideous."[25]

Katherine, Freas's mother, joined her for a week in Glens Falls, where Freas unloaded her feelings. She hired a lawyer. Smith was given visitation rights to see the girls two days a week during their three months in Glens Falls. Freas would retain custody. Smith would have the right to spend four weeks with the girls in winter and six in summer. He balked about paying child support unless they lived near enough for him to see them six months a year. Freas wanted him to pay her $5,000, "which she claims she put in during our 5 years marriage," including on clothing, medical, and household expenses, Smith wrote to Cherry.[26] He was ordered to pay $250 a month alimony.

A couple of weeks after Freas's departure, Smith went to the city, where, he wrote Orswell, he "attended Ionesco plays and an avant-garde piano recital" and a "bachelor dinner for fourteen artists."[27] He also visited East Hampton. Many artist friends were there, including Franz Kline and the sculptor Wilfrid Zogbaum; Greenberg, too. Smith let everyone know that he was now a bachelor, and he bemoaned the loss of his kids. Friends fixed him up with young women, who gave him no solace. The most common reason he gave for the breakup was "incompatibility." "Jeannie has moved out with my kids and is living in Glens Falls," he wrote to Orswell. "Her lawyer will either get a settlement and legal separation for her this or next week. There are no other people involved, purely incompatibility."[28] Smith returned to East Hampton twice more that summer, on one trip making six paintings, and considered renting a cheap studio in the city. Among the books that he ordered was Ernst Kris's *Psychoanalytic Explorations in Art*.

Other explanations for the marriage failure spun through Smith's mind. "I don't know what happened to us," he wrote to Kenneth Noland. "Maybe we are both married to fathers, at least Jean is—she never grew up from home. Every 2 weeks we were married she threatened to return to pappa, now she has . . . Alimony to her when she lives with

Big Daddy is a bit hard on me."[29] Gloria Gil of Bennington Pottery, with whom Freas spent a few days while living in Glens Falls, recalled Smith saying: "You know, my first wife was my mother, my second wife was my daughter. I could be so happy with a real woman." Gil added: "There was a certain wistfulness in him. He wanted a companion, but he didn't. He didn't want anything to interfere with his work."[30]

Smith was miserable. Joyce and Baird Maranville lived in Bolton Landing, where Baird ran the gas station. When Freas left, Joyce said, "[Smith] came in, he sat down in the living room . . . He was crying—he said he felt like he'd lost his girls, and he absolutely worshiped the two girls—Dida and Becca."[31] "Have never fealt worse personally," Smith wrote to Cherry. "I see the little girls growing up away and apparently Jean has a right to take them anyplace. Courts always do that—and I'm in hock forever—but I'll get a divorce as soon as possible after the legal separation." Alone again, he felt vulnerable and old. He wanted a family unit but did not want a woman his age and did not want more children: "I love my own kids—and new kids would seem like infidelity of some sort."[32]

Freas was getting herself together. She wrote that her "relationship with the girls has a balance & peace I've not had since their infancy." She was trying to come to terms with Smith's "hypocrisy and cruelty."[33] She told her mother, "The last fragment of sympathy for David, the last fragment of the image I had of him is gone. Even when I left him I felt he was a worthwhile person whom I couldn't get along with. I don't feel that at all now—& it makes things easier . . . David receives so much sympathy—'lost his children'—etc. If he wasn't famous, the same people who commiserate with him would be calling him an impossible bastard."[34]

Golda commiserated with her son:

So, so sorry to hear of Jean's leaving or that there was a cause for her going.

Those dear little girls how they will miss their Daddy.

I thought by all appearances you had found your happiness . . .

Wish I could do something to help but as you say it is your problem . . .

When I think of you away out there in the mts. I become
lonesome also . . .

Have no intentions of contacting Jean. I have not known
her or loved her for 25 years, like Dottie.[35]

In mid-September, Freas moved in with her parents in Bethesda. "I
remember really vividly the moment, ringing the doorbell at their house,
when we got to my grandparents' house, and looking at the door," Dida
said. "Then the door opened, and this sort of strange woman answered.
It was my grandmother." She felt trepidation, she said. "Would they
take us in?" Katherine became Dida's good grandmother: "[She] was the
world's most loyal person, and my own sort of confidante, in a way."[36]

"A very solid, regular little brick house, and it was painted kind of
light yellow," Becca remembered. "There was a beautiful, beautiful back-
yard, full of all these . . . azalea plants, in all these different amazing
colors. It was beautiful, really beautiful—and a couple of dogwood trees,
forsythias, lily of the valley . . . It felt very safe, but stifling."[37]

"Out there, they were all Republicans, so you had mostly mid-level
civil-service types," Dida said. "Horrible people. Horrible! And the kids
would tease me: 'You mean your father doesn't work for a living? He just
draws pictures?'" Bethesda was, in her word, "vicious": "I was scared to
play on our front lawn."[38]

Unaware that Freas had left, Dehner contacted Smith about the work
that she had left behind. She congratulated him on being selected for the
Venice Biennale. He told her that he was working on an addition to the
shop and mentioned her work still at the farm. "I'll bring everything,"
he wrote to her, "and let you do as you wish. I'll try to get everything—
I haven't gone thru drawings in little barn, but will do so as soon as pos-
sible . . . I've had plenty reverses, its not all roses but no complaints. See
my kids most weekends—Jean living Glens Falls getting separation."[39]

In the early fall of 1958, Dehner returned to Bolton Landing:

> David came rushing out of the house, and we embraced as if
> it were half an hour since I went shopping, or something like
> that. It was a tremendous emotional, overwhelming kind of
> situation. He said, "Well, I've got your paintings. They're all

wrapped up. They're all corded up in bundles. I've kept them dry," and so on. So he went into the cellar and he brought them . . . He said, "The rest are in the barn." I went in the barn, and my God, there in the musty hay . . . The roof was leaking on them, and they were ruined. It was terrible.

The leaking roof had ruined Smith's paintings as well. Dehner continued:

We talked to one another all day. It was like walking on very delicate, little, silver threads; walking up high, like in the circus trapeze, balancing on things. He said, "Well, come on in. I made a feast for you." And he did, indeed . . . He threw logs on the fire in my studio, and it was friendly, and tremulous, there was no anger, and he said, "You know, I've lost all my hostility to you" . . . I didn't have hostility for him. I had compassion by that time, because I felt he was an anguished person . . . I didn't say anything about these spoiled pictures. I was afraid. I didn't want to start any explosions.

Dehner returned to Croton-on-Hudson, where she was living with her husband, Ferdinand Mann, and destroyed the ruined paintings: "I burnt these things up, they crackled, and my life crackled away in flames a bit, a whole hunk of it." The four bundles of paintings that were okay she would not open because "all the rest had been so ruined." She asked her husband to store them. "After he died, the fellows from the shop brought them to me, because they were tagged with my name and address," she recalled. When she opened them, she saw that "each of the bundles had a David Smith painting in it. There were three paintings, and one of them had a picture painted on both sides of the canvas. They were all significant. One was done while we were in Paris, one at the farm, one in New York, and one in Greece."[40]

For Smith, Dehner's visit was heartening: "Dorothy was up to get her paintings etc. We spent a full day, very wonderful, reviewing things life, etc. I'm glad she is happy and working so good." Smith contrasted Dehner with Freas: "My present wife gets 250 month alimony and is a roaring bitch on the phone still chewing me out even after leaving." She

is "not like the lady Dorothy was, or is naturally."[41] Either on this or on a later occasion, Smith asked Dehner to return. "He begged me to come back after his second marriage broke up," Dehner told Miani Johnson.[42]

When Clement Greenberg and Jenny Van Horne, who married in 1956, visited Smith that fall, they arrived at night. This was Jenny's first visit, and she found the house stark, with no sign of a woman's touch. Dinner featured a deer Smith had shot. After dinner, "as the men settled in for more talk and cigars," she realized that her job was "to play the woman's part and clean up." She recalled what happened next:

> I was at the sink, washing the dishes, when David suddenly appeared behind me. He startled me with his closeness and anger. That graveled voice boomed. "Where do you think you are? Have you ever heard of a well? Do you think the world is made of water?" I heard the unspoken message. *You good for nothing stupid bitch!* He pushed me aside, turned off the water, grabbed for a dishpan out of thin air, slammed it into the sink, and started doing the dishes as he and God intended. He flung me a dishtowel. I wanted to scream, punch him, hang him from a tree. I didn't. I wanted Clem to punch him. He didn't.

They spent most of the next day in the shop-studio. Like Dehner and Freas, Jenny felt comfortable there:

> I liked the feel of it. It was what a sculpture factory should be like. The possibilities—anything could materialize. The men were so happy there, and now and then we went out into the fields to look at the finished pieces mounted on their concrete slabs. Everything was warmed and softened with the sunlight . . . I saw those steel pieces, some delicately filigreed and soaring, some as hefty as David, soldiering as they caught the sun and threw their shadows across that large field that sloped away from the cinder block house . . . This morning I liked where I was.[43]

New York City

Smith depended on the city now. When he needed sympathy for his wife driving off with—he often used the word "stealing"—his kids, he could count on receiving it there. When he needed to hook up with young women, he found them there. During his monthly visits, he could attend art world parties and be a regular at his beloved Five Spot. The Cedar Tavern became a stomping ground again. "Haven of lonesome lukes" is how he characterized it to Cherry in November.[1] In downtown Manhattan, as in Bolton Landing, he was on a first-name basis with shop owners. "When we'd go to these restaurants, these ethnic restaurants," Sidney Geist said, "I was amazed at the level of friendship he had with the people, the cooks, in the back."[2] He had driven to Connecticut with his "art mobile." Now he would move through the city carrying a notebook filled with photographs of his work. "He'd show them to [*ArtNews* editor] Tom Hess, etc., Clem, just anybody he happened to run into," Ken Noland said.[3]

Across the street from the Five Spot was the Dom (Polish for "home"), the site of dancing girls. The Dom, the painter Alfred Leslie said, "opened up as the kind of place in which you could do legal dancing, whereas, at the Five Spot, there was entertainment but you weren't allowed to dance." Leslie considered the Dom a transitional place, one in which "the drug culture, the generation after me—the acolytes of the

early Warhol group" soon gathered. "I saw David there many times," Leslie said, and recalled an incident involving a "fresh bride" who was "married to somebody everyone knew." Smith was friendly with both husband and wife. "She came in with a bunch of guys and, clearly, she was having an affair with one of them." Leslie and Smith "were sitting there drinking, and all of a sudden he saw her, dancing with these guys." He "rose up like a Goliath, in rage and anger. He got up and he just walked over, onto the floor, like out of a 1930s film. He pushed this guy aside, he grabbed her, and he said, 'I'm taking you home, right now,' and he dragged her out."[4]

Smith's social network included collectors, critics, curators, dealers, and editors, as well as writers, musicians, and, of course, other artists. New York City was its center, with offshoots in Bennington, East Hampton, and Provincetown. Cherry, Wilfrid Zogbaum, James Rosati, and the painter Landès Lewitin were part of one of Smith's core communities; all had close connections with de Kooning. Greenberg was the heart of another group that included Noland and the painter Friedel Dzubas. At the end of 1958, when Smith began staying at the Chelsea Hotel, he became part of yet another nexus—the "23rd Street boys"—which included Hilton Kramer, Adolph Gottlieb, and *Life* photographer Gjon Mili. He remained in contact with artists he had known on the WPA, and with a Woodstock group that included Cherry, Philip Guston, and Fletcher Martin, as well as with painters who may not have belonged to any group, like Newman, Rothko, and the painter Michael Goldberg.

The groups frequently overlapped. Smith saw Franz Kline on Long Island, in Provincetown, and in Manhattan; de Kooning on Long Island and in the city. He saw Frankenthaler and Motherwell, and the painter Fritz Bultman and his wife, in Manhattan and Provincetown. He saw Eugene Goossen in Bennington and Manhattan, where Goossen, like William Rubin, was in regular contact with Greenberg. Rubin was an up-and-coming critic and art historian who was teaching art history at Sarah Lawrence. In 1967, he was hired by MoMA, the institution with which his name and curatorial vision would become inseparable. Various cultural communities intersected at the Five Spot, where Smith could find himself in the same smoke-filled room as Frank O'Hara, with whom Smith developed a special artist-writer relationship, and other

poets. While most of the artists' gathering places were downtown, in the East and West Village and Chinatown, the Motherwells provided a social magnet at their Upper East Side townhouse at 173 East Ninety-Fourth Street. At one of their grander parties, in February 1959, guests included not just a cross section of New York artists but art world figures from Europe.

Gjon Mili threw famously extravagant parties, too, for an even greater variety of guests. He came to the United States from Hungary in 1923, at nineteen. For *Life*, he photographed prizefights and concerts, Harry S. Truman, Adolf Eichmann, and Chartres Cathedral, as well as Picasso, Braque, Matisse, and Jean-Paul Sartre. His 1939 photograph of a cockfight may have helped inspire Smith's 1945 sculpture of that title. His 1949 photograph of Picasso in Vallauris, France, drawing a centaur on glass with a beam of light, is iconic. On October 27, 1958, Mili gave a birthday party for the conductor Alexander Schneider, at which Smith was present, along with the cellist Pablo Casals. Although Smith's interest in music is largely identified with jazz, and to a lesser degree with avant-garde modern composers like Arnold Schoenberg and Igor Stravinsky, he spent more time listening to classical music. WQXR, New York's classical music station, was a constant in his life.

Like Smith's sculpture, art evenings could have an astonishing fluidity. Smith might have dinner in Chinatown, go to the Cedar for a couple of hours, walk the streets arguing and gossiping with people he met there, go to another night spot and take yet another walk, finally ending up at two or four in the morning in someone's apartment. Or an evening might begin with cocktails at Greenberg's apartment at 90 Bank Street, in the West Village, move to the Five Spot, and end up at a different apartment for more booze and banter. Such evenings were not just free-flowing and open-ended; they had an unpredictable seriality. Each event was related or akin to the preceding ones, but the movement from one to another was improvisational, and to those outside the evening's rhythm, the connections within the trajectory of a night might be a challenge to grasp.

Smith loved the ever-changing aesthetic and generational mix. One night at the Cedar, "David came in with [the abstract painter Bradley Walker] Tomlin," Leslie said. Then Edwin Dickinson came in. In his late

sixties, "dressed like a Victorian gentleman," Dickinson was a respected figurative painter, a resident of Provincetown as well as Manhattan, whose skillfully narrated compositions were a model of achievement at the National Academy of Design. "Then, all of a sudden," they were all sitting there, Leslie said. "It was Dickinson, Tomlin, David, and myself. And David said—I can't quote him exactly, but something like, 'Look at the spread of generations here.' It was something that he not only acknowledged but he had a feeling for." The "cohesiveness" across generations "was a crucial part of the street life of artists."[5]

Jenny Greenberg felt a closeness to Smith within the collective intimacies in the city that she had not felt upstate. She described an evening in which she and Greenberg went out with Smith, a girlfriend, and de Kooning:

> We hit the Five Spot to listen to jazz and met up with more people and then headed off to some parties. Bill drifted off, probably to the Cedar. We four wound up the night at the Chelsea Hotel, where David often stayed when he was in town from Bolton Landing. This time he had one of the penthouse rooms huge and shabbily grand, and on an oversize low table, in a bowl as big as a salad bowl, was grass. Clem and I were new to all that, but we gave it a try . . . David made a production of rolling a joint. I was fascinated by his big beefy hands, hands that could weld monuments of soaring steel, now so deft at such a delicate task. He lit up and earnestly demonstrated how to inhale. We passed the joint to one another. I liked that ritual. It bonded us.[6]

In this interconnected art world, artists were eager to know what other artists were making, the prices for their work and income from sales, with whom they were showing or thinking of showing, who was writing about and collecting them, and who was sleeping with whom. Although most artists of Smith's generation continued to live and act as if art were still anathema to corporate and celebrity America, money and glamour were now permeating the art world and reaching artists who had grown

weary of financial struggle even as they continued to assume that artistic necessity was incompatible with money and success. When MoMA bought three paintings from Jasper Johns's first show at the Leo Castelli Gallery in 1958, other artists knew about it. When Kline, on July 31, 1958, bought a fancy new car, news spread quickly. "Franz has a Thunderbird," Smith wrote to the Motherwells a few days later.[7] On October 17, he wrote to Cherry that his expanded shop "will be a beauty and cost about 2 Thunderbirds."[8] When Rothko got a lucrative commission to paint a series of murals for the Four Seasons, a swank East Side restaurant designed by Ludwig Mies van der Rohe and Philip Johnson, it, too, was an event. "Rothko got a 30,000 offer for 6 or 8 panel paintings for the Seagrams house," Smith noted.[9] If his painter peers, as well as younger painters, were profiting from the new money and prestige, Smith had to consider the consequences of these changing conditions, not just for himself but also for sculpture.

Smith's best buddies were Cherry and Noland. They palled around together and discussed art, money, women, sex, and particular Smith concerns: Freas, the girls, Bolton Landing, his hopes and fears, highs and lows. Cherry and Noland had great admiration not just for what Smith made but also for his capacity for work. "David knew more about how to go about working than any other artist I've known personally; in this sense he was an example for us all," Noland wrote.[10] Noland remembered how Smith looked at art: "He looked at it by taking a stand in relation to it. When David would look at something, he'd look at it, and he'd understand it, relative to himself . . . That's where I think he got a lot of titles, a lot of concepts of 'series' that he worked in."[11] Smith, in turn, stuck his neck out for his two friends. He pushed Noland's painting with Lois Orswell and Joseph Hirshhorn, who bought three paintings at bargain prices when Noland was in dire need of money.

Smith's letters to Noland and especially to Cherry could be startlingly uninhibited. In the immediate aftermath of Freas's departure, when his hunt for sex was obsessive, he wrote to Cherry about women who were on his mind and promised not to hit on any that Cherry was still interested in. Smith did not hold back: what he thought and felt he said. He knew that these friends would not chastise him even if his overtness and his objectification of women were more extreme than what they would

express themselves, certainly in letters. Smith could speak of women like meat: "Need a hot cunt for diversion. Haven't found a really good one in NYC yet."[12] The misogyny is blatant and disturbing, but it was precisely the unedited force of his speech and personality that made many people, particularly other artists, including women, believe and *trust* him, even if they did not like what he said, and Smith's unbound coarseness can be linguistically surprising in ways that suggest a generational interest in the novelist Henry Miller and in the no-holds-barred obscenity that was or would be emerging in the writings of William S. Burroughs and Hubert Selby, Jr. His coarseness contributed to an aura of defiance and authenticity. It reveals the mix of rage, vulnerability, buoyancy, and desperation packed within him at this moment. This mix had a terrible and fertile potency.

Smith's friendships with the sculptors Wilfrid Zogbaum and James Rosati were also indispensable, but he was different with them. He was not a rogue or outlaw. These artists were more family than buddy; his boundaries with them were more defined. Zogbaum, born in 1915, studied with John Sloan and Hans Hofmann. When he and Smith were members of American Abstract Artists in the late 1930s, Zogbaum was a painter and a talented photographer. He served in the Pacific during World War II and by the mid-1950s had begun to sculpt in metal. In the fall of 1958, Zogbaum and his second wife, Marta, visited Bolton Landing, and Smith visited them in Springs, Long Island, in a place that Zogbaum and his first wife, Betsy, now Kline's partner, found through the Pollocks. Zogbaum gave Smith the key to his studio at 107 Bank Street, almost across the street from the Greenbergs. His studio was another essential gathering place.

Rosati was a rock in Smith's life and his most important sculptor friend. He spoke more about sculpture with him than he did with anyone else. Their discussions could go on well into the night. Six years younger and seven inches shorter than Smith, Rosati grew up poor in a coal-mining town in western Pennsylvania. His first language was Italian. According to his daughter Margaret, when her father was a boy the housekeeper for one of the upper-class families in town "took a real liking to him and would bring him over to the house," where Rosati was introduced to books and the piano. When he was nineteen, Rosati played

the violin in the Pittsburgh String Symphony. "[He] always loved classical music. All my life my father played," Margaret said. In her 1964 profile of Rosati in *Art International*, Dore Ashton wrote that he taught himself stonecutting, modeling, and casting, "and became interested" in welding "while working in an airplane factory during the war." Rosati said, "When I saw what they could do with steel—bending and shaping those huge sheets—and when I saw the beauty of the great dies on which parts were cast, I became even more interested in forms as forms."[13]

Rosati visited Smith's shows at the Willard Gallery and occasionally struck up a conversation with him. Around 1955, they ran into each other at the Cedar Tavern and got into a discussion about Julio González. The next day, Cherry brought Smith to Rosati's studio off a courtyard at 92 East Tenth Street. De Kooning's studio was in an adjacent building; from the fire escape he could climb into Rosati's studio, which he often did. Rosati (who went by Jimmy); his wife, Carmel; and their three children lived at 252 West Fourteenth Street, two or three buildings west of where Kline lived. The Smith-Rosati friendship took off. Jimmy and Carmel provided an oasis for Smith, welcoming and often feeding him. "I can't tell you how much the friendship" between Smith and Rosati "meant to both of them," the painter Peter Stroud said. Rosati's place was "a safe haven for David. He would go there any time he wanted."[14] Smith convinced Otto Gerson of Fine Arts Associates to look at Rosati's work. "Our work . . . is visually different, but our attitudes were the same," Rosati said. "That's why we were so close and became very good friends . . . I worked not with the purpose that somebody likes this kind of work or this critic likes that kind of work, but . . . to make the best damn thing I could possibly make. It had no purpose for existing other than the fact that it expressed at that particular time something very definite within me. I found the same thing with Smith."[15] Rosati had a reputation for honesty. "He is one of the few artists that keeps out of the wrangling and competitive madness that goes on all around New York," Cherry said of him.[16]

By the end of 1958, Smith had found his city residence of choice for the next four and a half years: the Chelsea Hotel, at 222 West Twenty-Third Street, which was famous for its community of creative people. Dylan Thomas, Diego Rivera, Frida Kahlo, Allen Ginsberg, and William

S. Burroughs had lived there, and Hilton Kramer was a current resident. He and Smith periodically had breakfast together.

On December 20, Smith told Gerson that he had not decided whether to go with French & Company, where Greenberg had recently taken an advisory job. After specializing in antiques, French & Company was now making a commitment to contemporary American art. The gallery was on the Upper East Side, above the Parke-Bernet auction house at Seventy-Sixth and Madison Avenue. Greenberg lined up shows for Newman, Gottlieb, Dzubas, and Smith, as well as for Noland, Morris Louis, and Jules Olitski, younger abstract artists he would champion. Gerson believed Smith had made up his mind to show with French & Company and was livid: "Don't you think you should have told me about such plans while they were in the making instead of confronting me today with the FAIT ACCOMPLI. Your lack of consideration for Fine Arts Associates and your indifference to our past conversations and agreements is of great concern and puzzlement to us all." Gerson reminded him of "certain verbal agreements in addition to the understanding we had reached when Jane and I came to your studio. At that time it was agreed that you would always give us first choice and first refusal regarding your sculpture, and during our recent conversations you repeatedly agreed that you would not sell to other galleries or dealers but that such business should go through us." Now that trust had been compromised, "the moment has come when we should release you from any obligations regarding our gallery."[17] Reminding Smith that he had said he would always be willing to buy back works from him, Gerson asked him to buy back *Sentinel II* and *Pilgrim*, for each of which the gallery had paid $3,850. Smith did.

Smith assured Gerson he meant no unfriendliness. "I am considering 2 commissions from" French &. Company. "I am considering the offer of a show of my 12 to 18 ft work within the next year or two 1960 or 61. The size of these works are such that only a high place roof or museum garden could accommodate them."[18] Gerson made strict demands on Smith, including exclusive presentation. Smith resisted them. Their connection continued.

Freas, too, was livid with Smith. She lit into him about his behavior during their marriage and demanded more money for the children.

Negotiations were bitter. He was complaining about her to everyone he knew, and she was complaining about him to everyone she knew, and each received regular reports about the other's complaints. After agreeing to his seeing the girls over the Christmas holidays, she reneged, then finally agreed, driving them to Bolton Landing. For two weeks, he doted on them, cooking for them and taking them ice skating and putting curtains in their freshly painted room. After their visit, he brought them to Schenectady and put them on the train to Washington, apparently, and shockingly, by themselves—a nine-hour trip for two girls just three and four years old. A few days later, "sad and empty . . . after they left," Smith wrote to Cherry: "Am in debt high now. Have no incentive to make any money either. Would just as soon go bankrupt and let alimony try to be collected in that. I'm really low today."[19]

For the New Year, Hilton Kramer wished Smith "good health, a happier life and much good work."[20]

51
The Diner

As essential as the city was to Smith, his home was Bolton Landing. That's where his shop and fields were. That's where he worked, hunted, fished, and roamed the woods and spent most of his time. After Freas left with the girls, he bought a hi-fi system and a television. He also built an artesian well that would finally provide all the water he needed and render the outhouse obsolete. Of these additions in the wake of her departure, the one that most irked Freas was the well: "Every time I think about it . . . I get angry. [Now] you could flush to your heart's content."[1] His expanded shop would have an office and bathroom, as well as more light and up-to-date machinery. From the new shop terrace, he would have a panoramic view of the fields.

The quiet upstate contrasted with the international excitement that was building around his work. He had been a featured artist in the 1958 Venice Biennale. In 1959, his sculpture would be included in the two other major international art extravaganzas, documenta in Kassel, Germany, and the Bienal de São Paulo, where he would share the American spotlight with Philip Guston in an exhibition organized by Sam Hunter, who had left MoMA to become chief curator at the Minneapolis Institute of Arts. Hilton Kramer was planning a Smith issue for *Arts*, and Emanuel A. Navaretta was planning a book on Smith for Grove Press, to coincide with the opening of his show at French & Company. In Bolton

Landing, Smith didn't talk about his art or achievements. From news-
papers and magazines, and from the men who worked for him, towns-
people were aware of his growing stature, but they knew little about his
work, city life, or career.

Nevertheless, Smith was an integral part of the Bolton Landing com-
munity. Townspeople appreciated his neighborliness and conversation,
and respected his work ethic and know-how. They knew that Bolton
Landing was where he *wanted* to be. He provided and paid fairly for part-
time jobs, hiring local workers to haul ever-larger metal sculptures from
the shop to the fields and affix them to cement bases. He helped friends
in trouble. "He was very generous, very generous," Charlie French, one
of Smith's periodic helpers and a beneficiary of his generosity, said.[2] He
went out of his way for young people. When the son of Don Snyder, a
regular at the town diner, "bit an electrical cord and it burned his mouth,
severely distorted it," Smith "wrote a blank check and gave it to them." He
told Snyder, get your "son fixed up."[3] After his daughters left, he became
a regular at school board meetings, where he would often sit with John
McElroy, a military brat and World War II veteran. As a result of a tram-
poline accident, Johnny Mac was a paraplegic, and Smith was protective
of him.

In ways expected and unexpected, North Country residents contrib-
uted to Smith's work. His found objects still came mostly from Vermont,
New Hampshire, and the Adirondacks, where friends and acquaintances
were on the lookout for industrial and agricultural relics for him. When
they saw something he might be interested in, they threw it in their trucks
and brought it to him. They could see the impact of their contributions not
only in his work but also in the ever-larger scrap heap across the driveway
from the shop. "He was a scavenger and everyone knew it," Freas told an
interviewer in 1973. "And they'd bring him things . . . No one was raving
over him as an artist. They'd frankly said, 'I don't understand that. What's
that supposed to be?' But nobody ever said, 'He's a nut.'"[4]

In order to install a new furnace system, Milo Barlow dug out his
cellar. He recalled:

> While I was in there I come across a skeleton of a cat . . . It had
> crawled in there at some point in time and died . . . I happened

to be coming out with that in one piece when Dave was going by, and he stopped. He used to do this a lot. He'd stop, and just visit for a minute, then go on about his business. He spotted that and he said, "Oh, my goodness. What are you going to do with that?" I said, "Is this something you want, Dave?" and he said, "Absolutely." So he took it.

The cat skeleton was not unlike the dead black bird Smith had picked up in Arkansas on the day of his and Freas's wedding and incorporated into a work. When Barlow saw a drawing in Smith's basement of what looked like the fossilized cat, he asked: "Is this the cat?" "Yes, it is," Smith replied.[5]

With no one to make breakfast or bring him the paper, Smith became a regular at the Bill Gates Diner, a place that is singled out in almost every discussion about Smith with a Bolton Landing resident. "The little diner was right next to the blinking light, the amber light in the winter, red light in the summer," remembered the photographer Dan Budnik.[6] It "was really the nucleus of the town," Dave Rehm, a Smith neighbor, said.[7] In the 1960s, the diner was featured in a segment of Charles Kuralt's popular CBS Sunday morning program *On the Road*. Smith's presence in it helped to ensure its survival as a regional landmark, first in the Adirondack Museum in Blue Mountain Lake and currently in the Champlain Valley Transportation Museum in Plattsburgh.

The diner began as one of a hundred trolleys built by the Jones Car Company around the turn of the twentieth century in order to provide passenger service from Albany to Warrensburg. The trolley was 30 feet long, 10½ feet wide, and 9½ feet tall. By the end of the 1920s, automobiles had rendered trolleys largely obsolete. In 1937, the Liapus brothers from Glens Falls converted one of them into a diner and leased a location for it on Main Street in Bolton Landing. In 1949, thirty-year-old Bill Gates and his wife, Dawn, bought it. During World War II, Gates had served on a destroyer and was a welder at the American Locomotive Company in Schenectady. Gates was a huge man, six foot four and around 265 pounds.

The diner had eleven counter stools and eight two-person booths. Bill and Dawn, ever present, gave the place a family feel. They left it unlocked

so that customers who arrived before it opened could make the first coffee. Bill Jr. and his brother Bud were occasional waiters. "I ate here before I went to school," Bill Jr. said, "so I had breakfast with David Smith almost every morning. All the locals would come in. In the morning it was pretty much a man's place; in the summers, it was a family place. Politics was discussed. There was a tremendous amount of humor . . . I used to hate to go to school some mornings, because it was really rolling there."[8] The banter, like the banter in the city, could have an edge. "Your welding looks like chicken shit," Gates told Smith. When Bill and Dawn decided to move to another house, Smith said he'd give him a large sculpture if they'd make the move before Thanksgiving. "My father loudly retorted by telling David that he valued his long friendship but that he'd 'promised Dawn the new home wouldn't have any junk in the yard!'"[9] Bill Jr. believes that by calling Smith's work junk, his father and other local residents were letting him know that they liked him apart from his art. "We all started knowing that David Smith was a pretty important guy. We also wanted him to know we didn't care, we liked him the way he was . . . He could come in there and not be an artist. He could just be one of the guys, which he really was. He wanted to talk politics, hunting, fishing, and all that."[10] "If you knew the people" in the diner, Frances Herman, a painter who did housework and clerical work for Smith, said, "it was like being in the middle of a really good cat fight."[11] "He was a credit to my place," Bill Gates said of Smith. "It seemed like every time he came in here, there was a lot of hell-raising. By mouth only. It would get hilarious in here."[12]

The diner opened around six in the morning. "Everyone had their time slot," Henry Caldwell, president of the Bolton Historical Museum, said. "You could count on certain people being there at this or that time. All the people at that time would be friends. And they'd leave and the people in the next time slot would arrive. My slot was at seven. When I didn't show up, I'd get a call."[13] No longer rising at ten as he had when he was living with Dehner and Freas, Smith was on an early shift. He could be as chatty as other customers, but he could also be silent. He could eat lunch there as well. An enduring memory within diner lore is of a sore-throated Smith walking in, asking for a pen and paper, and drawing his order—cheeseburger and pickles, cherry pie with ice cream on top, and

coffee with cream. Gates put it on a hook like the other orders. "That was beautiful," Gates said. "That I'd rather have than one of his sculptures."[14]

Smith "came in and had breakfast, kidded around, then he went to work," Dave Rehm said. Rehm lived down the road from Smith, who gave him Moonshine after Freas's departure. Rehm remembered Smith's "eccentricities." "He used to wear these little, small goggles sometimes, instead of the big mask, and when he would wear those . . . sometimes his face would be dirty from the smoke, but his eyes would be white, from where the little goggles were, and I used to think, as a kid, he had raccoon eyes." Rehm remembered that Smith smoked "a cigar with his lips . . . it was always with his lips. He would roll them in his lips." When Smith was working, he didn't want anyone to bother him, Rehm said, "but when he wasn't working, everybody was welcome" to drop by "and it was a fun thing."[15]

Now Smith increasingly returned to town after dark. "Days and work are ok—It's the nights that are the worst," he wrote to Cherry.[16] Of Bolton Landing's restaurants and bars, he still preferred Alex's, which Dehner had pictured in her series *My Life on the Farm*. Many people, including Dida, remember with fondness Mary Drooby, the Lebanese woman with dyed black hair who ran the restaurant. Drooby looked after her customers, and they confided in her. Like the diner, Alex's had a family feel.

But Warren County had, of course, many histories, some of which connected Smith to eighteenth- and nineteenth-century Decatur in ways that were less apparent than the communalities and resourcefulness of small-town life. The writer Jean Rikhoff lived not far from Smith and had an affair with him. In *Earth Air Fire & Water*, a memoir structured around the memorable men in her life—Smith is "fire"—she made it clear that Smith had an understanding of backwoods violence:

> Smith was a dark, dense man and these dark, dense woods had always attracted dark, dense men. First, in the eighteenth century, came trappers, and then, in the nineteenth, big, muscular, hard-drinking loggers. Whether they were trappers or loggers, they were violent. Their cruelty seemed absolutely matter of fact. Boys cornered animals—rats, pet dogs and cats, squirrels, rabbits, deer, feral dogs and cats—solely for the purpose of tor-

menting them, backing them into corners where they could not escape and shooting them with BB guns, pounding their paws with rocks, throwing kerosene on them and setting them afire, shoving objects up their rectums and down their throats, picking their eyes out with sticks. People criticized bullfighting because it was cruel, but what went on in the bullring paled beside their random acts of cruelty . . .

David *looked* like one of those men. No one messed with him, not just because of his size, but also because he had a dangerous predisposition to go out of control at unexpected moments. The man who ran the gas station told me to look out for him. He didn't mean David was predatory in sexual matters; he meant that if I did something to make David mad, he could lose his temper. People got out of his way when he lost his temper.[17]

Smith told Ken Noland a story of what happened when local men tried to mess with him. Whether it's true or not—and some Bolton residents don't believe it—Noland liked telling it, and the story is indicative of Smith's awareness of local residents who were hostile to or scornful of him, and his imperative to make them respect him. During winters, Noland remembered, Smith would get into arguments in bars. Knowing that he was an artist, the men "would tease him, in various ways, and one guy, one night, attached something to the starter," so that when Smith "went out about 1:30 in the morning to start his truck . . . smoke started coming out, and all the guys were staring at the window, watching him." Smith knew who did it, and a couple of days later he took his "pistol and he shot a hole right through the doors of the guy's car . . . right through the front seat of the guy's truck. And he said he didn't have any more trouble with those guys."[18]

In 1959, Smith hired as an assistant Leon Pratt, who had served in the navy before becoming an electrician, plumber, and master welder. During the war he, like Smith, had worked on tanks at ALCO. "When Dave needed somebody to do some welding and he was trying to get something else done, or just needed two men to move and handle and hold, get the right angle on a piece to hold it where it had to be," he asked

Pratt, said Leon's son Tom Pratt. "Obviously he had lifts and things, but he didn't have an extensive amount of equipment to put something into the exact position he would want it, and then weld it. So he would need somebody to hold a piece, push, or something." When Smith realized he needed someone to work for him full-time, it was obvious that having a master welder would be "a boon for Dave . . . somebody who could handle all the different kinds of materials that he worked with. And a boon for my father because it was someplace right there in Bolton Landing where he could make a living without having to travel."[19]

Pratt had been a policeman in town and liked to hunt and fish. He was reserved, reliable, and well respected, with a formidable work ethic. When he drank, it was usually alone. "He wasn't an everyday drinker, but when he went on a bender, look out," Smith's helper Charlie French said. "When he went on a tear, he might be at it for two or three days. If you didn't know him and hadn't been around him that much, you'd never realize that."[20]

Tom Pratt described his father as "not huge but six foot, very strong, a very powerful fellow. So the pair of them would haul and twitch these hunks of metal around." As they did, Smith would kick the pieces of metal into configurations on the floor. "Finally Dave would say, 'Well, tack it up and let's see what it looks like.' At that point Dad would . . . spot weld, just to get an impression of what the overall piece was going to be like; whether or not Dave really wanted it quite like that, or he wanted to change the angle on the given piece. It was very casual, the way they worked, extremely casual. I don't know of any disharmony between the two. The two really seemed to get along very well." For the rest of Smith's life, Pratt would be his right-hand man.[21]

52
Battles

Although Bennington, Vermont, was seventy mostly back-road miles southeast of Bolton Landing, Smith thought nothing of driving there for a show, a party, or some other event. Bennington College was progressive and experimental, its student body consisting largely of gifted women. Many of its students came from progressive families in which they were adored by wealthy fathers, some of whom thought of themselves as poets or artists manqué and who were proud to send their daughters to a sophisticated experimental institution that would expose them to leaders in their cultural professions. Bennington students were *expected* to be pioneers. They were expected to be free. They were expected to have a solid intellectual grounding *and* to challenge taboos. "What is deviant elsewhere is socially accepted here," the journalist David Boroff wrote in "Cauldron of Creativity," his 1963 profile of the college in *Saturday Review*.[1] Students were expected to be mature enough to police themselves. There were "no house mothers" in the dorms.[2] There were "few thwarting maternal forces," a writer familiar with Bennington said. "Mama was out of the way." Frankenthaler and Jenny Greenberg had both attended Bennington, and Clement Greenberg was a major artistic influence there. Smith's friends on the faculty included the art historian Eugene Goossen; the painter Paul Feeley, head of the art department; and the poet Howard Nemerov. Students helped install the shows. Patricia Johanson,

a Bennington student in 1959, who would become Goossen's second wife and a visionary landscape design artist, remembered Smith's ease there: "David just used to sit in the Common and drink coffee . . . He hung out."[3]

Smith's exhibition of drawings and paintings opened on March 26, 1959, in the New Gallery, in the Carriage Barn. "In these two dozen drawings (sometimes virtually paintings) selected from the hundreds he has produced in the recent decade," Goossen, the curator, wrote in a three-paragraph "note" accompanying the show, "Smith proves himself a truly consummate artist and a rich personality whose 'oeuvre' will never be limited to a single means of expression." The exhibition included several of the "sprays," which blurred the lines between painting, drawing, and photography. They were, Goossen wrote, "created somewhat in the manner of the photogram by masking areas of the canvas before the paint is sprayed in various ways over the surface. This is the first time these new paintings have been shown and they represent but a tiny portion of the many more which Smith is now working on in his studio in Bolton Landing."

At Bennington, Smith was Mr. American Sculpture, and he appreciated the recognition, especially with much of his life in turmoil. He wrote to Noland a few days after the show opened:

> I'm harassed for money. Jean is pushing her lawyer her lawyer pushes mine. I can't be pushed for I don't have it . . . Will go to alimony court and what a stink I'll make there . . . I'm in debt thousands to keep my work going. My kids are stolen for her father and her selfishness. I'm a little looney and desperate and I feel like fighting but don't know how . . . I really am on the warpath.[4]

On April 16, Smith went to Columbus, where he met with students and faculty and juried a show at Ohio State. In his first public lecture in Ohio, even familiar words had urgency. He reflected on his life and studies in Ohio, when he "had a very vague sense of what art was . . . Mostly art was reproductions, from far away . . . certainly from no place like the mud banks of the Auglaize or the Maumee." He wanted the students in the audience to know that art could be made anywhere, with the tools

"at hand in garages and factories" or "from found discards in nature, from sticks and stones and parts and pieces." Sculpture was "made from rough externals by rough characters or men who have passed through all polish and are back to the rough again." He emphasized struggle and liberation: "no rules, no secret equipment, no anything, except the conviction of the artist, his challenge to the world and his own identity." He provided clues to his definition of "origins," a word he frequently used: "The conflict for realization is what makes art, not its certainty, not its technique or material. I do not look for total success. If a part is successful, the rest clumsy or incomplete, I can still call it finished, if I've said anything new, by finding any relationship which I might call an 'origin.'" Smith returned to one of his most lyrical statements, which he had first delivered, in somewhat different form, near the beginning of the decade. "Art is made from dreams, and visions, and things not known, and least of all from things that can be said. It comes from the inside of who you are when you face yourself. It is an inner declaration of purpose."[5]

Smith made a quick trip to Decatur and Paulding before returning home. To Dehner, he communicated his continuing anger against Ohio: "14 hrs a day and cheap. Culture suckers via faculty—a bit rural students, Wouldn't do it again." He informed her about his upcoming shows at French & Company—painting and drawing from September 15 to October 15, and sculpture in February 1960. "Raise your prices keep on market value," he advised her. "Don't go by Marian." Dehner had her first show at the Willard Gallery, at the beginning of the year. He signed off: "Work good as always."[6]

While Smith was again struggling financially, Willem de Kooning's show at the Sidney Janis Gallery sold out. Mark Stevens and Annalyn Swan, de Kooning's biographers, wrote: "The gallery was jammed by five p.m., the official opening time, but the line of admirers first formed at eight-fifteen that morning . . . Nineteen of the twenty-two oils were sold by noon, ranging in price from $2,200 for the smallest sketch to $14,000 for each of the five big canvases. By the end of the week every work had been sold. The notices in the press were adulatory."[7] The success of the show "changed the course of everything," Dan Budnik said.[8] Artists of Smith's generation, particularly those in the orbit of de Kooning, knew now that money for art was there and collectors were ready to spend it,

and that artists could succeed in the market on *their* terms. De Kooning, against Janis's judgment, had set the prices for his work.

Smith wanted his rules to determine his life and work. He got testy with his old ally Lloyd Goodrich, the director of the Whitney. Goodrich was helping the Sara Roby Foundation build a collection of modern art based loosely on the criterion of "form." After seeing a photograph of Smith's 1946 sculpture *Cello Player*, Goodrich persuaded the director of the Roby Foundation to buy it. When Goodrich reached Smith by phone at a cocktail party, Smith told him that the sculpture was at Lois Orswell's but that he could get it back. The price was $4,500. Goodrich agreed, but when Smith hand-delivered it to the museum, the Whitney demanded its usual 10 percent discount. Smith withdrew the sale. He accused Goodrich of taking advantage of him by approaching him at a party where he had been drinking:

> If you have loaned, sold or disposed of my work without my approval I shall take action to protect my interests.
>
> The Cello Player is my work. I refuse to accept your offer or any part of its payment. It would not be happy in your care after the rude manner in which you addressed me March 12 in a telephone conversation . . .
>
> In retrospect the Whitney paid me $500 less than I asked on Cockfight and $500 less than I asked on Hudson River [Landscape]. In this case you cannot make an offer nor is this work for sale at all to the Whitney Museum or whom it represents.[9]

Goodrich replied to Smith that attorneys "tell us that there is no question that the purchase of *Cello Player* was completed and that the piece legally is the property of the Roby Foundation. However, in view of your attitude in this matter, we do not wish to have the piece in the Collection."[10] On May 5, the museum informed Smith that it would hold *Cello Player* for him until May 15, at which point it would remove the sculpture from its insurance. Smith took it back.

Greenberg was French & Company's adviser and riding high. Princeton invited him to deliver the distinguished Gauss Seminars, and among artists, collectors, curators, and dealers, his judgment commanded spe-

cial respect. "He sure can level—fantastic pair of eyes," Noland wrote to Smith in early February after taking Greenberg to see the work of younger painters in Washington.[11] "Rather he help on choosing drawings than anyone else, I've got too many to be opinionated myself," Smith wrote to Cherry in early May.[12]

Greenberg not only wrote pointedly and knowledgeably about the artists he championed but also showed and marketed some of the painters privately. While a Bennington student, Patricia Johanson attended events at Greenberg's apartment at which he presented new work to collectors. She recalled:

> After everybody had had a lot to drink, you would go into the bedroom. And what was in the bedroom? Lo and behold, on the bed, would be all of Jules Olitski's latest canvases, or Ken's latest . . . And he would be unraveling them. He'd say, "Would you like to see—?" (This would be for the collector's benefit, not mine.) "Would you like to see Jules's latest work?" Of course, nobody knew who Jules was at this time. . . . He would roll them out, one at a time . . . They were unstretched . . . He would sell these paintings out of his bedroom.

Greenberg served many of the artists he supported in other ways as well. "I introduced Clem when he spoke at Bennington," Johanson said. "He came up to me after and said, 'Oh, that was the most beautiful introduction I've ever received. Would you like to see my Jackson Pollocks?' 'Oh, yes.' 'Could you come for dinner?' Well, it turned out he was trying to fix me up with Ken Noland, and Ken and I did not hit it off. But that was okay. So I learned about Clem very early on, because he would always invite some pretty young thing, and some guy he was promoting."[13]

After the Greenbergs left for Europe in May, Smith had to work out his arrangement with French & Company for himself. The gallery had not only scheduled two Smith shows but also given him a $15,000 sculpture commission for its terrace.

After visiting Bolton Landing, Spencer A. Samuels, president of French & Company, laid out terms: "Although we shall not be the exclusive agents for your works . . . you shall give us a commission on the sale of all works

sold within one year of exhibition at our galleries and shall give us the preference to purchase or sell your works and shall generally act as your agents."[14] Smith shot back:

> I am independent. I shall honor the rights of the dealer on sales on all work made by him. I don't like the "preference" part of the paragraph and the "shall generally act as your agent." This is new. I will honor your part on work you are involved in. I reserve the right to make my preference. We should not have trouble on this but I am not accepting any commitments. I am independent. This was my understanding when I came. I don't know how this will strike French Co so I return your check and place you under no obligation.[15]

From Florence, Samuels sent a conciliatory telegram: "long live liberty and independence do not wish to deprive you of same please accept check and proceed with exhibitions and commission will work out modus operandi with you and clem on return."[16]

Smith got what he wanted from Otto Gerson as well. He and Fine Arts Associates were good for each other: Smith made money for the gallery and helped solidify its reputation, and Fine Arts made money for him and exhibited his sculptures. When work sold, the gallery took its 33 percent and paid Smith promptly. By the end of the year, Gerson was buying sculpture outright from Smith to exhibit and sell.

By contrast, the battle with Freas seemed intractable. On the phone and in letters, she did not miss an opportunity to tell him what a lowlife he was. She trashed him even to those few friends of his with whom she remained in contact. She was aware that after she left him, Smith had been pursuing younger women, some of them younger than she had been when she and Smith began dating, star-struck women who would be grateful for his attention and unlikely to criticize him. Freas wrote Edith Rickey, George's wife: "While it is unfortunate for any of the young girls, some of them teen-agers, he has associated himself with in the past year, still it is shrewd of him to confine himself to very young females."[17]

Smith accused her of stealing the children and leveraging their visits with him to get more money from him. "You should want the children to

see me," he wrote to her. "Without a father an unbalance may take place in their lives . . . You want money to buy a house. You left this house [for] your own neurotic reasons. The house is your problem. I have my own financial problems."[18]

In late July, he had to pay $575 in back alimony payments or go to jail. "In deep trouble—contempt court etc—kids vs. money," he wrote to Orswell.[19] Because he was behind on payments, he had the girls for only five weeks that summer. At the end of August, he and Freas were in court again. After the girls left on September 1, he drove to Provincetown for several days by the ocean with artist friends. He longed to travel. He had hoped the government would pay for him to go to Brazil for the September opening of the Bienal de São Paulo. He continued to fantasize about Italy. Maybe after nearly three decades he would return to the Virgin Islands.

"David Smith: Paintings and Drawings" opened at French & Company on September 16. Greenberg chose twenty-two paintings and thirty-four drawings. It was Smith's first important painting show and would be his defining painting show during his lifetime. It was easy to find pictorial conversations with Pollock, Frankenthaler, Gottlieb, Rothko, and Newman, but the paintings were distinct in imagery, technique, and color. They were also curiously post–Abstract Expressionist. The stencil-like quality of many forms suggests Pop Art silkscreens. The funky MGM phosphorescence of Smith's red, greens, and yellows also had a Pop feel. Hilton Kramer "thinks the painting show will upset things a bit," Smith wrote to Orswell. Smith knew he was defying expectations: "Sculptors are not supposed to paint even painters think so except for Matisse + Picasso—but sculptors are always for painters sculpture."[20]

The paintings are vertical and big, all but two of them taller than 8 feet. Smith made them more quickly, with far less labor, than he made the large stainless-steel sculptures he was constructing at the same time. He placed found objects on the canvas (or paper, for the drawings), then sprayed over them with commercial aerosol spray enamel—recalling the enamel Pollock used in some of his "drips." When he removed the objects, their shapes remained traces. With a brush and usually oil paint, Smith painted around and sometimes into the ghostly presences. While spraying could spew paint over the surface, suggesting constellations

around astral bodies, the oil paint was carefully brushed on. Many edges are precise, which makes it seem as if some shapes are etched into the canvas.

While Smith largely avoided the illusion of interior mass in his sculptures, in these paintings the experience of interiority is paramount. Some of the shapes are blockier, more intact, than forms in the sculptures: all seem permeable; many are diaphanous. Forms overlap, bleed into, inhabit other forms. In *Red Heart*, which Orswell bought, a splotch of red (the red heart) occupies a cartoonish whitish rabbit-like body, set within another odd body, green tinged with blue, black, and gray, impinging on still another strange body, looming in the plane behind it, mostly red but itself a color mix. Interiors of varying small and large forms seem both protected and exposed. In all the paintings, we could be looking at an X-ray or a photographic negative. We could be looking into a head or belly or at an embryonic formation. Individual forms and whole canvases pulsate. Shapes and configurations seem to have just emerged, to be newly revealed or in the process of shifting from one shape or state to another. In *Island in Alaska*, one of the ghostly forms inside the giant, tot- and penguin-like reddish body—suggesting a maternal little girl—resembles an anvil; the larger form, beneath it, suggests a fish upright on two feet. (See Figure 7 in the insert.) The reddish-and-black shape is like a creaturely garment in which viewers could imaginatively wrap themselves. As with Smith's sculptures, the shapes seem to be at the same time seen and remembered, not yet born and an afterimage.

The titles are more diaristic than all but a few sculpture titles. They connect to Smith's life—for example, *March 9* (his birthday), *Chinese Restaurant, Edgecombe Pond, To Be a Golden Harbour, Space at Night, Two Fur Coats, Night Window, Blacksmith Shop,* and *Red Heart*. Every drawing title carries a date and signature. *Sept. 13, 1958*, which appears on four drawings, may be the day Freas drove the girls from Glens Falls to Washington. Eight drawing titles join Smith to his daughters: Four are called *David Smith R.* (Rebecca) and four *David Smith C.* (Candida), each one followed by a specific date.

"Pleased with 10 of my new big paintings," Smith wrote to Noland. "They're like no ones else. in conception technique either."[21] By June, he was calling them "pictures." He told Cherry that "they are not paintings

as such.["](22) He wrote to Belle Krasne after the show closed: "They are pic-
tures about sculptures—I don't have to make. Very simple but seemingly
confounding to most."[23]

Emily Genauer liked them. She would have welcomed anything by
Smith that was not the *Forgings*. "David Smith, who almost from the time
of his first one-man show in 1945 [*sic*], has had to be reckoned with as
one of America's most gifted, imaginative and vital sculptors, has turned
to painting," she wrote—inaccurately, since he never stopped painting.
They're abstractions, like his sculptures, "but they're as sensuous, as ro-
mantic and as lyrical as his structures in metal have been austere, spare
and uncompromising. Many of them suggest cloud shapes, painted in
almost puffy white, on a ground through which one catches the glint of
gold underpainting. They float in space as dark and infinite as night skies
spattered with multicolored flecks of paint."[24]

Other critics, too, took them seriously. "A preference for precise forms
in steel is translated into pictorial terms," Irving Sandler wrote in *Art-
News*. "He places cutout stencils of objects over the surface, sprays pig-
ment around them and paints the blocked out areas white. In one group
of pictures, *Furniture Store*, or *Don Quixote* (the actual title was *Qui-
xote Don*), for example, sculptures seem to have walked away from a wall
leaving white shadows."[25] While writing in *The New York Times* that they
"are more like amusing diversions than like the considered canvases of a
man determined to express himself fully through painting," Dore Ashton
was also intrigued by the process. "They are painted in an unorthodox
technique that seems to call for the use of an air brush. The ovals, disks,
monkey-wrench shapes and exclamation points, which are the dominant
forms, seem to have been cut in paper first, applied to the canvas, sprayed
over and removed, leaving white spaces."[26]

In *Arts*, Sidney Tillim, a painter and poet as well as an outspoken
critic, wrote one of the most blistering reviews in Smith's career: The
show "fail[s] miserably as art." The "implacable fact" is "that Smith is
not a painter, at least not yet." Tillim saw in the forms "the shallowest
signs of primitivism . . . His shapes—rather like fossils in Technicolor—
retreat into picturesque symbolism and association . . . Indeed, there
is a confusion between the plastic and literary, and it is interesting to
observe that though the flight of paint from the can to the surface is

free, the results are monotonous, the surfaces unappealing. When Smith turns to the cosmic, he is equally banal, indulging in a sort of atomic transcendentalism."[27]

"The show didn't set New York on fire," Greenberg remarked.[28]

The paintings seemed to come out of the blue, and the image of Smith's sculpture was so strong that it was probably impossible for his paintings to hold their own against it. While the show was up, *Time* listed Smith as one of sculpture's "modern masters"—"the best of the living ironmongers . . . the idol of young American sculptor-welders."[29] Lois Orswell was unusual among collectors in her attachment to Smith's multiplicity and desire to participate in the boundless sprawl of his work. By early October, no work had sold at French & Company and Smith had lost his bid to reduce his alimony.

The art event of the 1959 season was the opening, on October 21, of Frank Lloyd Wright's Solomon R. Guggenheim Museum. Located on Fifth Avenue, a few blocks north of the Met, what had been the Museum of Non-Objective Art was now a beautifully lighted spiral monument to modernist abstraction. Some of the European artists Smith most admired, like Kandinsky, Klee, and Mondrian, were enshrined in this modernist temple on Manhattan's Upper East Side. "All the artists I ever knew were there," Smith wrote to Cherry. He was not convinced the museum would succeed: "It could go—or fall . . . depending on how good his [director James Johnson Sweeney's] shows are. But it is not for big pictures or more than a few sculptures. I don't think it will work. Moma will still show pictures and sculpture better, despite its faults."[30]

Smith's social event of the fall was a November dinner party given by Frankenthaler and Motherwell. He was seated next to Hedy Lamarr, one of the movie stars now drawn to the art world. In Smith's view, they "hit it off . . . a little old for me but cute and fresh with a new face lift," he wrote to Cherry.[31] "She would make a hell of a mountain woman," he added nearly a month later.[32] Seated on the other side of Lamarr was the party's guest of honor, a thirty-five-year-old English sculptor named Anthony Caro, who was visiting the United States for the first time. During the summer, Caro, who would become the most acclaimed welded steel sculptor after Smith, had met Greenberg at a London party. Their discussion of sculpture led Greenberg to visit Caro's studio. "I had wanted

him to see my work because I had never had a really good criticism of it—a really clear eye looking at it," Caro said. "I was looking forward to this kind of a change. He really shook me to the roots. It was wonderful. Besides criticizing the sculpture I was doing, he also pointed to a whole different attitude."[33]

Caro learned of Smith's work through Elaine de Kooning's "David Smith Makes a Sculpture" in the September 1951 *ArtNews*. His response to Smith's sculpture was "That's not sculpture"—a reaction that drew him to it rather than putting him off. He wanted to see Smith's sculpture in person and to meet him. Frankenthaler and Motherwell arranged the dinner. "They had little tables, very beautifully done, with waiters and everything. And I was at a table with David, on one side of Hedy Lamarr," Caro said. "How about that!" After dinner, Smith said to Caro, "Let's meet downtown . . . We'll go and have a Chinese meal together." They met at the Cedar, where Franz Kline recommended a restaurant with a Mongolian hot pot. "It was sort of a sculptural little thing with heat in the middle and fish and meat and all sorts of things," Caro recalled. After dinner, they took a walk. Smith "was very nice. And he said, 'Let's buy something for my kids.' He was very, very keen on the kids, loved the kids and wanted to know my kids and everything." Smith invited Caro to Bolton Landing, but Caro refused because of a meeting with Greenberg: "Clem was very amazed that I'd put off David for him, but I did."[34]

On that trip to the States, Caro and his wife, Sheila Girling, a painter, met Noland, with whom Caro began a close friendship. Three times he visited the October exhibition at French & Company that followed Smith's and included, most notably, Noland's "target" paintings. The *Targets* were concentric circles, ring after ring of unexpected and sometimes eye-popping color, their centers often pulsating. Like Caro, Smith was impressed. He found the show "courageous."[35] He told Cherry that his new work, too, had "wonder." However, as supportive as Smith was of Cherry, particularly of his color, Cherry continued to bear the brunt of Smith's testiness about the work of sculpture versus the work of painting. "Now," Smith wrote to him, "painting or picture making is no labor and more enjoyable and sooner or later I'm going to be there more and more. Got 3 rolls 96" canvas want some square ones now."[36] Smith's plaintive superiority about sculptural labor could be tough to deal with, and when

he tried to explain that he meant no offense he could make things worse: "I said painting is easier—I diden't mean spiritually I meant physically." Sculpture involved "hard sweating labor—lifting—dust in lungs—dirty clothes & hands—Oh no I diden't demean the spiritual part—Painting is more difficult in that there is no sense of satisfaction in labor, which is a primitive response and quite gratifying at times."[37]

In December, Smith and Freas were legally separated. That month Dehner sent Smith what he described to Cherry as a "beautiful, little sculpture . . . with a prize ribbon designation. She is kind—and I hurt."[38] She underwent open-heart surgery for a valve problem resulting from rheumatic fever as a child. Smith thanked her for the sculpture and for the silver she sent, which he placed in the girls' room. He complained to her that Marian Willard was selling off his work, and he requested, "Buy it back for me, I'd like to pick it up. It destroys my prices which I've put way up."[39] "Look forward to your show," Dehner wrote back, referring to Smith's sculpture show at French & Company. Like him, she remained attached to their good times together and reassured him that "Marian has no sculpture of yours for sale. She did sell that one piece only . . . It was stated that nothing of yours from her own collection is for sale. I believe she likes those pieces too much to sell them. I hold a friendly but cool relationship there. Not like the old days."[40]

By the beginning of 1960, tension existed between Smith and Greenberg. Greenberg had supported and chosen the painting and drawing show, but it had not made money and he was not then or ever enamored of Smith's paintings or his color. "Clem and I seem to have differences," Smith wrote Cherry. "I have differences with everybody it seems."[41]

A Golden Month

In February 1960, two triumphant events launched Smith into a new decade. *Arts* included a special twenty-five-page Smith section that featured a substantial essay by Hilton Kramer, the editor of the magazine, and photographs of dozens of Smith sculptures, from the 1930s to the present. The section integrated artist, person, and work—and the place in which the work was made. In midmonth an exhibition of forty-four Smith sculptures opened in French & Company's "light and capacious" galleries.[1] *This* show Greenberg enthusiastically anticipated.[2] Critics were excited by Smith's new sculpture—its movement, its flow, its variousness, its activation of light, its "poetry" (a word critics now used freely). Some critics and artists felt swept away, even possessed, by the work. "It's fabulous—outrageously beautiful Stupendous. Everyone else should stop trying," Frankenthaler wrote to Smith.[3]

Kramer had been critical of Smith's 1957 MoMA show and catalog. In *Arts* the nearly seventy photographs, pretty much all of them taken or owned by Smith, were more numerous and their layout more imaginative than MoMA's. Kramer's essay was more insightful and comprehensive than that of MoMA's Sam Hunter. Kramer staked his reputation on Smith. "The sculpture of David Smith is one of the most significant achievements of American art, not only at the present moment but in

its entire history," his essay began. "It is a major contribution to the international modern movement, and at the same time the most important body of sculpture this country has ever produced. Smith is the only American sculptor . . . whose work has made a permanent change in sculpture itself. He is one of the few artists anywhere today whose work upholds the promise and vision of the modern movement at the same level at which it was conceived."

Photographs were revelatory. The juxtaposition of *Three Ovals Soar* in its larval stage, long steel rods lying on the shop floor, with the sculpture standing upright against the sky in the snow, is astonishing. Alongside Smith's photograph of *5½*, the sculpture seeming to rise like an endless column against the sky, Smith wrote a column of words also set against the sky: "Since 1956 unities of square tank or block forms have possessed my consciousness, these are stainless steel—painted called '5½.' I've made 4 unities equal 4 unities unequal—probably it will take 12 to 20 more before I'm through." Smith noted that this sculpture had never been shown and belonged to Lois Orswell. The Smith photograph to its right was of another recent sculpture, *Doorway on Wheels*, standing indoors, "in progress to be painted black." Orswell would acquire this sculpture as well. Another photograph reveals twenty-three gestural drawings in patterned rows, covering the living room floor. "Studio in house also this time both floors full," Smith wrote in intervals between drawings. "Sometimes I draw for days / I like it because its a balance with the labor of sculpture." Everything in Smith's work was in movement from one situation, one state, to another.

Kramer was one of the first writers to recognize that Smith kept returning to and transforming ideas and forms that he began working with during the aesthetic and political ferment of the 1930s. It seemed that Smith kept reusing and rethinking everything, that he did not reject any aspect of what he had seen, felt, and done, and that with each decade, perhaps each new body of work, even each new work, he surpassed himself, leading to what Kramer saw as his current magisterial culmination: "It is as if every motif and expressive idea Smith had ever had in embryo came to maturity in these fertile years." In his December 1959 preview of the French & Company exhibition in *Art in America*, Emanuel A. Navaretta noted Smith's "keen desire to partake of deep space" and his ability

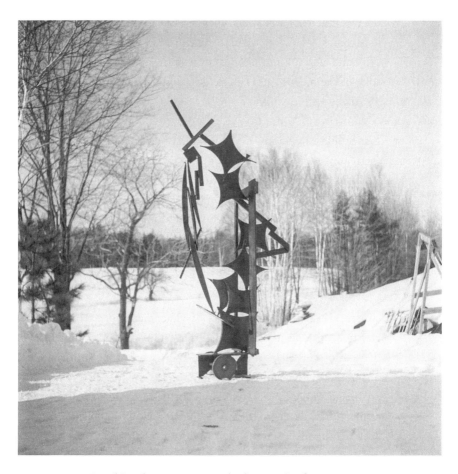

David Smith, *Doorway on Wheels*, 1960. Steel, paint,
92 × 38 × 21¼ in. (233.7 × 96.5 × 54 cm). Harvard Art Museums.

to do so with the help of his "cunning control of light."[4] While Navaretta
did not reflect on Smith's space, Kramer did, finding in it another ex-
pression of Smith's ever more encompassing synthesis:

> What is special about the genre of "drawing in space" and
> "open-space sculpture" is that, unlike a painting or a drawing
> or a monolithic sculpture, it is not something to see around but
> *through*. It does not focus our attention by obstructing a view
> of what is beyond it, but on the contrary, it draws strength from

the fact that it absorbs what is beyond or behind into itself, that it becomes a locus of visual concentration and generates its symbolic emotion *in the midst* of its surroundings and not in spite of them. It is rather more genial and sociable—closer to life, if you will.

For Kramer this extension—and sociability—helped explain why "even Smith's greatest works always look a little wounded when seen only in museums and galleries, which tend to be barren of something that could properly be called life."

Smith's integration of small-town factory and landscape traditions— "*a machine shop in a landscape*"—was a key aspect of his synthesis. To Kramer, the three most important living sculptors were Smith, Henry Moore, and Alberto Giacometti:

> There are artists—one thinks of Giacometti in Paris and Henry Moore on his Herefordshire estate—who are as much the authors of their milieux as of their work; and Smith is one of these. [But Smith's] workshop in the mountains evokes an image radically different for it brings together two old-fashioned ideals of American life: the proud individualism and keen workmanship of the man who lives by his skills, and the independent spirit of the man who lives on his own land . . . One might say that everything about Smith's art is up-to-date but the style of life which makes it possible for him to create it.

Moore, Giacometti, and Smith had all been able to come into their own in the 1930s because of the liberating impact of Surrealism. After World War II, Surrealism was largely exhausted and Moore and Giacometti lost their connection with it, more to Moore's detriment than Giacometti's. Smith's connection with key aspects of Surrealism remained—for example, automatism and the way in which his geometrical constructions "suddenly at times take on the look of mysterious, symbolic personages"— but, in Kramer's view, after the war Cubism became more important, and it is this that explained the "extraordinary optimism" of Smith's art: "The Cubist tradition in modern art is the optimists' tradition. It does

not harbor anxiety, it is the enemy of metaphysical disquiet. It asserts its
hegemony over experience. When Smith abandoned the Surrealist side of
his temperament, the Cubist-Constructivist side took over in force and
has carried him through the achievements of the last decade." Smith's
sculpture of the early 1950s had a "kind of metaphysical calm." *Austra-
lia*, the *Agricolas*, and the *Tanktotems* had "the kind of inspired finality
we associate with a great statement."⁵ It's hard not to sense here aesthetic
standards set by the ancient Greek monuments in Athens, Aegina, and
Delphi that Smith and Dehner had visited.

Smith's "Notes on My Work" is the only other essay in the section.
Smith was worried about whether expressing in public personal responses
perhaps better suited to conversations with friends would make the re-
sponses seem "different and pious pompous."⁶ The essay is retrospective
and current, jumping around in time. Smith wrote about materials and
the unplanned ways in which sculptural parts coalesced into sculptural
wholes and, in work and life, his antipathy to repeating himself. "I try to
let no sequence or approach in daily living repeat from the day before,"
he explained, "but like my work, my day can be identified by others." He
acknowledged mentors like Jan Matulka and John Graham—above all,
Graham—and looked back to the "WPA days, Romany Marie and Mc-
Sorley days" when he lived in a world of painters: "In those early days it
was Cubist talk. Theirs I suppose was the Cubist canvas, and my reference
image was the Cubist construction." He emphasized his trip to Europe.
While not romanticizing the idea of sculpture outdoors, he made clear
his growing preoccupation with it. His new stainless-steel sculptures,
from 9 to 15 feet tall, were "conceived for bright light, preferably the sun,
to develop the illusion of surface and depth. Eight works are finished, and
it will take a number of years for the series to complete it. Stainless steel
seems dead without light—and with too much, it [be]comes car chrome."

Kramer does not mention Dehner, not in the reference to Smith's
first trip to Bolton Landing in 1929, "where he later acquired the land,"
or in referring to the trip to Europe and building the house. The assump-
tion that it was Smith who bought the property and that he alone was
responsible for the house and property persists in the Smith literature.
The fault lies largely with Smith, who gave writers the impression that
he was the sole originator of his Bolton Landing life. In "Notes on My

Work," Smith does mention Dehner, once: "Probably what turned me most toward sculpture, outside my own need, was a talk with Jean Xceron walking down 57th Street in 1935, the day his show opened the Garland Gallery. That fall my wife Dorothy and I went to Greece."[7] The reference is intimate and cryptic, although it perhaps suggests the importance of Greece to his experience of sculpture. The intimacy emerges from using only her first name; his references to other artists, all men, include last names. The omission of her last name keeps her on the margins of his history even as his use of her first name brings her close. But when Smith writes about Paris and Moscow, the defining presence is Graham. While Smith writes that he and Dehner were together in Greece, he does not write that they were also together in Moscow and Paris. As a result of the ambivalence, Dehner exists in the essay as a full absence, or absent fullness. Barely mentioned, she seems intensely there. "Dorothy" hints at a partnership that is distinct from the male friendships that are formative parts of the text.

The publication was a shot in the arm. "Did you see Arts—some piece Hilton did," Smith wrote to Orswell.[8] However, the Smith section took the wind out of Navaretta's sails. He planned to write a book on Smith called "Sculpture Is" and expected Grove Press to publish it this same year. He wrote to Smith that he was disconcerted to see in the issue some of the points he said he had made to Kramer. "My book," he added, "will be different and more to the point of your art of sculpture."[9] But the book was never written.

Smith's French & Company show was larger than his MoMA exhibition. The gallery sent a truck to pick up forty-two of the forty-four sculptures; Smith was still working on the other two and drove them to the city himself. They ranged in size from 2 feet to more than 12 feet tall and in price from $3,300 to $21,000. The accompanying eight-page brochure did not include an essay and, after the February *Arts*, did not need one. The cover photograph of *Three Ovals Soar* on a hill in the snow is nearly identical to the one in *Arts*. The other sculptures in the show were photographed by Ernst Pollitzer indoors, aligned horizontally side by side, and grouped pretty much according to material—bronze, stainless steel, steel. The arrangements call to mind raucous circus troupes or comically anarchic families—suggesting, and Kramer used the adjective "Balza-

cian," that Smith had created his own human comedy. Some titles, such as *Walking Dida* and *Doorway on Wheels*, have a fairy-tale quality. Titles of more abstractly geometric stainless-steel sculptures are mechanistic: *Superstructure on 4, 4 Units Equal, Structure 37, Structure 38*.

Critics admired Smith's control. Robert Coates wrote in *The New Yorker*: "His attempt is always to dominate, and in his best work the result is an air of resistance tamed, of recalcitrance conquered and controlled, that adds immeasurably to the effect."[10] Emily Genauer wrote in the *Herald Tribune*, "His newest things are wonderful. Smith's figures are purely abstract shapes that dominate their surroundings like lords of creation."[11]

Fairfield Porter was more impressed by the outpouring. In *The Nation* he wrote that Smith "convinces by the weight of his endlessly various invention, like Victor Hugo, pouring out poetry." He saw not domination but "the direct experience of nature" and with it a distinct and equal way of existing in nature, one that contrasted with it and marked it without invading it:

> Smith's sculpture is sculpture for a new country, an empty country, where a high degree of technical achievement goes with the development of new and relatively uninhabited lands. It is the Coca-Cola bottle glinting in the wilderness, the abandoned gasoline pump at the edge of the virgin spruce forest, the railroad signal tower among the sunflowers of the prairie. It is these things, taken out of context, mischievously or artistically considered.

Porter went further than Kramer in rooting Smith's sculpture in the landscape: "Smith's sculpture seems to me not to be a sculpture for cities, where it is overwhelmed, and where it doesn't add."[12]

Writing in *The Baltimore Sun*, Kenneth Sawyer was enthralled. The French & Company show was "almost too good to discuss rationally." It surpassed the show at the Modern. "The only quarrel I have with David Smith," Sawyer continued, "is that he makes impossible demands on the critic. Each new exhibition is more astonishing than the one before, each new series drives one to the dictionary in search of fresh superla-

tives." Sawyer believed, as did Kramer, that Smith's sculpture had now gone beyond that of Picasso and González: "He may be the only complete sculptor apart from Brancusi this century has yet produced." His praise, too, could suggest classical Greece. "While Smith is never static he is sometimes magnificently serene," he wrote, and, in his concluding sentence: "He is unquestionably one of the Olympians of our century."

Among Sawyer's provocative responses was that Smith's work could "make for unbearable intensity were it not for his range." The implication is that if Smith's work did not develop in multiple directions at once and instead concentrated on single statements, those statements might be unable to contain all that Smith would have to concentrate in them and their intensity would overwhelm our capacity to experience them. Sawyer also perceptively remarked on both the availability and unavailability of the work. In the new sculpture the allure of the interior was felt, but the interior was off-limits:

> The recent stainless steel works have that quality of captive light that I had never before associated with his sculpture. In them he has heightened specific areas to shimmering brilliance, leaving others dull. The results are dazzling: each piece (they are generally large) seems mysteriously illuminated from within, at once challenging the eye to enter and forbidding it to do so.[13]

In her review in *Art and Architecture*, Dore Ashton presented even more startling intuitions. Like Kramer, she noted the "cumulative value" of Smith's "art of recapitulation." But in her view, accumulation and recapitulation were acts not just of dreaming but of redreaming that in each instance included within them hope of repair—hope of wholeness. Ashton began her review as follows: "David Smith's dreams come in all sizes. When they are grand, their grandeur smites the eye of the beholder. When they are trivial, the beholder must be forebearing [sic], for Smith's dreams are serialized and must be seen as an unending sequence. He has left nothing behind. What was dear to him in his youth is still dear to him and is carried again and again into his sculpture each time with a fresh determination to 'fix' the dream."

Ashton saw Smith's dreams both as his own and as continuations of

other sculptural projects: "The importance of his full body of work is that it not only throws us back to each 20th-century source, but it launches us forward into the lifelong dream that is David Smith's own. He is among the soloists in an anvil chorus that includes Tatlin, Rodchenko, Picasso, Gargallo and Gonzalez."

Ashton is another critic who did not believe Smith's sculpture could ever fully belong in a gallery or museum. Like Fairfield Porter, she saw the new sculpture as signs—and signals:

> They stand in the chic French & Company showrooms with the unease of a new tractor in an exhibition hall. Such superb semaphores belong to the American landscape. They are semaphores at rest: their ovals and disks set high above us remind us of what they *could* mean, but, like the arms and lights of a real semaphore in repose, they only hold the possibility of meaning. It is precisely the tension between the form—that of a sign—and its potential meaning, that distinguishes these steel mammoths (more than 12 feet high) from Smith's earlier signals.

Ashton ended her review with a sense of the inadequacy of words: "I know of no way to conclude this run through. Smith has always left me short of breath, and this instance is no exception."[14]

By March 31, twelve days after the show closed, French & Company had sold seven sculptures for $35,600. Four were stainless steel. *Structure 31* was bought by Arthur Kahn, who, with his wife, Anita, would become important Smith collectors. Smith splurged and acquired from French & Company nearly $5,000 worth of furniture. He bought wood columns, a cabinet, a chest, and a 31-foot-long, 4-foot wide "XVII century English Elm refectory table . . . Formerly in the Collection of the Duke of Devonshire, Compton Place, Eastbourne, England."[15]

Birthday Party

Smith and Robert Motherwell met in the late 1940s and became friends when Motherwell wrote the essay for Smith's 1950 Willard Gallery show. Like Smith, Motherwell absorbed defining principles of Cubism and Surrealism; worked serially; revered Picasso and Joyce ("It was from Joyce, as well as from Picasso," Motherwell scholar Jack Flam wrote, "that Motherwell first came to understand the profound ways in which collage could articulate the realities of modern life"); and believed that the necessity of art was connected to its ancient power, going back to the caves.[1] He showed with the Sidney Janis Gallery and was another Abstract Expressionist who had his first retrospective at Bennington College, in 1959. Smith was critical at times about what he saw as the tastefulness of Motherwell's collages and paintings, but he came to respect them and occasionally created exchanges with them in his work. In the catalog for his 1982 exhibition of Smith's series at the National Gallery of Art, the curator E. A. Carmean, Jr., wrote that "Smith had discussed with Motherwell the idea of the latter making a sculptural version of his painting series, *Elegies to the Spanish Republic*. 'Although David insisted it could be done, and said he would assist me in making it,' Motherwell remembers, 'I declined because I could never imagine what an Elegy would look like from the side.'" In his 1961 sculpture *Gondola*, Smith made his own sculptural version of an *Elegy*.[2]

Thirteen years younger than Motherwell, Frankenthaler was Freas's age. In the catalog for her 1960 retrospective at the Jewish Museum, which he curated, Frank O'Hara characterized her as "a dashing and irresistible artist"; O'Hara would curate a Motherwell show as well, for MoMA in 1966.[3] Frankenthaler's retrospective was the culmination of a decade of exhibitions and a remarkably rapid aesthetic and career development. Smith trusted both Motherwell and Frankenthaler but felt closer to her. She had visited Bolton Landing with Greenberg, discussed her work with Smith in her studio, and maintained a friendship with Freas until Freas left Smith in 1958; Frankenthaler and Freas would reconnect after Smith's death. She bought one Smith sculpture in 1951 and another in 1956, the second of which Smith was happy to allow her, at her request, to name—*Isabella*. In a 1957 letter to Smith and Freas after a visit to Bolton Landing, Frankenthaler wrote, "David—I can't get some of the new (+ older) work I saw out of my mind. My god it's exciting and you know I know it and mean it."[4] Beneath these words she sketched six sculptures, including *Sentinel II*. In 1960, she painted *Bolton Landing*, in the heart of which is a squarish red-and-black frame reminiscent of the rectangular steel portals or frames in several Smith sculptures. Ocher lines suggest prongs of an old agricultural implement. Atop the frame is a red splotch hinting at a head. The configuration resembles a Smith-like figure balanced on one leg and yet in motion. Smith liked Frankenthaler's work. Her dense yet flowing abstractions could be animated by gestures that seemed to come out of nowhere. For Smith, her paintings, like Noland's and Cherry's, had "wonder."

When Frankenthaler and Motherwell traveled, it was predominantly she who maintained connections with Smith, writing him postcards and long letters, keeping him abreast of their experiences, making him feel that there was nothing more important to her than sharing with him her and Motherwell's habits and adventures. Her acceptance of Smith was unconditional. She and Motherwell knew the worst of him, but they also knew the best and made it clear to him that the best was so special that the worst did not matter. Smith was the only person to whom they gave a key to their town house, and he was welcome to bring women there, no matter how young, which he did. They welcomed him in Provincetown, too, where their beach house on the bay gave him access to salt water and

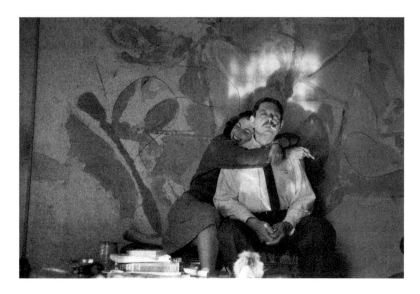

Burt Glinn (photographer), Helen Frankenthaler and David Smith
in front of *Mountains and Sea* (1952) at Frankenthaler's
West End Avenue apartment and studio, 1957.

an artistic community in which he felt at home. From his second mar-
riage, to Betty Little, Motherwell had two daughters, Lise and Jeannie,
who were the same ages as Becca and Dida. In Provincetown the four
girls played together.

Frankenthaler and Motherwell were born into wealth. They did not
believe that artists needed to struggle hand to mouth in fifth-floor walk-
ups in order to make work good enough to hang beside the Masters in
museums. They seemed to know everyone in New York and Los Angeles
who wanted to partake of the new glamour of art. Smith had moments of
discomfort with their lifestyle. "I like Helen and Bob but a lot of that so-
cial level I find a bit out of wavelength," he wrote to Cherry after the 1959
Anthony Caro/Hedy Lamarr dinner party.[5] Caro felt the sharp elbows of
Smith's class attitude. "He didn't like me being English," Caro said. If you
were British, you were to Smith "one of that lot." But Caro added that "of
'that lot,' the mostest was Motherwell and Helen. I would say they were
like the Duke and Duchess of York in those days. They were much more
sort of *up* in the stratosphere than any English people I knew. And yet,
David loved them."[6] Noland believed that Smith "liked Bob Motherwell

because Motherwell knew about all these class" luxuries, "how to dress, how to eat, etc." Smith "got a humidor at Dunhill. He got a whole bunch of Cuban cigars, and had stacks of them." He used to "drink Remy."[7] In Noland's view, without Motherwell, Smith would not have begun staying at the Plaza Hotel. But Smith also admired Motherwell's erudition and commitment: he was one of the great advocates for modernism and artists in the history of American art. And they were drinking buddies who could speak candidly with each other about pretty much everything. Frankenthaler and Motherwell were attuned to Smith's work and person, they wanted proximity to his integrity and creativity, and he was attuned to their love for him and their work, and intelligent passion for art and artists. And they had fun together. When they were together, they brought out the best in one another. Smith remained loyal to Frankenthaler and Motherwell even though many people he knew were put off by them, finding them, and particularly her, in the words of Beatrice Monti della Corte, an Italian art dealer friendly with Smith and Joseph Hirshhorn, "pretentious to the extreme."[8]

In preparation for his May 5, 1960, talk at a MoMA conference on art education, Smith jotted down some thoughts while staying at the Chelsea Hotel but found them pompous and didactic, "all the things I declaim against." Then Frankenthaler and Motherwell dropped by. Motherwell advised him to be honest. "I said that is a very hard thing to be, and is a very hard thing to ask other people tobe," Smith recalled. "What are your resentments?" Motherwell asked. Smith had a supply of them. He brought some into the talk. "They begin early," he said. His resentment at the way he was taught art at Ohio University helped inspire him to want to teach art himself and insist on the importance of "uninhibiting" and "unintimidating" people "before they get involved in the creative act." He spoke about "freedom of gesture and the courage to act" and emphasized that elusive "quality called determination." He was "much more concerned with the monsters than with what are called beauties." The monsters he referred to included his sculptures on wheels. He advocated vulgarity—"Provincialism or coarseness or unculture is greater for creating art than finesse and polish," and the value of statements by

artists and nonartists, "by Camus, Stravinsky, O'Casey" and "Gabo, Ben Shahn, Duchamp. There are hundreds of statements by artists." Above all, there was work. "Work has always given me back more than anyone or anything."[9]

"He only became himself when he was putting himself into metal," Jean Rikhoff would write of him. "Everything else was outside and essentially unimportant. He was only himself when he went inside and saw shapes and took up the metal and put it to the fire; then the vision he saw emerging stopped all questions and regrets, the disillusionment and guilt. In his work, he became whole."[10]

In the summer of 1960, Becca and Dida spent six weeks in Bolton Landing. Smith had hired a young couple to look after them, which ensured that he would have several hours a day for work. They took swimming lessons and swam almost every day. He cooked three meals a day, which Freas did not do in Bethesda. He hunted puff balls, and when friends brought deer or bear, he cooked that for his daughters, too. "On the skillet he'd make animal-shaped pancakes," said Dida, "and then we could all have a try, or overcook most of them and so forth, and really have fun . . . Sometimes he'd make what he said was his favorite— seven-bean chile . . . It would take forever, and then we'd eat it for a week." He attended to and entertained them. "Sometimes in the evening, we'd dance," Dida said. "He'd be playing music. I'd stand on his feet, and he'd dance." Becca said, "Then we played this game called 'Bear Trap,' where we would run around the bed and he would trap us in his legs as we went by. That, to me, was the most fun thing."[11]

Smith's birthday parties for his daughters were legendary. On these days he was determined to turn his hillside in Bolton Landing into a theater of the marvelous. "For my sister's August birthday we ritually breakfasted in our nightgowns on the patio on lobster and champagne (really ginger ale, but the small dash of real champagne and the bottle on the table convinced us)," Becca wrote. One of Smith's marvels was "a five-foot lollipop tree, spray-painted and drilled with holes into which the sticked candles"—literally candlesticks—"were inserted so that the construction bristled." Another was "a magic bird, mounted on a tall stand . . . spray-

painted pink and gold" with "a long plumed tail made of sequined or-
ganza to blow in the breeze." Smith "spray-painted golf balls and a bright
buoy hung from certain trees like fantastical fruit."[12] He borrowed a pony
or donkey from neighbors for children to ride. He asked Hugh Allen Wil-
son to cart his harpsichord to a party where, on Smith's hillside, Wilson,
a violinist, and a flautist played a Bach suite. Adults were welcome, too.

"Every kid David saw was invited, really. Our kids, any kids who lived
down the road, anybody he met," Charlie French, Smith's neighbor and
assistant, said. "God, it was nothing to go up there and see forty-fifty kids
playing in the fields."[13] Smith made paintings on children's backs, and
they loved it; on another occasion, when one of Mary Neumann's boys
visited Smith on his birthday, he painted a birthday cake on his back. He
photographed children around the sculptures in such a way as to make
it seem as if they were casting or releasing spells within the works. He
photographed them around *Australia*—in 1960 still installed just below
the house. His sculptures were not treated as precious objects, like sculp-
tures in a museum. "We would go and we would run around those fields
and climb his sculptures," said Lyn Noland, one of Cornelia and Ken
Noland's daughters. "Oh, my god, I just really liked them . . . He was a
big bear of a man who was really generous."[14] It would be hard to find
someone who as a child met Smith in Bolton Landing who did not feel
an abiding affection for him.

Before they left for Washington and the school year, Smith bought
his daughters three dresses each. He dreaded their departure. "My dolls
must go soon and I'll have to take off or do something strong on my
character to ward off the desolation," he wrote to the dealer Everett El-
lin.[15] To Cherry, he expressed his struggle to "get over that big hole in my
heart left by the kids removal."[16]

In the summer of 1960, Smith made *Tanktotems VII, VIII*, and *IX*. August
20, a week or so after the birthday party, is the date he inscribed on *Tank-
totem IX*. Its lean verticality—91 by 31 inches—suggests a tall woman (on
the drawing of the sculpture, dated August 30, he wrote and crossed out
"Hungarian Princess"). The flat body, odd proportions, and figural awk-
wardness also suggest a preadolescent girl. Belly, chest, and shoulders

are suggested by the large, flat rectangular steel plate that is somehow held up by the three spindly steel legs that seem to be leaning against the plate rather than supporting it. Welded onto the top edge of the plate—propped delicately on what seems like the figure's shoulders—is the round lower edge of about one third of a tank head sheared off in such a way as to make it suggest both a vessel-like offering and a person's head. While this head seems truncated, the blue paint brushed across the whitish field on one side, and the gold tinging the vessel-like head on the other side, give the sensation that the sculpture is lifting upward, and that the sky has a materiality that is as densely magnetic as the materiality of the earth. Rosalind Krauss believed that part of the radicality of this sculpture was that nothing in it was hidden; every surface was visible: "The surface seems legible as the whole object, since everything there is to know about the work is given to the eye in this reading . . . In achieving the surfaceness of *Tanktotem IX*, Smith achieves the surfaceness of painting, the conviction that everything in the work is coextensive with the surface, at last accessible to sight."[17] But however Smith's sculpture may deny the illusion of an interior, which for Krauss was a condition of radical modern sculpture, because of the diverse and unpredictable ways in which paint coats the steel, providing it with different skins, and with the sensation of something inside or underneath these skins, much in the sculpture seems beyond sight and naming.

At the end of August Smith drove with his daughters to Easton, New Hampshire, to visit Jimmy Rosati. The Rosati family was spending the summer in the guesthouse of Otto Gerson and his wife, Ilse. In a photograph, probably taken by Ilse, the sculptors are sitting on the loveseat by the entrance. Smith's black hair seems longer than usual, and his mustache is thick. He is wearing light pants and a dark shirt with a silky sheen. He is looking at the camera and smiling. Rosati, in a white polo shirt and light V-neck sweater, looks at Smith with a warm but perhaps questioning gaze, as if Smith were a stranger as well as a dear friend; maybe Rosati just said something to make Smith smile. The photograph is filled with friendship, but while Smith seems happy to be there he seems at the same time unreachable.

David Smith and James Rosati in the house of Ilse and Otto Gerson, Easton, New Hampshire, August 1960. The photograph was probably taken by Ilse Gerson.

Smith's first Los Angeles show opened on November 7 at the Everett Ellin Gallery on Sunset Boulevard and ran through December 3. Smith built his shipping crates, stenciling "CARE" and "ART WORKS" on them in big letters over white ovals and circles. Ellin found the crates so beautiful that he included photographs of them in the catalog, but Smith was ready for an end to work-related assignments, all of which now seemed to him chores. "This is my last piece of shipping," Smith wrote to Orswell. "I've made my last lecture . . . I want nothing but sculpture and painting . . . Weather is fine—health good and happy when I don't have book work lectures or shipping. How are you."[18]

In L.A., Smith saw art and visited collectors and attended a Sviatoslav Richter piano recital. "He is a great and perfect player with imaginative interpretation," he wrote to Frankenthaler and Motherwell. "Stay here has been sunny and very nice vacation."[19] Gifford Phillips, of the Phillips Collection family, bought *Bouquet of Concaves* from the Ellin Gallery show, which promised other sales. On the way back, Smith stopped in Washington to see the girls, then returned upstate via New York City, where he dined with friends and visited the Five Spot. When he was back at Bolton Landing, Orswell visited with wine and pastries and bought *The Fish*, a 1950–51 sculpture painted cadmium red.

Smith and Freas were in court on December 5, 6, and 7. Their separation agreement was signed on December 27, when Becca and Dida were in Bolton Landing. It stipulated that Smith owned his work and property and would return to Freas all prints and negatives of her and all her writings in his possession. He would pay $200 a month, $100 for her and $100 for the children. He would also contribute $600 per year for their daughters' education and be responsible for their college room, board, and tuition. He would take out a life insurance policy for them that would never be less than $19,000. He would have right of custody of the girls for eight weeks a year, six weeks during the summer. From this point forward, Freas would not "contract any bills or create any demands or liability for support, maintenance or otherwise against her Husband or upon his credit." She would "hold the Husband blameless of all claims and demands whatsoever which may have been contracted or created."

Shortly after the legal separation was signed, Smith splurged again, ordering hundreds of cigars from Dunhill and Famous Eddie's Cigar Store in Manhattan. Around this time, from a man in Bolton Landing, he bought a used 1956 black 300B Mercedes-Benz with red leather seats that could compete in its own Smith way with Frank Kline's shiny black Thunderbird and new Ferrari and Motherwell's recently acquired Bentley convertible; Kline had once been interested in a 1938 Bentley convertible.[20] Dida and Becca referred to the Mercedes as "black beauty" and "black princess." "The most magnificent chariot ever," Dida said of it. "We were really thrilled, and impressed . . . It was elegant! It was royalty! It had red leather seats. We'd never sat in anything like that before."[21] He drove it to the Bill Gates Diner and took friends for rides. "He was so proud of that Mercedes," Milo Barlow said.[22] In the Mercedes, Smith drove his daughters to the piano lessons in Wilson's house by the lake.

Unleashed

Although the Chelsea remained his primary city residence, Smith now also stayed at the Plaza, the swank and storied hotel in Midtown near Central Park. He went on drinking binges with friends and lovers and made sure everyone knew about his Mercedes. "You are a hot shot with your MERCEDES," Dehner wrote him.[1] Artistic discussions could turn into intellectual free-for-alls. In Bennington, he, Noland, Goossen, and the sculptor-painter-architect Tony Smith got into "2 hours of hair down verbal exchange and anecdote trading" about Gorky, Pollock, Newman, and other artists.[2] His letters to Everett Ellin brim with indiscretions, which Ellin welcomed, hoping that by indulging him at every turn he might become Smith's dealer of choice. After signing a letter of protest against John Canaday, the senior art critic of *The New York Times*, who attacked the Abstract Expressionists, Smith wrote to Lois Orswell: "I sign everything of a protest nature—and Canaday is a bad man . . . Basically he impugns the artistic enterprise [and] should be slapped down."[3]

Great sculpture seemed to pour out of him. His stainless-steel constructions were choreographies of light. His new color spread its dynamism over the more expansive sculptural surfaces. Some of his new sculptures were massive. His polychrome "monsters" balanced on small steel plates supported by preposterously tiny wheels are still more Smith

engineering feats. Bigger and better was now a mantra. "I'm ridding high and good," he wrote to Ellin in January 1961. "Should have lots of big works to show—but I don't evaluate them—I just keep visions flowing good or bad or not successes is not my problem—the impelling force and extemporaneous hunch is all I'm concerned with. Evaluation can come later . . . Im prolific."[4]

"Working good and hard and big and painted," he wrote to Noland in March, the month he finished the flashy and profane *Noland's Blues*.[5] "Which of my girls are you tailing," Smith asked him before describing the sculpture. "Blue black with red strip up pussy."[6] He wrote to Dehner, "Go to work now at 8 am—have Leon Pratt helping me—work is too big for me to handle. Need help."[7] At the beginning of 1961, he had two men working for him; by the end of the year, he had three.

There would be no compromising with dealers: "If we are to maintain future business accord we will have to do it my way . . . I'd rather not sell than have my position questioned," he told Ellin. No discounts and "no price concessions from me."[8] He wrote to Gerson, "I wish to direct my career and judgements, as I do with my life and my work judgements. I shall always, as I see it now, decide and arrange what seems to me for my own good. I've no commitments to anyone."[9]

Smith raised his prices to the point of outrageousness, determined that sculpture be recognized as a costly and valuable endeavor. When *Lectern Sentinel* sold for $17,000, he was proud to tell Dehner that the Whitney "never went so high for any thing before."[10] At $45,000, *Zig IV* was the highest priced of the 445 works in the 1961 Carnegie Museum's Pittsburgh Triennial, higher even than a painting by Picasso. Leon Arkus, the museum's assistant director, told Smith that "the likelihood" of selling his sculptures at his prices was "nil."[11] Smith reacted: "I'm not at all in accord with your qualitative evaluations, based on paintings and I presume reproductions especially since you do not have the facts of my costs and or need and since I do not base with what others may consider competation. My prices are based for 5 years with consideration to inflation and handling in that time. I'll get it or I'll give it to my children."[12] The reliable and efficient Gerson did manage to sell his work, netting Smith more than $45,000 that year. "If we had a better working

agreement," Gerson told him, he would have bought even more sculpture from him.[13]

Smith's sculptural fields continued to grow. They enabled him to watch his sculptural proliferation and experience each day his sculpture's interactions with the landscape. Making sculpture that he knew was too big for most galleries and museums and refusing museum discounts communicated his refusal to be defined by institutional expectations of accommodating artistic behavior, as well as his uncertainty about how much sculpture he wanted to leave his hands. "I don't want my work distributed around. I want it all where I can see it," he told Gerson.[14] He would continue to make sculptures available to devoted collectors like Orswell, who promised to keep her Smiths together. Smith now regularly referred to his work as "offspring" or "children." "Your children are on their way home. We've enjoyed having them," the Balin/Traube Gallery wrote to him.[15] In Bolton Landing, he could watch over his sculptural progeny, deciding when they would depart and return.

In his essay "What Should a Museum Be?" in the March 1961 *Art in America*, Robert Motherwell expressed the dissatisfaction many Abstract Expressionists felt with museums. He praised MoMA "for the completeness and quality" of its collections, and attacked the Whitney for its empty, meaningless ensemble and the Guggenheim for its lack of a clear identity. It did not serve art, artists, or viewers to see work by individual artists scattered here and there, in this museum and that, and to come across work by the same artists in one museum after another. "Everywhere in America," Motherwell wrote, "one sees the same Main Street, same Woolworths, same Coca-Cola, same chain drugstore, same movie, same motel, same fried shrimps, and the same local museum reflecting in the same lesser way the same big museum. O sameness!" As an alternative to this cultural homogenization, Motherwell singled out Smith: "Bolton Landing, N.Y. is to me one of the great places in America because of David Smith's metal sculpture strewn across his acres, and in his house and studios; otherwise, it is a banal resort on Lake George, where I suppose the main place to eat is Howard Johnson's." Smith's hillside offered an artistic experience curated by the artist, where art could be seen in relation to the artist's life. "The issue is passion, whether quiet

or wild," Motherwell concluded. "Museums distort the history of artistic passion, just as do the societies which museums reflect."[16]

In his love life, Smith embraced competition and courted scandal. Pursuing women who were involved with other men could activate a mix of excitement and guilt. "I broke with mistress," he wrote Ellin. "She got sad—morose—in drunken moment told husband [about the affair] he choked her—threw her around—raped her probably had the best piece he's had at home for years. I got moral—and noble thinking of her family etc and wrote the letter—what a Calvinist I am."[17] Smith and Noland egged each other on, bantering about which women they would share and which they would leave for the other. "Noland is here today—out fishing with my friend Linda (you met her)," he wrote to Ellin. "I'm working—She will probably be his girl now."[18] Smith considered pursuing Ruth Kligman, who had had notorious affairs with Pollock and de Kooning. He spent several hours with her one evening and took her home, but in Priscilla Morgan's words, he "couldn't stand her."[19]

Smith did pursue Morgan, the girlfriend of Isamu Noguchi, whom she had met in Paris in 1958. Morgan was a glamorous, well-connected, and professionally vigorous thirty-one-year old executive at the William Morris Agency. She was on warm terms with many artists, including de Kooning. "I was an agent for all these great writers, directors, and producers," Morgan said. "We were hot stuff. Bill loved that, and David loved it. I was Miss Glitz at the time." In January, when Noguchi was in Japan, Smith invited Morgan upstate. She recalled: "I think he had had a lot of groupies around him in the art world, and he was intrigued that Isamu had pursued me, and that I was so close to Bill. So I think he wanted to know who I was, and I think David . . . wanted to get together again and have a family. I felt that." While Noguchi was "elegant" and "refined," David "was a big, rough crude guy." But he could also "be very delicate." "That man would go out in the fields and pick a bouquet of little flowers that big, the most exquisite flowers you ever laid eyes on. And David would cook dinner for me . . . I'm sure you've heard that he was such a cook. Oh, my god! . . . And we would have these bottles of incred-

ible French wine." Morgan stayed in Bolton Landing two or three days. She was moved by Smith. In the bathroom, "he had drawn the sun on the window, for his daughters. He talked a lot about his daughters. They were little then, and he was just crazy about them. He missed them." When it came time for her to leave, there was a terrible blizzard, but he shoveled a path to the road and carried her to the truck. "It was so chivalrous."[20]

When Smith next ran into Noguchi, who would become the love of Morgan's life, he felt remorse. "Im in NYC on my way back from Pittsburgh got to Rothko opening," he wrote to her in March. "Met Noguchi he gave me odd look and quisical words—I was intending to call you but somehow I fealt [like I was] trespassing or felt that he was distressed—was he—did he—of course I have tried to phone you but that is difficult."[21]

The artist Patricia Johanson sat next to Smith at a city party at William Rubin's. They had met at Bennington College, where as a student she helped install his 1959 drawing show, and he asked if he could take her home. "I think he was really worried about me—would I get home?—because he had daughters," Johanson said in an interview. When he asked if she was spending her Bennington non-resident term in the city, she said she was working for Joseph Cornell. "His eyes rolled heavenward, and he said, 'You're working for Joe Cornell?' He said, 'Oh, I don't think you should be doing that.' I said, 'Why not?' He said, 'Oh, there have been incidents. I wouldn't keep going out there if I were you.' I said, 'No, no, I'll be fine.' Then he started telling me all these stories that he knew about, and he was clearly very concerned that I not get trapped out there . . . He really did care what was going to happen to me."[22]

Anne Truitt was a forty-year-old sculptor and writer who, inspired in part by Barnett Newman, had just begun a sustained and often inspired exploration of geometry, color, and light. She and James Truitt, her husband, a journalist who wrote sympathetically about the Color Field painters, and their two daughters, Alexandra and Margaret, who were the same ages as Becca and Dida, lived in the Georgetown neighborhood of Washington, D.C. Her studio was in the same building as Noland's. "It was a hot night," Truitt remembered of the dinner at Mary Pinchot Meyer's Washington apartment; Meyer was dating Noland. Truitt was pregnant and didn't feel well. "I just . . . didn't want to be bothered. So

I just simply did nothing . . . We had a nice supper, then I was just sort of lying on the couch when David turned to me and suddenly said, 'You haven't said a word.' I said, 'No, I haven't,' and that was that. That's how we met. But he didn't criticize . . . He just was commenting. So then I realized he was a man who wouldn't bother me."[23]

Beatrice Monti della Corte was another accomplished woman who entered Smith's life at this time and remained friendly with him until his death. She had opened a gallery in Milan in 1955 and over the next few years was one of the few Italian dealers interested in contemporary American art. In 1961, she approached Smith about showing with her; he didn't know enough about her as a dealer to accept. "I found him terribly appealing," she said. "Not sexually appealing, but I found him a tremendous presence, attractive . . . You know—don't be scandalized, because I love dogs—he looked a bit to me like a big St. Bernard." She contrasted him to Noland, whom she found "less interesting as an artist, and very complicated as a personality . . . He made passes for sure . . . I remember running through the studio."[24]

On her visits to New York, Monti met with Joseph Hirshhorn, who that year bought five more Smith sculptures. At a party at Pierre Matisse's, Hirshhorn asked her to have dinner with him. When she said she was having dinner with Smith, Frankenthaler, and Motherwell, he mentioned that he was friends with them and had bought their work. "I'll come along," he said. When they arrived at the Chelsea and Hirshhorn told Frankenthaler and Motherwell that he would be joining them for dinner, Frankenthaler was furious. "You are not invited," Monti remembers her saying to Hirshhorn. "This is not your dinner, it's our dinner." Monti was horrified. "I'd never seen anybody say 'You cannot come' . . . In Europe that doesn't happen? Never! Never! If it's somebody with whom you have a relationship, they would say: 'Well, listen, come along, but later we have to discuss something.' They would do it a little more gracefully." Monti called to Smith. "'Please come out of the loo or wherever you are. I don't know what to do' . . . So David came out . . . and he said, 'What is going on? Why are you all shouting?'" When Monti explained he said, "Well, listen, I understand the situation, but this is not my dinner. If it would be my dinner, you would come along. This is the

Motherwells' and I can't oblige them to invite you." Monti joined them, without Hirshhorn. The dinner, she said, "was very strange."[25]

In February 1961, Smith made *Zig II*, the first of his seven *Zigs*; *Zig I* was the second. (See Figure 8 in the insert.) Painted in a palette hinted at in earlier work but otherwise unfamiliar in modern sculpture, the series' metal plates, sheets, and beams evoke ships (sails, mast, and engine room), automobiles, weapons, altars, and preposterous toys. While some *Zigs* seem more architectural than figurative, the human body haunts this series, too. Smith said that the word "zig" was "affectionately diminutive" for "ziggurat," which *The Columbia Encyclopedia* defines as "a pyramidal structure, built in receding tiers upon a rectangular, oval, or square platform, with a shrine at the summit."[26] He told the *Pittsburgh Post-Gazette* that a ziggurat "is presumed to be a shrine, reaching toward the skies, with man elevating himself."[27] To another reporter, he said that the *Zigs* came "from the ancient ziggurat—a high place of worship—of the Sumerians and Babylonians—and signify man's elevation."[28] While the *Zigs* have a density and magnetism that may have intimations of ancient Near Eastern monumentality, however, and *Zig IV* features a squarish plate, nothing about the *Zigs* resembles an ancient ziggurat. While ziggurats were massively earthbound structures, the *Zigs*, with all their bulk—*Zig IV* weighs half a ton—seem unfixed and even pliable. Some of Smith's concave steel sheets seem effortlessly bent. In *Zig II*, black, red, and orange are applied with a brushiness and sometimes with a sponge so that the coats of paint seem to be porous—breathing. *Zig III*, roughly 7½ feet tall and 9 feet wide, is mostly blue-black, but the color is lustrous, and this is the first Smith sculpture to evoke a gateway through which people can pass. Here is architecture as passage, the language of architecture in motion. The playfulness of the word "zig," which suggests zigzag and with it an image of children running across a playground or field, helps give the steel bulk an aura of mobility and intimacy. Smith's experiences of Assyrian art, and the art of the ancient Near East, go back to his childhood—to his grandmother's house and images in the family Bible. "I have always been more Assyrian than Cubist," Smith wrote in 1951.[29]

Toward the end of his life, Smith would make clear not just how distinctive his approach to paint and color was in the *Zigs* but also that the application of paint was as unpredictable in its sequences as the arrangement of forms in a sculpture and as the unfolding of almost every Smith series. Looking at Smith's painted surfaces, it is clear that their process of development is important but that it is almost impossible to know what that process is. Smith would explain:

> The paint here is not artists' paint, it's Dulux auto enamel. I mix it, and it's much better than artist's paint for outdoors. First the iron is ground down so that it's raw, then it's primed with about fifteen coats of epoxy primer, and then a few coats of zinc chromate, and then a few coats of white, and then the color is put on after that—so it runs about twenty-five, thirty coats. That's about three times the paint coat on a Mercedes or about thirty times the paint coat on a Ford or Chevrolet. And if it doesn't get bumped or scratched or hammered, I think the paint coat will last longer than I do.[30]

The series asked for connections with painting. Emily Genauer linked the paint application to "the loose, uneven, shimmering spontaneous brushwork of certain abstract-expressionist painters" and also to "the late Monet or Turner."[31] But Frank O'Hara, the first writer to understand the seriousness of Smith's engagement with color, made the important observation that Smith's sculpture "is never sculpture being painting. It is sculpture looking at painting and responding in its own fashion."[32]

During Easter break, in Black Beauty, his sleek used Mercedes, Smith drove Becca and Dida to Captiva Island, off the southwest coast of Florida. At some point in Florida, Dida remembered, her father pulled over. "There was this guy selling pineapples on the side of the road," she said. With Cray-Pas pastels and a notebook, "he started explaining Analytic Cubism, with the pineapple. You know, all the planes of the pineapple, and all these angles and shapes." He did a "really Cubist pineapple." They visited a motel owner who also owned a motel in Lake George Village,

near Bolton Landing. "The grownups talked, and we walked around and looked at" his pet raccoon.[33]

One of Smith's more extravagant gestures that year was the party he helped organize in May on the floor below de Kooning's studio at Thirteenth Street and Broadway. Even though it was, in Smith's words, "a short-notice party," invitations were sent, albeit late. He made sure Lois Orswell and other friends were on the list. The party even had a doorman. "Will tell you about my fanciest party," Smith wrote Everett Ellin, his L.A. dealer. "De Kooning Guston & I were the hosts—Jamal Quartet and full flow liquor till 3–400 + people."[34] "That was the ball of the year that you-all gave, Thanks and thanks," Dehner wrote to Smith.[35] Cherry loved it: "From what I hear the party was a straight A. At a certain point neither saw nor heard—nor cared."[36]

Smith and Noland were now inseparable. Noland hinted at sexual foursomes with young women. They went to galleries, museums, and the Five Spot. When Noland thought of moving to New York, his first thought was Bolton Landing. He considered the now run-down fifty-acre property of Wilhelmina Weber Furlong, where Smith and Dehner had been introduced to Bolton Landing more than three decades earlier, for which Noland offered $7,000. The frail and aged Weber Furlong (whose husband, Tomás, had died in 1952) sought advice from Dehner, who told her not to sell all of the property. Dehner reported to Smith that she made sure Weber Furlong knew that $7,000 "wont keep her for her lifetime, and that's all she has. She is "broke . . . poor old Weber . . . mostly blind . . . still spirited . . . still full of MAGIC."[37]

When a minister in Warrensburg offered $10,000 for the property, Noland began looking for a place in Bennington. In 1963, in Shaftsbury, Vermont, just outside Bennington, he bought "The Gulley," a majestic hillside property that had belonged to Robert Frost and would later be acquired by the producer Norman Lear.

The sculpture Smith gave Noland that year was 7 inches tall and consisted of two circular forms, one on top of the other. The lower circle suggests a wheel with spokes. The upper one is unencumbered; its rim suggests cogs. "I'd been painting my circles by now," Noland remembered,

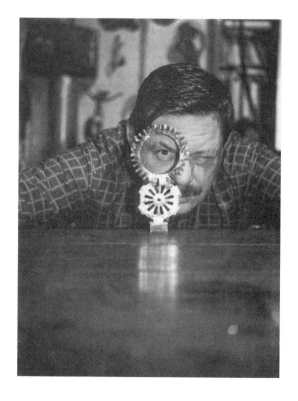

David Smith with *Untitled*
(*You Me and Uccello*) in his
living room, Bolton Landing,
New York, 1961. Steel, 7 × 4 ×
1⅛ in. (17.8 × 10.2 × 2.9 cm).

"so he said, 'I'm going to give you that.' And he scratched on it, around the ring, 'You, me and Uccello.' Then he wrote: 'This is for Ken Noland. Bolton Landing, 1961.'"[38]

In June, John Graham died. Smith learned the news from Dehner:

> Ivan died a few days ago in London in a hospital there, of luckemia . . . He died suddenly, as they thought he would live five or six months longer . . . I guess you and I knew him as well as anyone did, and more objectively than most . . . he had spoken to [his son] Nicholas some months before he died and mentioned us particularly . . . so much so that of all the people Graham knew, Nicholas was most anxious to meet us. He will be coming to this country soon, and I hope he looks me up . . .

Well that's the end of some kind of an era . . . he will be in my
memory in a hundred ways, as an amazement of my life . . .
plowing up new land. David, how are you? I hope well, and
working well.[39]

Smith was asked by Hilton Kramer to write about Graham but
couldn't. "I paid my reference several times where Ivan could read it
I have a block on posthumous admiration," he told Dehner.[40] Orswell
had an "agreement" with Smith that if she bought Graham drawings,
he would give her some of his. She would "keep the group separate 'in
memory of J.G.'"[41] Smith wrote to her on Christmas Day: "I will send the
drawings to match your Graham acquisition. I'll pick out two . . . Don't
worry about the memory part just give them from you—this was my
memory to John—alone."[42]

Smith and Dehner were in regular contact now. He needed to let her
know how and what he was doing. Her letters were longer and more ex-
pansive about her life and work. When she asked for advice, he gave it.
When people who had marked their lives together resurfaced in decline
and death, they had only each other with whom to reflect on memo-
ries they shared. Smith was more divided about the continuing impor-
tance of these people in his life, he had long ago tired of what he saw as
Weber Furlong's insularity and sanctimoniousness, and his friendship
with Graham broke after Graham turned his back on aesthetic beliefs
that remained formative to Smith, but these people were still in Smith's
heart, and in letters to Dehner his attachment was evident. Smith and
Dehner were getting older—Dehner would be sixty at the end of this
year—and for each of them their connection was irreplaceable.

The Carnegie

When Becca, seven, and Dida, almost six, arrived in Bolton Landing in late June 1961, waiting for them was a Black Angus bull and a black pony named Jo Jo. Smith got the Black Angus first, but not wanting him to be lonesome made a trade with a farmer—a sculpture for Jo Jo. He called Jo Jo "Horse" and the Black Angus "Hamburger."[1] The girls took riding lessons from a "nice woman down the road," Dida remembered. "We had this kind of wacky getup that we wore . . . English boots, blue jeans, cowboy western shirt with snaps . . . and an English riding hat." Smith, too, rode Jo Jo, even though the pony's "back had already gone," Dida said. "And [the pony] had this fat belly. I mean, he wasn't the epitome of equine poise. But he had a lot of character. He was ornery . . . It looked a little funny, with my father on him, but Jo Jo was big enough to throw my father, too."[2]

The condition for the gift of Jo Jo was that Becca and Dida learn about horses. "If you want to know about horses, or draw horses, we'll make a horse," Smith told them. Making a realistic one was not permitted. That "was very bourgeois," Dida said. Smith also had no use for those coloring books in which children filled in the outlines of animals. "He accused my mother of buying us coloring books, and warping our minds." When a friend of his daughters asked him how to draw a horse,

he wouldn't tell her. "She kept pushing him and pushing and pushing him, and finally . . . he said, 'Okay. I don't want to tell you how to draw a horse. But if I were to tell you how to draw a horse, you'd start from the section of power. That would be the haunches. Then you'd go from there.'"[3]

David Smith (photographer), Candida and Rebecca Smith making a plaster horse, Bolton Landing, New York, 1961.

Becca and Dida drew a horse's bones and muscles "and learned where the movement came from." Then they built a horse sculpture with their father. "He made an armature out of welded steel; we added muscles, flesh, and skin with plaster of Paris, old sheets, and burlap bags," Dida said. Becca recalled, "That was really wonderful. We did that in his studio . . . It was like the size of a real horse. Of course, it was really fun to put all this plaster on." They worked where he worked, "next to him," Becca said.[4]

With Freas in Europe on a rare vacation, Smith could feel that he had the girls to himself. "We are all well and I'm happier when girls are here," he wrote to Lois Orswell.[5] At the end of July, he gushed to Otto Gerson: "The kids are a joy—we run riding swimming and music lessons quite a full schedule."[6]

In the exuberance of this summer, Smith made *Zig IV* and *Zig V*. (See Figure 9 in the insert.) Greenberg called *Zig IV* a "masterpiece,"[7] and the

curator Edward F. Fry wrote that it "should be numbered among the artist's half dozen finest works . . . ZIG IV attains a level of realization within the artist's stylistic vision that Smith never surpassed and rarely equalled."[8] It was important to Rosalind Krauss, too, for whom in all its directness and availability the sculpture remained elusive, always beyond conceptual grasp. "The startling fact is that although *Zig IV* is all boundaries, made completely of curving walls and angled planes, these contours bound nothing, not even a comprehensible volume of air. We have only a visual display of surfaces slipping past one another . . . Given the ambivalent character of Zig IV, we cannot grasp it imaginatively."[9]

The sculpture is taller than 8 feet. Most of it, including the massive squarish steel plate—a platform or stage, turned and tipped onto one of its four points so that it looks like a diamond—is tilted up at roughly a 45-degree angle. The plate's lowest point rests not on the ground but just above it, on the edge of a small dolly-like platform whose four tiny wheels are comically disproportionate to the mass they support. The shifts of scale are as improbable as a clown on stilts emerging from a miniature car in a circus. The clean, planar, almost cardboard-thin steel shapes welded to the plate seem almost to have been cut with scissors. The incomplete shapes suggest industrially made objects from Smith's memory bank, such as a stamping machine or perhaps an aircraft gun, or going back to train tracks in Decatur, a pump car. Most forms hint at function, or an architectural model that was initiated and then abandoned. The wheels generate a desire to push the sculpture, but it seems that any pressure would cause it to topple over and lie on its side, beached. There is no sculptural precedent for the color mix. "I put a green alo-enamel, mixed with aluminum paint, on top of this red. So that there's a yellow metallic green on top of this coral-orange," Smith said. "These are all auto paints." When he made these remarks in May 1965, he had grown dissatisfied with the green paint; on the day before his late-1965 show in Los Angeles was scheduled to open, he was planning to "paint it red again."[10] Whatever his sense of *Zig IV*'s color, the yellow-green-orange combination, applied with all-over spongy brushwork, lightens the massiveness of the steel and gives it an acidic glow. Elusive, intrepid, monumental, prankish—what a sculptural mix!

Four days before Becca and Dida's August 12 birthday party, Frank O'Hara visited. O'Hara had become an assistant curator with the Department of Circulating Exhibitions at MoMA. He organized MoMA's 1957 traveling Pollock retrospective and was now in charge of its 1961–1963 traveling Smith show. The short, lean, urbane, gay thirty-five-year-old poet and the huge fifty-five-year-old mountain-man sculptor knew each other through mutual friends and evening hangouts. Both were at home with the attitudes and accomplishments of the New York School. Both had a quick-wittedness and charm with which they knew they could win over pretty much anybody. While O'Hara was a consequential figure in the institution that was most committed to Smith, like Smith he could not be institutionalized. "Sharp and funny and very frank" is how his fellow poet Joe Brainard famously described him.

During his two-day visit, O'Hara met Becca and Dida, and he and Smith drank, talked, and looked. "I've been thinking about the new work ever since leaving and it's staggering," O'Hara wrote after returning to his East Village apartment with the gift of a Smith painting. "They get to me but I don't get to them. They make me feel like the world going round and round and not knowing what's going on, in a word, alive." O'Hara included a postscript: "What I think I mean by the above is that I'd like to *be* one of those sculptures!"[11]

O'Hara began his article "David Smith: The Color of Steel" with a meditation on the fields:

> The Terminal Iron Works in Bolton Landing, N.Y., has become by now a landmark in American art . . . Smith's works in galleries have often looked rugged and in-the-American-grain, which indeed they are in some respects, but at Bolton Landing the sophistication of vision and means comes to the fore strongly . . . The contrast between the sculptures and this rural scene is striking: To see a cow or a pony in the same perspective as one of the *Ziggurats*, with the trees and mountains behind, is to find nature soft and art harsh; nature looks intimate and vulnerable, the sculptures powerful, indomitable.

O'Hara personified the sculptures. They were both human and more than human, sociable and unsociable. The new stainless-steel sculptures, "tall, glittering, leggy works," were "severer and dashing; to continue the meadow-party idea, they are the sort of people who are about to walk away because you aren't as interesting as they are, but they're not quite mean enough to do it." He communicates Smith's pleasure in materials and construction and reveals a recurrent Smith sculpture fantasy:

> Smith once said if he had the money he'd like to make a sculpture as big as a locomotive, and I think if Smith were asked to make a real locomotive he wouldn't care if it ever ran as long as he had the use of all that metal. Smith's work at certain times, often sarcastic or satiric, now seems to have been transformed into this delight toward the material and, coupled with the formidable structural achievement of the works, gives them an amiability and a dignity which is the opposite of pretentiousness.

O'Hara, echoing the postscript in his letter to Smith, ends his article with one of the most memorable lines in the Smith literature: "The best of the current sculptures didn't make me feel I wanted to *have* one, they made me feel I wanted to *be* one."[12]

After the girls left, loneliness and exhibition drudgework took over. For a respite, Smith drove to Provincetown to visit Motherwell and Frankenthaler, who had learned from O'Hara of his inspiring trip to Bolton Landing. Smith swam and rested as the Motherwells looked after him. In a late-summer photograph, he's standing on the far side of the circular deck table around which his hosts and Vita Petersen, a painter, and her husband, Gustav Petersen, are seated. Smith's sleeves are rolled up; he is wearing white suspenders; his mustache is thick. He looks a bit like a Saint Bernard. He returned via Pomfret, Connecticut, to have dinner with Orswell. "I'm refreshed from the delightful and best vacation I've ever had with the totally generous Motherwell family," Smith wrote

to the Motherwells. "I so needed those days and the friends and the water . . . Life seems bright and I'm charged—After the shop addition— new work."[13] He would spend Christmas with them as well.

Two weeks later, his mood swung the other way. "Despondent for my kids," he wrote to Orswell, "since that is my only love. I've got 2 shows off—1 more to go—With this sort of recognition [referring to the exhibitions] I should be elated but I'm still sad about something or lonesome, or something where in a hole exists."[14] In the fall, inspired by George Rickey's ponds in Chatham, New York, he had three small circular ponds excavated, two of which would be stocked with fish when the girls arrived next summer.

The Carnegie's Leon Arkus informed Smith that *Zig IV* would not fit through any of the doorways leading to the gallery for his one-person show. The museum decided instead to put *Zig III* in that show and *Zig IV* on its own, making it the work that would compete for prizes in the Triennial.[15] Smith refused to wear a tuxedo at the formal dinner. "I'll be at the opening later in tweed," he told Arkus.[16] "Ill go to that dinner as much as I hate to if I sit near you and if Madame Orswell sits next. She too is a lost duck."[17]

The Pittsburgh Triennial included 329 paintings and 116 sculptures by 441 artists. Gordon Washburn, director of the museum, made the selections. Every artist was represented by one work. De Kooning, Gottlieb, Kline, Motherwell, and Rothko were included, as were Noland, Morris Louis, Alfred Leslie, Jasper Johns, Jules Olitski, Larry Rivers, Ellsworth Kelly, and Frank Stella. The first prize in sculpture was awarded to Giacometti's *Walking Man*. George Sugarman's *Six Forms in Pine* won second prize. *Zig IV* was awarded third prize and $1,000.

Smith rejected the award. He wrote to the Fine Arts Committee of the board of trustees of Carnegie Institute on October 26:

> I do not wish to accept the prize your guest jury has honored me with.
>
> I wish the money involved returned to Institute direction, and I hope applied to use for purchase.
>
> I believe the awards system in our day is archaic.

In my opinion all costs of jury, miscellaneous expense of the award machinery could be more honorably extended to the artist by purchase.

A few years ago I was chairman of a panel in Woodstock, New York, wherein the prize system was under discussion. The majority of artists spoke against the prize system. Dr. Taylor, then President of the Metropolitan Museum, was recognized as a speaker for the prize system. He spoke eloquently and defended this as of being the donor's prerogative and ended by summing up that the prize system is longstanding and honorable and goes back to the days of Ancient Rome when a prize was given for virginity. After the applause—a hand was raised for recognition by painter Arnold Blanch. His question— would the last speaker care to qualify the technical merit for second and third prize.

Thank you and greetings.[18]

Now he had provoked an actual scandal. "A Winner Who Refused to Win" was the headline of a one-page article in *Life*. "Sculptor Rejects Award of $1,000" was the headline of the article in *The New York Times*. "Bolton Landing Sculptor Turns Down $1,000 Prize," exclaimed the *Glens Falls Gazette*. The *Troy Record* wrote:

Smith said that he and many other artists have long objected to the prize system used in most art competitions. It is impossible, he said, to properly judge one type of art against another and sometimes, even one picture or one piece of sculpture against another . . . First prizes are not too bad . . . but second through fifth prizes often smack of what the Bolton Landing artist called "royal patronage."[19]

He told the *Pittsburgh Post-Gazette*: "I don't acknowledge that one artist is better than another. It's kind of an arbitrary decision, an old-fashioned idea not in keeping with my ideas of democratic principles. I'd like to see the prize system abolished." Smith "praised Giacometti as a 'master,' who should have won a prize 20 years ago."[20]

Smith's resistance to awards did go way back. When he started out as an artist, he saw that the best modern artists were consistently overlooked in favor of lesser artists who reinforced familiar museum standards. He knew that a crucial reason for the prize system was that it maintained the aesthetic authority of the institution. Newman and Rothko were among his friends who had refused to appear in group shows that awarded prizes.[21] It is also true, however, that Smith was rankled by having been overlooked for prizes in Venice and São Paulo. He and others knew how good his sculpture was at the Carnegie. "Your room at the Carnegie was one of the most magnificent things I've ever seen," wrote Waldo Rasmussen of MoMA, a close friend of O'Hara's. "It was as if you walked into the room and the sculptures said 'now let's stop kidding and get down to it.' In short, a glory."[22] If he had been awarded second prize after Giacometti, Smith would surely have accepted. But to come in third, and for *Zig IV* to be judged inferior to the work by Sugarman, a fine but still emerging sculptor, galled not just him. "No one would begrudge Giacometti the first prize," William Rubin wrote in his review of the Triennial in *Art International*. "He is certainly one of the great sculptors of all time . . . Sugarman's python-like piece is excellent. I remember admiring it when it was exhibited some time ago in New York. But ranking it above Smith's astounding 'Zig IV' can, again, be interpreted only as the result of committee politics."[23]

"Ill definitely withdraw from prizes but I didn't care for 3rd," Smith wrote to Dehner two weeks after his letter of protest. "And I don't even care . . . Have been working to keep from being lonesome for my kids—will work hard now—have 8 big ones done now which I couldnt show."[24]

The Carnegie nevertheless wanted drawings by him, and he sold them two for $1,000. He understood the consequences of his action. He wrote to Ellin: "This really puts me in the no prize position forever."[25]

A month earlier, on October 9, after nearly three and a half years of separation, Smith and Freas were divorced. Freas, Becca, and Dida were still in Bethesda. Smith went to Washington a few times a year to see the girls. Freas kept him informed about their health and school. He spoke with them by phone, and during the next few years, his complaints

about loneliness in those conversations would wear on them. Freas was working for her father in his food produce business and building her own life. Studying Swahili at the University of Michigan and Howard University would lead to a job with the Voice of America reading the news to Swahili-speaking nations. In 1965, not long after Smith's death, Freas was hired to be a co-anchor on Washington's NBC News affiliate, becoming one of the first female news anchors in the country. In 1969, after marrying Geoffrey Pond, an NBC news director, she moved to Westchester.[26]

Eight days after the divorce, "The Last Works of Henri Matisse, Big Cut-Out Gouaches" opened at the Museum of Modern Art. While visiting the exhibition, Smith met Nancy Grossman, a twenty-one-year-old fashion student at Pratt Institute who was just beginning to define herself as an artist and would be best known for sculptures of wooden heads wrapped, and seemingly bound, in materials like leather. "He was just sitting at a table. He had just bought this book of David Duncan— a Picasso book," Grossman said. "He was there to see the Matisse cut-outs . . . He thought they were just genius things, and he said he loved that way of working; that he was cutting out things, too." Soon after, they went on a date. Then he called again. "He didn't sound like he was okay," Grossman recalled. "He sounded depressed. He said, 'I really would like you to come visit.' He may have been drinking at the time. I said, 'You mean now?' He said, 'I'd like you to come right now.' . . . Well, I think I came the next day." He arranged for her flight. On the way to his house, he stopped to pick some "wild watercress . . . I never had things like that before."

Grossman stayed several days. "I was just ready for anything," she said. "I had left school and gone back to school, and I'd been sort of an anarchist." For her, the age difference was unimportant: "I was about twenty, and he was fifty-five . . . I thought that he was practically my father's age, and that he was such a strong man . . . He was very honest, a really honest person—and hard working." When Smith went to the shop to work, he left her with drawing paper in the house. "He was an artist who knew that I was an artist," she said, adding that Pratt "was very oppressive. I had to have a secret life. He's a real person from my secret life."[27] After he went to see her at Pratt, she wrote to him: "I was so happy that you

came to visit me. Every time I see you I feel exhilarated afterward. It's partly because you're an acknowledgement that it *can be done!* You're so creative and real. All intact—you keep doing your work."[28] Over many decades, Grossman continued to express her affection for Smith and acknowledge his impact on her sculpture.

In a multitude of ways, Smith called to, named, and conjured his daughters in his work. Becca and Dida "are referenced in no fewer than two dozen sculptures, sometimes by name, sometimes by form," the art historian Paul Hayes Tucker wrote. Tucker points out not just titles, such as *Hirebecca* and *Hicandida*, both made in 1961, but also sculptural imagery and greetings welded onto bases.[29] When Smith delivered *Lectern Sentinel* to the Whitney on December 24, 1961, he informed the museum that he had inscribed "I greet you Becca, Dida" under its base: "This writing [acts] as reinforcement under base and signature note to my daughters."[30] The inscription on the painting Smith gave O'Hara mentioned the girls. In early 1962, Smith gave the Whitney two drawings as gifts from them, his first drawings to enter this museum's permanent collection. One was "Gift of Miss Candida Kore Nicholina Raleigh Helene Smith." The other was "Gift of Miss Eve Athena Allen Katheryn Rebecca Smith." The order was the same as the last time he had given gifts in their names, to MoMA in 1957, but the spelling was confusing. John Bauer, the Whitney's associate director, asked Smith to check it so as "to make sure we have not misread your inscriptions."[31] Smith was becoming forgetful, sometimes leaving things at friends' houses, and it's hard to be sure if the different spellings were intentional or the result of absentmindedness, inattention, or stress, but it is clear that in his work Smith was constantly speaking to his daughters and imagining their accompanying and intervening for him.

An Invitation

From its beginning in 1958, the Festival of the Two Worlds, held in the Italian city of Spoleto, had featured the performing arts. In 1961, believing that he needed a stronger visual arts presence, the festival's director, the composer Gian Carlo Menotti, brought in Giovanni Carandente, a thirty-eight-year-old critic and curator and student of ancient, Renaissance, and modern art. For the 1961 festival, Carandente installed "Modern Art Drawings," an exhibition MoMA organized. Carandente had a special feeling for sculpture. Since 1956, Alexander Calder had been an influential friend. For the 1962 festival, Carandente came up with a remarkable proposal. "[I wanted] to put modern sculpture in the streets of the medieval ancient town," he said in an interview. "I had the idea that it was a beautiful combination to put together the ancient and the modern."[1]

Carandente asked Beverly Pepper, an American sculptor who lived in Rome with her husband, Curtis Bill Pepper, the Rome bureau chief for *Newsweek*, to write and deliver an invitation to Smith. Her invitation read:

> [Carandente] is determined to get you to participate in the Spoleto SCULPTURES IN THE TOWN exhibition. He's managed to get Picasso's L'Homme et Mouton, Henry Moore, Max

Ernst, Arp, Chillida, Wotruba, Cesar, Penalba, Germaine Richier, and God knows who else.

Though he'd be delighted to get *any* sculpture from you, he would like, in addition, for you to see your way clear to working at one of the Italsider factories (I think I told you I am working at Piombino near Elba). They have factories in Genoa, Savonna [*sic*], Naples, Trieste—your decision. They will fly you here, board and lodge you and the sculptures you make are yours—they supply the workers and materials of course.[2]

Smith "was very funny and loved the idea of being given a whole factory," Pepper remembered, but he didn't know Carandente or the Italian steel manufacturing company Italsider, so before accepting, he needed more assurance and information.[3] Menotti met with him. He told Smith he could choose a factory in any one of five cities. Smith asked: "If you were me, where would you work?" "I would go to Genoa. I think it's a lovely old town." "'All right I'll go to Genoa.' I decided over a couple of drinks in the Ritz Bar on Madison and 60th Street where I met him."[4] What sealed the deal was Menotti's promise to dedicate an opera to Becca and Dida.

Smith had wanted to travel and since the 1940s had felt the lure of Italy, the country of the *paragone*, the centuries-old debate over the comparative merits of painting and sculpture, and great metal traditions. He had artist friends there, like Afro Libio Basaldella and Piero Dorazio, and newer acquaintances, like Beverly Pepper and Beatrice Monti della Corte. Italsider, the Italian equivalent of U.S. Steel, invited artists chosen by Carandente into their factories, where materials and workers were made available. For a month he could work all day in a factory and sleep in a luxury hotel. The sculpture he made would be shown in a beloved Umbrian hill town, layered with history, in the company of sculptors he admired, and whatever he showed he would own. The adventure would begin in May; Smith would be back in Bolton Landing at the end of June. He communicated his excitement to Orswell and Dehner and pretty much everyone else he felt close to.

In February and March, Smith had a visiting-artist gig at the University of Pennsylvania—which he largely accepted because of Philadelphia's proximity to Washington. After each visit to Penn, he went to Washington to see the girls. On his third and last trip to Penn and Washington, he attended the March 11 opening of his MoMA traveling show at the Phillips Collection in Washington. Then he flew to Florida for a couple of days on the beach. When he returned to Washington, he had lunch at the home of Duncan Phillips, associate director of the Phillips Collection. "Very charming old culture people," Smith wrote Ellin. "Chauffeur put velvet lap robe on my knees when he drove me out to their house."[5] Anne Truitt was another guest at that lunch. "David I saw for the first time in the role of Great Artist," she said in an interview. "Blunt, plain-speaking, not quite on the defensive but with an edge."[6]

By now, Smith was a regular at the Truitts'. The Smith and Truitt children would "all have Sunday dinner together, and then we'd take the children en masse to the zoo or something," Anne said. "And David used to stand in the front hall—I can see him now—he loved to shout . . . He'd look up the stairwell and he'd call, 'Smith girls! Smith girls!' in a very, very loud voice . . . So down would come the children."

Truitt would drive Smith and the girls to their home in Bethesda. "David had to direct me. I think it was someplace off Wisconsin Avenue." The girls "would be more or less silent . . . David would sit next to me, in a black cloud, which would increase and get blacker and blacker, a cloud of sadness, until we got to the house . . . [After leaving the children with Freas, we] would just drive silently, back to the house. Then David would call a taxi, we would get him a taxi, and he would fly back home . . . to New York."[7]

It was on one of his March trips to Washington that Smith ran into Dan Budnik while viewing an exhibition at the National Gallery of Art. Budnik had spent more than two years in Europe, where he began working as a photographer with Magnum Photos. Over breakfast after a party at the Truitts' they both attended, Budnik told Smith about the book Magnum was doing as a fundraiser for the Kennedy Center, which hadn't been built yet, called *Creative America*. "Some of us volunteered to do assignments for the book," Budnik said. "There wasn't any pay, except for maybe getting expenses covered. So they said, 'Who do you want

to photograph?' and I said de Kooning and David Smith." Smith "asked how Magnum responded to the suggestion. I said, 'Well, they asked me to come up with a budget, and you were like $167 and change, and de Kooning was like $47 and change . . . because I had to fly to Glens Falls. So they told me, 'Forget Smith, do de Kooning,' and I thought it was a cute story. He almost started crying. He said, 'Jesus, everyone does Bill. Everyone does Franz. No one does me.' And he was right. He was absolutely right."

Budnik promised to visit Bolton Landing. Smith urged him to come in August, when his daughters would be there and when they could go fishing and sailing. Budnik recalled, "And I said, 'No, I don't want to do that.' And he said, 'Damn it, you don't want to come up' . . . I said, 'I do want to come up.' So he said, 'All right, when, damn it?' I was thinking of December or January and his face dropped a mile. He said, 'Jesus. No fish, no dames, all I do is work.' I said, 'David, I don't want to go up to Bolton Landing, which is a long drive, and have you play. I want you working.' He said, 'That's a good time of the year. That's all I do.'"[8]

Between Clement and Jenny Greenberg's visit to Bolton Landing in early April, during which time, in Greenberg's words in his datebook, they "walked, talked, looked, and drank,"[9] and Becca and Dida's visit over Easter, Smith wrote a poem about staleness and loneliness that helps explain why the Italian invitation was so fortuitous:

ISNT IT GOOD—4-11-62

I forgot my coffee during its overboiling
while making a drawing
the meat was close tasting a bit high from
lying store-wrapped in the icebox—
the toast fell on the floor—but I'm free
it would have been good to have a girl breakfast
properly scrambled—properly made—Is a briefcase the
 requisite—the sounds were
not but the sounds
of expansion—birds and my own worries—
there were no complaints—and I am still free
but the coffee is cold now and still overboiled.[10]

On May 13, Franz Kline died at age fifty-two. "His friends knew, of course, that his prodigious drinking was dangerous," Mark Stevens and Annalyn Swan wrote in their de Kooning biography. "He had been seriously ill with rheumatic fever and suffered a series of heart attacks. But his death seemed sudden and unexpected nonetheless." To Stevens and Swan, Kline's death marked the end of an era. "He was the one to sit next to, the barstool raconteur who never became a bore. His death was the death of the Cedar and, for the downtown artists, a powerful symbol of the changing of the guard."[11]

On May 14, William Rubin and Joseph Hirshhorn visited Bolton Landing. For his own collection, Rubin had bought Smith's 1957 sculpture *Timeless Clock*, and for two to three years had been trying to convince Smith to sell him *Australia*, which MoMA continued to feature: it was part of Smith's traveling show. Rubin would finally succeed in buying *Australia* from Smith on the installment plan a year or so later; it would be one of his most consequential gifts to MoMA. Hirshhorn was famous, or infamous, for his buying style. The art dealer Carla Panicali said that when she did business with him, she always expected him to say, "'Let's buy ten.' He was always buying ten of everything. The artists were never happy with Joe Hirshhorn doing that."[12] After acquiring a new lode of art, Hirshhorn would say to his personal curator, Abram Lerner, "I did some damage today."[13]

"I was there with Joe Hirshhorn and his chauffeur," Rubin remembered. "He said, 'I'll take this and this.' This was for $5,000, that for $6,000, that for $10,000, whatever. He was writing it down and David was writing it down. The total came to $100,000. Joe said, 'I'll give you $40,000 for the lot.' That was the way he did things. Well, David, who was a big logger of a man, picked him up by the back of his neck, took him to his car, and said to the chauffeur, 'Get the hell out of here!'"[14]

The Acquisitions Committee of the Friends of the Whitney Museum spent its 1962 purchasing funds on sculpture. For "Sculpture Today," the *Whitney Review* invited spring contributions from Smith, Calder, Richard Lippold, and Louise Nevelson, all of whose sculpture the museum had recently bought. "The remarkable characteristic of present-day

American sculpture is its high quality," Howard W. Lipman, who was largely responsible for the museum's acquisition of Smith's *Lectern Sentinel*, wrote in the preface. "It is perhaps the first time in our history that such a statement could be made. Sculpture has not been one of our great achievements."[15] Of the four contributions to the round table, Smith's is the most forceful. It has the controlled acerbic stream-of-consciousness flow of his captions for the *Medals for Dishonor*.

He argued for productive rage: "Love or no love—food or no water—fire or no shelter—I maintain the rage and develop its resource—not the ulcer rage—the resource rage—which makes realization of the unattained closer—only a step—but the rage maintains the journey—rage is positive . . . I use what I have with the force that creates a want."

He would not bend before money and power: "The rich hibernate in guilt behind façades—wear middle class expressions—to accept their equality places me servile—I see always revolt—feeling from conflict for survival."

He was bitterly critical of duplication, a main cause for sculpture's subservience to painting: "Sculpture hasn't had a chance—In an atmosphere without honor—by cost ruled—perverted by patronage . . . committed fraud by reproductions after the hand and eye of the artist had long ceased to work—relatives—dealers—authorities indiscriminately fill museums with copies and untruth." By contrast "the fortunate world of painters is more honorable—not committing time to reproduction—not reproduced against."[16] In the fall, Smith and Barnett Newman would argue about sculptural editions. "You wouldn't make more than one copy of your painting," Smith told him.[17]

Smith's battle against duplication is fundamental to his life and his work. It reflects his resistance to the assembly line and his wariness of dealers, some of whom had been instrumental in making posthumous casts of sculptures by Honoré Daumier, Edgar Degas, and Gauguin, often with the approval of collectors, curators, and critics, acts that Smith saw as betrayals of the artist's work. Smith made sculpture that is impossible to copy. His color can't be duplicated; it is often hard to know how he built up his surfaces or even what his color mix is. His combinations of materials are unexpected, and the materials can be difficult to decipher. Smith's relationship to found objects and his joining of objects are

so personal that any attempt to copy a Smith construction would appear maladroit or dead. His sculptural syntax is a mystery, his sculptural equilibriums are feats. Forging a Degas or Daumier bronze would likely involve an overcasting, or *surmoulage*, a bronze cast from a mold taken from a bronze, which can make it hard to tell the difference between the artist's bronze and the fake. Even in rare instances when Smith did make editions, however, as with the *Medals for Dishonor*, the number of casts was limited by him and each bronze was individually patinated.[18] When he had bronzes made, they were often sent to him in parts so that he was the one to put them together. Smith's sculpture is its own secret society or mystery religion.

In preparation for Italy, Smith received a smallpox vaccination from Irving R. "Pete" Juster, who had been his and Dehner's doctor during their marriage. Juster wrote to Dehner: "He reminisced about the long happy association we had with you and David and the wonderful experience in coming up to Bolton." Smith "said how marvelous the old days with you had been. He missed them and was still deeply devoted to you as a person. He expressed many regrets as to what had happened."[19]

On Thursday, May 17, Smith wrote to Menotti, "I'll be in Milan 6:15 AM Saturday. Everything is in order. I'll be down for the opening on 21 June. Enclosed 1 photo of the daughters. 1 photo of the piece which will be over to Spoleto with the Modern Museum shipment. I'll do my best to make you and Italcider pleased."[20]

58
Voltri

Smith's Alitalia flight was scheduled for May 19, 1962, but after Sally, the married woman with whom he was having an affair, the illicitness of which seems to have excited both of them, had to cancel their rendezvous at the Plaza on May 18, he flew that day instead. "My ticket called for Saturday," he wrote to Noland. "I hadn't noticed it—but I came anyhow—they had space." When he arrived in Milan, there was no one to greet him, so he made the 120-mile trip to Genoa on his own. He asked the cabdriver what was the best hotel in Genoa and was told the Columbia.[1] "I walked up to the concierge and I said, 'My name is David Smith, has anybody made any inquiry for me?' He said, 'Oh, yes, Mr. Smith, you are expected. We have a room for you.' Now before I knew it the room was already arranged in the hotel. I just by chance walked into it. The next day the people who were to meet me in Milan, I met at the hotel. They called. I had already been there a day."[2]

Genoa rivaled Marseilles as the most prominent northern Mediterranean port. In 1962, its population was around 800,000. Badly damaged during the war, its harbor infrastructure was rebuilt and developed in the mid-1950s. With its narrow streets, harsh poverty, sumptuous mansions, Baroque churches, and wide boulevards, Genoa had a gritty intimacy, picturesque splendor, and imperial sweep. "The city is a beauty old—grand," Smith wrote to Noland at the Chelsea, where he had taken

over Smith's studio. "Without Italian its easy to get around jazz on bar phono now 1927 Chicago Dixi."

The Hotel Columbia Excelsior opened in 1927 on the Piazza Principe, near the city's central train station. The hotel was within walking distance of the Cruising Ships Terminal, the so-called Stazione Marittima. In front was a roundabout with a tropical garden. Behind was the Via di Pre. "Street of Prostitutes, behind Hotel—like on 22st if they had them there," Smith wrote to Noland.³ Two years later, he told the Art-News editor Tom Hess that he and the British sculptor Lynn Chadwick would walk "the full length of that God damned street to find a restaurant. We had a few favorite restaurants. Chadwick is a bum man he was always looking at every ass. I'm not so much an ass man myself but he could spot an ass two blocks away . . . We used to walk up and down that street and buy cigarettes and everything."⁴

Giovanni Carandente was fourteen years younger, a foot or so shorter, and a hundred pounds lighter than Smith. Beverly Pepper likened him physically to Truman Capote. He was tireless, instinctive, shrewd, and capable of exquisite charm. "He didn't seem to have any doubts," Alberto Zanmatti said. In 1961, Zanmatti was a young architect, still in school, when Carandente asked him to work on his exhibition "Sculptures in the City." "Carandente was skilled at making every artist believe that he was the greater [sic] than all the other artists," Zanmatti said.⁵

"Sculptures in the City" was not intended to be a careful and scrupulous up-to-date overview. It was a sculptural outburst. It included 102 sculptures by 50 artists, 80 percent of whom were European. Henry Moore, Hans Arp, and Henri Laurens were internationally known. Germaine Richier, Étienne Martin, Eduardo Paolozzi, Giacomo Manzù, and Marino Marini composed strange and sometimes disconcerting visions of the postwar European body. Carandente chose Smith and Calder. The other Americans—including Herbert Ferber, Jacques Lipchitz, James Rosati, and Theodore Roszak—were chosen by MoMA, which shipped all the American sculptures loaned to the Spoleto show, including Smith's 1961 Cubi IX, the first in his Cubi series, which Carandente placed in front of a fourteenth-century church.

Installing a hundred modern sculptures throughout an Italian hill town—what an idea in 1962! Marini's Warrior, Manzù's Cardinal, and

Moore's *Reclining Figure* were placed in the piazza in front of the cathedral. Calder's *La Veuve Noire* was placed on the sidewalk alongside the church of San Domenico. One of Chadwick's winged figures was set atop a stone ledge above a busy side street. Carandente "decided to use the city as a theatre, the whole city," Carla Panicali, the director of Marlborough Rome, said. He "did it in such a perfect way, because Spoleto was a small city, but Spoleto was beautiful, perfect, theatrical. Every corner was . . . needing a sculpture at the end."[6]

No less bold was inviting ten sculptors to spend a month in an Italian steel factory making one or two sculptures for the exhibition. Carandente chose the sculptors. Chadwick was British; Calder, Pepper, and Smith were American; the other six were Italian—Eugenio Carmi, Ettore Colla, Pietro Consagra, Nino Franchina, Carlo Lorenzetti, and Arnaldo Pomodoro.

The steel industry played a major role in Italy's economic revival during the period of unemployment and deprivation that followed World War II. Combining the words *Italia* and *siderurgia* (steel), Italsider promoted itself as Italy's national steel company. It adopted a postwar American model in which geopolitical dominance was attained through a combination of entrepreneurial audacity, infrastructure commitment, and cultural verve. It published its own magazine, which included long articles on culture and economics, as well as on modern art. It invested heavily in photography and film, documenting its facilities and advancing a visually sophisticated and progressive brand. Its forty-minute film *Steel on the Sea* won a prize at the 1964 Venice Biennale. Its 1963 publication *The Colors of Iron* demonstrated that steel could be a source of discovery and transformation.

Smith expected to work at Cornigliano. Bombed during the war, this factory complex on the western edge of Genoa, located on a polluted and desolate plain alongside a stream that carried its waste into the Mediterranean, began producing steel again in 1953. With its thirty thousand workers, ten million square feet, and thirty miles of railroad track, the complex was virtually a city. "Eight miles of streets inside the plant and five miles of underground passages," the poet Michele Parrella wrote in his essay for a book of photographs of the factory. "Eight miles of streets enveloped by smoke, steam and noise. Eight miles of streets in a continuous noon."[7]

Smith may have assumed he would be the only artist there. Under the best of conditions, it's hard to imagine him sharing with another artist a work site, even a vast factory complex. In Cornigliano, the din and commotion disrupted the concentration he needed. Carandente used the words "a little trouble" to describe Smith's first encounter with the factory. "I went to work [at Cornigliano], where Chadwick was but it seemed crowded and noisy for me so I asked if there weren't any old buildings they weren't using or something else," Smith said in an interview. "The office man said, 'Oh I don't think you would like this,' so I went out to these factories, five beautiful, old lonesome factories."[8]

The "beautiful, old lonesome factories" were in Voltri, roughly ten miles west of Genoa. Italsider had shut down its Voltri factory complex in 1960, and it had been abandoned a few months before Smith's arrival. Unlike the beach near Cornigliano, Voltri's beach was sandy; people were swimming there. The buildings seem nestled into the landscape. In Voltri, for the only time in his life, Smith had factory, hills, and sea. Though small compared to Cornigliano, the Voltri complex, too, had been a world. It had train tracks, storage areas, a forge with blast furnaces, a workers' restaurant, and medical and leisure facilities.

In Voltri's factory buildings—named Voltri 1, 2, 3, and so on—Smith found artifacts buried in the ground and a bounty of springs, bolts, nails, hooks, spikes, balls, disks, tongs, calipers, anvils, and wheels. Some objects were in different stages of completeness; most were newly obsolete. In Smith's photographs, the objects seem between states. They look expectant even as they radiate an anxiety of rejection. In Bolton Landing, Smith often lived with scrap metal for weeks or months, letting it "cure" before using it. In Voltri, he had less than a month. "A salvage crew was in several days a week with their gondolas and switch engine for heavy scrap to feed the melt at Cornigliano . . . I felt opportunity time even shorter than in Bolton."[9]

In Ugo Mulas's photographs, one of the Voltri factories has the stark grandeur of a pillaged early Christian church. The largest building, with its huge arched portals and circular windows, recalls the Baths of Caracalla, the Colosseum, or a Roman aqueduct. The scale was epic. Italian steel magnates clearly believed that steel could change the world.

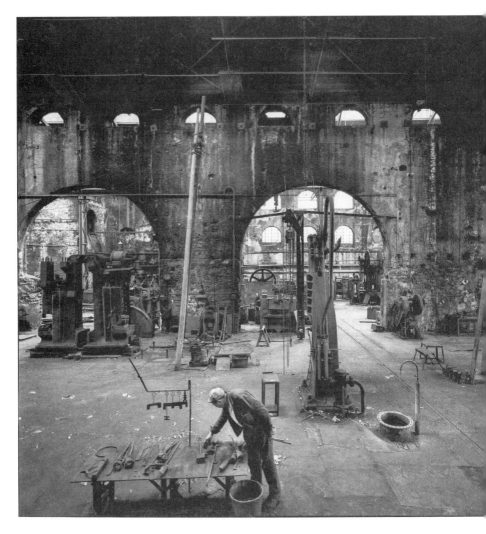

Ugo Mulas (photographer), David Smith in Voltri, 1962.

On weekends there, alone, Smith "felt the awe and the scared air, like one returning survivor after holocaust, and as I had felt, very young in Decatur, when I went through the window in my first abandoned factory."[10]

Smith worked with some objects in the buildings in which he found them. He carried or dragged others to another factory. He set up work

tables on which he placed objects. He drew outlines on floors with chalk and arranged objects on the floor before raising them up and tack-welding them to examine them upright. He changed some objects and incorporated others intact. In the sculptures they are both buried and transfigured. At some point, the sculptures were moved outdoors, where they interacted with other Smith sculptures and different factory remnants before being moved again.

His wish was Italsider's command. "What I wanted I got . . . I took scrap off of scrap cars, I took ends," Smith said. "I found plates that had been failures in the rolls . . . And I picked them up and marked my name on them and had them cut off."[11] Italsider arranged for him to be driven to and from Voltri:

> I had a chauffeur to call for me at 6:30 every morning and at the plant at 6:30 at night to take me back. I went back, took a bath, had a drink and went to the Berlitz School and tried to study Italian a little bit and went out to dinner at 10:30. Went back and poured myself into bed at 11:30 and got knocked out of bed by the bells on a church tower, right next door to the hotel, at 5:30 up and was off to work at 6:30, after having my breakfast in the room. I did that 7 days a week. I was happy.[12]

"In my own country I've never had such cooperation or interest," Smith wrote in a five-page letter to help the English art critic David Sylvester prepare an article on Spoleto for the *Sunday Times*. "Maybe it takes a socialist turn of the government to do such things."[13]

Italsider provided seven assistants, all of whom had worked in the Voltri plant. They were "about equally divided politically between communism and socialism," Smith wrote. "All living in sight of the factory—and at work without political dissension. I've always moved thru the climate of workmen more evenly than that of the connoisseurs."[14]

Since his job at the Studebaker plant in South Bend, Indiana, in 1926, Smith had dreamed of being part of a community of workingmen. He found such a community at Terminal Iron Works, where the men who ran the factory accepted him as an artist and gave him a space to construct and weld. This dream persisted even after his World War II job

building tanks and locomotives at the American Locomotive Company in Schenectady led him to assume a breach between artist and worker. He believed that he had found an ideal community in Voltri.

The workmen helped Smith with tack welding, forging, and most likely also with the primary welding. They surely helped with the surfaces, some of which Smith did not need to treat himself. With a team of helpers who were used to handling steel, Smith could readily move any object so that it could be seen in a multiplicity of configurations. They also made golden lockets with angels for Smith's daughters, inscribed "Voltri to Candida, Voltri to Rebecca."[15] The Italians and Smith did not speak the same language, but they understood one another. Verbal precision was obviously important, and a workman named Ruello, with whom Smith spent the most time, was a translator, but in their interactions, words were as much signs and gestures as explicit information. Smith's understanding with the workers depended as much on nonverbal as on verbal communication.

Smith wrote to Frankenthaler:

> They have been with me 7 days a week. They say they will miss me I say to them the same—the open and free feeling of sentiment is different than in the US factory . . . Afternoons each man brings a bottle of wine he made—pleasentries—kidding about the grades etc are exchanged One day we had snails— the man Cortezie [Cortezia] who brot them—has a mother famous for her snails—they were the greatest Ive ever had—of cours[e] wine bread salad all at 4 pm
>
> Another day Cova [the electrician] a bird snitcher brot baby birds beautifully cooked—you eat bones and all—salad bread wine
>
> One day fresh anchovies—I'm soft in the heart for them, & Italy.[16]

Beverly Pepper, too, was struck by the satisfaction felt by the workmen collaborating with artists. They told her, she said, "'You know, we only work on parts, we never see a whole. Working with you, we see the whole.' That's very exciting."

Smith did not study Italian seriously and he did not always go to bed at 11:30. Pepper said:

> David could not speak Italian, so he used to call me in Piombino and ask me to translate for him. On occasion, my family would come up to see me, but on occasion I'd go back to Rome, because we still had two little children. Once, in the middle of the night, it must have been about 2:00 in the morning, the phone rings, and my husband answers, and he says, "Listen old man, is your old lady there?" He says, "Who's this?" He says, "David Smith." David says to me, "I'm sorry to do this to you, kid, but how do you say blow job in Italian?" So I say to Bill, "How do you say blow job in Italian?" He looks at me and he says, "Pompino." And then he says, "What the hell is going on?"[17]

In 2004, Carandente was still offended by what he believed to be Smith's interest in prostitutes, not only in Italy but also in Bolton Landing when he visited in December 1963. When they met in New York, Gian Carlo Menotti told Smith he would be given the "red carpet" in Italy, which Smith tested by irreverently asking for "a big-busted girl interpreter."[18] This may be what the architect Alberto Zanmatti was referring to when he said, "I remember that among the various requests he made of Carandente there was the one concerning a large-breasted woman, but I don't know whether or how satisfactorily the request was ever granted."[19] Carandente revered Smith but found it boorish that this big-name American sculptor seemed to be making a spectacle to him, a gay Italian, of his heterosexuality.

Smith arrived with drawings for possible sculptures but soon put them aside. Recent spray paintings, which included images of rings penetrated by long vertical forms, in astral fields, remained on his mind. In his hotel room, perhaps also in the car and in restaurants or cafés, he made other drawings and paintings. Some drawings were landscapes. Several were made with green egg ink on paper and given titles such as *Voltri 4* or *Voltri 5*. With their bunched gestures, tender and furious and at times almost pornographic, some drawings suggest fields from which buried images of people or factories may or may not be extracted.

Although the titles might seem to refer to sculptures, and elements in the drawings can suggest particular sculptures, the drawings are so distinct from the sculptures with the same titles, including in Smith's use of numbers rather than Roman numerals in drawing titles, that they constitute a related yet different series.

The only *Voltris* that Smith dated precisely are *Voltri I* and *Voltri II*. Smith wrote, "Voltri I came desperately—the first piece to unify after gathering plates—pieces—trimmings from the big mill and moving all to the solitude of the Voltri factories. It was the first, it began to move then other works until two three four were in progress. It and Voltri II finished May 26."[20] All the other sculptures in the series are either dated

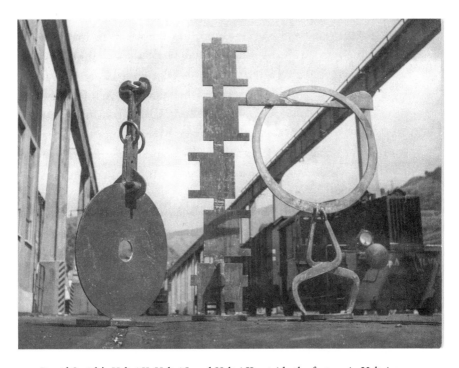

David Smith's *Voltri X*, *Voltri I*, and *Voltri II* outside the factory in Voltri.
Voltri X, 1962. Steel, paint, 64¼ × 34¼ × 12 in. (163.2 × 87 × 30.5 cm). Private
collection. *Voltri I*, 1962. Steel, 92⅞ × 22⅛ × 19 in. (235.9 × 56.2 × 48.3 cm).
Hirshhorn Museum and Sculpture Garden, Smithsonian Institution,
Washington, D.C. Gift of Joseph H. Hirshhorn, 1966 (66.4640). *Voltri II*, 1962.
Steel, 68¹¹⁄₁₆ × 41⁹⁄₁₆ × 15¹⁄₁₆ in. (174.5 × 105.5 × 38.3 cm). Kawamura
Memorial Museum of Art, Sakura, Japan. Photograph by Publifoto.

"6/62" or, in one instance, "Giugno 1962," or undated but almost certainly made in June. If Smith made only two sculptures in May, he completed twenty-five sculptures in nineteen days in June. Because precise dates are not given, the June dating makes the series seem largely a single, nearly simultaneous creative mass or throng. The absence of precise dates discourages attempts to determine chronological development. Not "first he did this and then he did that, and then that," but rather "the *Voltris* are an outburst and don't even try to understand individual sculptures apart from it."

Other than in Smith's own work, there is no sculptural precedent for the *Voltris*. The speed of their formation and invention is astonishing. They seem to have emerged not just as physical presences but also as afterimages. For Carandente, the series is mythical. "And Vulcan went to Voltri,"

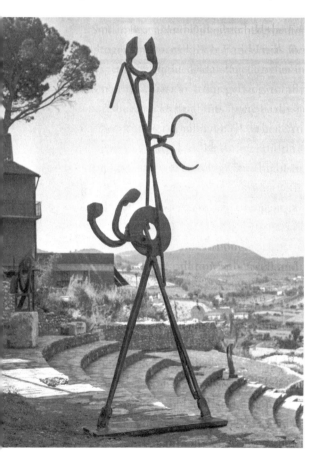

he wrote in his essay on the series. Smith's Voltri sculptures are "the freest and most independent [sculptures] to have been forged since the Sumerian and Etruscan chariots and Hittite ritual reliefs."[21]

Figurative recalls are everywhere. "He was in a certain fever," Carandente said. "When he saw all this material," it was "a figurative stimulation for him. Because every sculpture, every Voltri, is a kind of

David Smith, *Voltri XX*, 1962. Steel, 77¾ × 27¼ × 9⅜ in. (197.5 × 69.2 × 23.8 cm). Whereabouts unknown. Photographed in the Anfiteatro Romano, Spoleto, Italy, 1962.

figure ... A kind of ballerina, a kind of pregnant lady."[22] He saw *Voltri XVII* as the bust of a warrior and *Voltri III* as a "fleeting nun."[23] "*Voltri III* was called the little old lady by one of my workmen," Smith wrote.[24] *Voltri XX* hints at Giacometti's *Walking Man*, but rather than striding forward, this sculpture seems to move in many directions at once. Its put-up-your-dukes stance is Chaplinesque, its crustacean pincers more comically predatory than menacingly self-protective.

 Voltri V and *VI* include silhouetted signs—like a recently excavated alphabet or script—on ledges of structures with wheels whose vehicular movement has shut down even as exchanges among the signs continue. The forgings in *Voltri VII* seem quiet, almost somber—like medieval Burgundian mourning figures—as well as outlandish in their somnambulistic back-to-back, belly-to-belly gyrations. Mourning and partying are impossible to pull apart.

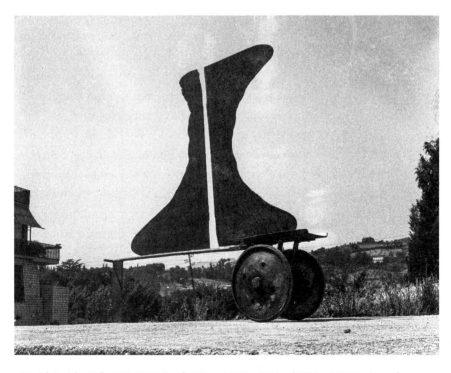

David Smith, *Voltri VI*, 1962. Steel, 98⅞ × 102¼ × 24 in. (251.1 × 259.7 × 61 cm).
Nasher Sculpture Center, Dallas, Texas. Photographed in the
Anfiteatro Romano, Spoleto, Italy, 1962.

In *Voltri VI*, the thin vertical opening between the huge foot or cloud forms could be a tip of the hat to Barnett Newman, who had asked Smith to help him weld steel in 1961, but the associational content is very different from that in Newman's paintings. Onto one of the foot-shaped clouds, turned out in ballet's first position, Smith scribbled with a blowlamp, "andiamo a Spoleto" (let's go to Spoleto). Carandente wrote: "This quip, and the smile that went with it, were the highlight of his creative orgy, alone in the Ligurian scrapyard among the no-longer empty or inert sheds."[25] On the other cloud, he scribbled "David Voltri Sally." Sally was the married woman with whom he was supposed to hook up on May 18, the day he left early for Italy. Smith in Voltri, Sally in New York, two people or two bodies connected and yet separated by the word and the place "Voltri."

In *Voltris XVI*, *XVIII*, and *XIX*, workbenches become miniature theaters. *Voltris XVI* and *XIX* are three-legged tables on which found objects seem casually yet purposefully arranged. Each object is in a state of expectancy. In *Voltri XVII*, a bit more than a yard long and tall, the anvils seem architectural as well as figurative. Here, too, past use seems lost, and the loss is both final and absorbed into a new sculptural present. The sculptor's eye and hand transform the objects into memory banks and toys, solemn and extraordinary, scenarios of exchange, with echoes of Egyptian, Etruscan, and pre-Columbian tableaus.

Many *Voltris* feature the timeless and multivalent circle, Smith's first form, which in this series can become the sign of a head, eye, belly, target, or well. *Voltri XV* includes a large circle ring welded to the top edge of a steel beam. The blunted, knifelike forms welded to the front and back of the ring squeeze it from both sides, so that the sculpture has no clear front and back. They give the space within the circle the sense of an invaded opening, one to peer through but not enter.

Painting sculpture took time, which Smith did not have in Italy. He painted only one *Voltri*. "All the rest," he wrote, "were cured with phosphoric acid, washed, and lacquered."[26] He wanted a sheen that held and reflected light and made old or used metal look new. Pepper said that Smith asked for help in treating some surfaces, and she found a very strong transparent spray. "Just one or two coats would have done it, but he must have put on ten coats." Smith's sculpture "looked like—it had a small patina. It wasn't a real patina, but . . . If you were looking for it, you

saw it. But the drama of his work was such that you didn't look for those things."[27]

Several sculptures are carefully coated; others seem attacked. Smith's scratching, or incising, can seem to violate the surface. Sometimes the marks communicate a floriate or furious excess, an intoxicated scribbling that resembles graffiti but is more frenzied, like a patch of ice tracked by skaters over an entire winter. The scribbling makes the surfaces seem etched, or written into. Some surfaces seem virginal, others not just used but ravaged. Smith referred to steel as "bones" or "skeletons." Carandente referred to the "flesh" of steel. Pressure to illuminate, release, and get inside or under the skin is part of the experience of the *Voltris*.

Carandente did not visit Smith in Voltri. It was on the phone that he found out Smith had "misunderstood" an essential condition of his stay in Italy, which was that he would make one or two works for "Sculptures in the City." When he said, "I'm doing five, I'm doing six, I'm doing eight," Carandente said to himself, "Mama mia, what I do?"[28] If he was showing just one or two sculptures by the other nine artists working in a factory, and just two Henry Moores, what was he going

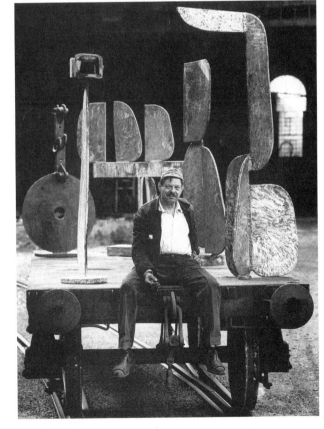

Ugo Mulas (photographer), David Smith in Voltri, 1962.

to do with the profusion of Smiths? In his own act of audacious impro-
visation, he decided to place the *Voltris* in Spoleto's first-century Roman
amphitheater, whose edges had over centuries been bled into by a Bene-
dictine convent and a Romanesque church.

Smith knew very well how many works he had been asked to make.
He simply refused to abide by the rules. But given that he thrived on
workflow and had a once-in-a-lifetime opportunity for sculpture mak-
ing to keep up with the velocity of his ideas, how could he have concen-
trated on one or two works? Carandente's welcoming of the series, his
capacity to think imaginatively—unbureaucratically—about sculpture,
artist, and exhibition, and his ability to act on his own instincts, estab-
lished him as a special ally. "Of course it takes 10 people at the museum
to make a decision," Smith would write to Carandente in September, ex-
pressing one of his frustrations with museums.[29] The two had uneasy
moments, but their collaboration remained a high point of both their
lives. With no other curator is a Smith project as strongly connected.

When Smith arrived in Spoleto, *Voltri I* had already been installed
in the Piazza Bernardino Campello, *Voltri II* in the Piazza della Libertà.
Voltri XIII was set onto a specially built brick base and placed on a small
bridge. Through the work of Zanmatti and Carandente, eighteen of the
Voltris were installed in the amphitheater. Several were installed on or
around what had been the stage; with the help of construction workers
and manual cranes, many *Voltris* were spread over tiers of what Caran-
dente described as the "horseshoe-shaped hollow."[30] None was bolted in.
Because of their considerable weight, the larger sculptures did not have
to be. Smaller ones were wedged into crevices and cracks in the stone.
Except for special visitors and tours, the amphitheater was closed off,
which meant that the sculptures were primarily seen from a distance—
below, from windows within or doors leading from the museum, and
above, through a grating along a street by the Piazza della Libertà. Seen
from the street, the sculptures were set against the Tuscan hills, "like the
spectators of an ideal show," Zanmatti said.[31] "Like figures in a Greek
theater, dreaming," Carandente said.[32]

While "Sculpture in the City" was a landmark exhibition in the his-
tory of public art, Smith's exhibition is remembered as the 1962 Spoleto
festival's signature event. Smith's sculptures "looked as if they'd been

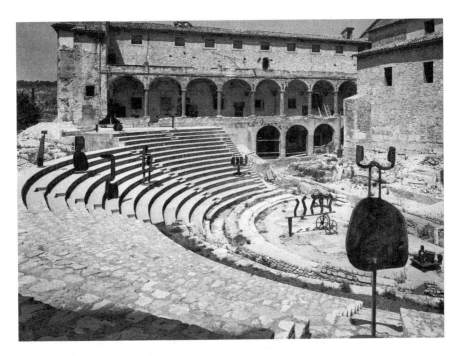

Ugo Mulas (photographer), David Smith sculptures,
Anfiteatro Romano, Spoleto, Italy, 1962.

there for centuries," Carla Panicali said. "They looked like they were
born there, and they stayed, and you were privileged to experience them
in your own time."[33]

"Thank you for the brilliant idea of the forum," Smith wrote to Caran-
dente in July. "My work has never been treated better."[34] In the early fall, he
expressed his thankfulness again: "I am so grateful to you, Menotti, Ital-
sider for my Italian period, it was the greatest and most prolific of my life."[35]

During his three nights in Spoleto, Smith went regularly to the
fair. "There are places where you can shoot, and gain some prize—a
poupée—a doll—or pack of bon bon," Carandente said. He went every
night "with Calder, after having drunk a lot of wine."[36]

One drunken evening lodged in Pepper's memory:

> He made lots of drawings, and he, Arnaldo [Pomodoro],
> and I were drinking one night, and he had had about thirty

drawings rolled up, just it was on ordinary little scrap paper, but they were big, the kind of paper that butchers wrap things up in . . . As we were going down the street . . . we came across the carabinieri, and they wanted us to keep quiet, and David said, "Oh, let's go see where you live," and he convinced them that we should go back to the barracks (me, a woman, you know). We went back there, he had a bottle under his arm, and we all continued drinking with them, and . . . he gave them all the drawings.[37]

Carlo Bavagnoli (photographer), Alberto Zanmatti,
David Smith, and Beverly Pepper, Spoleto, Italy, June 1962.

Smith spent two or three days in Rome. Carandente remembers him staying in the Locarno, a hotel frequented by artists on the Piazza del Popolo, and visiting the painter Afro and the sculptor Nino Franchina, who, like Lynn Chadwick, had worked in Cornigliano. Carandente said that Smith spoke to his sister about Becca and Dida and how much he missed them. "Whether it was in Bolton, or Italy, or in New York," Smith talked about his daughters, Pepper said.[38] In Voltri, he made an iron

ballet dancer for the Peppers' daughter, Jorie, now the celebrated poet Jorie Graham.

Smith wanted the *Voltris* to remain as a group and not be for sale. The plan was for Carandente to look after them and arrange a traveling European show, which Carandente believed would be a snap. "Ill have a 1 man show in the Roman Forum—and later in Rome Milan & Paris," Smith wrote to Nancy Grossman.[39] On June 23, Smith gave Carandente instructions:

> The work will be shown after the festival only in public muse-
> ums etc. meaning that until otherwise notified the work will
> not be in commercial hands. I would agree as a gift from the
> artist and Italsider for the bridge sculpture. Voltri II to remain
> in its position for the city of Spoleto (Or Voltri I, over by Sig.
> Menotti's house) I think the bridge sculpture Voltri II most
> pleasing for the city . . . Later if there is a museum exhibition I
> wish you to write the forward and any books you wish . . . Any
> expenses for storage, write me.[40]

Before leaving Voltri, Smith "piled up all the parts—tongs—wrenches, wheels—safety signs (in Italian) which I wanted for my shop in Bolton . . . all on the floor in one pile—and said—send them to me in USA—they did and I will finish my Italian period here."[41] It took "real chutzpah to do that, I must say," Pepper said.[42] Italsider agreed to this request, too.

"It seems to me that my Italian work took on a different feeling than my USA work ever had," Smith wrote to Sylvester. "I'll never work without certain influences of this Italian period nor forget."[43]

Smith never again saw the *Voltris*. They did not return to the United States until after his death.

"My father returned home that summer invigorated and jubilant," Dida wrote. "I had never seen him quite so happy. Before that summer, there were a few sculptures around the pond at the bottom of the upper field. It was after his return from Italy that the fields began to burgeon at an amazing rate."[44]

59

Circles

One of the surprises awaiting Becca and Dida on their arrival in Bolton Landing in late June 1962, after Smith returned from Italy, was the television in their father's bedroom. The three new circular ponds that Smith had excavated on both sides of the driveway were an even bigger hit. "We had a little rowboat," Dida said. "We'd play dress up, then get in the rowboat, and go around. Or fish. Leon [Pratt] and my father were close enough that you could holler, and they would come, and give you a hand with the hook, or whatever."[1] To Anne Truitt, the ponds were yet another Smith invention. The one closest to the shop "was very poetic . . . full of vegetation and sort of scummy looking, and that made a wonderful contrast" with "the steel and the building." She felt as if "a naiad would rise up out of" it.[2]

But the return from Italy was difficult. Bills and letters had piled up, and Smith was intent on regaining possession of most of his work in gallery hands. However fearful he was about losing his daughters—in the early fall he was shaken by a dream in which he lost them at a fair—he could not prevent them from leaving after their visits. At least he could keep near more of his sculpture family and work to keep together other of his sculpture gatherings. He urged Lois Orswell to maintain her Smiths as a group. "Please live in hope for you are safe even if I die (safer)," she

assured him.³ She promised her collection to Harvard and told him that after her death Harvard would also receive their correspondence.

Unable to regain a sculptural rhythm, Smith threw himself into dutiful work. He installed ten to fifteen new cement bases in the fields and packed the fourteen sculptures and twenty-one drawings for his fall show at the Everett Ellin Gallery. He fixed *Auburn Queen*, which had been cracked in two places. Since the Guggenheim Museum wanted the sculpture for its October exhibition of Hirshhorn's sculpture collection, it had to be repaired immediately. Abram Lerner, the curator of the Hirshhorn Collection, asked Smith to do it. "No one else can make the repair," Smith told him. "Give Joe my best tell him I went to town in Italy—I have 20 odd pieces in the Roman Theatre at Spoleto—in a 1 man show."⁴

At every opportunity Smith spoke about Voltri and Spoleto. When he ran into Barnett Newman and the sculptor Robert Murray after an opening on Fifty-Seventh Street, "his feet weren't even on the ground," Murray said. "He was still totally high on the whole experience. It was quite extraordinary. He was so wound up."⁵ After a curator's visit, he wrote to Carandente that he had extolled his virtues "to him, and suggested that he take an American town" and "hire you to make an International City Exhibition as you did in Spoleto."⁶

In late July, Anne and James Truitt drove to Bolton Landing. They wanted to see not only Smith but also Kenneth Noland, who had rented a summer house by the lake. Larry Rubin, Noland's art dealer in Paris and William Rubin's younger brother, and Elizabeth de Saint Phalle, his new bride and the sister of the sculptor Niki de Saint Phalle, were in Bolton Landing as well.

Visiting Smith changed Truitt's life "in the same way that going to a retrospective of Mondrian at Sidney Janis changed it in 1951." She had little sense of what an artist's studio could be. "In a way it's the first studio I ever saw, except Ken's." Smith "had the most marvelous equipment. He had great chains hanging . . . from the ceiling. I was very impressed by the ingenuity with which he'd solved the problems of how to get the steel upright, so he could weld it, and how to protect himself with his shoe protectors—which he taught me about almost immediately after he

saw my work . . . He was very interested that I not hurt myself. They're steel toes that are built into boots, so if anything falls on your foot it doesn't break it." She "loved the way he used the space," loved the "platform on the left, as you went in, a long platform, open to the air." It was from this terrace-platform that Smith watched over the ponds and fields. She noticed "these big pieces of paper" on which "he had these big pieces of steel laid out, as he intended to lift them up and weld them."

They walked up the driveway to a big barn that they didn't go into but that she understood was filled with paintings. When she saw the house, she was impressed that "there wasn't anything extra . . . It was made of cinderblocks." Smith and Dehner "built it together. David always really loved Dorothy Dehner . . . He never spoke of her except with the utmost affection and respect, and true, deep affection and love . . . They built it together, with their own hands, mostly David's probably." Smith led her "into the back room, and there I saw the drawers and drawers and drawers of drawings. He showed me this icebox, in which he kept his ink. He would whip up egg yolk—and then he'd stick Carter's black ink in it, then stick it in the icebox."

Smith seemed to Truitt magnificently intact—unpretentious and incorruptible and a model for other artists. She knew he could be overbearing and saw his selfishness: at dinner the first night, she said, "he wouldn't lift a hand to help Ken, who was really his very best friend." But she was moved by his earthiness, his practical imagination, and his dream life, and inspired by his ability to make a world. "You know certain places where you feel at home? I felt at home."[7]

Larry Rubin met Smith through Clement Greenberg at an art world party and knew him mostly through the party scene. He was a well-connected art dealer with a gallery on the Left Bank who represented a number of the artists Greenberg championed, including Frankenthaler, Morris Louis, and Noland. Like his brother, he had acquired Smith's work. He believed that Smith "was simply the best sculptor, probably, certainly in America, and maybe in the world at the time" but concluded, with regret, that it was not possible to bring his work to Paris. The cost of shipping the work "of an artist who was so little known in Europe would have sunk my gallery." He did exhibit Smith's work after he died, as president of New York's Knoedler Gallery. To Rubin, Smith was several

people. "The one thing that gave me pause about David as a person," he said, "was that *act*, of the country blacksmith." Smith was, in fact, "a very smart, knowledgeable, intense art person."

The Rubins, too, visited Smith. "We spent the day there," Rubin said. "We walked around with him in the fields. We went to the studio, where he had pieces laid out that he was putting together." He remembered Noland coming and going as he wished, sometimes smoking pot. Rubin smoked a joint, too. He recalled getting drunk and said of Smith, "I don't know how drunk he was, because *I* was drunk . . . and I remember that driving back to the lodge [in town], or whatever you call it, that I couldn't adjudge at all how far I was from the one traffic light along the lake there, and that the light changed three times and each time I advanced a little bit, but I never got to the light. Of course, the road was empty (it must have been about 2:00 in the morning or something)." The sculptures in the fields "looked gorgeous," he said: "Unbelievable! I've never seen them look better anywhere."[8]

At dinner in town, Truitt recalled, Smith, Rubin, and the Truitts sat "at a round table, and it was in the evening with a very mellow sun coming in." She then detailed what happened next:

> [Larry] was called to the telephone, and came back and he looked very serious. We had all been laughing and talking. He came back and said—he was sad—he said, "Morris [Louis] has just been operated on for lung cancer, and they think he won't live more than a few months." He just said it flatly, so there was just silence at the table. It makes me cry to remember it, really. David was sitting on my right, so we just sat there. Then David pushed his chair back, scraped his chair back (he was a heavy man) . . . and he put his two hands on his knees like that (he had a way of doing that), and he said, "Well, Morris lived the life he wanted to live." I'll always remember that.[9]

In August, after the well had run dry, Smith took Dida and Becca to Provincetown, where they stayed with Frankenthaler and Motherwell, and Motherwell's daughters Jeannie and Lise, at their Commercial Street

house by the bay. Frankenthaler organized a birthday party for Becca and Dida. "What a delight to have it so nicely managed," Smith wrote to her and Bob, "a load off my mind while I love it—3 [birthday parties] so far have me bogged down—To you all again gratitude."[10] From Provincetown he wrote to Orswell: "Am planning to work bigger better from now on I've seen the light all will be different. This is some postcard. I've waited to receive them."[11] The photograph on the postcard was of his sculptures in the Spoleto amphitheater. He ordered well over a hundred from Carandente and sent them to dozens of acquaintances and friends.

Smith could not get Italy out of his mind. It was strange to know that the *Voltris* would be on display in the amphitheater until mid-November but that he couldn't be with them and none of his friends in the States would see the Spoleto show. When Pepper told him there was a possibility Carandente would visit New York, Smith invited him to Bolton Landing and pushed him to encourage Ugo Mulas to send his photographs of Smith in Voltri; and he wanted more postcards. Smith used *Primo Piano*—the Italian words for first floor—as the title of a new series in which flat circles are prominently featured.

In August, Smith wrote a startling question to an Italsider official: "Do you think anyplace in USSR would be interested in our Spoleto Exhibition? You have been there recently and know their feelings."[12] The exhibition could be part of the tour Carandente was planning. The factory workers in Voltri were socialists and communists, and Smith believed the socialist government had been essential in making his Voltri miracle possible. It was in fact Italsider, a private company that received financial help from the government, that was responsible for unconditionally meeting Smith's requests. In Smith's mind, however, maybe in the Soviet Union, in the aftermath of the construction of the Berlin Wall, the Voltri collaboration between factory workers and modern artists could be an inspiration. Maybe the freedom and optimism of the *Voltris* could be an inspiration. Smith had not forgotten Paris in 1935, when he and Dehner were convinced that communists or socialists would support radical modernism. Smith knew how unrealistic this dream was in 1962, but he continued to dream big—and why not ask? His belief in the world-making power of art was unshakable. His belief in the *Voltris* and in his Voltri experience was profound.

"Modern Sculpture in the Joseph H. Hirshhorn Collection" opened at the Guggenheim on October 3 with 444 sculptures, less than half the number Hirshhorn had acquired. He owned fifty-one Moores, thirty-six Daumiers, thirteen Rodins, seventeen Degas, nine Picassos, fifteen Giacomettis, and nine Smiths. In the world's most comprehensive exhibition of modern sculpture so far, Smith more than held his own. "As a group, it is the David Smiths that have the greatest immediacy and contemporary relevance," Henry Geldzahler wrote in *ArtNews*; Geldzahler would become the first curator of twentieth-century art at the Met.[13] *Art in America* asked Hirshhorn and Thomas Messer, the Guggenheim's director, who selected and installed the show, to choose their three favorite sculptures in the collection. Hirshhorn chose Brancusi's *Torso of a Young Man*, Moore's *King and Queen*, and Rodin's *Burghers of Calais*. Messer chose Giacometti's *Monumental Head*, Matisse's *Reclining Nude No. 2*, and Smith's *Sentinel II*. The youngest of these artists—Giacometti was the closest in age and he was five years older—Smith was in an exalted league.

Circles I, II, III, and *IV* were dated within a week during October 1962. *Circle V*, the last sculpture in the series, was completed nearly a year later. (See Figure 10 in the insert.) While *Circles I, II, III*, and *IV* share the *Voltris'* propulsive energy, the two series also seem so different from each other that it is hard to imagine them emerging just four months apart. *Circles I, II, III*, and *V* are structured around an upright circle, at least 6 feet tall and ¼ inch thick, cleanly cut out of a steel plate. Like the rings symbolizing the Olympic Games, each of these *Circles* is open in the center, a circle within a circle, and each is painted a dominant color. Each has at least one flat painted-steel form welded to it in such a way as to suggest the gesturing arms of a railroad signalman or Dumbo-like ears on a perfectly round head. When *Circles I, II, III*, and *V* are aligned in a row, the openings, each of a different size, suggest a telescopic lens or camera shutter, or an expanding and contracting orifice, or, with *Circles I, II*, and *III*, hoops for children and animals to climb through.

Noland is an unmistakable presence. The openings in these sculptures are as active as the centers within the concentric circles Noland was painting between 1958 and 1963. He began each of these works by painting a solid circle in the center of an unprimed, unsized canvas. Then he painted concentric rings around it. The results could have an electric

dynamism. After seeing a selection of these paintings, Smith wrote to Herman Cherry, "Nolands show was courageous—nothing but circles diamonds, all painting confined to these limited structures—to get wonder out of there takes a gut."[14] In his *Circle* sculptures, Smith left the centers open yet made them pulsate. Void becomes space, and that space is alive.

Smith dated *Circle IV* October 18, 1962—after *Circle I* and before *Circles II* and *III*. (See Figure 11 in the insert.) *Circle IV* is not in dialogue with Noland. It does not seem to belong to the same series. Smith installed *Circles I*, *II*, *III*, and *V* in the sculpturally dense north field. He installed *Circle IV* in the more serene south field. He did not paint it right away; he added the paint only after observing it in relation to other sculptures, in the landscape.

Circle IV's main orientation is vertical, and the perimeter of the closed circular form near its center is not continuous but suggests a slightly lopsided torso-belly. The two triangular slabs below it evoke Giacometti's oversized sculptural feet except that, like a clown's duck feet, the slabs face in opposite directions. The figurative associations seem to recall Picasso as well, perhaps his painting of a boy with a hat. Like *Circles I*, *II*, and *V*, *Circle IV* contains a rectangle, but from certain points of view this one, nearly 5 feet long and horizontal, which seems sliced into the "neck" of the figure, hints at a cannon or gun-head. The *Circle* series now evokes artillery as well as targets, but once again the violence is mitigated by its mixing with the comical and the balletic. As in *Voltri VII*, the big feet suggest a ballet dancer's first position, but in addition here the rectangle atop the sculpture provides an echo of the spread arms of an awkwardly girlish ballet dancer in preparation.

Color and paint application are different as well. *Circles I*, *II*, *III*, and *V* show minimal evidence of the artist's hand. Paint was largely applied with industrial brushes. The surface uniformity and sharp edges bring to mind the reaction against the painterly that helped define Post-Painterly Abstraction, which in 1964 Greenberg identified with "a relatively anonymous execution," "geometrical regularity of drawing," and "trued and faired edges" that "get out of the way of color." "The painterly," he wrote, "means, among other things, the blurred, broken, loose definition of color and contour."[15] By the late 1950s, according to Greenberg, the painterly was a sign of a moribund Abstract Expressionism.

Circle IV, in contrast, is painterly, and the application of paint has a handmade insistence. The colors are muddier or murkier than those in the other *Circles*. The wavering edge at the point where the reddish and whitish sections meet is an exquisitely delicate juncture. In this sculpture, nothing seems to fit. While each section of *Circles I, II*, and *III* gives an impression of all-at-once immediacy, *Circle IV* seems to have come together slowly, with disparate parts. Paint and steel are more distinct. Sculptural edge is different from painted line. While they still carry surprises, even secrets, *Circles I, II*, and *III* give the impression of being flashy, geometrical, and, even with objects attached to the rings, unencumbered. They have a concise linearity that hints at the precision of Roy Lichtenstein's comic-book paintings and Minimalism. By contrast, *Circle IV* goes back to earlier modernism and perhaps to ancient fertility statues and offers discovery through slow, thick attention.

During the fall, Smith went to the city sporadically. He visited with Cherry, Guston, Newman, and Rosati. While the Five Spot remained a personal landmark, he did not go there as often. His hotel of choice was now the Plaza. While the hotel was a symbol of fortified prosperity and elite luxury, Smith's room was inexpensive, usually around $20 a night. He liked the hotel's restaurant, where he invited friends and spent more money on food than he did on lodging. When he called young women from the Plaza, it made an impression. Ruth Ann Fredenthal, a Bennington College graduate and painter whom Smith occasionally took to dinner and the Five Spot after she returned from her Fulbright in November 1961, saw his stays at the Plaza as treats to himself.[16] Smith would leave laundry there to be picked up, fresh and clean, on his next visit.

On one of his October trips to Washington, Smith shared photos of the *Voltris* with the Truitts. "The only time I saw David really happy, truly happy, with his work" was on that trip, Anne Truitt said. "He came roaring" into their house in Georgetown, she recalled:

> [And he] didn't even bother to take off his coat . . . Then he took out a whole lot of photographs. I was so surprised, because he never talked about his work—and he threw them

on the couch . . . He just strewed them out like that, isn't that amazing, and he said, "Look at what I was doing." He was so—he was like a child, a very wise child. He knew what he had done . . . You know, artists are very, very deeply happy when they're happy. It's a special sort of thing and it doesn't happen very often.[17]

On October 31, "The New Realists" opened at the Sidney Janis Gallery in New York. The gallery perhaps most identified with the success of Abstract Expressionism now presented work by Pop artists such as Roy Lichtenstein, Claes Oldenburg, and Andy Warhol. "Sidney Janis, whose gallery represented de Kooning, Rothko, Guston, and other top Abstract Expressionists, opened a two-location exhibition of 'factual' (i.e., illusionistic) painting and sculpture," Harold Rosenberg wrote. "Under these auspices and after fifteen years of the austerity of abstract art, the new New Realism hit the New York art world with the force of an earthquake."[18]

Feeling betrayed, Gottlieb, Guston, Motherwell, and Rothko left Janis. Other artistic developments, including Minimalism and Happenings, could make artists of Smith's generation feel not only irrelevant but also old. "These young artists are out to murder us," Rothko said.[19] Smith was never convinced by Pop Art. "I'm not much with Pop—not concerned with their issues," he would write to Cherry. "I generally am with all artists of conviction—but I await several years of contribution."[20] But he was aware of its infectious energy, confidence, and appeal to younger audiences, and his responses to new art were rarely dismissive and never moralistic. He understood that aesthetic and generational shifts were often violent. Art had a new generation of viewers raised in postwar prosperity. For hotshot new collectors, the new art brought with it prospects for investment and chic. The American mass media was mesmerized by art and money. Smith understood the challenges of new art but did not feel threatened by them. He never believed new art would kill him.

In his own ways, Smith responded imaginatively to Pop Art, Post-Painterly Abstraction, Minimalism, and Environments. His *Circles* and *Zigs* were snappy and interactive with their environments. With their sleek, fabricated stainless-steel parts and geometrical forms, the *Cubi*

series that was about to take off reflected both a more anonymous industrial approach, like Minimalism, and in its interactions with light a dependence on its environment. Smith continued to incorporate everyday objects into his work, but those objects could now have a gritty intimacy. In the mid-1950s, he had made sculptures out of frying pans and egg cartons. Now cosmic forms could be generated by refuse. Hilton Kramer's article "David Smith: Stencils for Sculpture" in the winter *Art in America* reproduced a number of the "sprays," with their astral shapes and blasts of light. Kramer wrote: "The stencil drawings are quick sculptural studies; they are arrangements and assemblages of forms—rectangles of cardboard, crescents of watermelon rind, metal rods—that are momentarily 'fixed' on the page with a spray of paint, and then quickly improvised into still further arrangements and new inventions. (The metallic colors, he says, suggest a 'metallic frame of reference' for the sculpture.)"[21] Smith moved fluently, across media. It was hard to imagine him being left behind.

New Prominence

In early December 1962, Dan Budnik finally visited Bolton Landing. He was roughly half Smith's age and taller and lankier. His volubility, curiosity, and passion for storytelling drew people to him and made it easy to underestimate his ambition. Like Henri Cartier-Bresson, the most famous of the four founders of Magnum Photos, for which he worked, Budnik had studied to be a painter. To Budnik, artists were earthy visionaries, and for him, as for Cartier-Bresson, the artist's studio was a mythical world. He had proposed a photo essay on Smith to his editor at *Life*, but she had said the magazine would never do it. "I said, 'Really?'" he recalled, "and she said, 'Really.'" But he went to Bolton Landing anyway. The crates from Voltri shipped by Italsider had recently arrived. Factory parts were, Budnik said, "scattered all over the floor." Smith was "working on two or three pieces simultaneously."[1]

In the *Voltri-Boltons*, Smith mixed objects from Voltri with objects from Bolton Landing. This series, too, was a celebration of circles. The numbering of the first five *Voltri-Boltons* runs backward—V, IV, III, II, I—like an announcement of liftoff. *Voltri-Bolton V* is dated December 2, so it was made very shortly before Budnik's arrival. Its five circles, two evoking a belly, two a breast, and one a head, are welded to a steel rod atop a relatively small triangular plate that suggests both a dress and feet.

Voltri-Bolton IV is dated December 3. Its primary form is an upright rectangular plate out of which a triangle-like opening seems to have been cut. On top of the plate, an object like a metal joint is placed so as to suggest one of Smith's recurring images—a bow or curl on a little girl's head. *Voltri-Bolton III*, dated December 4 and taller than 8 feet, is all lines and angles, with a hook-like phallus and two long rods projecting from the neck area like tentacles or feelers. This figurative presence seems strangely blind. The 79-inch-tall *Voltri-Bolton II*, dated December 5, has the elongated rectilinearity of a New Hebrides idol. A closed circle is set low, near the base; a smaller open circle—the handle of a tong used for forging—is placed like a lens within the square metal frame evoking a head. *Voltri-Bolton I*, dated December 6, features a tiny circle, not much larger than a steel dot, suggesting a head, delicately squeezed between the tips of two arcs, and a massive wrench driving down off the circular belly—a humongous dick with claws pointed like a divining rod toward the earth.

During this month, Smith would make ten sculptures in the series. *Voltri-Boltons VI* through *X* would also be dated consecutively, but this time consecutively forward, not in reverse, which is how the remaining seventeen are dated, giving the series a conspicuously onward thrust. Like the *Voltris*, the *Voltri-Boltons* were mostly unpainted. Many of them, like the *VB's*, *Voltrons*, and *Voltons*—which even with their different names are part of the same series—are more linear and insistently vertical and geometrical than the *Voltris*. The lines and shapes seem more streamlined, although they are still wildly unexpected and their efflorescence surprising.

Budnik made several visits to Bolton Landing that winter. He had free run of the property, walking the fields and visiting each building with Smith and on his own. He photographed Smith working in the shop and house and installing sculpture in the fields. He photographed him walking, arranging, welding. He photographed him looking pensive and gauging formal relations. Budnik believed that winter was the best time to see the work. "I knew that [the snow] would isolate the sculpture, and it was perfect," he said. "It's perfect any time of the year, but to see the pieces just outlined" against the whiteness "was really quite good. And to have him in the snow, this bearlike guy, rummaging around."

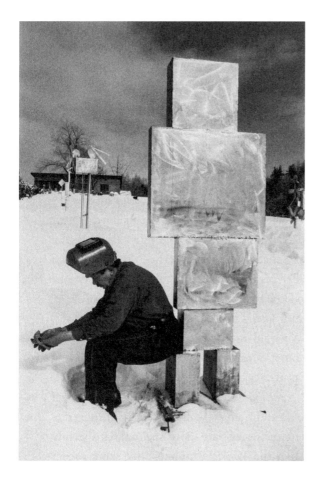

Dan Budnik (photographer), David Smith with *Cubi III*, South Field, Terminal Iron Works, Bolton Landing, New York, March 1963.

For lunch they went to the Bill Gates Diner "just to get away from the studio for an hour." Budnik photographed Smith in the diner and accompanied him through town. "At the IGA or one of the markets in Bolton," Budnik said, "he induced the manager to take on live lobster, in the winter time. The guy said, 'I'm gonna lose my shirt.' David made a pact with him. He said, 'Anything you don't sell, I'll buy,' and he just kept his fingers crossed that it would be enough of a novelty that people would buy them, and they did." Budnik remembered Smith buying lobsters and throwing them in the sink. Smith cooked for them. "God, it was like better than Chinatown."

Budnik understood the burdens as well as the grandeur of Smith's life. He saw not just his creativity and passion for work but also his labor,

solitude, and neediness. Smith drank a lot and Budnik drank with him, even when he didn't want to. Budnik got a sense of what it must have been like for Smith's wives. He needed "adoration and support . . . He wanted someone to be there, nailed to the kitchen and whatever. He wasn't about to give as much as he was ready to receive."

In March, Budnik took his photographs to *Look*. When they rejected them, he called the *Life* editor. "I told you we would never do him," she said. He answered, "I'm not asking you to do him, but I am asking you to look at the pictures, and that's your job, right?" All right, bring them over. "She started looking at the pictures and she said, 'Dan, I had no idea. I had no idea.' She said that for twenty minutes."

"David's Steel Goliaths" appeared in *Life*'s April 5, 1963, issue. The lead photograph shows Smith standing in snow, wearing a cap and gloves but no coat, cigarette dangling from his mouth, with snow on the roofs and leafless trees behind him. He labors to hold upright—to *tame*—the behemoth *Volton XVIII*. Other photographs show him from the back, kneeling on the shop floor deliberating and welding, and dwarfed beside the 15-foot-tall stainless-steel *Windtotem*, which he installed by the upper pond. The article features Budnik's now-iconic photograph of Smith seen from the back, sitting on the stone bench behind the house. He holds a cigar and looks over his sculptures in the south fields. Beyond the thick corridor of trees at the bottom of the hill is Lake George. Not all the snow on the bench has melted, but Smith is not wearing a coat here either. Budnik said that this was the only photograph he set up.

The text emphasizes Smith's procedures and persona: "Once a riveter in a Studebaker plant, David Smith now runs his own small factory at Bolton Landing. He employs two steel workers to keep his studio in order, lay in supplies (a truckload of steel a month), coat his sculptures with submarine paint. Smith himself works steadily and wordlessly." At the same time, he is a searcher, constantly resisting limits: "Winter is his ally. 'There's no place to go, no dames, no fish to catch. Winter presses you to extend,' says Smith, 'and I'm trying to push out to some place that's not known yet.'" He had "up to a dozen works going at once." Sculpture was his life: "'I go to bed thinking about sculpture,' he says, 'and I'm still hammering at it in my dreams.'" The article reported, erroneously, that an exhibition of his work was "touring Europe."

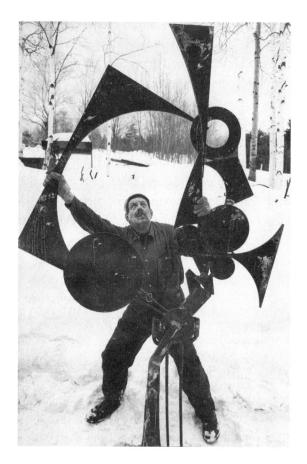

Dan Budnik (photographer), *David Smith with Volton XVIII, Terminal Iron Works, Bolton Landing, New York, March 1963.* Steel, paint, 109½ × 66¼ × 15 in. (278.1 × 168.3 × 38.1 cm). State University of New York, Governor Nelson A. Rockefeller Empire State Plaza Art Collection (P661.6).

"Some place that's not known yet," Smith said. A place in the imagination, beyond where he was and where we are, but one that depends upon physical things and the physical world, a place where encounters with those things can inspire a new sense of what can be experienced, perceived, and built. At Bolton Landing, Smith was building a new kind of sculptural place. For the first time, his fields were referred to as a museum. The article concludes:

> Planted with his sculpture, the snow-steeped fields around David Smith's house near Lake George have become a 30-acre outdoor museum. Some 40 works are on display to the

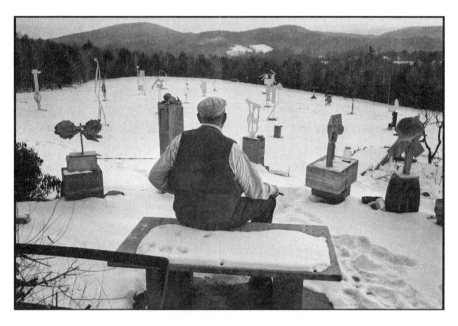

Dan Budnik (photographer), David Smith, South Field, Terminal Iron Works,
Bolton Landing, New York, 1963.

postmen and farmers, deer and fox that pass by. Twisted and
truncated images of bronze tilt along the slopes. Signposts of
polished and painted steel scale the sky, their messages spelled
out in circles, shafts, rectangles and cubes . . . Smith long ago
filled up his cellar and then his garage. With no storage space
left, he hauled out his sculptures with a bulldozer and trailer
and bolted them into concrete blocks set about the fields. For
the solitary sculptor they are good company. He broods over
them in the morning, rambles around them by moonlight.
"Someday," he muses, "I'll have all my fields covered. To let a
piece get away from me, I'll have to need the money bad."[2]

The article brought letters from people he had not heard from in years, going back to Mike's Saloon on the Brooklyn waterfront. It brought respect from people who did not understand his work or care much for art. It brought tours. "They used to drive in the driveway," his neighbor Jean Rikhoff said. "Then he had this chain put up that said, 'Private,' but they just took it off, or they just walked in . . . When he came bellowing out, I think they just scattered."[3] With celebrity came new assumptions and pressures. "You seem to be becoming more famous constantly," Robert Samuels of French & Company wrote him, in hopes of receiving payment for the seventeenth-century refectory table for which he had sent an invoice a year earlier. "You see David, this is what publicity does."[4]

Smith was again having financial problems. On December 15, 1962, Otto Gerson, whose sales had provided Smith with reliable income, died of a heart attack. Smith had no shows planned. Materials were expensive. Stainless steel cost between 65 and 87 cents a pound, five to seven times more than the low-carbon steel he had often worked with. Cutting, bending, and tack welding had costs as well, which meant that making one large stainless-steel sculpture could cost him hundreds of dollars.[5] In his latest feat of creativity—two dozen new sculptures over the fall and winter—he had gone through a huge quantity of stainless steel. In addition, he was now paying the salaries of two men.

Still living with the girls at her parents' house in Bethesda, Freas was aware that Smith flew back and forth to Washington, smoked fancy cigars, and stayed at the Plaza. The *Life* article led her to sue him for more money. Her lawyer sent letters requesting records of Smith's sales from Lois Orswell, Ilse Gerson (Otto Gerson's widow), Joseph Hirshhorn, and others. "My attorneys said to ignore it," Smith wrote to Orswell in April.[6]

Shortly before the *Life* spread, Smith reported to Everett Ellin that Frank Lloyd, the founder of the London gallery Marlborough Fine Art, was in town, trying to sign on some of the dealer Sidney Janis's clients. "None committed," he wrote. "He offers, total salvation—big money international etc."[7] Shortly after the article was published, Lloyd wrote to Smith that he planned to visit Bolton Landing in May.

Born Franz Kurt Levai into a family of antique dealers in Vienna in 1911, at nineteen he went into the oil business. When the Nazis invaded

Austria in 1938, he fled to Paris. In 1939, his family moved to Biarritz. He and his brother were interned near Bordeaux as Jewish refugees. His parents died in Auschwitz. He later made his way to London. "Just before the invasion of Normandy," in which he fought, Franz Levai "changed his name to Francis Kenneth Lloyd, after the bank."[8]

"He was treated like a dog in England," said Stephen Weil, a lawyer hired by Lloyd in December 1963 to manage his New York gallery. "They all were. The whole group . . . The British never trusted that these were not Nazi infiltrators, disguised as Jewish refugees. So they were set to ditch-digging during the war, and at the end of the war doing the dirty work, and cleaning up the concentration camps."[9]

In the military corps, Lloyd met Harry Fischer and soon after the war the two set up a rare-book business and art gallery. Lloyd "named it Marlborough, after the duke." Their first art exhibition, in 1947, included three small Cézannes. Convinced that contemporary art would open up new markets, they promoted living British artists, including Lynn Chadwick, Henry Moore, and Francis Bacon. They also organized historical exhibitions. In 1961, they opened the Marlborough Galeria d'Arte in Rome. Marlborough quickly gained a reputation as a high-powered gallery with international connections that would spare nothing to serve its artists. "He promised long-term contracts, international exposure, lavish color catalogues, higher prices, corporate scale, modern business methods," James E. B. Breslin, Rothko's biographer, wrote. "He offered free secretarial help, legal advice, accounting services, real estate and travel aid, estate planning, tax guidance—all perks to make his artists feel like important people . . . In exchange, Marlborough received a 50 percent commission, not the traditional one-third. 'If they want to ride in a Rolls Royce instead of a Volkswagen, they have to pay for it,' said Lloyd."[10]

After buying the Gerson inventory, Lloyd opened a gallery in New York. Marlborough-Gerson was enormous, twelve thousand square feet, the entire sixth floor of the Fuller Building at 41 East Fifty-Seventh Street, on the northeast corner of Madison Avenue. It would bring the work of European artists to New York and show the work of American artists in Europe. Its American stable would include some of Gerson's sculptors and painters who had left Janis. "Frank Lloyd knew there was some money to be made out of the preceding generation," Weil said.

"David was floating around." So was "Seymour Lipton . . . plus Mother-well, Gottlieb, Baziotes."[11] Marlborough-Gerson would represent Philip Guston, Adolph Gottlieb, Jacques Lipchitz, Larry Rivers, and, at Smith's urging, Jimmy Rosati as well.

Smith wanted a dealer who would sell and place his work and make enough money for him so that he could stop worrying about materials; and it was time for him to be part of an international network. Even though Giovanni Carandente continued to assure him that a traveling European show of the *Voltris* was a done deal, the show was not materializing. Lloyd was the most international art dealer of this moment and perhaps the first multinational one. With his aura of European cosmopolitanism and his charismatic salesmanship, surely he would give Smith the European presence he needed.

Lloyd was capable of big gestures. After his July trip to Bolton Landing, he sent Smith a case of champagne. He liked ostentation and beautiful women, which helped make him a figure of gossip, which increased his fame. When he went to Provincetown at the end of the summer to meet with Motherwell, half expecting to find Smith there, he stayed on a yacht and had a young woman on each arm, one of whom, Motherwell reported to Smith, "was the most beautiful (+ destructive) girl Helen and I have ever seen." Motherwell found dinner on the yacht "pretty ghastly—I freeze in his presence, + it is painful for us both. Very disappointed that you weren't there, + I wish you had been." Lloyd "plans to open the gallery Nov. 5."[12]

For Lloyd, success depended on ramping up the connection between art, glamour, and money. "Many dealers are hypocrites—they say we're here to educate the public," Lloyd said. "I don't believe it. For a business, the only success is money."[13] After the war, he did not trust government or institutions. He believed that by representing and selling art he could support creative individuals who resisted what President Kennedy, in late October 1963, a few days before Marlborough-Gerson opened, would refer to as "an intrusive society and an officious state," and at the same time get filthy rich.[14] Lloyd was a "ruthless" businessman. "Polished," "audacious," and most of all "cunning" were other words Everett Ellin used to describe him. Ellin worked for the Marlborough-Gerson Gallery. "He felt like he owned you," he said of Lloyd.[15]

In early June, Smith signed a three-year contract with Lloyd in which he negotiated the gallery's percentage down to 33 percent of his sales. Marlborough would promote his work in Europe and publish the kind of substantial catalog that painters of his stature were accustomed to. Lloyd assured Smith that he could deal with him directly. The agreement would begin in the fall, which was when Ellin would begin working at the gallery after returning to New York from Los Angeles. When Carandente wrote to Smith about the need to remove rust from the *Voltris* and storing them in Rome, Smith could now tell him to hire men to do the work and "bill Marlborough."[16]

At some point this year, Lloyd advanced Smith money—something between $35,000 and $50,000—for stainless steel for his *Cubis*, a show of which he scheduled for October 1964.[17]

Smith planned to revisit Italy; Switzerland was on his itinerary as well. "I'm involved with Marlborough Europe and on loan here [New York]," he wrote to Orswell.[18] Exhibiting in Europe, with sales income going into a Swiss bank, Smith could stow money where Freas and the IRS could not get it.

A week after Smith and Lloyd signed their contract, Orswell visited Bolton Landing. She bought the 1960 sculpture *Doorway on Wheels* directly from Smith for $12,000. "It does take my breath away to write a check for this amount, it seems simply astronomical," Orswell wrote to Smith, "but I know once it is done I will feel nothing but the greatest happiness that it is mine if I never have another piece."[19] In August, for $5,000, she bought her last Smith, a small 1961–62 bronze. "I suppose this is the finale for LO's DS COLL," she wrote. "And most probably, the finale to COLL: LO. But a good one. It's you who have made it possible and thank you. I like to think of you and the Girls, all having fun with lobster and champagne and ponies and music."[20]

A Troubled Summer

On May 7, 1963, Smith ran for a five-year term on the Bolton Landing school board. He had long been a regular at the board meetings, where he had been outspoken about school issues, including the attention given to music and art and the value of an educational system that would be shaped by each student's needs. In his mind, it was still possible that one day Becca and Dida might live in Bolton Landing. "That was a real fiasco," Frances Herman, a painter who occasionally typed letters and cleaned for Smith, remembered of the election.[1] Of the 214 votes cast, Smith received 44. The winner received 167. Smith "was just crushed," the writer Jean Rikhoff said. "This great, big, huge man. And I said to him, 'You don't want to be on the school board, anyway. You've nothing in common with those people. You'd just be in arguments with them all the time. Why would you want to do that?'"[2]

During the previous winter, Smith and Rikhoff had begun an affair. She and Allison, her two-year-old daughter, had recently moved to Bolton Landing from Greenwich Village, to get away from her second husband. She saw a newspaper ad for a cottage in Bolton Landing for $45 a month, and thought, "Well, I can afford that, and I can get out of the city." A gifted novelist, she was thirty-five, a good deal older than most of the women Smith was involved with during these years. Her *David Smith, I Remember*, published in 1984, is a vivid memoir. She, too, was

from Indiana. "If you've ever been in Indiana," Rikhoff said, "it's a bond if you meet somebody else . . . The way I described Indiana is that it's so flat you feel like you're walking around under sea level, and all that weight is on your head—all that conservatism." Her attraction to Smith's sculpture *The Puritan* led her to contact him. Made in the early 1950s and consisting primarily of an elongated oval brass face with eyes and mouth formed with a doorknob backplate and keyhole covers, the sculpture seems a farcical emblem of a prying puritanism. Smith gave her this work.

She watched him plant his garden. "Spring was a time of frenzied activity for you," she wrote. "You had a mammoth garden beautifully laid out, lovingly tended." She admired his extravagance: "All summer long you carried armfuls of vegetables to friends; they augmented the baskets of wine, the lobsters you brought back from Albany, fish fresh from the lake, a beautiful roast you just couldn't resist buying but that was too big for one man alone on his own, the Sunday paper, books and magazines, always something, you never came empty-handed."[3]

Rikhoff said in an interview:

> He was the most generous man I ever knew. He always wanted to do something. He always wanted to take me somewhere. He'd stop and say, "I'm going to Albany. Can I bring you back lobsters, or something?" . . . I was too young to understand that he had everything he wanted, and yet it wasn't enough. I didn't understand it at the time. I just felt something was terribly wrong, but I didn't know what it was . . . I could tell that he was sort of manic. But maybe he was that way all the time.

Smith decided that it was Rikhoff's job to tame the pony Jo Jo so that when Becca and Dida arrived, "the animal would be placid and pleasant." In photographs, Jo Jo can be seen grazing around the sculptures, contributing mightily to the image of idyllic pastoral calm. To Rikhoff, however, Jo Jo was a hellion:

> "Now, listen," David said, "this horse has got some bad habits."
> "I should say he does. Do you know what he did when I

went out to get him? He ran at me all teeth— . . . *You* get on him first."

"I'm way too big for him, for crisssake. I'd stove him in . . . Put the saddle on. Here. I'll put the saddle on. Just try him. It won't hurt just to try him, will it?"

Jo-Jo took off down that field in front of the house and in and out of all those wickedly sharp sculptures bucking and crow hopping, plunging sideways, sitting down, rearing up, and over all my screaming and Jo-Jo's heavy breathing, the clatter of hooves, and the rattle of steel as we rushed by. I could hear David roaring. "Hang on, *just hang on*. He's going to settle down. He's bound to settle down—"

Jo-Jo stopped dead, planted his front feet squarely and lowered his head. I sailed fifteen feet over his head barely missing an outstretched steel lance. While I lay stunned on the ground, he came at me with that menacing mouthful of teeth. Oh God, I thought, and shut my eyes.

"Why didn't you hang on? You almost had him," Smith said. "You would have had him if you'd only hung on. My god, are you *all right*?"[4]

David Levy visited Bolton Landing in early July, just prior to the girls' arrival. He expected Smith to provide him and his wife with lodging, as Smith and Dehner had done with his parents, Edgar and Lucille Corcos Levy, when he was a child. "I can't have anybody in the house. I've gotten too solitary," Smith told him. He took them to "a motel room, down in Bolton. So we went back and forth. We'd sleep in and spend the days with him."

Levy remembered Smith on the phone trying to get Freas to send the kids: "They were supposed to come, and then they didn't, and this was just going on and on and on."[5] Rikhoff heard him rant at Freas. "When he had a lot to drink he would get on the phone—He was very angry with her at that point," she said. "Very angry. And he'd say, 'I'm gonna get the Mafia to wipe you out! I'm gonna do this, I'm gonna do that,' and I'd say

to him, 'That's a party line! You shouldn't say that over the phone.' But he was furious with her. Just furious."

Bec-Dida Day is a radiant work. (See Figure 12 in the insert.) The 7-foot-tall sculpture is constructed around a large upright tank end, painted Jamaica blue on its concave side and gleaming yellow on its convex side so that the thick steel seems a concentration of sun and sky. Perched atop the tank end is a short strip of I-beam painted red and black. The top point of a horizontal, roughly L-shaped beam of steel, yellow on one side and red on the other, seems to support the tank end like the legs of a weight lifter trying to keep from collapsing under the load of a barbell. The sculpture has a playful zest: a big moon face wearing a single curl of hair or a fashionable hat; a child looking out at us while running; a juggler allowing a large steel circle to roll down his back or shoulder. The date on it is July 12, soon after Becca and Dida arrived upstate.

July was hot. "Rare for us in the mountains Its 90 in the shade—we swim each day—Have a young girl to help with house—kids take piano in mornings—Painting white coats on all the primed sculpture—before I paint the color," Smith wrote to Helen Frankenthaler.[6] Smith took the girls fishing in Edgecomb Pond and to "Figaro opera for kids." *Figaro* was part of a children's opera series that took place every Saturday morning in the nearby town of Lake Luzerne.[7] He walked with them in the woods. "He really, really knew all these plants, and all these things," Becca said. "He gave me a sense of the world being incredibly rich." He wanted them to know that he was part of a community. "He was very, very sociable and he knew everybody," Becca said. "And every time we went to town—which was maybe once a day—he would spend a lot of time checking in with a lot of people."[8] At night, Becca and Dida often went to sleep to the sound of jazz.

But this was a troubled summer. Around the time of the girls' arrival, Kenneth Noland was in an automobile accident. He was driving, and his kids—Lyn, Bill, and Cady—were in the car. Lyn believes that the accident occurred on the way to Bolton Landing. "David came to the hospital and he talked to me," she said. "He was very kind. He was the first one I saw when I came to consciousness."[9] Becca had broken her wrist in Washington, which limited her activities—no horseback riding. Her

parents' separation was painful for both girls, and the transition from Washington to Bolton Landing and from Bolton Landing to Washington was difficult in the best of situations. "Rebecca adjusting harder this year," Smith wrote to the Motherwells. "This year Dida at ease."[10]

When Freas visited, she stayed with Mary Neumann, across the road. Becca recalled, "She knew that we really liked it when she came to visit, although probably, in retrospect, it was not a good idea. We would beg and beg for her to visit . . . Eight weeks is a really long time not to see your kids." When Freas arrived, the four of them talked in the kitchen and Becca said she wanted to return to Washington with her mother. She recalled that her father said, "'Okay.' I went over to thank him, and I hugged him, and I was really happy that I was going to get out. He didn't look at me or hug me back. I felt like I was really betraying him. But I was relieved."[11]

Smith, Becca, and Dida watched the *Ed Sullivan Show* together. When the program was over, Becca and Freas went to Mary Neumann's, where they spent the night. Dida stayed, believing that by so doing she would prevent the situation from getting totally out of control. "It was very tense," she said. Her parents "were really horrible about each other. They were petty and cruel about each other. 'Your father doesn't love you. He just hates *me*!' That kind of thing. I didn't say anything . . . My father was getting more upset."[12] When Smith got in his truck and drove through the hills, Dida made a point of going with him. The next morning Freas tried to convince Becca to remain. "You can't go. You have to go back. The court says you have to."[13] Becca returned. "I realized I had to stay with my father."[14]

Smith's phone call to Motherwell and Frankenthaler alarmed them. We "hope the summer's developed into an easy time and a happy vacation with Becca and Dida. I can imagine how helpless and forlorn you might be occasionally with the children," Frankenthaler wrote to him on August 9, "trying to do the best and give them everything and feeling frustrated or weak. Believe me, if they don't seem to respond in depth to what's really going on, you will feel it soon, as they grow into young women."[15]

Smith made sure that Bec-Dida Day was a celebration. As usual, the birthday party had many guests and the children were joyful. "We were

going like madmen around his place, and he didn't seem to be bent out of shape by it," Granville Beals said. "It was almost as though he encouraged it." He was the son of John Alden Beals, a drinking buddy of Smith's who ran a fully equipped metal shop in Glens Falls that did all manner of jobs for him, like cutting the "ovals" for the 1960 stainless-steel sculpture *Three Ovals Soar*, one of the stars of Smith's 1960 French & Company show. Granville was impressed by Smith's attention to his daughters and by their own creativity: "They had cool stuff hanging all over the place. It was a great little creative zone."[16]

Dida's "# 8 birthday was fun," Smith wrote to Jeannie and Lise Motherwell, thanking them for their presents of jelly and soup.[17]

Rikhoff had warned Smith about the danger to Smith's daughters of Jo Jo's orneriness. Sure enough, toward the end of their stay, Jo Jo bit Dida. "Thot she was a carrot—just a pinch nab," Smith wrote Orswell, "but we are selling old pony this fall. I gave them riding lessons in a Wash DC school for birthdays."[18]

On August 25, Ruth Ann Fredenthal and Louise "Weezie" Fenn visited. Fredenthal was the daughter of the figurative painter David Fredenthal, an acquaintance of Smith's who shared a midtown Manhattan studio with Fletcher Martin, one of Smith's Woodstock friends. Ruth Ann met Smith in 1957, at Bennington, where she was studying art.

"Weezie was singing in the Lake George Lyric Opera Company in Diamond Point," Fredenthal said. "I went to visit her, and I said to her, 'Look, David Smith, my dear friend David Smith, lives up the road. Let's go visit him.' So I called David at about 10:00 a.m. and he said, 'Hell, *yes!* Come up. I'll take the day off.'" After showing them the shop, painting studio, and house, he sat with them on the terrace overlooking the fields. Speaking about the sculptures, he told them he had "sunk them all in a half a ton, or a ton . . . of concrete. This is how I want it to stay. Someday, this will be a national monument." Fredenthal thought the sculptures were beautiful: "They were everywhere . . . a good thirty, forty pieces . . . built to withstand the weather, those winters . . . He would go and smack them, and drum on them." Over several hours, Fredenthal and Fenn danced around the sculptures, "jumping around, front and back . . . He

just loved it." He cooked dinner and they drank through what Freden-
thal remembers as practically a whole case of wine. Smith "was used to
it [so much drinking]," Fredenthal said. She and Weezie weren't. It was
a "wonderful day," Fredenthal remembered. "The autumn leaves were
starting in. He had a workhorse there. Weezie remembers him tying it
to the *Cubi*."[19]

Waldo Rasmussen and Frank O'Hara visited Bolton Landing after Labor
Day. They wanted to finalize their MoMA traveling show of fifty Smith
drawings that would open on December 2 in Plattsburgh, New York, and
to discuss a European show of his sculpture that Smith badly wanted. "I
was greatly impressed, not to say staggered by the new sculptures," wrote
O'Hara. "They, along with key earlier works, will make a great show.
Considering the magnitude and importance of the show we are organiz-
ing, I think it is fortunate for its impact that so many major works will
be shown for the first time in Europe." O'Hara wanted to make sure that
works that led up to the major statements, "each with its own intrinsic
power," were shown with them. On his upcoming European trip, O'Hara
planned to see the *Voltris* in Rome. "PS," O'Hara wrote, "Give an extra
pile of horse husks to horse for me, will you?"[20]

Then both the "workhorse" and Hamburger were gone. Smith re-
turned Jo Jo to its previous owner—the horse eventually died in a barn
fire—and decided it was time for Hamburger to become beef. "The Black
Angus he had killed [at] about . . . twenty-six months old," George More-
house said; it was Morehouse who had housed both animals during the
winter. "He read up a lot in books and stuff on beef, and he said that was
the prime time, from twenty-four to thirty-six months, for Black Angus
beef."[21]

On September 19, Smith wrote to Fredenthal saying that he had
driven his daughters to Washington. "Am sad but have some good pho-
tos of them." He was "digging holes to make 20 more cement bases."[22]

62

Bennington

In the early summer of 1963, Paul Feeley, the head of the Bennington College art department, needed someone to teach sculpture. Anthony Caro, who lived in England, had sent Kenneth Noland photographs of recent work. Noland mentioned Caro to Feeley. Caro recalled: "In the middle of the night, I got this call saying, 'Will you come to Bennington?' And I said, 'Hold on,' and I turned to my wife, woke her up, and said, 'Shall we go to America?' and we had two kids. She said yes . . . So we went." Caro was to begin in September, but because of his exhibition at London's Whitechapel Art Gallery, his departure was delayed. "Who should stand in for me but David? Which was really lovely of him. He did a wonderful job, because he actually set up the whole place for welding, which it never had been."[1]

To teach Caro's Tuesday class, Smith usually left Bolton Landing early in the morning and returned the same night. He commented on student work but did not give assignments. "I think he just felt like he was kind of baby-sitting. He wasn't really there to be teaching," said Patsy Nichols, who as Patsy Norvell would become known for her public art projects.[2] While painting and architecture were taught in the main building, sculpture's facilities were shabbier. Smith brought in supplies. "Jazzing the Bennington department up a bit," he wrote to Frankenthaler and Motherwell. "Will have 30 new lady welders in the world. I've

hired a welder to give lessons 2 nights a week."[3] "May have daughters there who knows," he wrote to Dehner. "In 8 years or less one is ready Rebecca skipped 3rd grade she is 9 and in 5th."[4]

Caro, his wife, the painter Sheila Girling, and their sons Tim and Paul arrived in Bennington on October 15. Noland met the train and told Caro that Smith was waiting for him. Caro had not seen him in four years, since the time of the Hedy Lamarr dinner at the Motherwells'. "I went into this little French restaurant in North Bennington," Caro recalled, "and there was this man who stood up—I always remember his standing up, he was so big . . . and said hello, and said, 'I got it all going' . . . He used to come down quite often, when I was teaching there, and he would always be very nice, and he would call me 'Mr. Professor' . . . in a way it was kind of condescending. But it was all right. It was all right. Because he was a lot older than me."

Bennington was now Smith's home away from home. In the fall of 1963, not just Caro but Jules Olitski and Peter Stroud, an English painter represented by the Marlborough-Gerson Gallery, who would also become a Smith friend, began teaching at Bennington. Noland was a social focus—a magnet. He lived on a gorgeous property, on a hill, by a pond, in a house spacious enough for parties in which faculty and students socialized together. "On the weekends, all the people like [Frank] Stella, Larry Poons, Clem [Greenberg,] and Ray Parker—all those people used to come down and stay with Ken," Caro said.[5] Whenever he wanted to spend the night, Smith could stay with him, too.

The college was progressive. With 350 students and a student-teacher ratio never higher than 1 to 10, its atmosphere was intimate, its students and teachers exceptional. One of the pedagogical principles of John Dewey on which Bennington was founded was that you learn by doing. Before taking art history and art appreciation courses, students had to make art.[6] The classes were seminars, which meant that even literary stars like Bernard Malamud, Kenneth Burke, and Wallace Fowlie knew their students. Instead of grades, teachers wrote comments. "I don't think any student went unrecognized or unencountered," Stanley Rosen, a sculptor and longtime faculty member, said. Bennington's academic culture was known for the quality of its attention. "I took a course with Stanley Edgar Hyman on *The Odyssey*, and we read it line by line, and it

was probably the best course I ever took," the painter Susan Crile said. "I had someone in freshman English who literally went through every paper (we wrote a paper a week) . . . and it would come back red. It was fantastic. It was great."[7] Rosen saw Bennington as a continuation of Black Mountain College, the enormously influential experimental school, modeled on the Bauhaus, in the western hills of North Carolina. Noland attended Black Mountain; Greenberg lectured there; Smith was asked to teach there; and artists, poets, and musicians built a vital community there. "I thought it [Bennington] was sort of like the next generation, and I've always defended it in those terms," Rosen said.[8]

Bennington's commitment to contemporary art is legendary. "Even though it was a Formalist school, you had [the realist painter Philip] Pearlstein come in, you'd have Minimalists come in," said the sculptor James Wolfe, who began working at the college in 1965 as technical director for the dance and drama department.[9] It wasn't just artists who gave talks and met with students about their work. So did critics, including William Rubin and Michael Fried. Greenberg, a close friend of Feeley's since Frankenthaler had introduced them in the early 1950s, was a forceful enough presence that art world insiders nicknamed the college "Clemsville." Dealers, too, came through, including André Emmerich (who represented Noland and Frankenthaler), Leslie Waddington, Paul Kasmin, and Larry Rubin.

Feeley "did anything he could to get contemporary art in front of the students," Vincent Longo, an abstract painter who began teaching at Bennington in 1958, said. "That was his goal. To teach art properly, you had to let them know what the most advanced things were . . . so they could match wits with it."[10] Being in front of contemporary art required trips to the city. "We were really forced into looking at what was happening currently, to thinking about it, to going into New York and looking at work," Crile said.[11]

The students who went to the talks, helped artists install their shows, and contributed to the racy glamour of Noland's parties were young women. The faculty was predominantly male. Nichols said her only "woman teacher was Marilyn Farley, who taught drawing, and she was a graduate student." The visiting artists were almost exclusively male. The art shown in the college was largely by men. Students were in the company

of male artists who seemed to be models of triumphant creativity, alongside of whom the male students their age at nearby Williams College or at Amherst College could seem woefully earnest and unevolved. "Sometimes Williams College guys would come over and sort of gawk at Bennington girls, and we would say, 'They're so preppy!'" Constance Kheel, who began Bennington in 1963, said.[12]

At Bennington, Smith was revered. "He was a very big person, not just in his stature and physical presence, but everyone idolized him at the school," Nichols said. "He was like a god walking in, to everyone. The faculty there were in awe of him. It was his reputation. He was this *king of sculpture*, and was so successful, and *major* in art history. After I graduated people would come up, people who never spoke to me before came up and asked me, 'What was it like to be with the great god?'"

Smith, said Nichols, "was buddies with Noland and he was friendly with people there. Greenberg, in a way, kind of set up a climate. Within that Greenbergian framework, he [Smith] probably had a chance to emerge in a way that was fairly close to the way he was. He's unquestionably a great artist, but there was something about the environment that made it possible for people to see him that way."[13]

The driving force behind the Bennington art scene was Paul Feeley. He organized the visiting artists program and was responsible for Smith's 1958 drawing show in the Carriage Barn. Like Jackson Pollock, Feeley had studied with Thomas Hart Benton at the Art Students League and then become an abstract painter. He began teaching at Bennington in 1939; with the exception of three years in the U.S. Marine Corps during World War II, he continued teaching there until his death in 1966 at the age of fifty-six. "He was a brilliant, fantastic character," Ruth Ann Fredenthal said. "He was so beautiful, so glamorous, so unique as a personality. Everyone was in love with him—students, teachers, artists . . . He was uncontrollable and gorgeous . . . Although he was miserable in some ways, and a drunk, he was kind of like Odysseus . . . His method of teaching was so brilliant and personal." Olitski "came to teach because of Paul Feeley. Tony Smith came to teach because of Paul Feeley."[14] "I was a little frightened of him," Rosen said of Feeley. He "cut his hair in weird ways . . . He had bangs at a time when people didn't have bangs. He put

some odd color in his hair once." Along with his dramatic personality, "he was an intense listener. I never saw anybody listen so totally."[15]

The heart of Bennington's pedagogical structure was the student-faculty relationship. Students were expected to meet weekly with their faculty advisers. "You were supposed to tell them everything about your life," Kheel said, "and spend hours talking to them, take long walks or sit in a tree together . . . The system encouraged that type of intimacy, which then led to other things." The tutor was a "selling point. That's why it was so expensive—because you had this close contact with the professors."[16] In 1963, Bennington's tuition, covering all costs, was $3,450, which may have been the highest of any four-year college in the country.[17] Crile made a point about the incestuous impulses built into this structure and the implicit permission to indulge them. She believed that this student-faculty interaction "put the structure of the whole educational system on the parental/child model, as opposed to the peer model, and I think that was at the heart of one of the problems, ultimately, about Bennington—particularly at that moment in time."[18] At Bennington, the boundaries between the peer model and the parent/child model were blurred.

The system was conducive to student-faculty affairs. There were faculty members who competed for students and students who competed for faculty and everyone in the college knew that students and faculty were sleeping together. "It was very competitive," Sheila Girling said. "If one [of the male artists] was looking at the girl, the other one would want the same girl."[19]

"Lawrence Alloway joined the college for one year during the '60s," Florence Rubenfeld wrote in her biography of Greenberg. "His wife, painter Sylvia Sleigh, described what Bennington was like when she arrived, and why they left: 'I'm something of a prig . . . find it disgusting when professors run after young girls, and the girls run after the professors. But I don't really blame the girls, because, after all, the professors are supposed to give them a good example. One of the things I think was a very great mistake at Bennington was to have this thing called counseling . . . The girls would have weekly sessions with their professors, and, of course, the consequence was that they all fell in love. When we got there the girls were invited to faculty parties, but not the wives.'"[20]

Bennington's sexual culture during these years has provoked an abundance of criticism and consternation. "The little red whorehouse in the woods" was one characterization of the college. In the 1950s, "art tarts" was already a term for art students who had sex with faculty. In her 2002 memoir, the radical feminist Andrea Dworkin wrote that "anyone famous who came to Bennington was provided with one or more Bennington girls; my college was the archetypal brothel, which may have been why, the semester before I matriculated [spring 1964], the English seniors recreated the brothel in Joyce's *Ulysses* as a senior project and for the enjoyment of the professors."[21]

The power differential between teacher and student could be enormous, and sexual cultures like those of Bennington and other culturally and politically progressive colleges and universities in the 1950s and '60s could sanction exploitative, predatory, and sordid behavior. But many Bennington students valued the varied presences of faculty and closeness to remarkable and successful teachers, and prided themselves on their agency, and while some women I spoke with who studied at Bennington to be artists were still grappling with the complexities of consent and desire that were revealed to them as students, none of them expressed to me that she felt she had been a victim there. "It was lots of fun," Sophia Healy said of the atmosphere. Healy transferred from Yale because of the excitement of Bennington's artistic culture, and in 1964–65 was its fine arts graduate student. She continued:

> Some people thought that it wasn't, because they felt that there might be an element of favoritism; if somebody slept with some teacher, that teacher might try to advance that person's career. But to me it just seemed like a normal part of life. In fact, even some of the professors previous to this "wild period" that everybody talks about, had already married their students. Some of them were staid professors, in the other divisions. It didn't seem very unusual, and it seemed like fun, because you got to go to parties. Students and teachers mingled in a very friendly way.
>
> You've got to remember that these weren't the politically correct times that we have now—which is fine, times vary. But I don't think people even thought of it that way. There were

like intense friendships that—we had intense friendships . . . there could also be, besides affairs, there could be intense friendships, and they seemed fine. I think back then we somehow saw ourselves as adults already, more than adolescents. Nowadays, people are treated more like children than adults.[22]

The Bennington student Londa Weisman was nineteen and Smith fifty-eight when they began their affair. She was drawn to his "energy." "He was lit up," Weisman said. "He was doing stuff I was interested in . . . We didn't want to marry these people. We wanted to be them." We wanted "to be with them because of what they were doing . . . I think we were exploiting each other."[23]

Caro was in a stable marriage and remained apart from the incestuous aspects of Bennington's culture; Jane Harrison, an art critic from England, used the word "incestuous" to describe the art world at that time, particularly the culture around Greenberg.[24] "I'm sure it took a toll on the girls," Caro said of the sexual climate. "I think it's very unhealthy, but I also think that the place went downhill a lot when it started to have boys there as well." Caro loved Bennington. He found its students remarkable in the maturity of their curiosity, intelligence, and receptiveness. He looked after them while valuing them as peers. "Something about those girls was just marvelous," he said. "They would listen, they would pay attention, you could talk to them about art or about whatever, and they really took it in and they really worked on it. They were great."[25]

Smith did not teach at Bennington and visited sporadically. He was esteemed there and moved about campus with the dignity of his stature. Most often he was introduced to students by Noland and Gloria Gil, friends who had known him for more than a decade and to whom he had spoken often of his loneliness and desires. Smith knew that Bennington believed in art and artists and that sexual relations between older men and younger women were common there, as they were throughout the New York art world. While he could anticipate affairs, however, he was also an outsider at Bennington and he knew that, for him, such relationships were disjunctive. They were always unbalanced. Desire and control were tinged with guilt. Smith had intense friendships with former and current Bennington students, *and* he had affairs with current students about which

they, like he, could experience conflicting responses. They could feel both in over their heads and grateful for intimate access to his work and, even more important, to his being as an artist and to how he worked. It is not possible to generalize about their responses, as a group, to the affairs. Power was unstable. As often as not, affairs with students that began with Smith's domination ended with his feeling rejected and abandoned.

That fall, both Smith and Budnik took a liking to Patsy Nichols, who met Smith in Caro's class at the beginning of the semester. Budnik was spending the weekend at Bolton Landing when Smith suggested that they drive to Bennington and have lunch with Eugene Goossen. They walked around the college. Smith showed Nichols and two other students how to use a welding torch. "Her hair was in her face and she was wearing jeans," Budnik remembered. "I took some very nice pictures of the two of them outside." There were plaster casts nearby and "a dog or two that came through. It was a nice Bennington scene."

After Smith returned to Bolton Landing, Budnik and Nichols didn't know what to say to each other. According to Budnik, she began the conversation: "'We were watching you photograph our favorite tree, then we figured you had to be a good guy.' So I was like, all right—'Are you free for dinner?' She said, 'Yeah.' I said, 'Are there any good restaurants?' She said there was a good French restaurant in town. So I wound up picking her up at six or seven and she was all dressed up. We went to this very nice French restaurant." Budnik said he was "interested in photographing the foliage, and she said, 'Well, I've got the next four days off . . . I know this area very well . . . I can show you some great places' . . . So we spent the next four days together."

Budnik wrote to Smith saying that Nichols was "a great young lady, very bright. She's deciding whether she wants to be an artist." Smith wrote back, "Yeah, we had lunch together, she's really a terrific lady.'"

Sometime later, Herman Cherry telephoned Budnik. "What did you do to David?"

"David? I haven't seen him for three or four months."

"Well, he called you a sonofabitch the other day. He's never done that before."

"Oh, I think I know what it is," Budnik said.[26]

63

Bolton Landing Girls

College and college-age women were now integral to Smith's life. He sought them and they sought him. Particularly if they were studying to be artists, they were likely to admire him. They posed for drawings and paintings and performed in relation to his sculptures. In conjunction with the *Menand* series ("men and"), named for Menands, the village near Albany where he bought steel, seven and perhaps all eight of which he made while he was sitting in for Caro at Bennington College, he made gelatin silver prints of a full-bodied young woman interacting naked with the compact sculptures. The shapes of her body dramatized by Smith's camera eye—thighs, belly, breasts, buttocks, pubic triangle—have a sometimes delicate, sometimes disorderly, always irrepressible power.[1] On Smith's instructions, other young women painted some sculptures. He was sexually involved with some but by no means all of the women. In many instances, he was grateful for their company. "I'm so glad you're here" were his first words to Stephanie Rose, a painting student at Skidmore College, grasping her hands when he saw how stunned she was by his sculpture fields.[2] Some of the young women treasured his presence; others made him feel ineffectual and old. For some, their time with him elicited such conflicted responses that decades later the mixture of gratitude and confusion was a knot. For others, he remained an inspiration,

a person and artist they continued to miss. To pretty much every one of the young women who now entered his life, he was unforgettable.

In the fall of 1963, Tina Matkovic was a junior at Skidmore. "Really, really gorgeous" was how Stephanie Rose described her.[3] Samuel Magee Green, the director of the Institute of Contemporary Art in Philadelphia, remembered ambition: "She had her charm, but she was ruthlessly driven to become a well-known artist."[4] Green included Matkovic's sculpture with Smith's, Caro's, and Truitt's in a 1966 show.[5] Her sculpture teacher, Robert Davidson, drove her to Bolton Landing to meet Smith.

Matkovic remembered:

> He was working at the time. We waited. We were patient. Then after about twenty minutes he broke off from his work and came to talk to us . . . Of course, by this time, my jaw is on the floor, because when you drive up that hill to Bolton Landing, and see hundreds of those things descending the hillside, it's like—I just went, "Wow, what is this? This is superhuman! This is like nothing you've ever seen." I had no notion that art could be like that, or that anybody could do something so heroic and work so hard at it—just the sheer amount of labor involved . . . was staggering. It was so far beyond anything I'd been taught or was aware of. So by this time I'm like, "Who is this person, who could do this?"[6]

Matkovic showed Smith photographs of her lost-wax bronzes and told him that "this casting thing doesn't make much sense." She was looking for a "way of putting metals together." She recalled his response: "'I don't teach anybody, and I don't want anybody around here who doesn't know what they're doing.' He was kind of gruff and grumpy. So I said, 'Well, that's too bad but . . .' And then he said something really strange. He said, 'But if you learn how to weld somewhere else, you're welcome.'"

After taking welding lessons, she contacted him. A week or so later, she received a letter with a glove she must have left behind on her visit. He gave her his number. Matkovic started going there on weekends:

> When I first went there, the old part of the studio had a clean space in it, and he said, "Well, you can work over there" . . . I

was never sure whether he cleaned it out for me, or if it was always that way. But, looking back, at the way he was, in a very subtle way, a very courtly person, I suspect he made a place for me to work . . . He never let me touch the TIG stuff. [Tungsten inert gas (TIG) welders are used with stainless steel.] I could always use the acetylene and all of that, and the arc welder— because there were several of those. As long as I didn't get in his way, I was fine. I could do whatever I wanted, in the other end of the studio.

At first, Matkovic made the forty-mile drive up and back the same day; then, sometimes, she stayed over. "We became good companions— working companions—Everybody always asked me, 'Did I have an affair with David Smith.' I didn't. He was my friend. He was like my best friend . . . He had a little folding bed, and he used to set it up for me in the spare room . . . That was our arrangement. That way, I was able to work through both Saturday and Sunday, and then get back to school."

At one point, Smith asked Matkovic to model for him. She did, but she refused to take off her underwear. She posed in the living room. "I'd lean on a little stool, he'd put the little table there, and then he'd put the sheets [of paper] down on the top of the table." Often he made lines and forms by squirting paint from "something that looked like the ketchup bottle in a diner." Sometimes he painted with brush on canvas. He said little.

Matkovic said that she posed for around a hundred drawings. "It was a favor," she explained. "He needed a model. He was doing me a big favor by letting me into his studio and into his life . . . After a while it did become kind of tense."

One of Smith's paintings of Matkovic includes a scramble of black lines that seem to attack and wrap around her body. She's wearing a bra, a garter belt, and stockings. Her head is tilted, her eyes closed, her butt leaning uncomfortably against a stool. Beside her, touching her, is a round table supporting a vase of flowers with which her head and left arm are intertwined. The scene is posed and its energies untamable. Her body and the black lines seem too large for the confines of the paper. By contrast, a drawing of her beside the same stool and table with flowers is

David Smith, *Untitled*,
1963. Black drip enamel
on Millbourn paper,
39½ × 26¾ in.
(100.3 × 67.9 cm).
The Estate of David
Smith, New York.

restrained. She stands upright. Her left hand, as oversized as her clawlike
right hand, is cupped suggestively on her left hip but her arms and shoul-
ders are so muscle-bound, so overblown in relation to her head, that she
seems as much male as female. She looks almost pharaonic. Alongside
her power, the flowers now seem to pull back. "He had this thing in his
head about some Egyptian statuary," Matkovic said. "So it was a very
rigid, frontal pose, like the [Greek] Kouroi." Smith told her, "Everything
I am doing has existed before, since antiquity. Yet not in the form I am
doing it."

Matkovic brought Rose and two other Skidmore friends to Bolton
Landing to introduce them to Smith and show them where she had been
working. Rose and the two others returned to Skidmore. That evening

David Smith, *Untitled*,
1963. Black drip enamel
on Millbourn paper,
39½ × 26¾ in.
(100.3 × 67.9 cm).
The Estate of David
Smith, New York.

Smith and Matkovic showed up at Rose's dorm. "Get your things. We're
going to Vermont," Smith told Rose. "We get into the truck, and I have
no fucking idea where we're going." They went to Jules Olitski's house for
dinner, then to Kenneth Noland's. Smith said that "Ken would be there,
and Tony Caro, Bill Rubin, and—Jesus, that's who was there!" Noland
was, Rose said, "very sexy, and you could tell right away this guy was real
trouble." They smoked pot in Noland's living room as Rose gaped at the
art on the walls. When it was time for bed, "Ken says, 'Help me make
the bed.' It was his bed, which was the downstairs bedroom . . . David
comes in when Ken and I are making the bed—because I have no idea
what's going on . . . David comes in and says, 'The girls are going to sleep
in here. We're going upstairs.' . . . Ken thought I'd 'got brought' for him.

They slept upstairs, Tina and I slept downstairs." At dawn Rubin had to catch a train. Rose and Matkovic heard him creeping through the house. "He peeked into Ken's room, to see who was in the bed. When he finally left the house to go to the train, we just fell apart laughing."[7]

More than a year after her regular visits to Bolton Landing, Matkovic learned that she was not Smith's only model at that time. Another young woman had been posing for more risqué drawings. "She was a sculpture major at Bennington . . . He was having some kind of relationship with her for a couple of years, but he was so discreet and compartmentalized that I never knew that girl was there," Matkovic said. The daughter of a local family was also posing for him.

Through that fall and winter, Smith and Jean Rikhoff saw each other regularly. "He had compartmentalized lives," Rikhoff said. "It was really interesting. He had his New York friends, he had his Bolton friends, he had Barnett Newman, who was like in another category," that of his city artist friends. "He had friends" upstate, like his neighbor Evans Herman, who worked on a newspaper, "and he put these people in categories, and he didn't want to mix them. He didn't want them to meet one another. I don't know why."[8] Smith's life, like his sculpture, seemed to be constructed with multiple parts, some of which clearly belonged together, others of which seemed disparate and even alien, all of them forming a precarious and often mystifying equilibrium.

In October, Smith sent Dehner the sculpture that he had promised her. It was one of his *Albanys*, his other series, along with the *Menands*, of dynamic small-scale works whose titles, like the *Voltris*, reveal the importance to Smith of place, in these cases towns and cities that had been part of his life for years. "I guess it is about the best present I ever got and I thank you," Dehner wrote. "It is so beautiful and alive and it nourishes my spirit, and is very much appreciated. I like to sit and look at it, against the white wall with one of my big drawings next to it . . . Thank you David, also for the charming pictures of your Candida and Rebecca. They are merry looking, free and lovely, I guess you are a good papa." At the end of the letter she thanked him again "for the great sculpture. Did you know it was the one you had in the Whitney a couple of years ago that stood in front of my wall piece there? So I had seen it before and admired

it then, as my favirite of the Albany series. It is the special thing in my house."[9]

At the end of October, on one of his rare trips to the city this fall, Smith spent three nights at the Plaza. Giovanni Carandente was beginning an extended visit to the United States sponsored by the State Department. The two met at the Waldorf Astoria, where Carandente was staying. His news was disheartening. All his attempts to find venues for a European *Voltri* show "were completely zero."[10]

The subject of Smith's November 7 Pratt lecture was familiar. More than twenty years after he had first written on architecture and architects, he was still ranting about the arrogance of architects and a cultural system that conspired to keep artists in a subordinate position. "Sculpture in our century has been nurtured on total freedom," Smith wrote. "If it has been linked with architecture, it is only by circumstance. Its esthetic is shared only by painting: the two have been interchangeable since Cubism. But neither painting nor sculpture has been helped by architecture." The architect had come close to the point of being part of a "collective of engineers and businessmen" in which the independence of the sculptor "had no chance."[11]

Sidney Geist, the sculptor and critic who had written eloquently on Smith before incurring Freas's wrath for not paying rent on her East Side apartment, sat in the balcony with his Pratt sculpture class. In 2002, his memory of the subject of Smith's talk bore no relation to its published record, but it was characteristic of Smith's talks to begin with prepared introductory remarks and move to an informal discussion of his work, with slides. Geist recalled: "The talk went like this: 'This piece weighs 694 pounds. It has seven coats of paint, such-and-such, and three coats of this. Next slide. This piece weighs 842 pounds, and has twelve coats of paint. Four are enamel, such-and-such-and-such,' and he would designate the 'cut.' This went on for an hour and a quarter, or an hour and a half or something." When the talk was over, Geist raised his hand. "'David, we learned a lot about the weight of the sculptures and the layers of paint. Could you tell us something about how you came to do one or

the other, and some of the relations between them?' He said, 'Professor Geist, I think you could do that much better than I could. Any other questions?'"

After the talk, Pratt people went with Smith to a bar. Geist didn't join them. "I was pissed off with this 'Professor Geist' thing," he said. "He had taught two or three times as much as I had at that point . . . I didn't see him after that."[12] In fact, however, he did.

When Smith returned to Bolton Landing, he found a letter from Matkovic. "I never meant to put anyone on and I hope you don't think that's what I was doing to you," it read. "As to coming back, if you don't want me around say so. Although I think you do, even if it hurts you a little. LET ME know if and when or I'll call you. And since I cramp your week end activities a bit, perhaps I could come on a Sunday . . . I love you many ways anyway—or in another way."[13]

On November 22, 1963, President John Fitzgerald Kennedy was killed. "God—what a disaster—what an infamy—assination, of all things in our age in this country," Smith wrote to a friend the next day, mentioning in the next sentence that pressure was on from Freas for more money and they would be in court on December 12. "Its harrassing and interfers with work."[14] On November 25, Frances Herman, a painter who did various jobs for Smith, and her daughter Myra went to Smith's house and watched Kennedy's funeral. "He had a television then," Herman said, "and he was always very anxious to point out that 'that hole down there' in the photograph of Jean is a bullet hole, because he had a picture of Jean, and he would shoot it!"[15]

When Carandente arrived in Bolton Landing in early December, there was a coating of snow on the ground and Smith was not present. Carandente and a dealer from Marlborough-Gerson entered the house and saw a naked woman on the bed. "She said hello. She was a typical American woman," Carandente said. He referred to her as one of Smith's "pleasure girls." Carandente believed that Smith had wanted him to see her. "I think he had very many problems with women," Carandente said. "Because he

used to drink so much, and to contact prostitutes . . . There is a meaning why he gave me [a drawing] of the Bolton Landing girls, naked, seated like this in the drawing, because this was exactly the position of the prostitute who was in his bed."[16] When Matkovic arrived that day, Carandente and Smith were in the house. Smith made lunch and dinner. "My mother was a great cook, but David was a fabulous cook," Matkovic said. "When somebody like Giovanni Carandente or a curator was coming—he'd really go all out."

Before returning to Italy, Carandente wrote a letter thanking Smith for the good time: "I'll keep always the souvenir of your sculptures there: never had before a more stimulating acknowledgment of your magnificent sculptures, neither in Spoleto."[17] His essay for *Voltron*, on the *Voltris* and the *Voltri-Boltons*, to be published by the University of Pennsylvania Press, would be ready by January 15. "Bolton Landing is the true museum of David Smith's work," Carandente wrote in his essay. It is there, "among the trees and rolling hills of that expanse of wild, open moorland, you get the real feeling of the greatness of his work. It is then that you come to appreciate the full importance of his place in modern sculpture."[18]

Smith and Freas appeared in Warren County Family Court on December 12. The agreement of December 27, 1960, was amended. Now he would pay $2,500 a year each for Becca and Dida. On their taxes, each parent could claim a dependency exemption for one of their children. Paying Freas alimony while she lived with her parents had infuriated him. Now, "no part of this sum or any other sum paid by David R. Smith shall be alimony or considered as alimony to Jean F. Smith." He continued to be responsible for putting aside money for Becca's and Dida's college educations. One of his many motivations for keeping so many of his sculptures at Bolton Landing was to ensure that they would eventually belong to his daughters. He knew that after his death, his sculptures would increase in value. By keeping them near him, he was providing for Becca and Dida and putting his sculptures in their hands.

Light

Although *Cubi I* was the seventh *Cubi*—Smith dated it March 4, 1963—the slightly more than 10-foot-tall stainless-steel sculpture does suggest a mother totem. Its six cubic elements resemble fertility forms—with a large belly welded to the base and above it a column of vertebral breasts that make it impossible to differentiate between the front, back, and sides of the body. The forms are stacked, but their alignment is irregular: some seem to tip off the axis or lean off the body like the head of a stick insect. Each is rotated so that it is as much diamond as cube. Each cubic-looking form—none is a perfect cube—is not only distinctive in size but also joined to adjacent forms in a distinctive way. The human is a presence here, but so are trees, insects, and crystals; humans are just one part of nature. The sculpture is animated by several of Smith's art historical icons, including Brancusi's *Endless Column*, Mondrian's paintings of squares and diamonds, and African fertility idols. A tiny diagonally upright disk set near an edge of the pedestal seems protectively wedged under the sheltering belly of the largest cube-diamond. Preposterously and poignantly, this baby disk also seems itself protective, responsible for holding up the entire construction, whose balance, without the disk, would seem impossibly precarious.

Dan Budnik photographed Smith after long labor on *Cubi I*, leaning against the doorway of his shop. Beside him is a ladder. On the ground is

David Smith,
Cubi I, 1963.
Stainless steel,
124 × 34½ × 33½ in.
(315 × 87.6 × 85.1 cm).
Detroit Institute
of Arts.

snow. Budnik observed what he believed to be Smith's ritual of burying and excavating sculptures from the snow. He watched him leave *Cubi I* outdoors in the cold and then bring it indoors and pour hot water on it to thaw its surface.[1] The photograph makes the point that the sculpture was born in this place, with its cinder-block walls, cubic windows, and factory equipment. Like a newborn calf that has just struggled to its feet, the sculpture seems to be at its moment of emergence. Smith looks both exasperated and triumphant, communicating something to the effect of "You've been a monster to build, and you are a monster, but there you are."

Cubi I is one of Smith's unforgettable works. To the Guggenheim curator Edward F. Fry, "the empirically determined piling up of steel cubes,

Dan Budnik (photographer), David Smith in his studio-workshop
with *Cubi I*, Terminal Iron Works, Bolton Landing, New York, ca. 1963.

coupled with the resulting lack of symmetrical verticality, transforms CUBI I into a soaring gesture of the human longing for transcendence."[2] Greenberg wrote: "There have been complaints about the over-use of the word, 'monumental,' but if ever its use were justified it is here: *Cubi I* seems to communicate the very essence of what the word truly means."[3]

The *Cubis* are Smith's most numerous and best-known series. He began them in 1961—the first, *Cubi IX*, was shown in Spoleto in 1962—and made thirteen of the twenty-eight in 1963, more than in any other year. Most are between 9 and 10 feet tall. He made them while other series—such as the *Zigs*, *Circles*, *Voltris*, *Voltri-Boltons*, *Primo Pianos*, and *Menands*—came and went. He continued making them until he died. Many began with "spray" drawings, others playing with and taping together brandy boxes that he stored in his basement. All are stainless steel. To construct them, he often needed two men as well as a hoist. The *Cubis* were "designed for outdoors. They are not designed for Philip Johnson's building," Smith told Thomas Hess in 1964, referring to Johnson's new addition to MoMA. "Philip Johnson doesn't need me and I don't need him."[4] He told Frank O'Hara, "Though they look pretty good inside with artificial light, I think."[5]

They're composed of geometrical forms that Smith referred to as "found."[6] The cylinder, circle, rectangle, and cube had inspired form makers across the world and from prehistory through Cézanne, Cubism, and abstract art. The *Cubis* do not include found objects. Like every other Smith series, their approach is distinctive. Leon Pratt, not Smith, did most of the burnishing of the surfaces with a revolving carborundum disc, as well as much of the polishing and welding. The sculptural parts were made to order by Ryerson Steel. Budnik said, "Stainless steel . . . had to be factory cut. He didn't have the equipment to do that . . . Everything had to be customized."[7] In his article on Smith's new stainless-steel sculptures in the December 1963 *Art International* that reproduced *Cubi I* and, in effect, introduced the *Cubis* to the broad art public, William Rubin noted the importance of Smith's shift to a different way of working, one in which he did not control the entire process himself: "These pieces cannot be intimate in the manner of his earlier, 'one-man' sculptures [in which] the execution remained entirely his own, and at every point the articulation reflected his hand."[8]

The *Cubis*, too, however, are entrancingly and at times eerily unpredictable. The series includes the ascendant *Cubi I*; the taller and sparer *Cubi II*, the flat top of which seems to be a perch for birds; and the horizontal *Cubi XXIII*, which seems ready to stride over the earth. *Cubi XVII* is one of the *Cubis* that resembles a Braque or Picasso still life. In *Cubi XXI*, the largest part of the construction resembles a gigantic hollow barbell, a prop, which brings into the series the comical theatricality of the clown and the circus. (See Figure 13 in the insert.) *Cubi XXI* is one of several Smith sculptures that seems to turn hypermasculinity into farce. The burnishings of the *Cubi* surfaces are in effect automatic and unduplicatable machine drawings. The stainless Smith preferred was 18-8 chrome metal steel (18 percent chrome, 8 percent nickel), a bit more than ⅛ inch thick. Smith usually maintained a stock of forty to fifty boxes of different sizes. The boxes appear modular and standardized, but the sculptural process was elaborate and distinctive to each work. The forms he used were carefully chosen, and in no work are two forms identical. Each form required intervention. "In order to vary the basic cube, Smith had them plate rolled and then tack welded (to prevent unrolling) at Ryerson," the sculptor and critic Stanley E. Marcus explained. "The resulting cylinder would then be welded"—the seams sealed by Pratt—"in Smith's shop."[9] When welding the steel strips together, Smith often had to cut a 4-to-5-inch hole in the boxes to allow air to escape so that the metal wouldn't buckle; he usually sealed the holes the following day.[10] And the welding, even if Pratt did it, had an important connection with Smith's personal history. "It welds beautifully. It welds just the same as armor plate," Smith told O'Hara.[11]

From the time he began using stainless steel regularly in the mid-1950s, just after his daughters were born, Smith was fascinated to the point of intoxication by its responsiveness to light. Discussing the *Cubis* in 1965, he wrote, "This is the only time—in these stainless steel pieces— the only time that I have ever been able to utilize light, and I depend a great deal on the reflective power of light . . . It does have a semi-mirror reflection, and I like it [stainless steel] in that sense because no other material in sculpture can do that."[12] It is not so much that the sun and moon are drawn to the ruts and paths incised in the burnished steel. It seems as if the sun and moon can't get enough of Smith's steel. Astral

bodies that humans have been watching with awe and fear since prehistory seem to want to perform on and with the sculptures. Light moves not just onto the incisions but seemingly *into* the steel skin, making it seem softer, transforming it into a membrane. Because the sun's desire to get inside the sculptures seems irresistible, and because the burnished scribbles invite such entry, the desire to inhabit the steel seems more than human. In the course of a day, outdoors, pretty much the entirety of a *Cubi*'s surface is touched, but it's not Smith's touch that owns the work. It's that of light. Each *Cubi* box or cylinder seems like a canister built for survival that centuries of war and decay could not crack open. Each seems to contain a secret. While light and, with it, space outside the sculptures press in, the space within the canisters seems to press against the skins from the inside. This double pressure makes the steel pulsate. As the perpetually fresh and youthful sculptural skins—stainless steel is by definition beyond stain—seem written over and into by light, the sculpture is dematerialized. Weight and gravity, for centuries synonymous with sculpture, seem defeated. (See Figure 14 in the insert.)

To the painter Alfred Leslie, the *Cubis* were "the most remarkable invention of David's." With the burnished surfaces, "he achieved everything that Brancusi wanted to with the *Bird in Flight*. The *Bird in Flight* never dissolved in the way Brancusi wanted it to, with that high polish. But the layering of light—those fucking things dissolve in front of your eyes." To Leslie, "the greatness of his discovery of the dissolution of the object . . . represented a challenge to the whole twentieth-century concept of volume."

The *Cubis* obliged viewers to adjust to the light in a way that Leslie saw as a response to advanced painting. He compared them to Ad Reinhardt's black paintings and to the Rothko Chapel in Houston—works that demand and then give "the gift of time." As "you stand, the work appears and emerges in front of your eyes. It means your vision clarifies in the way that—like the kind of thing that happens in a movie theatre. You come out in the afternoon, adjusting to the light . . . I think there's a direct relationship between David and his uses of light, which has always been a part of sculpture."[13]

Smith was aware of the history of sculpture and light. In Greece in 1936, he had seen the effect of the Mediterranean sun on limestone

and marble. Greek sculptors and architects knew that their stones would come alive and respond to seasonal change when light enveloped and inhabited them. The *Cubis* reminded Leslie of Gian Lorenzo Bernini's mid-seventeenth-century *Ecstasy of St. Teresa* in the Cornaro Chapel in Santa Maria della Vittoria in Rome, which every sculptor knew about and Smith may have visited in June 1962, just before the *Cubis* became a preoccupation. Bernini's light seems both to envelop and pierce the marble, to be both outside and inside the stone and St. Teresa's body. Rodin modeled so as to enable light to activate every inch of his bronze surfaces, ensuring that light would be its own focus of attention, its own source of value, as integral to the sculpture as image. The Italian sculptor Medardo Rosso's waxes seem thick with light. Their surfaces can seem like films, thresholds between light from afar and the sculptural figure's mysterious inwardness.

From the mid-1950s on, Smith's most sustained sculptural discussions were with Jimmy Rosati, who was known as a sculptor of light. Rosati revered Rosso and Brancusi, from whom, in Dore Ashton's words, he "learned containment, absolute sensuousness of surface, and economy." Ashton wrote, "Rosati is concerned with releasing the light 'born in the marble' and allowing it to marry the light around it."[14] In the *Cubis*, however, the space inside and the space outside the sculpture cannot wed. Unlike the life that Michelangelo famously sensed inside his marbles, which he believed was waiting to be released by his chisel, the interiors of the *Cubis* remain unknowable and ultimately beyond reach.

The title of the series names Cubism, for Smith and many of his Abstract Expressionist peers, and for MoMA, the foundational modernist movement. "My own history—knowledge of art—started with Cubism," Smith told O'Hara in 1964. "In the very great days of Cubism, of early Cubism, there was no difference in the concept between the sculptural form and the painting of it. They were about equal. You know, it *wasn't* painted sculpture, and it wasn't *sculpture painted*. It was just a natural alliance."[15] Combining sculpture and painting opened up limitless possibilities. In this series Cubism is the capacious frame within which almost the entirety of Smith's art historical family finds a place at the table. Contemporary, modern, Baroque, Renaissance, and ancient are all in play

here. Constructivism, Surrealism, and Abstract Expressionism. Cézanne, Monet, Rodin, Picasso, Braque, Brancusi, and Moholy-Nagy. Rothko, Newman, Noland, Caro, and Rosati. In no other series does Smith seem to have had as much *need* for his vast artistic family.

His approach to color is radical. Form in his sculpture is not fixed, and now color is equally yet differently fluid. The *Cubis* are, in effect, painted, but not by him. In his fields, they were painted by the sun, moon, sky, and hills. Color does not burst from the *Cubis*, as it does in *Bec-Dida Day*, but washes over them in crests and waves. Like the sculptural image, which changes with each viewpoint, color on the *Cubis* can change in a flash. The "brightness" of the sculptures "reflects the sky and the afternoon— the golden of an afternoon sun, or the hard blue of a noon sky, or the hard blue of a bright sun," Smith told O'Hara, "and sometimes the green of mountains gets in."[16] Smith made color contingent, the art historian Sarah Hamill wrote: "Not a secondary ornament . . . it is grounded, like sculptural shape and form, in time and space." Smith asks "viewers to grasp and differentiate color's dimensionality and tactility in a situational environment."[17]

People who saw the *Cubis* during Smith's lifetime understood their importance largely in terms of painting. Rubin mentioned Rothko.[18] Leslie mentioned Rothko and Reinhardt. In *The Nation*, Max Kozloff aligned the *Cubis* with the gestural "mentality" of Gottlieb, with the "broadness, sleekness and suppression of all drawing" in de Kooning, and with Hans Hofmann's "joy of creation."[19] In *Arts*, Donald Judd, whose fabricated Minimalist boxes are hard to imagine without the *Cubis*, downplaying or missing their idiosyncrasies, wrote that the *Cubis* "have the wholeness" as well as the "simple and nondescriptive parts" of the best contemporary painting, "that of Newman, Rothko and Noland."[20]

But the *Cubis* should also be seen in relation to Impressionism, which Smith studied in book after book during the 1950s as he developed his thinking about reflective steel. He felt a special kinship with Monet, for whom light was a muse. In the *Cubis*, Smith came as close as he would come to a sculptural equivalent of Monet's series paintings, of which the *Water Lilies* are probably the best known. In Monet's rural world of vegetation and water, detached from and yet informed by the vicissitudes of

the time and of urban existence, color generated through reflections of light and the surface of the painted canvas seems to be in a perpetual state of becoming.

It is not just light that Smith was working with in stainless steel. It was fire, the divine and dangerous element with which smiths have been identified since the beginnings of history. Fire was the element— the power—that Zeus punished Prometheus for stealing and giving to humankind. Smiths were known as "masters of fire." In *The Forge and the Crucible*, the historian of religions Mircea Eliade wrote, "It is with fire that [the smith] controls the passage of matter from one state to another."[21] The proximity to fire linked smiths with shamans. "It is through fire that 'Nature is changed,'" Eliade explained, "and it is significant that the mastery of fire asserts itself both in the cultural progress which is an offshoot of metallurgy, and in the psycho-physiological techniques which are the basis of the most ancient magics and known shamanic mystiques. From the time of this very primitive phase of culture, fire is used as the transmuting agent."[22] Depending on the weather and time of day, the temperature of the *Cubis* changes. At night, or under clouds, they can seem glacial. In bright sun, they look hot. They can seem aflame. Fire is the element with which Jean Rikhoff identified Smith in her 2011 memoir, the element that Smith depended on and feared.[23]

65

ICA

The day after Christmas, Smith took his daughters to the Virgin Islands for two weeks. He wanted to give them a magical holiday and fortify himself with sea and sun. It had been more than thirty years since he and Dehner had lived simply and abundantly, fully a couple, on St. Thomas, where he began his sculptural and photographic work.

They flew to San Juan, Puerto Rico, then boarded a small plane to Charlotte Amalie and went to the Grand Hotel, which Smith remembered as the most elegant on St. Thomas. "Actually, by the time we got there it was pretty seedy, and Becca was kind of upset with it," Dida said.[1] Becca remembered that she "sneakily found a phone and called" her mother to tell her she "was miserable and upset."[2] Dida said, "When he saw the bill in the morning he didn't get mad or anything. We just went to a different hotel."

That didn't work out either. "There was something wrong with the reservation, and he just blew up, and got really angry, and stormed out," Becca said. "I felt really scared and really embarrassed. Then we went to another hotel," the Hotel Flamboyant.

Smith rented a jeep and showed the girls around. "He would kind of lecture us about the flora and fauna," Becca said. "I remember going to a restaurant and his showing us the different kind of fish you can get." He arranged for a catamaran to take them to St. John. They went regularly to

the beach, where they swam and played and he read and drew. "Kids are
water sprites we picnic have fun go to bed 10 pm—by then I'm worn out
but happy," Smith wrote to Noland.³ Even in the Virgin Islands, however,
with his daughters in his charge, Smith sought women. "I remember a
woman in our little cottage, or whatever it was; me opening a door and
she was changing into her bathing suit, and I was very embarrassed,"
Becca said. "We must have been alone a lot, because I remember shaving
my sister's back with peanut butter, and snooping around the hotel. It
was as if he wasn't there."

In January 1964, after more than five years in Bethesda, Freas and the
girls moved to a small two-story house at 807 Third Street in southwest
Washington. Since September, Freas had been working as an interna-
tional radio information specialist for Voice of America. Her salary was
$5,540. She was broadcasting in Swahili. Their house was near the radio
network's headquarters, in what Becca described as an early "urban re-
newal" development. In the fall of 1964, Becca and Dida entered George-
town Day School, which Cornelia Langer and Ken Noland's children also
attended. Finally, they were around other children of artists and children
of single parents. "In those days, being a single-parent family was really
weird," Dida said, adding that "most of the children [in Bethesda] were
told that they couldn't play with me." At Georgetown Day, Becca said, "I
felt like the world went into color from black and white."

A few days after he and Freas appeared in court in Glens Falls, shortly
after installing three new sculptures in the fields, Smith took the train
to Philadelphia. At the February 1 opening of "David Smith: Sculptures
and Drawings," at the University of Pennsylvania's Institute of Contem-
porary Art, he wore a dark suit, a white shirt, and a tie. Photographs
taken at the opening provide rare post-1945 images of Smith without a
mustache.⁴ Frankenthaler came down for the opening.
 The ICA was located in the basement of the Furness Building, be-
low Penn's prestigious art history library. A driving force behind the
new exhibition space was Ti-Grace Sharpless, who as Ti-Grace Atkin-

son would become an important feminist activist and thinker. Wanting to make a splash, she opened the ICA with a Clyfford Still exhibition.[5] "David Smith: Sculptures and Drawings" followed. Thomas Godfrey, the chairman of Penn's graduate department of fine arts, provided the impetus. He was overseeing the publication of the book *Voltron* and had organized Smith's visits to Penn during the previous three years. Smith's *Voltri-Boltons*, *Voltrons*, *Voltons*, and *VBs* were reproduced in the book. Showing them would generate interest both in the ICA and in the Penn publication.

A basement was an improbable setting for vertical sculptures, some more than 9 feet tall, but their sculptural vitality still came through. The first image in the catalog is a pensive portrait by Budnik of Smith looking down while smoking a cigar. The second photograph shows metal objects on the factory floor in Voltri that would be integrated into the *Voltri-Boltons*. All sixteen sculptures are photographed from pedestal height against a white background, which emphasizes what Greenberg referred to as their "transparency and cursiveness," as well as their power as signs. The catalog includes the reproduction of a contact sheet showing Smith's photographs of related, earlier sculptures in the landscape.

Attendance was pathetic, on average twenty visitors a day. "Pennsy show No sale sort of prestige show," Smith wrote to Lois Orswell before it opened, anticipating the lack of interest.[6] Thanks to the reviews and catalog, however, the show had an impact. In the March *Arts*, Hilton Kramer called it "the most perfect exposition of Smith's sculpture I have seen" and "a major event for the history of contemporary sculpture." He praised Smith's "anarchic and free-wheeling" temperament, his "personal and aesthetic continuity that, far from preserving itself against crisis and innovation, goes out of its way to confront and enlist them as a source of energy . . . He has been able to avoid the main pitfall of the most recent developments in" painting, "its increased narrowness and specialization—even as he has profited from them."[7]

For the new institution, getting Clement Greenberg to write for the catalog was a coup; the essay would be reprinted in the May *Art International*. Greenberg emphasized the sustained quality of Smith's work. "The long career in which development continues throughout has become a rather rare phenomenon. David Smith's stamina as an artist is almost a

unique one." Greenberg made the point that "from the start," Smith had "practiced several manners concurrently," then defined "three clearly demarcated veins" in his present work. The point needed to be made. Smith's refusal to settle into one style, one image, one way of working, contributed to the market instability of his sculpture even as respect for it deepened. Smith kept expanding the ways he worked. He refused to become a brand, refused to be the kind of artist in front of whose work collectors could say, here is the Smith style, this is a David Smith. Greenberg praised Smith for being both "as adventurous as ever" and "even more prolific. This, too, is a phenomenon." He praised what he saw as the "reconciliation" of the "contradictory impulses" in his work and his ability to make sculpture that kept up with painting. He concluded with a fateful statement:

> I am not able to talk about the content of Smith's art because I am no more able to find words for it than for the ultimate content of [Jacopo della] Quercia's or Rodin's art. But I can see that Smith's felicities are won from a wealth of content, of things to say, and this is the hardest, and most lasting, way in which they can be won. The burden of content is what keeps an artist going, and the wonderful thing about Smith is the way that burden seems to grow with his years instead of shrinking.[8]

As always, Greenberg's writing on Smith is marked by insight and pronouncements. But this essay is also an indication of the limits of Greenberg's criticism. Although he mentions Smith's "prodigious burst of energy and inspiration" in Voltri, there is no sense in his essay that the exhibition had a responsibility to provide background for the sculpture in it. There is no discussion of Voltri or of Smith's time there, no engagement with his interest in abandoned factory objects, no interest in his sculptural and geographical hybridizations. Greenberg's statement about being unable to talk about Smith's content while making a point of its fullness is, while consistent with his nearly programmatic refusal to discuss artistic "content," still disconcerting. Smith had given numerous talks and written many essays in which he discussed ideas and issues that mattered to him. Other critics, including Fairfield Porter, Frank

O'Hara, and Kramer, had written essays that opened up thematic directions in Smith's work. But Greenberg had little or no use for artists' writings and did not believe other critics were worth reading on living artists about whose work he considered himself an authority. He believed that his guide to art had to remain his immediate experience of it. He wanted his criticism to be grounded in observational engagement with formal issues whose historical development and internal logic he had labored to articulate and interpret. It wasn't so much that he could not find words for Smith's content. He did not want to.[9]

Smith expressed gratitude for the essay. "Clem's forward most complimentary," he wrote to Frankenthaler.[10] Smith and Greenberg were still meeting regularly in the city for drinks and/or dinner. They also saw each other at Bennington College, where Greenberg made studio visits with Noland and Olitski and was a regular in the poker games that Smith occasionally observed but rarely joined. He never stopped respecting Greenberg's intelligence and knowledge and remained grateful for their discussions. When in his June interview with Smith, Thomas Hess criticized Greenberg's essay for not accounting for "linkage between categories" and making "everything . . . much too complicated," Smith, to Hess's irritation, would not criticize Greenberg. He was loyal to critical supporters and did not want to be drawn into the conflict between Hess and his *ArtNews*, which published O'Hara and Harold Rosenberg, and Greenberg—Rosenberg's arch-enemy. But his words indicate discontent. "There are flaws in artists and flaws in critics," he said.[11]

Hess brought up the end of Greenberg's essay, where "he said that he does not understand your content." "I don't remember that," Smith replied. "I don't see why content has to be so difficult," Hess said. Smith proceeded to speak about content in terms of "human physiognomy . . . human relationship." By contrast, he said, the subject matter "was *me* and what I could make and invent." No, Hess said. That was content. Subject matter was "like plot in a novel." Content concerned "all kinds of relationships and underlying ideas or concepts that [the artist] projects through those relationships." Smith ended the discussion by turning to "personage," a word that carried great meaning for him, which in the context of this conversation seemed as much deflection as clarification. "I would say that most of those in the *Voltri-Bolton* series were personages.

As such, a personage is built in a figure relationship. Not all the time, not all the time. There was no rule in them."[12]

The interviews with Hess in the spring and O'Hara in the fall of 1964 broke open the Smith literature. Smith spoke openly and even urgently about aspects of his work that Greenberg had either ignored or given short shrift. He made clear how much color mattered to him, and he talked with Hess about biographical, aesthetic, and political issues—his ancestry and background, the 1930s, socialism, "girls," Voltri, survival, his life in Bolton Landing, his relationships with other artists, art history, and James Joyce. With O'Hara, on television, he would speak more intensively about color and also about sculpture and gender and his lives upstate and in the city. Particularly in the Hess interview, it seems as if his mind never rested. He could not stop it. It kept going and going. He saw, felt, and worked in many, often contradictory, ways; his work was uncontrollable, and so was he. By the end of 1964, Greenberg's writing on Smith, while always pertinent, had become dated and cramped.

66

Bennington Pottery

Sometimes, Anthony Caro said, Smith would travel to Bennington College, where he would "see the students and get a breath of life from his lonely place up in Bolton Landing." Sometimes Caro took his Bennington students to Bolton Landing:

> You drive up and on the left is a field of sculptures—a field, I mean there are forty big sculptures there. Then the house and another forty sculptures on the other side. That's a man possessed by his need to make art. Every sculpture was exciting. Such variety there, that was extraordinary to see, how David was and how he was able to live through his work . . . He never skimped on materials, everything to do with his art came first . . . That's a very American attitude.[1]

Smith showed the students around and asked them about their work. He served champagne and watercress and provided what one Caro student referred to, gratefully, as "memorable words of wisdom on Art." He spoke of his dream of building a train that would transport his sculptures around the country on a barnstorming tour, making them available to people outside cities, far from galleries and museums. "How lucky I feel to have seen the works in their own fields, and to have enjoyed your most

unique maison," that Caro student wrote him. "I have the feeling you're a very honest man whose success is taking its toll on him."

Smith wanted young women artists near him. "He used to say, 'You can come up and spend the summer. I'll house you, feed you, you can have the painting studio,'" Ruth Ann Fredenthal said. "'You paint, I make sculpture, and at the end of the day we'll go downtown to the local bar. As long as you stay in the girls' room, and don't come to my room to watch TV, you're safe.' Meaning, if I came in to watch TV with him, he would ravish me."[2]

During her last semester at Skidmore, Stephanie Rose drew and painted in Smith's drawing studio. She knew that he wanted to have sex with her, but she felt safe with him. "David used to make a joke. He would say, 'Come here. Sit on my lap. It's too bad you don't have a father fixation.' This was the line." She saw how much he was drinking. He "was dead drunk every night . . . After dinner—by 9:00 . . . he was really loaded . . . Usually cognac. He liked to have a glass of wine with dinner. But the cognac and the cigar after dinner, and Beethoven . . . he was really into Beethoven." Then "he would get up and work early in the morning."

Smith took Rose to Bennington. She recalled:

> I remember the point at which it became clear to me that David and Ken were really best friends . . . They would sit around, at a certain point at night, dead-drunk in front of the fire, saying, "I slept with your wife first." "No, I slept with your wife first." Like this teen-age pissing contest. They were going back to Sarah Lawrence days . . . It was hysterical when you thought about it. Here's two brilliant guys, and they'd be carrying on like something between fourteen-year-old boys . . . This repartee was almost like a comedy bit. It wasn't an argument.

She had no idea if there was any truth to their one-upmanship. "I have the impression," she said, "that some of it might have been for my benefit."[3]

"He was drinking more," Tina Matkovic said. "Obviously, whatever demons are with you are going to get magnified . . . After a while I started

not going, because we'd go out to the local bar and he'd keep running off the road. Fortunately, there were still snowdrifts, so you'd end up in a snowdrift."[4] Fredenthal said, "He was warned about drinking and driving, and he did it all the time."[5]

Patsy Nichols was one of the Caro students who visited Bolton Landing. In California, she had been captivated by the studio of Peter Voulkos, the dimensions of which—24 feet high, 150 feet long, and 50 feet wide—Cherry related to Smith when he taught at Berkeley. With his energy and inventiveness, and the scale of his ceramic production and his synthesis of East Coast and West Coast approaches, the forty-year-old Voulkos was already a legendary figure. "Peter's relationship to his work was just gorgeous to watch," Nichols said. "It was just vital and sexual and exciting . . . So I was kind of looking for that kind of fire about work . . . I came back and decided I wanted to work with an artist again . . . as an apprentice." Gloria Gil, of Bennington Pottery Works and the director of Bennington College's nonresident terms, suggested that Nichols could stay at Bolton Landing for the summer, working as Smith's assistant and taking care of his daughters during their annual visit.[6]

On March 21, Smith and Nichols began finalizing summer plans following her June graduation. In exchange for looking after Becca and Dida, she would be given room and board and a place in the shop to work. She was excited but also apprehensive. "He called all the time, drunk, all spring . . . He was very lonely, really lonely up there . . . I was concerned, because I didn't think I could handle this adult being drunk. I didn't know what to do . . . I think someone who was really clear would have just said, 'Forget it, mister. I'm not coming up there with you drunk.'" Smith wrote to her on May 3, "Put 9 pieces out in the field this week I need you for summer. I'm sure we can make equitable arrangements. David Gil is making me 50 plates to paint." He added that he'd come to Bennington to work on them. "Called Thurs. night—you'd gone NYC #2 Wagon done #3 underway."[7]

All three *Wagons* were completed in the first six months of 1964. Although Smith had been making sculptures on wheels for close to a decade, the *Wagons* are most closely related to *Voltri VI* and *VII* and the small Voltri wagons. Each *Wagon* carries a heavy upright load balanced on a pole-thin horizontal steel axle. On each axle, one or more sculp-

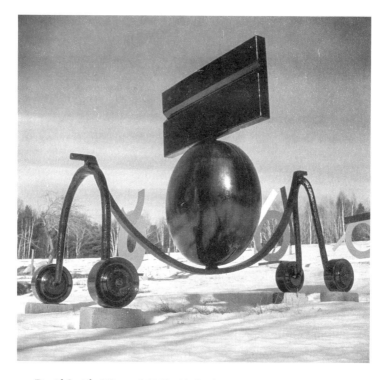

David Smith, *Wagon I*, 1963–64. Steel, paint, 88½ × 121½ × 64 in.
(224.8 × 308.6 × 162.6 cm). National Gallery of Canada.

tural objects seem to be waiting to be transported, except that the wheels
are not uniform and movement would be all but impossible. The objects
emanate personality and purposefulness, and with all their ancientness
a hopeful futurity. In *Wagon I*, the only painted *Wagon*, a rectangle
is perched on an equally massive round form, more than a disk but not a
sphere, that seems to have been dipped in a vat of lustrous black paint. In
Wagon II the silhouette of a tall, thick, flat, forged bar of steel, welded to
the long low axle connecting the front and back wheels, is on display like
a personage on an auction block. "The upright in the center of the yoke
was a rejected railroad coupling from Bethlehem Steel," Stanley Mar-
cus noted. "The heaviest of Smith's sculptures," *Wagon II* "weighed well
over eight tons."[8] *Wagon III* also seems like the remnant of a fairy tale.
Perched on the nearly 14-foot-long steel beam are four steel forms, each,
like the upright forms in *Wagons I* and *II*, both human presence and

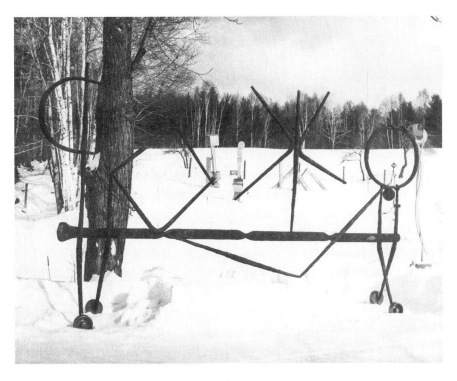

David Smith, *Wagon III*, 1964. Steel, bronze, 100 × 163 × 30 in.
(254 × 414 × 76.2 cm). Nelson-Atkins Museum of Art.

alphabetic or pre-alphabetic sign, the four together emitting an irresist-
ible yet indecipherable message. This is the *Wagon* on which Smith was
working when he urged Nichols to join him for the summer. In the *Wag-
ons*, alphabetic signs have an annunciatory yet secret desire. Each *Wagon*
would find sculptural kinship in a Greek, Etruscan, or Roman museum.[9]

Smith and Jules Olitski spent Easter at Noland's. In photographs, they're
all wearing sports jackets; only Smith wears a tie. In two photographs,
he's smoking a cigar. In another one, he looks at the camera. His thick
mustache is back. His eyes communicate fierce will and intelligence, but
there are bags under them and the slackening of his lower lip suggests
dissipation.

In May, Smith traveled regularly to Gloria and David Gil's Bennington

Pottery Works. "What would happen if a group of prominent American painters and sculptors were asked to work in ceramic?" Cleve Gray, a painter and the director of the *Art in America* project, wrote in "Ceramics by Twelve Artists," in *Art in America*'s December 1964 issue. "We were excited by the prospects of inviting in this program artists who had seldom or never worked in ceramic."[10] The plan was for the ceramics to be produced in limited editions and tour in an exhibition. But Smith refused to allow his work to be cast in an edition.

Bennington Pottery was a small, homey factory. Smith had known the Gils since his early years with Freas and considered them family, particularly Gloria. Nichols saw Gil and Frankenthaler as "the two women who were kind of his confidantes and nurturers." On April 12, Smith gave drawings to each of the Gils' four children.

Smith had seen great ceramic art in Greece and Crete, and he was aware that Pollock and Picasso had made ceramics. It took a while for him to adjust to clay. He "wasn't satisfied with the first 20 or 30 he produced," Cleve Gray reported. "He said, 'it wasn't until I forgot that ceramic crap that I could make something I liked.'"[11] Smith wrote to Frankenthaler, another of the twelve artists, "Happened to see your plates Helen out of the kiln—came out beautiful—colors and painting very dramatic—You had a few cracked ones—so did I. I'm learning tobe more careful I hope. Raw dry clay is so delicate."[12]

David Gil made the fifty plates according to Smith's specifications: their diameters are around 14 inches. Smith asked Londa Weisman, a Bennington freshman, to pose nude within a huge iron hoop. "They propped that up on a table," Weisman said, "then I posed inside it, so that he had that ring, that would represent the plate, as a point of reference."

After 1962, Smith painted and drew hundreds of female nudes. For some paintings, he delineated images by squirting paint from an ear syringe onto a canvas. For others, he painted or drew with short straight lines, flowing lines, or violent bursts. At Bennington Potters, he started out "squirting stuff out onto the clay, but it wasn't working very well," Weisman said. Smith began incising outlines of bodies into the clay. Often he then painted the body around the etched lines so that the painted and incised lines relate but do not quite align. "When he started doing that [the incising], he really got fluid," Weisman said. "That worked." It

"was a tactile way of making the line, that he had a different kind of control over." He was "happy to have discovered it."

Sometimes he painted first and then incised. Sometimes he painted green, brown, and black areas around white bodies, making the space around the figures densely active. Sometimes the paint seems to press against the body, or envelop it, like the paint on the belly of *Wagon I*.

David Smith, *Untitled (Nude)*, 1964. Hand-painted ceramic plate, glazed and incised, diameter 13½ in. (34.3 cm). The Estate of David Smith, New York.

The circle of the plate structures the space. Sometimes the female nude seems to sit within the circular frame reading. Sometimes she stands up, hands on hips, brazenly staring out. In one plate, she lies on her side. In another, the white within black outlines gives the body a ghostly air. The range of styles is startling. As in the *Wagons*, the echoes of the ancient world are multiple and direct. The geometry is inhabited by the female image. Smith had found another way to enter the circle and give it life.

Weisman said she was thrilled to work with him: "The particular opportunity of watching him work that way was really important to me." He had "this tremendous vigor. He was an enormously appealing, impressive, likable person, on that level."[13]

Gil said that Smith took away the plates in a bushel basket. "Some of them come out looking awful Greek, real pretty," Smith told Hess. "Each one unique, drawn from life, and very often there is a change. Be fucked if I know what I'm going to do with them. How are you going to give that to your daughters?"[14] Gil said, "Plaques on the wall. I really do believe that" was how he intended to display them.[15]

On May 25, Smith was in the city for a dinner celebrating the opening of MoMA's new galleries and enlarged sculpture garden, in which three of his sculptures were exhibited. He was seated next to Louise Nevelson. He was happy to report to Frankenthaler and Motherwell, who were abroad, that thirty to forty artists, including the three of them, had their signatures on the walls. The guest of honor was Lady Bird Johnson. She said "Hooray for art," Smith wrote. "6-8000 artists about town (and gallery museum personel) came after dinner at 10:30 to see Lady Bird—drink champagne—chat and snipe."[16]

The next night, Smith was in Waltham, Massachusetts, to receive the Creative Arts Award from Brandeis University, which was accompanied by a check for $1,000. "Leonard Bernstein was bestower of awards—He is real smooth adept and fluent," Smith wrote.[17] He splurged the $1,000 on a festive New York City dinner and Cuban cigars. "In those days you went to a place called Dunhill's, and you had your own cedar box in which your cigars were kept," said Stephen Weil of Marlborough-Gerson, who was at the dinner. "When you wanted a cigar, you went and withdrew it from your cigar account."[18]

On the eve of summer, Smith lost three women on whose company he had depended—Stephanie Rose, Tina Matkovic, and Jean Rikhoff. Rose announced that she would be getting married on June 14. "He called me at school . . . He congratulated me on my forthcoming marriage . . . That was the whole phone call," she recalled. Instead of attending her Skidmore graduation, Rose went to Bolton Landing. A few days before, Smith had

brought in a bulldozer to raze the two old barns on the property in order to build a fireproof storage studio. Attached to it would be a studio apartment for visitors. The morning of her departure, Smith tried to entice her to stay. "'Come here,'" Rose remembers his saying to her after breakfast. "'I have something I want to show you.' He opens the door to the kitchen, we take a few steps out, he opens the door to this cinder-block studio . . . There were rolls of canvas in there . . . They looked like they were ten feet high. They were huge. And he said one line to me. He said, 'This is for you. You can stay if you want to.' That was it." Rose declined his offer and left for the city and her marriage, but, she said, "I cried on that fucking bus all the way home, like a child leaving camp."[19]

After Noland visited Matkovic's Skidmore thesis show, the two hooked up. "We [David and I] had a little falling out—not a little falling out, a big falling out—at some point, because I started seeing Ken Noland, and [David] got really angry at me," Matkovic said. "First of all, he said he didn't mind, 'That's no big deal,' but after a while he started getting really pissed off and made an issue of it. He said, 'Don't come back. Get your love in Vermont.'"[20]

Rikhoff, like Rose, was getting married. After she informed Smith of her plans, he never spoke to her again. "I really liked him as a friend. I really did," she said. "But . . . I just wasn't in love with him. I loved him, the way you love friends. I couldn't imagine anything worse than being married to somebody like that. Could you?"[21]

"Plenty of lonesome nights," Smith told Hess. "I have guests on occasion, but not near enough and there is no woman at this particular point in my life that I love and adore. Maybe I'm kind of worn out on the response I don't know. Maybe . . . I don't have the price to pay what it takes to have it . . . I'm not sure I have loved . . . I'm not much good for marriage anymore."[22]

67

Fear

When Becca and Dida arrived for the summer, Patsy Nichols was installed in a room that Smith had fixed up for her in the basement. "The affair started before the girls got there, and I was very upset by it," Nichols said. "I was never comfortable with it."[1] Smith bought her a welding outfit, and she welded her own sculpture near the basement. She spoke with him about art and met visiting art luminaries: Greenberg, Frankenthaler, Motherwell, Goossen, and others. She saw the thought he put into his upcoming Marlborough-Gerson show and the emergence of half a dozen new sculptures, including *Becca*, a figure-bird construction of two dozen jutting rectangles and cylinders made from brown industrial steel stock. She watched him put roofs on the new studio and guest quarters and helped him maintain the garden by throwing things at the raccoons that were eating the vegetables.

Her days were structured around the girls' activities. She took both of them swimming and drove Becca to piano lessons. "I was the first one he let drive his Mercedes," she said. One of her jobs was to "to help make" them "into 'young ladies, proper young ladies.' They had to learn how to do things the right way. I was supposed to teach them how to cook . . . But he cooked a lot. He was a great cook." They baked apple pies together.

When Becca and Dida were with him, Smith drank less. But on occasion he took Nichols to town for dinner, where he drank more than he did at home. It was not unusual for her to drive him home.

Tina Matkovic may have been the first artist Smith asked to apply paint to his sculptures. "We would go out there with buckets of industrial enamel, car enamel, really heavy-duty enamel," Matkovic recalled. The harsh winters tend "to make little dings in the paint, so you have to go back and repaint . . . After a while he trusted me to go out and do it on my own."[2] In the spring of 1964, Smith had asked Stephanie Rose to do similar work, touching up a couple of the painted sculptures. She was happy to do it. Smith asked Nichols actually to paint a sculpture. "It was really grueling and boring, and I couldn't bear working on someone else's work," Nichols said. Matkovic and Rose were inspired by Smith's fields. Nichols struggled to maintain her identity amid so much sculptural presence. It was "like being with an army."

She was direct with him. "I had this chutzpah to tell him what to do with his work. I would look at his things and say, 'You shouldn't put that there, put it there,' and we would have big arguments about things like that. That's kind of a generous act—instead of saying to this little girl, 'Shut up, you stupid little twit.' He gave you respect and support and things, in a way . . . At one point I asked him for one of his pieces and he said, 'Make your own.' I thought that was kind of wonderful. That was meant as a supportive thing, how he said it, and when he said it."

The house provided evidence of the culture and curiosity that Nichols expected from Smith. By the woodstove was Smith's library of books and magazines. He had an extensive record collection. The tools and other objects hanging on two walls a couple of feet behind the stove, many acquired during Smith and Dehner's trip to Europe, brought into the warmest corner of the house a daily connection with metalworking cultures around the world. Three of Smith's paintings from the 1930s hung in the kitchen, one from the 1950s above the dining table.

But while his sculptural imagination was as vital as ever and his processes of thinking, dreaming, drawing, painting, and constructing still

flowed, the Smith with whom Nichols spent two months as an au pair
in the summer of 1964 was worried. He could control his work but not
much else—not his income; not his family, friendships, and love rela-
tionships; not Freas's demands; not his drinking and the trajectory of
his lonesomeness; not what would happen with his work after his death.
And often, not his desires or behavior. Smith had long cultivated con-
flict, believing that the more of it his work could direct and transform,
the greater it would be. In letters to the Levys during and just after World
War II, Dehner had mockingly referred to Smith as "superman." He was
determined to prove to her and the rest of the world that no mental or
physical labor was too much for him. What would happen when he no
longer believed that the problems of his life could be creatively assimi-
lated within the ever expanding dynamism of his work? In a letter, the
nineteenth-century French novelist Gustave Flaubert wrote: "It is by
sheer force of work that I am able to silence my innate melancholy. But
the old nature often reappears, the old nature that no one knows, the
deep, always hidden wound."[3] Smith was increasingly exposed to the im-
mensity of his deep but now not always hidden wound.

To Hess a month or so before Nichols's arrival, Smith spoke of fear:
"I'm scared something is going to happen. That I'm not going to have
enough to eat." No one who had lived through the Depression could be
rid of the threat of scarcity and deprivation. "Once you've lived through
a Depression, Thomas, I don't think you can outgrow it." He seemed
haunted by his pioneer ancestry: "I came from pioneer people. . . . Salt
and flour and sugar, things like that, they were deprived of for periods of
time. I never got over that because I came directly from pioneer people
that were scared for survival."[4]

But the Darwinian harshness of nature had a truth and beauty that
he needed:

> I saw a hawk dive on a squirrel one day, right down my wal-
> nut tree. The hawk finally grabbed the squirrel by the tail and
> skinned that poor little old squirrel's tail right bare. The god
> damned tail was just sticking out as raw as could be. Finally,
> the squirrel got away, but the hawk had nothing but fur in
> his talons. I like that. I like trees, I like the mountains, I like

the winds. I like 40 below zero in blizzards whirling past my windows. I feel like I'm living. I think better. I need to live in nature.[5]

Smith shot ducks, which he roasted. With guilty pleasure, he confessed to Hess that he had shot robins, too. "But I don't want you to tell the birdwatchers society about it," Smith said. "God damn it, I had to knock off the robins. It was either my strawberries or the robins."[6] In one window of his house, probably in the drawing studio, he locked a rifle into a vise and installed a spotlight above it. When a deer was in its sights, all he had to do was pull the trigger. "He'd shoot the critter, and then he'd call us and we'd go up and get it and clean it out and cut it up for him," Wesley Huck, a neighbor, said.[7]

Smith spoke proudly to Hess about his revolutionary war cannon:

I got a bronze cannon which I put the girls' names on . . . This was the one that was found in the lake. It was originally cast in Scotland. It was brought over during the French and Indian wars and when they pulled up to dock they found seven old cannons shoved in underneath to hold up the railway carriage that carried boats out in the lake. One of them was in pretty good shape. A friend of mine had his brother make a pattern of it as it was originally and I pasted strawberry, maple, chestnut leaves on it and cut out the girls names and pasted it on the cannon before he cast it for me.

Smith collected frozen juice cans, filled them with cement, and dyed them with black powder to look like artillery shells. "You can shoot it a mile with three ounces," he said.[8]

Smith lived with a sense of injustice that hard-earned money he was going to put into his work would be taken away from him for taxes. "I'm not a goddam bit afraid of god. I'm more afraid of the IRS coming around," he told Hess.[9] In July, Smith agreed to create a trust fund for Becca's college education; he was legally bound to provide college funding for both daughters but he also saw the advantages of this requirement. He liked imagining Becca in college, and building the trust fund

would mean that money invested in it would not be taxed. But Freas continued to demand more for child support. "He was ready to kill her," Nichols said. "He talked about hiring someone to shoot her. He also got really angry about airplanes flying over, and he went to get his gun, to shoot the airplanes."

Smith wanted to provide for his daughters, but not through Freas as an intermediary, and not so much with money that he could invest in his work and in luxuries that after years of scarcity he believed he deserved, but with the legacy of his work, with which he trusted them alone. His work would provide for them, and they would look after it. "When you're dead they are going to make all sorts of casts" of your sculptures, Hess said provocatively. "My daughters won't make them," Smith replied. "I have given explicit instructions to my daughters not to make them. Tom, you'll be around. You could write an editorial that would say so, that I told you, that I had told them . . . It's not their right . . . They are destroying part of me when they do that."[10] "Tom, you'll be around," Smith said. He was convinced that Hess would outlive him.

This was not paranoia. Smith knew the exploitative history of posthumous casts and knew that his art would become more valuable after he was dead, which infuriated him even if he felt heartened that the increase in value would benefit Becca and Dida. "Right now I'm not worth a nickel, but the day I die my daughters will be millionaires," he told Johnny Mac, his quadriplegic friend in town, a few years earlier. "I want my daughters to have everything they'll always need."[11] After their visit to Bolton Landing, the sculptor John Chamberlain said to Henry Geldzahler, "What struck me about that trip was when he took us into the basement and you couldn't get in because it was so full [of sculptures]. And he said, 'This is for my daughters.'"[12]

Smith's friendships had their own forms of precariousness. When Cherry told Budnik that Smith had called him a son of a bitch because of his affair with Patsy Nichols, it pissed off Budnik for months. Greenberg had turned much of his attention to a younger generation, in particular Olitski, Caro, and Noland. In Greenberg's pantheon, Caro was replacing Smith as the greatest living sculptor. At this point, Greenberg saw much more of Noland than of Smith. Noland was now a star. His work

was selling, and he could buy what he wanted. By early August, he was driving an MG.

Smith and Noland remained close, but Nichols felt rivalry as much as friendship. "It was supposed to be friendly, but there was a meanness to [their relationship]," she said. She felt a pronounced difference between them: "There was something about David that was like a little boy, in his fears and his desires for things to be so grand and big. . . . Whereas, there was something smug about Ken, and more somehow grounded in reality, somewhere, whereas David was off, somewhere else."

On August 14, two days after Dida's birthday, Smith, Nichols, and the girls drove in the Mercedes to Provincetown to spend four days with Frankenthaler and Motherwell. While there, they ran into Geldzahler and Sidney Geist, who Smith was convinced was interested in Nichols. During the 340-mile drive, Nichols was struck by Smith's awkwardness with his daughters. He was often wonderful company for Becca and Dida, solicitous and inventive, such a joy for them to be with that their summers together remain treasured memories, but to others he now communicated a lack of confidence that he could be what he needed to be with the two people he loved most. Nichols felt that he wasn't sure how "to relate to them . . . He just didn't have any idea what to do." Smith's neighbors Evans and Frances Herman had two daughters. Evans remembered that Smith wanted the girls to sleep over with Becca and Dida because Myra, the oldest, and Becca were close. "He would say to Frances, 'Now, what do I do with them? I don't know how to handle children.' And we said, 'Love them, David. Don't do everything they want,'" Evans recalled.[13] Jean Rikhoff said, "Frances told me this terrible story about the girls being up there, and he was so (this was after I had gone), he was so rattled—he was trying to make cookies and be nice to them and all—he measured the salt into the recipe instead of the sugar."[14]

On August 23, the day after the girls returned to Washington, Nichols left for the city. "He told me that he was feeling love again," she said, "and I was someone who had touched him in a way that other people hadn't." He asked her to stay. "He wanted me to move up there, but he didn't want me to live with him. He wanted me to get a house down the road, and be there . . . it was the convenience of having me down the road, is what it

felt like to me." Nichols felt their age difference: "It didn't feel right to me. And the relationship had to be hidden from the girls. That was the other thing. It had to be this hidden thing."

In early September, before returning to Bolton Landing to pick up her belongings, Nichols stopped at the Gils' in Bennington. Smith called and made a scene. "Your call to me at the Gils' hurt and upset me very much," Nichols wrote a few weeks later from Berkeley. "It destroyed any belief I had in you in your relationship to me."[15] She explained, "I moved to California to get away, basically, is what I did."

During the same late-August trip to the city when he took Nichols to the Five Spot, Smith had also taken Jane Harrison there. Harrison had dropped out of school in England at sixteen and, after beginning to make a mark as an art critic, gained admission as a special student to the graduate art history department at Harvard. Deeply impressed by Clement Greenberg's 1961 anthology, *Art and Culture*, she met him in 1963, the year she settled in the United States. Through him, she "met Anne Truitt, and David, Ken Noland—the whole group . . . I'd known Tony Caro before I met any of those folks, through my own family."[16]

"I don't believe I've ever enjoyed sculpture so much in my life," Harrison wrote to Smith in response to his January 1964 ICA show. "It is a gorgeous show and I came away feeling a hundred times lighter and happier."[17] Smith sent her money for the bus ride to Bolton Landing. On September 7, she thanked him for the "marvelous evening we had together and I'm so glad to have met you" and returned the money. She was involved with Noland, who was "furious" when she told him she had spent time with Smith.[18] "It was a tense relationship with David, because he was really hitting on me. It was before the days of feminism, too, so there was no context for feeling somehow something's wrong here, and there was no real vehicle for outrage at that point . . . It was difficult to be a young woman in New York . . . But through it all I could see that he was a phenomenal sculptor." She, too, felt the age difference. "I think I was taken aback because he was, on the face of it, quite a bit older than my dad." When she told him "I'm Ken's girl," that was the end of it.[19] Still awed by his work, Harrison would organize the first Smith memorial exhibition after his death.

68

Success

Voltron finally appeared in the early fall of 1964. The eighty-page book begins with Giovanni Carandente's essay and Smith's elegantly hand-written letter to David Sylvester and features eloquent black-and-white matte photographs of the *Voltris* by Ugo Mulas and of the *Voltri-Boltons* by Dan Budnik. Smith gave the book to the Bolton Landing public library in the names of Becca and Dida, and sent it with a dedication to Dr. William Fels, the president of Bennington College, who was gravely ill in the hospital. He sent the book to Lois Orswell. "I am simply moved to tears by the beautiful book and the inscription and the enclosure, and by your kindness in sending it," wrote Orswell. "You have no idea how it is loved and appreciated . . . Your sojourn at Voltri was one of the great moments in the history of modern art and I am so pleased it has been commemorated this way."[1]

He also sent a copy to Golda, who wrote to Dehner, "I thought how much of your life went into the production. I have told him but for the influence and work of Dottie you never would have made the advancement you made."[2] Dehner received a copy, too. "Thank you so much for the beautiful book," she wrote to Smith. "I was greatly moved by all of it, and the pictures most of all. As you say, it took a long time—That's the way it should be—to fill the whole life—how sad to be a great success at 25—for you its been *building*—Anyhow I was proud that it all came out

with great beauty and dignity and warmth—and that I had had a long time watching it build."[3]

Smith's last solo gallery exhibition during his lifetime opened on October 15 at the Marlborough-Gerson Gallery. Its twenty-nine sculptures included ten *Cubis*, more than in any other New York show ever, and three *Zigs*, among them *Zig IV*. "I remember David finishing the painting on [one of the *Zigs*] as the show was opening," Stephen Weil, the vice president and managing director of the gallery, said. "There were people coming in. We had the customary wine and crackers, and there was David, down on his knees working."[4] The show included all eight *Menands*, as well as small bronzes. Series were mixed with other series and with non-series sculptures so that the exhibition echoed the variability and profusion of the fields. "[Smith's] new show, at the Marlborough-Gerson—a big one, and for the most part, effective, contains works in no less than five styles," Robert M. Coates remarked in *The New Yorker*.[5] The range contributed to John Canaday's declaration in *The New York Times* that sculpture now had a breadth of invention and experimentation with which painting could not compete.[6]

Thirteen of the sculptures were too big for the elevators. Getting them to the sixth floor was a feat. Each *Zig* "weighs over a ton, somewhere around a ton and a half," Smith told Marian Horosko in an October 25 radio interview for WNCN-FM. "That is absolutely maximum for hoisting and getting in through the window . . . Santini's . . . have real pro movers and riggers and shifters and they got it all in."[7] Weil said, "The sight of the *Cubis* being hauled up the side of the building from 57th stunned everyone. I remember vividly Mark di Suvero being there to help install them. Mark had been" nearly crushed to death in an elevator accident in 1961 "and he still very much hobbled on a cane. But he insisted that he wanted" to be there, "just out of sheer admiration for David."

Smith's paintings of nudes were not installed with the sculptures, but two were reproduced in the catalog and were therefore part of the show. Kenneth Noland was one of the few people who liked Smith's late figure drawings and paintings. "The sheer force of them, the sheer directness of them, the uneditedness of them," Noland said.[8] Weil said:

He came with these huge bundles and just rolled them out, chortling that he had developed this entire new technique . . . filling a hospital syringe with black ink, and then having one continuous line, for as long as he wanted it. Everybody else was trapped by having to put a brush back in ink, or break the line, and he had this truly sinuous line on these things. I thought they were wonderful. It was a question, at that point, of their marketability . . . The only one that I know of that was sold . . . during David's lifetime, went to the Art Institute of Chicago, as a sweetener on a deal for a *Cubi.*

David Smith, *Untitled* (*Nude*), 1963. Enamel on canvas, 50½ × 25¾ in. (128.3 × 65.4 cm). The Estate of David Smith, New York.

The opening was posh, with two bars, one tended by a man in a white tuxedo. Becca and Dida were there. "He was fussing over them before the crowd came in," Weil said. "He was working their hair, he was getting their dresses adjusted, so they were just hanging perfectly. It was just an astonishing scene."

Smith's wish to control sales was a factor in his pricing. He needed money, but the more he made, the more the court could require him to pay Freas. The more his annual income surpassed what he was writing off for materials, the more he would have to pay the government. "The *Cubis* were very highly priced," Weil said. In his memory each was originally priced at $50,000. By pricing his sculptures too high, Smith hoped to establish their financial worth while making sure that not too many of them sold, gambling that he would still sell enough sculpture to support his work and studios, and his luxuries in the city. The reason his sculpture "didn't sell that much was because it was so highly priced," Weil said. "The reason it was highly priced was that David was almost paranoid about Jean taking his money away."

Smith wanted young women artists to share his sense of achievement. During the opening, he telephoned Stephanie Rose. "I get a call from him," Rose said. "'Where the hell are you?' . . . I didn't realize I was invited. I didn't know that I could go." Smith took Nancy Grossman and Tina Matkovic to his show. He took young women artists to other shows as well. At the opening of "Recent American Sculpture" at the Jewish Museum, Rose met Frankenthaler. "I was like, 'Oh, my god.' She was wearing an Evan Picone double-knit, and she had a Gucci scarf. I couldn't believe—she looked so bourgeois!" Rose and Smith "got together with her and Motherwell" after the opening. "I want to tell you, I felt like Cinderella that night."[9] The Jewish Museum's show's seven sculptors included di Suvero, John Chamberlain, and George Sugarman. At the November 6 opening of the Calder retrospective at the Guggenheim, Smith introduced Matkovic to Calder. He "was drunk as a skunk," Matkovic remembered. "I'll never forget being sort of saddened by such a genius being four-sheets-to-the-wind at his own opening."[10]

The critical response to Smith's show was overwhelming. While not reviewing a show that "would take a column to describe," Canaday told his readers "don't miss [it]," and called Smith "an old master of contem-

porary sculpture."¹¹ "Smith's exhibition, at the Marlborough Gallery, may well be the greatest of his career," Hilton Kramer wrote in *The New Leader*. "If one hesitates to proclaim it as such, it is not, in this case, because of any doubts about the work but simply because Smith is now producing major sculpture at a rate of speed that mocks one's choice of superlatives in describing it."¹² Charlotte Willard wrote of the *Cubis* in the *New York Post*:

> Smith seems to have come to a new high point in his art with his stainless shining steel spectaculars. These nine and ten-feet-high sculptures are meant to be set out in the weather to reflect the sun and the moon. They bear on their smooth surfaces engraved drawings that, like forms embedded in ice, seem to move as one walks by them.¹³

Donald Judd began his review in *Arts*: "David Smith's sculpture is some of the best in the world, the previous work and most in this show."¹⁴

When Smith's show opened, Clement Greenberg was in South America. In his appointment books, he generally noted exhibitions he visited. He went to Marlborough-Gerson during the run of the show but does not mention Smith's exhibition and does not mention Smith this fall. He does note that he hung Noland's November show at the André Emmerich Gallery, which was located in the same building as Marlborough-Gerson; that he went to a dance party at Noland's during Thanksgiving weekend and "watched tv football in Ken's bedroom"; that he went to the Emmerich Gallery on November 30 to help Noland install Caro's show; and that he attended Caro's opening on December 2 and on December 5 went to a dinner party for Caro at the Motherwells'.¹⁵

By this point Greenberg was regularly trashing Smith as a person. "Clem was very snobby about David," Gloria Gil said.¹⁶ Jimmy Rosati told Peter Stroud, a Marlborough-Gerson artist who began teaching at Bennington in 1963, "Clem can't really stand David."¹⁷ He "admired David as a great, great artist, but he could be . . . harshly appraising of the man," Jules Olitski said. "The way Clem put it, he could take David for five minutes, but he would be looking at his watch all the time, measuring it."¹⁸ In 1982, in a lecture at the Metropolitan Museum of Art on

Smith's work, Greenberg referred to the ruthlessness of Smith's creative drive, which Dehner would comment on as well, but also felt compelled, in public, in a great museum, to attack Smith's person: "Smith's confidence came, as I saw it, from something deeper lodged, more egotistical, and almost more impervious—which is part of what made him boring, personally, because Smith could be a terrible boor."[19]

Greenberg had a history of fraught relationships. "Something always turned out sour with people who were close to Clem, at a certain point," William Rubin said.[20] Caro said of Greenberg's behavior some years later, "It was a good relationship until at one stage he started being shitty, and said nasty things, and I had a row. [He said things] about me. He said, 'You know, you're a craven Jew,' or something. He had an incredible ability to hit his friends . . . He could be very personally disagreeable. He was very tough on my wife. He was never nice to her."[21]

Stroud used words like "sadistic" and "malevolence" to describe Greenberg: "It was almost as if Greenberg wanted a successor or a rival to David." In Stroud's view, within the Bennington art circle the competitiveness with Smith was intense. Stroud wondered if they all had "a very odd love-hate relationship" with him. "Olitski, Noland, even Greenberg . . . envied his macho-ness." Smith "tended to overwhelm people . . . He was like the alpha male, always. There was a certain charisma he had, it was like a presence . . . There was a quality—I don't know if the word fits—of unswervingness in David . . . It was known that Greenberg influenced art's making, but David would never have that."[22]

Other artists could be afraid of losing their selves in Smith's presence. The prominent British sculptor Phillip King taught at Bennington during the 1964–65 academic year and avoided visiting Bolton Landing until after Smith died. "I think I avoided it in some way, unconsciously," he said. Noland urged him, "'You must go there, you must go there,' and in the three months I was [at Bennington], I never did." Smith "was a very powerful personality, and I guess I was afraid of being taken over . . . It was like he wanted to get inside of you in some way. He had a great human sense of wanting to get to grasp people—'Who are you?'"[23]

Caro felt Smith's competitiveness. "I didn't know until after he died . . . that David respected my work," Caro said. "I remember David coming down and looking at the work. I don't think I ever took it very

kindly in a way. He would be critical . . . 'Why don't you try this?' or, 'Why don't you—?' . . . I think I could take it much more from Clem . . . or from Ken—more than I could from David."[24] But Caro felt deep gratitude to Smith and a lasting bond with him. Sophia Healy remembered of one party, "We were all having a good time, and there was a bit of talk about the fact that the young English sculptors were David's progeny, in a way—his little children. And Tony [Caro] was laughing, everybody was taking it very lightly . . . And then David . . . said, 'Come over here, Tony. Sit on my lap,' so little . . . Tony Caro . . . cherubic, with his beautiful curls—popped right up on David's lap and sat there, just like he was his son. Tony was willing to go along with the joke. It was a beautiful, very warm moment."[25]

Greenberg's disparaging of Smith the person reflected irreconcilable aesthetic differences. While Greenberg would continue to praise and even celebrate Smith's work, that work was in clear ways anti-Greenbergian. Smith could violate one material with another and his combinations of metals and disciplines challenged the Greenbergian notion of medium specificity. His sculpture was designed to reward visual perception, but experiencing it involved more than eyesight: viewers discovered the sculpture by continually moving their bodies. His sculpture did not promise stability of engagement in the same way that a painting can on a wall in a museum. Engaging a Smith sculpture in the fields or elsewhere outdoors was contingent on the changing conditions of time and space. For Smith, unity was only credible in disunity, and while he valued the uninhibited openness that often accompanied childhood innocence, he considered purity a lie. The Marlborough-Gerson show was a formidable example of Smith's impurity. No other abstract artist Greenberg supported would have made anything like Smith's nudes.

What Greenberg could have interpreted as Smith's disobedience is most evident in his approach to color and paint. Greenberg was complimentary about only one of Smith's painted sculptures, the 1946 *Helmholtzian Landscape*. "The question of color in Smith's art (as in all recent sculpture along the same lines), remains a vexed one," Greenberg wrote in 1964. "I don't think he has ever used applied color with real success."[26] Greenberg's wariness of color in sculpture was programmatic. In 1958, while making an argument for the most necessary new sculpture, he

wrote that "applied color is sanctioned."[27] In order for sculpture to be optical—appealing to vision alone, the eye able to move freely, unhindered, over a two-dimensional surface, as it did in Caro's sculpture—the tactility and materiality of paint were problems. No aspect of the surface could be weighed down or filled in. For color not to compete with sculpture, it had to be essentially superficial in relation to it. By contrast, as Sarah Hamill wrote, Smith's color was "substantive, tactile, and three dimensional."[28] Smith wanted the eye to linger, to journey up and down and over and through and even into the surface, discovering more and more. "Unification is approached by inviting the eye to travel over the complicated surface exhaustively," Frank O'Hara wrote of Smith's sculpture, "rather than inviting it to settle on the whole first and then explore details."[29]

Smith had been thinking about color and paint since the Virgin Islands and had studied polychrome sculpture in Paris and Greece. He had spoken and written constantly about the union of painting and sculpture in Cubism and the limitless possibilities that emerged from considering painting and sculpture together. Greenberg could approach Smith's color only on his own terms. He felt intellectually superior to Smith. "Crashing bore" and "stupid," some of the insults he leveled at Smith, were the same as those he leveled at many other artists, including de Kooning, Pollock, Rothko, Gottlieb, and Clyfford Still.[30] It was not just that Greenberg did not like Smith's color; other critics questioned it as well. He did not take it seriously.

For other influential sculptors of the next two generations as well as Caro, Smith was a major figure. "When I saw David Smith's work, it didn't remind me of anything, and that was the key," John Chamberlain would say. "It was like: America, we have arisen."[31] In his thinking about color, Chamberlain is one of the most adventurous American sculptors. For Mark di Suvero as well, another sculptor who used color in powerfully physical ways, Smith was a sculptor who seemed to make anything in sculpture possible. Around 1963, di Suvero made the pilgrimage to Bolton Landing with Chamberlain and Henry Geldzahler. For the catalog of an exhibition on Smith's fields, di Suvero wrote, "I was so impressed by his field of sculpture that I wrote him a poem for Becca and Dida, which he remembered and mentioned the last time I saw him, at

his show at Marlborough-Gerson . . . The young sculptors of my genera-
tion were in awe of him."[32]

Even sculptors who defined themselves almost against him demon-
strated, by so doing, his influence. At Bennington in 1964, Smith could
be in the presence of Carl Andre, whose wood and metal work rejected
sculpture as a composed, vertical, handmade figurative presence on a
pedestal, constructed with differentiated parts. "I remember talking to
[Carl Andre] one time, at Max's Kansas City, and somehow Smith's name
came up," the sculptor Robert Murray said. "He said he couldn't imagine
doing sculpture like Smith, because Smith did it so well. He was the god-
father, so to speak, of sculpture, as far as my generation was concerned."[33]

In December, Smith went to the hospital to visit his close friend Wil-
frid Zogbaum, who had gotten sick, Budnik believed, from inhaling
"propellent, some sprays," the sorts of materials Smith was also work-
ing with. Smith was a factor in Zogbaum becoming a sculptor.[34] "He is
hopeful says its not leukemia," Smith wrote to Cherry. "I feel for Zog—
he doesn't look well."[35]

Smith and Patsy Nichols remained in touch. He told her that Irving
Penn had been at Bolton Landing for three days to photograph him for
Motherwell's January article on him in *Vogue*. "He photographed me in
your room with the canvases," he wrote. "I could feel you still, but it
doesn't hurt now. I've got several of your things—a scarf and a shirt." He
was worried about her falling in love with Budnik, who was in the Bay
Area. He told her that he would be back in court. "I'll never be rid of her
[Freas] it seems."[36] A week before Christmas, he wrote to Cherry: "Jean
has me in court Jan 11—wants 10,000 yearly. I don't have it like that—
I'm sure she can't get it." He was worried about his debt to the gallery: "I
owe Marlborough $28,000 before I get cash for my bank loan." Dental
bills were piling up; he had had five bridges made. At the end of the let-
ter to Cherry, he wrote: "I drink too much—get lonesome and take the
synthetic catharsis."[37] After Becca and Dida's Christmas visit to Bolton
Landing, Smith spent New Year's Eve with Frankenthaler and Mother-
well. He was invited to the inauguration of Lyndon Johnson.

69
Girl Sculptures

On November 6, 1964, Smith and Frank O'Hara taped "Sculpture Master of Bolton Landing," a segment of Channel 13's *Art New York* that would air five and seven days later. O'Hara's introduction provided a sculptural overview that included images of the fields, with which he continued to be impressed. He noted the "astonishing variety and versatility" of Smith's work and his gift of scale that enabled small sculptures to evoke both "Aztec sacrificial implements" and "enormous buildings of the future." O'Hara's David Smith was "the sensitive Dreiser hero who abandons commerce but becomes, thereby, world-famous . . . a Thomas Wolfe hero who stops yearning for the sound of locomotives, and proceeds to make his own versions of them; a Henry James hero, who dominates and influences Europe, instead of being corrupted by it." Both men wore jackets and ties and smoked, O'Hara a cigarette, Smith a cigar. At one point it seemed that Helen Frankenthaler, to whom both were close, would be part of the segment—an intriguing fact, one that raises the possibility of Smith's anxiety about being on television in New York.[1] Her presence would have been a security blanket for him. But the atmosphere was cordial. O'Hara had no reservations about Smith's work. He did write about Smith's content and he was uniquely insightful about Smith's paint and color. He and Smith were friends.

About three-quarters of the way through the half-hour program,

after a substantive conversation about color, O'Hara asked Smith about his relationship with his sculptures. "Do you feel like they're people around your house? Are they aesthetic things? What are they? I mean, you must feel that they're all these strange objects surrounding your whole studio and on the lawn." Smith responded: "Well, they're all girls, Frank." O'Hara shot back: "They're all girls?" Smith: "Yeah, they're all female sculptures." O'Hara, laughing: "Oh, they are." Smith: "I'm sure." Still bemused, O'Hara replied: "Very angular girls?" Smith elaborated: "I don't make boy sculptures. But they become kind of personages. And sometimes they point out to me that I should have been better or bigger. And, mostly, they tell me that I should have done that 10 years before—or 20 years before." O'Hara: "Well don't they ever tell you that they're very glad you did them?" Smith shifted again: "I like their presence—yes."[2]

Because of the words "Well, they're all girls, Frank," this exchange has become a landmark in the Smith literature—"a touchstone in the writing on the sculpture," the art historian David J. Getsy wrote in an extended and probing analysis of the exchange. Their impact has been reductive. "They have been used to forestall any question of gender variability in Smith's work," Getsy wrote. Accepting Smith's remark at face value "forecloses the more open and unprecedented possibility that Smith's sculptures present."[3] Getsy argues that Smith's statement that his sculptures were "all girls" contradicts the reality of the work, deflecting attention from its fluidity and multiplicity and by so doing undermining the work's potential to imagine alternative, as-yet-unknown identities and bodies.

The exchange must be considered within the Smith-O'Hara relationship. O'Hara had written passionately and originally about Smith's work, and at the time of their television interview he was in the process of organizing his third Smith exhibition. It was his nature to ask questions that no one else would, ones that could encourage a proximity to the person and work that often pushed the boundaries of propriety. In O'Hara's poetry the intimate could rear up at any moment. Like Smith, O'Hara was a master of the unpredictable and the image that seemed to come out of the blue, including the non sequitur. Both Smith and O'Hara were used to good-natured but edgy banter in which artists and poets egged each other on while demanding verbal improvisations

that would keep the conversation moving in ways that allowed for the formation of fresh responses without getting mired in explanation. In Smith and O'Hara's Cedar Tavern and Five Spot social circles, every participant was expected to keep their companions informed, amused, and periodically provoked.

Three years earlier, O'Hara had written that Smith's best sculptures made him want to *be* one. Getsy believes that Smith's quip or joke, "they're all girls, Frank," announced to O'Hara, in effect: They're mine; you can study and poetically personify and embrace them, but you can't be one. By saying "they're all girls," Smith both accentuated his feeling of closeness with O'Hara and pulled the sculptures back from the possibility that O'Hara, and that anyone but he, could possess them. Even more emphatically than Getsy, the art historian Sarah Hamill sees Smith's gendering of his sculptures as a provocative joke: "Smith's claim that his works are female . . . seems meant to proclaim his heterosexuality to the homosexual critic . . . To take Smith at his word, to read his sculptures as female, would entail dismissing the absurdity embedded in his claims, launched rhetorically as assertions of the artist's straight-male bravado."[4]

The claim does seem absurd. A number of Smith's titles refer to men, among them *Lonesome Man, Ninety Father, Ninety Son, History of LeRoy Borton, Rosati's Landing,* and *Blackburn, Son of an Irish Blacksmith.* The *Voltri* and *Voltri-Bolton* series include sculptures that seem both female and male. And in a number of sculptures, gender, like everything else in them, can seem to change depending on position—as in *Personage Seeking Australia,* which includes a long projection that from one or more points of view, but not others, can seem burlesquely phallic. It would be difficult to read as "girls" Smith's work tables or tiered constructions such as the *Primo Pianos. Zig II* and *Cubi VIII* are among the Smith sculptures that evoke children and parents, huddled families, and architecture. Sentinel was a male role, and Smith did a whole series of *Sentinels; Sentinel II* is one of the Smith sculptures that defies gender specificity.

Getsy and Hamill point out that many of Smith's gender markers are indefinite. They *invite* speculative engagement. Despite the masculine title, Rosalind Krauss had no doubt that *The Hero* (1951–52) was a "female totem." She describes the pyramidal protrusions within the "torso" as "incipient breasts."[5] To Hamill, however, *The Hero* "gains its power by

confusing gender identity, not by resolving into a concrete vision of feminine identity." The sculpture's "upright, 'heroic' stance and a linear torso marked by tiny protrusions of breasts" help make "the relation of male to female . . . ambiguous."[6] And these two pyramidal protrusions, facing in opposite directions, can also be interpreted as vertebrae, which reinforces the sense that the back of this construction is indistinguishable from the front, and that inside and outside are simultaneously visible. To assign stable meaning to any Smith form, or even any Smith sculptural gesture, is to court drastic misinterpretation. Smith's figuration is forever in process, an unsettled compound of images, many of which seem to have emerged from the depths of the unconscious to that preconscious moment, just before consciousness, en route to identities whose ultimate definitions are perpetually deferred. In Getsy's view, to take at face value Smith's statement "they're all girls" would mean "obscuring the complexity that [Smith] more often desired for his sculptures."[7] It would distort what Smith's sculpture is and how it works.

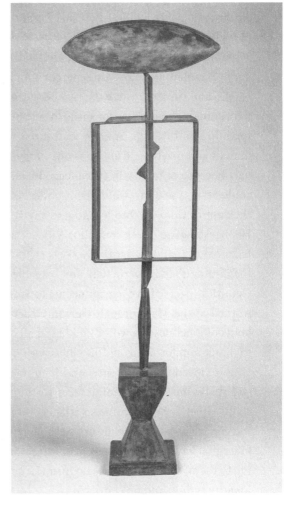

David Smith, *The Hero*,
1951–52. Steel, paint,
75 × 25½ × 11¾ in.
(190.5 × 64.8 × 29.8 cm).
Brooklyn Museum.

Visitors to Bolton Landing used many words to personify Smith's sculptures. "Girls" was rarely, if ever, one of them. To O'Hara, who, Getsy points out, "never literalized gender in his writings" on Smith, the sculptures could be "friends" and "party guests" as well as "people around your house."[8] To the sculptor James Wolfe, in the fields at Bolton Landing, "You felt that you were in the presence of people. It was kind of overwhelming, and very personal."[9] Stephanie Gordon, a recent gradu ate of Sarah Lawrence, met Kenneth Noland in November 1964 and visited Bolton Landing with him soon after. "I think all those sculptures" in the fields "were his children, his mother and his . . . family," she said.[10] To the painter Peter Stroud, the tall sculptures in particular were "the children he never had." Stroud said Smith spoke often of his sculptures in such terms.[11]

Smith's sculptures do indeed, as Getsy points out, expand the category of human. Human being merges with bird and insect; animal, vegetable, and mineral; earth, stars, and planets. Sculptures with hints of figuration make perches for birds to rest on and openings for dogs and foxes to run through. Smith's sculpture can also suggest the fusion of human and machine. *Cubi VI* is one of several Smith sculptures that, in part because of their stiff three-leggedness, suggest automatons. If they could walk, their gait would be robotic. Associations reach far back, in the case of *Cubi VI* into legend and myth, in particular Daedalus and Hephaestus, the Greek name for Vulcan, and project forward into the technological and futuristic. Getsy is right to insist that in Smith's work the "human" is in perpetual flux, capable of continuous redefinition. Countless people have felt connected to Smith's work. Jane Willa Norris worked at the Marlborough-Gerson Gallery and adored Smith; during bouts of loneliness he would call her at all hours of the night. She wrote to thank him for "sharing" his *Cubis* with her during the fall 1964 show: "I, too, 'loved their presence' and hate to see them carried away . . . I will really miss their shining faces staring at me all day. Never, in my short career, have I become so attached to a group of works."[12] To limit the gender of Smith's sculpture risks denying the generosity and possibility that have made so many people feel that the sculptures were speaking to them. In Smith's work, no form, structure, or image seems settled. Identity is fluid and unknowable.

David Smith, *Cubi VI*, 1963. Stainless steel, 112³⁄₁₆ × 29⅝ × 21⅞ in.
(285 × 75 × 55.5 cm). Israel Museum, Jerusalem.

But the Smith-O'Hara exchange is also vexing. It's not just Smith's statement "they're all girls" that must be taken seriously. After O'Hara's query "They're all girls?," "girls" becomes "female sculptures" and "female sculptures" becomes "personages." The trajectory is revealing.

When Jean Freas entered Smith's life in 1950, the image of a dynamic girl-woman entered his sculpture. *Agricola I* (1951), the sculpture that initiated his postwar series, suggests a young girl at play, a dancing girl, and a presiding woman holding the scales of justice at the tip of her arabesque. Girls became presences in Smith's work with the births of Becca and Dida in 1954 and 1955, respectively. Many sculptures bear his daughters' names, and others include messages to them. A number of other sculptures evoke girls in their imagery. Just as important, many

sculptures exude the uninhibited delight of young girls playing. *Bec-Dida Day* has an infectious and irradiant openness. With its pristine surface or skin, stainless steel is eternally youthful. Smith's stainless-steel sculptures seem trustingly available, to the sun, moon, trees, water, animals—everything. In his sculpture, "girl" could be a symbol for the instantiation of potential, which "girls" can still symbolize, particularly when women use the word to refer to other women.[13] "The instantiation of potential" remains largely gendered: the organic vitality of potential is rarely symbolized by boys.

After Freas left Smith and took their daughters with her in 1958, Smith was continually around young women, some of whom he was sexually involved with. He referred to some of the youngest of them in letters to Herman Cherry, communicating excitement and guilt. After 1963, when Bennington became his home away from home, Smith was often in the company of women as young as eighteen. A number of them he had affairs with. He wanted to be seen with young women, making sure that everyone in the city who knew him saw his ease with them, their ease with him, and his and their desires to be part of one another's lives.

In his three interviews in 1964, Smith referred to "girls" in ways that indicate obsession. To Hess: "I just made 130 or 140 paintings this year. So far, I have not made one of them from a photograph . . . These are all nude models. I don't use drapery. When there's pussy, I put pussy in. And when there's a crack—on some of these girls who are so young you can't even see a definition in the division of certain parts of the physiognomy. So I put it in because I think it will be there sooner or later."[14] To Marian Horosko in their fall radio interview, in response to her question about touching sculpture, Smith declared the response to sculpture to be a visual one, as it is with "any other art." Then he said, "I touch, I think the sensibility mostly is from the eye. You touch girls but you look at sculpture."[15] In all three interviews, Smith's reference to "girls" borders on creepy and to many current ears will actually seem creepy. While none of the interviewers were offended by or felt compelled to express offense, Marlborough-Gerson did exclude from the interview in its catalog the provocative words to Hess and would not have done so if Smith had not agreed to it. He wanted attention to be focused on the exhibition;

the words have been included in subsequent publications of the interview. But with Horosko and O'Hara, Smith indicated his determination to press attention onto "girls." He *wanted* people to think about "girls" in relation to his work. He wanted people to ask themselves what was going on between him and his sculpture, which would ripple out into the fundamental question: What was going on all through the sculpture? Smith's uses of "girls" in the interviews are a way of both confessing an obsession and planting in the minds of others the possibility of his work as the site of acts that may not be bound by propriety or law. When Smith responded, "I like their presence—yes," to O'Hara's question "Well don't they ever tell you that they're very glad you did them?" he hinted that his sculptures might in fact not be glad, and if they weren't, what had he done to make them wary of him? In his writings on Smith, O'Hara kept blurring the line between actual humans and sculpture, and now Smith himself was blurring that line. O'Hara had asked audiences to consider Smith's relationship to his work and now Smith was, too. Were his welded metal constructions sculptures or girls—or females? Were they sculpture or human? Through the long history of statuary, the power of sculpture has revolved around this question.

For centuries, pretty much every Western sculptor felt the weight of the myth of Pygmalion and Galatea. "A sculptor falls in love with a statue he has made and finds it miraculously animated," the professor of English Kenneth Gross wrote in his thumbnail description of Ovid's telling of the myth in *Metamorphoses*.[16] For Gross, Ovid's fable is "one of the urtexts in the history" he was writing of "the dream of the moving statue."[17] As a model for sculpture, Smith detested this myth. It was the embodiment of the "monolithic concept" that until Cubism had constrained sculpture for centuries. "Somebody gave [sculptors] a Galatea complex," Smith told an audience of artists in 1956, "and they got the idea they always had to release this virgin from a hunk of stone or a tree as a simple—single—form."[18] His sculptural model was largely the opposite: not a solid carved block, but multiple metal parts, each one different, almost none of them blocking vision, the tenderly and forcefully handled parts activating a flow of associations that awaken images, fantasies, and ideas asking, it seems, to be completed by the beholder. This is an Abstract Expressionist model, a painting model, one aligned with the

deferred and anticipatory figurations of de Kooning, Pollock, Rothko, and Gottlieb.[19]

But for sculptors personally invested in their materials and in making, the Pygmalion myth is difficult to shed. In the sculptor's intense attachment to his creations, one that often includes an erotic dimension, the presence of the myth persists in one way or another in the work of many sculptors, including Smith. Pygmalion fell in love with his sculpture, even taking the stone body to bed with him. It was when he kissed the pure white stone that it came to life, its skin softening, the stone's blush flushing and staining the white marble. "The ivory grew soft to his touch," Ovid wrote, "its hardness vanishing, gave and yielded beneath his fingers."[20] Stainless steel's receptivity to light as a result of burnishing made Smith's steel skins seem not just touched but soft and inhabited. The illusion of marble as actual flesh and blood would have been anathema to Smith, but the enlivening of obdurate material through acts on and sometimes seemingly inside it, the line often blurred between awakening and defiling, is a feature of his work. Motherwell would refer to Smith's attraction to his daughters' skin in a way that suggested preoccupation.[21] While particular impulses and acts that energized Smith's art are obviously noteworthy, more significant is his ability to work with them in such a way as to generate cultural and aesthetic consequence. The tension between the experience of actual transgression and the aesthetic performance of transgressive behavior has been part of Smith's work since 1950. His ability to be both inside and outside his work, in the belly of and beyond or above its dramatic content, is reflected in a statement he made in 1952: "My position for vision in my works aims to be in it, but not of it . . . I seem to view it equally from the traveling height of a plane two miles up."[22]

While "girls" *is* relevant to thinking about Smith's sculpture, so is "female." The movement from girl to woman, the existence of the woman in the girl, is implied in Smith's words: "So I put it in because I think it will be there sooner or later." In Smith's 1958 drawing *Becca Running*, a little girl seems not only full-breasted but even pregnant. Pretty much every Smith sculpture that suggests a trusting and innocent little girl also suggests a powerful and at times punitive big girl. *Voltri II*, one of several sculptures that affectionately evoke a tot with a big curl or a ribbon in

her hair, is 6 feet tall and as hieratic as it is childlike. *Bec-Dida Day* and *Voltri II* are among the multitude of Smith sculptures that seem to grow bigger as we look at them. They seem to appeal to audiences, inspiring free association, welcoming interpretation—but even as we approach them, or feel a sense of connection with them, they are more than us, and other. They are right there, immediate and available, but on another level it is as if we cannot find them.

While Smith's sculptures can suggest both girls and women, females, they are also personages. One dictionary definition of "personage" is "a person not meriting specific identification." Another is "person of rank, note, or distinction: an eminent man or woman." For the sculpture critic and historian Alex Potts, "personage" is a word that "suspends conclusions about gender, even as it disrupts figuration itself." The experience of the sculpture as a "personage" distances it, making it impossible to identify with the figurative elements in the sculpture. One cannot empathize with it. "One is blocked from appropriating it as a projection of oneself," Potts writes. "This is its abstraction. It does not embody or reify a living human figure. It is not even quite a figure, often seemingly more like a cipher or a motif seen from afar. Yet at times, it appears close and oddly familiar."[23]

"Personage" is an apt description for one of the most crucial and hard-to-define aspects of Smith's sculpture. Being a "personage" often, but not always, depends on a verticality that suggests but also maintains its distance from the human figure. The verticality of the *Tanktotems* and *Sentinels*, or of some of the *Voltri-Boltons*, or of *Ninety Father* and *Ninety Son*, functions within the figural associations but at a certain point, sometimes because of what Smith does to activate and extend the "neck," breaks free of them, lifting the sculptures into a more impersonal realm. At a certain point in the encounter with many Smith sculptures, they become abstractions: the steel plate that is so much more than a steel plate becomes a steel plate, a cube becomes a cube, a rectangle a rectangle, a line a line. The experience of almost unlimited associative freedom hits against something else in the sculpture that is anonymous and cold, at times hollow, of the sculpture but also alongside it, or perhaps elsewhere, or, as Potts suggests, far away. The sculpture both encourages projection and stops it. It is reachable and it isn't. As personages, the sculptures

become impervious. Krauss and Getsy see Smith's sculpture as a rejection of the statuary tradition. "His sculptures represent the final attack on the coherence of the statue," Getsy writes.[24] While Smith's sculptures adamantly reject the statue's fixity and unitary subjectivity, however, as personages they affiliate themselves with statuary. The sculptures absolutely proclaim Smith's mantra "No rules!" but they also preserve the law. As statuary, they become totems, and as totems they become statuary. Smith's sculpture is a radical reinvention of, as well as a radical break with, the statuary tradition.

Catharsis was an essential idea for Smith. The first time he mentioned it in print was in 1950, one of his most turbulent years. "I hope to have made art a life interest for you," he wrote in "Notes on Books" to his Sarah Lawrence students. "Whether you make it or consume it, it can be an added dimension in living and understanding, a catharsis, a truth, the vision of free men."[25] Catharsis referred to his experience making work and the experience it offered others. If his sculpture was going to be totem as well as taboo, it had to demonstrate that taboo behavior was being watched and guarded against. O'Hara's voice-over at the end of their program ended with this statement: "The primary passion in these sculptures is to avert catastrophe, or to sink beneath it in a grand way. So, as with the Greeks, Smith's is a tragic art." O'Hara's perception about Smith's art averting catastrophe is astute. But is Smith's art "tragic"? If tragedy is understood as a condition burdened by fate, weighed down by drives and actions that the artist is conscious of yet unable to control and is eventually crushed by, Smith's art isn't tragic. But if tragedy is a theater in which dangerous forces are in play, which the sculpture mobilizes, guards against, and rises above, then Smith's may indeed be a tragic art.[26]

70
Help

By the end of 1964, Kenneth Noland and Stephanie Gordon were a couple. Curious, articulate, and self-assured, Gordon had been drawn to the paintings of Frankenthaler and Noland she'd been introduced to in William Rubin's art history class at Sarah Lawrence. During her junior year, she invested some of her inheritance in art and bought one of Noland's *Targets*. Rubin mentioned the November 1964 Noland opening at André Emmerich's, and there she met Noland and told him she had purchased a painting. A day later he called and invited her to dinner. He was seventeen years older, and the world he introduced her to was eye-opening. Painters, sculptors, writers, and photographers: "These were people who were doing something, and they said what was on their minds," Gordon said. They were leftists who "had read some part of Marx" and "traveled and seen a lot of the world." They crossed "different social strata . . . and were proud of it." Smith and Noland followed their whims. They "would go to Chinatown and they would order the whole left side of the menu."[1]

Noland was riding high. He was one of the eight artists chosen to represent the United States at the 1964 Venice Biennale, along with Robert Rauschenberg, Morris Louis, Jasper Johns, John Chamberlain, Jim Dine, Claes Oldenburg, and Frank Stella. He would exhibit at the Jewish Museum in February 1965 and at a London gallery that spring. Along

with a spacious house and studio in Vermont, he had a pied-à-terre in the city. He was an art world golden boy with no financial worries.

In early January 1965, soon after Gordon had moved in with No-land, they drove in his Buick convertible to Bolton Landing and spent the night. Smith showed her around and introduced them to the two Bennington students who would devote their two-month nonresidency terms to cataloging his work. Gordon said of the property, "[It was] like nothing I had ever seen . . . the landscape with the sculptures outside." After dinner, she said, "when we came to kind of clear the plates, I think David, in a gesture to free me up from the cleaning up, just threw the plates out." She continued her description of him:

> He just was a very big man, in every sense of the word. I felt comfortable learning about life from him, like what it was to live, and how to live, and his philosophy of life. He treated me like an equal. That was important to me. I mean, there was always that sort of macho quality that he and Ken could get into—"girls," and "you've got a great eye, baby," and that kind of stuff . . . I knew the troubles he was having with seeing his children. He was pretty open about his life.

On January 7, 1965, Wilfrid Zogbaum died of leukemia at forty-nine. He had been a good friend to Smith. Herman Cherry wrote to Smith from Berkeley:

> And now it's Zog. I remember when I was a kid, I used to see parades with Civil War veterans. Each year there were less and less until there was only one. Finally he too disappeared. I'm beginning to feel that in my milieu, the ones who stay alive are caught in a boisterous shouting, fuckitall, rockits-up-their-ass, pissant group of young bandits. The whole thing is a fuck-ing battle for survival, but then, you see all around you your friends, chums, pals dying from exhaustion—or boredom—or attrition.[2]

"Zog was a great guy," Budnik said. "No one knew what the hell [poisoned him]. We tried to figure it out . . . Then he got pneumonia, and his immune system was too weak, and he died. Marta, his wife, asked me to call David and tell him." Budnik had not been in touch with Smith for more than a year. "Why don't you come up?" Smith said when he called. Budnik replied: "Yeah, maybe I'll come up in the spring."[3]

The day Zogbaum died, Becca wrote her father asking him to send the case for her braces that she left over Christmas: "When you find please send it by airmail immediately . . . P.S: Please send check for January."

Smith and Patsy Nichols were writing each other regularly. He let her know that he had been invited to the Johnson inauguration. That the Los Angeles County Museum of Art was planning a Smith retrospective for the spring. That he would be back in court with "dear wife #2," adding, "I think I'd be afraid to try for 3. Great sizes in sculpt. planned for coming year." He continued to try to make her feel that she had abandoned him: "Pat you hit me hard—it doesn't hurt now."[4] He mentioned the two Bennington students and their cataloging.

Gloria Gil, who organized the winter nonresidency terms at Bennington, wanted to do everything she could for Smith. When he had told her that he needed help organizing and cataloging, she immediately set about finding a pair of students to help him. The job was enormous, and on Smith's hillside during an Adirondack winter two students could keep each other company.

Patricia Burns, a senior and an art major, was the first student to arrive. She was the granddaughter of the filmmaker Robert Flaherty. "She was beautiful, tall, striking," said Frances Herman, who came by once a week to help Smith with cleaning and letter writing; she typed some of his angry letters to Freas. Barbara Davenport, the other student, was a sophomore and a literature major. She had no idea who Smith was. "One girl was ravishing, and knew it," Herman said. The other was "not a fashion model, and was not flirtatious at all—she was short, sturdy . . . She was extremely bright—and David was starting to fancy her a lot more than the prettier girl."[5]

Davenport had felt "very depressed" at Bennington. "I was sort of a restless, introspective, geeky adolescent who didn't fit in . . . I was feeling

mildly countercultural, before that word was invented . . . I wanted something kind of different." College was a shock. "I was a real simple midwestern girl. I didn't know any Jews. I didn't know anybody with pierced ears. I was a white-bread girl." Bennington was "a startling, amazing place . . . fascinating and overwhelming. I was also another one of those smart kids who gets to college and the whole world is full of smart kids, and suddenly it was a much larger pond and I was a much smaller frog." She had planned to "ski bum" during her nonresident term, but with the warm weather and rain there was no snow. "What else you got?" Davenport asked Gil. "She had this."[6]

Davenport and Smith discussed her residency over the phone. She followed his directions to Bolton Landing and at the foot of the driveway drove her 1955 Ford into a snowbank. Smith was meeting with Ira Lowe, his new lawyer, and "some young guy . . . who was a sculptor and admirer and a bit of hanger-on." Smith and the young man "both drove their trucks down to pull my car out of the snowbank." Smith had a "panel truck—which looked more like a drycleaner truck or something." He "was the one who pulled me out, and he was obviously very pleased about that."

Davenport learned immediately about the battle with Freas:

> The reason Ira was there was the mother of his daughters . . . was suing him for back child support. I remember being struck that, on the one hand, he was just crazy about Becca and Dida—their pictures were all over the place, he talked very warmly and affectionately about them—but he saw her as a grasping bitch, who was trying to squeeze him dry, and I was real struck at that discrepancy.

Burns and Davenport stayed in Becca and Dida's room. "I think I started a sexual relationship with David . . . I'll bet you within a couple weeks," Davenport said. She "maintained a presence in" the assigned "bedroom, but also . . . spent many nights in his bedroom." Davenport was sure that Burns "was never sexually involved with him. So, from the start, that was a very awkward position. It immediately cast her as a kind of third wheel, and it was uncomfortable."

On January 11, Smith and Freas appeared in Warren County Family Court. The trial took an entire week. Smith was represented not by local counsel, as he had been in previous trials with Freas, but by Lowe, a Washington attorney. The trial was bitter. At one point, Lowe recalled, Freas in her rebuttal "chose to testify concerning physical acts against her and excess drinking, all of which testimony was thrown out after my objection."[7]

Stephen Weil remembered:

> Jean wanted to increase child support. David's defense was that he had no money . . . The issue was David's unsold sculptures, and Jean testified, or had somebody testify, that David was worth a fortune; that there were these fields full of sculpture that were the equivalent of money. I testified that the sculpture is not an asset but a liability; that you had to take care of them until somebody wanted them; all they did was cost him money; there was no guarantee that there was any market for them; these were monumental things that were really impossible for individuals to own, they could only be sold to institutions and there were only so many institutions that would be interested in absorbing these; that the likelihood is that they would be an albatross for him, economically, for the rest of his life . . .
>
> He behaved very badly . . . He was just like a child. "She's not going to take it away from me," he said. I finally said, "David, this is your two daughters." She was testifying about the raggedy clothes they were wearing to school.[8]

In a letter that he dated, as if in a fog, "Jan 13 or 19 or something," Smith reported to "Patz" Nichols (whom he called by several names):

> [I have] been in a last week Kafka trial Momma and money—real greed needs a piece of my future work and those finished—
> I won't do it
> I've made trust funds for kids.[9]

January 12 is the date welded onto *Cubi XXVI*, one of his most hor-
izontal sculptures. Except for the baby cube, easily the smallest form in
the work, on the ground, supporting the 10-foot-tall and 12½-foot-long
construction at one end, all the stainless-steel parts are diagonals. From
the center of the rectangle to which it is welded, a cylinder 2–3 feet long
projects out and up like a cannon. The way in which this rectangle and
cylinder are balanced on another long rectangle evokes a large child
standing or playing on the thighs of a parent, or perhaps a rider on the
back of a slow earthbound fantasy creature. The rectangle and cylinder
seem in danger of slipping down the rectangle supporting them and fall-
ing away. This is another *Cubi* that suggests jugglers and tumblers. More
surprising, this is another *Cubi*, part of a cluster of late *Cubis*, that sug-
gests alphabetic, or pre-alphabetic, signs, here hinting at a "T," a "W," and
perhaps an "I" in formation. Here, too, as he has been doing in unexpected
and apparitional ways since 1950, Smith evokes in sculpture a preconcep-

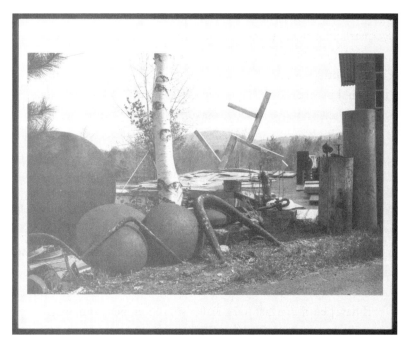

Alexander Liberman (photographer), Smith, David, Print 30, 1965.
Alexander Liberman photography archive.
Getty Research Institute, Los Angeles.

tual language, language before language, where the components of letters seem to still be in motion, in a state both prior to and beyond literalization. Language cannot be disconnected from image and new origins are forever possible. It is up to viewers, and archaeologists of the future, to decide messages that are forever soliciting and resisting interpretation.[10]

When Smith went to Washington for the January 20 inauguration, he visited his daughters at Georgetown Day School. He had not paid their spring tuition—Al Freas had. He saw Motherwell's show at the Phillips Collection: "strong and great," he wrote his friend. He chose the Lavender Hill Mob Pit Stop, the Georgetown club of the Lavender Hill Mob Racing Association, over the presidential dinner. "Talked cars etc—safe sane evening," he wrote Motherwell.[11] He told friends in Washington that he did not go to the dinner because "of the iron rules on dress."[12]

In his last will and testament, signed in Washington on January 21, Smith left everything to his daughters and appointed Greenberg, Motherwell, and Lowe his executors and trustees. He gave them great authority: "In the disposal of my works of art and other property, real and personal, said Trustees shall have as full and unlimited power and discretion as if said trust property were their own absolute estate." Concerning "the disposition of my works of art" in particular, he nevertheless requested "that my Executors and Trustees shall consult with and be advised by Helen Frankenthaler, Kenneth Noland, and Cornelia Noland."

The choices checked the right boxes. An influential, well-connected critic who had supported his work for two decades; an established, well-spoken, and well-connected artist who revered him as an artist and person; and a left-wing lawyer who represented artists—the list of his art world clients would include Joseph Hirshhorn, Aaron Siskind, Louise Bourgeois, Mark di Suvero, Noland, and Frankenthaler—and was recommended by Cornelia Noland, Smith's former student at Sarah Lawrence and one of the handful of people whom he trusted completely. Cornelia and Lowe, who was forty, were dating. But Smith did not ask Motherwell before naming him executor and trustee, and in all likelihood he did not ask Greenberg either. Lowe, every bit as self-important as Greenberg, had only recently begun to work with Smith and knew little about his career and work. Smith does not seem to have had discussions about the future of his work with any of the three executors. Lowe

pushed Smith to do the will; it was at his suggestion that Smith named the other executors and the advisers.[13] Smith was clearly in a hurry to get the will done.

Stephanie Gordon believed that Smith gave Lowe too much control. "I just had my doubts about Ira representing him, and being so involved with Cornelia, and us . . . It just felt like he didn't know anybody else to go to," she said. "Also, he was doing his will." He was lawyer, executor, and trustee, which to Gordon seemed inappropriate.

Soon after finalizing his will, Smith went to see Jules Olitski in South Shaftsbury, Vermont. Smith, Olitski said, "got out of his van, and this huge, hulk of a man went down, on the ground. Collapsed drunk." He pulled himself together and did not drink again that day. At dinnertime, Olitski continued, "he and I spoke quite a bit . . . He was celebrating that he had made his will, and that the kids would be taken care of." He spoke excitedly about his new drawing studio and the "other project he had in mind, that he was going to do—and he was absolutely serious about this, I swear it—that he was going to build a sculpture a mile high, a mile high, and the base of it would be one of these huge derricks, or whatever you call them, that you see when they're building skyscrapers."[14]

Burns and Davenport began their cataloging with paintings and drawings, recording measurements and descriptions on notebook paper. Then they moved to sculpture. Davenport learned about Smith's art by being with it and studying publications that were lying around. "I began to really get a clue about who this guy was," she said. She was stunned by the fields. "It was just amazing to go out there and look . . . It continued to be an amazement every morning . . . I was naive and untutored, but I told myself, 'I've never been in a place like this and I'd never seen anything like this, and once I leave here, I'll never see anything like— This is just one of a kind.'"

Periodically Smith flew into rages. "He had a kind of big, bold, wild-man, sweeping dismissal quality that was both intriguing and annoying," Davenport said. She stayed away from the shop. "My fantasy of what Leon [Pratt] thought of me was, 'sleazy college girl sleeping with him.' So I felt uncomfortable being there." The shop "felt like, really, his private turf." On their one trip together to the city, Smith and Davenport stayed

with Frankenthaler and Motherwell. Davenport remembered "making polite conversation" and feeling "overwhelmed." They "were very nice, very gracious . . . I just was feeling kind of dumb, and dumbstruck and awestruck, by the two of them, and was tongue-tied. Also, I had never been in a real fancy New York brownstone. I was blown away."

The February *Vogue* included an article on Smith by Motherwell, clearly written several months earlier. One of Smith's admirers called it a "long love letter," and in its affection and respect, it was. Smith was "not only the sculptor most related to our native Abstract Expressionism, but a major American sculptor of international esteem and influence." He was "a Hoosier from Indiana, and a streak of Paul Bunyan lives on" in him, but so did "a more generalized American trait, that given world enough and time, anything is possible. In his case, he has made a quantity of great sculpture of a size never realized by an individual before nor of such weight."

Like Greenberg in his essay for the 1964 Institute of Contemporary Art catalog, Motherwell made a point of Smith's rejection of a signature style or way of working:

> For some years now during daylight hours, David Smith works on four separate streams of sculptural concepts—painted pieces in which colour is of major importance, stainless steel structures, a series of iron "wagons" with bronze wheels and heavy, welded structures of raw iron. At night, he continues an endless series of drawings ("the delicate pursuit of my life"). These are often nudes from life.

As he had in 1950, in his first writing on Smith, Motherwell evoked Smith's Bolton Landing world:

> It is not an especially comfortable place, especially for women, but on its grounds, like sentinels, stands the greatest permanent one-man show of heroic contemporary sculpture in the Americas . . . It takes an iron will to have made all those weighty iron sculptures strewn about his mountain landscape, each silhouetted against an enormous sky.

Motherwell then formulated one of the enduring Smith characterizations: "Oh, David! You are as delicate as Vivaldi and as strong as a Mack Truck."[15]

While Irving Penn's photographs capture that sculptural domain, his close-up portrait tells a more complicated story. The tip of Smith's nose is red, his mustache is thick, and his mouth is open, almost slobbering. With his left hand, he holds a pipe in his mouth. The joint of his left thumb is knobby, the thumbnail rotting or smashed. The photo oozes deterioration. Lois Orswell said she liked the photo. Dan Budnik didn't. "I never saw fear in his face," Budnik said. "I don't photograph fear."[16] Jean Freas railed at its one-sidedness—"all injury, flesh and eyes, a grieving face, not to be remembered thus."[17]

Noland and Gordon wondered if Smith was slowing down. "He wasn't in great shape," Gordon said. "There was chronic feeling of . . . reaching sixty . . . Ken would comment about the fact that there were physical problems he was having with his urinary tract . . . that some piece of his masculinity was being challenged." Smith continued to write to and receive adulatory letters from young women. Gordon, who would become a psychologist, found Smith troubled. "The complaint was so chronic, about Jeannie and the kids," she said, "that it just felt like a broken record, and that he should get some help."

A National Honor

Not long after returning from Washington, Smith received word that he had been chosen to represent the field of visual artists on the National Council on the Arts, the twenty-four-member advisory body of the newly established National Endowment for the Arts. What company he was in: Leonard Bernstein, Ralph Ellison, Agnes de Mille, Gregory Peck, Richard Rodgers, George Stevens, Isaac Stern! With the NEA's commitment to support artistic creativity of all kinds, including in its most adventurous forms, the Johnson administration, following President Kennedy's lead, signaled that the United States now needed artists. On the eve of his fifty-ninth birthday, Smith was the voice for artists in what would become the greatest experiment in arts policy in the history of the country. Without his achievement, it would have been inconceivable for a sculptor to have been chosen as this voice. "He was really gratified," Stephanie Gordon said, and "thought he could make a difference." Stephen Weil said, "He was so proud of his NEA role. He thought that was a phenomenal recognition that he had received."[1]

Smith completed *Untitled* (*Candida*) on February 23. It has a luxuriant bloom. Given its size—8½ feet wide and 10 feet tall—the sculpture is startlingly flat, little more than an inch or so thick, but the eight heavy stainless-steel plates, each a different size, are welded to one another in such a way as to create an accordion-like sense of overlapping

planes. The burnished plates seem slapped together, not so much welded as glued, and magically light. A bit more than halfway up the construction is an opening roughly the size of another pair of plates that seems to offer a privileged lens into the Bolton Landing hillside, where the sculpture still stands, or a frame through which a pair of special people, his daughters, could look at him.

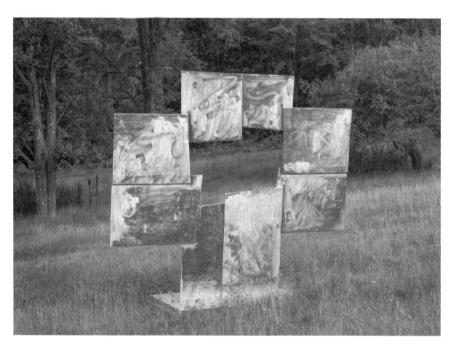

David Smith, *Untitled* (*Candida*), 1965. Stainless steel, 103 × 120 × 31 in. (261.6 × 304.8 × 78.7 cm). The Estate of David Smith, New York.

Cubi XXVII, dated March 5, is Smith's second *Gate*, or "arch." More than 9 feet tall and 7 feet wide, it's constructed with one cylinder and one cube, plus six rectangles and a horizontal form, shaped like a T turned on its side, its long beam parallel to the ground, providing a kind of bench. While *Untitled* (*Candida*) offers an opening to look through, *Cubi XXVII* suggests a portal or threshold to pass through. All of Smith's stainless-steel sculptures interact with their environment, but the *Gates* are differently interactive. *Cubi XXVII* offers a place where people can sit quietly while being performed upon by geometry in action.

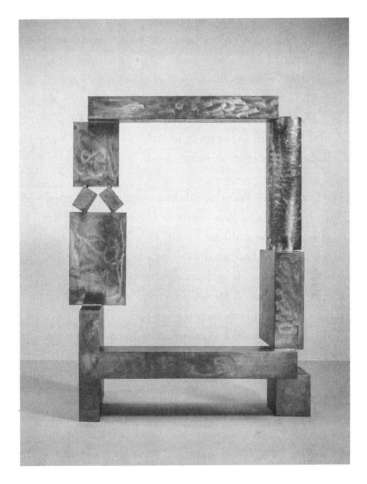

David Smith, *Cubi XXVII*, 1965. Stainless steel, 111⅜ × 87¾ × 34 in.
(282.9 × 222.9 × 86.4 cm). Solomon R. Guggenheim Museum, New York.

Barbara Davenport and Patricia Burns were back at Bennington. "I knew, from the day I took up with him, that I was walking out of there at the end of the [nonresident] term," Davenport said. "I was polite about it but very clear that I would be going back to college. He was a very lonely guy, and as it got closer to the end of the work term, he asked me, 'Would you stay?' And I said, 'No. It won't work for me.'" He asked her to marry him. "I remember a line from a Maureen Dowd column, writing about [Bill] Clinton taking up with his intern, and she wrote, 'He's a man. He'll take the nearest cookie on the plate.' And I just think I was the nearest

cookie on the plate . . . I knew, in one way, I was very important to him. But, on the other, it wasn't me. I just felt like any young, available woman could have stepped in—it was a slot." For Davenport, the age difference was jarring: "Fifty-eight was just so monstrously old for me at that point." Smith "was fat. He had a big gut . . . Twenty-year-old boys don't have that." He was "very vital, but he felt old to me. He was older than my parents, and that kind of sweeping irascibility, and that automatic exercise of what, a decade later, we came to call 'male privilege,' felt . . . 'that's not me.'"[2]

In the span of two years, Smith had asked three women—Jean Rikhoff, Patsy Nichols, and now Barbara Davenport—to marry him. He must have known the unlikelihood of their saying yes, but each rejection pained him and further drove home the finality of his loneliness. He *was* slowing down. He needed eight hours of sleep a night, and by the end of 1964, he was occasionally so tired at day's end that for the first time in his life he regularly had to go to bed early. He was making less work. Ten years earlier, at the University of Indiana, he had assigned his students *Picasso and the Human Comedy: A Suite of 180 Drawings by Picasso*, a book that communicates Picasso's feelings about turning sixty. In contrast with the fullness and naturalness of many young women's bodies, Picasso depicted himself as short, fat, and disfigured; as comical and obscene.

Even in the early 1950s, near the beginning of their relationship, Smith had communicated his dread of sixty to Freas. "It came up many times," Freas said. "He always said . . . that he was going to quit at sixty, because it was too hard on his health—that steel dust and all that—that's very bad, particularly for someone with sinus trouble, the way he had [it]. And it was unheated down there [in the shop]. It was hard. It was very hard." Freas believed that Smith "intended to live to be very old, because he was always going to paint and draw. But in those days, nobody wanted to see his drawings, let alone his paintings . . . That was why he was under such pressure to produce as a sculptor; because he was going definitely to have this cut-off period . . . I don't see how he could have kept on like that, after sixty."[3]

"He had an obsession with this number," Tina Matkovic said. "[He spoke] very frequently about Ernest Hemingway and what a heroic figure

he was; that he was able to end it before he became too old. I think, to some degree, in his mind, this had a sexual connotation—male potency, and 'I might be losing it.'"[4]

In early March, soon after completing *Cubi XXVII*, around the time of his birthday, Smith took off for the Virgin Islands. "Made quick decision no reservation just came down, resting swimming sailing fishing," he wrote to Noland. "A week will cure me."[5] Sam Green, now head of the Institute of Contemporary Art in Philadelphia, ran into him on St. John. He remembered Smith "under a palm tree on the beach," pulling out a flask and a cigar.[6] The day after he returned to New York, Smith visited Dehner's exhibition of sixty small bronze sculptures at the Jewish Museum. "It was great," he wrote to her. "You had so many pieces I thot the latest big looking north"—*Looking North* was the title of a sculpture—"where there was bigger form and less elaboration, best in some ways. You have sure been working hard and prodigiously."[7]

On March 23, on Plaza letterhead, Smith wrote to Cornelia Noland that he was sending drawings to her and Ira Lowe—probably in payment for Lowe's legal work. He was concerned that Freas would prevent him from speaking on the phone with his daughters. He was terrified that he would be cut off from them. On April 1, he wrote Lois Orswell a dispirited letter. He had learned from obituaries in *ArtNews* that two more artist friends, the painters Earl Kerkam and Burgoyne Diller, had died, and he was worried that he was being forgotten by collectors. "Havent heard from you in a long time," he wrote. "What are you collecting. Did you get any more Kirkhams before he died . . . Ive got to quit drinking. I drink too much. Partly out of after hours lonesomeness—I've got to work." He mentioned his upcoming show at the L.A. County Museum of Art and his contribution to an outdoor summer exhibition at the Rodin Museum in Paris.[8]

With her special elegance, Orswell made clear what she thought of him:

> It was so good to have your letter . . . but . . . rather sad too . . . Yes, you do take too much. It is no good reminding you that every swallow shortens your life and makes you just so much less capable of using your great genius. You are just simply

STOOpid to spend a life time developing your genius and
your skill and then throw it away for a little self-pity. You are
not just a "talent" you are a true genius, and probably no one
really knows until you die how big a one. Once you smash it up
you will never be able to go back in time and pick it up again.
Did you see those poor Bowery derelicts on OPEN END? Those
sagging, twitching faces and trembling hands on once good-
looking and clever men who got all soggy with self-pity and re-
sentment against some one else, so this is all they are good for.
YOU ARE A GREAT MAN . . . PLEASE stay that way.

After commenting on Picasso's "explanation of the differences between
Matisse's painting and his," she wrote: "But you are my Great Hero and
I am not likely to change THAT; when I decide you are a great artist you
jolly well better be."[9]

No European museum was interested in a *Voltri* exhibition. The best
Giovanni Carandente could do was show the *Voltris* outside the Mu-
seum of Modern Art in Rome, where he worked. When Smith asked
Frank Lloyd, the head of the Marlborough-Gerson Gallery, to return the
Voltris to the United States, Lloyd told him he would cover only the costs
of shipping the smaller ones. This disheartened Smith. "He was desper-
ate to get those works back to be seen and known in America," Don-
ald McKinney, a Marlborough-Gerson dealer, said.[10] When Smith asked
Carandente to release some of the small *Voltris* to Marlborough Rome,
Carandente felt betrayed. He did not like Marlborough, and Smith had
made him commit not to separate any of the sculptures in the series. He
had not asked Smith for money for storage costs and cleaning rust from
a couple of the sculptures but expected to be paid eventually.

While in Washington for the April 8–10 National Council on the
Arts meetings at the White House, Smith told Cornelia Noland of his
dreams for an arts and artists complex. What he imagined was years
ahead of its time. He intended to use his role on the NEA

to help fellow artists get the scholarships, grants, and purchases
that other officials had long failed to obtain for them. He had
visions of turning the Eighth and G Street areas around the

National Collection of Fine Arts into an artistic mecca. The government would buy and preserve the fine small buildings in several streets surrounding the collection, leasing them out at low rentals for studios, coffeehouses, artists' bars, and many galleries—one for unknown artists, one for art faculties from universities, and so on.[11]

The second National Council meeting was scheduled for late June. Each member was assigned a topic. Smith's was "the sculptor in today's society." He agreed to be part of a four-member subcommittee on cultural inventory that would meet in New York on May 27.

On the National Council and in the studio, Smith was lucid. He had loyal friends. He continued to receive admiring and sometimes adoring letters from young women with whom he remained in contact after their visits to Bolton Landing or after meeting them here or there. In response to his check and accompanying note after she had completed her winter nonresidency term at Bolton Landing, Patricia Burns expressed the "fascination" and "importance . . . of being with you and in your environment the last few months. The extraordinary person you are, the things you choose to surround yourself with—the warmth and generosity, together with a lovely egocentrism all these things with still always an element indefinable—I can only say it was unique—I shall never forget it."[12] After Beverly Pepper visited Bolton Landing at the end of April, she wrote to him, "I wanted to call before I left [the country] to tell you how much it meant to me to spend the day—the quality of your work—your way of life—and the fun." Her family had a place in Todi, in Italian hill country. She and Smith spoke about exchanging some land there for his girls for land in Bolton Landing for hers. "We have some natural gas on our land—so it may be not only a delightful landscape—but profitable as well," Pepper wrote.[13]

But increasingly he could make a fool of himself. He and Barbara Davenport went to a party at Noland's. "[Ken] had a studio that looked like a barn," Davenport remembered. "As you drove up, on the outside, it had a sign put out by some chicken-feed—some feed company—that said, 'Lay or bust.' . . . I always found Ken offensive and lecherous." She was dancing, "shimmying and shaking with some other male guest."

When she sat down with this younger man and put her head in his lap, Smith lost it. What he said "was angry and it was loud . . . I'm not at all proud of my behavior that elicited it, but, 'Geez, fella. Could you lighten up a little?'"

Around that time, Frances Herman visited Smith with her husband, Evans. She recalled:

> He had invited us to come over after dinner sometimes and have a drink and listen to music and one of the pretty Bennington girls was there, and we arrived at about the right time, and he was chasing her around the house, and we left. He had forgotten that we were coming . . . He was very punctilious in dealing with the men who worked for him, or anybody who came to do a service [but now] he wasn't being as meticulous. [His behavior was] a little bit sad.[14]

The last time Davenport saw Smith was in Bolton Landing on a Sunday afternoon in late April. There was tension when it came time for her to leave: "We were quarreling, and he was so pissed he wasn't even going to take me to the bus station. He called a cab, the cab came, and I just said goodbye."[15]

For Smith, the unbearable emotion was shame. Now girls, young women, and mature women were scolding him. In Bennington, where he was a hero, he humiliated himself. On May 5, he wrote to Gloria Gil: "With due consideration hold off recommending me for that trusteeship. I've got a certain embarrassment to get over—(Noland party)."[16]

Gil wrote to Smith, "I don't know which Noland party you mean. There are so many of them." She was planning her own party on May 12 just prior to his lecture at Bennington: "Party for you—Wed cocktails 5 to 7—I am prepared to feed the remnants of the party and have you sober and sincere by 8. Remember the time I got you slightly plastered and you got your notes mixed up—suggestion—use a tela prompter [sic] like Eisenhower."[17]

Smith welded "May 5" onto his third *Cubi Gate*, his last sculpture. *Cubi XXVIII* is another open portal stainless-steel structure composed of rectangles, cubes, and cylinders but it is not as hospitable as *Cubi*

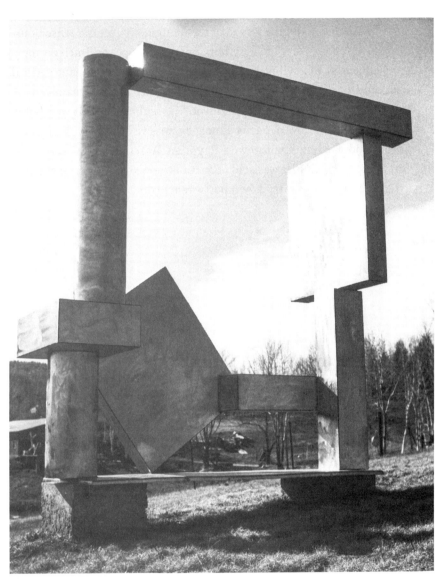

David Smith, *Cubi XXVIII*, 1965. Stainless steel, 108 × 110 × 45 in.
(274.3 × 279.4 × 114.3 cm). Broad Museum, Los Angeles.

XXVII. A large upright diamond blocks part of the opening. The geometry seems to tip, turn, lift, revolve, fire. The sculpture offers a place for one person to sit, but the wedge of the diamond prevents a sense of unimpeded repose. That the long horizontal rectangle, or lintel, on top is not affixed to the cylindrical post that is the most dominant vertical, but only touches it, gives the sculpture a heightened and dynamic provisionality. It is an unsettled monument. The sculpture is this way, but its desire to be other ways seems almost aggressive. This *Cubi* joins Mondrian and Analytic Cubism with Egyptian, Assyrian, and Cretan gates. In 2005, *Cubi XXVIII* was sold at auction for $23.8 million, at the time the highest price ever paid for a postwar artwork.

72
May

At Gloria Gil's May 12 party, Smith got drunk. He was in no shape to drive to his talk, so Gil drove him. "He got all washed up," she said. "He put on cologne, and he said, 'How do I look?' and I said, 'You look gorgeous. Come on, let's go . . .' He forgot his notes completely. He spoke extemporaneously, but it was the most exciting talk . . . He had his slides. He talked . . . to the students as though they were fellow artists . . . He would discuss every piece in a workmanlike way."[1]

Smith began with the *Cubis*: "I've made three sculptures in the form of gates, and this is the next to the last one . . . It's kind of big and heavy, and I couldn't move it out to a better location, but I guess you can see the stainless steel form of just an arch." While he showed images of the *Zigs*, *Menands*, and *Primo Pianos*, and of *Becca*, a pendant to *Untitled (Candida)*, which he had finished twelve days earlier, he was preoccupied with the *Cubis*: "I think I am about number 28 now, in this group. . . . Every time I do four or five I think I've exhausted my thinking in that way, but then I buy more stainless steel and make more sculptures. But I hope it finishes off pretty soon."

Smith discussed his distinctively sequential and labor-intensive process of painting the *Zigs*, one closer to the paintings of Willem de Kooning and Philip Guston than to any other sculpture.

He showed slides of old tractors acquired for him by a "former pro-
fessor at Bennington"—surely Eugene Goossen—and described one of
the fabulous dreams with which he inspired others and willed a sense
of expectancy for himself: "I'm going to make them into sculptures—
I'm going to make the sculptures on top of them so that I can drive the
tractors."

He ended the Q&A on a hopeful note: "There are a lot of things yet to
be done. Nothing is closed—everything is open."[2]

Smith spent much of the next week preparing for visitors. Cleve Gray
and his wife, Francine du Plessix Gray, who would become an acclaimed
writer; their two sons, Thaddeus and Luke; and Alexander Liberman, ab-
stract sculptor, noted artists' photographer, editorial director of *Vogue*,
and husband of Francine's mother, Tatiana, arrived from Connecticut
in one car on Saturday, May 15. Frankenthaler, Motherwell, and Liber-
man's houseguests, the Italian dealer Beatrice Monti della Corte and the
Italian sculptor Andrea Cascella, were in a second car, which arrived a
bit later. "We pressed the Motherwells to ask us up," Cleve Gray said. "I
never was a big fan of [Smith's] work at that time, the way I am now . . .
But he was so big in their lives, and we were very friendly with them. We
felt we didn't know him and we wanted to know him, because they said
how wonderful he was."[3]

Smith pulled out all the stops. His house looked orderly and spotless.
He had gone to Albany and who knows where else to gather the ingre-
dients for a feast in the mountains that his guests would not forget. The
cheese and blanc de blancs were bought, but Smith's beloved watercress
was homegrown, and he picked the asparagus and fried it, Chinese-style.
"[That's] where I first learned to do stir-fried asparagus," Francine Gray
said.[4] He deviled the eggs and "exquisitely baked" the sole "in wine and
herbs." He smoked the two turkeys. The food was abundant, the meal
distinct, and Smith was at once host, chef, and server.

Liberman photographed Smith in the house, shop, fields, and paint-
ing studio. Gray noted the multiplicity of attitudes and styles: "Nudes
crouching, lying, standing, contorted or at ease, fat or thin, ranging
from the classical and realistic to the expressionist and abstract, but all
defined by a highly charged, bounding line that was tense, excited, im-
petuous, violent and destructive. They were attacks on womanhood."

Smith was "delighted with the fact that there were so many female nudes surrounding him; he joked like a schoolboy," Gray wrote. "Out on the terrace, he took a long look at Francine and said: 'You're the THINNEST broad I've ever had in my house!'"

The visitors were awed by the fields. "We were all, like children in Disneyland, gaping at the pageantry outside," Gray wrote. "Rank upon rank of these behemoths were massed down the grassy slopes to Lake George. He called the place his 'sculpture farm.' He knew how astonishing the sight was to us and enjoyed our exclamations, the amazement of our first visit."

Frankenthaler asked for a ride on Smith's new red Honda trail bike. Motherwell tried to stop her. "No, Helen, it's madness!" but, Gray wrote, she "was already being driven off, clutching David's back, up the hill and between his sculptures. We saw Helen make a graceful arc through the air and David and his motorcycle collapse seconds later. Everyone laughed with relief as Helen walked back and David put the motorcycle away. 'I've fallen off seven or eight times already,' David confessed."

"You don't know how happy I am that you are all here," Smith told them. "It's the nights I mind. I work all day and it's fine, but at night it's such an effort to get dressed and go to town that I just stay here. I mix myself a couple of drinks, make my dinner and go to bed. I watch the television set in front of the bed and often fall asleep that way . . . Sometimes I go down to a bar in town, and if I drink too much, I call up the state troopers, and they bring me home. It hasn't happened very often—only two or three times."[5]

While Cleve Gray found him "so warm, and giving, being the perfect host, jolly. Oh, he was absolutely wonderful,"[6] to Beatrice Monti he was "upset" and "nervous." He expressed two worries so insistently that she referred to them as "neuroses." He was afraid of fire. For her, the house was like "a bunker . . . It's not what you would imagine a place in the country could be, even for a sculptor . . . He kept saying, 'It's fireproof.'" His other worry was Marlborough:

> He wanted to get rid of them . . . So he said, "If you give me twenty-five thousand dollars"—I remember that number anyway—"I can repay that crook"—he said exactly that—"and

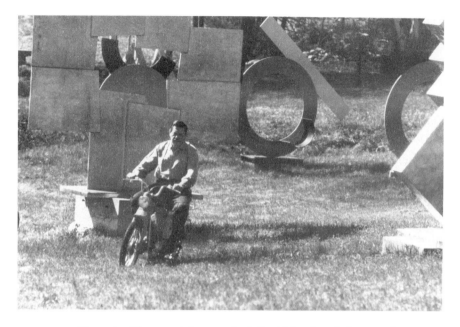

Alexander Liberman (photographer), David Smith in Bolton Landing,
New York, 1965. Getty Research Institute, Los Angeles.

be a free man again." He said it again and again. I said, "I
don't know where to find twenty-five thousand dollars." That
was a lot of money at that time . . .

We all hated the Marlborough Gallery, because the Marl-
borough, first of all, was not a gallery in the sense that I was, or
Betty [Parsons] was; it was a place which was very com-
mercial . . . and it was a great corruption for the artist . . . If
they would join the Marlborough, under false pretense, they
would say, "We'll give you a two-museum exhibition in four
years . . . And you'll become a major artist there" . . . And they
would . . . just do nothing for the artist except for giving them
a bunch of dollars.

Monti was enthralled by one of Smith's *Wagons*: "'I don't know what
I would give to have this piece,' I told him. He said, 'It's very simple. Let
the other ones go away, stay here two or three days, it's yours.'"[7]
President Johnson's letter of appointment to the National Council

was pinned to the door of Smith's daughters' bedroom, along with photographs of and letters from them. Smith told his guests that he would make two proposals at the next council meeting. The first would be each year "to have five or ten of the best artists chosen" and given "a good sum of money to use in whatever way they want." The second would be to choose several hundred younger artists, under thirty-five, "and give them a sum of money to complete their studies and to buy whatever materials they might need . . . You know I'm a Socialist," Smith said.

Smith did not want his guests to leave. As he waved goodbye he said, "The party's just getting going."[8]

Of the dozens of photographs Liberman took, the one that has been most frequently reproduced is of Smith standing in front of his woodstove with the tribal and folk objects visible on the two walls behind it. He is dressed casually in a whitish striped shirt open at the collar and light-colored pants. He holds a glass of champagne in his right hand. His left hand is extended, palm up, as if welcoming everyone into his house. In some photographs, he looks tired but animated, even happy. In others, however, he looks appalling: his eyes are glassy, his bloatedness communicates dissipation, and he appears lost.

Smith spent the next few days crating sculptures and preparing them for shipping. He and Noland spoke by phone. Noland and Gordon had recently returned from his shows in London and at the Fogg Art Museum. Smith was depressed. "He was thinking about his girls—his daughters," Noland remembered, "and we said, 'Well, why don't you come over and see us?' And he said, 'I can't. I've got to do this work.' So I said, 'Well, all right, we'll drive over and see you.'"[9] They spent the night in Bolton Landing and encouraged him to spend the weekend with them. There would be many people he knew at Noland's house, and Sunday evening the Bennington art community would attend the painter Sophia Healy's opening and then a party at Susan Crile's. Smith put the motorbike in the back of his truck and drove over.

On the evening of Saturday, May 22, Smith and Anthony Caro spoke. That was "the only time he spoke to me really," Caro said. Smith said that he'd die without a woman sleeping next to him. He said that he had asked girls to spend the night with him, without sex, so he would not have to spend the night alone.[10]

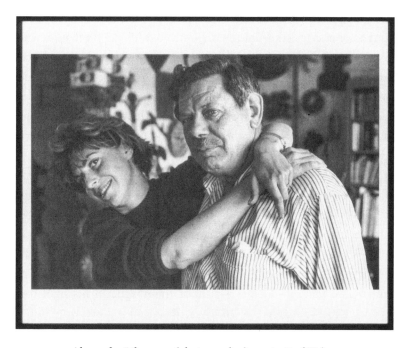

Alexander Liberman (photographer), portrait of Helen
Frankenthaler and David Smith, Print 51, 1965, Bolton Landing,
New York. Getty Research Institute, Los Angeles.

The next morning, Smith visited Gloria Gil. "We always looked at
each other's garden," she said. "He looked at what I had growing there
and said he wanted some of whatever it was." She dug up the vegetables
or flowers and gave them to him. He mentioned financial concerns, tell-
ing her that he hadn't sold a sculpture in more than a year.

At Noland's, Smith invited friends to ride his trail bike. Olitski did
and "fell in love with it." Noland rode it, too. "I had gone back up around
this hill," he said, "back in the woods, made a circle and came back
down, on a different path." Then Smith decided to take "it for a spin."
Noland said, "I told him that when he got up in the woods that there
was a fork in the road (a cliché right?), that he should take the left fork."
But when Smith got to the fork, he disregarded Noland's directions: "He
made the right turn [and ran into] a barbed-wire fence across the trail,
at the property line . . . He cut a big gash [in his right forearm]. He came
back, and went to the sink and started washing it off and he said, 'Oh,

it'll be all right and so on.' I said, 'No, you've got to go to a doctor' . . . He didn't want to go, but he went."

Dr. Elizabeth C. Faris was on call that day in her and her husband Arthur S. Faris's family practice office in Shaftsbury. She remembered:

> I recall it as a beautiful day . . . There were two gentlemen in the waiting room, neither in acute distress. They told me of the motorcycle accident ending in a barbed-wire fence and said they wanted me to see the injury to his arm and to help control the minimal bleeding at the time.
>
> The arm was covered with open bleeding lacerations of various depth. Most were superficial, but the longest were deep into the muscle. It was obviously in need of repair to prevent a long slow healing.
>
> Ken, whom I had met before but didn't know well . . . introduced me to David Smith, the reluctant patient . . .
>
> Their manner was a little strained and it appeared that they had had a comfortable amount of alcohol to relax. I started to assemble the needs for suturing and cleaning the wounds. David became the macho man and . . . repeated several times that it didn't matter and would be fine. I said if I were the one who took care of the injuries I had to do it properly or I would refer him . . . I remember his surrender to my insistence: "All right, little girl, have it your way."
>
> The arm was badly cut; one deep cut went from the hand almost to the shoulder; and the session was long and hot . . . Both men had a good sense of humor and the time spent was enjoyable. I was proud of my repair and felt that he would of course have a scar but the wound would heal cleanly. Perhaps I got a few whiffs from their cocktail party. I have no idea what we discussed over the more than two hours, but it was friendly and David made no complaints. We set a time for me to see him the next day.[11]

After they left the office, Noland and Smith fished for trout in Noland's pond and Smith caught a fishhook in his finger. "They came in the

house about that," Stephanie Gordon said. "So there were already two accidents . . . I spent a total, alone with him, of twenty minutes. Again, it was the talk of Jeannie." Smith anticipated a court ruling on Monday, May 24, and feared losing and having to pay more money. According to the lawyer William Bacas, when the ruling came down, it turned out in Smith's favor.[12]

Olitski recalled a conversation with Smith that same day:

> David made some harsh remarks about certain artists—I won't name names—and how they were fearful, and he spoke about his dying, most likely before me—he being older—and what I had to do after his death, at which point, I said, "What a lot of bullshit" . . . I was about to get in my microbus when David called me over to his van. He was standing there with a big box of Havana cigars . . . He opened the box. There were two big cigars and he gave them to me, saying, "These are the last ones." He also handed me the large wooden separation from the box. "Do a spray painting on this for me." I said I would. I drove off.[13]

The last three people at the house were Smith, Noland, and Gordon. Noland had recently bought a Lotus Elan, a snazzy two-seater convertible sports car. Smith asked Gordon to ride with him in his truck. She was sitting in the passenger seat with the door open when Noland pulled his Lotus around and said to her: "Ride with me." She switched vehicles, and they drove to the opening.[14]

It was 8:45. Dusk. Smith descended the long driveway. Less than a quarter of a mile from Noland's property, on East Street, he sped up a slight incline that became uneven on the descent, not dramatically so, but driving fast, it would have been easy to lose control. The *Bennington Banner* reported the accident this way: "[Smith's] 1965 Dodge truck went out of control on a curve, careened off an embankment on the right side of the road, went across the road, and into a ditch and came to a stop after colliding with some trees and a power pole."[15]

When they did not see Smith behind them, Noland and Gordon drove back to look for him. By now it was dark. "As we got to the intersection on

Route #7, going across, we saw blinking red lights and something going on beyond, on the other side of the road, at kind of the foot of this hill," Noland said. "We both knew something had happened. So as we got closer I stopped. I couldn't go any further because I was really afraid." Gordon asked the police what had happened. The Bennington Rescue Squad had taken Smith to Bennington's Putnam Memorial Hospital, where Gordon and Noland saw him, unconscious but not bleeding. At 10:23, the hospital called the police department in Troy, New York, requesting a police escort to drive Smith to Albany Medical Center. Dr. Faris received a call from the hospital. The caller, she remembered, said that Smith "was in the ER following an auto accident, and was being stabilized to go to the neurosurgical unit at the Albany hospital. The hospital and rescue squad were upset because there had been a delay in the time of the call and his getting to the ER. This was caused by confusion of East Street and East Road."[16]

Noland and Gordon, and Caro and Olitski, drove to Albany. Noland called Frankenthaler and Motherwell, who raced upstate in their Mercedes. When the ambulance carrying Smith arrived at Albany Medical Center, he was dead.

His death was shocking. "It was horrible. It was overwhelming," Noland said. "It was terrible," Caro said.[17] He told the Motherwells. "Helen was crying," Caro said, and "Bob was comforting her." Olitski's response to the death was to retreat into his studio: "I was there, I think, for at least a week. I wouldn't leave the studio. I wouldn't go teach. I wouldn't speak to anybody. I just sat there in that studio. I didn't do a damn thing. I was numb. I just could not speak."[18]

"In many ways we'll never recover from the shock of losing him," Frankenthaler wrote to Dore Ashton and her husband, the painter Adja Yunkers, three weeks after Smith's death. "We think of him at every turn; realizing how much we counted on sharing so many thoughts and events with him. He was so much there—taking up space and time in all his generous expansive ways—his liveliness, patience, humour filled our house; now so dead, gone. Bob and I have never shared a loss so deeply, and it has changed our lives separately and together."[19]

Dan Budnik said, "It was like a giant redwood tree, the biggest redwood tree in the forest, being felled . . . You don't believe that's possible.

You don't believe something that great can fall, and here was someone who I would say was our greatest modern sculptor, and suddenly he's gone." Budnik called Herman Cherry, "and he lost it completely, which resulted in my losing it, too."[20]

The chief cause of death was given as "Fractured Skull." The report also listed "Lacerations Knees, Legs, Accident, Automobile." Smith never used a seat belt. Legend has it that he was killed by a sculpture he was transporting in his truck. The loose steel plates in the truck were not sculpture. There's no surviving documentation about which part of Smith's skull was fractured, or whether it was by glass or metal. Motherwell would write that Smith's "beautiful head was crushed against the cargo guardrail" but it's unclear if there was a guardrail separating the front and back of the truck.[21] Since Smith's face showed no signs of damage and Noland remembered signs of injury near the crown of his head, toward the back, the fracture may well have been caused by metal.

Noland remained at the Albany Medical Center making calls. He called young women who adored Smith, like Stephanie Rose. He called Cornelia Noland, who called Ira Lowe. He called Jean Freas.

"I remember standing over the sink, and answering the phone, and it was Ken, and I was so shocked," Freas said. She had just returned from a party in New York, and the girls were still with her parents. She and Noland spoke "for the longest time, like an hour . . . I remember his telling me what had happened. I had kind of a very fraught relationship with Ken. For one thing, after I moved to Washington . . . he had come on to me, [but] I just had to talk to somebody. And he answered. If I had asked him, 'What was his last meal,' he would have told me. He told me everything he could think of. And I'd say, 'Now say it again.' And I got all mixed up . . . He was really nice and he was really patient . . . Then I must have wakened my mother, because I had to tell her. I didn't tell the girls. I couldn't tell them. I was so shocked. I was so . . . shocked . . . I just couldn't."

The next morning she told them. She recalled:

> It was terrible. It was agonizing . . . They both were just so, so shocked. And Becca started to cry. She cried non-stop for three days. She must have dozed off to sleep sometimes, but

you could hear her. You could hear her outdoors. She was just wailing, and wailing, and wailing, and wailing. And in this time, Dida went across the street . . . to this family we were very close to, the divorced mother and two kids. The kids and my kids were best friends. She told them, and my friend, the mother, thought she said "my mother," not "my father." So she came running across the street.[22]

Dida remembered:

We were spending the night at my grandparents' house and there were phone calls in the night. I was having a lot of very violent nightmares, about very scary faces peering in at me and stuff— distorted and ghoulish faces, peering down . . . We got up and my mother was there . . . We got up and got dressed, and were heading back to our house, and we were saying how that summer my father was going to take us to see the Beatles at D.C. Stadium . . . My mother sat us down and she said we weren't going to go to school right away. She sat us down on the sofa, and she told us. I went into instant hiding, inside myself, and knew I had to handle the situation, so my feeling was, so nobody else would die.[23]

Opinion is divided on whether Smith's death was a suicide. Many people who knew him believed he never would have killed himself. He was a life force, and life forces don't take their lives. "He wouldn't have committed suicide," Ira Lowe said. "He had too much zest."[24] Caro felt the *Cubi Gates* were fresh and vital works and understood one of Smith's messages in his Bennington talk to be that he was at a new beginning.[25] Smith drove fast, Freas said, but "wasn't such a maniac driver . . . or so drunk or out of sorts or whatever" that he would not know what he was doing. She believed that his arm hurt and that he looked at it, "and that's all the time it took, for him to . . . take his eyes off the road. And that's when it happened. I know there are those who believe it was suicide. I think that's a lot of baloney."[26]

Dehner, however, told an interviewer that she believed that Smith's

death was a suicide.[27] In 1971, Motherwell declared: "[Smith] killed him-self in his truck."[28]

Dr. Faris believed that Smith was suicidal:

> My memory of the day is so clear because I knew that I had not made the full diagnosis not "lacerations of right arm from barbed wire" but, "attempted suicide." His words came back to me all evening. "It doesn't matter, it will be all right." His calmness was typical of a depressed person who had reached that decision. While I was suturing he was preparing how to do a better job the next time.[29]

While it is impossible to know what was going on in Smith's mind as he left Noland's house, and unlikely that he consciously decided to smash his panel truck into trees and a telephone pole, it is clear that on the evening of May 23, 1965, he was in a perilous state. His sculptural imagination was still intact, and he looked forward to his first museum show on the West Coast later in the year, but he was less productive, and he could no longer count on his legendary capacity for work to channel his energies and structure his life. He was despondent, alcoholic, and desperately lonely. All week he had been, in Noland's word, "disasso-ciated." No work of his had sold in recent months, he owed Marlbor-ough thousands of dollars, his beloved *Voltris* were still in Italy, and he feared he would have to pay more to Freas. On his last day, he had two accidents before the fatal one and let friends know that he believed his days were numbered. When he drove off for the gallery opening, he had been not only drinking and taking painkillers but perhaps also smoking pot. To this day, members of the Bennington art community have not forgiven Noland for allowing Smith to drive to the opening by himself. Even though Smith was revered as a transformative artist, an American icon, the sense of disapproval and misfittedness that he had felt since childhood, and that had been a source of great purpose and power in his work, had become corrosive and he could not slow his deterioration. Gordon believes that if she had ridden with him, it would not have made a difference: "I could never change the way either David or Ken drove." She believes that Noland saved her life. "I think David's judgment was

particularly impaired that day by his depression, medication, and alcohol," she said.[30] Given his affection for her, it's possible that if she had ridden with him, he would have arrived at the opening without incident. Even if he had, however, his situation seemed to him hopeless.

From the time he began making art, Smith, like other great modernists, had been obsessed with survival. Working with steel he made sculpture that would be hard to destroy. With the acclaim he had received, and with his magnificent fields, he knew that his work would have a secure place both in art history and in the American cultural imaginary. He also knew that with his work he had provided for his daughters. He did not need to make more work to prove himself. Anne Truitt believed that Smith knew what he had accomplished. "He knew he was a great artist," she said.[31]

Smith's body was taken to Stafford's Funeral Home in Lake George Village, ten miles from Bolton Landing. When Freas went to visit, the director asked if she wanted to be alone with him. She recalled:

> I just had to look at his arm, myself. I remember the expression on his face. It was, like, a very hostile expression, and—honest to god—he still looked like he had great vitality . . . And I looked at his arm, and it had stitches in it . . . I didn't look at the back of his head, because it never occurred to me that anything had happened to the back of his head. But I did want to see . . . his arm—I don't know why, when I think back on it—I knew that arm hadn't killed him, but why did I want to see that? . . . I knew exactly which arm I was going to look at, because I looked at it, then I pulled the sleeve down.[32]

Olitski, too, saw Smith in the casket. "This huge man, and there he was. It was unbearable."

The memorial was organized quickly, almost "frantically," Stephen Weil said, "by committee." Weil, Frank O'Hara, and Jimmy Rosati were instrumental in putting it together.[33]

May 26 was a glorious spring day. The town shut down for an hour while the memorial was taking place in Rogers Park, by the dock on which Smith had photographed his work and been photographed by Dan Budnik peering down into the water as if the secret of life were waiting

there. Hundreds of people attended, sitting in chairs but also standing and sitting on rocks and wherever else they wanted to be present. Villagers and the New York art world, which Smith had kept largely apart, were together en masse. "There were so many people," Jean Rikhoff said. "Everybody from Bolton, even the ones who didn't vote for him, turned out. And it was just so appropriate. You could see the lake behind—that's the best funeral I've ever been at."[34]

Freas, Becca, and Dida were there. So were Dan Budnik, Anthony Caro, Herman Cherry, Eugene Goossen, Stephanie Gordon, Frank Lloyd, Tina Matkovic, Barnett Newman, Kenneth Noland, Frank O'Hara, Jules Olitski, Edith and George Rickey, Stephanie Rose, and Londa Weisman. Freas and Helen Frankenthaler went off by themselves to talk. Gloria Gil drove a carload of Smith's "widows" from Bennington. The music was Bach. "They played his favorite quartets," Alfred Leslie said. "It was devastating."[35]

Clement Greenberg was in Europe. "There was some anger there," Caro remembered of Greenberg's response to Smith's death.[36] "The main thing he said [afterward] was that David was stupid—which I thought was in pretty bad [taste]," the painter Vincent Longo said.[37]

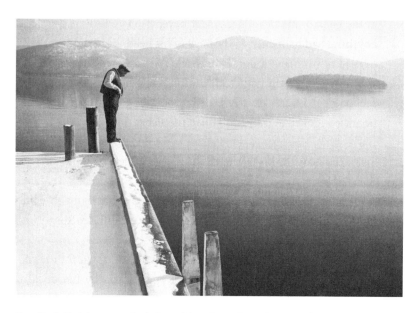

Dan Budnik (photographer), David Smith on the Bolton Landing dock, ca. 1963.

Dehner said she was not well and did not come, but friends reported to her in detail about the event. The eighty-four-year-old Golda did not make the trip from Ohio, but Smith's sister, Catherine, and her husband, Frosty Stewart, who had last seen Smith in 1958, did.

Stanley Young, representing President Johnson and the National Council on the Arts, read a statement from the president to Smith's family: "Through his untimely death our nation has been deprived of an illustrious artist whose generosity of spirit, creative genius and genuine desire to preserve and enhance America's natural beauty won him the respect and admiration of people everywhere."

Speaking of Smith's "drive" and "fire," a visibly shaken Robert Motherwell quoted from a 1960 talk: "Creative art has a better chance of developing from coarseness and courage than from culture."

The most eloquent words were those of Rosati:

> The measure of David Smith was a sum total of himself. Each effort was more demanding than the last. This, of course, became more and more apparent, and it was difficult at times for those around him to cope. Everything about him became gigantic: his sculptures, his working arena, his emotional life—all had to satisfy that insatiable measure.
>
> I remember once, in my studio, David was questioning the value of his efforts in art as well as in his personal life; why did it all seem so unrewarding? I reminded him that his needs "absorb most of the oxygen in the room and leave so little for the others" and that his demands were simply too strong for others to live up to. He answered, "Hell, I can't change now; the oak is too firmly formed. To bend it would mean to break it" . . .
>
> David understood and acknowledged the position he had attained in American art. He fully and proudly accepted the responsibilities. If he ranted and roared at times, that was his measure, too. And when he did, it was usually in defense of what he felt was some attack against artists. He was first and above all for the artist. And he demanded equal respect for sculpture. He used to say, "No more of this second cousin business" . . .
>
> David did not, as is so often claimed in the popular press,

make sculpture as an "American," or "big, strong, rough," etc. It is simply that Smith's measure became American sculpture.[38]

After the memorial, many of Smith's friends gathered in a bar, as they felt he would have wanted them to. "People were getting drunk, and crying, and telling stories about David," Barbara Davenport said. "It was a wonderful wake."[39] The sculptor George Rickey and his wife, Edith, were among those who made their way up the hill to reflect on the fields.

A number of friends spent the night in Smith's house. Noland stayed in the girls' room. Leon Pratt slept in Smith's bed. Stephanie Rose remembered Budnik sprawled out like a stiff on the refectory table, although Tina Matkovic does not remember Budnik there and said that it was she who slept, passed out, on the table. Rose slept in a green chair. Other artists, perhaps the painter Friedel Dzubas, may have slept in the house as well.[40]

Smith was cremated. A couple of years later, Freas asked Leon Pratt to weld a box for the ashes.[41] Pratt also made a plaque the size of a conventional tombstone and on it welded Smith's name and dates. Becca wrote that his "ashes were buried in the woods in a clear spot under big trees at the bottom of the little mountain he called 'Mt. Sinus'—named for his deviated septum."[42] It was from that spot that Smith and his daughters began the climb to their "picnic rock." On the other side of the old tall trees, visible through them in winter, was the sculptural expectancy of the south field.

Afterword

The exhibition of twelve *Cubis* and two *Zigs* that opened at the Los Angeles County Museum of Art in the fall of 1965 was now a memorial one. The Smith exhibition of nearly fifty sculptures that began touring Europe in spring 1966, selected by Frank O'Hara and prepared under the auspices of the International Council of the Museum of Modern Art, was now also in memoriam. "David Smith: 1906–1965," which opened at Harvard's Fogg Art Museum in the fall of 1966, was conceived as a memorial exhibition. The curator, Jane Harrison Cone, had been introduced to Smith and his work less than three years earlier. Her exhibition was small, only twenty-one sculptures, but extensively researched and the first museum show to emphasize the importance of Smith's series. Cone provided a substantial bibliography and, with the help of Margaret Paul, assembled a "handlist" of 544 Smith sculptures, preparing the way for the Smith sculpture catalogue raisonné that was completed in 1977 by Rosalind Krauss, Cone's grad school classmate at Harvard, whose enthusiasm for Smith began with this show.[1]

O'Hara and Herman Cherry discussed memorial publications. "What I suggested to Frank," Cherry wrote to Kenneth Noland, "was a book with photos by Dan Budnik (he has hundreds that have never been used), and a short statement from as many friends as was needed. The statement would be simple—some experience or other that would give a detail of

David's life. The whole would then come together as a picture. What do you think of the idea?" The book would include statements from "some of the local people closest to him . . . After all he spent a greater part of his life there."[2]

Cherry's idea foreshadowed the powerful tribute to Smith in the January–February 1966 issue of *Art in America*. On the cover was a Budnik photograph of a parade of Smith sculptures in the snow—painted and unpainted, open and closed, gesticulating and contained. (See Figure 15 in the insert.) In the twenty-six-page Smith section, Dorothy Dehner and Marian Willard recounted "First Meetings" with Smith, and Cleve Gray the "Last Visit" to Bolton Landing the weekend before Smith's death. The section, edited by Gray, includes statements by Smith as well as ones about him by Cherry, Motherwell, Noland, Rosati, and Kramer. Photographs by Budnik and Ugo Mulas evoke the labor and poetry of Smith's work and the solitude and reverie of his mountain life. Greenberg, described by the magazine as Smith's "official critic," provided commentaries on eleven sculptures made after 1960, each accompanied by a Budnik or Mulas photograph of that sculpture outdoors. Greenberg remarked on the work's "unevenness and sprawl . . . its bewildering diversity." It "remains open, unfinished. No amount of classifying or cataloguing, or art-historical or art-critical scrutiny, will ever change that for me."[3] (See Figure 16 in the insert.)

The *Art in America* tribute led to the publication, in 1968, of *David Smith by David Smith*, a 175-page book in which Cleve Gray interspersed Smith's statements on his life and work—and on color, vision, and dreams—with his photographs of his sculpture and his world. Published by Holt, Rinehart and Winston, the book remained in print for roughly twenty-five years and inspired widespread admiration, even love, for Smith. In the words of Christopher Lyon, editor of the 2021 David Smith catalogue raisonné, in an essay on the critical reception of Smith, it is "one of the most successful illustrated books on a contemporary American artist ever made."[4]

Clement Greenberg was now widely assumed to be the authoritative critical voice on whom Smith's work depended. Not only had his support for Smith been sustained over two decades, but he was the critic chosen by Smith to serve as executor and trustee of his estate. Becca and Dida

were Smith's heirs, but they would not take ownership of the estate until they turned twenty-five, which in Becca's case was not until 1979. After Smith's death, everything he owned went into a trust. The will gave the three executors, who were also its trustees, pretty much carte blanche to do what they wished. Ira Lowe looked after the legal affairs. He led the successful suit against the Internal Revenue Service when in 1969 the IRS suddenly doubled the value of the estate and declared that it had a tax deficiency of more than $2 million.[5] Robert Motherwell, the third executor/trustee, had a fine instinct for what would serve Smith's work: he encouraged Gray's book and suggested removing the sculptures from the fields and putting them in a warehouse, where they would be protected. But he was reluctant to risk conflict with Greenberg, who had written about his work, or with the Marlborough-Gerson Gallery, which represented him as well as Smith. Although the will required a two-thirds majority on executorial actions, Lowe and Motherwell let Greenberg know early on that pretty much all decisions regarding the selling, exhibiting, and conserving of Smith's work were in his hands.

It was Greenberg who worked with Marlborough, who arranged for Smith's archives to be made available to Cone and other scholars, and who communicated with Edward Fry as he prepared his landmark 1969 Smith exhibition—nearly a hundred sculptures—at the Guggenheim Museum. Greenberg was the only one of the three executors/trustees to regularly visit Bolton Landing, the only one to make himself available to potential buyers who were interested in seeing Smith's sculpture where it was made. It was he who negotiated the sale of thirteen Smith sculptures to the Storm King Art Center, ensuring that some Smith sculptures would continue to be experienced in the hills of New York State, albeit in a landscape far tamer than that at Bolton Landing. It was he who in 1966 invited Noland to make sculptures in Bolton Landing with Smith's stainless steel, with the welding assistance of Leon Pratt, and it was he who sold to Noland much of Smith's scrap heap. Whether it was from Greenberg or Noland, Caro also acquired metal from the scrap heap and Smith's stainless steel, which he had shipped to London, where some of it would enter his work. Working in Caro's London studio in 1972, Helen Frankenthaler would incorporate Smith's metal scraps into her experiments with sculpture. Both she and Caro constructed tributes to Smith.[6]

Largely because of Greenberg, the trustees brought a substantial amount of money into the estate and many sculptures wound up in important private collections and museums. During Smith's lifetime, only around eighty of his sculptures were sold, earning him a total of around $100,000 between 1940 and 1963; in 1963 and 1964 alone, from sales by Marlborough, he made $108,000. Between 1965 and 1970, around two hundred Smiths were sold. By 1968, Smith's sculpture had brought in more than $2 million.[7] As Robert Hughes wrote in *Time* in 1974: "With one-half of the legacy sold, the estate has already netted an estimated $4.5 million."[8]

Yet the trustees never did a professional inventory or developed a long-term business plan. There is no indication that they discussed how to develop Smith's reputation in Europe, where he had been increasingly interested in having his work shown. Although they brought in Ugo Mulas, who had made great images of Smith in Voltri, to photograph the work and property, Mulas's photographs are more poetic evocation than rigorous documentation. By not fully documenting the shop-studio, the trustees made it impossible to ever attain a full picture of this crucial place in Smith's life. "Smith's studio was completely dismantled," Peter Stevens said. Stevens and Rebecca Smith met at Sarah Lawrence College and married in 1979. For more than two decades, Stevens ran the Estate of David Smith, the organization that works with scholars, curators, galleries, and auction houses to promote the legacy of Smith's art and life. It is the home of the Smith archives. "All of his tools and equipment, and even fragments of sculptures, disappeared," Stevens said. "The work in progress at the studio was basically just disseminated by Greenberg to other artists and friends."[9]

Greenberg consigned Smith sculptures to be sold by Marlborough. But he also sold sculptures from the estate directly to the gallery, which, in Stevens's words, was "a horrible conflict of interest."[10] The estate *had* to sell work, to get the sculptures into the world, pay the inheritance tax, maintain the property, and generate resources for the Smith family, but it was also to the trustees' advantage to sell. Greenberg "readily admits that he—as well as the other trustees—has profited, too," *Newsweek* wrote. "They are paid a 2 per cent commission and Greenberg's share has been his main livelihood for nine years."[11] The trustees insisted

that their approach to sales was carefully calibrated to develop Smith's reputation and market, but in Stevens's view, the gallery "sold way too much too quickly at too low prices."[12] He also wrote, "During that long period of fourteen years, the balance went 100 percent toward selling the work."[13] The girls' connections to their father's work, and to their father through his work, were hardly a factor in the trustees' decisions. By the time Becca turned twenty-five, no more than a dozen sculptures remained in the fields from the roughly eighty that were there at the time of her father's death. Of the twelve *Cubis* in the fields when Smith died, only one remained. "Going up to Bolton Landing" each summer, Stevens said, Becca and Dida "would see the sculptures vanishing from the fields with a total disregard for their feelings or input."[14]

The fields were a dilemma. Given the harshness of the Adirondack climate and its destructive impact on steel and paint, maintaining the sculptures outdoors would have required a full-time conservator. Also, preserving in situ a representative grouping of sculptures would have kept many significant works out of museums and private collections and therefore limited Smith's place in art history. In his working and thinking, Smith was constantly in conversation with other artists and with many forms of art across time and space, and many of these conversations become apparent in museums. Prior to 1950, Smith's work was made for galleries, museums, and homes, and he continued to make sculptures for these locations for the rest of his life. But beginning in 1951 with *Australia*, *Hudson River Landscape*, and other drawings in space, he also made many sculptures that pushed at the limits of museums. His fields provide the most complete vision of his sculpture as a diverse and permanently unsettled population, in which hierarchies and relationships were dependent on point of view, new departures and arrivals, the climate and seasons. This is a social as well as an aesthetic vision, one that asks for his sculpture to be considered within modernist narratives of transformation. It is only by thinking about his work in Bolton Landing that its contingency and politics demand attention. So not seeing his work there also limits his place in art history. Patricia Johanson, the visionary landscape design artist, believed that "if people didn't see David Smith's fields, they didn't see his work."[15]

For Frank O'Hara, as for other critics before him, Terminal Iron

Works *was* a "museum." In the catalog for his 1966 traveling show, O'Hara referred to all the work Smith kept together, much of it for his daughters, as Smith's "collection." Once again he emphasized the difference between experiencing the work in Bolton Landing and experiencing it in urban institutions. In Bolton Landing, "one was struck by these brilliant and sophisticated stainless steel or painted structures, poised against the rugged hills and mountains, the lake in the distance, and the clouds, an assertion of civilized values not nearly so surprising in the confines of a gallery or museum, where, conversely, these same sculptures took on an aspect of rugged individualism and often an almost brutally forthright power." To O'Hara, Smith was one person in the city and a different person upstate. At a city party or opening, "he appeared a great, hulking, plain-spoken art-worker out of Whitman or Dreiser . . . something of a bull in a china shop."[16] It was upstate, O'Hara believed, where he shed all attitude, that Smith's curiosity, generosity, and culture flowed. Lois Orswell, Smith's great collector, believed that Bolton Landing remained a magnet for Smith's sculpture: "His works were born and lived in a rural if not wild atmosphere with children and animals and perhaps rough human surroundings and they feel the change when removed. This sounds like fantasy and yet I have found humans who feel it in the sculpture. I personally think they are homesick for Bolton Landing."[17]

If the trustees had held meetings about the fate of the fields that included Smith's family and art professionals familiar with Smith, his environment and his love-hate relationship with museums, like William Rubin, Hilton Kramer, Noland, Cherry, Frankenthaler, O'Hara, and Orswell, for example, perhaps they could have enabled a version of the fields to survive. It's also possible that such meetings may have determined that a truncated and fixed version could only offer a sad distortion of Smith's ever-expanding, ever-changing sprawl; and the family may have decided that they did not want their property to become a tourist site. In these cases Greenberg's decision to leave only a handful of sculptures may have been deemed the right one—but, if so, the sculptures that remained could have been meticulously chosen and a thorough record made of the fields with the understanding that they were a vision, a dream, a phenomenon. While five sculptures remain in the fields today, Smith's vision can now be deciphered only from photographs, primarily

Smith's own but also those of Mulas and Budnik. Budnik's photographs after Smith's death shot from a plane, with a number of cement bases deserted, make the fields seem bereft and haunted.

In 1970, the rapaciousness of Marlborough was exposed in a sensational scandal. The executors of the Mark Rothko Foundation, whom Rothko had put in charge in 1968, two years before he committed suicide, sold 100 paintings to the gallery at a cut-rate price and consigned to it the remaining 698 Rothko paintings. In a brazen conflict of interest, Bernard Reis, one of the three executors of the Rothko estate, worked for Marlborough-Gerson. According to the book *Artists' Estates: Reputations in Trust*, edited by Magda Salvesen and Diane Cousineau, "In 1971, Kate Rothko, realizing that she and her small brother would inherit no work by their father, petitioned, through her guardian, the New York Surrogate Court to remove the three executors, to stop Marlborough from selling the paintings, and to void two contracts." Frank Lloyd, the head of Marlborough, continued to sell paintings even after the "restraint against sales." "In 1975, Marlborough was ordered to return 658 Rothko paintings to the estate and pay a fine of $9.3 million."[18]

Greenberg "quickly removed the estate from Marlborough, not wanting to be tarnished by that scandal," Stevens said. He began to sell Smith's sculpture through Larry Rubin, whose interest in Smith went back to his years as an art dealer in Paris.[19] In 1972, Rubin became president of the Knoedler Gallery, which would represent Smith for the next twenty-five years. By 1972, Motherwell, a year after he and Frankenthaler divorced, was showing with Knoedler. Twenty years later, Frankenthaler joined the gallery as well.

Doubts about Greenberg's understanding of Smith's work and his ability, as chief executor, to protect it, came to a head in 1974. In its September–October issue of that year, *Art in America* provided evidence of dramatic changes in a number of Smith's sculptures resulting from Greenberg's actions. When Budnik began comparing photographs he had taken during Smith's lifetime with those taken after Smith's death, he noticed deterioration in the surfaces of several sculptures. Greenberg had had layers of primer and white paint removed from five sculptures and left a grouping of three other painted sculptures outdoors so that their surfaces would corrode. Accompanying Budnik's jolting before-and-after

photographs, the magazine ran "Changing the Work of David Smith," an essay by Rosalind Krauss, who was becoming the most influential writer on sculpture in the United States.

The essay was damning:

> Among the sculptures that are still in the estate of the artist, several have been deliberately stripped of paint—sandblasted, allowed to rust, then glossily varnished. Others have simply been left outdoors, unprotected over the years; their surfaces are flaking off under the pressures of heat and cold, rain and sun. Given the identity of the executors of the Smiths [sic] estate—Clement Greenberg, a well-known critic; Robert Motherwell, a well-known artist; and Ira Lowe, a Washington lawyer—all this becomes particularly disturbing.

In Krauss's view, "these pieces reveal an impairment of the integrity of the oeuvre of a major artist—an aggressive act against the sprawling, contradictory vitality of his work as Smith himself conceived it—and left it."

Krauss ended her article with Smith's outrage when his 1950 sculpture *17 h's* was repainted by the owner. In letters to *ArtNews* and *Arts*, Smith called the alteration a "willful act of vandalism" and said that after being tampered with, the sculpture was no longer his: "I renounce it as my original work, and brand it as a ruin."[20] After *17 h's* was returned to him, Smith restored its original surface.

The debate triggered by the photographs and Krauss's article is a watershed. Smith's colors, surfaces, and uses of paint now became essential issues. So did finish. What do "finished" and "unfinished" mean in work in which nothing seems to stay put? Does "unfinished" disqualify a work from being seen? Why were the penetrating observations of O'Hara, whose understanding of Smith was as acute in the 1960s as Greenberg's was in the 1940s, not fully acknowledged until half a century later, when Sarah Hamill and David J. Getsy wrote him into the mainstream of the Smith literature? If O'Hara had not died in 1966, at forty, while his Smith show was on tour, Smith's critical history would surely have been different.

Much of the debate revolved around whether the white paint Smith used on eight of the sculptures was intended as a finished surface or as an intermediate primer on the way to another surface. If it was understood as preparatory, which Greenberg claimed, would the sculptures be better served if the paint, which had apparently peeled off here and there, were entirely removed? "David would revolve in his grave if he knew they had been left in white primer," Greenberg told Bill Marvel of the *National Observer*.[21] But even if the paint was primer, which is flat matte paint, it has aesthetic value. It makes it possible to see form clearly, and seeing form clearly was one of Smith's intentions in his photographs. And Smith did in fact paint and leave sculptures white, a color with a particular complexity for him, one to which he had many responses.[22] It's impossible to know what he would have done with these five works. What is clear is that, for Smith, the process of painting these sculptures had begun and their intended state was not rusted steel.[23]

Many of Smith's sculptures evolved from his living with them over time. It could take him a year to decide how to paint them and he could keep making changes. For O'Hara, seeing finished and unfinished sculptures together was essential to the Smith sculpture experience. In 1961, he had written:

> The house commands a magnificent view of the mountains and its terrace overlooks a meadow "fitted" with cement bases on which *finished* stainless steel and painted sculptures were standing. Around the other sides of the house more *unfinished* works are placed for Smith to ponder. The effect of all these works along the road and around the house was somewhat that of people who are awaiting admittance to a formal reception and, while they wait, are thinking about their roles when they join the rest of the guests already in the meadow.[24]
> [Italics mine.]

Greenberg had strong defenders, including Noland, Larry Rubin, and Jean Freas, who in 1974 was Jean Pond, having married Geoffrey Pond, an NBC news director, in 1969. Those defenders trusted Greenberg's judgment and were sure that Smith would have, too. Freas never

forgot Greenberg's support for Smith during the hard years. "There was no individual in the art world—critic, dealer, artist, academic, museum person—whose aesthetic judgment [Smith] valued more than Mr. Greenberg's," Freas wrote Hilton Kramer in response to his articles critical of Greenberg's actions.[25] Freas was not aware that Greenberg's relationship with Smith had become more conflicted after 1958, the year she left Bolton Landing, in part because of disagreement over Smith's use of paint.

Greenberg was defiant. "I take full responsibility," he told *The Washington Post*. "I made the decision. I'd make it again."[26] To Bill Marvel he wrote, "Not one of those who have raised this fuss have been people whose character or practice or taste I respect. None of them gives a damn about the art."[27] To Robert Hughes: "I can answer to my conscience. Were I to have known that this fuss would come up I would still have done the same thing, and I'm only sorry I didn't do it earlier." Hughes responded:

> But conscience is not the point. The point is that altering the work of a dead artist—especially one of Smith's eminence—is an arrogant intrusion that borders on vandalism. We are entitled to the work as it left Smith's hand, warts and all. Perhaps the best thing to be said for Greenberg's action is that, aberrantly, he has given the art world a dismaying lesson in the limits of criticism.[28]

Leaving no doubt about the dysfunctional relationship among the Smith executors, Lowe and Motherwell disassociated themselves from Greenberg's actions. "When I saw those photographs, I was shocked beyond words," Lowe told *The Washington Post*. "Bob and I didn't know anything about the stripping of the sculptures. I intend to do everything I can to see those works restored."[29] Motherwell: "I hadn't known Greenberg was making these changes . . . It's wrong."[30]

Dehner's defense of Smith's work, and of artists' estates after their deaths, was fierce. In letters to Kramer and Hughes, she mentioned that Smith's first sculpture, in the Virgin Islands, was painted, that he loved his painted work, and that in Greece he understood that polychrome, which looked so awkward to modern eyes, was integral to the great his-

tory of sculpture.[31] She called Greenberg's actions "mutilation."[32] It was Dehner's belief that Greenberg would not have done what he did if he took seriously Smith's decades of thought about color and paint.

By the end of 1974, Greenberg's role as Smith's "official critic" was over. Greenberg's assumption that he was smarter than everyone else, particularly artists, and did not have to listen to critics with different perspectives, and his deep-seated ambivalence about Smith and his work had led to actions that permanently damaged his reputation.

The white paint was eventually restored on the five sculptures from which paint had been removed. The three other sculptures whose surfaces had been damaged were restored as well.

More than a half century after his death, Smith's work has continued to reveal itself. In 1979, the Whitney Museum of American Art presented an exhibition of Smith's drawings. In 1982, the National Gallery of Art organized the only show devoted to Smith's series, which ran concurrently with "David Smith: Painter, Sculptor, Draftsman," at the Hirshhorn Museum and Sculpture Garden, the first museum show to concentrate on Smith's work across media. In 2006, the Guggenheim organized a second Smith retrospective, this time a centennial one, which highlighted the tactile intelligence of the early sculpture and the splendor of the *Voltris* and *Cubis*: it traveled to the Pompidou Center in Paris and the Tate Modern in London. Partly in response to the centennial's omission of the *Zigs* and limited treatment of Smith's painted surfaces and his increasing focus on geometrical abstraction after 1950, the Los Angeles County Museum of Art organized "David Smith: Cubes and Anarchy," which opened in 2011 and traveled to the Whitney. In 2011, the Institute of Modern Art in Valencia devoted an exhibition to the sculptural dialogue between Smith and Julio González. In 2014, the Clark Art Institute presented "The Circles of David Smith," a model for a superbly focused exhibition, devoted to a particular Smith series. No museum has taken on the monumental task of putting together an exhibition that would consider the totality of Smith's work—sculpture, painting, drawing, photography, ceramics, writing, and working process.[33]

After the Estate of David Smith left Knoedler, it worked for well over a decade with the Gagosian Gallery, which organized exhibitions on Smith's painted sculpture, personages, nudes, and, in 2013, the *Forgings*.

Since 2017, the Estate of David Smith has been working with Hauser & Wirth, a gallery with an even stronger contemporary and modern art presence and a commitment to showing its artists abroad as well as in the United States. In 2017, Hauser & Wirth Zurich curated an exhibition dialogue between Smith and Calder. A new three-volume catalogue raisonné of Smith's sculpture was published in 2021.

Rebecca Smith is a sculptor; Candida Smith was for many years a dancer. They visit Bolton Landing every summer and oversee the Estate of David Smith.

Notes

In citing works in the notes, the following short titles and abbreviations have been used for frequently cited archival sources and for interviews about or with David Smith. The sources in bold font are particularly important.

Archives/Archival Sources

AAA
Archives of American Art, Smithsonian Institution.

Dehner papers, AAA
Dorothy Dehner papers, 1920–1987, bulk 1951–1987, Archives of American Art, Smithsonian Institution.

Ellin papers, AAA
Everett Ellin papers, circa 1958–1963, Archives of American Art, Smithsonian Institution.

Frankenthaler/Motherwell papers, AAA
Helen Frankenthaler and Robert Motherwell material about David Smith, 1953–1965, Archives of American Art, Smithsonian Institution.

Genauer papers, AAA
Emily Genauer papers, circa 1920–1990, Archives of American Art, Smithsonian Institution.

Gerson papers, AAA
Otto and Ilse Gerson papers, 1933–1980, Archives of American Art, Smithsonian Institution.

Levy/Corcos papers, AAA
Edgar Levy and Lucille Corcos papers, 1928–1975, Archives of American Art, Smithsonian Institution.

Smith–Cherry letters, AAA
Herman Cherry letters from David Smith, 1950–1964, David Smith papers, 1926–1965, Archives of American Art, Smithsonian Institution.

Smith–Krasne letters, Storm King
Belle Krasne Ribicoff and David Smith Correspondence, Storm King Art Center Archives.

Smith–Xceron letters, AAA
Jean Xceron letters from David Smith, 1940–1957, Archives of American Art, Smithsonian Institution.

Willard Gallery records, AAA
Willard Gallery records, circa 1940–1956, Archives of American Art, Smithsonian Institution.

Interviews

Cherry interview (1965), Tully, AAA
Herman Cherry, oral history interview conducted by Judd Tully, September 1965, Archives of American Art, Smithsonian Institution.

Dehner interview (1965–1966), McCoy/Krauss, AAA
Dorothy Dehner, oral history interview conducted by Garnett McCoy and Rosalind Krauss, October 1965–December 1966, Archives of American Art, Smithsonian Institution.

Dehner interview (1973), Fortess, AAA
Dorothy Dehner, interview conducted by Karl Fortess, February 11, 1973, Archives of American Art, Smithsonian Institution, transcribed by the author.

Dehner interview (1980), Tully
Dorothy Dehner, interview conducted by Judd Tully, March 5, 1980, transcribed by the author; courtesy of Judd Tully.

Dehner interview (1987), Renick/Bloomfield
Dorothy Dehner, interview conducted by Patricia Renick and Maureen Bloomfield, June 21, 1987, transcribed by the author; courtesy of Patrica Renick.

Dehner interview (1992), Johnson
Dorothy Dehner, interview conducted by Miani Johnson, February 11, 1992; courtesy of Miani Johnson, Willard Gallery.

Dehner interviews (1981–1984), Rapp, AAA
Dorothy Dehner, interviews conducted by Gordon D. Rapp, 1981–1984, Archives of American Art, Smithsonian Institution, transcribed by the author.

Hayter interview (1970–1971), Cummings, AAA
Stanley William Hayter, oral history interview conducted by Paul Cummings, March 11, 1971, Archives of American Art, Smithsonian Institution.

Miller interviews (1970–1971), Cummings, AAA
Dorothy Miller, oral history interviews conducted by Paul Cummings, May 26, 1970–September 28, 1971, Archives of American Art, Smithsonian Institution.

Smith interview (1964), Hess
David Smith, "Interview by Thomas B. Hess," 1964, in *David Smith: Collected Writings, Lectures, and Interviews*, ed. Susan J. Cooke (Oakland: University of California Press, 2018), 373–411.

Willard interview (1969), Cummings, AAA
Marian Willard Johnson, oral history interview conducted by Paul Cummings, June 3, 1969, Archives of American Art, Smithsonian Institution.

Books

Carmean, *David Smith*
E. A. Carmean, Jr., *David Smith*, exhibition catalog (Washington, D.C.: National Gallery of Art, 1982).

Cohn, *Lois Orswell, David Smith, and Modern Art*
Marjorie B. Cohn, *Lois Orswell, David Smith, and Modern Art, with the Lois Orswell/David Smith Correspondence*, exhibition catalog (Cambridge, Mass.: Harvard University Art Museums, 2003).

Gray, *David Smith by David Smith*
Cleve Gray, *David Smith by David Smith* (New York: Holt, Rinehart and Winston, 1968).

Cooke, *David Smith*
David Smith: Collected Writings, Lectures, and Interviews, ed. Susan J. Cooke (Oakland: University of California Press, 2018).

Hamill, *David Smith in Two Dimensions*
Sarah Hamill, *David Smith in Two Dimensions: Photography and the Matter of Sculpture* (Oakland: University of California Press, 2015).

Krauss, *Passages in Modern Sculpture*
Rosalind E. Krauss, *Passages in Modern Sculpture* (Cambridge, Mass.: MIT Press, 1977).

Krauss, *Terminal Iron Works*
Rosalind E. Krauss, *Terminal Iron Works: The Sculpture of David Smith* (Cambridge, Mass.: MIT Press, 1971).

Author's Note

1. Jean Freas, interview with the author, September 24, 2002, in New York City.
2. Grace Hartigan, interview with the author, October 22, 2002, by telephone.
3. Marian Willard to David Smith, February 28, 1947, Estate of David Smith.

Introduction

1. Robert Murray, interview conducted by the author, November 18, 2007, in West Grove, Pennsylvania.
2. Kenneth Noland, interview conducted by the author, April 7, 2001, in North Bennington, Vermont.
3. Edward F. Fry quoted in Marjory Weber, "Works of Bolton's David Smith Exhibited," *Adirondack Life*, July 3, 1969, 6.

4. David Smith to Sidney Geist, November 18, 1962, quoted here courtesy of Sidney Geist.
5. Herman Cherry to Kenneth Noland, July 3, 1965, quoted here courtesy of Kenneth Noland.
6. Beverly Pepper, interview conducted by the author, October 28, 2003, in New York City.
7. Anne Truitt, interview conducted by the author, July 28, 2001, in Washington, D.C.
8. Robert Motherwell quoted in John Gruen, *The Party's Over Now: Reminiscences of the Fifties—New York's Artists, Writers, Musicians, and Their Friends* (New York: Viking Press, 1972), 194, cited in Robert Motherwell, "On David Smith," in *The Collected Writings of Robert Motherwell*, ed. Stephanie Terenzio (Oxford: Oxford University Press, 1992), 204.
9. Dehner interview (1965–1966), McCoy/Krauss, AAA.
10. Jean Freas, "Living with David Smith," *David Smith: Drawings of the Fifties*, exhibition catalog (London: Anthony d'Offay Gallery, 1988), 6.
11. Jean Freas, interview conducted by the author, December 11, 2001, in New York City.
12. Freas, "Living with David Smith," 16.
13. David Smith to Marian Willard, January 23, 1945, Willard Gallery records, AAA.
14. Rosalind E. Krauss, *Passages in Modern Sculpture* (Cambridge, Mass.: MIT Press, 1977), 158.
15. David Smith, "The Artist in Society," 1955, in *David Smith: Collected Writings, Lectures, and Interviews*, ed. Susan J. Cooke (Oakland: University of California Press, 2018), 252.
16. David Smith, "Lecture, Skowhegan School of Painting and Sculpture," 1956, in Cooke, *David Smith*, 275.
17. Clement Greenberg, "Review of the Exhibition *American Sculpture of Our Time*," *The Nation*, January 23, 1943, in *Clement Greenberg: The Collected Essays and Criticism*, vol. 1: *Perceptions and Judgments, 1939–1944*, ed. John O'Brian (Chicago: University of Chicago Press, 1986), 140–41.
18. Clement Greenberg, "Review of the Whitney Annual and Exhibitions of Picasso and Cartier-Bresson," *Nation*, April 5, 1947, in *Clement Greenberg: The Collected Essays and Criticism*, vol. 2: *Arrogant Purpose, 1945–1949*, ed. John O'Brian (Chicago: University of Chicago Press, 1988), 138.
19. E. C. Goossen, "David Smith," *Arts* 30 (March 1956): 27.
20. Freas interview, December 11, 2001.
21. Truitt interview, July 28, 2001.
22. David Smith to Henri Goetz, October 14, 1955, David Smith Estate.

1. Roots

1. French Quinn, *A Short, Short History of Adams County, Indiana* (Berne, Ind.: Economy Printing Concern, n.d.), 30.
2. *Decatur Daily Democrat*, October 2, 1923, 1.
3. T. A. Lynch, *Reminiscences of Adams, Jay, and Randolph Counties* (Fort Wayne, Ind.: Lipes, Nelson & Singmaster, 1897), 83.
4. "William Pendleton Rice," *Decatur Democrat*, September 14, 1899, 1.
5. Smith interview (1964), Hess, 402.
6. M. Jane Diller, "A Discriminative Study of the Early Life of David Smith," un-

published research report for an education course in the Faculty of the Graduate Division, St. Francis College, Brooklyn, New York, January 1987, 8. I'm extremely grateful to Diller for making her report available to me. (Note: A copy of this text is in the archives of the Museum of Modern Art, New York City, Department of Publications Collection on Proposed David Smith Monograph, folder II.B.8.)

7. Smith interview (1964), Hess, 410.
8. Dehner interview (1965–1966), McCoy/Krauss, AAA.
9. Smith interview (1964), Hess, 379.
10. Alexander Piatigorsky, *Who's Afraid of Freemasons?* (New York: Barnes & Noble Books, 1997), 100.
11. M. Jane Diller, "A Discriminative Study," 15.
12. Golda Smith to Dorothy Dehner, n.d. [ca. 1970], Dehner papers, AAA.
13. Jim Stahl, interview conducted by the author, December 20, 2004, in Paulding, Ohio.
14. Freas told this story to Gloria Gil, one of Smith's closest friends during the last years of his life. Gloria Gil, interview conducted by the author, December 2, 2003, in Burlington, Vermont.
15. Jean Freas, interview conducted by the author, January 24, 2002, in New York City.
16. Jean Freas, interview conducted by the author, January 30, 2004, in New York City.
17. M. Jane Diller, "A Discriminative Study," 7.
18. M. Jane Diller, "A Discriminative Study," 9.
19. Wayne County, Ohio, Court of Common Pleas, Case 14967 (1881), Eliza Stoler v. David Stoler, Eunice B. Stoler, Byrus Anson Stoler, Maria Stoler, Mellissa E. Stoler, George Hinish and Amos Swartz, County Microfilm Office, Wooster, Ohio, 3.
20. Wayne County, Ohio, Court of Common Pleas, Case 896 (1881), Eliza Stoler v. David Stoler, Eunice Stoler, Cyrus Anson Stoler, Maria Stoler, Melissa E. Stoler, George Hinish, Amos Swartz and Eunice B. Stoler Guard., Final Records 72:285, Roll 72, Years August 1881–February 1882; County Microfilm Office, Wooster, 318.
21. Wayne County, Ohio, Court of Common Pleas, Case 896, 287.
22. Wayne County, Ohio, Court of Common Pleas, Case 896, 287.
23. Wayne County, Ohio, Court of Common Pleas, Case 896, 319.
24. Wayne County, Ohio, Court of Common Pleas, Case 896, 326.
25. Wayne County, Ohio, Court of Common Pleas, Case 896, 320.
26. Wayne County, Ohio, Court of Common Pleas, Case 896, 368.
27. Wayne County, Ohio, Court of Common Pleas, Case 896, 337.
28. Wayne County, Ohio, Court of Common Pleas, Case 14967, 12.
29. Wayne County, Ohio, Court of Common Pleas, Case 14967, 16.

2. Growing Up

1. David Smith, "The Landscape; Spectres Are; Sculpture Is," in *David Smith: Collected Writings, Lectures, and Interviews*, ed. Susan J. Cooke (Oakland: University of California Press, 2018), 69–70.
2. Belle Krasne, "Notes on David Smith Interview," 1951, Bolton Landing, New York. Belle Krasne Ribicoff was good enough to make available to me her unpublished notes in response to her meeting with Smith in preparation for her profile of him in *Art Digest*, April 12, 1952.
3. Dehner interview (1965–1966), McCoy/Krauss, AAA.

4. Dehner interview (1987), Renick/Bloomfield, June 21, 1987. I'm grateful to Patricia Renick for making this interview available to me.
5. Dehner interview (1965–1966), McCoy/Krauss, AAA.
6. Dehner interview (1965–1966), McCoy/Krauss, AAA.
7. Dehner interview (1965–1966), McCoy/Krauss, AAA.
8. Carol Sklenicka, *Raymond Carver: A Writer's Life* (New York: Scribner, 2009), 11.
9. M. Jane Diller, transcript of recorded interview conducted with Golda Smith, 1967, unpublished; quoted here courtesy of M. Jane Diller.
10. M. Jane Diller, "A Discriminative Study of the Early Life of David Smith," unpublished research report for an education course in the Faculty of the Graduate Division, St. Francis College, Brooklyn, New York, January 1987, 14.
11. Estelle M. Hurll, *Greek Sculpture* (Boston: Houghton Mifflin, 1901).
12. David Smith, *David Smith by David Smith*, ed. Cleve Gray (New York: Holt, Rinehart and Winston, 1968), 137.
13. David Smith, "Tradition," 1954, in Cooke, *David Smith*, 214.
14. David Smith, "Statement, WNYC Radio," 1952, in Cooke, *David Smith*, 173.
15. M. Jane Diller, interview conducted by Dorwin T. Dean, in "Interviews with Teachers and Friends of David Smith," unpublished, 1967, quoted here courtesy of M. Jane Diller.
16. Diller, interview conducted with Golda Smith, 1967.
17. Diller, "A Discriminative Study," 15.
18. Diller, "A Discriminative Study," 17.
19. Aline Jean Treanor, "Giant of Modern Sculpture," *Toledo Blade Pictorial*, August 16, 1953, 16.
20. Dehner interview (1965–1966), McCoy/Krauss, AAA.
21. Diller, interview conducted with Golda Smith, 1967.
22. Rebecca Smith, in conversation with the author, April 9, 2009, in New York City.
23. Diller, "A Discriminative Study," 34.
24. Dehner interview (1965–1966), McCoy/Krauss, AAA.
25. David Smith, "Jim and Minnie Ball," ca. 1963, in Cooke, *David Smith*, 369.
26. Wolfgang Schivelbusch, *Railway Journey: The Industrialization of Time and Space in the 19th Century* (Berkeley: University of California Press, 1977), 37.
27. Smith interview (1964), Hess, 416, 379.
28. Smith interview (1964), Hess, 379.
29. David Smith, "Report on Voltri," 1962–1963, in Cooke, *David Smith*, 359.

3. Paulding

1. Virginia Paulus, interview conducted by the author, November 8, 2003, in Paulding, Ohio.
2. "History of Paulding Village," handout available at the Paulding County Library, 1.
3. Paulus interview.
4. Jim Stahl, interview conducted by the author, December 20, 2004, in Paulding, Ohio.
5. "A Bit of Historical Trivia About Paulding County, Ohio," in *The Echo*, Paulding High School yearbook, Paulding, Ohio, 1922.
6. *The Echo*, 1922.
7. Dehner interview (1965–1966), McCoy/Krauss, AAA.
8. Rosalind E. Krauss, *Terminal Iron Works: The Sculpture of David Smith* (Cambridge, Mass.: MIT Press, 1971), 63.

9. Joan Marter, "Arcadian Nightmares: The Evolution of David Smith and Dorothy Dehner's Work at Bolton Landing," in *Reading Abstract Expressionism: Context and Critique*, ed. Ellen G. Landau (New Haven: Yale University Press, 2005), 627–28.
10. Diller, interview conducted with Golda Smith, 1967.
11. This quote is from a part of the transcript of the Diller interview that was not included in the paper.
12. *The Echo*, 1924, 25.
13. *The Echo*, 1923, 41.
14. The poem is one of three early texts by Smith that M. Jane Diller included in her unpublished notes as "Early Writings of David Smith." The poem first appeared in *Ravelings*, the literary magazine published by Decatur High School's senior class of 1921. Diller transcribed the last word in line 3 as "comma," but the original word must have been "command"—to rhyme with "stand," and because the tone of the poem is neither irreverent nor ironic.
15. *The Echo*, 1923, 15, 49.
16. *The Echo*, 1923, 38.
17. *The Echo*, 1923, n.p.
18. *The Echo*, 1924, 94.
19. *The Echo*, 1924, 96.
20. *The Echo*, 1923, n.p.
21. Diller, notes from her 1967 interview with Golda Smith.
22. "Early Writings of David Smith," in Diller notes, unpublished.
23. Rebecca Smith, in conversation with the author, November 7, 2003.
24. *The Echo*, 1924, 29.
25. *The Echo*, 1924, 32.
26. *The Echo*, 1924, 86.

4. Transitions

1. David Smith to William Darrell Herron, March 30, 1926. The William D. Herron collection is in the Robert E. and Jean R. Mahn Center for Archives and Special Collections, Ohio University.
2. The Keats book with the drawings of the liquor bottles is in the Estate of David Smith.
3. Dehner interview (1965–1966), McCoy/Krauss, AAA.
4. Kurt Rohde, "One for the Road: Steel, Sweat and David Smith," *Lake George (NY) Mirror*, August 29, 1952, 14.
5. David Smith, "Lecture, Ohio State University," 1959, in *David Smith: Collected Writings, Lectures, and Interviews*, ed. Susan J. Cooke (Oakland: University of California Press, 2018), 307.
6. David Smith, "Memories to Myself," 1960, in Cooke, *David Smith*, 330–31.
7. David Smith, *David Smith by David Smith*, ed. Cleve Gray (New York: Holt, Rinehart and Winston, 1968), 53.
8. M. Jane Diller, interview conducted with Golda Smith, 1967.
9. Dehner interview (1965–1966), McCoy/Krauss, AAA.
10. David Smith, "Autobiographical Notes," 1950, in Cooke, *David Smith*, 98.
11. Thomas E. Bonsall, *More Than They Promised: The Studebaker Story* (Stanford, Calif.: Stanford University Press, 2000), 124.
12. Smith, *David Smith by David Smith*, 53.

13. Bonsall, *More Than They Promised*, 119.
14. David Smith, "Interview by Katharine Kuh," 1962, in Cooke, *David Smith*, 344.
15. Dorothy Dehner to Jane Harrison Cone, May 19, 1966, quoted here courtesy of Cone. I'm grateful to her for making available to me her exchange of letters with Dehner. Cone organized the first Smith retrospective, for the Fogg Art Museum in 1966, after Smith's death; see Jane Harrison Cone, *David Smith, 1906–1965: A Retrospective Exhibition* (Cambridge, Mass.: Harvard College, 1966).
16. Smith's name can be a confusing issue. In 1946, when Dal Herron asked Smith about his name, he mentioned that "for 15 years I've used my first name, David"—even though Herron knew that David was not his first name; Smith to Herron, August 26, 1946, the William D. Herron collection on Ohio University alumni and staff, the Robert E. and Jean R. Mahn Center for Archives and Special Collections, Ohio University. In response to questions from Bill Berkson for the Smith chronology that Berkson was preparing for the Museum of Modern Art, David's sister, Catherine, asserted, incorrectly, that his birth name was David Roland Smith; Catherine Smith Stewart to Bill Berkson, February 2, 1966, Department of Publications Collection on Proposed David Smith Monograph, I.32. The Museum of Modern Art Archives, New York. Smith would consistently play with his name, turning it into a multiplicity through different signatures in letters and on his sculptures.
17. Dehner interview (1965–1966), McCoy/Krauss, AAA.
18. Smith to Herron, March 18, 1926. All of Smith's letters to Herron are in the Robert E. and Jean R. Mahn Center for Archives and Special Collections, Ohio University.
19. Smith to Herron, March 30, 1926.
20. McCready Huston, *Hulings' Quest* (New York: Charles Scribner's Sons, 1925), 88.
21. Smith to Herron, March 18, 1926.
22. Smith to Herron, March 30, 1926.
23. Smith to Herron, March 30, 1926.
24. Smith to Herron, June 8, 1926.
25. Smith to Herron, June 22, 1926.
26. Smith to Herron, June 8, 1926.
27. Smith interview (1964), Hess, 399.
28. *Poems from Shelley*, selected and with an introduction by Olwen W. Campbell (London: Methuen, 1925). The book is in the Estate of David Smith.
29. Smith to Herron, June 27, 1926.
30. Smith to Herron, June 8, 1926.
31. Smith to Herron, August 1, 1926.
32. Dehner interview (1980), Tully. I'm grateful to Judd Tully for making this interview available to me.
33. Smith interview (1964), Hess, 400.

5. A New Life

1. Dehner interview (1987), Renick/Bloomfield.
2. Dehner interview (1987), Renick/Bloomfield.
3. Dehner interview (1987), Renick/Bloomfield.
4. Dehner interview (1980), Tully.
5. Dehner interview (1987), Renick/Bloomfield.

6. Dehner interview (1987), Renick/Bloomfield.
7. Dorothy Dehner to Abby Mann, her stepdaughter, n.d., Dehner papers, AAA, microfilm roll D298.
8. Dehner interview (1980), Tully.
9. Dehner interviews (1981–1984), Rapp, AAA.
10. Dehner interview (1980), Tully.
11. Dehner interviews (1981–1984), Rapp, AAA.
12. Dehner interview (1980), Tully.
13. Dehner interview (1987), Renick/Bloomfield.
14. Dehner interviews (1981–1984), Rapp, AAA.
15. Dorothy Dehner (1980), Tully.
16. Dorothy Dehner interview conducted by Karl Fortess, February 15, 1973, AAA.
17. Dehner interview (1980), Tully.
18. Dehner interviews (1981–1984), Rapp, AAA.
19. Dehner interview (1980), Tully.
20. Dehner interviews (1981–1984), Rapp, AAA.
21. Dehner interview (1980), Tully.
22. Dehner interview conducted by Fortess, 1973.
23. Dehner interview (1980), Tully.
24. Dehner interview (1987), Renick/Bloomfield.
25. Paula Wisotzki, "David Smith's 'Medals for Dishonor'" (unpublished PhD dissertation, Northwestern University, 1988), 15.
26. Dehner interview (1987), Renick/Bloomfield.
27. Dehner interview (1980), Tully.
28. Dehner interview (1965–1966), McCoy/Krauss, AAA.
29. Dehner interviews (1981–1984), Rapp, AAA.
30. Dehner interview (1980), Tully.
31. Dehner interview (1987), Renick/Bloomfield.
32. Dehner, interviews (1987), Renick/Bloomfield.
33. Dehner interview (1987), Renick/Bloomfield.
34. Dehner interviews (1987), Rapp, AAA.
35. Robert Henri, *The Art Spirit* (Boulder, CO: Westview Press, 1923), 18–19, 225.
36. Dehner interviews (1981–1984), Rapp, AAA.
37. *Stuart Davis*, ed. Diane Kelder, Documentary Monographs in Modern Art (New York: Praeger, 1971), 20.
38. Henri, *The Art Spirit*, 18, 20, 135, 147.
39. Dehner interview (1980), Tully.
40. Dehner interview (1987), Renick/Bloomfield.

6. Deeper Bonds

1. Dorothy Dehner to David Smith, n.d., Dehner papers, AAA, microfilm roll D298A.
2. Dehner to Smith, n.d., Dehner papers, AAA, microfilm roll D298A.
3. Dehner interview (1987), Renick/Bloomfield.
4. Dehner interview (1980), Tully.
5. David Smith, "Notes on My Work," 1960, in *David Smith: Collected Writings, Lectures, and Interviews*, ed. Susan J. Cooke (Oakland: University of California Press, 2018), 314.
6. Robert Coates, "Profile of John Sloan: 'After Enough Years Have Passed,'" *New Yorker*, May 7, 1949, 40, 42.

7. Dehner interview (1980), Tully.
8. John Sloan, *John Sloan on Drawing and Painting (Gist of Art)* (1939; repr. Mineola, N.Y.: Dover Publications, 2000), 4.
9. Sloan, *Gist of Art*, 23, 36, and 27.
10. David Smith, "Autobiographical Notes," 1950, in Cooke, *David Smith*, 98.
11. Smith interview (1964), Hess, 400.
12. Dehner interview (1987), Renick/Bloomfield.
13. Dehner interview (1987), Renick/Bloomfield.
14. Dehner interview (1965–1966), McCoy/Krauss, AAA.
15. Ross Wetzsteon, *Republic of Dreams Greenwich Village: The American Bohemia, 1910–1960* (New York: Simon & Schuster, 2002).
16. Dehner interview (1980), Tully.
17. Dehner interview (1987), Renick/Bloomfield.
18. April Kingsley, *Turning Point: The Abstract Expressionists and the Transformation of American Art* (New York: Simon & Schuster, 1992), 180.
19. Rosalind E. Krauss, *Terminal Iron Works: The Sculpture of David Smith* (Cambridge, Mass.: MIT Press, 1971), 66.
20. David Smith, "The Landscape; Spectres Are; Sculpture Is," 1947, in Cooke, *David Smith*, 69.
21. David Smith, *David Smith by David Smith*, ed. Cleve Gray (New York: Holt, Rinehart and Winston, 1968), 174.
22. David Smith to Flora Uphof, February 13, 1928, Dorothy Dehner papers, AAA, microfilm roll D298, frame 1549.
23. David Smith to Flora Uphof, March 12, 1928, Dehner Papers, AAA, microfilm roll D298A, frame 1553.
24. Smith to Uphof, February 13, 1928, frame 1549.
25. David Smith to Flora Uphof, March 12, 1928, roll D298A, frame 1553.
26. David Smith to Flora Uphof, n.d. [1928], Dehner Papers, AAA, microfilm roll D298A, frame 1556.
27. Dehner interview (1965–1966), McCoy/Krauss, AAA.
28. Kimon Nicolaides, *The Natural Way to Draw* (Boston: Houghton Mifflin, 1941), 45.
29. Dehner interview (1987), Renick/Bloomfield.
30. Dehner interviews (1987), Rapp, AAA.
31. David Smith, "Autobiographical Notes," 1950, in Cooke, *David Smith*, 99.
32. A copy of the application is in the DS Estate.

7. Bolton Landing

1. Edgar M. ("Ted") Caldwell, in conversation with the author, January 11, 2010. Caldwell is a historian of Bolton Landing.
2. Dehner interview (1965–1966), McCoy/Krauss, AAA. Smith did send this painting to Paulding, where eventually it was stored in the family attic and damaged. After Smith's death, the family tried to find it but couldn't.
3. Dehner interview (1965–1966), McCoy/Krauss, AAA.
4. Dehner interview (1980), Tully.
5. "Reminiscences by Dorothy Dehner," in *David Smith of Bolton Landing: Sculpture and Drawings*, exhibition catalog (Glens Falls, N.Y.: Hyde Collection, 1973), n.p.
6. Thomas Jefferson quoted in Erin B. Coe, Gwendolyn Owens, and Bruce Robert-

son, *Modern Nature: Georgia O'Keeffe and Lake George* (London: Thames & Hudson, 2013), 7.

7. William Preston Gates, *Old Bolton on Lake George, NY* (Queensbury, N.Y.: W. P. Gates, 2006), 18.

8. Charles King, *Gods of the Upper Air: How a Circle of Renegade Anthropologists Reinvented Race, Sex, and Gender in the Twentieth Century* (New York: Doubleday, 2019), 9.

9. See "The Sportsman Pilot," Aeroflight: The Website for Aviation Enthusiasts, www .aeroflight.co.uk/mags/magazine-details/the-sportsman-pilot-magazine.htm.

10. Dorothy Dehner, "Memories of Jan Matulka," in *Jan Matulka: 1890–1972* (Washington, D.C.: Smithsonian Institution Press, 1980), 77.

11. David Smith, "Notes on My Work," 1960, in *David Smith: Collected Writings, Lectures, and Interviews,* ed. Susan J. Cooke (Oakland: University of California Press, 2018), 314.

12. David Smith, "Interview by Katharine Kuh," 1962, in Cooke, *David Smith,* 344.

13. Dehner, "Memories of Jan Matulka," 78.

14. Patterson Sims, "Jan Matulka: A Life in Art," in *Jan Matulka,* 25.

15. David Smith, "Autobiographical Notes," 1950, in Cooke, *David Smith,* 99.

16. Sims, "Jan Matulka," 25.

17. Dorothy Dehner to Margaret Haggerty, September 6, 1967, David Smith, I.32. MoMA Archives, New York.

18. Paula Wisotzki, "David Smith's 'Medals for Dishonor'" (unpublished PhD dissertation, Northwestern University, 1988), 24.

19. Michael FitzGerald, *Picasso and American Art* (New York: Whitney Museum of American Art, 2007), 107.

20. David Smith, "Interview by Katharine Kuh," 1962, in Cooke, *David Smith,* 344.

21. Dorothy Dehner, "Memoir of John Graham," Dehner papers, AAA, in series 4, box 4, file 76, and on microfilm roll D298A, frames 1531–41; and Dorothy Dehner, "Unexpurgated Memoir of John Graham," Dorothy Dehner Foundation, www .dorothydehnerfoundation.org/writings.html.

22. Art Students League minutes, October 4 and November 22, 1929, Art Students League records, 1875–1955, Art Students League, New York.

8. John Graham

1. Dehner interview (1965–1966), McCoy/Krauss, AAA.

2. *David Smith by David Smith,* ed. Cleve Gray (New York: Holt, Rinehart and Winston, 1968), 174n5.

3. Dorothy Dehner, "Unexpurgated Memoir of John Graham," n.p., Dorothy Dehner Foundation, www.dorothydehnerfoundation.org/writings.html.

4. Dorothy Dehner, foreword to *John Graham's System and Dialectics of Art* (1937; repr. Baltimore: Johns Hopkins University Press, 1971), xiii.

5. William C. Agee, Irving Sandler, and Karen Wilkin, *American Vanguards: Graham, Davis, Gorky, de Kooning, and Their Circle, 1927–1942* (New Haven: Yale University Press, 2012).

6. Dehner, "Unexpurgated Memoir of John Graham."

7. Dehner, foreword to *John Graham's System and Dialectics of Art,* xiii.

8. This information, including the spelling of Graham's Russian name, is from Anne Carnegie Edgerton, "John D. Graham, 1886–1961" (unpublished PhD dissertation, University of California, Santa Barbara, 1984).

9. *John Graham's System and Dialectics of Art*, 195, 160.
10. Marcia Epstein Allentuck, introduction to *John Graham's System and Dialectics of Art*, 46.
11. John D. Graham, "Primitive Art and Picasso," *Magazine of Art*, April 1937, 236–39, 260.
12. *John Graham's System and Dialectics of Art*, 124, 127.
13. William C. Agee, "Graham, Gorky, de Kooning: A New Classicism, an Alternate Modernism," in Agee, Sandler, and Wilkin, *American Vanguards*, 120.
14. Edgerton, "John D. Graham, 1886–1961," 110.
15. Dehner, "Unexpurgated Memoir of John Graham."
16. Edgerton, "John D. Graham, 1886–1961," 110.
17. Irma and Mordecai Bauman, interview conducted by the author, June 16, 2002, in New York City.
18. The portraits are reproduced in Agee, Sandler, and Wilkin, *American Vanguards*, 194, 204.
19. Patterson Sims, "Jan Matulka: A Life in Art," in *Jan Matulka: 1890–1972* (Washington, D.C.: Smithsonian Institution Press, 1980), 27.
20. Dehner interview (1973), Fortess, February 15, 1973, AAA.
21. David Levy, interview conducted by the author, November 6, 2002, in New York City.
22. Larry Rivers, introductory essay in *Edgar Levy: The Thirties*, exhibition catalog (New York: Babcock Galleries, 1993), n.p.
23. *John Graham's System and Dialectics of Art*, 154.
24. David Smith to Lucille Corcos and Edgar Levy, December 23, 1931, Levy/Corcos papers, AAA, NDSMITHE1, frame 6.
25. Paul Gauguin, *Noa Noa: The Tahiti Journal of Paul Gauguin* (1920; repr. San Francisco: Chronicle Books, 1994), 213, 37, 48.
26. Robert Goldwater, *Primitivism in Modern Art* (1938; repr. Cambridge, Mass.: Belknap Press, enlarged edition, 1986), 63, 65.
27. Dehner interview (1965–1966), McCoy/Krauss, AAA.
28. Dehner, "Unexpurgated Memoir of John Graham."
29. Dehner interview (1980), Tully.

9. The Virgin Islands

1. Dorothy Dehner, notes for *Memory of St. Thomas #1* and *Memory of St. Thomas #2*, 1942; these are two gesso paintings in her *Life on the Farm* series. They are in the Storm King Art Center Archives; see https://collections.stormking.org/Detail/collections/870.
2. Smith, "Autobiographical Notes," 1950, in *David Smith: Collected Writings, Lectures, and Interviews*, ed. Susan J. Cooke (Oakland: University of California Press, 2018), 99.
3. Dorothy Dehner interview with Joan Pachner about David Smith's photographs, August 20, 1986. I'm grateful to Pachner for making the interview available to me.
4. Dehner interview (1986), Pachner.
5. Dehner interview (1986), Pachner.
6. Dehner interview (1986), Pachner.
7. All of David Smith's photographs and captions referred to in this chapter belong to the Estate of David Smith.
8. David Smith to Edgar Levy and Lucille Corcos Levy, December 23, 1931, Levy/Corcos papers, AAA, NDSMITHE1, frames 5, 6.

9. Dorothy Dehner to Lucille Corcos and Edgar Levy, n.d., Levy/Corcos papers, AAA, NDSMITHE1, frame 3.
10. Dehner to Corcos and Levy, n.d., frames 2, 3.
11. Dorothy Dehner to Lucille Corcos and Edgar Levy, August 4, 1953, Levy/Corcos papers, AAA, NDSMITHE1, frame 361.
12. Dehner to Corcos and Levy, n.d., frames 3, 4.
13. David Smith to Edgar Levy and Lucille Corcos Levy, December 23, 1931, Levy/Corcos papers, AAA, NDSMITHE1, frame 6.
14. Joan Pachner, "David Smith's Photographs," in *David Smith: Photographs 1931–1965* (New York and San Francisco: Matthew Marks Gallery and Fraenkel Gallery, 1998), 109.
15. "Pachner's Interview with Dorothy Dehner About David Smith's Photographs."
16. Joan Pachner, "Interview with Ralph and Ethel Paiewonsky" (unpublished transcript), October 14, 1986, quoted here courtesy of Joan Pachner.
17. Eric L. Santner noted that W. B. Sebald used the word "orphaned" "to characterize objects that have survived the form of life in which they had meaning" and are now "without a master." See Eric L. Santner, *On Creaturely Life: Rilke, Benjamin, Sebald* (Chicago: University of Chicago Press, 2006), 100.
18. David Smith, "Sketchbook Notes: From the Textures; the Part to the Whole; There Is Something Rather Noble About Junk," 1953, in Cooke, *David Smith*, 189.
19. Dehner interview (1980), Tully.
20. Dorothy Dehner, "Unexpurgated Memoir of John Graham," Dorothy Dehner Foundation, www.dorothydehnerfoundation.org/writings.html.
21. Walter Benjamin, "Surrealism," in *Reflections: Essays, Aphorisms, Autobiographical Writings* (New York: Harcourt Brace Jovanovich, 1978), 181.
22. "[Smith] laid the foundation for the photography of sculpture at the very moment that he was beginning to make sculpture." Sarah Hamill, *David Smith in Two Dimensions: Photography and the Matter of Sculpture* (Oakland: University of California Press, 2015), 19.

10. Entering the 1930s

1. Dehner interview (1987), Renick/Bloomfield.
2. Dorothy Dehner, "Unexpurgated Memoir of John Graham," Dorothy Dehner Foundation, www.dorothydehnerfoundation.org/writings.html. The information about Graham's paintings on the walls is from the memoir.
3. Dorothy Dehner, notes on *Untitled (Standing Figure)*, coral, David Smith, I.45. MoMA Archives, New York.
4. Dehner, "Unexpurgated Memoir of John Graham."
5. Anne Carnegie Edgerton, "John D. Graham, 1886–1961" (unpublished PhD dissertation, University of California, Santa Barbara, 1984), 101.
6. Edgar J. Bernheimer, "To American Museums," *Art Digest* 6 (June 1, 1932): 1, quoted in Patricia Hills, *Stuart Davis* (New York: Harry N. Abrams, 1996), 105.
7. Stuart Davis, "Autobiography," 1945, in *Stuart Davis*, ed. Diane Kelder, Documentary Monographs in Modern Art (New York: Praeger, 1971), 27.
8. James E. B. Breslin, *Mark Rothko: A Biography* (Chicago: University of Chicago Press, 1993), 83.
9. Dorothy Dehner to James Brehm, Knoedler Gallery, November 18, 1972, Dehner papers, AAA, microfilm roll D298.
10. Dehner, "Unexpurgated Memoir of John Graham."

11. Lois Wright, *Untitled*, 1933, David Smith, II.E.15. MoMA Archives, New York.
12. Hayden Herrera, *Arshile Gorky: His Life and Work* (New York: Farrar, Straus and Giroux, 2003), 217, 218.
13. Herrera, *Arshile Gorky*, 174.
14. Dehner, "Unexpurgated Memoir of John Graham."
15. Herrera, *Arshile Gorky*, 174.
16. Smith interview (1964), Hess, 409.
17. Herrera, *Arshile Gorky*, 174.
18. Dehner, "Unexpurgated Memoir of John Graham."

11. Mounting

1. Frank Crowninshield, quoted in Christa Clarke, "John Graham and the Crowninshield Collection of African Art," *Winterthur Portfolio* 30, no. 1 (Spring 1995): 38.
2. James Johnson Sweeney, quoted in Clarke, "John Graham and the Crowninshield Collection," 29.
3. Dorothy Dehner, "Unexpurgated Memoir of John Graham," Dorothy Dehner Foundation, www.dorothydehnerfoundation.org/writings.html.
4. Dehner, "Unexpurgated Memoir of John Graham."
5. Clarke, "Graham and the Crowninshield Collection," 29.
6. John D. Graham, quoted in Clarke, "Graham and the Crowninshield Collection," 33.
7. Graham, quoted in Clarke, "Graham and the Crowninshield Collection," 32.
8. William Rubin, "Picasso," in *"Primitivism" in 20th Century Art: Affinity of the Tribal and the Modern* (New York: Museum of Modern Art, 1984), 1:266.
9. Dehner, "Unexpurgated Memoir of John Graham."
10. Dorothy Dehner, "Foreword," *John Graham's System and Dialectics of Art* (1937; repr. Baltimore: Johns Hopkins University Press, 1971), xiv.
11. Dehner, "Unexpurgated Memoir of John Graham." The new catalogue raisonné of Smith's sculpture concludes that Smith probably made four rather than three sculptures from the leftover wood. Christopher Lyon, ed., *David Smith Sculpture: A Catalogue Raisonné, 1932–1965* (New York: Estate of David Smith, 2021), 24.
12. Dorothy Dehner, *Reclining Figure*, 1933, David Smith, I.45. MoMA Archives, New York.
13. David Smith to Edgar Levy, September 6, 1933, Levy/Corcos papers, AAA, NDSMITHE1, frame 49.
14. Dorothy Dehner to Lucille Corcos and Edgar Levy, August 1933, Levy/Corcos papers, AAA, NDSMITHE1, frame 7.
15. Smith to Levy, September 6, 1933, frame 49.
16. Dorothy Dehner to Lucille Corcos and Edgar Levy, n.d., Levy/Corcos papers, AAA, NDSMITHE1, frame 26.
17. Dehner interviews (1981–1984), Rapp, AAA.

12. Welding

1. David Smith, "Notes on My Work," 1960, in *David Smith: Collected Writings, Lectures, and Interviews*, ed. Susan J. Cooke (Oakland: University of California Press, 2018), 314.
2. David Smith to Roberta González, n.d. [1955], in Carmen Giménez, ed., *Picasso and the Age of Iron* (New York: Solomon R. Guggenheim Museum, 1993), 293.

3. Josephine Withers, *Julio González: Sculpture in Iron* (New York: New York University Press, 1978), 3.

4. Julio González, "Picasso as Sculptor," 1936, in Giménez, *Picasso and the Age of Iron*, 287.

5. Margit Rowell, *Julio González: A Retrospective* (New York: Solomon R. Guggenheim Foundation, 1983), 19.

6. John Richardson, *A Life of Picasso: The Triumphant Years, 1917–1932* (New York: Alfred A. Knopf, 2010), 352.

7. David Smith, "Autobiographical Notes," 1950, in Cooke, *David Smith*, 99.

8. Matt King, email to the author, August 21, 2009.

9. Smith, "Autobiographical Notes," 99.

10. David Smith, "Lecture, Portland Art Museum," 1953, in Cooke, *David Smith*, 184.

11. Smith, "Lecture, Portland Art Museum," 184.

12. Christopher Lyon, ed., *David Smith Sculpture: A Catalogue Raisonné, 1932–1965* (New York: Estate of David Smith, 2021), 30.

13. Mircea Eliade, *The Forge and the Crucible: The Origins and Structures of Alchemy* (Chicago: University of Chicago Press, 1978), 29, 56, 99.

14. Dore Ashton, "The Forging of New Philosophical Armatures: Sculpture Between the Wars and Ever Since," in Giménez, *Picasso and the Age of Iron*, 29.

15. Paul Gauguin, quoted in Ashton, "The Forging of New Philosophical Armatures," 28.

16. Santiago Rusiñol, quoted in Ashton, "The Forging of New Philosophical Armatures," 3.

17. Frank Lloyd Wright, "In the Cause of Architecture: Steel," 1927, in *The Essential Frank Lloyd Wright: Critical Writings on Architecture*, ed. Bruce Brooks Pfeiffer (Princeton: Princeton University Press, 2008), 98.

18. David Smith, "Notes for Elaine de Kooning," 1951, in Cooke, *David Smith*, 128.

19. David Smith, "The New Sculpture," 1952, in Cooke, *David Smith*, 150.

20. E. A. Carmean, Jr., *David Smith*, exhibition catalog (Washington, D.C.: National Gallery of Art, 1982), 41.

21. Anne Wagner, "David Smith: Heavy Metal," in *David Smith: Cubes and Anarchy* (Los Angeles: Los Angeles County Museum of Art, 2011), 72.

22. Wagner, "David Smith: Heavy Metal," 81.

23. Dehner interviews (1981–1984), Rapp, AAA.

24. Smith, "Autobiographical Notes," 100.

25. Dehner interviews (1981–1984), Rapp, AAA.

13. Terminal Iron Works

1. David Smith, "Autobiographical Notes," 1950, in *David Smith: Collected Writings, Lectures, and Interviews*, ed. Susan J. Cooke (Oakland: University of California Press, 2018), 100–101.

2. Dehner interviews (1981–1984), Rapp, AAA.

3. Elizabeth McCausland, "David Smith's Abstract Sculpture in Metals," *Springfield Sunday Union and Republican*, March 31, 1940, 6E.

4. David Smith, "Notes for Elaine de Kooning," 1951, in Cooke, *David Smith*, 129.

5. David Smith, "Letter to Emmanuel Navaretta," November 1959, in *David Smith*, ed. Garnett McCoy (New York: Praeger, 1973), 208.

6. Smith, "Letter to Emmanuel Navaretta."

7. Dehner interviews (1981–1984), Rapp, AAA.

8. Dorothy Dehner, "Unexpurgated Memoir of John Graham," Dorothy Dehner Foundation, www.dorothydehnerfoundationorg/writings.html.

9. Francis V. O'Connor, ed., *The New Deal Art Projects: An Anthology of Memoirs* (Washington, D.C.: Smithsonian Institution Press, 1972), 52.
10. Audrey McMahon, "A General View of the WPA Federal Art Project in New York City and State," in O'Connor, *The New Deal Art Projects*, 53.
11. Mildred Constantine, interview conducted by the author, August 24, 2001, in Nyack, New York.
12. Audrey McMahon, oral history interview conducted by Harlon Phillips, November 18, 1964, AAA.
13. David Smith, "Autobiographical Notes," 1950, in Cooke, *David Smith*, 101.
14. Dorothy Dehner, quoted in David Smith, *David Smith by David Smith*, ed. Cleve Gray (New York: Holt, Rinehart and Winston, 1968), 174.
15. Dehner interviews (1981–1984), Rapp, AAA.
16. Dehner interview (1980), Tully.
17. Dehner interview (1980), Tully. Mayer, in the preface to his seven-hundred-page reference work on materials for artists, included the following acknowledgment: "I am especially indebted to Mr. David Smith and to Mr. I. N. Steinberg for suggestions and assistance in the final preparation of my manuscript." Ralph Mayer, *The Artist's Handbook of Materials and Techniques* (New York: Viking, 1940), vii. Continuously in print for more than eighty years, this is probably still the most exhaustive book on paint techniques ever published.
18. Dehner interviews (1981–1984), Rapp, AAA.
19. Charles Mattox, oral history interview conducted by Lewis Ferbrache, April 9, 1964, AAA.
20. Kirk Varnedoe, "Abstract Expressionism," in *"Primitivism" in 20th Century Art: Affinity of the Tribal and the Modern* (New York: Museum of Modern Art, 1984), 2:649.
21. Dehner interview (1980), Tully.
22. Smith, *David Smith by David Smith*, 174.
23. Paula Wisotzki, "David Smith's 'Medals for Dishonor'" (unpublished PhD dissertation, Northwestern University, 1988), 37–38.
24. Stuart Davis, quoted in Patricia Hills, *Stuart Davis* (New York: Harry N. Abrams, 1996), 109.
25. "A Dialogue: Audrey McMahon, Olive Lyford Gavert, Marchal E. Landgren, Jacob Kainen, Francis V. O'Connor," in O'Connor, ed., *The New Deal Art Projects*, 319.
26. Thomas Craven, *Modern Art: The Men, the Movements, the Meaning* (Garden City, N.Y.: Halcyon House, 1934), 260.
27. Craven, *Modern Art*, 192.
28. Craven, *Modern Art*, 181, 182.
29. Craven, *Modern Art*, 188.
30. Craven, *Modern Art*, 347.
31. Dehner interview (1987), Renick/Bloomfield.
32. Stuart Davis, "The New York American Scene in Art," 1935, in *Stuart Davis*, ed. Diane Kelder, Documentary Monographs in Modern Art (New York: Praeger, 1971), 152–53.
33. Stuart Davis, "The Cube Root," 1943, in Kelder, *Stuart Davis*, 130.

14. Radical Decision

1. David Smith, "Atmosphere of Early '30's," 1952, in *David Smith: Collected Writings, Lectures, and Interviews*, ed. Susan J. Cooke (Oakland: University of California Press, 2018), 152.

2. Emily Genauer, "'Another Language' at the Whitney," *New York World-Telegram*, February 16, 1935.

3. Stuart Davis, "Abstract Painting in America," 1935, in *Stuart Davis*, ed. Diane Kelder, Documentary Monographs in Modern Art (New York: Praeger, 1971), 113.

4. David Smith, "Letter to Jean Xceron," February 7, 1956, in *David Smith*, ed. Garnett McCoy (New York: Praeger, 1973), 206.

5. Dorothy Dehner to Lucille Corcos and Edgar Levy, August 1, 1935, Levy/Corcos papers, AAA, NDSMITHE1, frame 12.

6. Dehner to Corcos and Levy, August 1, 1935, frame 13.

7. Dorothy Dehner to Lucille Corcos and Edgar Levy, August 17, 1935, Levy/Corcos papers, AAA, NDSMITHE1, frame 16.

8. Dehner to Corcos and Levy, August 17, 1935, frame 17.

9. Dorothy Dehner to Lucille Corcos and Edgar Levy, n.d. [1935], Levy/Corcos papers, AAA, NDSMITHE1, frame 36.

10. David Smith, "Autobiographical Notes," 1950, in Cooke, *David Smith*, 103.

11. R. Palme Dutt, *Fascism and Social Revolution: A Study of the Economics and Politics of the Extreme Stages of Capitalism in Decay* (New York: International Publishers, 1935), 13, 45.

12. Dehner to Corcos and Levy, August 17, 1936, frames 17, 18.

13. Dorothy Dehner to Lucille Corcos and Edgar Levy, n.d. [1935], Levy/Corcos papers, AAA, NDSMITHE1, frame 35.

14. Paula Wisotzki, "David Smith's 'Medals for Dishonor'" (unpublished PhD dissertation, Northwestern University, 1988), 39–40.

15. Jacob Kainen, "Revolutionary Art at the John Reed Club," *Art Front*, January 1935, 8.

16. Dutt, *Fascism and Social Revolution*, 91.

17. Dehner interview (1965–1966), McCoy/Krauss, AAA.

18. David Smith to Edgar Levy, n.d. [1935], Levy/Corcos papers, AAA, NDSMITHE1, frame 33.

19. Dorothy Dehner, "Unexpurgated Memoir of John Graham," Dorothy Dehner Foundation, www.dorothydehnerfoundationorg.

20. Smith to Levy, n.d. [1935], frame 33.

21. Dorothy Dehner to Lucille Corcos and Edgar Levy, 1935 [n.d.], Levy/Corcos papers, AAA, NDSMITHE1, frames 37, 38.

22. Dorothy Dehner to Lucille Corcos and Edgar Levy, 1935 [n.d.], Levy/Corcos papers, AAA, NDSMITHE1, frame 235.

23. Audrey McMahon to Dorothy Dehner, October 8, 1935, Dehner papers, AAA, microfilm roll 248.

24. "Call for an American Artists' Congress," *Art Front* 1, no. 7 (November 1935): 6, www.marxists.org/history/usa/parties/cpusa/art-front/v1n07-nov-1935-Art-Front.pdf.

15. Paris

1. Dorothy Dehner to Lucille Corcos and Edgar Levy, n.d. [1935], Levy/Corcos papers, AAA, NDSMITHE1, frames 22, 23.

2. David Smith, "Is Today's Artist with or Against the Past?," 1958, in *David Smith: Collected Writings, Lectures, and Interviews*, ed. Susan J. Cooke (Oakland: University of California Press, 2018), 304.

3. David Smith to Edgar Levy, n.d. [1935], Levy/Corcos papers, AAA, NDSMITHE1, frames 65, 66.

4. Dorothy Dehner, "Unexpurgated Memoir of John Graham," Dorothy Dehner Foundation, www.dorothydehnerfoundation.org/writings.html.
5. John Rewald, "Félix Fénéon: I," *Gazette des beaux-arts* 32 (July–August 1947): 46.
6. Dehner interview (1965–1966), McCoy/Krauss, AAA.
7. Dorothy Dehner to Lucille Corcos and Edgar Levy, n.d. [1935], Levy/Corcos papers, AAA, NDSMITHE1, frame 61.
8. Dorothy Dehner to Lucille Corcos and Edgar Levy, n.d. [1935], Levy/Corcos papers, AAA, NDSMITHE1.
9. Dehner, "Unexpurgated Memoir of John Graham."
10. Dorothy Dehner, quoted in Karen Wilkin, *David Smith: The Formative Years, Sculptures and Drawings from the 1930s and 1940s* (Edmonton: Edmonton Art Gallery, 1981), 10.
11. Dorothy Dehner, quoted in *John Graham's System and Dialectics of Art* (1937; repr. Baltimore: Johns Hopkins University Press, 1971), xix.
12. Hayter interview (1971), Cummings, AAA.
13. *David Smith: The Prints,* catalogue raisonné by Alexandra Schwartz, essay by Paul Cummings (New York: Pace Prints, 1987), n.p.
14. Dehner to Corcos and Levy, n.d. [1935], frame 61.
15. R. Palme Dutt, *Fascism and Social Revolution: A Study of the Economics and Politics of the Extreme Stages of Capitalism in Decay* (New York: International Publishers, 1935), 8–9.
16. Dorothy Dehner to Lucille Corcos and Edgar Levy, n.d. [1935], Levy/Corcos papers, AAA, NDSMITHE1, frame 58.
17. David Smith to Edgar Levy, postcard, December 3, 1935, Levy/Corcos papers, AAA, NDSMITHE1, frame 50.
18. Franz Boas, *Primitive Art* (1927; repr. New York: Dover, 1955), 2, 19.
19. Dorothy Dehner to Lucille Corcos and Edgar Levy, n.d. [1935], Levy/Corcos papers, AAA, NDSMITHE1, frame 57.
20. Dehner to Lucille Corcos and Edgar Levy, n.d. [1935], Levy/Corcos papers, AAA, frame 56.
21. Dorothy Dehner to Lucille Corcos and Edgar Levy, December 9, 1935, Levy/Corcos papers, AAA, NDSMITHE1, frame 73.
22. Smith to Levy, postcard, December 3, 1935, frame 50.

16. Greece

1. David Smith to Edgar Levy, n.d. [1936], Levy/Corcos papers, AAA, NDSMITHE1, frame 74.
2. Dorothy Dehner to Lucille Corcos and Edgar Levy, n.d. [1936], Levy/Corcos papers, AAA, NDSMITHE1, frame 91.
3. Dorothy Dehner to Lucille Corcos and Edgar Levy, n.d. [1936], Levy/Corcos papers, AAA, NDSMITHE1, frame 80.
4. The drawings are reproduced in Paula Wisotzki's important essay "Americans Abroad: The 1930s, Politics, and the Experience of Europe," *Southeastern College Art Conference Review* 15, no. 5 (2010): 591.
5. Wisotzki, "Americans Abroad," 590–93.
6. Dorothy Dehner to Lucille Corcos and Edgar Levy, n.d. [1936], Levy/Corcos papers, AAA, NDSMITHE1, frame 89.
7. Dehner to Corcos and Levy, n.d. [1936], frame 79.

8. Dorothy Dehner to Lucille Corcos and Edgar Levy, n.d. [1936], Levy/Corcos papers, AAA, NDSMITHE1, frame 79.
9. David Smith to Edgar Levy, n.d. [1936], Levy/Corcos papers, AAA, NDSMITHE1, frame 75.
10. Smith to Levy, n.d. [1936], frame 75.
11. Dehner to Corcos and Levy, n.d. [1936], frame 80.
12. Dorothy Dehner to Lucille Corcos and Edgar Levy, March 25, 1936, NDSMITHE1, frame 84.
13. Smith to Levy, n.d. [1936], frame 75.
14. David Smith to Edgar Levy, n.d. [1936], Levy/Corcos papers, AAA, NDSMITHE1, frame 67.
15. Smith to Levy, n.d. [1936], frame 66.
16. Smith to Levy, n.d. [1936], frame 75.
17. Wisotzki, "Americans Abroad," 587.
18. Wisotzki, "Americans Abroad," 588–89.
19. David Smith to Edgar Levy, n.d. [1936], Levy/Corcos papers, AAA, NDSMITHE1, frame 69.
20. Christina Stead, foreword to *Medals for Dishonor*, exhibition catalog (New York: Willard Gallery, 1940), n.p.; repr. in Jeremy Lewison, *David Smith: Medals for Dishonor, 1937–1940* (Leeds: Henry Moore Centre for the Study of Sculpture, 1991), 63.
21. Dorothy Dehner to Lucille Corcos and Edgar Levy, n.d. [1936], Levy/Corcos papers, AAA, NDSMITHE1, frame 94.
22. George Seldes, *Freedom of the Press* (Cleveland: World Publishing Press, 1935), 215, 222.
23. Dorothy Dehner, "Unexpurgated Memoir of John Graham," Dorothy Dehner Foundation, www.dorothydehnerfoundation.org/writings.html.
24. Dorothy Dehner to Lucille Corcos and Edgar Levy, May 5, 1936, Levy/Corcos papers, AAA, NDSMITHE1, frame 97.
25. Dorothy Dehner to Lucille Corcos and Edgar Levy, December 9, 1935, Levy/Corcos papers, AAA, NDSMITHE1, frame 73.
26. Dehner to Corcos and Levy, n.d. [1936], frame 91.
27. David Smith to Edgar Levy, n.d. [1936], Levy/Corcos papers, AAA, NDSMITHE1, frame 64.
28. David Smith to Lucille Corcos and Edgar Levy, n.d. [1936], Levy/Corcos papers, AAA, NDSMITHE1, frame 69.
29. Dorothy Dehner to Lucille Corcos and Edgar Levy, n.d. [1936], Levy/Corcos papers, AAA, NDSMITHE1, frame 20.
30. Dehner to Corcos and Levy, May 5, 1936, frame 98.
31. Dehner, "Unexpurgated Memoir of John Graham."
32. Dehner interview (1965–1966), McCoy/Krauss, AAA.
33. Wisotzki, "Americans Abroad," 593.
34. Dehner interview (1965–1966), McCoy/Krauss, AAA.
35. Wisotzki, "Americans Abroad," 59–93.
36. Wisotzki, "Americans Abroad," 593.
37. Dehner interview (1965–1966), McCoy/Krauss, AAA.
38. Dehner, "Unexpurgated Memoir of John Graham."
39. Dehner interview (1965–1966), McCoy/Krauss, AAA.
40. Dehner, "Unexpurgated Memoir of John Graham."

41. Dorothy Dehner to Lucille Corcos and Edgar Levy, n.d. [1936], Levy/Corcos papers, AAA, NDSMITHE1, frame 47.
42. Dehner, "Unexpurgated Memoir of John Graham."
43. David Smith, "Interview by David Sylvester," 1960, in *David Smith: Collected Writings, Lectures, and Interviews*, ed. Susan J. Cooke (Oakland: University of California Press, 2018), 320.

17. Back in the Swing

1. Dorothy Dehner to Lucille Corcos and Edgar Levy, August 12, 1936, Levy/Corcos papers, AAA, NDSMITHE1, frame 101.
2. David Smith to Edgar Levy, n.d. [1936], Levy/Corcos papers, AAA, frame 109.
3. David Smith to Edgar Levy, postcard, n.d. [1936], frame 110.
4. Dorothy Dehner to Lucille Corcos and Edgar Levy, September 25, 1936, Levy/Corcos papers, AAA, NDSMITHE1, frame 106.
5. Dehner to Corcos and Levy, September 25, 1936, frame 105.
6. Florence Webster, "Exhibition of 4 Artists on Display Here," *Post-Star* (Glens Falls, N.Y.), September 24, 1936, 7. A copy of this review is in Levy/Corcos papers, AAA, NDSMITHE1, frame 106.
7. Dorothy Dehner to Lucille Corcos and Edgar Levy, October 27, 1936, Levy/Corcos papers, AAA, NDSMITHE1, frame 112.
8. David Smith, "Autobiographical Notes," 1950, in *David Smith: Collected Writings, Lectures, and Interviews*, ed. Susan J. Cooke (Oakland: University of California Press, 2018), 102.
9. Rosalind E. Krauss, *Terminal Iron Works: The Sculpture of David Smith* (Cambridge, Mass.: MIT Press, 1971), 19.
10. Alfred H. Barr, Jr., ed., *Fantastic Art, Dada, Surrealism* (New York: Museum of Modern Art, 1936), 10.
11. Dorothy Dehner, *Portrait of Lucille Corcos*, Dehner papers, AAA, microfilm roll D298A, frame 1763.
12. David Levy, interview conducted by Gordon Rapp, April 21, 1984, transcribed by the author, AAA, quoted here by permission of David C. Levy.

18. In the Mix

1. David Smith, "Autobiographical Notes," 1950, in *David Smith: Collected Writings, Lectures, and Interviews*, ed. Susan J. Cooke (Oakland: University of California Press, 2018), 102.
2. Dorothy Dehner to Lucille Corcos and Edgar Levy, January 11, 1937, Levy/Corcos papers, AAA, NDSMITHE1, frame 119.
3. Dorothy Dehner to Lucille Corcos and Edgar Levy, January 29, 1937, Levy/Corcos papers, AAA, NDSMITHE1, frames 123, 124.
4. Dorothy Dehner to Lucille Corcos and Edgar Levy, March 7, 1937, Levy/Corcos papers, AAA, NDSMITHE1, frame 128.
5. Dorothy Dehner to Lucille Corcos and Edgar Levy, March 16, 1937, Levy/Corcos papers, AAA, NDSMITHE1, frame 130.
6. Dehner to Corcos and Levy, March 16, 1937, Levy/Corcos papers, AAA, frame 131.
7. Elizabeth McCausland, "Save the Arts Projects," *The Nation*, July 17, 1937, 67.
8. "Death in Spain: The Spanish Civil War Has Taken 500,000 Lives in One Year," *Life* 3, no. 2 (July 12, 1937): 19.

9. David Smith, "Second Thoughts on Sculpture," 1954, in Cooke, *David Smith*, 209.

10. "Artists Congress Denounces Japan," *New York Times*, December 18, 1937, 22.

11. David Smith, "Interview by David Sylvester," 1960, in Cooke, *David Smith*, 318–19.

12. Susan Carol Larsen, "The American Abstract Artists Group: A History and Evaluation of Its Impact Upon American Art" (unpublished PhD dissertation, Northwestern University, 1974), 229.

13. Larsen, "The American Abstract Artists Group," 279.

14. Larsen, "The American Abstract Artists Group," 280.

15. Larsen, "The American Abstract Artists Group," 281–82.

19. Showing

1. Willard interview (1969), Cummings, AAA.

2. Willard interview (1969), Cummings, AAA.

3. Miller interviews (1970–71), Cummings, AAA.

4. This title came later. At the time, the sculpture may have been given the more abstract title *Construction with Points*.

5. Sidney Geist, "Prelude: The 1930's," *Arts* 3, no. 12 (September 1956): 53, quoted in Eleanor M. Carr, "The New Deal and the Sculptor" (unpublished PhD dissertation, New York University, 1969), 80.

6. Esther Gottlieb, interview conducted by Stephen Pearsen, in partial fulfillment of the requirements for the degree of master of art, Hunter College, City University of New York, 1975, archives of the Adolph and Esther Gottlieb Foundation.

7. Howard Devree, "A Reviewer's Notebook," *New York Times*, January 23, 1938, 162.

8. Carlyle Burrows, "Steel Sculptures," *New York Herald Tribune*, January 23, 1938, 15.

9. Jacob Kainen, "Abstract Art Exhibit Barely Comprehensible," *Daily Worker*, February 1936.

10. Edward Alden Jewell, "WPA Art Display Opens Here Today," *New York Times*, March 23, 1938, 21.

11. David Smith, "Autobiographical Notes," 1950, in Cooke, *David Smith*, 103.

12. Adolph Gottlieb to Paul Bodin, March 3, 1938, Adolph and Esther Gottlieb Foundation archives, New York.

13. Ernest W. Watson, "From Studio to Forge," *American Artist* 4, no. 3 (March 1940): 21.

14. Dehner interview (1965–1966), McCoy/Krauss, AAA.

15. Carr, "The New Deal and the Sculptor," 40.

16. Carr, "The New Deal and the Sculptor," 54.

17. Carr, "The New Deal and the Sculptor," 72.

18. Jane Harrison Cone, *David Smith, 1906–1965: A Retrospective Exhibition*, exhibition catalog (Cambridge, Mass.: Harvard College, 1966), 5.

19. David Smith, "Modern Sculpture and Society," 1939–40, in *David Smith: Collected Writings, Lectures, and Interviews*, ed. Susan J. Cooke (Oakland: University of California Press, 2018), 31.

20. Dorothy Dehner to Jane Cone, May 19, 1966, quoted here courtesy of Jane Harrison Cone.

21. The sculpture is reproduced on an unpaginated insert in *David Smith*, ed. Garnett McCoy (New York: Praeger, 1973).

22. Carol S. Eliel, "Geometry in David Smith," in *David Smith: Cubes and Anarchy* (Los Angeles: Los Angeles County Museum of Art, 2011), 32.

23. Edward F. Fry, *David Smith* (New York: Solomon R. Guggenheim Foundation, 1969), 33.
24. Anton Refregier, "Notes on Mural—WPA Building—New York World's Fair," 1938–39, quoted here courtesy of Francis V. O'Connor.

20. Fractures

1. Dehner interview (1965–1966), McCoy/Krauss, AAA.
2. James E. B. Breslin, *Mark Rothko: A Biography* (Chicago: University of Chicago Press, 1993), 148.
3. Breslin, *Mark Rothko: A Biography*, 148.
4. Francis V. O'Connor, interview conducted by the author, February 13, 2015, in New York City.
5. Audrey McMahon, "A General View of the WPA Federal Art Project in New York City and State," in *The New Deal Art Projects: An Anthology of Memoirs*, ed. Francis V. O'Connor (Washington, D.C.: Smithsonian Institution Press, 1972), 56.
6. Catherine Smith Stewart to Dorothy Dehner and David Smith, July 20, 1939, Estate of David Smith.
7. "Harve Smith Dies Friday," *Decatur Daily Democrat*, August 5, 1939, 1.
8. "Harvey M. Smith," *Paulding Democrat*, August 10, 1939, 1.
9. Adolph Gottlieb to Paul Bodin, August 26, 1939, Adolph and Esther Gottlieb Foundation archives, New York.
10. Herman Baron, announcement for ACA Gallery exhibition, September 18–30, 1939, typed ms., ACA Gallery records, 1917–1963, AAA, box 2, folder 1: ACA Publications, 1939–1960, frame 4.
11. Hananiah Harari, statement for ACA Gallery exhibition, frame 5.
12. David Smith, "Modern Sculpture and Society," 1939–40, in *David Smith: Collected Writings, Lectures, and Interviews*, ed. Susan J. Cooke (Oakland: University of California Press, 2018), 29.
13. "Blacksmith-Sculptor Forges Art," *Popular Science Monthly: Mechanics and Handicraft*, July 1940, 69.
14. László Moholy-Nagy to David Smith, November 8, 1939, Estate of David Smith. Sarah Hamill refers to the influence on Smith of Moholy-Nagy's "New Vision" in *David Smith in Two Dimensions: Photography and the Matter of Sculpture* (Oakland: University of California Press, 2015), 37, 39, 65.
15. Holger Cahill, quoted in Herschel Browning Chipp, *Theories of Modern Art: A Source Book by Artists and Critics* (Berkeley: University of California Press, 1968), 471.
16. Eleanor M. Carr, "The New Deal and the Sculptor" (unpublished PhD dissertation, New York University, 1969), 92.
17. Carr, "The New Deal and the Sculptor," 91–92.
18. Hamill, *David Smith in Two Dimensions*, 39, 41.
19. Dorothy Dehner, quoted in Anne Carnegie Edgerton, "John D. Graham, 1886–1961" (unpublished PhD dissertation, University of California, Santa Barbara, 1984), 160.

21. Leaving the City

1. David Smith, "Abstract Art in America," 1940, in *David Smith: Collected Writings, Lectures, and Interviews*, ed. Susan J. Cooke (Oakland: University of California Press, 2018), 34–35.
2. Smith, "Abstract Art in America," 35.

3. Smith, "Abstract Art in America," 35.
4. Smith, "Abstract Art in America," 36.
5. David Smith, "Autobiographical Notes," 1950, in Cooke, *David Smith*, 103.
6. Howard Devree, "A Reviewer's Notebook," *New York Times*, March 31, 1940, 132.
7. J[ames] L[echay], "Abstract Creations by David Smith," *Art News* 38, no. 26 (March 30, 1940): 15.
8. "Blacksmith-Sculptor Forges Art," *Popular Science Monthly: Mechanics and Handicraft*, July 1940, 69.
9. Elizabeth McCausland, "David Smith's Abstract Sculptures in Metals," *Springfield Sunday Union and Republican*, March 31, 1940, 6E.
10. "Boilermakers Share Shop with Sculptor," *New York Daily News*, November 8, 1940, B35.
11. Ernest W. Watson, "From Studio to Forge," *American Artist* 4, no. 3 (March 1940): 20.
12. Maude Riley, "Sewer Pipe Sculpture," *Cue*, March 16, 1940, 17–18.
13. Gerald M. Monroe, "The American Artists Congress and the Invasion of Finland," *Archives of American Art Journal* 15, no. 1 (1975): 17.
14. Monroe, "American Artists Congress and Invasion of Finland," 17.
15. Monroe, "American Artists Congress and Invasion of Finland," 18.
16. Monroe, "American Artists Congress and Invasion of Finland," 19.
17. Harold Rosenberg, "The Fall of Paris," in *The Tradition of the New* (Chicago: University of Chicago Press, 1959), 209.
18. Dehner interview (1965–1966), McCoy/Krauss, AAA.
19. Dorothy Dehner to Lucille Corcos and Edgar Levy, n.d. [1940], Levy/Corcos papers, AAA, NDSMITHE1, frames 457, 458.

22. Adjusting

1. Dorothy Dehner to Lucille Corcos and Edgar Levy, n.d. [1940], Levy/Corcos papers, AAA, NDSMITHE1, frame 434.
2. David Smith to Marian Willard, September 21, 1940, Willard Gallery records, AAA.
3. David Smith to Cameron Booth, July 28, 1940, Estate of David Smith.
4. Elizabeth McCausland to David Smith, August 30, 1940, Estate of David Smith.
5. David Smith to Elizabeth McCausland, n.d. [1940], Estate of David Smith.
6. David Smith to Jean Xceron, September 10, 1940, Smith–Xceron letters, AAA.
7. David Smith to Elizabeth McCausland, September 22, 1940, Estate of David Smith. Smith's remarkable discussion of his *Medals for Dishonor* is published as "*Medals for Dishonor*, Responses to Questions from Elizabeth McCausland," 1940, in *David Smith: Collected Writings, Lectures, and Interviews*, ed. Susan J. Cooke (Oakland: University of California Press, 2018), 37–41.
8. Dehner interview (1987), Renick/Bloomfield.
9. Dorothy Dehner to Lucille Corcos and Edgar Levy, August 21, 1940, Levy/Corcos papers, AAA, NDSMITHE1, frame 141.
10. Dehner to Corcos and Levy, August 21, 1940, frame 142.
11. David Smith to Elizabeth McCausland, n.d. [1940], Estate of David Smith.
12. Dehner to Corcos and Levy, August 21, 1940, frame 140.
13. Smith to McCausland, September 22, 1940, Estate of David Smith.
14. Marian Willard to David Smith, August 14, 1940, Estate of David Smith.

15. Dorothy Dehner to Lucille Corcos and Edgar Levy, n.d. [1940], Levy/Corcos papers, AAA, NDSMITHE1, frame 430.

16. Dehner to Corcos and Levy, August 21, 1940, frame 141.

17. David Smith to Marian Willard, November 1940, Willard Gallery records, AAA.

18. Dorothy Dehner to Lucille Corcos and Edgar Levy, n.d. [1940], Levy/Corcos papers, AAA, NDSMITHE1, frame 433.

19. David Smith, "Autobiographical Notes," 1950, in Cooke, *David Smith*, 105.

20. David Smith, "Sculpture: Art Forms in Architecture—New Techniques Affect Both," 1940, in Cooke, *David Smith*, 42.

21. David Smith to Marian Willard, December 5, 1940, Willard Gallery records, AAA.

22. Dehner to Corcos and Levy, n.d. [1940], frame 433.

23. Medals for Dishonor

1. David Smith, "*Medals for Dishonor*: Responses to Questions from Elizabeth McCausland," 1940, in *David Smith: Collected Writings, Lectures, and Interviews*, ed. Susan J. Cooke (Oakland: University of California Press, 2018), 37–38.

2. David Smith, "Interview by David Sylvester," 1960, in Cooke, *David Smith*, 321.

3. Dorothy Dehner, "Medals for Dishonor—The Fifteen Medallions of David Smith," *Art Journal* 37, no. 2 (Winter 1977–78): 144. The sentence about Henry Ford is not included in the published article but is part of the manuscript of the essay preserved in the Dorothy Dehner papers, AAA.

4. Dehner, "Medals for Dishonor," 147.

5. Smith, "*Medals for Dishonor*: Responses to Questions from Elizabeth McCausland," 41.

6. Smith, "*Medals for Dishonor*: Responses to Questions from Elizabeth McCausland," 37.

7. Dehner, "Medals for Dishonor," 147.

8. Smith, "*Medals for Dishonor*: Responses to Questions from Elizabeth McCausland," 38–39.

9. Smith, "*Medals for Dishonor*: Responses to Questions from Elizabeth McCausland," 48.

10. Paula Wisotzki, "Constructing Meaning: The Albany Exhibition of David Smith's *Medals for Dishonor*," *Left History* 15, no. 2 (Summer 2011): 16.

11. Smith, "*Medals for Dishonor*: Responses to Questions from Elizabeth McCausland," 40.

12. Rosalind E. Krauss, *Terminal Iron Works: The Sculpture of David Smith* (Cambridge, Mass.: MIT Press, 1971), 71.

13. Dehner, "Medals for Dishonor," 148.

14. David Smith to Marian Willard, n.d. [1941], Willard Gallery records, AAA.

15. Paula Wisotzki, "David Smith's 'Medals for Dishonor'" (unpublished PhD dissertation, Northwestern University, 1988), 132.

16. Dehner, "Medals for Dishonor," 148.

17. David Smith to Elizabeth McCausland, September 22, 1940, Estate of David Smith.

18. David Smith, "Autobiographical Notes," 1950, in Cooke, *David Smith*, 104.

19. Howard Devree, "A Reviewer's Notebook," *New York Times*, November 10, 1940, 158.

20. Carlyle Burrows, "Medals for Dishonor," *New York Herald Tribune*, November 10, 1940, sec. 6, 8.

21. "Mr. Smith Shows His Medals," *Time*, November, 18, 1940, 57–58.
22. Dorothy Dehner to Lucille Corcos and Edgar Levy, Thanksgiving 1940, Levy/Corcos papers, AAA, NDSMITHE1, frame 429.
23. Elizabeth McCausland, "Notable Current Exhibitions: David Smith's New Sculptural Idiom," *Springfield Sunday Union and Republican*, November 10, 1940, 6E.
24. David Smith to Elizabeth McCausland, n.d. [1940], Estate of David Smith.
25. David Smith to Marian Willard, n.d. [1940], Willard Gallery records, AAA.
26. Marian Willard to David Smith, November 20, 1940, Estate of David Smith.
27. David Smith to Marian Willard, December 5, 1940, Willard Gallery records, AAA.
28. Marian Willard to Elodie Courter, January 8, 1941, Willard Gallery records, AAA.
29. Marian Willard to Elodie Courter, March 22, 1942, Willard Gallery records, AAA.

24. Life on the Farm

1. Dehner interview (1980), Tully.
2. Dehner interview (1987), Renick/Bloomfield.
3. Dorothy Dehner to Lucille Corcos and Edgar Levy, n.d., Levy/Corcos papers, AAA, NDSMITHE1, frame 373.
4. Dorothy Dehner to Lucille Corcos and Edgar Levy, December 20, 1944, Levy/Corcos papers, AAA, NDSMITHE1, frame 248.
5. Wolf F. Muller to Margit W. Chanin, May 20, 1967, David Smith, I.44. MoMA Archives, New York.
6. Dorothy Dehner, "The Garden of Eden," notes about her 1942 painting with the same title, which she wrote in 1975 for the Storm King Art Center in Mountainville, New York; Storm King Art Center Archives.
7. Dehner interviews (1981–1984), Rapp, AAA.
8. Dehner interviews (1981–1984), Rapp, AAA.
9. Dehner interviews (1981–1984), Rapp, AAA.
10. Dehner interviews (1981–1984), Rapp, AAA.
11. Irma Bauman and Mordecai Bauman, interview conducted by the author, June 18, 2002, in New York City.
12. Dorothy Dehner to Lucille Corcos and Edgar Levy, n.d. [1941], Levy/Corcos papers, AAA, NDSMITHE1, frame 373.
13. Judd Tully, "Dorothy Dehner and Her Life on the Farm with David Smith," *American Artist* 47 (October 1983): 60.
14. Mary Neumann, interview conducted by the author, November 16, 2002, in Bolton Landing, New York.
15. Tom Pratt, interview conducted by the author, December 3, 2003, in Clifton Park, New York.
16. Dorothy Dehner to Lucille Corcos and Edgar Levy, May 4, 1941, Levy/Corcos papers, AAA, NDSMITHE1, frame 418.

25. What to Do

1. Paula Wisotzki, "Strategic Shifts: David Smith's China Medal Commission," *Oxford Art Journal* 17, no. 2 (1994): 64.
2. Wisotzki, "Strategic Shifts," 64.
3. Dorothy Dehner to Lucille Corcos and Edgar Levy, n.d. [1942], Levy/Corcos papers, AAA, NDSMITHE1, frame 159.

4. David Smith to Marian Willard, April 21, 1942, Willard Gallery records, AAA.
5. Rosalind E. Krauss, *Terminal Iron Works: The Sculpture of David Smith* (Cambridge, Mass.: MIT Press, 1971), 62.
6. David Smith, "Design for Progress—*Cockfight*," 1947, in *David Smith: Collected Writings, Lectures, and Interviews*, ed. Susan J. Cooke (Oakland: University of California Press, 2018), 71.
7. David Smith to Marian Willard, May 15, 1942, Willard Gallery records, AAA.
8. Wisotzki, "Strategic Shifts," 67.
9. David Smith to Robert Nathan, May 30, 1942, Estate of David Smith. Paula Wisotzki provides a detailed and rigorous analysis of Smith's attempts during World War II to negotiate the provocative content of the *Medals*, in "Constructing Meaning: The Albany Exhibition of David Smith's *Medals for Dishonor*," *Left History* 15, no. 2 (Summer 2011): 11–41.
10. David Smith to Sherman Miller, June 1, 1942, Estate of David Smith.
11. Joel Corcos Levy, interview conducted by the author, September 16, 2008, in New York City.
12. Dorothy Dehner to Lucille Corcos and Edgar Levy, March 19, 1942, Levy/Corcos papers, AAA, NDSMITHE1, frame 171.
13. Dorothy Dehner to Lucille Corcos and Edgar Levy, n.d. [1942], Levy/Corcos papers, AAA, NDSMITHE1, frame 177.
14. Dorothy Dehner to Lucille Corcos and Edgar Levy, n.d. [1941], Levy/Corcos papers, AAA, NDSMITHE1.
15. Dorothy Dehner to Lucille Corcos and Edgar Levy, n.d. [1941], Levy/Corcos papers, AAA, NDSMITHE1, frame 462.
16. Marian Willard to David Smith, May 13, 1941, Estate of David Smith.
17. Marian Willard to David Smith, December 11, 1941, Estate of David Smith.
18. David Smith to Marian Willard, April 21, 1942, Willard Gallery records, AAA.
19. David Smith to Marian Willard, February 20, 1943, Willard Gallery records, AAA.
20. Piet Mondrian, quoted in Steven Naifei and Gregory White Smith, *Jackson Pollock: An American Saga* (New York: Clarkson N. Potter, 1989), 444.
21. Naifei and Smith, *Jackson Pollock*, 347.
22. David Smith, "Interview by David Sylvester," in Cooke, *David Smith*, 320.
23. Marian Willard to David Smith, March 28, 1942, Estate of David Smith.
24. David Smith to Marian Willard, March 2, 1942, Willard Gallery records, AAA.
25. David Smith to Marian Willard, April 15, 1942, Willard Gallery records, AAA.
26. Marian Willard to David Smith, June 6, 1942, Estate of David Smith.
27. Dorothy Dehner to Lucille Corcos and Edgar Levy, n.d. [1942], Levy/Corcos papers, AAA, NDSMITHE1, frame 423.

26. Welding for War

1. Dorothy Dehner to Lucille Corcos and Edgar Levy, n.d. [1942], Levy/Corcos papers, AAA, NDSMITHE1, frame 181.
2. Dorothy Dehner to Celia and Alter Brody, n.d. [1942], Levy/Corcos papers, AAA, NDSMITHE1, frame 386.
3. Dorothy Dehner to Lucille Corcos, n.d. [1942], Levy/Corcos papers, AAA, NDSMITHE1, frame 175.
4. Dorothy Dehner to Lucille Corcos and Edgar Levy, n.d. [1942], Levy/Corcos papers, AAA, NDSMITHE1, frame 187.
5. Dehner to Corcos, n.d. [1942], frame 175.

6. Dorothy Dehner to Lucille Corcos, n.d. [1942], Levy/Corcos papers, AAA, ND-SMITHE1, frame 190.

7. Maude Riley, "David Smith, Courtesy American Locomotive," *Art Digest* 17 (April 15, 1943): 23.

8. David Smith to Marian Willard, August 28, 1942, Willard Gallery records, AAA.

9. Dorothy Dehner to Lucille Corcos, Edgar Levy, and David Levy, n.d. [1942], Levy/Corcos papers, AAA, NDSMITHE1, frame 202.

10. Dehner to Celia and Alter Brody, n.d. [1942], frame 386.

11. Dorothy Dehner to Lucille Corcos and Edgar and David Levy, n.d. [1942], frame 375.

12. Dehner to Celia and Alter Brody, n.d. [1942], frame 388.

13. Dehner to Corcos and Levy, n.d. [1942], frame 376.

14. Dorothy Dehner to Lucille Corcos and Edgar Levy, n.d. [1942], frame 378.

15. Dorothy Dehner to Lucille Corcos and Edgar Levy, November 13, 1942, Levy/Corcos papers, AAA, NDSMITHE1, frame 189.

16. Clement Greenberg, "Avant-Garde and Kitsch," 1939, in *Clement Greenberg: The Collected Essays and Criticism*, vol. 1: *Perceptions and Judgments, 1939–1944*, ed. John O'Brian (Chicago: University of Chicago Press, 1986), 6–7.

17. Clement Greenberg, "Towards a Newer Laocoon," 1940, in O'Brian, *Clement Greenberg*, 1:28.

18. Clement Greenberg, "Review of the Exhibition *American Sculpture of Our Time*," *The Nation*, January 23, 1943, in O'Brian, *Clement Greenberg*, 1:140–41.

19. David Smith to Marian Willard, February 9, 1943, Willard Gallery records, AAA.

20. David Smith to Marian Willard, February 20, 1943, Willard Gallery records, AAA.

21. Clif Bradt, "Few Welders at ALCO Plant Know Their 'Buddy' Is Famed Sculptor," *Knickerbocker News*, February 3, 1943, 1.

22. "Local Sculptor's Work Exhibited," *Schenectady Gazette*, June 24, 1943.

23. David Smith to Marian Willard, March 7, 1942, Willard Gallery records, AAA.

24. "Welder-Sculptor," *Newsweek*, April 19, 1943, 76, 78.

25. Bradt, "Few Welders at ALCO Plant Know Their 'Buddy' Is Famed Sculptor," 1.

26. Riley, "David Smith, Courtesy American Locomotive," 23.

27. David Smith, "The Modern Sculptor and His Materials," 1952, in *David Smith: Collected Writings, Lectures, and Interviews*, ed. Susan J. Cooke (Oakland: University of California Press, 2018), 158.

28. David Smith, "The Recurrence of Totemism," handwritten notes, ca. 1945, in Cooke, *David Smith*, 52.

29. David Smith to Edgar Levy, April 23, 1943, Levy/Corcos papers, AAA, ND-SMITHE1, frame 206.

30. David Smith to Marian Willard, n.d. [1943], Willard Gallery records, AAA.

31. Smith to Willard, n.d. [1943].

32. Clement Greenberg, "Review of the Whitney Annual and the Exhibition *Romantic Painting in America*," *The Nation*, January 1, 1944, in O'Brian, *Clement Greenberg*, 1:171.

33. Dorothy Dehner to Lucille Corcos and Edgar Levy, n.d. [1943], Levy/Corcos papers, AAA, NDSMITHE1, frame 226.

34. David Smith to Marian Willard, February 16, 1944, Willard Gallery records, AAA.

35. Dorothy Dehner to Lucille Corcos. n.d., Levy/Corcos papers, AAA, NDSMITHE1, frame 232.

36. David Smith, *David Smith by David Smith*, ed. Cleve Gray (New York: Holt, Rinehart and Winston, 1968), 174n42.

37. Joan M. Marter, "Arcadian Nightmares: The Evolution of David Smith and Dorothy Dehner's Work at Bolton Landing," *Reading Abstract Expressionism: Context and Critique* (New Haven: Yale University Press, 2005), 644n29.
38. Mary Gabriel, *Ninth Street Women* (New York: Little, Brown, 2018), 809n64.
39. Dorothy Dehner to Lucille Corcos and Edgar Levy, December 11, 1943, Levy/Corcos papers, AAA, NDSMITHE1, frame 244.
40. David Smith to Marian Willard, November 3, 1943, Willard Gallery records, AAA.
41. Dorothy Dehner to Lucille Corcos. n.d., Levy/Corcos papers, AAA, NDSMITHE1, frame 225.
42. David Smith to Marian Willard, n.d. [March 10, 1943], Willard Gallery records, AAA.
43. Paula Wisotzki, "Strategic Shifts: David Smith's China Medal Commission," *Oxford Art Journal* 17, no. 2 (1994): 64, 66. Wisotzki is the only scholar to have studied this commission, and she did so in depth.
44. David Smith to Marian Willard, July 24, 1944, Willard Gallery records, AAA.
45. Dorothy Dehner to Lucille Corcos and Edgar Levy, February 28, 1944, Levy/Corcos papers, AAA, NDSMITHE1.
46. David Smith to Dorothy Dehner, n.d. [June 1942], Dehner papers, AAA, microfilm roll D298A, frame 1696.
47. David Smith to the Museum of Modern Art, July 14, 1942, Estate of David Smith.
48. David Smith to Marian Willard, July 24, 1944, Willard Gallery records, AAA.

27. To Begin Again

1. James Fitch to Dorothy Dehner, May 18, 1944, Dehner papers, AAA, microfilm roll D298A, frame 1632.
2. "Welder-Sculptor," *Newsweek*, April 19, 1943, 6, 78.
3. David Smith to Marian Willard, June 17, 1945, Willard Gallery records, AAA.
4. David Smith to Dorothy Dehner, June 17, 1944, Dehner papers, AAA, microfilm roll D298A, frame 1648. Unless otherwise noted, all the quoted passages referring to Smith and Dehner in May, June, and early July 1944 in this chapter are from cards and letters in the Dorothy Dehner papers.
5. David Smith to Edgar Levy, May 27, 1944, Levy/Corcos papers, AAA, NDSMITHE1, frame 237.
6. Dorothy Dehner to Lucille Corcos, May 29, 1944, Levy/Corcos papers, AAA, NDSMITHE1, frame 239.
7. Dehner interviews (1981–1984), Rapp, AAA.
8. Dehner interview (1980), Tully.
9. Quoted in Michael Leja, *Reframing Abstract Expressionism: Subjectivity and Painting in the 1940s* (New Haven: Yale University Press, 1993), 5–6.
10. David Smith, "Symposium: Art and Religion," *Art Digest* 28 (December 15, 1953): 11.
11. David Smith to Marian Willard, January 23, 1945, Willard Gallery records, AAA.
12. David Smith to Marian Willard, May 21, 1945, Willard Gallery records, AAA.
13. Dorothy Dehner to Lucille Corcos, February 25, 1945, Levy/Corcos papers, AAA, NDSMITHE1, frame 253.
14. Dorothy Dehner to Lucille Corcos, March 2, 1945, Levy/Corcos papers, AAA, NDSMITHE1, frame 254.
15. Jerry Dodge, "The Visual Arts," *Post-Star* (Glens Falls, N.Y.), May 4, 1945.
16. Dodge, "The Visual Arts."

17. Smith to Willard, June 17, 1945.
18. Robert Cronbach, "David Smith," *New Masses*, February 19, 1946, 27.
19. David Smith, "Autobiographical Notes," 1950, in *David Smith: Collected Writings, Lectures, and Interviews*, ed. Susan J. Cooke (Oakland: University of California Press, 2018), 106.
20. Smith to Willard, June 17, 1945.
21. W. R. Valentiner, "David Smith," in *David Smith*, ed. Garnett McCoy (New York: Praeger, 1973), 218.

28. Outbursts

1. Dorothy Dehner to Lucille Corcos, June 7, 1945, Levy/Corcos papers, AAA, NDSMITHE1.
2. For a groundbreaking study of Boas's work in Bolton Landing and her exchanges with Dehner and Smith, and her impact on Dehner in particular, see Paula Wisotzki, "Art, Dance, and Social Justice: Franziska Boas, Dorothy Dehner, and David Smith at Bolton Landing, 1944–1949," *Panorama: Journal of the Association of Historians of American Art* 7, no. 2 (Fall 2021), https://doi.org/10.24926/24716839.12446.
3. Ellen Berland, interviews with the author, October 19 and December 3, 2004, by telephone.
4. Dorothy Dehner to Lucille Corcos, July 9, 1945, Levy/Corcos papers, AAA, NDSMITHE1, frame 260.
5. David Smith, *David Smith by David Smith*, ed. Cleve Gray (New York: Holt, Rinehart and Winston, 1968), 174n44.
6. Dehner interview (1987), Renick/Bloomfield.
7. Dorothy Dehner, interview conducted by Miani Johnson, February 11, 1992, courtesy Miani Johnson, Willard Gallery.
8. Dehner interview (1987), Renick/Bloomfield.
9. David Smith to Marian Willard, n.d. [July 1945], Willard Gallery records, AAA.
10. David Smith to Marian Willard, August 10, 1945, Willard Gallery records, AAA.
11. Dorothy Dehner to Lucille Corcos, September 5, 1945, Levy/Corcos papers, AAA, NDSMITHE1, frame 262.
12. Smith to Willard, August 10, 1945.
13. Smith's description of *Pillar of Sunday* was published by the Willard Gallery in conjunction with *The Sculpture of David Smith*, an exhibition at the Buchholz Gallery and the Willard Gallery, January 2–26, 1946. Willard Gallery Records, AAA.
14. Smith interview (1964), Hess, 408–9.
15. Emily Genauer, "Sculpture in Metal," *New York World-Telegram*, January 5, 1946, 5.
16. Stanley Meltzoff, "David Smith and Social Surrealism," *Magazine of Art* (March 1946): 99.
17. David Smith, "Letter to Edgar Levy," September 1, 1945, in *David Smith*, ed. Garnett McCoy (New York: Praeger, 1973), 96.
18. David Smith to Marian Willard, October 5, 1945, Willard Gallery records, AAA.
19. David Smith to Marian Willard, n.d. [October 1945], Willard Gallery records, AAA.
20. Marian Willard to David Smith, November 5, 1945, Estate of David Smith.
21. Marian Willard to David Smith, October 17, 1945, Estate of David Smith.

22. Smith to Willard, n.d. [October 1945].
23. Dehner interview (1987), Renick/Bloomfield.
24. Mildred Constantine, interview conducted by the author, August 24, 2001, in Nyack, New York.
25. Dorothy Dehner to Lucille Corcos and Edgar Levy, May 26, 1946, Levy/Corcos papers, AAA, NDSMITHE1, frame 268.

29. Retrospective

1. Robert M. Coates, "Past and Present," *New Yorker,* January 12, 1946, 39.
2. Clement Greenberg, "Art," *The Nation,* January 26, 1946, 109.
3. "David Smith, Sculpture," *New York Herald Tribune,* January 13, 1946, sec. 5, 7.
4. Emily Genauer, "Sculpture in Metal," *New York World-Telegram,* January 5, 1946, 5.
5. Robert Cronbach, "David Smith," *New Masses,* February 19, 1946, 27.
6. Maude K. Riley, "The Modern Idiom in Concrete Terms: The Sculpture of David Smith," *MKR's Art Outlook* 1 (February 1946): 5.
7. Milton Brown, "After Three Years," *Magazine of Art* 39, no. 4 (April 1946): 66.
8. W. R. Valentiner, *The Sculptures of David Smith, January 2–26, 1940,* exhibition catalog (New York: Buchholz Gallery and Willard Gallery, 1940), n.p.
9. H.C., "Solo Exhibitions of Interest," *New York Sun,* January 5, 1946, 9.
10. Coates, "Past and Present," 39.
11. *Tomorrow* 5, no. 8 (April 1946).
12. Genauer, "Sculpture in Metal," 5.
13. Cronbach, "David Smith," 27.
14. Robert Goldwater, "Art Chronicle: A Season of Art," *Partisan Review,* July/August 1947, 418.
15. Stanley Meltzoff, "David Smith and Social Surrealism," *Magazine of Art* 39 (March 1946): 100.
16. Meltzoff, "David Smith and Social Surrealism," 101.
17. Robert Goldwater and Marco Traves, eds., *Artists on Art from the XIV to the XX Century* (New York: Pantheon, 1945), 46–47.
18. Goldwater and Traves, eds., *Artists on Art,* 48.
19. Goldwater and Traves, eds., *Artists on Art,* 66.

30. Building

1. David Smith to Darrell Herron, August 26, 1946, the William D. Herron collection on Ohio University alumni and staff, the Robert E. and Jean R. Mahn Center for Archives and Special Collections, Ohio University.
2. Lura Beam to David Smith, May 29, 1946, Estate of David Smith.
3. David Smith to Lura Beam, July 8, 1946, Estate of David Smith.
4. Sarah Hamill, *David Smith in Two Dimensions: Photography and the Matter of Sculpture* (Oakland: University of California Press, 2015), 30.
5. Hamill, *David Smith in Two Dimensions,* 43.
6. Lura Beam, "Memorandum to the Branches, David Smith: Photographs of Sculpture, AAU Exhibition," 1946, 5. The typescript included other sections on "Materials and Process." I believe the memorandum was present in the galleries and museums accompanying the exhibition.
7. Lura Beam to David Smith, August 3, 1947, Estate of David Smith.
8. Lewis L. Smith to David Smith, May 17, 1947, Estate of David Smith.

9. Dorothy Dehner to Lucille Corcos and Edgar Levy, May 26, 1946, Levy/Corcos papers, AAA, NDSMITHE1, frame 267.

10. David Smith to Marian Willard, October 1945, Willard Gallery records, AAA.

11. Dorothy Dehner to Lucille Corcos and Edgar Levy, October 1946, Levy/Corcos papers, AAA, NDSMITHE1, frame 273.

12. Dehner interviews (1981–1984), Rapp, AAA.

13. Dorothy Dehner to Lucille Corcos and Edgar Levy, September 27, 1946, Levy/Corcos papers, AAA, NDSMITHE1, frame 270.

14. Johanna Crockwell, interview conducted by the author, August 20, 2004, in Jericho, Vermont.

15. Dehner to Corcos and Levy, October 1946, frame 272.

16. Dorothy Dehner to Lucille Corcos and Edgar Levy, October 1946, Levy/Corcos papers, AAA, NDSMITHE1, frame 270.

17. Dehner to Corcos and Levy, September 27, 1946, frame 270.

18. Rosalind E. Krauss, *Terminal Iron Works: The Sculpture of David Smith* (Cambridge, Mass.: MIT Press, 1971), 90n43.

19. David Smith, *David Smith by David Smith*, ed. Cleve Gray (New York: Holt, Rinehart and Winston, 1968), 174.

20. Dehner to Corcos and Levy, October 1946, frame 272.

21. Marian Willard to David Smith, October 31, 1946, Estate of David Smith.

22. David Smith to Marian Willard, n.d. [November 1946], Willard Gallery records, AAA.

23. David Smith postcard to Marian Willard, [postmark date unclear, probably December 1946], Willard Gallery records, AAA.

31. Creation Myths

1. Stephen E. Ambrose, *Eisenhower*, vol. 1: *Soldier, General of the Army, President-Elect, 1890–1952* (New York: Simon & Schuster, 1983), 468.

2. Clement Greenberg, "The Present Prospects of American Painting and Sculpture," *Horizon*, October 1947, 29, in *Clement Greenberg: The Collected Essays and Criticism*, vol. 2: *Arrogant Purpose, 1945–1949*, ed. John O'Brian (Chicago: University of Chicago Press, 1988), 169.

3. David Smith, "Lecture, Skidmore College," 1947, in *David Smith: Collected Writings, Lectures, and Interviews*, ed. Susan J. Cooke (Oakland: University of California Press, 2018), 66–67.

4. Ernst Kris, "Approaches to Art," in *Psychoanalysis Today*, ed. Sandor Lorand (New York: International University Press, 1946), 355.

5. Smith, "Lecture, Skidmore College," 65.

6. Dorothy Dehner to Lucille Corcos, March 1, 1947, Levy/Corcos papers, AAA, NDSMITHE1, frame 275.

7. Marion D. Pease to David Smith, n.d. [1947], Estate of David Smith.

8. The letter and the reference to the Bible appear in David Smith, *David Smith by David Smith*, ed. Cleve Gray (New York: Holt, Rinehart and Winston, 1968), 174n15. The letter is also published on the Dorothy Dehner Foundation website, www.dorothydehnerfoundation.org/writings.html.

9. Dorothy Dehner papers, AAA.

10. Marian Willard to David Smith, February 19, 1947, Estate of David Smith.

11. David Smith to Marian Willard, February 23, 1947, Willard Gallery records, AAA.

12. Smith to Willard, February 23, 1947.

13. David Smith, "Spectres Are," from "The Landscape; Spectres Are; Sculpture Is," 1947, in Cooke, *David Smith*, 69.

14. David Smith, "The Landscape," from "The Landscape; Spectres Are; Sculpture Is," 1947, in Cooke, *David Smith*, 68.

15. Marian Willard to David Smith, February 28, 1947, Estate of David Smith.

16. David Smith, "Sculpture Is," from "The Landscape; Spectres Are; Sculpture Is," 1947, in Cooke, *David Smith*, 69–70. The ani is a cuckoo bird of the American tropics, 12 to 14 inches long and almost entirely black. The cuckoo is a bird with associations both to the Bible and to myth.

17. David Smith to Claire Rumsey of the Willard Gallery, n.d. [March 1947], Willard Gallery records, AAA.

18. Smith, "Sculpture Is," 70.

19. Kenneth Gross discusses the dream of Nebuchadnezzar in *The Dream of the Moving Statue* (University Park: Pennsylvania State University Press, 1992), 47.

20. Smith, "Sculpture Is," 70.

21. Edward S. Casey, *The Fate of Place: A Philosophical History* (Berkeley: University of California Press, 1997), 27.

22. Smith, "Sculpture Is," 70.

23. Ben Wolf, "David Smith Displays Mechanized 'Sculpture,'" *Art Digest* 21, no. 19 (April 15, 1947): 18.

24. Clement Greenberg, "Review of Exhibitions of David Smith, David Hare, and Mirko," *The Nation*, April 19, 1947, in O'Brian, *Clement Greenberg*, 2:141.

25. Maude K. Riley, "New York Exhibitions," *MKR's Art Outlook*, April 14, 1947, 4.

26. Greenberg, "Review of Exhibitions of David Smith, David Hare, and Mirko," 141.

27. David Smith to Marian Willard, April 13, 1947, Willard Gallery records, AAA.

28. Marian Willard to David Smith, April 15, 1947, Estate of David Smith.

29. Greenberg, "Review of Exhibitions of David Smith, David Hare, and Mirko," 140.

30. Clement Greenberg, "Art," *The Nation*, April 19, 1947, repr. as "Review of the Whitney Annual and Exhibitions of Picasso and Henri Cartier-Bresson," in O'Brian, *Clement Greenberg*, 2:138.

31. Clement Greenberg, "The Present Prospects of American Painting and Sculpture," in O'Brian, *Clement Greenberg*, 2:167.

32. Clement Greenberg to Marian Willard, May 12, 1947, Willard Gallery records, AAA.

33. Clement Greenberg to David Smith, May 12, 1947, Estate of David Smith.

34. David Smith to Marian Willard, October 17, 1947, Willard Gallery records, AAA.

35. David Smith to Marian Willard, n.d. [1947], Willard Gallery records, AAA.

32. The House

1. Dorothy Dehner to Lucille Corcos, October 8, 1947, Levy/Corcos papers, AAA, NDSMITHE1, frame 282.

2. Dorothy Dehner to Corcos, August 27, 1947, Levy/Corcos papers, AAA, NDSMITHE1, frame 280.

3. Dehner to Corcos, August 27, 1947, frame 281.

4. Dehner to Corcos, October 8, 1947, frame 283.

5. Regina Cherry, interview conducted by the author, March 17, 2008, in New York City.

6. David Smith, "The Sculptor's Relationship to the Museum, Dealer, and Public," 1947, in *David Smith: Collected Writings, Lectures, and Interviews*, ed. Susan J. Cooke (Oakland: University of California Press, 2018), 74–75.

7. Ernst Kris and Otto Kurz, *Legend, Myth, and Magic in the Image of the Artist: A Historical Experiment* (New Haven: Yale University Press, 1979), 116.

8. Dehner to Corcos, October 8, 1947, frame 282.

9. Dehner to Corcos, October 8, 1947, frame 282.

10. Dorothy Dehner to Lucille Corcos, December 15, 1947, Levy/Corcos papers, AAA, NDSMITHE1, frame 284.

11. Dehner to Corcos, October 8, 1947, frame 282.

12. David Smith to Edgar Levy, March 27, 1947, Levy/Corcos papers, AAA, NDSMITHE1, frame 276.

13. David Smith to Marian Willard, n.d. [probably February 1947], Willard Gallery records, AAA.

14. "CALL to conference on cultural freedom and civil liberties," Auspices of the Arts, Sciences and Professions Division, Progressive Citizens of America, October 25 and 26, 1947, Hotel Commodore, New York City.

15. Robert Motherwell and Harold Rosenberg, opening statement, *Possibilities 1* (Winter 1947). While Smith insisted to Willard that his catalog copy for the 1947 exhibition not be touched, for *Possibilities 1*, he agreed to allow "I Have Never Looked at a Landscape" and "Sculpture Is" to appear in truncated form.

16. Mildred Constantine to Dorothy Dehner, December 10, 1947, Dehner papers, AAA, microfilm roll D298A.

17. Jean Freas, interview conducted by the author, September 24, 2002, in New York City.

18. Dorothy Dehner to Lucille Corcos, June 27, 1947, Levy/Corcos papers, AAA, NDSMITHE1, frame 279.

19. David Smith to Marian Willard, February 7, 1948, Willard Gallery records, AAA.

20. Dorothy Dehner to Lucille Corcos, February 28, 1948, Levy/Corcos papers, AAA, NDSMITHE1, frame 289.

21. Dehner to Corcos, February 28, 1948, frame 290.

22. Dehner to Corcos, February 28, 1948, frame 296.

23. Dehner interview (1987), Renick/Bloomfield.

24. Dorothy Dehner to Lucille Corcos, July 15, 1948, Levy/Corcos papers, AAA, NDSMITHE1, frame 299.

25. Dehner to Corcos, July 15, 1948, frame 299.

26. David Smith to Marian Willard, May 14, 1948, Willard Gallery records, AAA.

27. Marian Willard to David Smith, May 19, 1948, Estate of David Smith.

28. Dehner to Corcos, July 15, 1948, frame 299.

29. Dehner to Corcos, July 15, 1948, frame 299.

30. David Smith to Marian Willard, September 10, 1948, Willard Gallery records, AAA.

31. Dehner's annotated addition that she wrote on Smith's September 10, 1948, letter to Willard.

32. Dorothy Dehner to Lucille Corcos and Edgar Levy, September 15, 1948, Levy/Corcos papers, AAA, NDSMITHE1.

33. Dehner to Corcos and Levy, September 15, 1948.

33. Teaching

1. Dehner interview (1987), Renick/Bloomfield.
2. David Smith, "Lecture, Skowhegan School of Painting and Sculpture," 1954, in *David Smith: Collected Writings, Lectures, and Interviews*, ed. Susan J. Cooke (Oakland: University of California Press, 2018), 235.
3. Cornelia Langer Noland, "David Smith Remembered," *Washington Magazine*, October 1969, 79.
4. Cornelia Langer Noland, interview conducted by the author, October 25, 2002, in New York City. In this chapter, all the quoted remarks by Langer except the first one are from this interview.
5. Jean Freas, interview conducted by the author, September 24, 2002, in New York City.
6. Clement Greenberg, "Review of the Water-Color, Drawing, and Sculpture Sections of the Whitney Annual," *The Nation*, February 23, 1946, in *Clement Greenberg: The Collected Essays and Criticism*, vol. 2: *Arrogant Purpose, 1945–1949*, ed. John O'Brian (Chicago: University of Chicago Press, 1993), 58.
7. Robert Slifkin, *The New Monuments and the End of Man: U.S. Sculpture Between War and Peace, 1945–1975* (Princeton: Princeton University Press, 2019), 54.
8. Jean Freas, interview conducted by the author, December 11, 2001, in New York City.
9. David Smith, "Report for Interim Week," 1950, in Cooke, *David Smith*, 85–86.
10. David Smith, "Foreword, Dorothy Dehner: Drawings, Paintings," 1948, in Cooke, *David Smith*, 81.
11. Dehner interview (1980), Tully.
12. David Smith to Edgar Levy, March 27, 1947, Levy/Corcos papers, AAA, NDSMITHE1.
13. Dorothy Dehner to Lucille Corcos and Edgar Levy, August 30, 1949, Levy/Corcos papers, AAA, NDSMITHE1, frame 321.

34. Jean Freas

1. Jean Freas, "Living with David Smith," in *David Smith: Drawings from the Fifties*, exhibition catalog (London: Anthony d'Offay Gallery, 1988), 5.
2. Freas, "Living with David Smith," 4–5.
3. Jean Freas, interview conducted by the author, September 24, 2002, in New York City.
4. Freas, "Living with David Smith," 5.
5. Jean Freas, interview conducted by the author, December 11, 2001, in New York City.
6. Freas interview, December 11, 2001.
7. Rebecca Smith, email to the author, July 10, 2021.
8. Freas interview, December 11, 2001.
9. Freas interview, December 11, 2001.
10. Freas interview, December 11, 2001.
11. Freas interview, September 24, 2002.
12. Cornelia Langer Noland, interview conducted by the author, October 25, 2002, in New York City.
13. Freas, "Living with David Smith," 5.
14. Freas interview, September 24, 2002.
15. Jean Freas, interview conducted by the author, January 30, 2004, in New York City.
16. Freas interview, January 30, 2004.
17. Freas interview, September 24, 2002.

35. The End of an Era

1. David Smith, "The Question—What Is Your Hope," ca. 1947, in *David Smith: Collected Writings, Lectures, and Interviews*, ed. Susan J. Cooke (Oakland: University of California Press, 2018), 62.
2. Dehner interview (1980), Tully.
3. David Smith, "Statement, *Herald Tribune* Forum," 1950, in Cooke, *David Smith*, 87.
4. David Smith to Jean Freas, August 16, 1950, Estate of David Smith.
5. Jean Freas, interview conducted by the author, September 24, 2002, in New York City.
6. April Kingsley, *The Turning Point: The Abstract Expressionists and the Transformation of American Art* (New York: Simon & Schuster, 1992), 188.
7. Clement Greenberg to David Smith, postcard, March 31, 1950, Estate of David Smith.
8. Charles Z. Offin, "Gallery Previews in New York," *Pictures on Exhibit* 12 (May 1950): 12.
9. Margaret Breuning, "Smith's Genetic Metal," *Art Digest* 24, no. 18 (May 1, 1950): 11.
10. Robert M. Coates, "The Art Galleries," *New Yorker,* April 29, 1950, 72.
11. David Smith, Sketchbook 40, 51, 1950, Estate of David Smith.
12. Rosalind E. Krauss, *Passages in Modern Sculpture* (Cambridge, Mass.: MIT Press, 1977), 151–52.
13. Robert Motherwell, "For David Smith, 1950," in *David Smith*, exhibition catalog (New York: Willard Gallery, 1950).
14. "Artists' Session at Studio 35," in *Modern Artists in America: First Series*, ed. Robert Goodnough (New York: Wittenborn Schultz, 1951), 9–22.
15. Irving Sandler, "The Irascible Eighteen," brochure for *The Irascibles*, an exhibition at CDS Gallery, New York, February 4–27, 1988.
16. Dorothy Dehner to Lucille Corcos and Edgar Levy, June 1950, Levy/Corcos papers, AAA, NDSMITHE1, frame 340.
17. Freas interview, September 24, 2002.
18. David Smith to Jean Freas, June 10, 1950, Estate of David Smith.
19. Freas interview, September 24, 2002.
20. Dehner interview (1987), Renick/Bloomfield.
21. Edith Halpert, in John D. Morse, ed., *The Artist and the Museum: The Report of the Third Woodstock Art Conference Sponsored by Artists Equity Association and the Woodstock Artists Association, September 1–2 and 9, 1950*, ed. John D. Morse (New York: American Artists Group, 1951), 49.
22. Francis Henry Taylor, in Morse, *The Artist and the Museum*, 57–58.
23. Jean Freas, interview conducted by the author, January 24, 2002, in New York City.
24. David Smith to Dorothy Dehner, n.d. [November 1950], Dehner papers, AAA, microfilm roll D298A, frame 1612.
25. Debra Balken, *Harold Rosenberg: A Critic's Life* (Chicago: University of Chicago Press, 2021), 268.
26. Jean Freas, "Living with David Smith," in *David Smith: Drawings from the Fifties*, exhibition catalog (London: Anthony d'Offay Gallery, 1988), 8.
27. Dorothy Dehner to David Smith, October 1950, Dehner papers, AAA, microfilm roll D298A, frame 868.
28. Kingsley, *The Turning Point*, 188.
29. David Smith to Jean Freas, November 13, 1950, Estate of David Smith.

30. Jean Freas to David Smith, November 1950, quoted here courtesy of Rebecca and Candida Smith.
31. Theta Curri, interview conducted by the author, October 15, 2002, in Bolton Landing, New York.
32. Dehner interview (1992), Johnson.
33. Kingsley, *The Turning Point*, 188.
34. Golda Smith to Dorothy Dehner, 1950, Dehner papers, AAA, microfilm roll D298A, frame 945.
35. Catherine Smith Stewart to Dorothy Dehner, Christmas 1950, Dehner papers, AAA, microfilm roll D298A, frame 906.
36. Dorothy Dehner to Lucille Corcos and Edgar Levy, n.d. [1950], Levy/Corcos papers, AAA, NDSMITHE1, frame 363.
37. David Smith to Jean Freas, December 8, 1950, Estate of David Smith.
38. Emily Genauer, "Art: Some Themes of the Machine Age," *New York Herald Tribune*, April 1, 1951, 7.
39. Edward F. Fry, "The Letter," in *David Smith*, exhibition catalog (New York: Solomon R. Guggenheim Museum, 1969), 62.
40. Rosalind E. Krauss, *Terminal Iron Works: The Sculpture of David Smith* (Cambridge, Mass.: MIT Press, 1971), 84.
41. Fry, "The Letter," 62.
42. David Smith, "The Language Is Image," 1952, in Cooke, *David Smith*, 145.
43. Smith, "The Language Is Image," 145.
44. Dehner interview (1973), Fortess, AAA.

36. A New Landscape

1. David Smith to Edgar Levy, January 5, 1951, Levy/Corcos papers, AAA, NDSMITHE1, frame 344.
2. Jean Freas, interview conducted by the author, January 30, 2004, in New York City.
3. David Smith to Edgar Levy, n.d. [February 1951], Levy/Corcos papers, AAA, NDSMITHE1, frame 343.
4. Jean Freas, "Living with David Smith," in *David Smith: Drawings from the Fifties*, exhibition catalog (London: Anthony d'Offay Gallery, 1988), 7.
5. Kenneth Noland, interview conducted by the author, April 7, 2001, in North Bennington, Vermont.
6. Jean Freas, interview conducted by the author, December 11, 2001, in New York City.
7. Freas interview, December 11, 2001.
8. Gloria Gil, interview conducted by the author, December 3, 2003, in Burlington, Vermont.
9. Clement Greenberg to David Smith, postcard, November 7, 1951, Estate of David Smith.
10. Dorothy Dehner to Lucille Corcos and Edgar Levy, February 4, 1951, Levy/Corcos papers, AAA, NDSMITHE1, frame 344.
11. David Smith to Dorothy Dehner, n.d. [1950], Dehner papers, AAA, microfilm roll D298A, frame 1700.
12. *Christian Science Monitor*, April 7, 1951.
13. "With the Help of Gas," *Time*, April 16, 1951, 56.
14. Emily Genauer, "Art: Some Themes of the Machine Age," *New York Herald Tribune*, April 1, 1951, 7.

15. Robert M. Coates, "Signs and Symbols," *New Yorker*, April 14, 1951, 61.
16. David Smith to Emily Genauer, February 27, 1951, Genauer papers, AAA.
17. Robert M. Coates to David Smith, April 4, 1951, Estate of David Smith.
18. Alfred Leslie, interview conducted by the author, September 24, 2008.
19. Freas, "Living with David Smith," 7.
20. Jean Freas, interview conducted by the author, January 24, 2002, in New York City.
21. Freas interview, January 24, 2002.
22. Freas interview, December 11, 2001.
23. Krasne, "Notes on David Smith Interview," 1951, quoted here courtesy of Belle Krasne Ribicoff.
24. Freas interview, December 11, 2001.
25. Dehner interview (1992), Johnson.
26. David Smith to Emily Genauer, March 19, 1951, Genauer papers, AAA.
27. Freas interview, January 30, 2004.
28. Freas interview, December 11, 2001.
29. Freas interview, December 11, 2001.
30. Krasne "Notes on David Smith Interview," 1951.
31. Dorothy Dehner to Lucille Corcos and Edgar Levy, September 27, 1951, Levy/Corcos papers, AAA, NDSMITHE1, frame 352.
32. Christopher Lyon, ed., *David Smith Sculpture: A Catalogue Raisonné, 1932–1965* (New York: Estate of David Smith, 2021), 332.
33. Elaine de Kooning, "David Smith Makes a Sculpture," *ArtNews* 50, no. 5 (September 1951): 38, 50–51.
34. David Smith, "Hudson River Landscape," *Bennington College Alumnae Quarterly* 3, no. 3 (1952): 17.
35. David Levy, interview conducted by the author, November 6, 2002, in Washington, D.C.
36. Freas interview, January 24, 2002.

37. Embattled Freedom

1. David Smith to Jean Freas, January 5, 1952, Estate of David Smith.
2. Jean Freas, interview conducted by the author, September 24, 2002, in New York City.
3. David Smith to Jean Freas, n.d. [1952], Estate of David Smith. Freas wrote on the letter, "around Xmas."
4. David Smith, "The New Sculpture," 1952, in *David Smith: Collected Writings, Lectures, and Interviews*, ed. Susan J. Cooke (Oakland: University of California Press, 2018), 149–50.
5. Smith, "The New Sculpture," 150.
6. David Smith, "Aesthetics, the Artist, and the Audience," a talk given in Deerfield, Massachusetts, September 24, 1952, in *David Smith*, ed. Garnett McCoy (New York: Praeger, 1973), 106.
7. Smith, "Aesthetics, the Artist, and the Audience," 106.
8. Belle Krasne, "A David Smith Profile," *Art Digest* 26, no. 13 (April 1, 1952): 2.
9. Leo Steinberg, "Sculpture Since Rodin" (book review of *Sculpture of the 20th Century* by Andrew Carnduff Ritchie), *Art Digest* 27, no. 19 (August 1953): 22.
10. David Smith, "Tradition," 1954, in Cooke, *David Smith*, 217.
11. Sidney Geist, "Man of Iron," *Art Digest* 27, no. 10 (February 1, 1953): 16.

12. Clement Greenberg to David Smith, June 18, 1951, Estate of David Smith.
13. Lura Beam to David Smith, July 29, 1952, Estate of David Smith.
14. Victor Wolfson to David Smith, April 17, 1952, Estate of David Smith.
15. Gordon Washburn to David Smith, October 10, 1957, Estate of David Smith.
16. Gordon Washburn to David Smith, January 17, 1958, Estate of David Smith.
17. Jean Freas, email to the author, March 8, 2005.
18. Candida Smith, "The Fields of David Smith," in *The Fields of David Smith*, exhibition catalog for exhibition at Storm King Art Center, May 17–November 15, 1999 (New York: Thames and Hudson, 1999), 28.
19. David Smith, "Lecture, Skowhegan School of Painting and Sculpture," 1952, in Cooke, *David Smith*, 165.
20. For an extensive study of Smith's series, see Michael Brenson, "Series, Sequence, and the Radical Imagination: The Sculpture of David Smith," in *David Smith Sculpture: A Catalogue Raisonné, 1932–1965*, ed. Christopher Lyon (New York: Estate of David Smith, 2021), 1:1–29.
21. David Smith to Belle Krasne, January 2, 1953, Smith–Krasne letters, Storm King.
22. Eric L. Santner, *On Creaturely Life: Rilke, Benjamin, Sebald* (Chicago: University of Chicago Press, 2006). Santner's discussion of creaturely life and of natural history—rooted in readings of these three German writers, plus Kafka, Freud, Giorgio Agamben, and Lacan—has rich potential for thinking about Smith's sculpture.
23. David Smith, "And This Being the Happiest—Is Disappointing," in Cooke, *David Smith*, 25–26. Cooke dates the text 1951. E. A. Carmean, Jr., in his essay for his exhibition on Smith's series, dates this text to the winter of 1951–52; E. A. Carmean, Jr., *David Smith* (Washington, D.C.: National Gallery of Art, 1982), 17.
24. Dorothy Dehner to David Smith, n.d., Dehner papers, AAA, microfilm roll 298A. Part of the letter is quoted in Cooke, *David Smith*, 125.
25. David Smith to Dorothy Dehner, May 7, 1952, Dehner Papers, AAA, microfilm roll D298A, frame 1711.
26. Dorothy Dehner to David Smith, May 1952 [dated May 1, 1952, by Dehner, but clearly sent later], Dehner Papers, AAA, microfilm roll D298A, frame 886.
27. Cornelia Noland, interview conducted by the author, October 25, 2002, in New York City.
28. Jean Freas, interview conducted by the author, January 24, 2002, in New York City.
29. David Smith, "Lecture, Fourth Annual Woodstock Art Conference," 1952, in Cooke, *David Smith*, 168.
30. Barnett Newman, "Remarks at the Fourth Annual Woodstock Art Conference," in *Barnett Newman: Selected Writings and Interviews*, ed. John O'Neill (New York: Alfred A. Knopf, 1990), 242, 246–47.
31. Jean Freas, "Living with David Smith," in *David Smith: Drawings of the Fifties*, exhibition catalog (London: Anthony d'Offay Gallery, 1988), 12–13.
32. Freas, interview conducted by the author, December 11, 2001, in New York City.
33. Freas interview, December 11, 2001.
34. Gail Levin, *Lee Krasner: A Biography* (New York: William Morrow, 2011), 285.
35. Freas interview, December 11, 2001.
36. Levin, *Lee Krasner*, 285.
37. Steven Naifeh and Gregory White Smith, *Jackson Pollock: An American Saga* (New York: Clarkson N. Potter, 1989), 608.
38. Naifeh and Smith, *Jackson Pollock*, 608.
39. Cornelia Noland interview, October 25, 2002.

40. Clement Greenberg, "David Smith," lecture at the Metropolitan Museum of Art, April 27, 1982, my transcription from a tape recording of the lecture made available to me by Kenneth Noland. (There is a manuscript draft of this lecture in the Clement Greenberg papers, 1928–1995, Getty Research Institute, series III, box 31, folder 6.)
41. David Smith to Kenneth Noland, May 20, 1952. I'm grateful to Noland for providing me with copies of Smith's letters to him.
42. Smith to David Durst, September 21, 1952, Estate of David Smith.
43. Jean Freas, email to the author, March 10, 2005.
44. Jean Freas, interview conducted by the author, April 14, 2003, in New York City.
45. Jean Freas, email to the author, March 10, 2005.
46. Freas interview, April 14, 2003.

38. Arkansas

1. Brochure for the exhibition *David Smith: New Sculpture*, at the Kootz Gallery, New York, in association with the Willard Gallery, January 26 through February 14, 1953.
2. Joan and Harry Jackson to David Smith, postcard (or perhaps a note), n.d.
3. David Smith to Belle Krasne, February 24, 1953, Smith–Krasne letters, Storm King.
4. Sidney Geist, "Man of Iron," *Art Digest* 27, no. 10 (February 1, 1953): 16.
5. The quotes by Nunnelley here are from Robert Nunnelley, "Remembering David Smith: Education of a Young Painter," an unpublished memoir he provided to me, and from my interview with him on August 20, 2007, in Greenwich, New York.
6. David Smith, "Books: African Classics for the Modern," 1953, in *David Smith: Collected Writings, Lectures, and Interviews*, ed. Susan J. Cooke (Oakland: University of California Press, 2018), 187–88. For this quotation, I've preferred the wording in Smith's typescript to the wording in the anthology.
7. David Smith, "Lecture, Portland Art Museum," 1953, in Cooke, *David Smith*, 185.
8. David Smith, "Who Is the Artist?," 1953, in Cooke, *David Smith*, 175.
9. David Smith to Jean Freas, February 2, 1953, Estate of David Smith.
10. David Smith to Jean Freas, Estate of David Smith. Smith dated the letter January 11, 1953, but the actual date must be February 11.
11. Smith to Freas, January 11 (or February 11), 1953.
12. Smith to Freas, January 11 (or February 11), 1953.
13. David Smith to Jean Freas, n.d. [1953], Estate of David Smith.
14. David Smith to Jean Freas, March 16, 1953, Estate of David Smith.
15. Jean Freas, interview conducted by the author, January 24, 2002, in New York City.
16. Jean Freas, interview conducted by the author, September 24, 2002, in New York City.
17. Freas interview, January 24, 2002.
18. Jean Freas to Mr. and Mrs. S. A. Freas (her parents), n.d. [April 1953], quoted here courtesy of Rebecca and Candida Smith.
19. Jean Freas, "Living with David Smith," *David Smith: Drawings of the Fifties*, exhibition catalog (London: Anthony d'Offay Gallery, 1988), 9.
20. Freas interview, September 24, 2002.
21. Jean Freas to Mr. and Mrs. S. A. Freas (her parents), April 17, 1953, quoted here courtesy of Rebecca and Candida Smith.
22. David Smith to Thomas Colt, April 12, 1953, Estate of David Smith.
23. David Smith to Marian Willard, April 12, 1953.

24. Marian Willard to David Smith, April 17, 1953, Estate of David Smith.
25. Freas, "Living with David Smith," 10.
26. Samuel Kootz to David Smith, May 15, 1953, Estate of David Smith.
27. David Smith to Samuel Kootz, April 12, 1953, Estate of David Smith.
28. Jean Freas to Mrs. S. A. Freas (her mother), April 17, 1953, quoted here courtesy of Rebecca and Candida Smith.
29. Jean Freas to Helen Frankenthaler, April 20, 1953, Frankenthaler/Motherwell papers, AAA.
30. Jean Freas to Mrs. S. A. Freas (her mother), April 27, 1953, quoted here courtesy of Rebecca and Candida Smith.
31. Jean Freas to Mr. and Mrs. S. A. Freas (her parents), May 6, 1953, quoted here courtesy of Rebecca and Candida Smith.

39. Life Change

1. Jean Freas to Mrs. S. A. Freas (her mother), June 12, 1953, quoted here courtesy of Rebecca and Candida Smith.
2. Jean Freas to Mr. and Mrs. S. A. Freas (her parents), August 8, 1953, quoted here courtesy of Rebecca and Candida Smith.
3. David Smith, "The Modern Sculptor and His Materials," 1952, in *David Smith: Collected Writings, Lectures, and Interviews*, ed. Susan J. Cooke (Oakland: University of California Press, 2018), 56–57.
4. Jean Freas to Mr. S. A. Freas (her father), July 12, 1953, quoted here courtesy of Rebecca and Candida Smith.
5. Jean Freas to Mrs. S. A. Freas (her mother), October 2, 1953, quoted here courtesy of Rebecca and Candida Smith.
6. Jean Freas, interview conducted by the author, January 30, 2004, in New York City.
7. Freas interview, January 30, 2004.
8. Jean Freas to Mrs. S. A. Freas (her mother), August 1, 1953, quoted here courtesy of Rebecca and Candida Smith.
9. Jean Freas, interview conducted by the author, January 24, 2002, in New York City.
10. Jean Freas, "Expressionist Meets Girl: A Love Affair with a Famous Artist Led to Some Unforgettable Meals," *Saveur*, no. 92 (2006): 33.
11. Jean Freas to Mr. and Mrs. S. A. Freas (her parents), August 25, 1953, quoted here courtesy of Rebecca and Candida Smith.
12. Freas to Mr. and Mrs. S. A. Freas (her parents), August 25, 1953.
13. Jean Freas, interview conducted by the author, December, 11, 2001, in New York City.
14. Jean Freas to Mr. and Mrs. S. A. Freas (her parents), September 11, 1954, quoted here courtesy of Rebecca and Candida Smith.
15. Marian Willard to Samuel Kootz, June 17, 1953, Willard Gallery records, AAA.
16. Marian Willard to David Smith, July 8, 1953, Estate of David Smith.
17. David Smith to Katharine Kuh, September 11, 1953, Estate of David Smith.
18. Jean Freas to Mrs. S. A. Freas (her mother), July 1, 1953, quoted here courtesy of Rebecca and Candida Smith.
19. David Smith to Samuel Kootz, August 31, 1953, Estate of David Smith.
20. Samuel Kootz to David Smith, September 21, 1953, Estate of David Smith.
21. Samuel Kootz to David Smith, October 5, 1953, Estate of David Smith.
22. David Smith to Marian Willard, October 7, 1953, Willard Gallery records, AAA.

23. Freas interview, December 11, 2001.
24. David Smith to Mrs. S. A. Freas (Freas's mother), November 25, 1953, quoted here courtesy of Rebecca and Candida Smith.
25. Jean Freas to Mrs. S. A. Freas (her mother), November 28, 1953, quoted here courtesy of Rebecca and Candida Smith.
26. Jean Freas to Mrs. S. A. Freas (her mother), n.d. [fall 1953], quoted here courtesy of Rebecca and Candida Smith.
27. Thomas Hess to David Smith, July 15, 1953, Estate of David Smith.
28. David Smith to Belle Krasne, October 7, 1953, Smith–Krasne letters, Storm King.
29. Alfred M. Frankfurter to David Smith, October 27, 1953, Estate of David Smith.
30. David Smith to Alfred M. Frankfurter, November 15, 1953, Estate of David Smith.
31. Alfred H. Barr, Jr., to David Smith, November 24, 1953, Estate of David Smith.
32. David Smith to Alfred H. Barr, Jr., December 1, 1953, Estate of David Smith.
33. David Smith to Emily Genauer, December 30, 1953, Genauer papers, AAA.

40. Totems

1. Fairfield Porter, "David Smith," *ArtNews* 52, no. 9 (January 1954): 65.
2. Sidney Geist, "A Smith as a Draftsman," *Art Digest* 28, no. 7 (January 1, 1954): 14.
3. David Smith, "Lecture, Skowhegan School of Painting and Sculpture," 1954, in *David Smith: Collected Writings, Lectures, and Interviews*, ed. Susan J. Cooke (Oakland: University of California Press, 2018), 225.
4. Joseph Campbell, *The Masks of God: Primitive Mythology* (New York: Viking Press, 1959), 311.
5. Emily Genauer, "Bonnard and Smith Solo Exhibits," *New York Herald Tribune*, January 17, 1954, sec. 4, 5.
6. Robert Slifkin, *The New Monuments and the End of Man: U.S. Sculpture Between War and Peace, 1945–1975* (Princeton: Princeton University Press, 2019), 86.
7. Slifkin, *The New Monuments and the End of Man*, 47–57. My awareness of the technological watchfulness of the *Tanktotems* and other sculptures by Smith from the 1950s comes from Slifkin's book.
8. Rosalind E. Krauss, *Terminal Iron Works: The Sculpture of David Smith* (Cambridge, Mass.: MIT Press, 1971), 154.
9. Charles Roberts Aldrich, *The Primitive Mind and Modern Civilization* (London: Kegan Paul, 1931), 101.
10. Sigfried Giedion, *The Eternal Present*, vol. 1: *The Beginnings of Art: A Contribution on Constancy and Change* (New York: Bollingen Foundation, 1962), 89–90.
11. Sigmund Freud, *Totem and Taboo: Resemblances Between the Psychic Lives of Savages and Neurotics* (New York: Vintage Books, 1946), 26.
12. Freud, *Totem and Taboo*, 44.
13. Freud, *Totem and Taboo*, 44, 15.
14. Aldrich, *The Primitive Mind and Modern Civilization*, 93.
15. Aldrich, *The Primitive Mind and Modern Civilization*, 112.
16. Freud, *Totem and Taboo*, 24.
17. Ernst Kris, "Approaches to Art," in *Psychoanalysis Today*, ed. Sandor Lorand (New York: International University Press, 1946), 355.
18. Ernst Kris, *Psychoanalytic Explorations in Art* (New York: Schocken Books, 1952). The first chapter of the book, "Approaches to Art," incorporates and expands upon the essay "Approaches to Art" that Smith refers to.
19. Smith interview (1964), Hess, 386.

41. Rebecca

1. Jean Freas, interview conducted by the author, January 30, 2004, in New York City.
2. Jean Freas, interview conducted by the author, January 20, 2002, in New York City.
3. Freas interview, January 30, 2004.
4. Jean Freas to Mrs. S. A. Freas (her mother), March 1954, quoted here courtesy of Rebecca and Candida Smith.
5. Kenneth Noland, interview conducted by the author, April 7, 2001, in North Bennington, Vermont.
6. Freas to Mrs. S. A. Freas (her mother), March 1954.
7. Marian Willard to David Smith, May 11, 1954, Estate of David Smith.
8. David Smith, a note attached to a letter to him from Towle Silversmiths, March 23, 1954, Estate of David Smith.
9. David Smith, "The Artists, the Critic, and the Scholar," 1954, in *David Smith: Collected Writings, Lectures, and Interviews*, ed. Susan J. Cooke (Oakland: University of California Press, 2018), 214–15.
10. David Smith, "Lecture, Skowhegan School of Painting and Sculpture," 1954, in Cooke, *David Smith*, 228.
11. On Becca's birth certificate "Katherine" is spelled "Kathryn." Sure that the name refers to her maternal grandmother "Katherine," Becca is convinced that the spelling is a mistake. Rebecca Smith, email to the author, August 11, 2021.
12. David Smith to Dan Johnson, postcard, n.d., Willard Gallery records, AAA.
13. David Smith to Belle Krasne, April 4, 1954, postcard, Smith–Krasne letters, Storm King.
14. Jean Freas, interview conducted by the author, September 24, 2002, in New York City.
15. Cornelia Langer Noland, interview conducted by the author, October 25, 2002, in New York City.
16. Jean Freas, interview conducted by the author, December 11, 2001, in New York City.
17. Jean Freas to Mr. S. A. Freas (her father), June 23, 1959, quoted here courtesy of Rebecca and Candida Smith.
18. Freas interview, January 30, 2004.
19. David Smith to Herman Cherry, May 3, 1954, Smith–Cherry letters, AAA.
20. James Lord, *Giacometti: A Biography* (New York: Farrar, Straus and Giroux, 1985), 332.
21. Jean Freas, interview conducted by the author, January 24, 2002, in New York City.
22. G. David Thompson to David Smith, June 22, 1954, Estate of David Smith.
23. G. David Thompson to David Smith, July 23, 1954, Estate of David Smith.
24. David Smith to G. David Thompson, July 26, 1954, Estate of David Smith.
25. Jean Freas to Mrs. S. A. Freas (her mother), July 26, 1954, quoted here courtesy of Rebecca and Candida Smith.
26. Freas interview, January 24, 2002.
27. G. David Thompson to David Smith, August 9, 1954, Estate of David Smith.
28. G. David Thompson to David Smith, August 19, 1954, Estate of David Smith.

42. Bloomington

1. David Smith to Lucy Mitten, n.d. [1954], Willard Gallery records, AAA.
2. Jean Freas to Belle Krasne, October 4, 1954, Smith–Krasne letters, Storm King.
3. Porter A. McCray to David Smith, September 17, 1954, Estate of David Smith.

4. David Smith to Marian Willard, September 3, 1954, Willard Gallery records, AAA.

5. Mrs. Henry P. Russell, "Report to the U.S. National Commission for UNESCO on the International Congress of Plastic Arts, Venice Italy, 28 September–3 October, 1954," Estate of David Smith. Angelo Spanio's speech is on page 27.

6. Giuseppe Ungaretti, quoted in Russell, "Report to the U.S. National Commission for UNESCO on the International Congress of Plastic Arts," 31.

7. Gino Severini, quoted in Russell, "Report to the U.S. National Commission for UNESCO on the International Congress of Plastic Arts," 32.

8. David Smith sketchbook, microfilm roll DSMITH2, David Smith papers, 1926–1965, Archives of American Art, Smithsonian Institution.

9. David Smith to Porter McCray, January 21, 1955, Estate of David Smith.

10. David Smith to Herman Cherry, October 31, 1954, Smith–Cherry letters, AAA.

11. David Smith to Lloyd Goodrich, November 4, 1954, Estate of David Smith.

12. Jean Freas to S. A. Freas (her father), October 10, 1954, quoted here courtesy of Rebecca and Candida Smith.

13. Jean Margolin, interview conducted by the author, August 6, 2007, in Cold Spring, New York.

14. David Smith to Herman Cherry, December 7, 1954, Smith–Cherry letters, AAA.

15. Jean Freas to Helen Frankenthaler, April 24, 1957, Frankenthaler/Motherwell papers, AAA.

16. Jean Freas, interview conducted by the author, January 24, 2002, in New York City.

17. David Smith to Herman Cherry, November 12, 1954, Smith–Cherry letters, AAA.

18. Jean Freas to Belle Krasne, October 21, 1954, Smith–Krasne letters, Storm King.

19. David Smith to Lloyd Goodrich, November 4, 1954, Estate of David Smith.

20. Katharine Kuh, "David Smith," *Archives of American Art Journal* 27, no. 3 (1987): 32.

21. Jean Freas, interview conducted by the author, December 11, 2001, in New York City.

22. Jean Freas to Belle Krasne, November 14, 1954, Smith–Krasne letters, Storm King.

23. David Smith to Herman Cherry, n.d., Smith–Cherry letters, AAA.

24. Jean Freas, interview conducted by the author, December 11, 2001, in New York City.

25. Jean Freas, interview conducted by the author, April 14, 2003, in New York City.

26. Jean Freas, interview conducted by the author, January 22, 2002, in New York City.

27. Freas interview, January 24, 2002.

28. Freas interview, April 14, 2003.

29. Jean Freas, interview conducted by the author, January 30, 2004, in New York City.

30. Freas interview, January 30, 2004.

43. Forgings

1. Jean Freas, interview conducted by the author, January 24, 2002, in New York City.

2. Jean Freas, "Living with David Smith," in *David Smith: Drawings of the Fifties*, exhibition catalog (London: Anthony d'Offay Gallery, 1988), 6–7.

3. David Smith to Herman Cherry, January 7, 1955, Smith–Cherry letters, AAA.

4. David Smith to Lucy Mitten and Marian Willard, January 12, 1955, Willard Gallery records, AAA.
5. Jean Freas to Mr. and Mrs. S. A. Freas (her parents), April 4, 1955, quoted here courtesy of Rebecca and Candida Smith.
6. Jean Margolin, interview conducted by the author, August 6, 2007, in Cold Spring, New York.
7. David Smith, quoted in Carmen Giménez, ed., *David Smith: A Centennial*, exhibition catalog (New York: Solomon R. Guggenheim Museum, 2006), 323.
8. Dorothy Dehner to David Smith, March 22, 1955, Dehner papers, AAA, Correspondence 1927–1987, box 3, folder 70–71, and microfilm roll D298A, frame 887.
9. David Smith, handwritten notes ca. 1955, in *David Smith: Collected Writings, Lectures, and Interviews*, ed. Susan J. Cooke (Oakland: University of California Press, 2018), 243.
10. Warren Dennis, "University of Mississippi Department of Art Student Account of David Smith."
11. Jean Freas to Mr. and Mrs. S. A. Freas (her parents), n.d. [March 1955], quoted here courtesy of Rebecca and Candida Smith.
12. Jean Freas to Mr. and Mrs. S. A. Freas (her parents), March 17, 1955, quoted here courtesy of Rebecca and Candida Smith.
13. Jean Freas, interview conducted by the author, September 24, 2002, in New York City.
14. David Smith, "The Artist in Society," 1955, in Cooke, *David Smith*, 244–45.
15. David Smith, "Drawing," 1955, in Cooke, *David Smith*, 254–56.
16. David Smith to Herman Cherry, April 8, 1955, Smith–Cherry letters, AAA.
17. David Smith, "Some Late Words from David Smith," 1965, in Cooke, *David Smith*, 440.
18. Betty Chamberlain, "Echoes of a Triumphant Shout," *ArtNews* 55, no. 2 (April 1956): 25.
19. David Smith, "Some Late Words from David Smith," in Cooke, *David Smith*, 441.
20. Hal Foster, "To Forge," in *David Smith: The Forgings*, exhibition catalog (New York: Gagosian Gallery, 2013), 12.
21. David Smith to Robert Nunnelley, April 3, 1955, quoted here courtesy of Robert Nunnelley.

44. Candida

1. David Smith to Herman Cherry, July 23, 1955, Smith–Cherry letters, AAA.
2. David Smith to G. David Thompson, July 11, 1955, Estate of David Smith.
3. G. David Thompson to David Smith, July 20, 1955, Estate of David Smith.
4. Jean Freas, interview conducted by the author, September 24, 2002, in New York City.
5. David Smith to Herman Cherry, August 15, 1955, Smith–Cherry letters, AAA.
6. David Smith to Marian Willard, August 15, 1955, Willard Gallery records, AAA.
7. Marian Willard to David Smith, August 22, 1955, Estate of David Smith.
8. In the first reference I'm aware of by Smith to all five given names, he spells "Nicolina" with an "e" instead of an "i." David Smith to G. David Thompson, October 31, 1955, Estate of David Smith. Dida, like her mother, spells Nicolina with an "i," which is how the name is spelled on Dida's birth certificate. Candida Smith, email to the author, July 2, 2021. Not long after Smith's letter to Thompson, Freas sent a

letter to her father in which she provided a different order for each of her daughter's names. Becca's name, she wrote, was Rebecca Allen Athena Eve Katherine. Dida's name was Candida Rawley Nicolina Kore Helena. Freas to her father, n.d., fall 1956, courtesy of Rebecca and Candida Smith. Dida writes that her name as it was taught to her by her parents is Candida Kore Nicolina Rawley Helene Smith, and this is the order to which she continues to adhere. Candida Smith, email to the author, July 2, 2021.

9. Smith to Thompson, October 31, 1955.
10. André Malraux, *The Metamorphosis of the Gods* (Garden City, N.Y.: Doubleday, 1960), 64.
11. Thomas B. Hess to David Smith, August 18, 1955, Estate of David Smith.
12. David Smith to Herman Cherry, n.d. [1955], Smith–Cherry letters, AAA.
13. David Smith to Henri Goetz, October 14, 1955, Estate of David Smith.
14. David Smith to Roberta González, October 1955, quoted in Susan J. Cooke, "Lighting the Torch: David Smith on Julio González," in *Julio González–David Smith: Un diálogo sobre la escultura* (Valencia: Institut Valencia d'Art Modern, 2011), 429.
15. David Smith to Herman Cherry, September, n.d. [1955], Smith–Cherry letters, AAA.
16. Smith to Goetz, October 14, 1955.
17. David Smith to Jean Xceron, December 7, 1955, Smith–Xceron letters, AAA.
18. "Metal Sculpture: Machine-Age Art," *Time*, August 15, 1955, 52.
19. Freas interview, September 24, 2002.
20. Jean Freas to Mr. and Mrs. S. A. Freas (her parents), October 10, 1955, quoted here courtesy of Rebecca and Candida Smith.
21. David Smith to "Mrs. Jean Freas and family," October 18, 1955, Estate of David Smith, quoted here courtesy of Rebecca and Candida Smith.
22. Smith to Thompson, October 31, 1955.
23. David Smith to Jean Freas (addressed to "Mrs. David Smith"), October 24, 1955, Estate of David Smith.
24. David Smith to Marian Willard, December 8, 1955, Willard Gallery records, AAA.
25. Florence Rubenfeld, *Clement Greenberg: A Life* (New York: Scribner, 1997), 198.
26. Rubenfeld, *Clement Greenberg*, 199.
27. Rubenfeld, *Clement Greenberg*, 197.
28. Jean Freas, interview conducted by the author, December 11, 2001, in New York City.
29. David Smith to Marian Willard, n.d., Willard Gallery records, AAA.
30. Smith to Willard, December 8, 1955.
31. David Smith to Jean Freas, n.d. [October 1955], Estate of David Smith.
32. David Smith to Marian Willard, November 14, 1954, Willard Gallery records, AAA.
33. Marian Willard to David Smith, December 2, 1954, Estate of David Smith.
34. David Smith to Marian Willard, December 7, 1954, Willard Gallery records, AAA.
35. Marian Willard to David Smith, October 21, 1954, Estate of David Smith.
36. Jean Freas, interview conducted by the author, January 30, 2004, in New York City.
37. Freas interview, January 30, 2004.
38. Jean Freas to Mr. and Mrs. S. A. Freas (her parents), February 1, 1956, quoted here courtesy of Rebecca and Candida Smith.

39. Jean Freas to Mr. and Mrs. S. A. Freas (her parents), n.d., quoted here courtesy of Rebecca and Candida Smith.

40. David Smith to Herman Cherry, January 7, 1956, Smith–Cherry letters, AAA.

41. Jean Freas to Mrs. S. A. Freas (her mother), n.d. [1955], quoted here courtesy of Rebecca and Candida Smith.

45. Down and Up

1. Jean Freas, interview conducted by the author, December, 11, 2001, in New York City.

2. Jean Freas, interview conducted by the author, January 30, 2004, in New York City.

3. David Smith to Jean Xceron, March 7, 1956, Smith–Xceron letters, AAA.

4. David Smith to Dan Johnson, n.d. [March 1956], Willard Gallery records, AAA.

5. Smith to Johnson, n.d. [March 1956].

6. David Smith to Herman Cherry, December 28, 1955, Smith–Cherry letters, AAA.

7. Susan J. Cooke, "Lighting the Torch: David Smith on Julio González," in *Julio González–David Smith: Un diálogo sobre la escultura* (Valencia: Institut Valencia d'Art Modern, 2011), 429.

8. E. C. Goossen, "David Smith," *Arts* 30, no. 6 (March 1956): 24–27.

9. Goossen, "David Smith," 27.

10. Betty Chamberlain, "Echoes of a Triumphant Shout," *ArtNews* 55, no. 2 (April 1956): 93.

11. Emily Genauer, "Critic Deplores New Art of Nothingness," *New York Herald Tribune*, March 1956.

12. Jean Freas to Mr. and Mrs. S. A. Freas (her parents), March 25, 1956, quoted here courtesy of Rebecca and Candida Smith.

13. Jean Freas to Mr. and Mrs. S. A. Freas (her parents), April 12, 1956, quoted here courtesy of Rebecca and Candida Smith.

14. David Smith to Herman Cherry, n.d. [April 1956], Smith–Cherry letters, AAA.

15. *ArtNews* 55, no. 2 (April 1956): 7.

16. Kenneth Noland, interview conducted by the author, April 7, 2001, in North Bennington, Vermont.

17. David Smith to Herman Cherry, April 6, 1956, Smith–Cherry letters, AAA.

18. Vincent Longo, interview conducted by the author, September 25, 2002, in New York City.

19. David Smith to Herman Cherry, n.d. [April 1956], Smith–Cherry letters, AAA.

20. Smith to Cherry, n.d. [April 1956].

21. David Smith to G. David Thompson, June 3, 1956, Estate of David Smith.

22. Willard interview (1969), Cummings, AAA.

23. Cherry interview (1965), Tully, AAA.

24. Marjorie B. Cohn, *Lois Orswell, David Smith, and Modern Art, with the Lois Orswell/David Smith Correspondence*, exhibition catalog (Cambridge, Mass.: Harvard University Art Museums, 2003), 148–49.

25. Cohn, *Orswell, Smith, and Modern Art*, 21.

26. Cohn, *Orswell, Smith, and Modern Art*, 45.

27. Cohn, *Orswell, Smith, and Modern Art*, 128.

28. David Smith to Herman Cherry, June 21, 1956, Smith–Cherry letters, AAA.

29. David Smith to Herman Cherry, June 27, 1956, Smith–Cherry letters, AAA.

46. An Untimely Death

1. Herman Cherry to David Smith, n.d. [summer 1956], Estate of David Smith.
2. Jean Freas to Herman Cherry, July 31, 1956, Smith–Cherry letters, AAA.
3. Jean Freas to Mr. and Mrs. S. A. Freas (her parents), August 14, 1956, quoted here courtesy of Rebecca and Candida Smith.
4. David Smith to Herman Cherry, December 10, 1957, Smith–Cherry letters, AAA.
5. David Smith, "Lecture, Skowhegan School of Painting and Sculpture," 1956, in *David Smith: Collected Writings, Lectures, and Interviews*, ed. Susan J. Cooke (Oakland: University of California Press, 2018), 263–88.
6. David Smith to Herman Cherry, October 16, 1956, Smith–Cherry letters, AAA.
7. Smith to Cherry, October 16, 1956.
8. Sarah Hamill, *David Smith in Two Dimensions: Photography and the Matter of Sculpture* (Oakland: University of California Press, 2015), 62–63.
9. Carol Armstrong, *Cézanne's Gravity* (New Haven: Yale University Press, 2018), 211.
10. Steven Naifeh and Gregory White Smith, *Jackson Pollock: An American Saga* (New York: Clarkson N. Potter, 1989), 781.
11. David Smith to Herman Cherry, August 13, 1956, Smith–Cherry letters, AAA.
12. David Smith to Clement Greenberg, August 14, 1956. The postcard is reproduced in Clifford Ross, ed., *Abstract Expressionism: Creators and Critics* (New York: Harry N. Abrams, 1990), 187.
13. David Smith to Robert Nunnelley, August 14, 1956, quoted here courtesy of Robert Nunnelley.
14. Clement Greenberg to David Smith, August 16, 1956, Estate of David Smith.
15. Herman Cherry to David Smith, n.d. [August 1956], Estate of David Smith.
16. Cherry to Smith, n.d. [August 1956].
17. David Smith to Helen Frankenthaler, n.d. [August 1956], Frankenthaler/Motherwell papers, AAA.
18. David Smith to Herman Cherry, August 21, 1956, Smith–Cherry letters, AAA.
19. David Smith to Adolph Gottlieb, August 23, 1956, archives of the Adolph and Esther Gottlieb Foundation.
20. Jean Freas to Mr. and Mrs. S. A. Freas (her parents), September 10, 1956, quoted here courtesy of Rebecca and Candida Smith.
21. David Smith to Herman Cherry, October 16, 1956, Smith–Cherry letters, AAA.
22. Hamill, *David Smith in Two Dimensions*, 1, 29.
23. David Smith, "The Artist in Society," 1955, in Cooke, *David Smith*, 252.
24. Smith to Frankenthaler, n.d. [August 1956].
25. David Smith to Herman Cherry, n.d. [November 1956], Smith–Cherry letters, AAA.
26. David Smith to Herman Cherry, December 9, 1956, Smith–Cherry letters, AAA.
27. Smith to Gottlieb, August 23, 1956.
28. Herman Cherry to David Smith, December 3, 1956, Estate of David Smith.
29. Clement Greenberg, "David Smith," *Art in America* 44, no. 4 (Winter 1956–57): 30–33.

47. Visits

1. Herman Cherry to David Smith, n.d. [January 1957], Estate of David Smith.
2. David Smith to Herman Cherry, January 12, 1957, Smith–Cherry letters, AAA.

3. Jean Freas, "Living with David Smith," *David Smith: Drawings of the Fifties*, exhibition catalog (London: Anthony d'Offay Gallery, 1988), 13.

4. Jean Freas, interview conducted by the author, December 11, 2001, in New York City.

5. Laura de Coppet and Alan Jones, *The Art Dealers: The Powers Behind the Art Scene Tell How the Art World Really Works* (New York: Clarkson N. Potter, 1984), 87.

6. Freas interview, December 11, 2001.

7. Jean Freas to Mr. and Mrs. S. A. Freas (her parents), February 16, 1957, quoted here courtesy of Rebecca and Candida Smith.

8. Jean Freas to Mr. and Mrs. S. A. Freas (her parents), n.d. [1957], quoted here courtesy of Rebecca and Candida Smith.

9. Jean Freas to Mrs. S. A. Freas (her mother), March 16, 1957, quoted here courtesy of Rebecca and Candida Smith.

10. Jean Freas to Mr. and Mrs. S. A. Freas (her parents), n.d. [1957], quoted here courtesy of Rebecca and Candida Smith.

11. Jean Freas, interview conducted by the author, September 24, 2002, in New York City.

12. "New York's Spreading Upper Bohemia . . . Life Among the Avant-Garde," photo essay, with photographs by Burt Glinn, *Esquire*, July 1957, 46–52.

13. David Smith to Herman Cherry, March 9, 1957, Smith–Cherry letters, AAA.

14. David Smith to Herman Cherry, April 30, 1957, Smith–Cherry letters, AAA.

15. David Smith to Herman Cherry, August 13, 1957, Smith–Cherry letters, AAA.

16. David Smith to Herman Cherry, May 29, 1957, Smith–Cherry letters, AAA.

17. Rebecca Smith, interview conducted by the author, March 11, 2003, in New York City.

18. Jean Freas, interview conducted by the author, January 24, 2002, in New York City.

19. Jean Freas, interview conducted by the author, April 14, 2003, in New York City.

20. Selden Rodman, *"David Smith," Conversations with Artists* (New York: Devin-Adair, 1957), 127–28.

21. David Smith to Herman Cherry, March 6, 1957, Smith–Cherry letters, AAA.

22. David Smith, "False Statements," *Arts* 31, no. 9 (June 1957): 20, in *David Smith: Collected Writings, Lectures, and Interviews*, ed. Susan J. Cooke (Oakland: University of California Press, 2018), 297.

23. David Smith to Herman Cherry, May 13, 1957, Smith–Cherry letters, AAA.

24. Jane Wade to David Smith, May 14, 1957, Estate of David Smith.

25. Otto Gerson to David Smith, May 20, 1957, Estate of David Smith.

26. David Smith to Herman Cherry, May 15, 1957, Smith–Cherry letters, AAA.

27. Jean Freas to Mr. and Mrs. S. A. Freas (her parents), July 2, 1957, quoted here courtesy of Rebecca and Candida Smith.

28. Jean Freas to Mr. and Mrs. S. A. Freas (her parents), July 7, 1957, quoted here courtesy of Rebecca and Candida Smith.

29. Jean Freas to Mrs. S. A. Freas (her mother), June 18, 1957, quoted here courtesy of Rebecca and Candida Smith.

30. Jean Freas to Mr. and Mrs. S. A. Freas (her parents), n.d. [summer 1957], quoted here courtesy of Rebecca and Candida Smith.

31. Freas to Mr. and Mrs. S. A. Freas (her parents), July 2, 1957.

32. Richard Carver Wood to David Smith, July 14, 1957, Estate of David Smith.

33. David Smith to Herman Cherry, n.d. [June 1957], Smith–Cherry letters, AAA.

34. David Smith to Herman Cherry, April 21, 1957, Smith–Cherry letters, AAA.
35. David Smith to Herman Cherry, August 10, 1957, Smith–Cherry letters, AAA.
36. David Smith to Helen Frankenthaler, July 27, 1957, Frankenthaler/Motherwell papers, AAA.

48. MoMA Show

1. David Smith to Herman Cherry, July 29, 1957, Smith–Cherry letters, AAA.
2. David Smith to Herman Cherry, August 31, 1957, Smith–Cherry letters, AAA.
3. Gordon Washburn to David Smith, October 10, 1957, Estate of David Smith.
4. Edgar C. Schenck to David Smith, October 7, 1957, Estate of David Smith.
5. Sam Hunter, "David Smith," *Museum of Modern Art Bulletin* 25, no. 2, exhibition catalog (1957): 9.
6. Hilton Kramer, "Month in Review," *Arts* 32, no. 1 (October 1957): 48.
7. Clifford Odets to David Smith, October 21, 1957, Estate of David Smith.
8. Hunter, "David Smith," 5.
9. Hunter, "David Smith," 11.
10. Hunter, "David Smith," 6.
11. Hunter, "David Smith," 7, 8.
12. Fairfield Porter, "David Smith: Steel into Sculpture," *ArtNews* 56, no. 5 (September 1957): 42.
13. Kramer, "Month in Review," 50.
14. Hunter, "David Smith," 7, 8.
15. Porter, "David Smith: Steel into Sculpture," 42.
16. Porter, "David Smith: Steel into Sculpture," 42, 54.
17. "Sculpture in the Raw," *Time*, September 23, 1957, 78.
18. Ormonde Plater, "A Rugged Art Shapes Out of Iron," *Knickerbocker News*, October 12, 1957, centerfold.
19. Hunter, "David Smith," 3, 4.
20. Kramer, "Month in Review," 49.
21. Hunter, "David Smith," 9.
22. Kramer, "Month in Review," 50.
23. Hunter, "David Smith," 4.
24. Kramer, "Month in Review," 51.
25. Porter, "David Smith: Steel into Sculpture," 42.
26. Porter, "David Smith: Steel into Sculpture," 54.
27. Porter, "David Smith: Steel into Sculpture," 55.
28. Plater, "A Rugged Art Shapes Out of Iron."
29. Jean Freas to Helen Frankenthaler, October 5, 1957, Frankenthaler/Motherwell papers, AAA.
30. David Smith to Helen Frankenthaler, October 6, 1957, Frankenthaler/Motherwell papers, AAA.
31. Golda Smith to David Smith, January 6, 1958, Estate of David Smith.
32. Jean Freas, interview conducted by the author, September 24, 2002, in New York City.
33. Herman Cherry to David Smith, November 1, 1957, Estate of David Smith.
34. David Smith to Herman Cherry, December 10, 1957, Smith–Cherry letters, AAA.
35. David Smith to Herman Cherry, December 30, 1957, Smith–Cherry letters, AAA.
36. Jean Freas interview conducted by the author, April 14, 2003, in New York City.

49. Moving Out

1. Lois Orswell to David Smith, n.d. [January 1958], quoted in Marjorie B. Cohn, *Lois Orswell, David Smith, and Modern Art, with the Lois Orswell/David Smith Correspondence*, exhibition catalog (Cambridge, Mass.: Harvard University Art Museums, 2003), 222.
2. Lois Orswell to David Smith, quoted in Cohn, *Lois Orswell, David Smith, and Modern Art*, 141.
3. Orswell to Smith, quoted in Cohn, *Lois Orswell, David Smith, and Modern Art*, 142.
4. David Smith to Helen Frankenthaler, January 21, 1958, Frankenthaler/Motherwell papers, AAA.
5. Lois Orswell to David Smith, n.d., quoted in Cohn, *Lois Orswell, David Smith, and Modern Art*, 224.
6. David Smith to Fine Arts Associates, January 24, 1958, Estate of David Smith.
7. Lois Orswell to David Smith, n.d., quoted in Cohn, *Lois Orswell, David Smith, and Modern Art*, 228.
8. David Smith to Lois Orswell, April 1, 1958, quoted in Cohn, *Lois Orswell, David Smith, and Modern Art*, 229.
9. Smith to Orswell, April 1, 1958, quoted in Cohn, *Lois Orswell, David Smith, and Modern Art*, 230.
10. Jean Freas interview conducted by the author, April 14, 2003, in New York City.
11. David Smith to Lois Orswell, May 5, 1958, quoted in Cohn, *Lois Orswell, David Smith, and Modern Art*, 230.
12. Lois Orswell to David Smith, n.d., quoted in Cohn, *Lois Orswell, David Smith, and Modern Art*, 232.
13. David Smith to Herman Cherry, May 5, 1958, Smith–Cherry letters, AAA.
14. Smith to Orswell, May 5, 1958, quoted in Cohn, *Lois Orswell, David Smith, and Modern Art*, 230.
15. Vincent Longo, interview conducted by the author, April 25, 2002, in New York City.
16. Clement Greenberg, "Introduction to an Exhibition of Barnett Newman," talk given at Bennington College, May 1958, in *Clement Greenberg: The Collected Essays and Criticism*, vol. 4: *Modernism with a Vengeance, 1957–1969*, ed. John O'Brian (Chicago: University of Chicago Press, 1993), 55.
17. David Smith to Herman Cherry, October 15, 1958, Smith–Cherry letters, AAA.
18. Smith to Orswell, May 5, 1958, quoted in Cohn, *Lois Orswell, David Smith, and Modern Art*, 230.
19. Golda Smith to David Smith, August 11, 1958, Estate of David Smith.
20. David Smith to Herman Cherry, May 22, 1958, Smith–Cherry letters, AAA.
21. Herman Cherry to David Smith, January 23, 1958, Estate of David Smith.
22. David Smith to Helen Frankenthaler and Robert Motherwell, May 22, 1958, Frankenthaler/Motherwell papers, AAA.
23. David Smith to Belle Krasne, December 26, 1958, Smith–Krasne letters, Storm King.
24. Jean Freas, interview conducted by the author, January 30, 2004, in New York City.
25. Rebecca Smith, interview conducted by the author, March 4, 2003, in New York City.
26. David Smith to Herman Cherry, October 8, 1958, Smith–Cherry letters, AAA.
27. David Smith to Lois Orswell, June 12, 1958, quoted in Cohn, *Lois Orswell, David Smith, and Modern Art*, 233.

28. David Smith to Lois Orswell, July 26, 1958, quoted in Cohn, *Lois Orswell, David Smith, and Modern Art*, 234.

29. David Smith to Kenneth Noland, n.d. [1958], quoted here courtesy of Kenneth Noland.

30. Gloria Gil, interview conducted by the author, December 2, 2003, in Burlington, Vermont.

31. Joyce Maranville, interview conducted by the author, November 16, 2001, in Bolton Landing, New York.

32. David Smith to Herman Cherry, July 30, 1958, Smith–Cherry letters, AAA.

33. Jean Freas to Helen Frankenthaler, August 20, 1958, Frankenthaler/Motherwell papers, AAA.

34. Jean Freas to Mrs. S. A. Freas (her mother), n.d. [1958], quoted here courtesy of Rebecca and Candida Smith.

35. Golda Smith to David Smith, August 11, 1958, Estate of David Smith.

36. Candida Smith, interview conducted by the author, March 3, 2003, in New York City.

37. Rebecca Smith, interview conducted by the author, March 11, 2003, in New York City.

38. Candida Smith, interview conducted by the author, March 11, 2003, in New York City.

39. David Smith to Dorothy Dehner, August 5, 1958, Dorothy Dehner papers, AAA.

40. Dehner interview (1980), Tully. Nine years after her interview conducted by Tully, Dehner provided April Kingsley with a less coherent and more extreme narration of that day: "I put them [the paintings and drawings] on the station wagon and I put a tarp over them and he knew. When I drove down to the house and he came out he said, 'Well, the feast is all ready' and I was afraid to say anything. I was afraid for my life. I didn't know what any remark might bring out, so I went in and there was the feast and we talked and talked . . . about anything else, until it was safe for me to leave." April Kingsley, *The Turning Point: The Abstract Expressionists and the Transformation of American Art* (New York: Simon & Schuster, 1992), 193.

41. David Smith to Herman Cherry, October 8, 1958, Smith–Cherry letters, AAA.

42. Dehner interview (1992), Johnson.

43. Janice Van Horne, *A Complicated Marriage: My Life with Clement Greenberg* (Berkeley, Calif.: Counterpoint, 2012), 47–48.

50. New York City

1. David Smith to Herman Cherry, November 3, 1958, Smith–Cherry letters, AAA.

2. Sidney Geist, interview conducted by the author, May 16, 2002, in New York City.

3. Kenneth Noland, interview conducted by the author, April 7, 2001, in North Bennington, Vermont.

4. Alfred Leslie, interview conducted by the author, September 24, 2008, in New York City.

5. Leslie interview, September 24, 2008.

6. Janice Van Horne, *A Complicated Marriage: My Life with Clement Greenberg* (Berkeley, Calif.: Counterpoint, 2012), 122.

7. David Smith to Helen Frankenthaler and Robert Motherwell, August 5, 1958, Frankenthaler/Motherwell papers, AAA.

8. David Smith to Herman Cherry, October 17, 1958, Smith–Cherry letters, AAA. For the art historian Serge Guilbaut, this acquisition marked a turning point:

"The acquisition of the car was more than the acquisition of an object; it was the acquisition of a way of life, of a set of new cultural symbols, which for many years will define American culture at home and abroad. Suddenly the American Avant-Garde *belonged*. Bohemia had finally developed into the Avant-Garde, into the heart of the system; finally, speed and modernity were not only a metaphor on a canvas, but were being lived in everyday life without too many ethical problems." Serge Guilbaut, "Marketing Expressivity in New York During the 1950s," English version by Guilbaut; originally published in French as "Le marketing de l'expressivité à New York au cours des années cinquante" in *Le Commerce de l'Art de la Renaissance à nos jours*, ed. Laurence Bertrand Dorléac (Besançon: Éditions La Manufacture, 1992), 243. My thanks to Paul Hayes Tucker for sending me this essay.

9. David Smith to Herman Cherry, October 27, 1958, Smith–Cherry letters, AAA.
10. "David Smith: A Tribute to One of the Greatest Sculptors of Our Time," *Art in America* 54, no. 1 (January–February 1966): 44.
11. Noland interview, April 7, 2001.
12. David Smith to Herman Cherry, November 8, 1958, Smith–Cherry letters, AAA.
13. Dore Ashton, "James Rosati: World of Inner Rhythms," *Studio International* 167, no. 853 (May 1964): 197.
14. Peter Stroud, interview conducted by the author, October 10, 2003, in Princeton, New Jersey.
15. Albert Elsen, "Interview with James Rosati," in *James Rosati: Sculptures, Reliefs and Drawings 1955–1968*, exhibition catalog (New York: Marlborough Gallery, 1968), 25–26.
16. Herman Cherry to David Smith, October 9, 1957, Estate of David Smith.
17. Otto Gerson to David Smith, December 20, 1958, Estate of David Smith.
18. David Smith to Otto Gerson, January 7, 1959, Gerson papers, AAA.
19. David Smith to Herman Cherry, January 7, 1959, Smith–Cherry letters, AAA.
20. Hilton Kramer to David Smith, January 6, 1959, Estate of David Smith.

51. The Diner

1. Jean Freas, interview conducted by the author, January 24, 2002, in New York City.
2. Charlie French, interview conducted by the author, August 18, 2005, in Bolton Landing, New York.
3. William Gates, Jr., interview conducted by the author, December 4, 2004.
4. Jon Halvorsen, "After Death, David Smith May Have Become 'No. 1 Boy,'" *Post-Star* (Glens Falls, N.Y.), September 1, 1973, clipping in the archive of the Bolton Landing Historical Museum.
5. Milo Barlow, interview conducted by the author, August 16, 2005, in Bolton Landing, New York.
6. Dan Budnik, interview conducted by the author, October 25, 2001, in New York City.
7. Dave Rehm, interview conducted by the author, August 19, 2004, in Bolton Landing, New York.
8. Gates interview, December 4, 2004.
9. William Preston Gates, "Bill Gates Diner," *Lake George Mirror*, July 2, 1999.
10. Gates interview, December 4, 2004.
11. Frances and Evans Herman, interview conducted by the author, November 17, 2001, in Bolton Landing, New York.

12. Halvorsen, "After Death, David Smith May Have Become 'No. 1 Boy.'"
13. Henry Caldwell, in conversation with the author, December 5, 2003, in Bolton Landing, New York.
14. Gates interview, December 4, 2004.
15. Rehm interview, August 19, 2004.
16. David Smith to Herman Cherry, October 5, 1959, Smith–Cherry letters, AAA.
17. Jean Rikhoff, *Earth Air Fire & Water: A Memoir* (Bloomington, Ind.: iUniverse, 2011), 244.
18. Kenneth Noland, interview conducted by the author, April 7, 2001, in North Bennington, Vermont.
19. Tom Pratt, interview conducted by the author, December 3, 2003, in Clifton Park, New York.
20. French interview, August 18, 2005.
21. Pratt interview, December 3, 2003.

52. Battles

1. David Boroff, "Cauldron of Creativity," *Saturday Review*, December 21, 1963, 47.
2. Boroff, "Cauldron of Creativity," 45.
3. Patricia Johanson, interview conducted by the author, April 8, 2005, in Buskirk, New York.
4. David Smith to Kenneth Noland, April 6, 1959, quoted here courtesy of Kenneth Noland.
5. David Smith, "Lecture, Ohio State University," 1959, in *David Smith: Collected Writings, Lectures, and Interviews*, ed. Susan J. Cooke (Oakland: University of California Press, 2018), 307–8.
6. David Smith to Dorothy Dehner, n.d., Dehner papers, AAA, microfilm roll D298A, frame 1759.
7. Mark Stephens and Annalyn Swan, *De Kooning: An American Master* (New York: Alfred A. Knopf, 2004), 412.
8. Dan Budnik, interview conducted by the author, October 25, 2001, in New York City.
9. David Smith to Lloyd Goodrich, April 6, 1959, Estate of David Smith.
10. Lloyd Goodrich to David Smith, April 8, 1959, Estate of David Smith.
11. Kenneth Noland to David Smith, February 3, 1959, Estate of David Smith.
12. David Smith to Herman Cherry, May 2, 1959, Smith–Cherry letters, AAA.
13. Johanson interview, April 8, 2005.
14. Spencer A. Samuels to David Smith, July 11, 1959, Estate of David Smith.
15. David Smith to Spencer Samuels, August 8, 1959, Estate of David Smith.
16. Spencer Samuels to David Smith, telegram, August 18, 1959, Estate of David Smith.
17. Jean Freas to Edith Rickey, December 20, 1959, quoted here courtesy of the George Rickey Foundation, Inc.
18. David Smith to Jean Freas, April 15, 1960, Estate of David Smith.
19. David Smith to Lois Orswell, July 22, 1959, quoted in Marjorie B. Cohn, *Lois Orswell, David Smith, and Modern Art, with the Lois Orswell/David Smith Correspondence*, exhibition catalog (Cambridge, Mass.: Harvard University Art Museums, 2003), 243.
20. David Smith to Lois Orswell, July 8, 1959, quoted in Cohn, *Lois Orswell, David Smith, and Modern Art*, 243.

21. Smith to Noland, April 6, 1959.
22. David Smith to Herman Cherry, June 15, 1959, Smith–Cherry letters, AAA.
23. David Smith to Belle Krasne, November 18, 1959, Smith–Krasne letters, Storm King.
24. Emily Genauer, "Two Leading Artists Show Radical Change," *New York Herald Tribune*, September 20, 1959, sec. 4, 7.
25. Irving Sandler, "David Smith," *ArtNews* 58, no. 6 (September 1959): 9.
26. Dore Ashton, "Art: David Smith, Painter," *New York Times*, September 21, 1959, 62.
27. Sidney Tillim, "Month in Review," *Arts* 34, no. 1 (October 1959): 49.
28. Belle Krasne to David Smith, November 15, 1959, Smith–Krasne letters, Storm King.
29. *Time*, September 21, 1959, 81.
30. David Smith to Herman Cherry, November 1, 1959, Smith–Cherry letters, AAA.
31. David Smith to Herman Cherry, November 9, 1959, Smith–Cherry letters, AAA.
32. David Smith to Herman Cherry, December 4, 1959, Smith–Cherry letters, AAA.
33. Ian Barker, *Anthony Caro: Quest for a New Sculpture* (Aldershot, England: Lund Humphries, 2004), 84.
34. Anthony Caro, interview conducted by the author, February 19, 2002, in London.
35. Smith to Cherry, November 9, 1959.
36. Smith to Cherry, November 9, 1959.
37. David Smith to Herman Cherry, November 25, 1959, Smith–Cherry letters, AAA.
38. David Smith to Herman Cherry, November 14, 1959, Smith–Cherry letters, AAA.
39. David Smith to Dorothy Dehner, January 30, 1960, Dorothy Dehner papers, AAA, microfilm roll D298A, frame 1728.
40. Dorothy Dehner to David Smith, n.d. [1960], Dehner papers, AAA, microfilm roll D298A.
41. David Smith to Herman Cherry, January 18, 1959, Smith–Cherry letters, AAA.

53. A Golden Month

1. Stuart Preston, "Full Speed Ahead," *New York Times*, February 21, 1960, X11.
2. David Smith to Herman Cherry, February 2, 1960, Smith–Cherry letters, AAA. Smith mistakenly dated the letter "2-2-59."
3. Helen Frankenthaler to David Smith, February 20, 1960, Estate of David Smith.
4. E. A. Navaretta, "New Sculpture by David Smith," *Art in America* 47, no. 4 (Winter 1959–60): 97, 99.
5. Hilton Kramer, "The Sculpture of David Smith," *Arts* 34, no. 5, special issue devoted to Smith (February 1960): 22–43.
6. David Smith to Herman Cherry, January 24, 1960, Smith–Cherry letters, AAA.
7. David Smith, "Notes on My Work," 1960, in *David Smith: Collected Writings, Lectures, and Interviews*, ed. Susan J. Cooke (Oakland: University of California Press, 2018), 313–15.
8. David Smith to Lois Orswell, n.d., quoted in Marjorie B. Cohn, *Lois Orswell, David Smith, and Modern Art, with the Lois Orswell/David Smith Correspondence*, exhibition catalog (Cambridge, Mass.: Harvard University Art Museums, 2003), 253.
9. E. A. Navaretta to David Smith, February 10, 1960, Estate of David Smith.
10. Robert M. Coates, "The Art Galleries: A Sculptor and Two Painters," *New Yorker*, March 5, 1960, 128.

11. Emily Genauer, "This Week's Menu: Omelette of Arts," *New York Herald Tribune*, February 21, 1960.

12. Fairfield Porter, "Perfection and Nature," *The Nation*, March 12, 1960, in Fairfield Porter, *Art in Its Own Terms: Selected Criticism 1935–1975* (Boston: MFA Publications, 1979), 77–78.

13. Kenneth Sawyer, "Dazzling David Smith Sculpture," *The Sun* (Baltimore), March 13, 1960, A4.

14. Dore Ashton, "Art," *Arts and Architecture* 77, no. 4 (April 1960): 6–7.

15. Robert Samuels, Jr., to David Smith, May 15, 1962, Estate of David Smith.

54. Birthday Party

1. Jack Flam, *Motherwell: 100 Years* (Milan: Skira/Dedalus Foundation, 2015), 27.

2. E. A. Carmean, Jr., *David Smith*, exhibition catalog (Washington, D.C.: National Gallery of Art, 1982), 46–47.

3. Frank O'Hara, "Helen Frankenthaler," in John Elderfield, *Painted on 21st Street: Helen Frankenthaler from 1950 to 1959* (New York: Harry N. Abrams, 2013), 139.

4. Helen Frankenthaler to Jean Freas and David Smith, n.d., Estate of David Smith.

5. David Smith to Herman Cherry, December 14, 1959, Smith–Cherry letters, AAA.

6. Anthony Caro, interview conducted by the author, February 19, 2002, in London.

7. Kenneth Noland, interview conducted by the author, April 7, 2001, in North Bennington, Vermont.

8. Beatrice Monti della Corte, interview conducted by the author, January 9, 2004, in New York City.

9. David Smith, "Memories to Myself," 1960, in *David Smith: Collected Writings, Lectures, and Interviews*, ed. Susan J. Cooke (Oakland: University of California Press, 2018), 330–37.

10. Jean Rikhoff, *Earth Air Fire & Water: A Memoir* (Bloomington, Ind.: iUniverse, 2011), 242.

11. Rebecca Smith interview, March 4, 2003, in New York City.

12. Candida N. Smith, Irving Sandler, and Jerry L. Thompson, *The Fields of David Smith*, exhibition catalog (New York: Storm King Art Center, 1999), 34.

13. Charlie French, interview conducted by the author, August 18, 2005, in Bolton Landing, New York.

14. Lyn Noland, interview conducted by the author, October 9, 2007, in New York City.

15. David Smith to Everett Ellin, n.d., Ellin papers, AAA.

16. David Smith to Herman Cherry, September 21, 1960, Smith–Cherry letters, AAA.

17. Rosalind E. Krauss, *Terminal Iron Works: The Sculpture of David Smith* (Cambridge, Mass.: MIT Press, 1971), 98.

18. David Smith to Lois Orswell, n.d., quoted in Marjorie B. Cohn, *Lois Orswell, David Smith, and Modern Art, with the Lois Orswell/David Smith Correspondence*, exhibition catalog (Cambridge, Mass.: Harvard University Art Museums, 2003), 256.

19. David Smith to Helen Frankenthaler and Robert Motherwell, November 12, 1960, Frankenthaler/Motherwell papers, AAA.

20. B. H. Friedman, a psychologist who was friends with many Abstract Expressionists and wrote an early biography of Pollock—*Jackson Pollock: Energy Made Visible* (New York: McGraw-Hill, 1974)—mentioned in the December 1960 en-

try in his journal his desire to write a book on "contemporary dandyism": "The artists are delighted with their new-found ability to afford things. They are self-conscious in an unapologetic way, a contrast to the fifties. Kline has had his Thunderbird and has just bought a Ferrari, but Motherwell told me a week ago that he bought a Bentley convertible. He was quite apologetic about the purchase. That may be because, unlike Kline, and some of the others, he was born comparatively rich." Bernard Harper Friedman, diary, November 27, 1960, Bernard Harper Friedman papers, 1926–2011, bulk 1943–2010, AAA. I'm grateful to Jack Flam for this information.

21. Candida Smith, interview conducted by the author, March 11, 2003, in New York City.

22. Milo Barlow, interview conducted by the author, August 16, 2005, in Bolton Landing, New York.

55. Unleashed

1. Dorothy Dehner to David Smith, n.d. [1961], Dehner papers, AAA, microfilm roll D298.

2. David Smith to Everett Ellin, March 10, 1961, Ellin papers, AAA.

3. David Smith to Lois Orswell, n.d., quoted in Marjorie B. Cohn, *Lois Orswell, David Smith, and Modern Art, with the Lois Orswell/David Smith Correspondence*, exhibition catalog (Cambridge, Mass.: Harvard University Art Museums, 2003), 260.

4. David Smith to Everett Ellin, January 15, 1961, Estate of David Smith.

5. David Smith to Kenneth Noland, n.d., quoted here courtesy of Kenneth Noland.

6. David Smith to Kenneth Noland, September 25, 1961, quoted here courtesy of Kenneth Noland.

7. David Smith to Dorothy Dehner, n.d., Dehner papers, AAA.

8. David Smith to Everett Ellin, Ellin papers, AAA; the letter is dated December 4, 1961, but the actual date is probably January 4, 1961.

9. David Smith to Otto Gerson, July 30, 1961, Gerson papers, AAA.

10. David Smith to Dorothy Dehner, February 27, 1962, Dehner papers, AAA, microfilm roll D298A, frame 1741.

11. Leon Arkus to David Smith, August 30, 1961, Estate of David Smith.

12. David Smith to Leon Arkus, September 5, 1961, Estate of David Smith.

13. Otto Gerson to David Smith, August 6, 1961, Estate of David Smith.

14. David Smith to Otto Gerson, February 1, 1961, Estate of David Smith.

15. Balin/Traube Gallery to David Smith, n.d. [surely October 1963], Estate of David Smith.

16. Robert Motherwell, "What Should a Museum Be?," a symposium with Herbert Ferber and Edward Durrell Stone, *Art in America* 49, no. 1 (March 1961), in Stephanie Terenzio, *The Collected Writings of Robert Motherwell* (Oxford: Oxford University Press, 1992), 131.

17. David Smith to Everett Ellin, February 28, 1961, Ellin papers, AAA.

18. David Smith to Everett Ellin, May 11, 1962, Ellin papers, AAA.

19. Priscilla Morgan, interview conducted by the author, September 18, 2007, in New York City.

20. Morgan interview, September 18, 2007.

21. David Smith to Priscilla Morgan, March 10, 1961, quoted here courtesy of Priscilla Morgan.

22. Patricia Johanson, interview conducted by the author, April 8, 2005, in Buskirk, New York.

23. Anne Truitt, interview conducted by the author, July 30, 2001, in Washington, D.C.

24. Beatrice Monti della Corte, interview conducted by the author, January 8, 2004, in New York City.

25. Monti interview, January 8, 2004.

26. Mel Gonick, "Area Artist Returns $1,000 So Museum May Buy Art," *Troy Record Morning*, November 2, 1961.

27. Alvin Rosensweet, "Sculptor Refuses $1,000," *Pittsburgh Post-Gazette*, November 1, 1961.

28. Gonick, "Area Artist Returns $1,000 So Museum May Buy Art."

29. David Smith, "Progress Report and Application for Renewal of Guggenheim Fellowship," 1951, in *David Smith: Collected Writings, Lectures, and Interviews*, ed. Susan J. Cooke (Oakland: University of California Press, 2018), 121.

30. David Smith, "Some Late Words from David Smith," 1965, in Cooke, *David Smith*, 431–32.

31. Emily Genauer, "A Shahn Miracle," *New York Herald Tribune*, October 15, 1961, sec. 4, 10.

32. Frank O'Hara, "David Smith: The Color of Steel," *ArtNews* 60, no. 8 (December 1961): 32–34, 69.

33. Candida Smith, interview conducted by the author, March 3, 2003, in New York City.

34. David Smith to Everett Ellin, n.d., Ellin papers, AAA.

35. Dorothy Dehner to David Smith, n.d., Dehner papers, AAA.

36. Herman Cherry to Dorothy Dehner, June 16, 1961, Dehner papers, AAA, microfilm roll D298A, frame 818.

37. Dorothy Dehner to David Smith, April 30, 1961, Dehner papers, AAA, microfilm roll D298A.

38. Kenneth Noland, interview conducted by the author, April 7, 2001, in North Bennington, Vermont.

39. Dorothy Dehner to David Smith, n.d. [1961], Dehner papers, AAA, microfilm roll D298A.

40. David Smith to Dorothy Dehner, n.d. [1961], Dehner papers, AAA, microfilm roll D298A, frame 1737.

41. Lois Orswell wrote this on a note card clipped to Smith's Christmas letter; Cohn, *Lois Orswell, David Smith, and Modern Art*, 267.

42. David Smith to Lois Orswell, December 25, 1961, in Cohn, *Lois Orswell, David Smith, and Modern Art*, 266.

56. The Carnegie

1. Jean Rikhoff, interview conducted by the author, November 15, 2001, in Glens Falls, New York.

2. Candida Smith, interview conducted by the author, March 11, 2003, in New York City.

3. Candida Smith interview, March 11, 2003.

4. Rebecca Smith, interview conducted by the author, March 4, 2003, in New York City.

5. David Smith to Lois Orswell, n.d., quoted in Marjorie B. Cohn, *Lois Orswell, David*

Smith, and Modern Art, with the Lois Orswell/David Smith Correspondence, exhibition catalog (Cambridge, Mass.: Harvard University Art Museums, 2003), 262.

6. David Smith to Otto Gerson, July 30, 1961, Gerson papers, AAA.

7. Clement Greenberg, "David Smith," *Art in America* 54, no. 1 (January–February 1966): 28, in "David Smith: Comments on His Latest Works," in *Clement Greenberg: The Collected Essays and Criticism*, vol. 4: *Modernism with a Vengeance, 1957–1969*, ed. John O'Brian (Chicago: University of Chicago Press, 1993), 223.

8. Edward F. Fry, *David Smith*, exhibition catalog (New York: Solomon R. Guggenheim Museum, 1969), 72.

9. Rosalind E. Krauss, *Terminal Iron Works: The Sculpture of David Smith* (Cambridge, Mass.: MIT Press, 1971), 13.

10. David Smith, "Some Late Words from David Smith," 1965, in *David Smith: Collected Writings, Lectures, and Interviews*, ed. Susan J. Cooke (Oakland: University of California Press, 2018), 432.

11. Frank O'Hara to David Smith, August 17, 1961, Estate of David Smith.

12. Frank O'Hara, "David Smith: The Color of Steel," *ArtNews* 60, no. 8 (December 1961): 32–34, 69–70.

13. David Smith to Helen Frankenthaler and Robert Motherwell, n.d., Frankenthaler/Motherwell papers, AAA.

14. David Smith to Lois Orswell, September 29, 1961, quoted in Cohn, *Lois Orswell, David Smith, and Modern Art*, 264.

15. Leon Arkus to David Smith, September 6, 1961, Estate of David Smith.

16. David Smith to Leon Arkus, September 6, 1961, Estate of David Smith.

17. David Smith to Leon Arkus, September 16, 1961, Estate of David Smith.

18. David Smith, "Letter to the Board of Trustees of the Carnegie Institute," 1961, in Cooke, *David Smith*, 341.

19. Mel Gonick, "Area Artist Returns $1,000 So Museum May Buy Art," *Troy Record Morning*, November 2, 1961.

20. Alvin Rosensweet, "Sculptor Refuses $1,000," *Pittsburgh Post-Gazette*, November 1, 1961.

21. A number of French artists had refused to appear in the Triennial because of the prize system. Before the Triennial, Barnett Newman, long a believer that juries were biased, wrote a letter to John C. Warner, president of the Carnegie Institute, protesting its selection and award process. See Barnett Newman, "Letter to John C. Warner, President of the Carnegie Institute," September 6, 1961, in *Barnett Newman: Selected Writings and Interviews*, ed. John P. O'Neill (New York: Alfred A. Knopf, 1990), 42.

22. Waldo Rasmussen to David Smith, December 7, 1961, Estate of David Smith.

23. William Rubin, "The International Style: Notes on the Pittsburgh Triennial," *Art International* 5, no. 9 (November 20, 1961): 34.

24. David Smith to Dorothy Dehner, November 8, 1961, Dehner papers, AAA, microfilm roll D298A.

25. David Smith to Everett Ellin, December 12, 1961, Ellin papers, AAA.

26. I'm grateful to Rebecca Smith for this information.

27. Nancy Grossman, interview conducted by the author, March 19, 2003, in New York City.

28. Nancy Grossman to David Smith, November 24, 1961, Estate of David Smith.

29. Paul Hayes Tucker, "Family Matters: David Smith's Series Sculptures," in Carmen Giménez, ed., *David Smith: A Centennial*, ed. Carmen Giménez, exhibition catalog (New York: Solomon R. Guggenheim Museum, 2006), 85.

30. David Smith to Howard Lipman, Chairman for the Committee: Friends of the Whitney Museum, December 21, 1961, Estate of David Smith.
31. John L. H. Bauer to David Smith, January 29, 1962, Estate of David Smith.

57. An Invitation

1. Giovanni Carandente, interview conducted by the author, March 4, 2004, in Rome, Italy.
2. Beverly Pepper to David Smith, n.d. [1961].
3. Beverly Pepper, interview conducted by the author, October 28, 2003, in New York City.
4. Smith interview (1964), Hess, 374.
5. David Smith to Everett Ellin, May 11, 1962, Ellin papers, AAA.
6. Anne Truitt to the author, August 30, 2001.
7. Anne Truitt, interview conducted by the author, July 18, 2001, in Washington, D.C.
8. Dan Budnik, interview conducted by the author, October 25, 2001, in New York City.
9. Alice Goldfarb Marquis, *Art Czar: The Rise and Fall of Clement Greenberg* (Boston: MFA Publications, 2006), 184.
10. David Smith, "Sketchbook Notes: The Found Object; Isn't It Good," *David Smith: Collected Writings, Lectures, and Interviews*, ed. Susan J. Cooke (Oakland: University of California Press, 2018), 352.
11. Mark Stephens and Annalyn Swan, *De Kooning: An American Master* (New York: Alfred A. Knopf, 2004), 437.
12. Carla Panicali, interview conducted by the author, November 22, 2002, in New York City.
13. Barry Hyams, *Hirshhorn, Medici from Brooklyn: A Biography* (New York: Dutton, 1979), 129.
14. William Rubin, interview conducted by the author, October 17, 2002, by telephone.
15. Howard W. Lipman, *Sculpture Today: The Whitney Review 1961–62* (New York: Whitney Museum of American Art, 1962), n.p. [29].
16. David Smith, "Sculpture Today," in Cooke, *David Smith*, 348–49.
17. Robert Murray, interview conducted by the author, May 18, 2006, in West Grove, Pennsylvania.
18. I'm grateful to Marc-Christian Roussel for his insights into Smith's methods and materials.
19. Irving R. "Pete" Juster to Dorothy Dehner, dated "the 15th" (probably May 15, 1962), Dehner papers, AAA, microfilm roll D298.
20. David Smith to Gian Carlo Menotti, May 17, 1962, Estate of David Smith.

58. Voltri

1. David Smith to Kenneth Noland, postcard [1962], [postmark is illegible], quoted here courtesy of Kenneth Noland.
2. Smith interview (1964), Hess, 375.
3. Smith to Noland, postcard, [1962], [postmark is illegible].
4. Unpublished section from transcript of Smith interview (1964), Hess.
5. Ludovico Pratesi, *Alberto Zanmatti: Una vita con l'arte* (Madrid: Petruzzi, 2014), 110–11.

6. Carla Panicali, interview conducted by the author, November 22, 2002, in New York City.

7. Michele Parrella, *Immagine di una fabbrica* [Pictures of a Factory] (Zurich: Fretz & Wasmuth, 1961), n.p.

8. Smith interview (1964), Hess, 375. Cooke reads Smith's words in the transcript of the interview as "just the way they were left the day they walked out at the beginning of the twentieth-century, to a mid-twentieth century fast-running steel mill."

9. David Smith, "Report on Voltri," 1962–63, in *David Smith: Collected Writings, Lectures, and Interviews*, ed. Susan J. Cooke (Oakland: University of California Press, 2018), 361.

10. Smith, "Report on Voltri," 359.

11. Smith interview (1964), Hess, 375.

12. Smith interview (1964), Hess, 375.

13. David Smith to David Sylvester, November 12, 1962, quoted in *David Smith: Voltron* (Philadelphia: Institute of Contemporary Art, University of Pennsylvania, 1964), 13.

14. Smith, "Report on Voltri," 357.

15. Smith to Sylvester, November 12, 1962, 12.

16. David Smith to Helen Frankenthaler, n.d. [1962], Frankenthaler/Motherwell papers, AAA.

17. Beverly Pepper, interview conducted by the author, October 28, 2003, in New York City.

18. Smith, "Report on Voltri," 357.

19. Pratesi, *Alberto Zanmatti*, 110.

20. Smith, Report on Voltri, 361.

21. Giovanni Carandente, interview conducted by the author, March 4, 2004, in Rome.

22. Carandente, untitled essay, in *David Smith: Voltron*, 10.

23. Carandente, untitled essay, in *David Smith: Voltron*, 7.

24. Smith, "Report on Voltri," 362.

25. Carandente, untitled essay, in *David Smith: Voltron*, 7.

26. "Report on Voltri," 363.

27. Pepper interview, October 28, 2003.

28. Carandente interview, March 4, 2004.

29. David Smith to Giovanni Carandente, September 18, 1962. Smith's letters to Carandente are in the Giovanni Carandente Library, Spoleto.

30. Carandente, untitled essay, in *David Smith: Voltron*, 7.

31. Pratesi, *Alberto Zanmatti*, 110.

32. Carandente interview, March 4, 2004.

33. Panicali interview, November 22, 2002.

34. David Smith to Giovanni Carandente, June 23, 1962, Giovanni Carandente Library, Spoleto.

35. David Smith to Giovanni Carandente, September 28, 1962, Giovanni Carandente Library, Spoleto.

36. Carandente interview, March 4, 2004.

37. Pepper interview, October 28, 2003.

38. Pepper interview, October 28, 2003.

39. David Smith to Nancy Grossman, June 16, 1962, quoted here courtesy of Nancy Grossman.

40. Smith to Carandente, June 23, 1962.

41. Smith to Sylvester, November 12, 1962, 14.

42. Pepper interview, October 28, 2003.

43. Smith to Sylvester, November 12, 1962, 14–15.

44. Candida Smith, "The Fields of David Smith," in *The Fields of David Smith*, exhibition catalog (New York: Storm King Art Center, 1999), 30, 32.

59. Circles

1. Candida Smith, interview conducted by the author, March 2, 2003, in New York City.

2. Anne Truitt, interview conducted by the author, May 29, 2001, in Washington, D.C.

3. Lois Orswell to David Smith, August 20, 1962, quoted in Marjorie B. Cohn, *Lois Orswell, David Smith, and Modern Art, with the Lois Orswell/David Smith Correspondence*, exhibition catalog (Cambridge, Mass.: Harvard University Art Museums, 2003), 272.

4. David Smith to Abram Lerner, July 7, 1962, Estate of David Smith.

5. Robert Murray, interview conducted by the author, May 18, 2006, in West Grove, Pennsylvania.

6. David Smith to Giovanni Carandente, September 28, 1962. Smith calls the curator who visited "Peter Seldes." He may have been referring to the MoMA curator Peter Selz.

7. Anne Truitt, interviews conducted by the author, July 18 and 30, 2001, in Washington, D.C.

8. Larry Rubin, interview conducted by the author, October 20, 2003, in New York City.

9. Truitt interview, July 18, 2001.

10. David Smith to Helen Frankenthaler and Robert Motherwell ("Dearest Friends"), n.d. [September 1962], Frankenthaler/Motherwell papers, AAA.

11. Smith to Orswell, n.d. [but postmarked Provincetown, September 4, 1962], quoted in Cohn, *Lois Orswell, David Smith, and Modern Art*, 272.

12. David Smith to Carlo Fedele, August 19, 1962, Giovanni Carandente Library, Spoleto.

13. Henry Geldzahler, "Taste for Modern Sculpture: The Hirshhorn Collection," *Art-News* 61, no. 5 (October 1962): 56.

14. David Smith to Herman Cherry, November 9, 1959, Smith–Cherry letters, AAA.

15. Clement Greenberg, "Post-Painterly Abstraction," in *Post-Painterly Abstraction*, exhibition catalog (Los Angeles: Los Angeles County Museum of Art, 1964), in *Clement Greenberg: The Collected Essays and Criticism*, vol. 4: *Modernism with a Vengeance, 1957–1969*, ed. John O'Brian (Chicago: University of Chicago Press, 1993), 192, 197.

16. Ruth Ann Fredenthal, interview conducted by the author, October 5, 2006, in New York City.

17. Truitt interview, July 30, 2001.

18. Harold Rosenberg, "The Game of Illusion: Pop and Gag," in *The Anxious Object: Art Today and Its Audience* (Chicago: University of Chicago Press, 1966), 63.

19. James E. B. Breslin, *Mark Rothko: A Biography* (Chicago: University of Chicago Press, 1993), 425.

20. David Smith to Herman Cherry, December 16, 1964, Smith–Cherry letters, AAA.

21. Hilton Kramer, "David Smith: Stencils for Sculpture," *Art in America* 50, no. 4 (Winter 1962): 41–42.

60. New Prominence

1. Unless otherwise noted, all Dan Budnik quotes in this chapter are from my interview with him (and in informal conversation afterward) on October 25, 2001, in New York City.
2. "David's Steel Goliaths," *Life*, April 15, 1963, 129–33.
3. Jean Rikhoff, interview conducted by the author, November 15, 2001, in Glens Falls, New York.
4. Robert Samuels to David Smith, April 22, 1963, Estate of David Smith.
5. Marc-Christian Roussel, email to the author, October 8, 2020. Roussel's study of Smith's materials and methods, titled "'Nothing You Can Speak About': Methods and Materials in David Smith's Sculpture," appears in *David Smith Sculpture: A Catalogue Raisonné, 1932–1965*, ed. Christopher Lyon (New York: Estate of David Smith, 2021), 1:52–97.
6. David Smith to Lois Orswell, April 18, 1963, quoted in Marjorie B. Cohn, *Lois Orswell, David Smith, and Modern Art, with the Lois Orswell/David Smith Correspondence*, exhibition catalog (Cambridge, Mass.: Harvard University Art Museums, 2003), 275–76.
7. David Smith to Everett Ellin, April 1, 1963, Ellin papers, AAA.
8. James E. B. Breslin, *Mark Rothko: A Biography* (Chicago: University of Chicago Press, 1993), 437.
9. Stephen Weil, interview conducted by the author, March 11, 2004, in Washington, D.C.
10. Breslin, *Mark Rothko*, 438.
11. Weil interview, March 11, 2004.
12. Robert Motherwell to David Smith, September 18, 1963, Estate of David Smith, quoted here courtesy of the Dedalus Foundation.
13. Frank Lloyd, quoted in Breslin, *Mark Rothko*, 436.
14. The text of Kennedy's speech at Amherst College was published in its entirety in *The New York Times*, October 27, 1963, 87.
15. Everett Ellin, telephone interview conducted by the author, January 30, 2006.
16. David Smith to Giovanni Carandente, telegram, June 8, 1963, Giovanni Carandente Library, Spoleto, Italy.
17. Carla Panicali, the director of Marlborough Rome, remembered the sum as $35,000. Pierre Levai, Lloyd's nephew and for more than four decades the CEO of New York's Marlborough Gallery, believed the amount was $50,000.
18. David Smith to Lois Orswell, n.d. [1963], quoted in Cohn, *Lois Orswell, David Smith, and Modern Art*, 82.
19. Lois Orswell to David Smith, n.d. [1963], quoted in Cohn, *Lois Orswell, David Smith, and Modern Art*, 278.
20. Orswell to Smith, n.d. [1963], quoted in Cohn, *Lois Orswell, David Smith, and Modern Art*, 281.

61. A Troubled Summer

1. Frances and Evans Herman, interview conducted by the author, November 17, 2001, in Bolton Landing, New York.

2. Jean Rikhoff, interview conducted by the author, November 18, 2001, in Glens Falls, New York. Unless otherwise noted, all quotes by Rikhoff in this chapter are from this interview.
3. Jean Rikhoff, *David Smith, I Remember* (Glens Falls, N.Y.: Loft Press, 1984), 17.
4. Rikhoff, *David Smith, I Remember,* 17–18.
5. David Levy, interview conducted by the author, November 6, 2002, in Washington, D.C.
6. David Smith to Helen Frankenthaler and Robert Motherwell, July 21, 1963, Frankenthaler/Motherwell papers, AAA.
7. Rebecca Smith, email to the author, July 12, 2021.
8. Rebecca Smith, interview conducted by the author, March 4, 2003, in New York City.
9. Lyn Noland, interview conducted by the author, October 9, 2007, in New York City.
10. Smith to Motherwell and Frankenthaler, July 21, 1963.
11. Rebecca Smith, interview conducted by the author, March 11, 2003, in New York City.
12. Candida Smith, interview conducted by the author, March 3, 2003, in New York City.
13. Rebecca Smith interview, March 11, 2003.
14. Rebecca Smith, email to the author, July 12, 2021.
15. Helen Frankenthaler to David Smith, August 9, 1963, Estate of David Smith.
16. Granville Beals, interview conducted by the author, June 27, 2005, in California.
17. David Smith to the "Motherwell Girls," September 3, 1963, Estate of David Smith.
18. David Smith to Lois Orswell, n.d. [1963?], quoted in Marjorie B. Cohn, *Lois Orswell, David Smith, and Modern Art, with the Lois Orswell/David Smith Correspondence,* exhibition catalog (Cambridge, Mass.: Harvard University Art Museums, 2003), 282.
19. Ruth Ann Fredenthal, interview conducted by the author, October 5, 2006, in New York City.
20. Frank O'Hara to David Smith, September 13, 1963, Estate of David Smith.
21. George Morehouse, interview conducted by the author, August 18, 2005, in Bolton Landing, New York.
22. David Smith to Ruth Ann Fredenthal, September 19, 1963, quoted here courtesy of Ruth Ann Fredenthal.

62. Bennington

1. Anthony Caro, interview conducted by the author, February 29, 2002, in London.
2. Patsy Nichols Norvell, interview conducted by the author, October 22, 2002, in New York City.
3. David Smith to Helen Frankenthaler and Robert Motherwell, October 4, 1963, Frankenthaler/Motherwell papers, AAA.
4. David Smith to Dorothy Dehner, n.d. [1963], Dehner papers, AAA, microfilm roll D298A, frame 1750.
5. Caro interview, February 29, 2002.
6. David Boroff, "Cauldron of Creativity," *Saturday Review,* December 21, 1963, 45.
7. Susan Crile, interview conducted by the author, September 27, 2001, in Cambridge, New York.
8. Stanley Rosen, interview conducted by the author, August 4, 2006, in Bennington, Vermont.

9. James Wolfe, interview conducted by the author, June 27, 2005, in Los Angeles.

10. Vincent Longo, interview conducted by the author, September 25, 2002, in New York City.

11. Crile interview, September 27, 2001.

12. Constance Kheel, interview conducted by the author, August 7, 2006, in Buskirk, New York.

13. Patsy Nichols Norvell, interview conducted by the author, October 22, 2002, in New York City.

14. Ruth Ann Fredenthal, interview conducted by the author, October 5, 2006, in New York City.

15. Rosen interview, August 4, 2006.

16. Kheel interview, August 7, 2006.

17. Boroff, "Cauldron of Creativity," 45.

18. Crile interview, September 27, 2001.

19. Sheila Girling, February 29, 2002, in London. During my interview with Anthony Caro, Girling came and went and periodically offered comments.

20. Florence Rubenfeld, *Clement Greenberg: A Life* (New York: Scribner, 1997), 248–49.

21. Andrea Dworkin, *Heartbreak: The Political Memoir of a Feminist Militant* (New York: Basic Books, 2002), 60.

22. Sophia Healy, interview conducted by the author, October 17, 2002, in Bennington, Vermont.

23. Londa Weisman, interview conducted by the author, October 17, 2002, in Bennington, Vermont.

24. Jane Harrison, interview conducted by the author, August 1, 2001, in Baltimore.

25. Caro interview, February 29, 2002.

26. Dan Budnik, interview conducted by the author, October 25, 2001, in New York City.

63. Bolton Landing Girls

1. For a discussion of these photographs of the nudes and the *Menands*, see Sarah Hamill, *David Smith in Two Dimensions: Photography and the Matter of Sculpture* (Oakland: University of California Press, 2015), chapter 5.

2. Stephanie Rose, interview conducted by the author, August 10, 2006, in Hudson, New York.

3. Rose interview, August 10, 2006.

4. Samuel Magee Green, interview conducted by the author, September 15, 2008, in New York State.

5. "7 Sculptors," at the Institute of Contemporary Art, University of Pennsylvania, Philadelphia, January 1966. The sculptors were Anthony Caro, John Chamberlain, Donald Judd, Alexander Liberman, Tina Matkovic, David Smith, and Anne Truitt. The catalog entry on Matkovic was written by Stephanie Rose.

6. Tina Matkovic Spiro, interview conducted by the author, December 3, 2006, in Miami. Unless otherwise noted, all quotes by Spiro in this chapter are from this interview.

7. Rose interview, August 10, 2006.

8. Jean Rikhoff, interview conducted by the author, November 15, 2001, in Glens Falls, New York.

9. Dorothy Dehner to David Smith, October 18, 1963, Dehner papers, AAA, microfilm roll D298A, frame 897.
10. Giovanni Carandente, interview conducted by the author, March 4, 2004, in Rome.
11. David Smith talk at Pratt Institute, Brooklyn, November 7, 1963, David Smith Estate.
12. Sidney Geist, interview conducted by the author, May 6, 2002, in New York City.
13. Tina Matkovic to David Smith, November 6, 1963, courtesy of Tina Matkovic Spiro.
14. David Smith to Sybil Meyersburg, November 23, 1963, quoted here courtesy of Robert Meyersburg.
15. Frances and Evans Herman, interview conducted by the author, November 17, 2001, in Bolton Landing, New York.
16. Carandente interview, March 4, 2004.
17. Giovanni Carandente to David Smith, December 18, 1963, Giovanni Carandente Library, Spoleto.
18. Giovanni Carandente, untitled essay, in *David Smith: Voltron* (Philadelphia: University of Pennsylvania, Institute of Contemporary Art, 1964), 8–9.

64. Light

1. Dan Budnik, interview conducted by the author, October 25, 2001, in New York City.
2. Edward F. Fry, *David Smith*, exhibition catalog (New York: Solomon R. Guggenheim Museum, 1969), 154.
3. Clement Greenberg, "David Smith," *Art in America* 54, no. 1 (January–February 1966): 28. The article is reprinted as "Comments on His Latest Works," in *Clement Greenberg: The Collected Essays and Criticism*, vol. 4: *Modernism with a Vengeance, 1957–1969*, ed. John O'Brian (Chicago: University of Chicago Press, 1993), 222.
4. Smith interview (1964), Hess, 406.
5. David Smith, "Interview by Frank O'Hara," 1964, in *David Smith: Collected Writings, Lectures, and Interviews*, ed. Susan J. Cooke (Oakland: University of California Press, 2018), 425.
6. Smith interview (1964), Hess, 376.
7. Budnik interview, October 25, 2001.
8. William Rubin, "David Smith," *Art International* 7, no. 9 (December 1963): 48.
9. Stanley E. Marcus, "The Working Methods of David Smith" (unpublished PhD dissertation, Teachers College, Columbia University, 1972), 134–35.
10. Marcus, "The Working Methods of David Smith," 163. I'm grateful to Marc-Christian Roussel for sharing his thoughts on how the *Cubis* were made; Roussel, email to the author, October 20, 2020.
11. Smith, "Interview by Frank O'Hara," 424.
12. David Smith, "Some Late Words from David Smith," 1965, in Cooke, *David Smith*, 429.
13. Alfred Leslie, interview conducted by the author, September 24, 2008, in New York City.
14. Dore Ashton, "James Rosati: World of Inner Rhythms," *Studio International* 167, no. 853 (May 1964): 197–98.

15. Smith, "Interview by Frank O'Hara," 422.
16. Smith, "Interview by Frank O'Hara," 425.
17. Sarah Hamill, *David Smith in Two Dimensions: Photography and the Matter of Sculpture* (Oakland: University of California Press, 2015), 140, 137.
18. "Like a Rothko in comparison with a Mexican mural," Smith's stainless-steel sculptures "are personal rather than collective images, not destined for public consumption." Rubin, "David Smith," 48.
19. Max Kozloff, "Spectrum of Sculpture," *Nation*, November 2, 1964, 314.
20. Donald Judd, "In the Galleries: David Smith," *Arts Magazine* 39, no. 3 (December 1964): 62.
21. Mircea Eliade, *The Forge and the Crucible: The Origins and Structures of Alchemy* (Chicago: University of Chicago Press, 1978), 79.
22. Eliade, *The Forge and the Crucible*, 170.
23. Jean Rikhoff, *Earth Air Fire & Water: A Memoir* (Bloomington, Ind.: iUniverse, 2011).

65. ICA

1. Candida Smith, interview conducted by the author, March 11, 2003, in New York City.
2. Rebecca Smith, interview conducted by the author, March 4, 2003, in New York City.
3. David Smith to Kenneth Noland, January 3, 1964, quoted here courtesy of Kenneth Noland.
4. Photographs of the opening and several reviews of this exhibition are in the Edward F. Fry papers in the collection of the Rare Book & Manuscript Library, Kislak Center for Special Collections, Rare Books and Manuscripts, University of Pennsylvania.
5. "The first task was to find a terrific opening exhibition, which would get us the kind of publicity nationally that we needed for the Philadelphia people to see that something really nice could be pulled off there. Clyfford Still looked good to me. He hadn't had a retrospective and was of great interest, especially in the early 1960s." Ti-Grace Atkinson, e-mail communication with Jenni Sorkin, February 3, 2005. I'm grateful to Sorkin for making her email exchange with Atkinson available to me.
6. David Smith to Lois Orswell, n.d. [1964], quoted in Marjorie B. Cohn, *Lois Orswell, David Smith, and Modern Art, with the Lois Orswell/David Smith Correspondence*, exhibition catalog (Cambridge, Mass.: Harvard University Art Museums, 2003), 286.
7. Hilton Kramer, "David Smith's New Work," *Arts* 38, no. 6 (March 1964): 28, 30, 34.
8. Clement Greenberg, "David Smith's New Sculpture," in *David Smith: Sculpture & Drawings*, exhibition catalog (Philadelphia: Institute of Contemporary Art, 1964), n.p., repr. as "David Smith's New Sculpture," in *Clement Greenberg: The Collected Essays and Criticism*, vol. 4: *Modernism with a Vengeance, 1957–1969*, ed. John O'Brian (Chicago: University of Chicago Press, 1993), 188–92.
9. The first writer to seriously take on the challenge of Smith's content was Rosalind E. Krauss, *Terminal Iron Works: The Sculpture* (Cambridge, Mass.: MIT Press, 1971).
10. David Smith to Helen Frankenthaler, n.d. [1964], Frankenthaler/Motherwell papers, AAA.

11. Smith interview (1964), Hess, 398. Smith's comment appears in the transcript of the interview, not in the published version of it.
12. Smith interview (1964), Hess, 398. The part of this discussion that does not appear in the published version is from the transcript.

66. Bennington Pottery

1. Anthony Caro, interview conducted by the author, February 19, 2002, in London.
2. Ruth Ann Fredenthal, interview conducted by the author, October 5, 2006, in New York City.
3. Stephanie Rose, interview conducted by the author, August 10, 2006, in Hudson, New York.
4. Tina Matkovic Spiro, interview conducted by the author, December 3, 2006, in Miami.
5. Fredenthal interview, October 5, 2006.
6. Patsy Nichols Norvell, interview conducted by the author, October 22, 2002, in New York City.
7. David Smith to Patsy Nichols, May 3, 1964, quoted here courtesy of Patsy Nichols Norvell.
8. Stanley E. Marcus, "The Working Methods of David Smith" (unpublished PhD dissertation, Teachers College, Columbia University, 1972), 112.
9. E. A. Carmean, Jr., included the *Wagons* in his 1982 exhibition at the National Gallery of Art; see E. A. Carmean, Jr., *David Smith*, exhibition catalog (Washington, D.C.: National Gallery of Art, 1982), chapter 6.
10. Cleve Gray, "Ceramics by Twelve Artists," *Art in America* 52, no. 6 (December 1964): 27.
11. Gray, "Ceramics by Twelve Artists," 33.
12. David Smith to Helen Frankenthaler and Robert Motherwell, May 30, 1964, Frankenthaler/Motherwell papers, AAA.
13. Londa Weisman, interview conducted by the author, October 17, 2002, in Bennington, Vermont.
14. Smith interview (1964), Hess, 405. The transcript of the interview reads: "Be fucked if I know what I'm going to do with them." In Cooke's anthology, "with them" is not included.
15. Gloria Gil, interview conducted by the author, December 2, 2003, in Burlington, Vermont.
16. Smith to Frankenthaler and Motherwell, May 30, 1964.
17. Smith to Frankenthaler and Motherwell, May 30, 1964.
18. Stephen Weil, interview conducted by the author, March 11, 2004, in Washington, D.C.
19. Stephanie Rose, interview conducted by the author, August 10, 2006, in Hudson, New York.
20. Matkovic Spiro interview, December 3, 2006.
21. Jean Rikhoff, interview conducted by the author, November 8, 2001, in Glens Falls, New York.
22. Smith interview (1964), Hess, 405. Here in my text, I have included more from the transcript of the interview.

67. Fear

1. Patsy Nichols Norvell, interview conducted by the author, October 22, 2002, in New York City. Unless otherwise noted, all quotes from Nichols in this chapter are from this interview.
2. Tina Matkovic Spiro, interview conducted by the author, December 3, 2006, in Miami.
3. Cited in Jean-Paul Sartre, *The Family Idiot: Gustave Flaubert, 1821–1857* (Chicago: University of Chicago Press, 1981), x.
4. Smith interview (1964), Hess, 402.
5. Smith interview (1964), Hess, 389.
6. Smith interview (1964), Hess, 386.
7. Wesley Huck, interview conducted by the author, August 18, 2004, in Bolton Landing, New York.
8. Smith interview (1964), Hess, 407.
9. Smith interview (1964), Hess, 405.
10. Smith interview (1964), Hess, 403.
11. Milo Barlow, interview conducted by the author, August 16, 2005, in Bolton Landing, New York.
12. "Interview with John Chamberlain by Henry Geldzahler," in *John Chamberlain: Recent Work*, exhibition catalog (New York: Pace Gallery, 1992), n.p.
13. Frances and Evans Herman, interview conducted by the author, November 17, 2001, in Bolton Landing, New York.
14. Jean Rikhoff, interview conducted by the author, November 18, 2001, in Glens Falls, New York.
15. Patsy Nichols to David Smith, n.d. [1964], Estate of David Smith.
16. Jane Harrison Cone, interview conducted by the author, August 1, 2001, in Baltimore.
17. Jane Harrison to Smith, n.d. [1964] [postmark on postcard is illegible], Estate of David Smith.
18. Harrison to Smith, n.d. [1964], Estate of David Smith.
19. Harrison interview, August 1, 2001.

68. Success

1. Lois Orswell to David Smith, n.d. [1964], quoted in Marjorie B. Cohn, *Lois Orswell, David Smith, and Modern Art, with the Lois Orswell/David Smith Correspondence*, exhibition catalog (Cambridge, Mass.: Harvard University Art Museums, 2003), 288.
2. Golda Smith to Dorothy Dehner, Thanksgiving Day 1964, Dorothy Dehner papers, AAA, microfilm roll D298.
3. Dorothy Dehner to Golda Smith, October 15, 1964, Dorothy Dehner papers, AAA, microfilm roll D298A, frame 905.
4. Stephen Weil, interview conducted by the author, March 11, 2004, in Washington, D.C. All quotes by Weil in this chapter are from this interview.
5. Robert Coates, "The Art Galleries," *New Yorker*, November 2, 1964, 165.
6. John Canaday, "Art: Pol Bury Sculptures at Lefebre's," *New York Times*, October 17, 1964, 26.
7. David Smith, "Interview by Marian Horosko," October 25, 1964, in *David Smith: Collected Writings, Lectures, and Interviews*, ed. Susan J. Cooke (Oakland: University of California Press, 2018), 413.

8. Kenneth Noland, telephone interview with the author, February 26, 2004.

9. Stephanie Rose, interview conducted by the author, August 10, 2006, in Hudson, New York.

10. Tina Matkovic Spiro, interview conducted by the author, December 3, 2006, in Miami.

11. Canaday, "Art: Pol Bury Sculptures."

12. "Hilton Kramer, "On Art," New Leader, December 7, 1964, 38.

13. Charlotte Willard, "In the Art Galleries," New York Post Magazine, November 15, 1964, 14.

14. Donald Judd, "In the Galleries: David Smith," Arts Magazine 39, no. 3 (December 1964): 62.

15. Greenberg's appointment books are in the collection of the Getty Research Institute.

16. Gloria Gil, interview conducted by the author, December 3, 2003, in Burlington, Vermont.

17. Peter Stroud, interview conducted by the author, October 10, 2003, in Princeton, New Jersey.

18. Jules Olitski, interview conducted by the author, May 10, 2001, in Bennington, Vermont.

19. Clement Greenberg. "Lecture on David Smith," Metropolitan Museum of Art, New York, April 27, 1982. I'm grateful to Kenneth Noland for giving me a tape of this lecture.

20. William Rubin, interview conducted by the author, October 17, 2002, by telephone.

21. Anthony Caro, interview conducted by the author, February 19, 2002, in London.

22. Stroud interview, October 10, 2003.

23. Philip King, interview conducted by the author, October 29, 2003, in New York City.

24. Caro interview, February 19, 2002.

25. Sophia Healy, interview conducted by the author, October 17, 2002, in Bennington, Vermont.

26. Clement Greenberg, "David Smith's New Sculpture" (1964), in Clement Greenberg: The Collected Essays and Criticism, vol. 4: Modernism with a Vengeance, 1957–1969, ed. John O'Brian (Chicago: University of Chicago Press, 1993), 192.

27. Clement Greenberg, "Sculpture in Our Time," 1958, in O'Brian, Clement Greenberg, 4:58.

28. Sarah Hamill, David Smith in Two Dimensions: Photography and the Matter of Sculpture (Oakland: University of California Press, 2015), 137.

29. Frank O'Hara, "David Smith: The Color of Steel," Art News 60, no. 8 (December 1961): 69.

30. Steven Naifeh and Gregory White Smith list some of Greenberg's insulting descriptions of artists in their book Jackson Pollock: An American Saga (New York: Clarkson N. Potter, 1989), 632–33.

31. "Interview with John Chamberlain by Henry Geldzahler," in John Chamberlain: Recent Work, exhibition catalog (New York: Pace Gallery, 1992), n.p.

32. Mark di Suvero, "The David Smith I Knew," in Candida N. Smith, The Fields of David Smith, exhibition catalog (Mountainville, N.Y.: Storm King Art Center, 1999), 41.

33. Robert Murray, interview conducted by the author, November 18, 2007, in West Grove, Pennsylvania.

34. Dan Budnik, interview conducted by the author, October 25, 2001, in New York City.

35. David Smith to Herman Cherry, December 16, 1964, Smith–Cherry letters, AAA.
36. David Smith to Patsy Nichols, November 3, 1964, quoted here courtesy of Patsy Nichols Norvell.
37. Smith to Cherry, December 16, 1964.

69. Girl Sculptures

1. David J. Getsy, *Abstract Bodies: Sixties Sculpture in the Expanded Field of Gender* (New Haven: Yale University Press, 2015), 62.
2. "Sculpting Master of Bolton Landing," interview with David Smith, conducted by Frank O'Hara, directed by Bruce Minnex and Ina Korek, Channel 13/WNDT, Educational Broadcasting Corporation, New York, November 6, 1964, transcribed in 2006 and the transcription made available to me by the Solomon R. Guggenheim Museum. The interview has been transcribed and edited as "Interview with Frank O'Hara, 1964," in *David Smith: Collected Writings, Lectures, and Interviews*, ed. Susan J. Cooke (Oakland: University of California Press, 2018), 422–27.
3. Getsy, *Abstract Bodies*, 82–83. Getsy revealed that for decades responses to the exchange were shaped by Cleve Gray's careless paraphrasing of it in *David Smith by David Smith* (New York: Holt, Rinehart and Winston, 1968), the widely read book edited by Gray. It was not until 2006, when the Guggenheim transcribed the interview for its Smith centennial retrospective, that an accurate transcription was available.
4. Getsy, *Abstract Bodies*, 72–73.
5. Rosalind E. Krauss, *Terminal Iron Works: The Sculpture of David Smith* (Cambridge, Mass.: MIT Press, 1971), 93; Getsy, *Abstract Bodies*, 93.
6. Sarah Hamill, *David Smith in Two Dimensions: Photography and the Matter of Sculpture* (Oakland: University of California Press, 2015), 165.
7. Getsy, *Abstract Bodies*, 93.
8. Getsy, *Abstract Bodies*, 80.
9. James Wolfe, interview conducted by the author, June 27, 2005, in Los Angeles.
10. Stephanie Noland, interview conducted by the author, July 12, 2004, in New York City.
11. Peter Stroud, interview conducted by the author, October 10, 2003, in Princeton, New Jersey.
12. Jane Willa Norris to David Smith, November 14, 1964, Estate of David Smith.
13. The phrase "instantiation of potential" comes from the poet Ann Lauterbach, in a telephone conversation with the author, November 30, 2020.
14. Smith interview (1964), Hess, 393.
15. David Smith, "Interview by Marian Horosko," 1964, in Cooke, *David Smith*, 417.
16. Kenneth Gross, *The Dream of the Moving Statue* (University Park: Pennsylvania State University Press, 1992), 7.
17. Gross, *Dream of the Moving Statue*, 72. Gross explores the Pygmalion myth in chapter 5, "You May Touch This Statue," 69–91.
18. David Smith, "Lecture, Skowhegan School of Painting and Sculpture," 1956, in Cooke, *David Smith*, 275.
19. I am grateful to Robert Slifkin for his insights into Harold Rosenberg and Abstract Expressionism and, in particular, into how figuration in Abstract Expressionism functioned. See Robert Slifkin, "The Tragic Image: Action Painting Refigured," *Oxford Art Journal* (June 2011): 227–46.

20. Quoted in Gross, *Dream of the Moving Statue*, 74.
21. "And we both knew damned well the black abyss in each of us that the sun and the daughters' skin and the bounty and the drink could alleviate but not begin to fill, a certain kind, I suppose, of puritanical bravado, of holding off the demons of guilt and depression that largely destroyed in one way or another the abstract expressionist generation." Robert Motherwell, "On David Smith," in *The Collected Writings of Robert Motherwell*, ed. Stephanie Terenzio (Oxford: Oxford University Press, 1992), 204.
22. David Smith, "The New Sculpture," 1952, in Cooke, *David Smith*, 148–49.
23. Alex Potts, "Personages: Imperfect and Persistent," in *David Smith: Personage* (New York: Gagosian, 2006), 17.
24. Getsy, *Abstract Bodies*, 88.
25. David Smith, "Notes on Books," 1950, in Cooke, *David Smith*, 94.
26. Slifkin's interpretation of tragedy in Abstract Expressionist painting is revelatory. It emerges from studying Harold Rosenberg's famous notion of "action" in his definition of Abstract Expressionism as "action painting" and depends on a reading of the unsettled allusive imagery in Abstract Expressionist paintings. Since their imagery is to some degree unpremeditated, the artist can only know to a limited degree what they have done. The viewer is pulled in by the imagery, which is in process, participates in this process, and comes to know it in ways that the artist can't, by so doing completing the work and carrying into the world ideas, impulses, and desires that the artist was controlled by and did not know. Slifkin suggests not just the transformative aspirations of this painting but its generosity. His notion of tragedy is different from the more familiar one suggested here but clearly relevant to Smith's work. Whether his notion of tragedy is as applicable to sculpture as it is to painting is an important question. See Slifkin, "The Tragic Image," 239–44.

70. Help

1. Stephanie Noland, interview conducted by the author, July 12, 2004, in New York City. All quotes from Noland in this chapter are from this interview.
2. Herman Cherry to David Smith, January 8, 1965, Estate of David Smith.
3. Dan Budnik, interview conducted by the author, October 25, 2001, in New York City.
4. David Smith to Patsy Nichols, January 9, 1965, quoted here courtesy of Patsy Nichols Norvell.
5. Frances Herman, interview conducted by the author, November 17, 2001, in Bolton Landing, New York.
6. Barbara Davenport, interview conducted by the author, June 26, 2005, in San Diego. All quotes from Davenport in this chapter are from this interview.
7. Ira Lowe, "Statement to Judge Dier," Ira Lowe papers, Estate of David Smith.
8. Stephen Weil, interview conducted by the author, March 11, 2004, in Washington, D.C.
9. David Smith to Patsy Nichols, January 13 or 19, 1965, Estate of David Smith.
10. For more on Smith and the alphabetic sign, see Michael Brenson, "David Smith, *Cubi XXV*, 1965," in *Frisson: The Richard E. Lang and Jane Lang Davis Collection*, ed. Catharina Manchanda (Seattle: Seattle Art Museum and University of Washington Press, 2021), 144–51.

11. David Smith to Robert Motherwell, January 21, 1965, Frankenthaler/Motherwell papers, AAA.
12. David Smith to Enid and Calvin Cafritz, n.d. [1965], Estate of David Smith.
13. Lowe, "Statement to Judge Dier."
14. Jules Olitski, interview conducted by the author, May 10, 2001, in Bennington, Vermont. In an interview with Henry Geldzahler, Olitski dated these remarks by Smith to the day Smith died; Jules Olitski, "Interview with Henry Geldzahler," in *Jules Olitski*, exhibition catalog (New York: Salander O'Reilly Galleries, 1990), 20. However, Olitski's emphasis on Smith's will and various discrepancies in Olitski's chronology indicate that in all likelihood this encounter with Smith took place earlier.
15. Robert Motherwell, "David Smith: A Major American Sculptor," *Vogue* 145, no. 3 (February 1, 1965): 134–39, 190–91.
16. Dan Budnik, telephone interview conducted by the author, March 15, 2005.
17. Jean Freas, "Living with David Smith," *David Smith: Drawings of the Fifties*, exhibition catalog (London: Anthony d'Offay Gallery, 1988), 16.

71. A National Honor

1. Stephen Weil, interview conducted by the author, March 11, 2004, in Washington, D.C.
2. Barbara Davenport, interview conducted by the author, June 26, 2005, in San Diego.
3. Jean Freas, interview conducted by the author, September 24, 2002, in New York City.
4. Tina Matkovic Spiro, interview conducted by the author, December 3, 2006, in Miami.
5. David Smith to Kenneth Noland, March 12, 1965, quoted here courtesy of Kenneth Noland.
6. Samuel Magee Green, interview conducted by the author, September 15, 2008, in New York State.
7. David Smith to Dorothy Dehner, April 9, 1965, Dehner papers, AAA, microfilm roll D298A, frame 753.
8. David Smith to Lois Orswell, April 1, 1965, quoted in Marjorie B. Cohn, *Lois Orswell, David Smith, and Modern Art, with the Lois Orswell/David Smith Correspondence*, exhibition catalog (Cambridge, Mass.: Harvard University Art Museums, 2003), 290.
9. Lois Orswell to David Smith, in *Lois Orswell, David Smith, and Modern Art*, 291.
10. Donald McKinney, interview conducted by the author, March 23, 2004, in Hudson, New York.
11. Cornelia Noland, "David Smith Remembered," *Washingtonian Magazine*, October 1969, 81.
12. Patsy Burns to David Smith, March 12, 1965, Estate of David Smith.
13. Beverly Pepper to David Smith, April 26, 1965, Estate of David Smith.
14. Frances Herman, interview conducted by the author, November 17, 2001, in Bolton Landing, New York.
15. Davenport interview, June 26, 2005.
16. David Smith to Gloria Gil, May 5, 1965, Estate of David Smith.
17. Gloria Gil to David Smith, May 9, 1965, Estate of David Smith.

72. May

1. Gloria Gil, interview conducted by the author, December 2, 2003, in Burlington, Vermont. All quotes from Gil in this chapter are from this interview.
2. David Smith, "Some Late Words from David Smith," 1965, *David Smith: Collected Writings, Lectures, and Interviews*, ed. Susan J. Cooke (Oakland: University of California Press, 2018), 428, 431–33, 441.
3. Cleve and Francine du Plessix Gray, interview conducted by the author, May 28, 2004, in Kent, Connecticut.
4. Gray interview, May 28, 2004.
5. Cleve Gray, "Last Visit," *Art in America* 54, no. 1 (January–February 1966): 23–26.
6. Gray interview, May 28, 2004.
7. Beatrice Monti della Corte, interview conducted by the author, January 8, 2004, in New York City.
8. Gray, "Last Visit," 23.
9. Kenneth Noland, interview conducted by the author, April 7, 2001, in North Bennington, Vermont. All quotes by Noland in this chapter are from this interview.
10. Anthony Caro, in conversation with the author, February 19, 2002, in London.
11. Elizabeth Faris to the author, August 28, 2006.
12. William Bacas, interview conducted by the author, August 23, 2006, in Glens Falls, New York.
13. Jules Olitski, interview conducted by Henry Geldzahler, April 11–12, 1990, in *Jules Olitski*, exhibition catalog (New York: Salander O'Reilly Galleries, 1990), 1:20.
14. Stephanie Noland to the author, January 16, 2005.
15. "Accident Kills Sculptor Here," *Bennington Banner*, May 24, 1965, 1, 12.
16. Faris to the author, August 28, 2006.
17. Caro interview, February 19, 2002.
18. Jules Olitski, interview conducted by the author, May 10, 2001, in Bennington, Vermont. All quotes by Olitski in this chapter are from this interview.
19. Helen Frankenthaler to Dore Ashton and Adja Yunkers, June 13, 1965, Dore Ashton papers, 1849, ca. 1928–2014, Archives of American Art, Smithsonian Institution.
20. Dan Budnik, interview conducted by the author, October 25, 2001, in New York City.
21. John Gruen, *The Party's Over: Reminiscences of the Fifties—New York's Artists, Writers, Musicians, and Their Friends* (New York: Viking Press, 1972), 194, in Robert Motherwell, "On David Smith," in Stephanie Terenzio, ed., *The Collected Writings of Robert Motherwell* (Oxford: Oxford University Press, 1992), 204.
22. Jean Freas, interview conducted by the author, April 14, 2003, in New York City.
23. Candida Smith, interview conducted by the author, March 11, 2003, in New York City.
24. Ira Lowe, interview conducted by the author, March 26, 2003, in Washington, D.C.
25. Caro interview, February 19, 2002.
26. Jean Freas, interview conducted by the author, September 24, 2002, in New York City.
27. Patricia Renick, telephone interview conducted by the author, October 31, 2003.
28. Gruen, *The Party's Over*, 194; Motherwell, "On David Smith," 204.
29. Faris to the author, August 28, 2006.
30. Stephanie Noland to the author, January 16, 2005.
31. Anne Truitt, interview with the author, July 18, 2001, in Washington, D.C.

32. Freas interview, September 24, 2002.
33. Stephen Weil, interview conducted by the author, March 11, 2004, in Washington, D.C. All quotes by Weil in this chapter are from this interview.
34. Jean Rikhoff, interview conducted by the author, November 18, 2001, in Glens Falls, New York.
35. Alfred Leslie, interview conducted by the author, September 24, 2008, in New York City.
36. Caro interview, February 19, 2002.
37. Vincent Longo, interview conducted by the author, September 25, 2002, in New York City.
38. James Rosati, "David Smith, 1906–1965," *ArtNews* 64, no. 5 (September 1965): 29, 63.
39. Barbara Davenport, interview conducted by the author, June 26, 2005, in San Diego.
40. Stephanie Rose, interview conducted by the author, August 10, 2006, in Hudson, New York. Rose's memories of that night are sharp; Tina Matkovic's are less so. It's Matkovic who believes that other artists may have slept in the house that night; Tina Matkovic Spiro, interview conducted by the author, December 3, 2006, in Miami.
41. Freas interview, September 24, 2002.
42. Rebecca Smith, email to the author, July 12, 2021.

Afterword

1. Christopher Lyon, "Shaping Attention: Key Concepts in Critics' Responses to David Smith's Sculpture," in *David Smith Sculpture: A Catalogue Raisonné, 1932–1965*, ed. Christopher Lyon (New York: Estate of David Smith, 2021).
2. Herman Cherry to Kenneth Noland, June 3, 1965, quoted here courtesy of Kenneth Noland.
3. Clement Greenberg, "Critical Comment," *Art in America* 54, no. 1 (January–February 1966): 27.
4. Lyon, "Shaping Attention."
5. The case is discussed in Martin S. Echter, "Equitable Treatment for the Artist's Estate: The Tax Court Takes a First Step," *Trusts & Estates: The Journal of Estate Planning and Administration* (June 1975): 394–97, and in "Peter Stevens on the David Smith Estate," in *Artists' Estates: Reputations in Trust*, ed. Magda Salvesen and Diane Cousineau (New Brunswick, N.J.: Rutgers University Press, 2005), 222–23.
6. Frankenthaler's sculptures were shown in an exhibition at the Knoedler Gallery in 2006.
7. These numbers are given in Echter, "Equitable Treatment for the Artist's Estate."
8. Robert Hughes, "Arrogant Intrusion," *Time*, September 30, 1974, 73.
9. "Peter Stevens on the David Smith Estate," 226.
10. "Peter Stevens on the David Smith Estate," 226.
11. "Alter Ego," *Newsweek*, September 30, 1974, 105.
12. "Peter Stevens on the David Smith Estate," 228.
13. "Peter Stevens on the David Smith Estate," 228.
14. "Peter Stevens on the David Smith Estate," 226.
15. Patricia Johanson, interview conducted by the author, April 8, 2005, in Buskirk, New York.

16. Frank O'Hara, "Introduction," *David Smith 1905–1965*, exhibition catalog (London: Arts Council of Great Britain, 1966), 9.

17. Lois Orswell, quoted in Marjorie B. Cohn, *Lois Orswell, David Smith, and Modern Art, with the Lois Orswell/David Smith Correspondence*, exhibition catalog (Cambridge, Mass.: Harvard University Art Museums, 2003), 155–56.

18. "Kate and Christopher Rothko, Daughter and Son of Mark Rothko," in Salvesen and Cousineau, *Artists' Estates*, 306. Lee Seldes wrote a famous book on the case, *The Legacy of Mark Rothko* (New York: Holt, Rinehart and Winston, 1978).

19. "Peter Stevens on the David Smith Estate," 228.

20. Rosalind Krauss, "Changing the Work of David Smith," *Art in America* 62, no. 5 (September–October 1974): 32–33.

21. Bill Marvel, "Art Critic Gets Below the Surface," *National Observer*, week ending October 5, 1974.

22. For a discussion of Smith's uses of white paint, see Sarah Hamill, *David Smith in Two Dimensions: Photography and the Matter of Sculpture* (Oakland: University of California Press, 2015), 128, 210–11n47.

23. In 2017, the Storm King Art Center presented "David Smith: The White Sculptures," an exhibition that considered Smith's uses of white and made the case for the importance of his white sculptures in his sculptural thinking and to the totality of his work.

24. Frank O'Hara, "David Smith: The Color of Steel," *ArtNews* 60, no. 8 (December 1961): 33.

25. Jean Pond to Hilton Kramer, Clement Greenberg papers, 1928–1995, Getty Research Institute, box 35, folder 2.

26. Paul Richard, "The Alteration of David Smith's Sculpture: An Aesthetic Crime?," *Washington Post*, September 22, 1974, H5.

27. Marvel, "Art Critic Gets Below the Surface."

28. Hughes, "Arrogant Intrusion."

29. Richard, "The Alteration of David Smith's Sculpture."

30. "Alter Ego."

31. Referring to the shots of painted statues in Jean-Luc Godard's film *Contempt* (1963), Krauss begins her essay "Changing the Work of David Smith" by making a point of the awkwardness to modern eyes of painted classical sculpture. Krauss, "Changing the Work of David Smith," 32.

32. Dorothy Dehner to Hilton Kramer, September 22, 1974, Dehner papers, AAA, microfilm roll 1372, frame 870.

33. When Kirk Varnedoe was Chief Curator of Painting and Sculpture at the Museum of Modern Art, he planned a David Smith centennial that would have filled the entire museum with Smith's works from all periods and in all media, including ceramics and jewelry. Varnedoe intended to give Smith the same full museum treatment that MoMA had given Picasso and Matisse. By doing so, the show would have argued that here was an American artist who was in the same league as the two greatest European modernists. When Varnedoe died in 2003, at the age of fifty-seven, hopes for an encyclopedic Smith show died with him. Peter Stevens, in a telephone conversation with the author, February 18, 2021.

Acknowledgments

I am fortunate to have many friends and colleagues who provided moral, scholarly, and editorial support during the many years since I began this project. First, I would like to thank the people who have been with me throughout what has turned into a twenty-year journey, without whose encouragement, interest, and belief this book would not have been possible: Judith Fleiss, Paul Hayes Tucker, Gabriella de Ferrari, Carmen Giménez, Ann Lauterbach, Rebecca Smith, Peter Stevens, David Levi Strauss, and Fawn Krieger. Some of them were kind enough to read various chapters; others corresponded with me and spoke with me regularly about David Smith's work and life, and about issues of biography. Some kept asking, "How's the book going?" Tucker, Lauterbach, and Krieger did all of the above.

In the contemporary art world that I've lived and taught in, Abstract Expressionism has receded further and further into the past, even as it has occasionally—always unexpectedly and irrefutably—erupted once again into the present. The Bard MFA sculpture department's core faculty, of which I was a part for nearly twenty years, never ceased to be interested in Smith. I extend my enduring gratitude to Taylor Davis, Kenji Fujita, Pam Lins, and Halsey Rodman. Arthur Gibbons, a sculptor and the longtime director of Bard's Milton Avery Graduate School of the Arts, the summer program in which we taught, kept a copy of *David Smith by David Smith* in his office. An afternoon I spent with Bard sculpture faculty and students at the Whitney Museum of American Art's 2011 exhibition *David Smith: Cubes and Anarchy* is one of my most memorable museum experiences. I'm also grateful to the Bard sculpture students who offered their insights into Smith's work, either at the Whitney or during

other conversations over the years: Timothy Eastman, Beka Goede, Rochelle Goldberg, Joshua Hart, Corin Hewitt, Krista Kashis, Matt King, Julia Klein, Adam Marnie, Caitlin Slegr, Charles Smith, and Allyson Veira.

To all those who agreed to be interviewed for this book—some of them several times—thank you! You provided me with information, texture, stories, and a keen sense of Smith's personality. This book would not exist without the remembrances and perspectives of Pat Adams, Nicolas Adam Apgar, William Bacas, Milo Barlow, Richard Bartlett, Irma and Mordecai Bauman, Granville Ames Beals, John Alden Beals, Ellen Berland, Judith Bettelheim, Willard Boepple, Marcella Brenner, Dan Budnik, Henry Caldwell, Ted Caldwell, Giovanni Carandente, Anthony Caro, Regina Cherry, Francis V. Connor, Susan Crile, Johanna Crockwell, Theta Curri, Barbara Davenport, Sally Defty, Jim Durre, Everett Ellin, Keaton Endsley, Jean Freas, Ruth Ann Fredenthal, Charlie French, Iris Gallagher, Bill Gates, Sidney Geist, Jill Maranville Gibeaux, Gloria Gil, Nosta Glaser, Cleve Gray, Francine du Plessix Gray, Samuel Magee Green, Nancy Grossman, Grace Hartigan, Sophia Healey, Lucille den Herder, Frances and Evans Herman, Olga Hirshhorn, Sam and Pat Hoopes, Joan and Monte Hoover, Wesley Huck, Jr., Sam Hunter, Patricia Johanson, Anita Kahn, Ray Keck, James Kettlewell, Constance Kheel, Philip King, David C. Levy, Vincent Longo, Ira Lowe, Joyce Maranville, Jean Margolin, Robert Meyersburg, George Morehouse, Mary Muratori, Robert Murray, Mary Newman, Cornelia Noland, Kenneth Noland, Lyn Noland, Stephanie Noland, Patsy Norvell, Robert Nunnelley, Francis V. O'Connor, Jules Olitski, Carla Panicali, Beverly Pepper, Gladys Plate, Tom Pratt, Dave Rehm, Patricia Renick, Belle Krasne Ribicoff, Jean Rikhoff, Margaret Rosati, Stephanie Rose, Stanley Rosen, Lawrence Rubin, William Rubin, Joanna Shaw-Eagle, Candida Smith, Rebecca Smith, Tina Matkovic Spiro, James Stahl, Peter Stroud, Alexandra Truitt, Anne Truitt, Stephen Weil, Londa Weisman, Hugh Wilson, James Wolfe, and Helen Wright.

I offer my deep appreciation to Miani Johnson, Joan Pachner, Patricia Renick, and Judd Tully for making available their interviews with Dorothy Dehner.

In 1996, Carmen Giménez commissioned me to write an essay for *David Smith 1906–1965*, the exhibition she curated at the Museo Nacional Centro de Arte Reina Sofía, Madrid; and in 2006, another essay, for *David Smith: A Centennial*, her exhibition at the Solomon R. Guggenheim Museum, New York. The latter essay, "The Fields," became the basis of my continuing preoccupation with the vision of sculpture that Smith kept reimagining on his hillside in Bolton Landing.

In 2008, the John Simon Guggenheim Memorial Foundation awarded me a Guggenheim Fellowship, which set in motion all subsequent funding for this book. A 2010 residency at the glorious Bogliasco Foundation, outside Genoa, made it possible for me to visit Voltri and study the Italsider archives in Sam-

pierdarena, where Annalaura Burlando and Dr. Alessandro Lombardo were models of graciousness. A warm thank-you to Bogliasco's wonderful staff and administration: Melissa Phegley, Kristin Nelson, Ariel Morneau, Carola Mamberto, and Laura Harrison. My first lecture on Smith at Voltri was given in 2012 for the Bogliasco Foundation at the Casa Italiana New York University.

A series of other opportunities, from 2009 to 2017, were instrumental in the evolution of my thinking about Smith and his work. In 2009, Douglas Dreishspoon, a great friend, then the chief curator at the Albright-Knox Art Gallery, invited me to participate in a panel in conjunction with the exhibition *Action/Abstraction: Pollock, De Kooning and American Art 1940–1976*, where I spoke about Smith's mud lion. In 2012, the University of Kansas and David Cateforis, a professor and the chair of art history, honored me with its 2012 Murphy Professorship; the lectures I gave during that semester included one on Smith's great 1951 sculpture *Australia*. In 2014, David Breslin, then a curator at the Clark Art Institute, in conjunction with his exhibition *Raw Color: The Circles of David Smith*, commissioned me to write an essay on Smith's *Circles* series. Then, in the fall of 2015, I spent an idyllic semester as a Clark Fellow; the lecture I gave during my residency there, on Smith's *Medals for Dishonor*, informs the chapter on the *Medals* in this book. My thanks to a number of people at the Clark: Christopher P. Heuer, who was then the interim director of the Clark's Research and Academic Program; Michael Ann Holly, the Starr Director Emerita of the Research and Academic Program; Deborah Fehr, who kept the scholars' quarters running smoothly; and Clark Fellows Spyros Papapetros, Maureen Shanahan, Kavita Singh, and Joanna Smith, all of whom provided incisive responses to Smith's work. In 2017, Ken Lum, an artist and a professor in the University of Pennsylvania's School of Design, where I had been a Visiting Senior Critic since 2006, organized a Smith symposium, for which I gave a lecture on Smith in Voltri; that lecture forms the basis for the Voltri chapter in this book.

The Whiting Creative Nonfiction Grant awarded to me in 2017 arrived at a bleak financial moment and expressed a belief in me and in the book that helped keep me going. The telephone call from the Whiting Foundation's Courtney Hodell and Daniel Reid notifying me of the grant was life-changing.

Other foundations also helped make this book possible. At the Helen Frankenthaler Foundation in New York City, I'm grateful to Elizabeth Smith, Douglas Dreishspoon, Sara Haug, and Grady O'Connor. Dreishspoon has been the director of the Frankenthaler Catalogue Raisonné project since 2017; in 2019, he organized "Helen Frankenthaler and David Smith: An Enduring Friendship," a public conversation at the foundation in which he and I spoke about Frankenthaler and Smith. Joan Marter, the president of the Dorothy Dehner Foundation—a major scholar of Dehner's work and an important thinker on

modern sculpture—was exceptionally generous in conversations about Dehner and Smith, with permissions, and in enabling me to visit the Dehner Foundation. Three other foundation heads were also a big help to me, not just with the access they provided to scholarly sources but with their collegiality: Jack Flam, the president and CEO of the Dedalus Foundation and a prominent Robert Motherwell and modernist scholar; Sanford Hirsch, the director of the Adolph and Esther Gottlieb Foundation; and Philip Rickey, the president of the George Rickey Foundation.

At the Storm King Art Center, David R. Collens, Director Emeritus, and Mary Ann Carter have been a joy to work with. Storm King's acquisition in 1966 of thirteen Smith sculptures was crucial to its development into what is surely this country's greatest sculpture park. Storm King also owns nineteen of the watercolors in Dorothy Dehner's superb *Life on the Farm* series.

David C. Levy, Smith's godson, spoke expansively with me about Smith and Dehner and gave me permission to quote from the archives of his parents, Lucille Corcos and Edgar Levy, both of whom were painters as well as Smith and Dehner's best friends.

The Archives of American Art is an astonishing resource. I spent well over a year and a half studying the Smith and Dehner papers and the papers of countless other artists, curators, and critics of Smith's time. I cannot say enough about the professionalism and goodwill of Joy Weiner, Charles Duncan, Liza Kirwin, and Marisa Bourgoin.

Regina Cherry spoke with me about her late husband, Herman Cherry, a painter and one of Smith's closest friends; she also gave me permission to quote from her husband's letters and from the restricted letters Smith wrote to Herman.

The following people also made contributions that reverberate through this book: Cheryl Abernathy, Terry Adkins, William C. Agee, Constance Baker, Debra Balken, Norton Batkin, Avis Berman, Bill Berkson, Donna Brandoli, Fred Brown, Phong Bui, Anne Byrd, Edgar N. ("Ted") Caldwell, Henry Caldwell, Peter Carravetta, Stephanie Cassidy, Laura Chapman, Christa Clarke, Michael Coffey, Harry Cooper, Lisa Corrin, Mary Cox, James Cummins, Arthur Danto, Rachelle Dattner, Valerie Davison, Richard Deacon, Martina Droth, Joan Dupont, Barney Ebsworth, Tom Eccles, Melvin Edwards, John Elderfield, Charles Eldredge, Michelle Elligott, Starr Figura, Elizabeth Frank, Susan Behrends Frank, Ann Freedman, Larry Gagosian, Barry Gealt, David J. Getsy, Eric Gibson, John Good, Marian Goodman, Jerry Gorovoy, Marc Gottlieb, Ronald Greenberg, John Griefen, Agnes Gund, Karen Gunderson, Kathy Halbreich, Sarah Hamill, Saralyn Reece Hardy, Helen Harrison, James Harrison, Rachel Harrison, Mark Haxthausen, Hayden Herrera, Susan Hill, Eva Hoffman, Zenas Hutcheson, Jane Irish, Mary Jane Jacob, David Jenkins, Jasper Johns, Matthew

Kangas, Dina Kellams, Marn Reva Kessler, James Kettlewell, the late Alain Kirili (a passionate supporter of Smith), Barbara Kruger, Pierre Levai, Peter J. Lysy, Barbara MacAdam, Catharina Manchanda, Elaine Werblud Moore, Joshua Mosley, Jeannie Motherwell, David Murphy, Mary Murray, Alessandra Natale, John Newman, Dianne Nilsen, Linda Norden, Margaret Rosati Norton, Lauren Olitski, Russell Panczenko, Fernanda Pessaro, Kerry Petersen, Vita Petersen, Sarah Pinard, Mark Pollock, Alessandra Pozzati, Nancy Princenthal, Brooke Kamin Rapaport, Eric Rayman, Ned Rifkin, Dorothea Rockburne, Alyse Ronayne, Barbara Rose, Kenneth Rosenbaum, Marc-Christian Roussel, Bartholomew Ryan, Tom Sachs, Jan Schall, Tamara Schenkenberg, Joel Shapiro, Jon Shirley, Michael Shulman, Amy Sillman, Charles Simonds, Lowery Sims, Patterson Sims, Robert Slifkin, Marion Smit, Jennifer Sorkin, Gisella Zanmatti Speranza, Judith Stein, Mark Stevens, Robert Storr, Elisabeth Sussman, Catherine Tatge, Ann Temkin, Elisabeth Thomas, Jackie Tileston, Sarah Tortora, Phyllis Tuchman, Anne Umland, Marcia Vetrocq, Wendy Vogel, Joan Washburn, Bruce Weber, Len Wechsler, Annette Wehrhahn, Christina Weyl, Véronique Wiesinger, Martha Wilson, Elan Wingate, Virginia Wright, and Sanford Wurmfeld.

Every scholar stands on the shoulders of other scholars. My references in this book to other critics' and art historians' writings on Smith are expressions of acknowledgment of their work and of an ever-expanding Smith writing community. From within this community, I would like to single out the books or book-length studies by Rosalind E. Krauss, Sarah Hamill, and Paula Wisotzki, each of which was formative to me.

Many people at Farrar, Straus and Giroux, my publisher, played a role in the book's development. At my first meeting at FSG, Jonathan Galassi was enthusiastic about the project. I had discussions about the book with John Glusman, Loren Stein, and Paul Elie (who were editors there at the time). Jackson Howard informed me about the production process. The assistant editor Ian Van Wye has worked with me throughout this process, to which the contributions of Janet Renard and Carrie Hsieh have also been crucial. Ileene Smith, FSG's editor at large, is a brilliant editor. Under her stewardship, the manuscript became a book.

A number of other editors helped either with this book or with essays I wrote about Smith that had an impact on it. I'm grateful to Stephen Robert Frankel, Nora Reichardt, Kristin Swan, and Jennifer Knox White. Christopher Lyon was a probingly engaged editor of the essay I wrote about Smith's sculpture series for the 2021 catalogue raisonné of Smith's sculpture. Terry Ann Neff helped me reduce the manuscript to close to its current length; our conversations about Smith throughout 2018 were as essential to me as her editing.

From the beginning to the end of this project, my agent Georges Borchardt

has been an anchor, assured and judicious and always available when I needed him. His belief in the book was unwavering. His experience and wisdom are a treasure.

No ambitious Smith project is possible without the support of the Estate of David Smith, whose directors and staff have been a pleasure to work with. For more than twenty years, Peter Stevens, the longtime director of the Smith Estate and a special friend, unstintingly shared with me his special knowledge of Smith. Jennifer Field, the Estate's current executive director, has been a model of warm professionalism. Tracee Ng, the Estate's head of research, was extraordinarily generous with her time and knowledge and with making available photographic images, even through the constraints of the pandemic year 2020. There is no one whom I approached with more questions than Susan Cooke, from 2002 to 2018 the associate director of the Estate of David Smith. She answered all of them. Cooke is a repository of knowledge about Smith and herself a Smith scholar. Her 2018 anthology of Smith writings for the University of California Press, as part of its Documents of Modern Art series, will remain an indispensable resource. The researcher Allyn Shepard and the exhibitions manager Jillian McManemin helped along the way.

Smith's daughters, Rebecca and Candida Smith, co-presidents of the Estate, were central to Smith's life and work, and they have been essential to this book—speaking with me about their father, providing names and addresses of people to interview, setting the tone for other people's cooperation, welcoming me to Bolton Landing, discussing works and exhibitions, and providing the most engaged sense of personality and place. The forms of knowledge about their father and the New York art world that Becca and Dida carry within them are inexhaustible. Jean Freas, their mother, was also indispensable. No one else I interviewed provided me with a more vivid sense of Smith's personality and of their Bolton Landing lives. Her opinions, memories, and storytelling are dynamic.

Most of all, I want to thank Sharon O'Connell, to whom this book is dedicated. We met at a softball game in the Bois de Boulogne in July 1975. She had moved to Paris in 1969 with her first husband and had recently ended a career as a professional dancer. I had just returned to Paris with a trunk and $5,000 and no idea what would happen next. Sharon understands artistic obsession and work. Our forty-six years together have been an amazing journey—as has been this book.

Index

Page numbers in *italics* refer to photographs.

Italy, 142, 253, 415, 511, 557, 599;
 Cornigliano, 565–66; Genoa, 563–64;
 Rome, *see* Rome; Spoleto, 556–57, 562,
 564–79, *577, 578,* 581, 584, 627; steel
 industry in, 557, 562, 565, 566; Voltri,
 563–79, *567, 571, 575,* 581, 584, 590,
 636, 655, 714

Jackson, Harry, 379
Jackson, Joan, 379
Jackson, Martha, 444, 455, 458
Jacob, Max, 134
James, Jesse, 386
Jamie's Visit (Dehner), 270
Janis, Sidney, 378, 596, 597; Sidney Janis
 Gallery, 441, 507–508, 526, 581, 588
"Janus" (Malraux), 421
Japan, 253, 260; Pearl Harbor attacked
 by, 239, 243
jazz, 136, 443, 467, 491, 492, 603
Jefferson, Thomas, 76
Jenkins, Paul, 450
Jewell, E. A., 187
Jewish Museum, 527, 658, 675; Dehner's
 exhibit at, 689
Jews, 194, 596–97
Johanson, Patricia, 505–506, 509, 539,
 715
John, Bob, 351
John Reed Club, 110
Johns, Jasper, 493, 551, 675
Johns Hopkins University, 3
Johnson, Dan, 264, 293, 392, 408, 429,
 438
Johnson, Lady Bird, 646
Johnson, Lyndon, 685, 698–99, 709;
 inauguration of, 663, 677, 681
Johnson, Miani, 275, 345, 488
Johnson, Philip, 493, 627
Johnson, Thomas, 12
Johnson, William, 76
Jones, Louis Webster, 380
Jones Car Company, 500
Joyce, James, 6, 23, 184, 223, 269–70, 276,
 278, 286, 323, 408, 526, 612, 638
Judd, Donald, 631, 659
Judith (Giraudoux), 445
Julien Levy Gallery, 146
Jung, Carl, 85, 184
Juster, Irving R. "Pete," 562

Kadish, Reuben, 375
Kahlo, Frida, 495
Kahn, Arthur and Anita, 525
Kahnweiler, Daniel-Henry, 421
Kainen, Jacob, 141, 186
Kalver, Roy, 266
Kandinsky, Wassily, 60, 70, 147, 336, 421,
 469, 514
Kasmin, Paul, 609
Keats, John, 49
Kelly, Ellsworth, 551
Kennedy, John F., 93, 598, 685;
 assassination of, 622
Kennedy Center, 558
Kent, Rockwell, 70, 185, 317, 393
Kerkam, Earl, 689
Kheel, Constance, 610, 611
Kiesler, Frederick, 83, 244, 401, 456
King, Eleanor, 387
King, Matt, 120
King, Phillip, 660
Kingsley, April, 333, 343, 345
Klee, Paul, 60, 174, 184, 214, 244, 322,
 410, 444, 514
Kleeman Gallery, 366, 367, 376, 395,
 431
Kligman, Ruth, 450, 538
Kline, Franz, 440, 441, 445, 451, 455,
 484, 490, 494, 515, 534, 551, 559; car
 of, 493, 773–74*n*, 778*n*; death of, 560
Knaths, Karl, 239–40
Knickerbocker News, The, 255, 471, 475
Knoedler Gallery, 4, 582, 717, 721
Kondylis, Georgios, 161
Kootz, Samuel M., 378, 387, 392–94
Kootz Gallery, 354, 378–80, 395
Kota figures, 113
Kozloff, Max, 631
Krackowizer, Marie, 77
Kramer, Hilton, 8, 354, 446, 466, 468,
 470–72, 476, 490, 496, 497, 498, 511,
 517–22, 524, 545, 635, 637, 659, 712,
 716, 720; "David Smith: Stencils for
 Sculpture," 589
Krasne, Belle, 24, 25, 353, 354, 355,
 357, 364, 367, 377, 379, 395, 408, 412,
 416–17, 483, 513
Krasner, Lee, 375, 392, 450; Bolton
 Landing visited by, 373–75, *373;* Freas
 on, 374–75

Smith, Rebecca (Becca; Athena)
(daughter) (*cont.*)
405, 406; locket made for, 569; names
of, 408, 429, 476, 555, 767*n*; Nichols
and, 641, 648–49, 654; on Ohio
and Indiana trip, 482–83; parents'
separation and, 483–84, 498, 603–604,
670; plaster horse made by, 547, *547*;
referenced in Smith's sculptures, 555,
603; Smith's death and, 704–705, 708;
Smith's gift of pony for, 546, 601–602,
605; Smith's Mercedes and, 534; Smith's
sculptures and, 623, 652, 707, 715,
716; Smith's will and estate and, 681,
712–13; Stevens and, 714; trust fund
for, 651–52; in Virgin Islands, 633–34
Smith, Tony, 610
Smith, William R. (grandfather), 13, 19,
292
Snooker (dog), 139, 170, 409
Snyder, Barney, 120
Snyder, Don, 499
socialism, 162, 568, 584, 699
Social Realism, 138, 154, 222
Société Anonyme, 60, 79
Solomon, Mitzi, 312–13, 318
Somerville, Brehon, 194
Song of Roland, The, 18
Soviet Union, 141, 146, 150, 155, 170,
177, 208, 238, 248, 249, 296, 354, 415,
584; Finland invaded by, 193; German
nonaggression pact with, 193, 208;
Smith and Dehner's trip to, 161,
163–68, 522
Spain, 179, 260; Spanish Civil War, 170,
178–79, 193, 260, 323
Spalding & Company, 71, 78, 108, 124
Spanio, Angelo, 413
Speaking of Books, 234
Spivak, John L., 161
Spoleto, 556–57, 562, 564–79, *577*, *578*,
581, 584, 627
Sportsman Pilot, The, 78
Sprague, Jack, 33–34
*Springfield Sunday Union and
Republican*, 126, 204, 229
Squibb Galleries, 186
Stable Gallery, 425
Stafford's Funeral Home, 707
Stahl, Jim, 18, 32

Stahl, Louise, 40
Stalin (Barbusse), 177
Stalin, Joseph, 208, 249, 296
Stead, Christina, 212
steel, 123; in Italy, 557, 562, 565, 566; in
Smith's sculptures, 120, 286, 351, 358,
469–70, 521, 524, 525, 627–29, 632,
670, 672
Steel on the Sea, 565
Steichen, Edward, 78
Stein, Gertrude, 111, 323
Stein, Leo, 111
Steinberg, Jay, 387
Steinberg, Leo, 364
Stella, Frank, 551, 608, 675
Stenographic Figure (Pollock), 243
Stephan, John, 311–12
Stephan, Ruth, 311–12
Stern, Isaac, 685
Sterne, Hedda, 337
Stevens, George, 685
Stevens, Mark, 507, 560
Stevens, Peter, 714–15
Stewart, Forrester "Frosty," 265, 418, 709
Stewart, Leigh, 265
Stieglitz, Alfred, 78, 102
Stieglitz, Edward, 78
Still, Clyfford, 312, 320–21, 635, 662
Stoler, Anson, 21
Stoler, Catherine Hileman
(grandmother), 19–22, 24, 25, 67, 71,
103, 300, 463
Stoler, Celestial Baird, 19, 20
Stoler, David (grandfather), 19–22,
24, 27
Stoler, Eliza Ann Shelly, 20–22
Stoler, Eunice, 19, 21, 22
Stone, Edward Durrell, 380
Storm King Art Center, 3–4, 713
Stravinsky, Igor, 79, 323, 491, 530
Stroud, Peter, 495, 608, 659, 668
Studebaker, 45, 46, 48; Smith's job at
factory of, 42–44, 120, 127, 221, 255,
568
Studebaker, Clement, 43
Studebaker, Clement, Jr., 46
Studebaker, Henry, 43
Studio 35, 337–38
Subjects of the Artists, 321, 337
Sugarman, George, 551, 553, 658

Illustration Credits

Page 115 © 2022 Estate of David Smith/Licensed by VAGA at Artists Rights Society (ARS), New York.

Page 116 The Dorothy Dehner Foundation, New York, courtesy the Dorothy Dehner Foundation, New York.

Page 119 The Baltimore Museum of Art: Gift of Elinor G. Graham, Towson, Maryland, BMA 1978.129. Photograph by Mitro Hood.

Page 119 Photograph by David Heald. © 2022 Estate of David Smith/Licensed by VAGA at Artists Rights Society (ARS), New York.

Page 122 Photograph by David Smith, Bolton Landing, New York, ca. 1960. The Estate of David Smith, New York. © 2022. The Estate of David Smith, New York. Estate of David Smith/Licensed by VAGA at Artists Rights Society (ARS), New York.

Page 129 Courtesy of the Dorothy Dehner Foundation, New York; courtesy of David C. Levy; Gottlieb Art © 2022 Adolph and Esther Gottlieb Foundation/ Licensed by VAGA at Artists Rights Society (ARS), New York; Smith Art © 2022 The Estate of David Smith/Licensed by VAGA at Artists Rights Society (ARS), New York.

Page 143 The Dorothy Dehner Foundation, New York.

Page 157 © 2022 Estate of David Smith/Licensed by VAGA at Artists Rights Society (ARS), New York.

Page 160 Musée d'Art Classique des Mougins. The Estate of David Smith, New York. © 2022 Estate of David Smith/Licensed by VAGA at Artists Rights Society (ARS), New York.

Page 167 © 2022 Estate of David Smith/Licensed by VAGA at Artists Rights Society (ARS), New York.

Page 172 Smithsonian Institution, Washington, D.C. Gift of Joseph H. Hirshhorn, 1972 (72.2670). Photograph by David Smith, Bolton Landing, New York, ca. 1936. © 2022 Estate of David Smith/Licensed by VAGA at Artists Rights Society (ARS), New York.

Page 175 David C. Levy. © 2022 Estate of David Smith/Licensed by VAGA at Artists Rights Society (ARS), New York.

Page 181 Mr. and Mrs. David Mirvish, Toronto. © 2022 Estate of David Smith/ Licensed by VAGA at Artists Rights Society (ARS), New York.

Page 182 Photographed at Terminal Iron Works, Brooklyn, ca. 1937. © 2022. The Estate of David Smith, New York. Estate of David Smith/Licensed by VAGA at Artists Rights Society (ARS), New York.

Page 183 Weatherspoon Art Museum, University of North Carolina at Greensboro. Museum purchase with funds from anonymous donors (1979.2668). © 2022 Estate of David Smith/Licensed by VAGA at Artists Rights Society (ARS), New York.

Page 212 Cleveland Museum of Art. Bequest of Dorothy Dehner (1995.36). Photograph by David Smith. © 2022.

Page 224 Photograph: Genevieve Hanson, courtesy of Hauser & Wirth. The Estate of David Smith, New York. © 2022 Estate of David Smith/Licensed by VAGA at Artists Rights Society (ARS), New York.

Page 225 Private collection. Photograph: Genevieve Hanson, 2016, courtesy of Hauser & Wirth. © 2022 Estate of David Smith/Licensed by VAGA at Artists Rights Society (ARS), New York.

Page 226 The Estate of David Smith, New York. Photograph by D. James Dee. © 2022

Estate of David Smith/Licensed by VAGA at Artists Rights Society (ARS), New York.

Page 227 The Estate of David Smith, New York. Photograph by David Heald. © 2022 Estate of David Smith/Licensed by VAGA at Artists Rights Society (ARS), New York.

Page 233 Storm King Art Center, Mountainville, New York. Gift of Margaret Hovenden Ogden, 1978. © The Dorothy Dehner Foundation, New York. Photograph by Jerry L. Thompson.

Page 251 The Estate of David Smith, New York. Photograph by Geoffrey Clements. © 2022 Estate of David Smith/Licensed by VAGA at Artists Rights Society (ARS), New York.

Page 254 Private collection. Photograph by David Heald. © 2022 Estate of David Smith/Licensed by VAGA at Artists Rights Society (ARS), New York.

Page 268 Private collection, Atherton, California. Photograph by David Smith. © 2022 Estate of David Smith/Licensed by VAGA at Artists Rights Society (ARS), New York.

Page 271 Denise and Andrew Saul. Photograph: EPW Studio. © 2022 Estate of David Smith/Licensed by VAGA at Artists Rights Society (ARS), New York.

Page 272 Saint Louis Art Museum. Museum purchase (188:1946). Photograph by David Smith, Bolton Landing, New York, ca. 1945. © 2022 Estate of David Smith/Licensed by VAGA at Artists Rights Society (ARS), New York.

Page 274 Private collection. Photograph: David Heald. © 2022 Estate of David Smith/Licensed by VAGA at Artists Rights Society (ARS), New York.

Page 277 Sidney and Lois Eskenazi Museum of Art, Indiana University (69.15). Photograph by Kevin Montague. © 2022 Estate of David Smith/Licensed by VAGA at Artists Rights Society (ARS), New York.

Page 278 The Estate of David Smith, New York. Photograph by Jerry Thompson. © 2022 Estate of David Smith/Licensed by VAGA at Artists Rights Society (ARS), New York.

Page 282 Tate Modern, London. Lent by the American Fund for the Tate Gallery and Candida and Rebecca Smith, the artist's daughters, fractional and promised gift, 2000 (L01025). Photograph by David Smith, Bolton Landing, New York, 1945. The Estate of David Smith, New York. © 2022 Estate of David Smith/Licensed by VAGA at Artists Rights Society (ARS), New York.

Page 303 Private collection. Photograph by David Smith, Bolton Landing, New York, ca. 1946. © 2022 Estate of David Smith/Licensed by VAGA at Artists Rights Society (ARS), New York.

Page 304 Harvard Art Museums/Fogg Museum. Gift of Lois Orswell (1994.17). © 2022 Estate of David Smith/Licensed by VAGA at Artists Rights Society (ARS), New York.

Page 316 Collection Helen Frankenthaler Foundation. Photograph by Jerry Thompson. © 2022 Estate of David Smith/Licensed by VAGA at Artists Rights Society (ARS), New York.

Page 316 Walker Art Center, Minneapolis. Gift of the T. B. Walker Foundation (1952.4). Photograph by David Smith, Lake George, Bolton Landing, New York. © 2022 Estate of David Smith/Licensed by VAGA at Artists Rights Society (ARS), New York.

Page 334 Seattle Art Museum. Gift of the Virginia and Bagley Wright Collection, in honor of the 75th Anniversary of the Seattle Art Museum (2016.17.5).

Photograph by David Heald. © 2022 Estate of David Smith/Licensed by VAGA at Artists Rights Society (ARS), New York.

Page 335 Lehmbruck Museum, Duisburg (1232/1968). Photograph by David Smith, Bolton Landing, New York, ca. 1950. © 2022 Estate of David Smith/ Licensed by VAGA at Artists Rights Society (ARS), New York.

Page 347 Munson-Williams-Proctor Arts Institute, Museum of Art, Utica, New York. Museum purchase (51.37). Photograph by David Smith. © 2022 Estate of David Smith/Munson-Williams-Proctor Arts Institute /Art Resource NY.

Page 355 Courtesy of the Estate of David Smith.

Page 360 Private collection. Photograph by David Smith, Bolton Landing, New York, ca. 1950. © 2022 Estate of David Smith/Licensed by VAGA at Artists Rights Society (ARS), New York.

Page 361 Whitney Museum of American Art, New York. Purchase (54.14). Photograph by David Smith, Bolton Landing, New York, ca. 1950. © 2022 Estate of David Smith/Licensed by VAGA at Artists Rights Society (ARS), New York.

Page 365 Museum of Modern Art, New York. Gift of William Rubin (1533.1968). Photograph by David Smith, Bolton Landing, New York, ca. 1951. © 2022 Estate of David Smith/Licensed by VAGA at Artists Rights Society (ARS), New York.

Page 368 Smithsonian Institution, Washington, D.C. Gift of Joseph H. Hirshhorn, 1966 (66.4638). Photograph by David Smith (in progress), Bolton Landing, New York, ca. 1952. © 2022 Estate of David Smith/Licensed by VAGA at Artists Rights Society (ARS), New York.

Page 373 Dedalus Foundation archives. © 2022 Estate of David Smith/Licensed by VAGA at Artists Rights Society (ARS), New York.

Page 398 Art Institute of Chicago. Gift of Jay Steinberg and Muriel Kallis Steinberg in memory of her father, Maurice Kallis (1953.193). Photograph by David Smith, Bolton Landing dock, Lake George, New York, ca. 1952. © 2022 Estate of David Smith/Licensed by VAGA at Artists Rights Society (ARS), New York.

Page 398 Photograph by David Smith, Bolton Landing dock, Lake George, New York, ca. 1953. © 2022 Estate of David Smith/Licensed by VAGA at Artists Rights Society (ARS), New York.

Page 426 Private collection. Photograph: David Heald. © 2022 Estate of David Smith/Licensed by VAGA at Artists Rights Society (ARS), New York.

Page 453 Storm King Art Center, Mountainville, New York. Gift of the Ralph E. Ogden Foundation (1967.7). Photograph by David Smith, Bolton Landing, New York, ca. 1960. © 2022 Estate of David Smith/Licensed by VAGA at Artists Rights Society (ARS), New York.

Page 454 Peter and Beverly Lipman. Photograph by David Smith, Bolton Landing, New York, ca. 1956. © 2022 Estate of David Smith/Licensed by VAGA at Artists Rights Society (ARS), New York.

Page 455 Harvard Art Museums/Fogg Art Museum, gift of Lois Orswell (1994.19). Photograph by David Smith, Bolton Landing, New York, 1956. © 2022 Estate of David Smith/Licensed by VAGA at Artists Rights Society (ARS), New York.

Page 474 Smithsonian Institution, Washington, D.C. Gift of Joseph H. Hirshhorn, 1966 (66.4634). Photograph by David Smith, Bolton Landing, New York,

ca. 1957. © 2022 Estate of David Smith/Licensed by VAGA at Artists Rights Society (ARS), New York.

Page 519 Harvard Art Museums/Fogg Museum. Gift of Lois Orswell (1994.16). Photograph by David Smith, Bolton Landing, New York, ca. 1960. © 2022 Estate of David Smith/Licensed by VAGA at Artists Rights Society (ARS), New York.

Page 528 © Burt Glinn | Magnum Photos, Helen Frankenthaler and David Smith in front of *Mountains and Sea* (1952) at Frankenthaler's West End Avenue apartment and studio, 1957. © 2022 Helen Frankenthaler Foundation, Inc./Licensed by VAGA at Artists Rights Society (ARS), New York.

Page 533 Courtesy of Margaret Rosati Norton.

Page 544 Courtesy Galerie Gmurzynska. Photograph by David Smith, Bolton Landing, New York, ca. 1961. The Estate of David Smith, New York. © 2022 Estate of David Smith/Licensed by VAGA at Artists Rights Society (ARS), New York.

Page 547 © 2022. Photograph by David Smith, Bolton Landing, New York. Estate of David Smith/Licensed by VAGA at Artists Rights Society (ARS), New York.

Page 567 Photograph © 2022 Ugo Mulas Heirs. All rights reserved.

Page 571 Photograph by Publifoto, outside the factory in Voltri. © 2022 Estate of David Smith/Licensed by VAGA at Artists Rights Society (ARS), New York.

Page 572 Photograph by David Smith, Anfiteatro Romano, Spoleto, Italy, 1962. © 2022 Estate of David Smith/Licensed by VAGA at Artists Rights Society (ARS), New York.

Page 573 Raymond and Patsy Nasher Collection, Nasher Sculpture Center, Dallas (NC. 1978.A.04). Photograph by David Smith, Anfiteatro Romano, Spoleto, Italy, 1962. © 2022 Estate of David Smith/Licensed by VAGA at Artists Rights Society (ARS), New York.

Page 575 © 2022 Ugo Mulas Heirs. All rights reserved.

Page 577 © 2022 Ugo Mulas Heirs. All rights reserved.

Page 578 Courtesy Gisella Zanmatti Speranza.

Page 592 © 2022 The Estate of Dan Budnik. All rights reserved.

Page 594 © 2022 The Estate of Dan Budnik. All rights reserved.

Page 595 © 2022 The Estate of Dan Budnik. All rights reserved.

Page 618 © 2022. The Estate of David Smith, New York. Estate of David Smith/Licensed by VAGA at Artists Rights Society (ARS), New York.

Page 619 © 2022. The Estate of David Smith, New York. Estate of David Smith/Licensed by VAGA at Artists Rights Society (ARS), New York.

Page 625 Detroit Institute of Arts, Founders Society Purchase, Special Purchase Fund (66.36). Photograph by David Smith, Bolton Landing, New York, 1963. © 2022 Estate of David Smith/Licensed by VAGA at Artists Rights Society (ARS), New York.

Page 626 © 2022 The Estate of Dan Budnik. All Rights Reserved.

Page 642 National Gallery of Canada. Purchased 1968 (15703). Photograph by David Smith, Bolton Landing, New York, 1964. © 2022. The Estate of David Smith, New York. Estate of David Smith/Licensed by VAGA at Artists Rights Society (ARS), New York.

Page 643 Nelson-Atkins Museum of Art. Gift of the Hall Family Foundation (F99-33/83). Photograph by David Smith, Bolton Landing, New York, 1964. The Estate of David Smith, New York. © 2022 Estate of David Smith/Licensed by VAGA at Artists Rights Society (ARS), New York.

Michael Brenson is a former member of the sculpture faculty at Bard College's Milton Avery Graduate School of the Arts and is the author of *Visionaries and Outcasts: The NEA, Congress, and the Place of the Visual Artist in America*. He holds a doctorate in art history from Johns Hopkins university and has been an art critic for *The New York Times* and a Guggenheim Fellow. Brenson has curated exhibitions at MoMA PS1 and the SculptureCenter, and he is currently the artistic director of the Jonathan and Barbara Silver Foundation. He lives in Accord, New York.